FUNDAMEN GEMENT

Fundamentals of Arts Management

Fourth Edition

Published by the Arts Extension Service

Division of Continuing Education

University of Massachusetts Amherst

Amherst, MA 01003

(413) 545-2360

FAX (413) 577-3838

Email: aes@contined.umass.edu

www.umass.edu/aes

Library of Congress Control Number: 2003100243

ISBN 0-945464-12-6.

Printed in the United States of America

First published in 1987 as *Fundamentals of Local Arts Management*

Dear Readers,

Since the initial publication of *Fundamentals* in 1987, various copies and editions have become dog eared, book marked and highlighted as arts and nonprofit organization managers across the country, and around the world, use it as their primary reference book on management issues from strategic planning and board development to marketing and fundraising.

Now with the fourth edition, Arts Extension Service provides updates and new chapters to keep pace with the emerging and changing field of community arts management. The readers of this book are changing as well. More than 800 colleges and universities now use this book in undergraduate and graduate level arts management courses. We use *Fundamentals* as the textbook for the University of Massachusetts on-line courses in arts management. In addition, nonprofit leaders in social service and environmental organizations find this book a useful reference tool.

Under the editorial guidance of AES director emeritus Craig Dreeszen, we have assembled an outstanding team of contributing writers who address the administrative needs of arts organizations through insightful writing that is both hands-on and practical in nature, while embracing the passion of the arts.

You may read this book cover to cover, but keeping it close throughout the administrative cycle of the year and referring to particular chapters as issues arise will be helpful.

Shirley K. Sneve, Director

Arts Extension Service

FUNDAMENTALS OF ARTS MANAGEMENT 4th Edition

Editor Craig Dreeszen, Ph.D.

Expanded and revised from the third edition edited by Craig Dreeszen and Pam Korza

Funded in part by the National Endowment for the Arts, the Bill and Sally Venman Community Arts Endowment Fund, the UMass Amherst Division of Continuing Education and the Massachusetts Cultural Council.

NATIONAL ENDOWMENT FOR THE ARTS

Massachusetts Cultural Council

Cover: Photograph by Marco Giammetti, Spiritree. Fifth grade students at the Littleton School in Parsipinnay, NJ.

Design by George Barham and Jack Cavacco

FUNDAMENTALS OF

ARTS

MANAGEMENT

Editor Craig Dreeszen, Ph.D.

Expanded and revised from the third edition
edited by Craig Dreeszen and Pam Korza

Published by the Arts Extension Service

Division of Continuing Education

University of Massachusetts Amherst

Table of Contents

3. Board Development: Leading to Effective Governance 71

6. Arts Education: Defining, Developing, and Implementing a Successful Program

By Marete Wester with Contributing Editor David O'Fallon

9 Marketing: Tools for the Arts **293**

Fundamentals of Arts Management is the classic text in arts management that has been helping professional and volunteer arts leaders learn to connect the arts and community since the first edition in 1987. As the field evolves so has this text. This fourth edition significantly updates chapters on strategic planning, fundraising, board development, and marketing. Four entirely new chapters on community organizing, program evaluation, arts education, and accessibility bring the book in line with the larger range of professional skills needed by 21st century community arts managers.

Fundamentals of Arts Management is published by the Arts Extension Service with funding from the National Endowment for the Arts, the Bill and Sally Venman Community Arts Endowment Fund and the Division of Continuing Education at the University of Massachusetts Amherst.

The Arts Extension Service (AES) is a nonprofit national arts service organization, a program of the Division of Continuing Education of the University of Massachusetts Amherst. Connecting Art and Community since 1973. The Arts Extension Service develops the arts in communities and community through the arts with continuing professional education for arts managers, artists, and civic leaders.

The Division of Continuing Education, University of Massachusetts Amherst, provides part-time study for people of all ages. The Division of Continuing Education provides access to the academic resources of the University to part-time students, to local, national, and international businesses, and to the general community. Undergraduate courses, specialized degree programs, noncredit workshops, and professional development certificates and programs are specifically designed for, and delivered to, people whose other responsibilities make full-time study difficult.

NATIONAL ENDOWMENT FOR THE ARTS

The National Endowment for the Arts enriches our Nation and its diverse cultural heritage by supporting works of artistic excellence, advancing learning in the arts, and strengthening the arts in communities throughout the country. The National Endowment for the Arts provides national recognition and support to significant projects of artistic excellence, thus preserving and enhancing our nation's diverse cultural heritage. The Endowment was created by Congress and established in 1965 as an independent agency of the federal government. This public investment in the nation's cultural life has resulted in both new and classic works of art reaching every corner of America.

Writers and editorial team. **Thanks to writers Mary Altman, Janet Brown, Christine (Tina) Burdett, Craig Dreeszen, Gay Drennon, Maryo Gard Ewell, Lisa Kammel, Pam Korza, Denise Boston-Moore, Halsey M. North, Alice H. North, Shirley K. Sneve, Barbara Schaffer Bacon, Paula Terry, Marete Wester, and Sally Zinno. Thanks also to Craig Dreeszen editor, Shirley K. Sneve, production manager; George Barham and Jack Cavacco, designers; John Fiscella, copy editor, and Alyson Marcell, administration and data entry. Pam Korza co-edited the third edition upon which this volume was based.**

FOREWORD

Earlier editions of *Fundamentals of Arts Management* have been helping thousands of arts professionals and volunteers learn the essential skills to lead arts organizations. I used the first version of this work in the early 1980s as a humble set of workshop handouts while teaching for the Arts Extension Service Summer Program in Arts Management. As the field of arts management has matured, so has this book. It has been gratifying to see this publication become the respected, standard textbook for the essential skills of arts management. The book is used by dozens of University programs in arts management, as the companion to online courses, and as an often-consulted reference for practitioners.

This 4th edition redefines the fundamental skills of arts management with all new chapters on accessibility, program evaluation, arts education, and community organizing. While based on research, the book is ultimately a practical guide to managing arts organizations. The practical skills are presented in the context of the history of the community arts movement. The book also has a point of view consistent with the AES mission to "develop the arts in communities and community through the arts."

Robert L. Lynch

President and CEO, Americans for the Arts

For those of us who believe that the arts make a real difference in people's lives and the well being of communities, the education of our next generation of arts managers and the continuing professional development of our current leaders are critical tasks. The quality of leadership makes a big difference in how well arts organizations serve their audiences and communities. Good leaders need a solid grounding in the fundamentals.

I am grateful for the new leadership at Arts Extension Service at the University of Massachusetts to continue to lead in developing arts management workshops and courses, educational conferences and texts such as this.

Craig Dreeszen, former director, Arts Extension Service

INTRODUCTION

THE POPULIST ARTS MOVEMENT

ALTERING THE FACE OF AMERICA

The Inaugural Robert Gard Lecture

Northampton Center for the Arts

June 18, 1999, Northampton, Massachusetts

by Janet L. Brown

"If we are seeking in America, let it be seeking for the reality of democracy in the arts. Let art begin at home and let it spread through the children and their parents, and through the schools and the institutions and government. And let us start by acceptance, not negation...acceptance that the arts are important everywhere, that they can exist and flourish in small places as well as large, with money and without it, according to the will of the people. Let us put firmly and permanently aside the cliche that the arts are a frill. Let us accept the goodness of art where we are now, and expand its worth in the places where people live."

Robert Gard

Each year the Arts Extension Service recognizes a distinguished leader who contributes significantly to the national community arts movement as the Robert Gard Lecturer. The honor goes to someone who works in the Gard tradition and the AES mission to develop the arts in communities and community through the arts. The award is accompanied by an invitation to reflect upon a career of community arts development and a commission to write and present a lecture. The complete set of Gard Lectures is online at www.umass.edu/aes

Robert Gard first came to me in the form of his daughter, Maryo Ewell. Her thoughts, her writings, her instincts are inspirational and self-assuring to me. Her belief in people and their power to build community through the arts shook me awake about thirteen years ago. It was my people she was talking about, my sense of place, my community.

I was asked by Patrick Overton at Columbia College, Columbia, Missouri to write a paper in 1990 for a symposium and publication he was coordinating. The symposium entitled "Grassroots and Mountain Wings" brought many of my heroes in the community development field together: Maryo, David O'Fallon, Chris Van Antwerp, Bob Lynch, Bill Pratt, Danielle Withrow, Joan Lolmaugh, Tina Burdett, Nola Ruth. But most importantly, the symposium and the subsequent publication by the same name were dedicated to Robert Gard, the poet, prophet and pioneer.

I met Robert Gard at that symposium. I listened to his remarks and he listened to mine. They were, indeed, incredibly similar in content and philosophy. I was grateful to have met him and to have been introduced to his writings and his accomplishments. He was truly a pioneer in community arts development. It is a great challenge to be honored in his name and I hope that my work can live up to his vision and boldness.

I was born to be a populist. Not that I was born a populist, I had to work at it. I grew up in Dell Rapids, South Dakota, population 2,000. My father sold commercial feed to farmers and my mother, educated as a teacher, stayed home and raised five kids. On my father's side, we are the descendants of Norwegian pioneers who arrived in South Dakota in covered wagons, lived in sod huts and survived the harsh winters and isolation of the prairie. My great-grandfather's diary became the basis for the classic novel, "Giants in the Earth" by my father's cousin Ole Rølvaag.

On my mother's side, we are Irish who fought the British in Massachusetts and moved west to fight the Indians in Minnesota and finally settle in South Dakota. As my husband is fond to telling everyone, the Irish half of me gets mad real fast and the Norwegian half of me stays mad for a long time.

I left South Dakota in 1976 for the "big time" in San Francisco, sure that I would find only the best, the brightest, the most talented and highest quality of arts offerings. It was an eye opener. Some things were wonderful, the institutions were grand: the symphony, the regional theatre, the opera, the modern art museum, the not-modern art museum, the ballet. But not every performance was the best, not every actor the most talented, not every play was brilliantly directed. There were moments of artistic euphoria and there were also moments of mediocrity and self-indulgent garbage.

From San Francisco, we moved to New York City; then a year touring the major cities of Europe and more of the same. Perceptions were shattered and the rule became that there was no rule and the reality was best described by a line from the movie, *Little Big Man*, "Sometimes the magic works and sometimes it doesn't."

In 1980, when I was living in New York City, I had a conversation with a man who at one time was general manager of Lincoln Center. We debated, rather heatedly, his premise that the National Endowment for the Arts should give money only to states that produce "good" art, in other words, New York. He wasn't really sure if any other states should get any funding at all. He believed the federal government should give funds to South Dakota for what it does well, grow corn and beef. He believed the government should fund only what someone would decide was "good" art and obviously, no "good" art came out of South Dakota.

Well, I was offended by that and I can pinpoint that day, as the beginning of my militant position as a populist arts administrator. My perceptions that great art

experiences occur only in metropolitan areas or in major institutions had been shattered. My concept of what makes art "good" changed forever. I delight in the fact that there are no rules of geography and environment in artmaking and that perceptions are ever changing.

Today's populist art movement, the community arts movement, flows on several different planes at the same time. Our job as arts professionals has become more complex as we attempt to connect those planes, understand the perceptions of our constituents and convene audiences, patrons and artists. We are working with education, social services, juvenile corrections, preservation and more. But at the root of it all is our work to give the arts a home, provide a place and time for people to come together to celebrate and to give our artists the opportunities they deserve.

I like to think of us these days not as arts administrators, which I have always thought was an oxymoron, but more like arts shepherds. I have a Sheltie dog at home and in the office. His name is Max. He is a herder. He worries when one of the flock Is missing, he doesn't eat until everyone is safe and at home and he always sleeps with his back up against the wall in case of attack. These are good traits for an arts administrator.

But as shepherds of the arts, we have several challenges facing us as we enter the 21st century. One of our greatest challenges is the shepherding of young people. How do we show value for their art? How do we involve them in our organizations, programs and value systems? How do we promote their talents as they grow into mature artists and arts consumers? What are we doing to embrace them? There is a dialogue that needs to happen in every community between youth and community arts organizations. This dialogue is more important today than ever before in the history of our country. Because in the arts, young people can find democracy, self-confidence, a voice of their own and a place to belong.

We must simply talk to them. What do they want? How can we help? They may not want what we want them to want. Oh horrors, then what will we do?

There is a also a great role for every community arts organization in the advocacy of arts education in our schools. In America, we have allowed creativity and imagination to take a back seat to the so-called basics when in fact, what is more basic? What is more basic than imagination? What is more basic than creativity? Many of our elementary schools have no arts specialists at a time in our children's lives when they are most creative. Most schools manage to pound the creativity and playfulness out of children by the time they reach middle school. If we are to play a dynamic role in the development of communities, we must be outspoken advocates for arts education at an early age.

We are also challenged to build bridges between the commercial and nonprofit arts worlds. It seems so ludicrous that we struggle so financially to keep theaters, museums, symphonies alive when *Star Wars* has grossed over $250 million. I'm not a communist and I don't believe that we should all share in George Lucas' earnings. However, there is a connection between the people trained in the nonprofit sector that go on to be commercial successes. How can we support each other? Americans for the Arts has done great work in this area with Michael Green and the National Academy of Recording Arts and Sciences. I would hope that we will begin at the local level to make the same connections.

When the National Endowment for the Arts (NEA) was created in the 60s, America needed a mechanism to nurture composers, writers, playwrights and visual artists. Major institutions were in great need of support to compete with European operas, symphonies and ballets. The perception of the Endowment as elitist today came from its focus on these rather well-heeled and metropolitan-based institutions thirty years ago. The NEA began its journey specifically to fund the

product of art. This became problematic almost immediately as the professional world of art which produced the product centered in only about a half dozen metropolitan areas.

Even though by the late 80s, the NEA had created the Locals program, the Folk Art program, and other populist programs, the perception was that it funded big institutions and weird artists. When the attack came, we didn't know what hit us and we had no idea how poorly we were perceived and how damaging the spin would be. We also had no perception of how poorly we could defend ourselves. It was damaging to the tune of $75 million dollars and we're still recovering.

The lesson for those of us who work in our own communities and states is that perception is reality and for the NEA it was too little too late. We must take a reality check more often than every 25 years to make sure that our reality equals the public's perception.

Community arts organizations are strengthened by a populist foundation. It's like that great Fats Waller tune, "Find out what they like and how they like it, and let 'em have it just that way." There are those among us that are absolutely appalled by this kind of thinking in the arts. That somehow we will degrade ourselves, that great art forms will disappear, that true artists will be overrun by the mediocrity of the masses. I don't believe that for one moment.

I believe that we know the difference between poorly done theatre and excellent theatre. Even the most untrained eye can tell the difference between The Nutcracker Ballet performed by Miss Terry's Dance Studio and by the Joffrey Ballet Company. The artistic experience had by the audience depends on the audience itself. If the audience is filled with parents and grandparents of children in Miss Terry's Dance Studio, the artistic experience is an incredibly moving one even though the art form itself has some developing to do.

The real connection between the two performances happens when that parent is witness to both performances at two different times in his child dancer's life. There is a connection between these two and we, as arts administrators, publicists, advocates and shepherds, make that connection. We advocate that there is a connection between arts education and the quality of instrumentalists of the Boston Symphony. The production of community and school theater in small towns in South Dakota and in Massachusetts, Vermont, Mississippi and Alaska makes for better theatre in New York and Washington, D.C.

This is a creative ecosystem. It needs nurturing and protection. In order for the creative ecosystem to thrive, the chain must be complete at every level, from Miss Terry's Dance Studio to the Joffrey Ballet.

In 1995, Garrison Keillor spoke before the Senate Subcommittee on Education, Arts and Humanities. I love this quote from that speech. He said'"Today, in every city and state, when Americans talk up their home town, invariably they mention the arts, a local orchestra or theater or museum or all three. It didn't use to be this way. Forty years ago, if an American meant to have an artistic career, you got on the train to New York. Today, you can be a violinist in North Carolina, a writer in Iowa, a painter in Kansas. Today, no American family can be secure against the danger that one of its children may decide to become an artist."

And he is right. We have come such a long way since Robert Gard began his work. We can pat ourselves on the back. We can take some credit. We must put into perspective that America is a young country. Where I live, we are just over a 100 years old. We've only recently determined that we have gathered enough food and wood for survival and that we can now turn our attention to celebrating as a community, a state, a people. We look to our native peoples, the Lakota, Dakota and Nakota Sioux, who have no word for "art" because art is synonymous with being a human being. We haven't quite achieved that level of understanding

yet amongst the northern European majority in my state. But, I'd like to think that we're moving in that direction.

To meet the challenges of the next century, the arts community must have leadership with passion, vision and guts. We must have a clear understanding who we are leading and the potential of where we can go. We are a people's movement, doing the people's bidding. We must fight for every citizen to have access and participation in the arts. We must take risks and we must take charge.

Year's ago, someone called me a public servant. I bristled at that since I thought the term was meant only for government workers. However, I have come to believe that as leaders of non-profit organizations with the gift of tax-exempt status, we have an obligation to serve the public. Our organizations cannot make decisions without the public's best interest in mind and we cannot survive without the public's interest in our product. We _are_ public servants and by serving the public, we will thrive and move forward with their support.

I believe we have always been a populist movement. There is a new and very public spin from the National Endowment for the Arts to reach out to America with programs like ArtsREACH and the Challenge America programs. These are great ideas and will be very helpful to all of us if the current Chairman Bill Ivey can increase the budget using these populist programs as bait. I'm sorry we had to go through all that pain to learn that this is the sermon we should have been preaching all along.

I once had a conversation several years ago at a NALAA convention (now Americans for the Arts) that had a real impact on me. I was speaking on rural arts development and someone in the audience said they had a problem with audience development in their community. It seems they had instigated a chamber music series in a very small southern town and after three years, the audiences had not

grown and only a handful of faithful chamber musicites came to every concert. "What can I do, I've tried everything?" he asked me. My unpopular response to him was, "Stop doing chamber music concerts. No one wants them." It all goes back to that tune made famous by Fats Waller, "Find out what they like..."

As community arts developers, you can make a huge difference. It is your job to assure that "the reality is democracy in the arts." You can make the arts more popular, more accessible, more publicized, more educational, more everything.

This is not just a job for us, this is a life's work. We have devoted our lives to it as Robert Gard devoted his life to seeking out democracy in the arts through the artists in the farms and small towns of the Midwest. If you can't do that, then change jobs. Passion will move us forward, not statistics (although they come in handy) or grant programs (although they also help). It is passion that will inspire creativity and secure support. I used to try to figure out how we could institutionalize our organizations so they were not so dependent on personalities. I do believe that can be done to some extent, however, one cannot deny that passionate leadership has created much of what we have today. Artistic leadership, administrative leadership, dynamic personalities.

The Arts Extension Service is a perfect example. Look at the list: Stan Rosenberg, Bob Lynch, Barbara Schaffer Bacon, Craig Dreeszen, Shirley Sneve—passionate leaders, all. So, we shouldn't create organizations and programs that just anyone can run. Our goal should be extraordinary programs that serve our public administered by extraordinary people.

I want to close with a poem written by Robert Gard, which appears in "The Arts in the Small Community: A National Plan" written in 1967 as the result of one of the first rural projects funded by the NEA.

If you try, what may you expect?

First a community

Welded through art to a new consciousness of self:

A new being, perhaps a new appearance…

A people proud

Of achievements which lift them through the creative

Above the ordinary…

A new opportunity for children

To find exciting experiences in art

And to carry this excitement on

Throughout their lives…

A mixing of peoples and backgrounds

Through art; a new view

Of hope for mankind and an elevation

Of man…not degradation

New values for individual and community

Life, and a sense

That here, in our place,

We are contributing to the maturity

Of a great nation.

If you try, you can indeed

Alter the face and the heart

Of America.

Do I believe the arts can alter the face and heart of America? I do. Because I have seen the faces and I know the hearts of the passionate people who lead the community arts movement. You will alter the face of America.

Thank you.

CHAPTER 1

COMMUNITY ORGANIZING:

BUILDING COMMUNITY THROUGH THE ARTS

by Maryo Gard Ewell

and Mary Altman

PART ONE

"COMMUNITY BUILDING" AND "COMMUNITY ORGANIZING"

by Maryo Gard Ewell

Certain phrases crop up a lot in the mission statements of community arts organizations. One such phrase that is popular now is "community building." The arts have an important part to play in community building, but let's be clear about what it means.

"Community" has lately become one of those much used feel-good words. Political candidates running for office use it in speech after speech. Marketing firms trying to sell anything from cars to Internet access use it in ad after ad. It is clearly a word that people respond to powerfully. If people weren't hungry for "it," politicians and advertisers wouldn't use it so much. In fact, it is used so often it is starting to lose its meaning.

Community defined. For the purposes of this chapter, we are using the word "community" to refer to geography: a neighborhood, a town, a watershed. We are not referring to the "community of Jamaicans in Michigan," the "community of users of America On-line," or the "community of gay people." These are groups of people who are demographically similar. Group power is a valid and important process in creating a sense of group identity, but is not within the scope of this chapter. Here, we are referring to places where people who are different from one another live together and try to carve out a good life together. We are using it in the sense that Lewis Thomas, the biologist, did when he said,

"...[there are] no independent creatures. The life of any given individual, of any species, is dependent on other individuals, on other species . Moreover, the existence of a given species depends upon the genetic diversity of that species."

–Lewis Thomas

Community organizing defined. Within the arts world, the term "community-building" is frequently used as a synonym for audience development—creating groups of people who attend new music events or diversifying the demographics of an audience. Once again, this is not what we are addressing here. What we are talking about is the process by which people in geographic communities make use of the arts to create in Thomas' terms, an effective interdependency leading to a better life for all. To do that, effective organizing skills are necessary. Accordingly, what this chapter on "Community Arts Organizing" is about:

> building the capacity of the community and key leaders to use the arts to create an effective interdependency among people in a geographic place. An "effective interdependency" refers to bettering the community, with "better" defined by the diversity of people who live there.

There are several things that are critical about this definition of community arts organizing:

- It refers to a geographic place.

- It recognizes the diversity of people who live in that place.

- It recognizes that though community members may be very different from one another, they are all interested in creating a good life for themselves and their families.

- It recognizes that a neighbor's idea of a "good life" is as important as your own.

- It recognizes different people in a community need to work together on common goals and ways of addressing those goals.

- It recognizes that the arts are a key to doing this and so maybe most important.

- It makes a "good community" the end, with arts of excellence as the means.

Our intention is community building. This last point is a very important one. For those people who use "community building" as a synonym for "audience development," the arts are still the ends. Our intention is to get more people, or different people, to arts events. Since increased artistic activity is a hallmark of a "livable community," arts people often concentrate on producing more, and better, arts events. While we believe that is the job of many arts organizations, it too is outside the scope of this chapter.

Here, our intention is a good community, as defined by the diversity of people who live there, not as defined by the art organization. Thus, the organization offers its knowledge and skills as a service to this concept of a "built community," and works collaboratively with other community groups in order to do so.

Arts excellence matters. Let us put aside once and for all time the common idea that doing this kind of work somehow prostitutes the arts or minimizes their "quality" in the interest of "social service." This is an old, tired argument. Community-building work is most effectively undertaken when artists or arts organizations with impeccable standards of excellence are involved. This is not "just social work;" rather, we believe that the melding of arts knowledge and skills with community ends is creating a new aesthetic, one which may, in time, be considered the "cutting edge" aesthetic of the early twenty-first century. We also believe that this kind of work is forging new definitions and standards of what "excellence" means—but that too is another chapter for another book.

There are lots of other threads—can you find these too? Read this chapter and see how many you can identify!

Community change takes time. Change takes time, and truly effecting deep change is the work of generations. You may make some short-term improvements, but larger-scale cultural change isn't going to be effected in your lifetime. We will address this in the part of this chapter on necessary skill sets, but this kind of work requires a person who thinks of him or herself as a player in a game that takes decades to "win," and is prepared not to see any deep results right away – maybe not in their lifetime.

Outcomes for this chapter. By the end of this chapter, you should know:

The *Music Man* as Exemplar. Is this all getting a little too heavy? Take a break and rent the video of Meredith Wilson's **Music Man!** with Robert Preston. Turn your Saturday night movie-watching experience into a learning experience (with humor, of course). Note that:

- Early on, the people of River City explore what it means to live in Iowa;

- Professor Hill spends a good deal of time considering, and rejecting, possible issues to organize around before he hits on the pool hall idea;

- Professor Hill, the outside organizer, nonetheless collaborates with a local partner, Marian the librarian;

- Marian moves into a position of community leadership, culminating in a very strong stand at the end of the film, and co-leading the final celebration;

- The people (the Mayor) who see no reason to change. What about his wife, who sees "art" as only about the classics? What can we learn from them?

- The people (the City Council) who through the arts realize that they have more common ground than they were aware of;

- Change for the youth at risk in the community (the kid with the speech disability; or Tommy, the potential juvenile delinquent) comes in the form of the arts;

- The Think System of preparing for a concert is based on the art of keeping the "big picture" in mind the as well as an unwavering faith that it is the right thing to do.

- Something about your own history—for that will ground and connect you to a lineage of community arts ideas and people. We as community arts organizers need this kind of "lineage" as much as we need to know who our family forebears were;

- The importance of keeping the "big picture" as your guiding star;

- Some of the skills you will need, or strive to acquire, in order to stimulate the arts in your community;

- A stepwise approach to doing art for community change;

- Where you can go to get assistance.

History and what it tells us

Before we get into the mechanics of this kind of work, it is important to talk a bit about the past, for community arts is not a new idea. These stories will connect you to generations of other community arts organizers. First, your lineage is that of the community "griot," or cultural story-holder. In communities everywhere, the storyteller passes on knowledge to subsequent generations. These are not just good anecdotes, they are ways by which a culture shares its goals and its successes and what it knows and how to evaluate its progress. Look, for example, at the work of the Roadside Theater in Kentucky. They are not just making plays based on stories, but works whose purpose is to articulate wisdom and evaluate cultural progress.

Village Improvement. Consider Anglo cultures in the United States, circa 1853. The Village Improvement movement, started in Massachusetts, addressed issues of ugly billboards, the need for community trees, paved roads, and recreational facilities. By 1900, there were about 3,000 such groups in the United States, trying to develop a sense of place through aesthetics.

City Beautiful. This in turn led to the City Beautiful movement, exemplified by the architectural ideas showcased at the Chicago World's Fair at the end of the nineteenth century, which emphasized a return to grand, classical architecture for public buildings. The Museum of Science and Industry, the Aquarium, and the Midway were all World's Fair buildings.

Olmstead and Wright. At about this time, Frederick Law Olmstead was stressing the importance of parks in cities, and a few public art commissions were created in urban areas. Two things slowed this civic aesthetics

movement down, however. First, the idea that grandeur was classist, just another amenity for the wealthy. Second, efficiency and functionalism were replacing aesthetics as values in the United States. There were a few voices raised in opposition to this. A notable one was Frank Lloyd Wright, who believed that the middle class had the same right to aesthetics that the upper class did; he even designed a line of wallpaper, drapes, and so forth to be marketed through F. Schumaker & Company. This story holds our roots of involvement in public art and design. As we take action to ensure that artists serve on city engineering teams for the design of everything from manhole covers to bridges, as we design public art processes based on public input, as we consider icons at the edge of town to welcome us to the community, we are acting in the tradition begun in the United States 150 years ago.

Lyceum movement. Now return to the early 1800s and follow another thread. In this story, Josiah Holbrook of Massachusetts started inviting neighbors to his home for discussions of books. Gradually, he started inviting professors, and the discussions expanded to encompass new ideas. This led to the founding of the American Lyceum Association in 1831; by 1850 there were about 3,000 of these groups. However, the idea was introduced that discussion leaders should be paid honoraria and the discussions should become lectures. The next logical step was to put lecturers on "the circuit," and James Redpath started a management organization to do exactly that. He valued efficiency, so naturally favored lectures in communities that could afford the fee and that were on the railroad line. The grassroots movement, begun as discussions by ordinary folks in people's homes, began to wither as this more "professional" movement grew.

Chautauquas. Now, cut to Chautauqua, New York, where Reverend John Vincent was experimenting with the use of the arts to teach the Bible. This approach proved very popular, and pretty soon, Reverend Vincent's study packages were being shipped to scores of local Chautauqua Circles. Back at the Redpath agency, now-manager Keith Vawter had a big idea; he had lecturers and the Chautauqua

Circles were a network of potential presenters. So he brought the two together; if the lecturer was hot enough and the town was small enough, he even provided tents for the lecture. Do you see our presenting roots in these stories? Furthermore, they reveal the linking of the arts to the introduction of new ideas and new ways of thinking, as well as the notion of learning about a given topic through artistic methodology.

Now think about the growth of the arts themselves. There were theater companies in America in the eighteenth century, especially in the urban areas, though a performance by a so-called professional company was reported in rural Kentucky in 1797. There were performances on showboats and there were Mexican vaudeville companies traveling throughout the southwest. Artists like Edwin Booth and Sarah Bernhardt appeared in many small towns. It was even said that in the Rocky Mountain West, the first building built after the assayer's office and the saloon was the opera house, and in many places that was probably true.

Community concerts. Redpath's idea of traveling lecturers spawned groups like Columbia Artists Management and suddenly there were community concert series growing throughout the country. Community-based arts were growing, too, especially in small towns. Fargo, North Dakota, had an art league well-established by 1911. Quincy, Illinois, had an orchestra with a paid conductor by 1947.

Local arts agencies. In 1944, the Junior League of America took arts management one step further, offering consulting services to communities wanting to expand the number of arts activities and to coordinate existing arts activities. The woman behind this idea, Virginia Lee Comer, was insistent that when she visited a community, she should talk to all groups of people – not just arts groups – about creative activity in the community. She saw churches, union halls, and housing projects as obvious places for arts activity because people already gathered there. (Is this not the forerunner of the "community cultural planning" that our generation believes we invented in the

1980s?) Comer's manual on assessing, coordinating and stimulating arts activities in small communities, and her work in Winston-Salem, North Carolina, in 1946-1947, probably led directly to the institution of community arts councils.

Settlement House movement. At the turn of the twentieth century in urban areas, the Settlement House movement begins. Jane Addams founded Hull House in Chicago to provide entry and orientation points for new immigrants to the United States, and to provide basic social services for them. She was adamant that neither poverty nor language barriers should mean disenfranchisement from one's culture. Her comprehensive social service program included meals and helping to locate housing, but it also included a gym, men's and women's clubs, programs in native languages as well as English, a library, art classes, an art gallery, and a drama group.

University extension services. Meanwhile, in rural areas, the Extension Services of the land grant universities were doing similar work with rural people. They were producing opera in Iowa, encouraging folk arts in Kentucky, inserting the arts into community planning efforts in Ohio, linking arts and recreation, arts and homemaking, and arts and the meaningful use of leisure time. Some individuals stand out: in upstate New York, Alexander Drummond was disgusted by the quality of so-called "rural plays" marketed by Samuel French, which portrayed rural people as hicks. So Drummond called for farmers who might want to write plays, and deployed his graduate students in theater as the dramaturgs to help them do so.

In North Carolina, Frederick Koch believed that because of the nature of the American ideal, America's culture could ONLY be recorded by ordinary Jo(e)s. So he required students in his theater program to start writing "folk plays"—plays about their background, about people in their communities. He insisted that his program be a mix of students rich and poor, sharecropper and landowner, black and white. Literally thousands of these "folk plays" were written in North Carolina during his time on the faculty and in other communities where he was asked to stimulate community playwriting.

Alfred Arvold, in North Dakota, was passionate that a community was an organic whole, and that the arts must not be broken off from the ongoing life of the community. To this end, he promulgated the notion of the community center where there would be a wonderful jumble of activity—It would be a recreation center, science center, arts center, government center at once, where the boundaries between activities blurred. In 1917 he wrote,

> *A community center is a place, a neighborhood laboratory, so to speak, where people meet in their own way to analyze whatever interests they have in common and participate in such forms of recreation as are healthful and enjoyable. The fundamental principle back of the community center is the democratization of all art so the common people can appreciate it, science so that they can use it, government so that they can take a part in it, and recreation so they can enjoy it. In other words, its highest aim is to make the common interests the great interests. To give a human expression in every locality to the significant meaning of these terms— "come let's reason and play together" is in reality the ultimate object of the community center.*[1]

Robert Gard. In Wisconsin, Robert Gard's initial dream was to get every Wisconsinite writing; this ideal grew from the notion of populist government that prevailed in Wisconsin at the time. This "Wisconsin Idea" interrelated civic involvement, public education, access to the newest ideas, and fulfillment of creative potential for all of the citizens of the state (Indeed, Gard's Arts Extension program at the University of Wisconsin inspired the founding of the Arts Extension Service at the University of Massachusetts—the publisher of this book!). In 1955, Gard wrote in *Grassroots Theater*[2] about the deep relationship between art and "sense of place." But Gard's dream kept expanding, and in 1967, in *The Arts in the Small Community*,[3] he urged arts groups to work with athletic groups like football teams, churches, ethnic organizations, senior citizens, and others, in the service of a healthy, whole community. These historical projects resonate with our expressed commitment to empowering the individual, and the notion of the role of the arts in whole communities.

Baker Brownell. Another arts activist, working a little earlier than Gard, was Baker Brownell. He was a philosopher from Northwestern University, brought to Montana in the 1940s to help small towns think about their future, especially their economic future. He believed that this process started with a review of the community's economic, religious, creative, ethnic, and educational histories. The self-study process that he designed culminated in the production of a pageant that didn't just recite these histories, but used them as a way of addressing the future. Brownell believed that there are periods when specialists are needed in a society, giving way to periods when generalists are needed. It is tempting, and easier, to remain in a world of specialists, but he saw overspecialization as the path to the death of the soul and of society. Rather generalists must stride forward—people who apply their knowledge to issues of the whole, integrated society—and he saw artists as people with this special knowledge. Brownell juxtaposed the "human community" to the "culture of specialism." In the human community, a place where the scale is shrunk so that people can know one another as whole persons, he saw the arts as a tool in community planning, but more importantly, as the way to reclaim a society's soul. He believed that art is a verb, that everyone is latently creative and thoughtful but that the art system too often reinforces passivity, and the way of passivity is the way of death.

Ours is a culture of displaced persons. It is tattered with escape and wandering, and as such is a culture founded on being lost. ...What the Germans did to millions in the concentration camps, and the Russians to tens of millions in the mass deportations, the western world in general does less dramatically but as effectively to hundreds of millions swarming homelessly to centers of vicarious and secondary culture. Their lives die out, love rots, and hope is replaced by avid stimulation. In all this, art may become merely one of the seducers to death. Or it may become the insight of life and survival itself. [4]

He tied artists literally to the life of a society and this, too, is something to which we are awakening today.

Rachel Davis-Dubois. (no relation to W.E.B. Dubois, though she worked with him) was an educator in New York working in the 1930s to 1950s. Her lifelong devotion was to multicultural education. But even more than this, she articulated the notion of "cultural democracy" as the third leg of the American stool, along with political and economic democracy the leg that had been neglected. She believed that the American dream could not be realized without equal emphasis on cultural democracy. In 1943 she said,

The melting pot idea, or "come-let-us-do-something-for-you" attitude on the part of the old-stock American was wrong. For half the melting pot to rejoice in being made better while the other half rejoiced in being better allowed for neither element to be its true self... The welfare of the group... means [articulating] a creative use of differences. Democracy is the only atmosphere in which this can happen, whether between individuals, within families, among groups in a country, or among countries. This kind of sharing we have culled cultural democracy. Political democracy—the right of all to vote—we have inherited. Economic democracy—the right of all to be free from want—we are beginning to envisage. But cultural democracy—a sharing of values among numbers of our various cultural groups—we have scarcely dreamed of. Much less have we devised social techniques for creating it. [5]

Much of her work was about enabling groups to study, understand and value their own cultures, and to equally value and delight in the cultures of others. Here again, you surely see some of your roots.

Finally, in the first half of the nineteenth century, we see an articulation of the responsibility of the artist to building a stronger civic society. Percy MacKaye, from a long family of theater people, articulated the responsibility of the artist to think explicitly of himself or herself as building civic infrastructure. For instance, he said, "...this potentiality of the drama could never be realized until the theatre...should be dedicated to public, not private, ends." [6]

Certainly, the artists later in the century, who were put back to work by the Works Progress Administration, wrote and produced plays and murals that challenged and raised questions while they also beautified and delighted. We strongly recommend the film, *The Cradle Will Rock*, released in 1999, as an important and provocative look at the WPA[7].

Isolation of the arts

Despite their positive approaches something happened in each of these stories, and the arts were left isolated. Civic beautification often reaches a point where it is seen as optional, expensive, and something just for the wealthy (how many truly glorious public buildings are being constructed now?), and there is a constant debate about the appropriateness of public funding for artists and arts organizations. The Lyceum-Chautauqua story, which began as two grassroots, participatory endeavors, evolved into one-way presentations by artists to audiences; true engagement evolved into "outreach." The Jane Addams and Extension Service stories have evolved so that now we separate "real" art from social work or recreation; indeed, the successors to Drummond, Koch and Arvold were charged by their university with "professionalizing" the art in their departments. As schools struggle, arts education and multi-cultural education are left behind the "core" subjects of reading, science, and math.

Interestingly, each of these stories began with a deep-seated notion of personal wholeness and community interdependence, and acknowledged the role of the arts in helping individuals and communities attain this wholeness and interdependence. Each of the stories ended with the arts being isolated—an "amenity," an educational option, a one-way artist-audience relationship.

Let's consider our own organizations. We have done a good job in the past decades becoming institutionalized in the best sense. We do many high-quality shows, we're asked to a lot of community meetings, we've learned how to raise money, we are part of the concept of "livable cities," we are becoming skilled in making the political process work for us. Yet as

we have become institutionalized, the stakes have also risen. We need more money to keep the doors open. We need more political goodwill to build a facility. And as we have struggled to do that we have often done it at the expense of other groups in the community against whom we have had to compete for increasingly scarce resources of money, goodwill, and volunteers' time. We are, in fact, segregating ourselves from our communities even, ironically, as the idea of "more arts for all the people" is becomingly an increasingly accepted slogan.

Yet interestingly, in a summary of a recent RAND Corporation study, we read that "Institutions seeing the biggest gains [in diversity and engagement of audiences] are those that are making service to their communities as important as promoting artistic quality."[8]

Headwaters goals

It is important to be aware of the philosophical origins of the stories we have just told, but also to be aware that they can evolve into relatively simple projects with few philosophical "teeth" which are easily set aside when "times get tough." For example, endeavors whose goals were about relating civic aesthetics to democracy evolved into programs about beautification. The Lyceum, whose goal was to engage neighbors in discussion, evolved into a program about "audience development." As an analogy, consider the Colorado River—it begins as a profoundly important source of life, but it is diverted, used and dammed so much that by the time it gets to Los Angeles it is but a dusty trickle. In community arts organizing, you must not start with goals analogous to that trickle; rather, start with goals that are analogous to the headwaters. For purposes of community arts organizing, a goal that is about "civic aesthetics and democracy" is a headwaters goal; a goal that is merely about "beautification" is a dusty trickle goal (without the passion to carry you when you are tired, impatient, and feeling as though it's just not worth it). Think about the philosophical "headwaters" of the historical stories we have just recounted, and see which, if any, relate to your situation:

- A better physical community, where beauty and invitations to gather are civic values—because in a democracy, public spaces and public buildings and thoroughfares ought to embody the highest aspirations of human beings. This is the story of the Village Improvement, City Beautiful, and Frank Lloyd Wright movements.

- A more thoughtful community, where people engage in genuine dialogue—questioning, critiquing, leading to more informed personal and collective action—because every individual has a right to improve or change his or her life. This is the story of Josiah Holbrook and his discussion groups, and the Chautauqua clubs.

- A multi-cultured community, where people prize the cultures of one another as they value their own—because coexistence is not enough We cannot move to true globalism without deep understanding. This is the legacy of Frederick Koch and Rachel Davis-Dubois.

- A community of empowered individuals, where each person explores his or her own creativity—because each person has a birthright of dignity and a wealth of individual opinions and ideas. This is the story of Alex Drummond, Robert Gard, and the Extension Service.

- A human community, where people learn to know one another well—because moving forward meaningfully as a community cannot happen until groups move past being "special interests" and learn to relate as people. This is the story of Alfred Arvold, of Baker Brownell.

- A just community, where the norm is decency, dignity and tolerance for all—because this is the meaning of being an American. This is the legacy of the Settlement House movement and the Civil Rights movements.

- A civic community, where everyone sees himself or herself as responsible to the community and its public processes—because without this individual commitment—there can be no true

democracy. This is the legacy of Percy MacKaye and the artists who participated in the arts programs of the New Deal.

Community arts stories

Let's look at a couple of examples where people are thinking about community arts programs with this kind of depth, and considering the deep philosophical context that leads to community arts organizing.

Animating Democracy. In the late 1990s, the Ford Foundation and Americans for the Arts undertook a bold new venture called Animating Democracy. Its purpose is to "foster artistic activity that encourages civic dialogue on important contemporary issues."

Given the name of the initiative, and its purpose statement, it is clearly a program whose philosophical grounding is a deep one. Here is a summary of a recently-funded Animating Democracy program that we picked at random as an example of how community arts organizing could be approached:

> *The Land Bridge Project, in collaboration with th* *Perpich Center for Arts Education, will bring together rural and urban residents of Montevideo and Minneapolis, Minnesota, in dialogue around issues of the expanding farm crisis. The Minnesota farming community is deeply divided between farmers struggling to maintain family farms and those who contract with agribusiness. Related tensions exist between farmers and banks, legislators and rural activists, and between neighbors. Children's Theatre Company will use the creation of a new play to illuminate the complexity of the issue and to make those further along the food chain aware that this crisis of food, economy, land use, and social well-being is their crisis.[9]*

Pathway to Peace Neighborhood Gateway. A good example of Animating Democracy at the local neighborhood level is the Pathway to Peace Gateway in the East Harriet Farmstead Neighborhood in south Minneapolis. The Gateway began as an effort of the local neighborhood association and Lyndale Park, which includes a peace garden, a contemplative place secluded from the rest of the park. Peace

garden activists wanted to create a stronger link between the neighborhood and the garden and solicited support from the City of Minneapolis Art in Public Places project for the creation of a gateway. Artists Teri Kwant and Greg Ingraham were commissioned to create a series of seven sculptural columns spanning the four-block area from the neighborhood to the garden. Each artwork contains text derived from community dialogues, where people shared their feelings and questions about peace in the community, across the world and within themselves.

Engaged Arts. At the 2001 Grantmakers in the Arts conference, a panel addressed the topic of meaningful community-building through the arts. Mark Valentine of the David and Lucile Packard Foundation said, "It's about knitting....It's not about expansive kumbaya moments where everybody practices guitar around the campfire. ...It's about finding places where programs are active concurrently, but in a disaggregated context, and bringing them together. My own bias is that art and culture are a significant part of that conversation. They're woven into the very heart of that community. As you envision what the future might look like, I think it's essential that it be engaged."[10] He cited projects that his foundation has reviewed in which artists are paired with environmentalists to help their community really think about issues of climate change. Similarly, Peter Pennekamp, of the Humboldt Area Foundation, said, "art outside the context of everyday life, art within a consumption model which is really almost all of what the professional arts world lives in, rather than a participation model, is what makes art not as important as I think all of us would like it to be.[11]

The point is that the arts can both become more important *and* serve an urgently needed role in our society now, if we shift our thinking back to the original ideas behind each of these historical tales. So whether you are an idealist ("this is the right thing to do") or a pragmatist ("we might not survive if we don't start thinking differently") we invite you to consider the idea of committing your arts organization to the community-building process.

Ways that arts organizations lead in community organizing

Investigate the things we have in common. An example is the work of the Roadside Theater Company in Appalachia, its home, in which the dramatic material is drawn directly from community knowledge and stories there.

Investigate our differences. Another of Roadside Theater's artistic thrusts is to collaborate with theater companies from other cultures, exploring what their cultural stories do and do not have in common.

Further community conversation. Any of the activities sponsored by the Ford Foundation in its "Animating Democracy" program, or by the Rockefeller Foundation in its "Partnerships Affirming Community Transformation" fall into this category. Whether the issue is the health of a river on which a town is dependent, youth violence, blighted neighborhoods, or a debate over whose history should be told and how in the local historical museum, examples abound. Go to *http://www.americansforthearts.org/AnimatingDemocracy/lab_summary.html* and read any of the summaries for yourself.

Educate others about us. In a ski town, which depends heavily on tourists for its economic life, the buses that transport skiers to the ski area are all painted with something important about the town—its history, current community members, even the dogs that everyone knows—to say, "We live here. Don't just spend money here: respect our place and people. Get to know us."

Mobilize people. In Los Angeles, the Bus Riders Union has collaborated with Cornerstone Theater to create a series of mini-plays which are performed literally on the buses by a small team of players who board dressed in costume, do their playlet—which has to do with an issue faced by bus riders—distribute leaflets, and get off the bus several stops later.

Prevent issues from developing. In Calgary, Alberta, a neighborhood planner is thinking about a new kind of planning process involving the community theater: Leading a short play. Act I might portray the status quo in the community, and groups of citizens would sketch

scenarios for Act II depending on which key decision is made about a particular issue. Visualizing alternatives and their consequences is difficult; this idea could lead to avoidance of poor choices.

Heal. Artists who had been in residence at Columbine High School in Littleton, Colorado, were among the first people that the school turned to after the shooting tragedy in which many students died; within two days the artists were offering activities to students and teachers, the first of a series of activities that continued for two years.

What is key in all of these ideas is that the arts organization is not isolated. It must work with a wide variety of non-arts groups in the community—teachers, therapists, "ordinary citizens," planners, union organizers, businesses, farmers. Each group must be equal in bringing what they know, and how they know it, to the table. Together, they devise a new approach to furthering the health of the community that they, as interdependent people, have in common.

Let us now turn from the history and the theory and get practical. What do you need to know to do this kind of work?

PART TWO
COMMUNITY ARTS ORGANIZING: METHODS

by Mary Altman

Purpose

The first part of this chapter talked about how communities can make use of the arts to create a better life for us all. Participating in the process of developing community arts activities can build community in another way—by building the capacity of the groups and people involved to create community change. This may include learning to effectively organize people, plan, make decisions, collaborate, train artists, evaluate and gather support.

Overlapping roles and processes

Simply put, the process of community arts organizing involves at least three parties: the community arts organizer, the community involved and the artists. It also involves three overlapping processes: the artist's creative process, the community's planning process and the organizer's capacity-building process. The relationships between these can be complex, fascinating and often confusing. This chapter discusses these roles and processes and describes some strategies for weaving them together.

COMMUNITY ARTS ORGANIZERS

The community arts organizer is the person who builds the capacity of community leaders and members to use the arts to make their community a better place. Most arts organizations and community agencies, however, don't have community arts organizers on their staffs. So who does community arts organizing, and what skills do they need?

Arts administrators as organizers

Frequently the community arts organizer starts out as an arts administrator doing outreach and beginning to see the value of community building. Your community may be facing a crisis. An organization may be feeling pressure to demonstrate its impact on the community or may be starting to build new relationships within the community.

Sometimes community arts organizers are the staff of social service organizations who have discovered the arts can magnify their impact on the people they serve. In the case of the Pathway to Peace Gateway, neighborhood and park volunteers saw an opportunity for public art project to address an important issue. When they received a grant from the city of Minneapolis, a community member stepped forward as the organizer.

This section mainly addresses the perspective of the arts administrator as organizer. We'll start by describing the qualities needed in an organizer and the skills his or her work entails.

Other Organizing Players

Artists. Artists who do community arts work frequently take on an organizing role—both facilitating community participation in the artistic process and teaching residents to develop projects.

Other partners. Being on an organizing team in partnership with another arts organization or community agency can be extremely helpful, because it provides other perspectives. Set aside time for team members to jointly determining values, goals and approach; otherwise you may work at cross-purposes and undermine the community's efforts.

Funders. A funder may initiate a project or work in partnership your organization. Most foundations avoid direct organizing roles, because they know groups are not always candid with them about community issues or problems. Of course funders and other influential supporters should be engaged early and kept informed.

Qualities desired

Community arts organizers need to be able to stand back, focus on the big picture and allow other community members to take responsibility. The Amherst Wilder Foundation describes the following essential qualities of community building organizers:

- Understanding of Community—have a thorough understanding of the culture, social structure, demographics, political structure, and issues in the community

- Sincerity of Commitment—convey a sincere commitment for the community's well-being.

- Relationship of Trust—develop trusting relationships with community members.

- Able to be Flexible and Adaptable—are flexible and adapt to constantly changing situations and environments[1]

In addition to these qualities, we suggest the organizer also have:

- strong belief in the role the arts can play in community building and in the community's ability to create their own unique approach;

- patience with the community, as they learn and struggle;

- the capacity to monitor the community planning process and the organizing process concurrently;

- an ability to assess what is needed in the community and to provide possible solutions;

- experience in guiding people through planning and meeting facilitation.

Above all, organizers need to know how to work with groups. For this reason, artists or arts administrators with a background in artistic collaboration are frequently naturals.

Skills needed

The main role of the community arts organizer is to build the capacity of all the individuals working together to create change. This role varies a great deal depending on the project and people involved. In 1994, the COMPAS Minnesota Rural Arts Initiative identified these responsibilities for their regional organizers:

- conducting field work and getting to know the community;

- identifying leadership, advocating for an inclusion, and teaching collaboration and leadership;

- helping to develop structures, schedules and procedures;

- facilitating challenging meetings;

- identifying sustainable resources, assisting in fundraising and the development of long-range plans;

- conducting training in evaluation;

- challenging the artistic direction of the project;

- providing focus and an outside perspective;

- helping to solve or mediate problems;

- lending encouragement.[2]

Generally the community arts organizer is not directly responsible for running or managing the project. This role is the responsibility of the entire team or steering committee. To avoid confusion, the relationship of the organizer to the project leaders should be clearly defined and understood by everyone.

Insider Versus Outsider: Which is Better?

If you are the community arts organizer, you may be working in your own neighborhood or with a new community. If you are seeking someone to serve in an organizing role, you may need to weigh the advantages of and disadvantages of hiring a local person versus an outsider. In either case, it's important to know the strengths and weaknesses that each can bring.

The advantage of the **insider** is that he or she may have knowledge of community needs, local artists and available resources. The insider may also be sensitive to the local political and cultural environment. The disadvantage of a local organizer may be the bias he or she brings because of their own agendas, experiences and relationships within the community.

The advantage of an **outsider** is the objective perspective he or she brings. Outsiders can be especially effective in situations where there is a lack of trust or sensitive issues. An outsider may bring skills that don't exist locally or may add credibility. (Remember that an outsider lives at least 50 miles away!) If an outsider is experienced, he or she can compare your town with others, or share examples of models from other places. The disadvantage of an outsider is his or her lack of knowledge of the community. In order to be effective, outsiders need trusted local contacts. Outsiders can sometimes unintentionally sabotage their own efforts by relying on the wrong people or by treading on another's territory.

Whichever type you choose—or happen to be—it's important to know your limitations and work to balance them by depending on the expertise of others.

MATCHING THE ORGANIZING APPROACH WITH COMMUNITY READINESS

The organizing process is the means used by the community arts organizer to build the capacity of the groups and the people involved in creating change through the arts. This section and those following describe organizing strategies for supporting the community throughout the planning and implementation of a project. We begin by talking about the organizer's style and approach, as well as two important ethical guidelines, "the prime directive" and "do no harm."

The organizer's approach

The prime directive. In community organizing circles the organizing process is sometimes referred to as an "intervention," which means interfering with a community's natural way of working by teaching them new techniques. We choose not to use this term, because of the obvious negative connotation, but also because we believe an effective organizer respects the community's natural process whenever possible, and only suggests changes when this natural process becomes counterproductive. Bob Burns of the Metropolitan Regional Arts Council in Minnesota compares this approach to what is known in Star Trek circles as the "prime directive." For non-Trekkers, the "prime directive" is a guiding principal suggesting that each civilization's natural cultural evolution is sacred, and no one may interfere in its development:

> *"As the right of each sentient species to live in accordance with its normal cultural evolution is considered sacred, no Starfleet personnel may interfere with the normal and healthy development of alien life and culture. Such interference includes introducing superior knowledge, strength, or technology to a world whose society is incapable of handling such advantages wisely."[3]*

Of course we rarely actually put our lives on the line in the arts, but as implied in the prime directive, key to the success of organizing is creating an appropriate match between the

organizer's approach and the community's readiness and natural way of working. This can be quite a challenge, as each community and organizer has his or her own style.

The organizer's personal style. We all have gifts, tendencies, and styles that make us suitable for this work, some of us are natural nurturers or coaches, some are great at diagnosing problems, some work like a detective seeking clues, while others are great educators. Some prefer to act as a resource, and some quietly lead from the back of the room. We all know that not all approaches work with everyone. Just as teaching styles need to be tailored to each student's learning, organizing styles need to be tailored to each community.

Do no harm. The phrase "Above all, do no harm" comes from the classical oath of Hippocrates[4] taken by physicians. As an organizer it's important to recognize your natural approach and also to understand its limitations. This will help to prevent unintentional damage. For example, if your natural style is to nurture, you may not be as effective at prescribing possible strategies. If you prefer to be brought in as an expert, you may not work well with groups that have a strong idea in mind. If you are a charismatic presenter, you may not be a great listener. If you're great at diagnosing problems, you may wonder how to help those who are unmotivated to solve them. After you assess your own personal style, then it's time to assess the community's readiness.

The community's readiness

Earlier in this chapter we defined "community" geographically, as in a neighborhood. The organizer, however, rarely begins with the entire community. Whether you begin by working with an existing committee or you create a new team, it's important to first consider this group's readiness. In other words, to what degree are they ready to make this project happen? When examining community readiness, it is necessary to look at both motivation and level of experience.

Motivation. The community's level of interest depends partly on how the project is initiated.

Developing Your Own Code

Where do you begin? For I have given you a frighteningly large mission. Maybe this exercise will help. It's one I had to do as a final paper in a community development course in graduate school. My professor's notion was that you have no business intervening in anyone's life, in anyone's community, until you are clear about your own life. So we had to wrestle with our minds and souls and lay out three of the biggest ideas we could—our ultimate big ideas. I'm talking about ideas about life, or God, or universal forces—whatever those ultimates are for you. Then, we had to derive from these ideas at least three other ideas about living beings, and especially what human beings are all about. And from that, we had to outline behaviors that we would engage in that directly relate to our ideas about human beings. This constituted a code of meaning for ourselves. Finally, we had to write down how we would know if we were violating that code—our danger sign that we were burning out, or that we ought to be re-thinking everything.

–Maryo Gard Ewell

If the impetus for a project is internal, from within your program or organization, it may be hard to excite people about the endeavor. You may be enthusiastic, but you'll have to persuade them of the need and build their buy-in.

If the catalyst is from within the community, such as a crisis or a funding initiative, people may come to the table more excited.

Indicators that a community is motivated are enthusiasm, confidence, and readiness to take action. Indicators that they are unmotivated are lack of energy, being drawn in another direction or desire for someone else to step in and do the work.

Level of experience. The second factor defining community readiness is level of experience. This includes leadership ability, artistic vision, connections within the community, and skills in project planning and management. The success of the Pathway to Peace Gateway has been

largely due to the experience of the committee members, who were familiar with the needs of the neighborhood and had organized major projects in the past. Of course it's a great idea to involve new leaders and people with less experience, but they will require different assistance than those who've been around the block—which brings us to our next step.

Making the match

Once the community's level of readiness is determined, the appropriate organizing approach for their needs must be established. Groups who are:

- **Motivated and experienced** need to be *guided*.

- **Less motivated but experienced** need to be *nurtured*.

- **Motivated but inexperienced** need to be *trained*.

- **Both unmotivated and inexperienced** need to be *managed*.

The following chart aligns the community's readiness with these four organizing strategies: guiding, nurturing, training, and managing. It is based on a model developed by the COMPAS Minnesota Rural Arts Initiative.[5]

It's often hard to put people in boxes, and you may want to place your group between the four choices. Adapt this concept as you need to, but remember the point is to assess your community's readiness and the best strategy for supporting them.

Examine where a group is when you begin working with them. Keep assessing their circumstances throughout the project's development, because their motivation and experience can change over time. Change can occur for many reasons. Often it's due to turnover in leadership—people leaving or new people coming on board. Of course it can and should change as a result of the work you are doing with them. Continue to modify your approach as needed.

If used appropriately, this assessment can also be done with your group. Ask them how they think they rate in terms of motivation and experience. One caution: Use it without judgment. Ask, "Do you think you need more education in this area? Are you feeling burned-out? Could this committee benefit from more members?" After they rate themselves, assess the group yourself. See if you agree. If not, why?

THE COMMUNITY PLANNING PROCESS

The community planning process is the step-by-step process for developing an arts and community-building project. The stages of this process are based on the eight AES strategic planning stages detailed in the planning chapter: organize, envision, assess, establish goals, write a plan and budget, approve and commit, implement, and evaluate and adapt. This section illustrates these stages as two parallel and interwoven community arts organizing tracks:

- **The community.** The first track describes the planning activities community members conduct at each stage and the challenges they may encounter along the way.

- **The organizer.** The second track provides strategies for the organizer to implement that support the community's efforts. It also provides ideas for addressing problems. Some of the sidebars in this section give examples for working with groups at each organizing level—encouraging, nurturing, training, and managing.

STAGE 1. ENVISION

How it starts

In chapter 2, the AES planning process starts with "organize." This chapter reverses the first two stages and begins with "envision," because the community or the organizer frequently begins with a vision or idea in mind. Once there is a vision, it's important to examine whether it's the right vision at the right time, and also to think creatively about integrating the arts into the process.

The organizer. Often the organizer or the organizer's institution initiates the idea. Your motivation may be a desire to expand what

Making the Match	
Community Readiness	**Organizing Approach**
Motivated and Experienced	GUIDE. Need less intensive support. Give them freedom and responsibility. Let them make decisions. Encourage them to take risks.
Unmotivated but Experienced	NURTURE. May benefit from new leadership and energy. Give them some guidance, but focus on providing recognition, incentives or additional assistance with their workload.
Motivated but Inexperienced	TRAIN. Generally need structure and training. Teach them the process while engaging their participation in decision-making. Explain procedures and answer questions.
Unmotivated and Inexperienced	MANAGE. Difficult to organize and require a lot of time and attention. The best strategy for these groups is to infuse them with new leadership. Provide training and consistent follow up. Reassess working with them or commit to a high level of support and assistance. Of course, if you're working in a small community, your choices may be limited.

you do best into the community. It may be a passion for addressing a neighborhood problem, or it may be pressure to demonstrate your organization's impact on local residents. The project could be based on a program you witnessed somewhere else, or it may a spin-off of another success. If the agenda emerges from your arts organization, chances are it's an artistic vision with some community building focus, such as "empower young people through theater" or "develop a public artwork embracing all of our local cultures."

The community. A local tragedy or opportunity may be the catalyst—the farm crisis, a new housing development or changes in neighborhood demographics. Grant makers may initiate efforts, as changes in their funding programs encourage communities to respond. In the case of the Pathway to Peace Gateway, it was both. Residents who initiated the project wanted to build community and global support for the concept of peace, and so they applied to a city public art program for funding.

Earlier in this chapter we provided a range of urgently needed visions for changing communities. Challenge yourself at this point. Ask yourself, "What does the neighborhood need most?" A clear vision sometimes emerges immediately. Other times it takes a while. Your community will have its own unique way of beginning.

Is this the right idea at the right time?

The community. Before you act, a critical question needs to be addressed: Is this the right idea at the right time? In other words, is this the appropriate time and place to implement your vision? Several factors need to be considered:

- **Compatibility with organizational goals and values.** If this agenda doesn't advance your mission, then pursuing it may be someone else's work.

- **Support from local leadership.** If local leaders are willing to dedicate their time to addressing the vision, it will be easier to gain support from them and others.

- **Broad community awareness.** If the agenda is clearly important—if it's on the front page of the paper—it will be easy to build enthusiasm. If the community is reluctant to talk about the issue or needs to be educated about its importance, your project will need to include a strong advocacy campaign.

The Midwest Academy suggests a number of additional factors to consider when selecting an issue, including these:

- result in real improvement in people's lives;

- give people a sense of their own power;

- be winnable;

- be deeply felt;

- be easy to understand;

- have a clear time frame that works for you;

- have a pocket-book [financial] angle.[6]

The organizer. The community arts organizer should share these factors with the community and use them to rate possible visions or issues. Don't be afraid to ask whether the chosen focus is truly important. One role of the organizer is to ask hard questions and help determine whether the effort is really worth your community's time and resources.

Forging new standards for artistic excellence

The collaborative planning you are embarking on shares many similarities with creative collaborative processes, such as theater and public art. Artists need to organize, envision, assess, etc. just as planners do. This is a great time to invite artists to contribute their ideas. Challenge yourself in terms of your artistic standards and approach. For example, if you're a large theater company with a professional, full-time cast, bring in local artists who have direct experience with community issues. If you're a small organization with a cadre of community artists, engage an outside artist to provide new insight and training.

The organizer. Through the use of guided imagery, mapping, metaphors and storytelling, artists can provide creative challenges that will enhance the visioning process. Consider which of these processes might appeal to your group. (Depending on who they are they may not be ready for the really arty stuff.) After they've had success with involving artists, encourage them to think about how artists and the creative process might be integrated into future planning.

STAGE 2. ORGANIZE

Once you have a vision, it's time to look at who else should be involved. As these stakeholders and leaders come to the table, you will also need to define a planning structure and way of working together.

Identifying stakeholders and leaders

The community. As we said earlier in this chapter, community should be defined by the diversity of people who live there. Be inclusive; reach out and include:

- a broad range of traditional, non traditional and emerging leaders—business leaders, educators social service representatives, students;

- people and artists with experience working on community issues;

- residents from a range of backgrounds—including age, gender, ethnicity and class;

- a small geographic area (expand with success);

- individuals who are flexible and motivated to participate in the planning process.(Tap people who want immediate results later, or give them specific tasks.)

Finally, it's important to consider who your allies are in achieving this vision, whose approval you will need, and who may cause you trouble. Involving naysayers or competitors in the beginning may help you avoid problems later on. Pathway to Peace organizers involved park staff from the beginning, because they knew they would ultimately need park board permission to place the Gateway on their property.

The organizer. Get to know the community and key leaders. How you initially approach people can make a lasting impression. Don't come to the table with pre-conceived strategies or solutions. Start by engaging people in a dialogue about the problem or opportunity. Listen to a variety of perspectives. Don't develop alliances or make judgments too quickly. Who you align yourself with in the beginning can have an enormous impact on the entire effort. Here are a few ways to make contact:

- Interview community members with a range of perspectives.

- Bring together a group of citizens to discuss the community's vision. Observe the leadership that emerges and invite them to become involved.

- Build partnerships with organizations that represent constituents with a stake in the vision.

- Join an existing group already working on the issue. Suggest ways the arts can be involved in addressing their challenge.

Two cautions during this phase:

1. Don't expect the program to take shape overnight. Provide time for people to build relationships. If you're working with new leaders, additional training in collaboration may be helpful.

2. Be clear about where the power lies. Encourage the community to involve detractors, but be realistic. They may not be able to win everyone over. Community organizing is about change, which often means changing institutions and power structures. Some people may resist. Look into who has the authority to make decisions and where there are opportunities for change.

Identifying the planning structure

The community. Once you've identified the players, then it's time to think about how you're going to work together. If organizations are involved that have established structures, such as advisory committees or community boards, you may choose to use their systems. If not, you may need to create your own. Choose an approach that is compatible with your values and needs. Keep the structure as simple as possible, but address the following questions:

- Should we form a steering committee or a leadership team?

- Who will lead the team? Will we have a chair or rotate responsibilities?

- Who will the members be? How will new members be oriented?

Providing Creative Challenges			
Guiding	Nurturing	Training	Managing
Encourage leaders to take creative risks.	Integrate art and fun into planning.	Train artists. Help leadership create artistic standards and procedures.	Provide examples of creative models and teach people to implement them.

- Will this be a partnership between multiple organizations? If so, what will each of their responsibilities be?

- Are all members representing agencies and being paid for their participation or are some community volunteers? If so, how can we support these volunteers so they stay involved?

- Will someone be compensated for coordination? What is his or her role? How does this person's role compare to that of the committee?

- How will meetings be run? How are decisions made—by vote or by consensus?

- How will meetings be documented? What communication systems need to be put in place?

The organizer. Establishing a clear structure can save time and maintain momentum. Many groups fail simply because they are unfamiliar with basic strategies for running meetings and making decisions. The organizer should be both a guide and resource during this phase. The preferred structure will depend on the group's past experience, their authority and the norms of their organizations. Here are some other important considerations:

- Provide options and help the group make decisions based on their values. Think beyond the traditional committee/chair structure by considering more collaborative models.

- Begin simply and with a small number of partners, especially when working with new leaders or complex relationships. Add new players and projects after they've had some experience. Not all stakeholders need to be on the steering committee. Provide plenty of opportunities for broader community contribution through surveys, town meetings, volunteer opportunities, and participation in programs.

- Be strategic about meeting facilitation. You may need to facilitate early on or when the decision–making becomes challenging, but hand over this responsibility to community leaders whenever possible.

- Provide sample tools and agendas, but don't generate a lot of paperwork.

- Provide time. Consider holding workshops or retreats for planning and skill development.

- Identify someone to start drafting your plan from the beginning. Create a working document and insert the vision, needs and goals as they are identified. This will make writing the plan and grant proposals much easier later. Review the document regularly and use it to orient new members. Also document ideas for specific strategies and save them for discussion during step 5.

STAGE 3. ASSESS

The community. Once you're organized, then it's time to conduct some research. You can study a broad range of information during this phase, including:

The issue. If you are working on an issue or problem, you will need to examine the issue itself, its causes, ways people are affected by it and solutions tried by others. For example, if your project is addressing community violence,

Addressing Leadership Issues			
Guiding	Nurturing	Training	Managing
Encourage leaders to mentor new leaders and prepare for succession.	Provide additional support. Recruit and orient new members with energy.	Provide training in leadership, planning, and team building.	Recruit and orient new leadership with experience and energy.

seek out stories from victims and offenders. Talk to experts about the causes of violence, including human service organizations, churches and the police department.

Current community demographics. Sources of information about your potential constituents include the U.S. census, the city clerk or your neighborhood association.

Local history. Reflect on your community's physical, social and cultural past through oral history or character-mapping projects. Also investigate community leaders and their history of organizing (labor, human rights, etc.). Consider how your project can build on these traditions.

Artistic history and character. Research your artistic history and traditions. The Maine Arts Commission has modeled this approach. Its Discovery Research program assesses rural communities' artistic potential, beginning with a cultural inventory by a folklorist and resulting in a visitor's guide to local cultural resources. [7]

Community needs and attitudes.
Understanding people's needs and attitudes as they relate to your vision is critical. When you ask about needs, also ask about the barriers people face in getting those needs met and strategies that have been successful in the past. Sample needs surveys are available in Louise Steven's *Community Cultural Planning Work Kit.* [8]

Assets and resources. Gathering information on available resources can be empowering—especially to people working on distressing community problems. In the 1990s, asset-based assessment was pioneered by John McKnight and John Kretzman. [9] Assets can be

arts resources, as well as broader community resources, including institutions, buildings, people, traditions and relationships.

Trends and models. Locating studies and articles on trends requires some research at the public library or internet, but they can provide your community with many examples of successful models.

Surveys of community members are the most common way to gather much of the information above, but beware—projects can get bogged down in the survey process. First check to see if someone else has recently conducted a similar survey. You may be able to save yourself a lot of work by using their results. On the other hand, conducting a survey can empower people by providing them with the ammunition they need. If you do a survey, keep it simple by sampling a representative group. (See chapter 8 on evaluation for more information.) There are also other methods for gathering this information, and most are far more interesting. They include:

- holding community meetings for gathering broad-based input;

- conducting interviews with elders or individuals or who are uninterested or unable to attend meetings;

- creating maps and visual diagrams of assets and needs;

- holding community story-telling events.

The Pathway to Peace project documented the history of the neighborhood and the park before the Gateway was commissioned. In a

Planning Structure			
Guiding	Nurturing	Training	Managing
Provide options for structure and decision-making, and encourage the group to run with it.	Provide options, but help them implement the structure. Set agendas and focus their attention.	Teach them options and skills. Help establish systems Provide feedback on their solutions	Provide simple and clear structure with clear roles. Train them on its use. Continually monitor the implementation.

Questions for Consideration:

Following are examples of questions that can be useful in assessing your history, needs, and resources:

- Who lives here? Who lived here before? How did this community begin? Who were the key leaders or visionaries? What are their stories?

- Is this community ever changing or does it have long-time members? Do the people who live here get along?

- What are the qualities of this community? What parts are beautiful? ugly? Is it industrial? residential? modern?

- What are the important landmarks? Which landmarks are gone?

- What are the important organizations, buildings, cultural sites and people?

- Where is the center of this neighborhood? Is it the school? the church? the river?

- What one word would describe this community?

- If you could change one thing in this community what would it be?

- Why do you live here?

- How does this place influence you? How do you derive strength from its landscape, buildings, and layout? How do you derive strength from your neighbors? (The last two questions taken from Maryo Ewell's Introduction to Grassroots Theater.)[10]

survey distributed at local meetings, they asked questions about the neighborhood's identity and the types of materials people would like to see used in the artwork.

The organizer. This phase can be very rewarding. History buffs and other community members enjoy uncovering the rich material. The stories that emerge can be a wonderful benefit of the process. They can energize your meetings, but they can also consume a lot of time. Committee members who want to see

things happen may get frustrated. Encourage the community to be deliberate in their research. As they sift through information, help determine a process for summarizing and analysis. Use meeting time for reporting results and determining priorities. Your group might also find it rewarding to hold a community event sharing the compelling stories it has gathered.

STAGE 4. ESTABLISHING GOALS

The community. Goals are important. "Headwaters" goals can motivate and unify your community. Developing shared goals together can also get everyone on the same page. The results of the Pathway to Peace survey resulted in powerful goals for the Gateway: "Act as a bridge between the community and the world," "Hope for peace in the future," "Reflect neighborhood spirit," and "Encourage contemplation and conversation."[11] The artist selection committee then used these goals as criteria for reviewing proposals.

The planning chapter outlines many strategies for developing goals. In terms of community arts organizing; it's also important to consider:

Findings from assessment phase. Develop goals that address the needs and the resources you've uncovered. Study goals from other successful models.

Involving key players. People may care about the vision for different reasons. Make sure all partners and organizations contribute their perspectives.

Discuss self-interests. People are more likely to make a long-term commitment to the project when they see opportunities for addressing their interests. Your organization's number one self-interest is probably your mission. For clues to other self-interests, ask yourself and your peers "Why are we involved in this project?"

Developing consensus. Reach agreement on the four to six most important goals. If there is disagreement, discuss the issue until you reach consensus among all partners. An unclear focus will haunt you later when you try to develop priorities or assign funds.

The organizer

During this stage, the organizer should encourage planners to:

Build on the earlier stages of the process. The goals should be strongly connected to the vision and assessment.

Help people state their self-interests. Examine the goals of each person and each organization, including yours. If you are hearing, "I'd love to be involved, but I'm too busy," it may be a sign real concerns aren't being addressed. Questions such as, "What's keeping you busy these days?" or "What are you working on that's really important?" will help identify agendas. Putting self-interests on the table can also build trust and eliminate negative assumptions people may have about each another.

Develop clear, agreed-upon goals. Most goals should be shared by everyone. Avoid a piecemeal compromise with individual goals meeting the needs of different groups. Your groups vision can be broad, but be sure their goals are measurable and obtainable during the project's lifetime. Once there are agreed upon goals, refer to them often and revisit them during times of conflict.

STAGE 5. WRITE A PLAN AND A BUDGET

By now you've developed a large portion of your plan. After you've identified specific strategies and a budget for implementing them, you'll be ready to write it.

Strategies

The community. This is the fun part. You survived the planning—now it's time to talk about what you are actually going to do. Many possible strategies have probably emerged during earlier stages. Before you select specific ones, however, do some more brainstorming. Remember what you learned during the assessment. Ask, "What can we do to address these needs?" and, "How can we put these assets to work?"

Once you have a long list of activities, determine which will best achieve your goals. If your proposed list includes controversial or challenging tactics, you'll also want to pick your battles by considering what is actually doable.

Put together a thoughtful time line for implementing your activities. Pilot some small projects for a taste of what's possible and which mistakes to avoid.

The organizer. Challenge your group to develop activities that will make a deep and lasting impact on the community. Consider how they might change existing systems. For example, if their project involves school residencies, encourage them to link the artists work to the curriculum. At the same time, encourage your group to maintain focus and begin with realistic activities that they can build on after some success. Continue to challenge them artistically as you did in Step 1.

Budget

The community. Chapter 11 outlines budgeting in depth. Here are two additional issues to consider if multiple organizations are involved:

- When developing a budget, include each organization's anticipated contributions (both in-kind and actual) and expenses. Maintain a master budget to thoroughly monitor this information.

- In choosing a fiscal agent, think carefully about which agency could best meet your needs.

The organizer. Determining who will be responsible for managing the budget is a critical decision. It's important to analyze the balance of power among the planners and how control over funds may affect that power. One option is to spread funds among partners, but this can be a bookkeeping challenge. Discuss these decisions thoughtfully.

Writing the plan

The community. At this point you should have determined and documented your vision, partners, community needs, a list of resources, potential models, goals, strategies and a

budget. All that remains is to package it in one clear and compelling document. Look to the communications and graphic design expertise on your team or within your organizations for assistance.

The organizer. This phase can be challenging and tiring for the community. If they lack experience, writing a plan can be overwhelming. Frequently the catalyst for a written plan is a grant deadline, which brings added pressure. The organizer can maintain momentum by framing the work and walking the group through each task, especially the budget.

STAGE 6. APPROVE AND COMMIT

The community. Achieving approvals and receiving funding should be easier, because you have regularly engaged and informed key stakeholders. The planning chapter 2 outlines Step 6 in depth. Here are some additional points to consider in the community organizing process:

Identify the spokesperson(s). Choose someone with passion and influence, although this may vary depending on whom you are approaching. For example, when meeting with a funder who traditionally supports community-based projects, lead with a community agency.

Identify which approvals and support are required. At a minimum, you need the backing of the staff and boards of all the organizations involved.

Share your plan. At a community meeting and with local neighborhood organizations. Ask for feedback and approval. This will lend credibility to your work and bring backing from officials. The park board approved the request to place the Pathway to Peace Gateway on their property in part due to the endorsement of the community and neighborhood association.

Think beyond the next grant deadline. Develop a fundraising plan that considers multiple and sustainable sources of support. Because your project addresses broader community issues, you may be able to tap sources that traditionally fund social services.

You may have to cut back if you are unable to obtain all the support you need on your plan or consider a different tactic.

The organizer. The organizer should encourage groups to work on achieving approval and support from the beginning. Intimidation can be the biggest hurdle in this area. Meeting with officials and asking for money can be daunting to those new to it. Build your group's confidence by developing talking points and rehearsing these meetings. You can model this behavior the first two or three times, but turn responsibility over to others as soon as possible. It might also be helpful to provide training in grant writing.

If the community is ultimately unable to raise the necessary funds, revisit their plan and further prioritize. You may even need to address the difficult question of whether it's realistic to move forward at all.

STAGE 7. IMPLEMENT

The community. Implementation—or the actual doing of the project—may seem simple, but it helps to develop a system that tracks tasks, deadlines and responsibilities. This is especially important if multiple organizations are involved. For Pathway to Peace this meant coordinating the work of several groups (the artists, the city, park staff, the steering committee and maintenance crews) all of whom were involved in multiple activities (community dialogues, fabrication of the Gateway, permits, a dedication ceremony and ongoing care).

Engaging new leadership is another important consideration. Your group is probably getting a little weary. This is the perfect time to contact those people who came to the first few meetings and left saying, "Call me when you're ready to do something."

The organizer. The main role of the organizer during this phase is to ensure that systems are in place and that the group continues to meet and monitor their progress. It may be helpful to revisit the committee structure and membership. Perhaps not every stakeholder needs to continue to be involved in the same way.

How This Might Change Your Organization

The nature of community organizing is to involve the community in shaping the work of our organizations, but not every organization is ready or able to become community-based in its programming efforts.

If experts or patrons have traditionally driven your organization, you will need to educate staff and board members about community needs. Share your successes, and demonstrate how your project advances your organization's mission. Encourage the board to recruit some of your community constituents as members. And, be patient-this is a new experience for them, just as it is for you.

People with implementation skills may need to be brought on board. Consider whether project managers or artists require training. It's a good sign if the community needs you less during this phase.

STAGE 8. EVALUATE AND ADAPT

The community. The chapter on evaluation provides detailed evaluation instructions. Evaluating community work, however, has some unique aspects. It's difficult to measure community change, and even harder to prove that your project caused it. If you developed clear goals in the beginning, it will be easier to identify measurable outcomes. A focused evaluation plan should examine, "What has changed," "How did this project support this change," and "How could we improve?" Here are some other tips:

- Whenever possible, make use of existing evaluation systems and sources of data within your organizations.

- Divide data collection and process tasks among your partners.

- Schedule regular meetings for sharing results and making program changes.

Most importantly, remember to celebrate your successes. Publicize it. Sometimes a sense of accomplishment can come from a culminating event. Above all, reward yourselves. You've committed a tremendous amount of time and energy to this project. Take time to share stories and have fun.

The organizer. During the evaluation phase, the role of the organizer is to demystify the evaluation and train the community in assessment methods. Here are some suggestions for guiding your group:

- Learning evaluation can be like learning a foreign language. Terms like "outcomes" and "indicators" may be new to people and are used differently by each group. To eliminate confusion, agree on basic definitions.

- Encourage them to keep the evaluation simple, evaluate only one or two outcomes, and avoid time-consuming processes, such as tabulating a lot of data.

Developing and Identifying Resources			
Guiding	Nurturing	Training	Managing
Refer to new resources.	Connect to resources. Consider providing grant-writing services.	Train in grant-writing and fundraising.	Conduct fundraising jointly. Provide grant-writing services.

Addressing Problems			
Guiding	Nurturing	Training	Managing
Identify problems as they occur and suggest solutions if needed.	Share successes and problems. Suggest solutions and monitor follow-through.	Identify issues. Problem-solve together and train them on strategies for addressing concerns.	Reinforce the positive. Mediate conflicts. Counsel individuals on their involvement and possible solutions.

- Discuss the unexpended outcomes. Surprising findings can lead projects in new and interesting directions.

- Review findings and determine which changes are needed to increase the project's effectiveness.

- Congratulate the group on their successes. Remind them to celebrate.

ETHICS AND GUIDELINES

Before beginning work with a community, it's important for an organizer to define the ethics and guidelines that will shape their work. We described the ethics of the "prime directive" and "do no harm." Many of the guidelines suggested below are borrowed from the COMPAS Minnesota Rural Arts Initiative.[12] We recommend you define your own ethics and revisit them on an ongoing basis—especially as problems arise.

1. **Listen at all times**. Ask questions. Seek to understand what people are saying and repeat their ideas and concerns back to them. Ask for clarification. Practice listening together.

2. **Form respectful collegial relationships.** This is not a teacher-student or a leader-follower relationship. You are not coming in to save the community from its problems. A successful outcome is the joint responsibility of the organizer and the project leaders. Their task is to develop the necessary skills to make change happen. The organizer's task is to support them through this development. Be positive and use criticism carefully.

3. **Advocate for an inclusive project.** Encourage the group to include people from a range of backgrounds and to look beyond traditional leadership and the arts community. Gather information and communicate in multiple ways to accommodate different styles and approaches.

4. **Support community ownership and autonomy**. Leave decision-making to the group and encourage them to assume responsibility. Only work behind the scenes when necessary, so everyone learns together. Don't come in with pre-conceived notions and remain open to plenty of options.

Keep the Motivation Going			
Guiding	Nurturing	Training	Managing
Encourage. Confirm their decisions and successes.	Recognize leaders for their work.	Cheerlead. Celebrate their successes.	Find out what excites them. Provide rewards.

Good Questions for Reflection

For the community arts organizer, evaluation means simultaneously assessing the community's progress and the support you're providing. We suggest you do this review every two to three months. Here are some questions to guide you:

- What are the project's primary strengths and weaknesses?
- Does the leadership team or steering committee understand these strengths and weaknesses?
- What could they do differently to improve the project? How could they build on their strengths?

- What support from me would help them improve? What support is needed from my organization or other experts?
- What are my goals for working with this group over the next period?
- What should their goals be?
- How has my work supported the community's primary goals? My organization's primary goals?

5. **Be neutral.** Avoid taking sides and developing ties with specific groups or individuals. If someone comes to you with a problem or concern about someone else, suggest they talk to that person directly. Intervene only after this fails.

6. **Avoid conflicts of interest.** Refrain from accepting other work that may compromise your objectivity. This may be difficult, because people may see other ways to use you as a resource. These conflicts often arise for artist organizers, who may be asked to conduct artistic work for the organizations involved. If you are unsure about whether something is a conflict, talk about it openly with the group. Let them make decisions about your role, and provide options. Beware of doing something else with high visibility in the community.

7. **Balance the perspective of your organization with the perspective of the community.** An organizer who represents an agency frequently has to walk the line between the agency and the community. At times you may need to advocate for your organization's goals within the community. Other times you may need to make a case for the community's concerns within your organization. Avoid bias in either direction.

Resources

Altman, Mary and Caddy, John. *Rural Arts Collaborations: The Experience of Artists in Minnesota Schools and Communities.* COMPAS: St. Paul, MN, 1994.

Altman, Mary and Caddy, John. A *Handbook for Rural Arts Collaborations.* COMPAS: St. Paul, MN, 1994.

City of Minneapolis Art in Public Places. *East Harriet Farmstead Neighborhood Criteria* (Handout). Minneapolis, MN: City of Minneapolis, 2001.

COMPAS, Minnesota Rural Arts Initiative. *Role of the Network Consultant* (Handout). St. Paul, MN: COMPAS, 1994.

COMPAS. *The Creative Current: Rural Arts as a Community Building Strategy*: St. Paul, MN: COMPAS, 1999.

Dreeszen, Craig. *Community Cultural Planning: Handbook for Community Leaders.* Washington, D.C.: Americans for the Arts, 1999.

Winer, Michael and Ray, Karen Louise. *Collaboration Handbook: Creating, Sustaining, and Enjoying the Journey.* St. Paul, MN: Amherst H. Wilder Foundation, 1992.

REFERENCES

Part One

1. Alfred Arvold, "The Community Center Movement" *College and State*, vol. 1, no. 3, North Dakota Agricultural College, (May-June 1917).

2. Robert Gard, *Grassroots Theater: A Search for Regional Arts in America* (Madison, WI: University of Wisconsin Press, 1999).

3. Robert Gard, Ralph Kohlhoff, and Michael Warlum, *The Arts in the Small Community* (Washington, D.C.: Americans for the Arts, 1995).

4. Baker Brownell, *The Human Community* (New York: Harper & Brothers, 1950).

5. Rachel Davis-Dubois, *Get Together Americans: Friendly Approaches to Racial and Cultural Conflicts Through the Neighborhood-Home Festival* (New York: Harper & Brothers, 1943).

6. Percy MacKaye, *The Playhouse and the Play* (New York: MacMillan 1909).

7. *The Cradle Will Rock*, (Touchstone Home Video, 1999).

8. *"Examining Why People Participate in the Arts"* RAND Corporation, www.rand.org/publications/RB/researchprofile/.

9. *Children's Theatre Company summary*, Americans for the Arts, www.americansforthearts.org/AnimatingDemocracy/lab_summary.html.

10. *Grantmakers for the Arts 2001 conference summary*, Grantmakers for the Arts, www.giarts.org/conf_01/BeyondArt.htm.

Part Two

1. Paul Mattessich and Barbara Monsey, *Community Building: What Makes It Work* (St. Paul, MN: Amherst H. Wilder Foundation, 1997).

2. COMPAS, Minnesota Rural Arts Initiative *Network Consultant Position Description* (handout) (St. Paul, MN: COMPAS, 1994).

3. www.startrekdatabse.com/lcars/articles/general.

4. University of Michigan Health System, *Medical School Institutional Review Board (IRBMED)*, www.med.umich.edu/irbmed/ethics/hippocratic/hippocratic.html.

5. COMPAS, Minnesota Rural Arts Initiative (handout) (St. Paul, MN: COMPAS, 1997). The COMPAS model was also adapted from a previous model created by the Leadership Research Institute: www.lrinet.com.

6. The Midwest Academy: Kim Bobo, Jackie Kendall, and Steve Max, *Organizing for Social Change: A Manual for Activists in the 1990's* (Santa Ana, CA: Seven Locks Press, 1991).

7. Kathleen Mundell, and Hillary Anne Frost-Kumpf, *Sensing Place: A Guide to Community Culture* (Augusta, ME: Maine Arts Commission 1995).

8. Louise Stevens, *Community Cultural Planning Work Kit: Conducting a Cultural Assessment* (Amherst, MA: The Arts Extension Service, Division of Continuing Education, University of Massachusetts1990).

9. John Kretzman, and John McKnight, *Building Communities from the Inside Out: A Path Toward Finding and Mobilizing a Community's Assets* (Chicago, IL: ACTA Publications, 1997).

10. Maryo Ewell, Introduction to *Grassroots Theater* by Robert Gard, (Madison, WI: University of Wisconsin Press, 1999).

11. City of Minneapolis Art in Public Places *"East Harriet Farmstead Neighborhood Criteria"* (handout) (Minneapolis, MN: City of Minneapolis, (2001).

12. COMPAS, Minnesota Rural Arts Initiative "Role of the Network Consultant" (handout) (St. Paul, MN: COMPAS 1994).

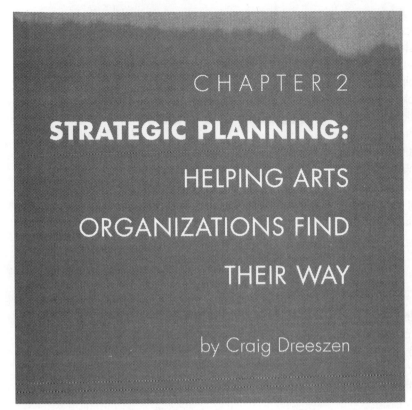

CHAPTER 2

STRATEGIC PLANNING:

HELPING ARTS

ORGANIZATIONS FIND

THEIR WAY

by Craig Dreeszen

"A learning organization is a place where people are continually discovering they can create their reality."

–Peter Senge, business strategy writer

Our friend Danielle Withrow advises leaders of nonprofit arts organizations to know their elevator speech. Imagine this: On your errand to fetch grant guidelines you enter the elevator to the foundation offices. There you are surprised to find a hard-to-reach officer of the foundation. You could just talk about the weather or you could add that you are looking for support "...to realize our dream to build a professional African American theater that gives voice to our community." You have a vision. And you know it so well that you can weave it into even casual conversations at a reception or intermission, in a fundraising call, or in an elevator. You know why you go to work each morning and can easily explain why people in the community should support your work. You've been planning.

Successful organizations, whether community arts organizations or multinational corporations, typically possess one thing in common—a compelling, articulate vision. Such a vision may be the inspiration of an individual who captures the imagination and commitment of others, or it may reflect the collective ideas of a group that has framed a common dream. If the members of an organization—from the president to the newest volunteer—share an understanding of what that organization values and where it may be headed, they will more effectively realize their shared intentions. An empowering vision expands personal dreams into ones that can unify, inspire, and mobilize.

WHY PLAN?

Strategic planning is a process through which an organization articulates what it may accomplish in the future, what needs it hopes to meet, and how it plans to do so. Strategic planning answers questions like: Who do we serve and what do they want? What difference do we want to make? What are our priorities? Where should we invest our time and money for best results?

Strategic planning helps an organization to identify who it should serve with what programs. Planning informs and excites people about the organization's work, motivating staff, boards, and volunteers. Planning helps an organization to communicate the potential impact of its work to funders, potential partners, and audiences. Planning helps an organization allocate scarce resources–people, funds, and facilities–to accomplish goals. Planning helps protect the organization from potential artistic, financial, or political catastrophes. It is both a process that clarifies a group's intentions and a product, the written plan. Arguably the planning process is as important as the product.

Keep planning simple

"OK," says the beleaguered arts administrator, "I understand the benefits of planning, but I've never been able to keep up with the demands of my work. Now, with less money and help, it's getting worse. I can't focus past the immediate crisis! I don't have time to plan!"

If you are in the midst of a crisis, by all means deal with whatever threatens you before undertaking strategic planning. You can't plan home improvements if the house is on fire.

If you are entirely preoccupied with the important but mind-numbing details of day-to-day operations, you may not notice opportunities or threats until it's too late and you must scramble to solve yet another crisis. Leaders who have embraced planning as a way of working recognize that planning saves more time than it takes. Planning can prevent some crises.

Still, there are always more tasks than time, so planning must be kept simple. If it isn't, people won't do it. If the resulting plan isn't clear, simple, and adaptable, it will be ignored.

Most administrators intuitively utilize elements of the strategic planning process. It is impossible to organize a performing arts season, write a grant, or recruit volunteers without being able to plan. Virtually everyone in the arts possesses the skills it takes to plan. Any process that brings together the people who care about an

organization to seriously consider its aims, audience, directions, and resources can serve as a model. The process doesn't have to be perfect. What is important is that it becomes an integral part of the life of the organization.

Planning at a glance

In essence, a sound planning process mobilizes you to:

- gather together the people who care about your work;

- dream of what you could accomplish together, what the organization could become, what difference it could make in the community;

- look around to identify what you do well or poorly, who your audience is and what they want or need, and your major problems and opportunities;

- decide what you want to do;

- select what steps will get you where you want to go;

- implement your plan;

- observe what happens;

- evaluate, revise, and adapt your plan as you carry out programs and services.

Planning is not as complicated as it seems. Planning is a bit like riding a bike. While bike riding is easy enough for a five-year-old to master, describing how to is more difficult. Everyday planning is also easy and we all do it. Somehow when we approach the task of systematically planning for an entire organization or a community, all the discussion can make the task appear more complicated than it actually is. Keep this in mind. Like bicycling, the real work of planning is active and forward moving.

WHAT IS PLANNING? TYPES AND TERMS

One of the complicating factors in thinking about planning is that there are so many different kinds of plans. Within the field that we call planning are the planning of routine

But, the cautious administrator says, how can I plan when everything is so unpredictable? How many plans anticipated the upheavals following the September 11, 2002, terrorist attacks?

Planning's fundamental paradox, which has always been true but has become more obvious after Sept. 11, is that the future is essentially unknowable. We plan to prepare for what cannot be known. In orderly times we forget this and plan with lots of unquestioned assumptions about how we think the world will unfold. In calmer periods this may work. But when we think of planning as accurately predicting the future, we're defeated before we begin. When we think of planning as understanding community needs, clarifying our organization's values, and articulating the kinds of differences we hope to make for our constituents and communities, we're on safer ground. These things are less volatile than the political, economic and social environment in which we work.

It is still very useful to forecast actions and their intended results into the future. In the current era of accountability for outcomes, this is essential. What we can't do is get too attached to our predictions or follow planned strategies without constant adjustment to changing conditions.

We get in trouble when we use metaphors like "blueprint" and "road map" that reinforce the mistaken belief that planning is a reliably predictable, step-by-step guide to the future. But the road changes—bridges wash out and new paths emerge. We need new metaphors. A plan is better thought of as a compass. With a general sense of direction, we can navigate regardless of what changes we encounter in the terrain. Planning is critical; printed plans are less so.

When times are tough and changing fast, we need, more than ever, planning's capacity to help us deepen our understanding of people's needs, center people in our organizations around shared values and vision, and describe the results we're trying to achieve. As planners we are faced with an apparent paradox: In the face of uncertainty, we need a sense of direction. We must plan for the future—yet the future is unpredictable. This paradox can be resolved. You don't have to know the future to plan.

This makes planning simpler and more real. Except for the near future, plans have little to do with predicting exactly what we will be doing by when. This resolves the typical problem of plans languishing in a file cabinet because they bear so little resemblance to the way things actually work out in the real world.

Fortunately, you don't have to know the future to plan or as the MassMutual Financial Group puts it, "You can't predict. You can prepare."sm

operations and the planning of major organizational change. The leaders of a local arts agency may plan for the annual concert series where much about the scheduling, budgeting, process of artist selection, and marketing are routine. These same leaders could also undertake planning to reevaluate their role as arts programmers in a community whose dance, theater, and music presenters are beginning to fill that need for the community. This non-routine planning could dramatically transform the organization. This will be clearer after we define some types of plans.

Long-range planning

A long-range plan describes the future results you hope to achieve. If you think of planning as a journey, a long-range plan focuses on the destination. It is a plan that describes goals and anticipates outcomes three to five years (or sometimes more) into the future. While some grand schemes–to build a new community arts center or document the oral history of a community–are conceived in longer time frames, the uncertainty of the future constrains most planners to limit their planning to the near future.

Strategic planning

If we carry our journey metaphor a little further, strategic planning is a way to describe both the destination and how you will get there.

Our *long-range* goal is to restore the old elementary school as a community arts center.

Our *strategy* is to launch a three-phase fundraising effort: (1) a leadership campaign targeting area corporations and foundations to achieve 50 percent of the goal before we go public; (2) a "Buy a Brick" campaign to attract many small gifts; and (3) a matching grant from the state arts council.

While it is useful in theory to distinguish between long-range planning (where you're going) and strategic planning (how you'll get there), in practice it is difficult to tell the destination from the path, so these terms may be applied interchangeably. The use of long-range versus strategic planning in this chapter

depends on to whether the *destination* or the *path to get there* is being emphasized. After this section on definitions, the rest of this chapter explains strategic planning.

Program planning

Some plans deal with a single aspect of an agency's operations, such as a plan for artistic programming, an arts education program, marketing plan, fundraising plan, or renovation of a facility. These may be called program, project, or component plans. Most arts managers have experience planning programs. It is the experience of planning programs that makes it likely you can succeed to do strategic planning for organizations.

As in any planning, you may plan for routine, repeating programs. Many such program plans are implicit or exist as a collection of paper and computer files, calendar notations, budgets, and notes on scraps of paper. A program plan can organize all these into one coherent file or binder that makes it easier to repeat the program or pass it on to someone else and to learn from experience to improve the program.

A simple project plan can be assembled as a planning and procedures manual in a single binder. For a volunteer-run organization this can be a breakthrough. Each lead volunteer amends the plan and procedures manual before he or she passes it on to the next volunteer; it becomes easier to recruit volunteers and to assure well-managed programs.

A procedures manual for an ongoing program is a good example of a plan that emerges from experience. Rather than just projecting how a project might be done, the plan also documents what is being done and what needs improvement.

> *"When you are immersed in a vision, you know what must be done. . . . But you may not know how to do it. You experiment, err, try again—yet, there is no ambiguity."*
>
> **–Ed Simon,** president and chief operating officer, Herman Miller

Procedures manual

The contents of a plan and procedures manual might contain the following elements:

- Program objectives
- Planning and implementation schedule often presented as a graphic timeline
- Program tasks
- Staff and volunteer job descriptions
- Funding sources
- Grant and contribution proposals
- Projected budget and statement of actual income and expenses
- Samples: Press releases, press clippings, promotions, letters, contracts, brochures, advertisements, etc.
- Evaluation forms and results (compared to program objectives)
- Recommendations for changes

Strategic program plans

Other program plans look very much like strategic plans for organizations, only they deal with one aspect of the organization. An arts education plan for a local arts agency, a facility-renovation plan, or an accessibility plan are examples. If leaders of an organization realized the need for clear priorities for one of these programs in a year that they were not doing organization-wide strategic planning, a strategic program plan would be appropriate. These issues might also be taken up with other programs and operations in a comprehensive agency strategic plan.

Alternatively, it is not unusual for leaders of a strategic planning process to write an overall plan for an agency that specifies some aspects that need more planning. Priority goals and objectives for some areas of the organization will become clear enough during the process of strategic planning (such as arts programming, fundraising, and marketing) to be written with considerable specificity. Other areas (perhaps staffing or facility improvement) might need more assessment and planning than can be

completed during the organization's strategic plan. It is common to do a strategic plan in year one, then plan programs in the second or third year, and then renew strategic planning in the third or fourth year of the planning cycle.

Annual work plans or operating plan

Other plans deal with the programs and operations of the entire organization over a fiscal year. These may be referred to as annual work plans. State arts agencies for example, often develop annual plans for each program or staff member with specific, measurable objectives (or performance goals) for that fiscal year.

A work plan could contain your strategies, lists of tasks, deadlines, and other details too specific for a strategic plan. Work plans might be developed for a single staff person, a program, or an entire organization.

Annual budget

A budget is a kind of annual plan expressed in strictly financial terms. A budget should be influenced by, and reflect the priorities of, the annual operating plan. If the board has determined that arts-in-education will be a greater priority next year, then the budget should reflect increased organizational resources of staff time and money spent on arts-in-education. Budgets and annual operating plans should be consistent with each other. For more information see the financial management chapter.

ALTERNATIVE TYPES OF AGENCY PLANNING

"As a grant reviewer, I first look at the mission statement and then turn to the budget before I even look at the project idea. The budget reflects the values of the mission statement, and if I see no link, I'm concerned that the project is probably not an appropriate one. If the mission is about supporting artists but the budget shows artists as in-kind, I rarely read on."

–Maryo Ewell, community arts coordinator, Colorado Arts Council

Scenario planning

Recognizing that the future is uncertain, some planners develop two or more alternative scenario plans. You may use any approach to planning and add alternative scenarios. Corporations use this kind of planning to anticipate how they will react if any of a number of variable conditions takes place. An energy company may anticipate two scenarios in their planning, one assuming oil embargoes and the other not. An arts center might prepare for two scenarios. In one the capital campaign is fully successful and the facility is expanded and the other scenario prepares for a less successful campaign and minor facility renovation.

Vision plus information plus unforeseen events equals opportunity.

Emergent planning

Most planners anticipate future actions in their planning. We develop a plan that describes what we intend to do. There is another approach that Harvey Mintzberg called emergent planning. In this more intuitive approach, program managers run programs, try new initiatives, and as they do so, they observe and document what works and does not. Emergent planning is a deliberate process of discovering a plan from experience. This is more sophisticated than what some planners call muddling through, in that planners are quite intentional about creating new written plans based on emerging experience.

TWO TYPES OF PLANS OUTSIDE A SINGLE ORGANIZATION

Collaborative planning

As organizations are increasingly engaged in collaborative work, you may find yourself planning for a program or larger initiative in partnership with other organizations. There has been a lot of collaborative planning between community arts organizations and schools to develop arts education programs. Other collaborative plans might produce statewide arts advocacy campaigns or a regional cultural tourism initiative.

While much of the principles of strategic

planning apply, there are some significant differences. If these differences are not accommodated in planning, the collaborations may be frustrating.

- First, the partners will seldom have a common mission, so the partnership lacks this central organizing principle. You should look though, for collaborative plans that will advance each of the partners' goals. This is simpler if each of the partners have done their own strategic planning. You will want to establish goals and objectives for the partnership.

- Leadership among the partners may not be clear and must be established as working relationships are formed.

- Membership of the partnership may be ambiguous and should be clarified.

- Power among the partners may be unequal. Mutual respect is essential.

- Cultural differences may affect how different partners think and act. Diversity can make for improved planning and partnerships, but differences must be appreciated.

- Implementation is not under the authority of a single organization. The partners must create systems to determine how decisions are implemented, progress monitored, and results evaluated.

Community cultural planning

While an agency long-range or strategic plan should concern itself with the needs and resources of the community, or at least of the agency's audiences, community cultural plans are explicitly concerned with the cultural needs and opportunities of the entire community, transcending the interests of any one arts organization. Community cultural planning is a structured process for assessing a community's cultural needs and preparing a comprehensive plan to respond to those needs.

To plan where one is going in the future, it is crucial to know where one is now. Particularly for local arts agencies, a community's needs and opportunities often require more resources

Ten Steps to Plan a Successful Partnership

The AES publication *Learning Partnerships: Planning and Evaluation Workbooks* and the online workshop *Learning Partnerships: Online help for arts education collaborations* lay out a detailed, ten-step process for collaborative planning. Visit www.umass.edu/aes for more information. As you can see, the first three steps are unique to collaborations and the remainder of the process is more like strategic planning.

1. Prepare for partnership
2. Explore a shared need
3. Decide to act in collaboration
4. Define goals
5. Set objectives
6. Describe activities
7. Budget
8. Plan fundraising
9. Anticipate evaluation
10. Summarize plan and timeline

than the local arts agency alone can provide. In such cases, the community may initiate a community cultural plan.

There are several types of community-wide planning. A community arts plan focuses specifically on needs and directions in support of the various artistic disciplines (visual, performing, literary, media). A community cultural plan is aimed at the more broadly defined cultural interests of a community. Culture in planning is often considered to include a community's visual and performing artists, arts organizations and their programs, and arts education. Often writers, literature and libraries are included. Cultural plans also typically consider multicultural programs, festivals, cultural facilities, arts funding, and needs of audiences. Many cultural plans extend to urban design, including the look of streets and

neighborhoods, and the preservation of historic buildings. Local arts agencies often assume leadership roles in community-wide planning.

It is not unusual to combine elements of these types of plans. A local arts agency may conduct a community-wide cultural assessment and then create an agency strategic plan to respond to some of the issues raised in the broader assessment that most closely relate to the local arts agency's mission and capabilities.

Planning approaches vary by type of plan

While these various types of plans share common elements, there are important differences among them. In practice, short-term, project-specific planning is approached quite differently than long-term, visionary, community planning. Short-term and specific plans are crafted more precisely and with a higher expectation of predictability than are longer-range and more comprehensive plans. Planning for ongoing operations is approached more routinely than is planning for organizational transformation. This chapter focuses upon the kind of planning most often conducted by community arts organizations—strategic organizational planning that has the potential for organizational transformation.

Individual compared with group planning

Leaders are effective because they possess a vision of what a group can accomplish, the energy to work on behalf of that vision, and the persuasive skills to convince others to support the effort. Why then, shouldn't a leader just make plans and then persuade the remainder of the group to support them? Even if an individually generated plan were as good as one created by a group, the apparent efficiency of individual leader planning may be undermined by the time and effort required to sell the finished plan to others.

Most observers of organizations recognize that members of a group are more enthusiastic about programs that they have helped to plan. Members of a board will raise funds more effectively if they have participated in decision

Types of Plans	
Project, program, or component plan	For a specific project (fundraising, marketing) or program (arts in education, exhibitions)
Annual operating plan	For all projects, programs, and administration over one fiscal year; linked to the budget
Budget	Expressed in financial revenues and expenses over a specified period, usually one year
Long-range plan	Desired future results, usually expressed as goals and objectives to be achieved over a three-year period
Strategic plan	Strategies—general approach and specific tasks—to realize long-range plan
Community cultural plan	An assessment of a community's arts and/or cultural needs and strategies to meet them; recommendations usually apply to many community agencies

making about fundraising priorities and goals. Even if board members participate only in a brainstorming session, they gain some sense of ownership in the resulting plan. An ethnic group in a community is more likely to support the local arts council's programs if they have been invited to the table to help translate that community's interests into action. Ownership can translate into commitment to do the work necessary to implement the plan.

Group participation in planning

It is, of course, possible to involve groups in token participation in planning where the leaders have predetermined the results. This Machiavellian sort of planning is usually recognized for what it is and backfires in the form of grudging support from board members, volunteers, and staff. When the work encounters obstacles, it is easy to give up on someone else's idea.

The difference between token and genuine participation in planning has little to do with the amount of time spent in group planning. A general sense of a group's priorities and intentions can be gathered in a relatively brief planning retreat or series of planning meetings. In genuine participation, the leader must be authentically open to new ideas, even those that may challenge the leader's own preconceptions. In a truly participatory process, a good idea gets tempered and improved, and a flawed one gets challenged and rejected.

If the members of the board and staff are largely united in their intentions and agree upon organizational priorities, the planning process can confirm this and provide the basis for coherent decisions on programming, marketing, fundraising, and volunteer recruiting.

What if planning provokes disagreement?

On the other hand, it may become apparent in planning that some members of the local arts agency want to support only established

western European culture and others want to encourage culturally diverse programming. Planning may provoke conflict. Here there may be at least two differing visions of an organization's mission and priorities.

Board and staff members should debate priorities in a planning retreat or series of meetings. The task of the planning team in the case of conflict is to clarify the implications of each choice in terms of fulfillment of community needs, financial development, and audience outreach. The planning team returns to a larger meeting of board and staff with a clearer picture of what the organization might look like if it moved along either of the proposed paths. There may be financial consequences for one choice that were not obvious when the alternative was first proposed. Or audience statistics may reveal a surprisingly high (or low) level of community support for one or the other option.

At times it is necessary to agree to disagree. Disagreements may be so profound that they prompt people to withdraw from organizations. While such conflicts are unpleasant, it is better to openly clarify what members of an organization believe in and are prepared to support than to allow conflicts to bubble up later when attempting to implement programs. It is usually better to achieve consensus on general principles, then it will become more obvious which specific decisions must be made.

THE LANGUAGE OF PLANNING

Planning terminology can be confusing. One person's goal is another's objective. We suggest some terms here, but don't be overly concerned if people in your organization are more comfortable with others. What is more important is that, within an organization, people understand the language used in their plan and that a word like "objective"

"Japanese management doesn't prescribe specific measurable objectives. Rather, leaders try to communicate a business philosophy—how to deal with customers, employees, competitors, world role—that allows individuals to determine their own objectives as they operate under any circumstance no matter how unusual or new."

–William G. Ouchi

means the same thing each time it is used throughout a plan.

Planners use words like *vision*, *mission*, and *purpose* to describe the broad, general, and long-term sense of what an organization values and where it hopes to go in the future. Long-term expectations of results are usually termed goals. Narrower, specific expectations are described as *objectives* or *intended outcomes*. The most detailed short-term actions may be called tasks. *Strategies* are the approaches or methods used to realize your objectives and goals.

In general, planning terminology ranges from more general, inclusive terms to the more specific. Broad terms like *vision*, *mission*, or *purpose* describe your organization's ultimate intentions in the broadest sense. Other terms like *goals* describe long-term results you hope to achieve. More specific words like *objectives* or *outcomes* describe results you hope to achieve in the short term. Don't be surprised though if members of your board have learned to use the word *goal* to describe everything from a formal statement of results five years into the future, to a more specific outcome next year, to their expectations for tonight's meeting. Don't waste too much time defining terms, but do agree on how to express your intentions in your written plan.

Terms describing intended results

Vision. A vision is a statement of values, ideals, or ultimate dreams for the future.

If you can imagine the essential difference your organization is trying to make or the kind of community you want to live in, you have a vision. Sometimes these are tightly crafted statements that complement the formal mission or they may be lists of idealized future results. Visions do not have to be practical or even achievable. While not all plans articulate a vision, they can help to set your sights high and provide context for a formal mission statement.

Vision examples

The Hawaii Community Foundation: "We want to live in a Hawai'i where people care about each other, our natural resources and

diverse island cultures—a place where people's ideas, initiatives and generosity support thriving, responsible communities."

Maine Performing Arts Network: "Five years from now the Maine Performing Arts Network will be the best source for Maine performing arts information; will serve more constituents and members, will directly support artists with touring funding, will have additional organizational capacity, will harness technology for information, networking and advocacy, and will be a consistent and vital advocate for the arts."

Mission. A mission statement is the formal statement of purpose or ultimate result your organization hopes to achieve. Your mission answers the questions why your organization exists and who you aim to serve.

Mission is a long-standing statement of why your organization exists.

The Arts Extension Service develops the arts in communities, and community through the arts with continuing education and learning opportunities for arts managers, artists, and civic leaders.

Maine Performing Arts Network maintains the communications, information, and assistance network that sustains Maine's community of performing artists and performance presenters. We work to enhance the artistic experience for Maine artists and audiences building more livable communities.

The Hawaii Community Foundation helps people make a difference by inspiring the spirit of giving and by investing in people and solutions to benefit every island community.

Young Audiences/New York: "To instill in young people from pre-kindergarten through high school an appreciation, knowledge and understanding of the performing, visual, and literary arts."

Sierra Arts: We are a regional arts organization dedicated to enhancing the quality of life and human experience by supporting an environment where arts and cultural diversity thrive.

The mission of Young Artists of Virginia is to enhance the education and ultimately the quality of life of Virginians by providing all the arts for all the children.

ArtServe Michigan supports and advocates for the arts and cultural education in the state of Michigan.

Values. Principles or beliefs tare often unstated assumptions about how the world works and what is important. In some plans, important values that define the organizational culture and inspire ethical action are stated as explicit values statements.

At Arts Kentucky...
We Believe that arts and culture

- Enrich the lives of our citizens
- Enhance the education of our children
- Strengthen the economic stability of our communities
- And make Kentucky a better place to live

We Value

- Creativity, diversity, accessibility, inclusivity and artistic vision
- Freedom of speech
- The right of all citizens to experience and participate in the creation of art

Slogans or tag lines

You may find it useful to boil down your mission or vision into a very short, compelling phrase that you may use as a memorable slogan or tag line. This is as much a marketing strategy as a planning issue. Especially if you choose to write a long mission statement, it is useful to capture the essence in a phrase that you can reproduce on your letterhead, business cards, publications, web site, email signatures, program notes, and fundraising materials. This is language you quote in your elevator speech.

The Arts Extension Service: "Connecting Arts and Community with Learning"

The Vermont Arts Council: "We don't make art, we make art work"

Arts Kentucky has a tag line, "Bringing

People, Arts and Cultures together" and a favorite quote they frequently cite, "Art is not a thing, it's a way".

National Arts Stabilization, "Helping Arts Organizations Thrive"

Goal. A desired long-term result or condition that is generally intermediate and consistent with the overall purpose.

Goals are general, long-term, result-oriented statements consistent with the mission. They answer why.

Goals often describe the overall intended results of the major program areas. If all your goals were achieved, you would fulfill your mission. It may be a good idea to lead with public-benefit goals and conclude with an internal, capacity-building goal.

Arts Extension Service Goals

1. Provide professional arts management learning opportunities through the national AES Learning Network.

2. Investigate, develop and deliver educational resources to advance the understanding of arts management.

3. Work with the region's arts organizations, artists, and university community through partnership projects and technical assistance delivery.

4. Build the capacity of Arts Extension Service for long-term viability.

The Maine Arts Commission' Long-Range Goals:

1. Develop Maine communities through arts and culture.

2. Support full access to learning in and through the arts.

3. Encourage and support Maine artists.

4. Build the capacity of Maine's creative sector

5. Develop art in public spaces

Objective. A specific, measurable, and achievable short-term result consistent with a goal. Objectives are similar to goals in that objectives describe desired future results. Objectives, though, are more specific than goals and predict results in a shorter time frame—often within the next year. Objectives are also anticipated outcomes. The terms *objective* and *outcome* may be used interchangeably (*objective* used more often in planning and *outcome* used more often in evaluation). This demonstrates the close relation between planning and evaluation. The Government Accounting Office uses *performance goals* to mean specific objectives to be measured through evaluation in a given fiscal year. Objectives should describe an intended observable result. A good test is what specific changes in people or the world can be observed or measured?

Many plans describe activities or tasks and label these objectives. You might think of these as *process objectives*. These may help focus your activities toward planned priorities, but they will be difficult to evaluate. A process objective may be to "offer professional development workshops for artists." You describe your activity. A better objective, "help artists learn to manage their businesses professionally with workshops."

This describes the changes you hope to see in artists and allows you to evaluate the effects of your programs on artists. If you do insist on writing process objectives, you will need to convert these into measurable outcomes when you prepare to evaluate your programs. See the program evaluation chapter.

An effective objective should meet three conditions. It should:

- Be specific (what will be achieved);

- Describe anticipated changes in the world or in people;

- Be achievable (realistic and feasible).

In addition, many objectives can also be time bound (when will it be achieved):

"Increase new and renewal subscriptions by 2% by mid-May." (very specific)

"Provide funds and opportunities for professional development of teachers, administrators, school volunteers, and

NEA Strategic Plan

The arts reflect the past, enrich the present, and imagine the future.

VISION

A nation in which the arts play a central role in the lives of all Americans.

MISSION

The National Endowment for the Arts, an investment in America's living cultural heritage, serves the public good by *nurturing* the expression of human creativity, *supporting* the cultivation of community spirit, and *fostering* the recognition and appreciation of the **excellence** and **diversity** of our nation's artistic accomplishments.

teaching artists to build their capacity to teach in and through the arts." (less specific)

Terms describing intended methods

Assessment. In the context of strategic planning, assessment is the process of observing constituent needs, organizational health, and environmental trends. Assessment may also be used to describe the monitoring and evaluation of programs to see what works and what doesn't and to evaluate results at the conclusion of programs. In formal educational evaluation, assessment is the measuring of student learning.

An assessment is a reality check. In planning, assessment is thought of as information gathering in preparation for taking action. In practice, assessment, decision making, and action are intermixed. In the planning process described in this text, assessment is a specific step that identifies internal strengths and weaknesses and external threats and opportunities, concluding with a list of critical issues. For example:

> **The organization had a great reputation for quality programming but now is hampered by dwindling audiences. The community is**

experiencing declining population overall, yet increasing cultural diversity.

Strategy. General approaches or methods an organization utilizes to fulfill its goals and objectives. Within your plan, strategies report how you will attempt to achieve each part of your plan.

> *Strategies describe programs and services to accomplish objectives. They answer how.*

Build the local audience for a subscription series through the coordinated strategy of a special intermission event for existing subscribers, combined with direct mail and supplemented by publicity and follow-up telemarketing.

Terms used in operational or short-term planning

Program. The events and services designed to achieve goals and objectives, usually linked to an operational budget.

List of specific concerts, dates, and locations, along with a budget of anticipated revenues and expenses

Budget. A plan expressing specific financial objectives over a specified period of time. Budgets are projections by category of anticipated revenues and expenses. Budgets must be consistent with the strategic plan objectives. Budgets help define priorities in that the organization should be spending on its planned priorities.

Tasks and actions. Activities that contribute to the achievement of goals and objectives, expressed in terms of whom does what by when.

> *Tasks are specific jobs to accomplish objectives.*

The artistic director will present his proposed budget for the upcoming season of concerts to the board of directors for their approval by the March 15th meeting.

Timeline. A tool that provides a graphic overview of key tasks in terms of persons responsible and deadlines (see appendix).

HOW TO PLAN: THE AES EIGHT-STAGE PLANNING PROCESS

Almost any planning process is beneficial if it regularly brings together people who care enough about an organization to answer important questions: How are we doing? What needs are we trying to meet? In what do we believe? If your organization already has an effective planning process in place, stick with it. However, organizations without one often want to begin with a tested process that is known to work. The Arts Extension Service uses the following eight-stage planning process. It is simple, flexible, and need not take much time.

"Finite human perception and an infinite world make accurate prediction impossible. . . . planning strategies that depend upon perfect foresight are inappropriate and sometimes misleading."

–T. J. Cartwright, planning theorist

The AES planning process relies upon the combination of a small planning team and a planning retreat. The planning team or committee organizes the effort and actually writes the plan. Assessment can be comprehensive or simplified. The planning retreat is a one-day (usually four to six-hour) meeting in which board and staff members participate. The retreat provides for broad, general participation in planning. The planning team does the specific planning work.

We recommend that the eight-stage planning process be undertaken to initiate an organization into a cycle of ongoing planning. After planning has become integrated into the organization, then assessing, monitoring, adapting, and planning become ongoing activities. With practice, planning is not a separate activity but a fundamental way of working. It becomes second nature and intuitive. If planning is seen as a way to systematically learn about and adapt to changes in the organization's environment, the planning organization becomes a learning organization–one in which learning is an internalized value.

Who's on first?

Each organization will determine who is most able to take responsibility for each stage of planning. The board's formal action usually starts and concludes the planning. The governing board is ordinarily the final, approving authority. In some public commissions, the commissioners are advisory and ought to participate in planning even if they are not called on to approve the finished plan.

The governing board usually authorizes that the planning be done. While the board is ultimately responsible for planning, the professional staff should have key leadership roles. In some organizations the board focuses on the larger issues of mission and goals while staff is primarily responsible for objectives and strategies. In the best case, the board and staff are partners in planning. Staff ought to influence mission and goals and board members ought to influence objectives. In all volunteer organizations, committee chairs may provide the perspective of staff.

- Board and staff initiate the plan by organizing and appointing a planning committee.

- The planning committee or consultant leads a community assessment if required.

- Board and staff gather in a planning retreat to make sense of the assessment, to envision, and to set goals. A volunteer or professional consultant facilitates.

- The planning committee (and/or planning consultant) writes the draft plan.

- The board considers the draft, amends it if needed and approves the plan. If necessary the planning committee writes a second draft before final approval.

The AES Planning Process

STAGE	WHAT	WHO	HOW
1. Organize	Recruit planning team, budget, determine scope, collect background information.	CEO & board president	Organize meeting.
2. Envision	Discuss vision, values, who we are and what we believe in (to be expressed in a set of governing ideas).	Board & staff	Hold planning retreat for steps 2-4.
3. Assess	Discover current internal and external conditions. Simple plans involve only board and staff; more team comprehensive plans assess community members' needs directly.	Board & staff	Conduct retreat and/or planning interviews, focus groups, surveys, public hearings. Review records.
4. Establish Goals	Explore alternatives and choose desired results and most likely ways to achieve them. May be expressed through mission, goals, objectives, strategies, and budgets.	Board & staff or planning team	Hold planning retreat and subsequent series of planning meetings.
5. Write the Plan	Write first draft, revise, review (board & staff), check with constituents, revise final draft.	Planning team	Write, revise, and rewrite.
6. Approve & Commit	Confirm board approval and organizational commitment to implement. Distribute plan widely.	Board, staff & volunteers	Explain, promote, and go public.
7. Implement	Determine who does what, and at what cost. Then do it.	Staff and/or volunteers	Link plan to budgets and program decisions.
8. Evaluate & Adapt	Regularly ask how are we doing? Monitor progress on objectives. Make course corrections as conditions change. Recycle through planning process.	Staff & board	Recruit champions for goals, schedule discussions, monitor progress.

STAGE 1. ORGANIZE

A planning effort requires organization. Typically a board or senior staff member decides that the organization would benefit from planning and initiates discussion with other board members and staff. They consider the scope and scale of the plan, possible candidates for the planning team, and the time and funds needed for the effort. They decide how to involve the full board and staff. At a subsequent board meeting, the idea is raised and support sought. If there are professional staff, the project is introduced to them at a staff meeting.

To prepare for planning, some initial topics need to be considered:

Timing. When should planning start and finish? What time period should the plan cover?

Process. What should the process be? If you adopt this eight-stage model, how and at what point should the assessment be made? Will it involve people outside the organization—through interviews, focus group meetings, or surveys—or will the board and staff assume they know the community, audiences, funders, and potential collaborators and competitors well enough to proceed?

Planning team. Who will lead the planning effort and who should be on the team? AES recommends using a small planning team of three to five people. Recruit people who can write, as well as those who represent a balance among the interests and constituencies served by your organization. A small, balanced group is needed to finish the planning work started at a retreat or series of planning meetings.

Budget. What funds are required and from what sources will they be drawn? If a professional consultant or retreat facilitator is used, this will be the major expense. Consultants are sometimes helpful but not always necessary. Other expenses may include refreshments for the retreat and any assessment meetings, flip charts, photocopying, and postage. State and local arts agencies often offer categories of support that provide funds

for planning. If you plan to seek a grant to underwrite your planning effort, this step will have to be accomplished well in advance of the start of planning.

Schedule the planning retreat. Your board and staff members are busy, and it is important to reserve the retreat date on their calendars. Allow enough time to collect information, including audience research or community assessment if they are part of your planning process.

Select the retreat site. You will want an attractive, easily accessible location where people will be comfortable and productive. Retreats may be held in corporate boardrooms (to encourage hard work), in private homes (to encourage informality and sociability), or at conference centers (to encourage productivity or make the retreat more of a special event).

Collect necessary materials. You will need an easel and large flip chart, markers, and masking tape. In addition have on hand copies of existing plans, budgets, mission statements, audience statistics, sample promotions, etc. Refreshments are essential. (See Appendix for a Planning Retreat Checklist as well as a detailed Retreat Agenda.)

The next three stages may be covered in part or in their entirety at the planning retreat. However, if your board and staff do not adequately represent the community you serve or wish to serve, an external assessment step is essential. In that case, this process works best if the assessment is conducted before the planning retreat. Assessment becomes the second step and Envision becomes the third. See the Sample Planning Retreat Agenda in the Appendix for more on how to organize this process.

STAGE 2. ENVISION

This may be the most important step in the planning process. Here members of the group ask

Planning and then not evaluating is like producing a play and then not asking how good it was, or planning a game strategy in football and not keeping score.

Should We Use a Consultant?

Consultants can help to organize your planning effort, facilitate a planning retreat, collect information about your community in the assessment phase, or advise you as you write the plan.

The advantage of using a consultant is that you can get right to planning issues without attending much to the process. You can enjoy a more effective and efficient retreat with professional facilitation, and the amount of volunteer and staff time devoted to the planning effort can be reduced. The biggest potential disadvantage is that the organization's leaders may not acquire the skills to plan on their own and will remain dependent upon consultants. To avoid this, insist on participating in the organizing stage with the consultant. Another potential disadvantage is that the consultant may deliberately or inadvertently divert the organization toward the consultant's own values and interests.

Consultants, of course, charge for their professional fees and expenses.

The facilitation of the planning retreat is the hardest to duplicate without a consultant. The retreat requires a skillful facilitator (see Appendix). A member of the organization can fulfill that role, though an in-house retreat facilitator must defer her or his own interests in favor of the interests of the group. If you use or adapt the AES eight-step planning model, you can employ a consultant just for retreat facilitation and save on expenses.

A recommendation from your colleagues in other arts organizations is a good way to find a consultant. Check with your local or state arts agency or your national arts service organization. Some state and regional arts organizations have assembled rosters of consultants. If there is a Business Volunteers for the Arts organization near you, they can refer you to business volunteers.

How to choose a consultant:

- Interview the consultant in person or over the phone.

- Ask the consultant to describe her or his approach to planning.

- Notice how well the consultant listens to you.

- Notice what questions the consultant asks and if she or he proposes a planning process before learning about your organization.

- Meet with more than one consultant.

- Ask for references.

- Ask for the consultant's fees and anticipated expenses.

- Ask for a simple written proposal.

- Trust your feelings. That you can respect each other's values and work well and comfortably together are more important than the specific planning methods the consultant plans to use.

the most fundamental questions: In what do we believe? Why does this organization exist? What difference, ultimately, do we wish to make in this community? What is our vision for the future? Vision refers to the inspiring sense of purpose or mission for which the organization works.

For an organization with a clearly established vision, this step becomes an opportunity to introduce new volunteers and staff to that vision and to remind everyone of the important work of which they are all a part.

"While we had a good plan, we hadn't realized until the retreat that almost a third of our board and half of our staff had never been part of our planning. To them the plan was just another document. You should have seen the excitement as the newer people began to understand that we weren't just in the business of presenting concerts; we were engaged in the business of rebuilding a community—a community where art and artistic values mattered. We've since started to refer to our annual planning retreats as revival meetings...and not completely in jest."

The importance of vision

A sense of vision, one that is meaningful, articulate, and widely shared by members of an organization, is the most powerful force in planning. A planning retreat that achieves such a sense of purpose, and nothing more, can be considered successful and well worth the effort. For this work we are more in the need of a vision and a compass than a road map. A clear sense of purpose and well-understood principles are more valuable in a rapidly changing environment than a detailed set of strategies that may become quickly outdated.

Stripped of all the jargon, the methods and advice, planning is, in essence, a creative act. A planner, like an artist, imagines what might be and then goes about to make it so. The playwright outlines a story, the painter sketches, and the sculptor builds a model. The planning team envisions what difference in the world the arts organization could make, talks about what future they would like to create, and writes down a plan that documents that vision.

Finding your vision

An inspiring vision is crucial to planning and to success. But how do we find one? One way is to recall one you already have. Another is to recognize a vision held by a visionary leader among you. A third approach is to create a new vision.

Recall your vision. Sometimes discussions among founding members or a review of early plans and promotions will reveal a powerful founding vision that may have been forgotten. Ask members to recall why it was that they joined the organization to regain a sense of this founding vision.

Recognize the vision of a leader. Sometimes arts organizations are blessed with a visionary leader. This is frequently the case for arts-producing organizations. The organization may have been formed to support the creative work of a choreographer, music director, or curator. This envisioning stage becomes a process of encouraging the visionary leader to communicate her or his artistic vision to the rest of the organization's members.

Many arts managers have complained that they don't plan because they don't have the skills. People who work in the arts, however, often have the most essential planning skill–the power to imagine something that does not yet exist.

Create a new vision. For arts organizations that are sustained less by the creative needs of an individual artist and more by community needs for artistic programs and services, this approach may be the most successful.

The experience of many planners is that it is difficult for most people to express their visions. While a vision must ultimately be expressed in writing, it often needs to emerge from a less literal process. Too much talking and writing may inhibit more imaginative thinking. A planning retreat should include envisioning exercises to assist people to tap their right-brain creativity. These may include the use of drawing, metaphors, storytelling, games, and guided visualization (See Sample Planning Retreat Agenda, Appendix).

An actress in Maine attended an AES planning workshop to learn how to start a theater company in her rural community. She had worked in other theaters and knew how they operated. There were a number of people interested in participating, but she was having considerable trouble getting started. How does one create an institution? She was daunted.

After she described her dilemma, it occurred to the instructor to ask if she could act and organize the production of a play. Of course she could. He suggested that she assume the role of an artistic director, imagine a scenario of her theater company in business, and then cast players in the roles needed to get the theater established.

"But the theater isn't real yet," she said. He asked her at what point it would be. Would it be real after they had built a theater, after they had produced their first play, or after they had a year's productions behind them?

"Why not create it now? Announce that a community theater has been started and that you are the first artistic director. Print some

business cards, call a meeting of interested community members, and plan your first production. Assume the role and act the part."

Soon after she wrote on her new letterhead to announce that it worked just as she had imagined. She had tapped the creativity of the art she knew so well.

While it is often possible for group members to glimpse a shared vision, it is typically difficult to write a concise and memorable vision or mission statement during a retreat. Most attempts result in something that reads as if a committee wrote it. More likely at this point in the retreat (or in a succession of planning meetings), the vision exists as a series of key words and phrases, perhaps some drawings or charts.

Try to condense onto one or two flip charts the essential parts of the visioning exercises. Post the mission statement on a flip chart alongside the written elements of the newly described vision.

Compare vision language to mission.

Assuming you are planning in a retreat, at this point it is wise to compare the vision statement with the existing mission statement. If the mission remains consistent with the language emerging as a vision, the planners can reconfirm the mission. Some of the words and phrases generated in the retreat can be used to interpret the mission in promotions, fundraising appeals, and communications with volunteers or staff.

The comparison of the mission and vision may prove the mission to be out of date. In that case the group should discuss whether they need to revise the mission.

Resist the temptation to write a new mission statement as part of the retreat. Rather, charge the planning committee or consultant work with the intentions of the planning retreat participants as summarized on the flip chart notes and return to the board and staff with one or more versions of a revised mission statement for their consideration.

An inspiring vision is crucial, but you must balance vision with a clear-eyed look at where

you are and how you are doing. The group must assess current conditions.

STAGE 3. ASSESS

An accurate assessment of your current situation—both internal and external to the organization—is the next step in planning. While assessment is considered here as a discrete phase in planning, it is actually a way of learning and working that goes on continually. The leaders of any successful arts organization are constantly observing and assessing what is going on within the organization and its community and adapting operations as required. In addition to this ongoing assessment, a deliberate taking stock of current conditions is a part of a strategic planning process.

Our eight-stage model assumes two assessment possibilities:

1) that the board and staff represent the community or constituency served by the organization and understands their needs;

2) the organization's leaders do not represent or do not understand constituency needs.

In the first scenario, artists, educators, and business leaders are represented, as are people from the neighborhoods and ethnic communities. In this case it may be possible to develop a good plan without extensive community assessment. This assumes that you are in close, frequent contact with the people you serve and you understand their concerns. However, planning and the organization are usually improved through the relationship building that happens when you go out into the community to ask about people's interests and needs and how your organization can help serve them.

If the group's leadership does not itself reflect and understand important resources or constituencies (scenario two), then external assessment is essential for the planning to be authentic. Beyond the obvious advantage of the

"Effective people are not problem-minded, they are opportunity-minded."

–Peter Drucker, management writer

planning information you will gather, there are other critical benefits. The relationships you establish or strengthen through assessment discussions will serve your organization well.

Julia Fabris of the Illinois Arts Alliance observed, "Plans inevitably change, but if you've built relationships in planning, you can adjust." There is also a political or public relations benefit from constituent assessment. Your organization can become visibly concerned with understanding community needs. This may put you on the radar screens of people who may be in a position to help you implement your plans. Many arts leaders found they could reach funders, political leaders, school officials, and newspaper publishers to ask questions in assessment in a way they could never do if they were asking for help. As Halsey and Alice North say in the fundraising chapter, the best way to get money is to ask for advice. If you want advice, ask for money.

External assessments can be accomplished by sampling the opinions of representatives of key funders, audiences, and potential collaborators through interviews, focus group meetings, or surveys. Internal assessments can be done by reviewing financial reports and evaluation results; by asking questions of staff, volunteers, and board members; and by identifying assessment issues as part of a planning retreat.

Internal assessment

Review your records. Most organizations have a significant amount of assessment information tucked away in file cabinets. Before going out to the community to gather more data, take a look at what you already have. Some information gathered in your internal assessment may originally have come from external sources.

Financial statements. The current year's budget compared with actual expenses to date provides valuable assessment data. You can get an even better sense of financial trends if you review three previous operating statements (statements of annual income and expenses). While much can be learned from a look at how specific line items change, summarized charts may be more useful for strategic

planning. Charts are especially helpful for people who are not used to working with financial statements. Create a pie chart showing the sources of income and the major expenses. Try creating a simple line chart with total income and expenses over a three or four-year period. Then a bar chart that shows changes over time in income from each major source can be enlightening.

If the data show changes, ask why. If ticket sales rose and then fell, ask if there were programming or promotion changes that could explain the variation. The point of the financial analysis is to help make strategic decisions in planning.

> An arts council board was recently discussing the wisdom of partnerships with non-arts agencies. A table showing the amount of money that partners invested in the arts council and directly to artists through employment contracts quickly settled the debate.

Evaluation reports. If there have been evaluations of programs or services, the findings should definitely be considered in planning. If evaluation forms from programs have not been summarized, the doing so makes for a great volunteer task.

Grant panelist comments. Comments and scores about your organization or proposals by grants panelist provide good assessment data. You should consider what they say about, you, good and bad, as you plan.

Attendance statistics. A summary of attendance at your programs, events, and services can be very useful as you plan. If you track visitors, calls for information, ticket sales, etc., organize these in summary charts or tables and ask what does the information tell you. People attending your arts programming and taking advantage of your services is strong evidence of their interests and needs.

Self-assessment questionnaires. It can be quite productive to ask questions of board and staff to elicit a clearer sense of what is working and what is not inside the organization. You might administer a self-assessment instrument (see

Appendix for one that you may copy and use). The scoring of anonymous responses can identify issues that people might otherwise be hesitant to raise. But more important than scores is that the questions provoke reflection. If you circulate assessment questions a couple of weeks before your first retreat or other significant planning meeting, you will stimulate critical thinking about the organization's strengths and weaknesses. This sets the stage for some candid self-assessment.

You can also write a shorter list of questions specific to the issues you know to be of concern. If you know there is ambiguity about whether your programs should stress arts for arts sake or arts in service of community development, then distribute a memo asking organization leaders to think about the issue in advance of a planning meeting. You can ask open-ended questions or, like the self-assessment instrument, fixed-response questions.

> Open-ended: "We have debated arts-for-arts-sake and arts-for-utility to build communities before. Which way has the pendulum swung in our organizational priorities: toward arts creation and presentation or towards arts applied to community development? What is lost and what is gained by this shift?"

> Fixed response: "To what extent do you agree with the following statements?
> 1. The arts council should program art without regard for its benefits to the community.

> ❑ strongly agree ❑ agree ❑ disagree

> ❑ strongly disagree

> 2. The potential for community benefit should be an expectation as we plan arts programs.

> ❑ strongly agree ❑ agree ❑ disagree

> ❑ strongly disagree

These two types of open and fixed-response questions can also be used in any written assessment tools such as evaluation forms or mailed surveys. Open questions allow for deeper and subtler understanding but are harder to summarize.

Interviews. You may also discuss assessment questions in one-to-one interviews or small group discussions. In one large arts center, the director met with small groups of professional and clerical staff, regular volunteers, and teaching artists to discuss their concerns and suggestions for planning. Then he summarized these discussions during a planning retreat for senior staff and board members.

"The formation of a group or the process of becoming a leader ultimately hinges on an ability to create a shared sense of reality."

–Gareth Morgan, organizational development writer

Strengths, weaknesses, opportunities, and threats. Invite board and staff members to brainstorm internal organizational strengths and weaknesses and external threats and opportunities (This could be done in a planning retreat). Planners call this step a **SWOT analysis** (an acronym for Strengths, Weaknesses, Opportunities, and Threats). While this is not as effective alone as a more thorough internal and external assessment, in a pinch a SWOT discussion in a planning retreat can satisfy much of the need for assessment in planning. This will work as an external assessment only if the board and staff understand their community well enough. If they understand the general intentions of important funders, the interests of audiences, the concerns of neighbors, and the likely impact of competitors and partners, then they might skip more thorough external assessment.

A SWOT analysis is a simple exercise that involves a facilitator and a group that understands the organization and its environment. There are two popular methods: brainstorming and nominal group process.

Brainstorming. The objective of brainstorming is to get as many ideas as possible from group members in a short time. The facilitator invites the group to think about the organization's internal strengths and weaknesses and external threats and opportunities. While ideas are being expressed, judgment should be suspended. People should feel free to propose

whatever comes to mind, even if it seems far-fetched, bouncing new ideas off earlier ones. The facilitator or an assistant jots down key words or phrases to keep track of each idea as it is introduced.

"It is easier to tone down a wild idea then to think up a new one."

–Alex Osborne, inventor of brainstorming

If the group gets stalled, suggest some categories of ideas within the broader headings. It may help to focus first on the internal strengths and weaknesses and then on the external threats and opportunities.

In most SWOT sessions, internal strengths and external opportunities get intermixed. Don't worry. Just mark an "S" on the flip chart next to each strength and an "O" next to the opportunity as it is named. A threat may also be seen as an opportunity and vice versa. One person's threat (an increasing number of school dropouts among community youth) may be another person's opportunity (for an arts program which addresses the problem). If the issue is both a threat and an opportunity, mark it "T/O." The SWOT exercise concludes when many issues have been identified and the pace of new suggestions slows.

Sometimes a group falls into a pattern of just listing problems. The mood can deteriorate, as more and more weaknesses and threats are recorded on the flip chart. A perceptive facilitator will prompt for some strengths and ask if some of the threats don't also suggest opportunities. Don't gloss over real problems, but the productivity of the retreat will be compromised if everyone is depressed by a litany of problems without relief.

A variation on brainstorming is to break up into smaller groups of five or six people and have each group brainstorm its own list. After a period of perhaps forty minutes, the full group reconvenes and each small group reports on their assessment.

Nominal group process. In this variation, members of the group are invited to individually write out a list of strengths, weaknesses, opportunities, and threats. After fifteen or twenty minutes of individual brainstorming, the facilitator asks each person in turn to identify one issue. Like group brainstorming, each issue is summarized on a flip chart until all ideas have been expressed.

Nominal group process is good for getting everyone to participate and is easier to facilitate. This approach, however, does not take advantage of a group's synergy. The people are only "nominally" a group. Brainstorming is good for generating ideas, as it builds on group enthusiasm. But brainstorming is challenging to facilitate, with lots of ideas being tossed out at once.

External Assessment

Often important community interests are underrepresented by an organization's board or staff. Direct community input may also be needed to test needs or potential support for new initiatives. In these situations the planning process should be adapted to collect assessment information from the community prior to the planning retreat/envisioning stage.

The three standard external assessment tools are interviews, focus groups, and surveys. Your staff and board may conduct interviews and focus groups, though the outside perspective and research skills of a consultant may prove useful. Surveys should be designed and administered with the advice or help of experienced survey researchers. For a discussion of interviews, focus groups, and surveys, see the Appendix item, "How-tos of External Assessment."

Interviews. A good interview requires some preparation and some skill. First, you must determine what information is needed, who to ask, and how to formulate questions. The information needed depends, of course, upon the agency and its plan. Typically, external perceptions are sought regarding community needs and interests, opportunities and threats, and potential resources.

The people most frequently sought out for assessment interviews are community leaders—people who can represent the interests of larger

groups of people. Real Art Ways in Hartford, Connecticut, sought out religious leaders and community organizers to better understand its Puerto Rican neighbors. The risk in interviewing spokespersons, however, is that they may not fully understand the interests of their constituency.

A good interviewer prepares a list of questions that will guide the interview. However, the best interviews seem more like conversations, with questions emerging naturally from the flow of discussion. Don't ask your questions in lockstep fashion. An answer to an open-ended first question may well anticipate your second and third questions. Inexperienced interviewers often make the mistake of talking too much. Listening is your job. It is important to listen actively, restating important points to be sure they were accurately understood.

Take notes. A tape recorder may help, although it may make your interviewee nervous at first, and transcribing tapes will take up additional time. Interview notes and tapes should remain confidential. Ask for permission to attribute any direct quotes; otherwise, report only summaries.

Focus Groups. Focus groups are interviews of a group of people with common interests. The approach was originally developed for commercial market research and has found applications in the areas of politics and nonprofit planning. Focus groups are a simple way to determine what a large number of people are likely to think about a given subject by interviewing a few carefully selected representatives. One can gain a general sense of preferences ("What kind of entertainment does your family prefer?") or reactions to specific programs ("How did you like the jazz concert?").

How to run a focus group:

- Determine what information you seek and compose specific questions to elicit that information. Limit focus groups to one or two general topics and no more than four or five specific questions.

- Determine which community segments you wish to hear from—your audience, non-

attenders, artists, educators—and select a representative sample. A common error is to invite only those who care most about the arts and then to assume that the entire population feels the same way. People who do not see themselves as interested in the arts may need an incentive to participate.

- Schedule focus group meetings. Always convene more than one meeting, as a single meeting could provide information unique to that group's dynamics. Usually focus groups consist of six to ten people. The minimum number is four, and twelve is the manageable maximum. Allow about one hour per meeting.

- Invite participants. Send a letter and follow up with a phone call. You may need to invite twelve people to get eight participants. Be sure to clearly explain why you seek their advice. Market and political researchers pay their focus group participants. Nonprofit arts groups tend more often to give tickets or just a thank you. Do understand though, that payment would attract non-interested citizens who would give a different perspective than those motivated to come to a meeting without compensation.

- The meetings require a moderator who introduces the topic, poses questions, and facilitates the conversation. The moderator can take a high profile and closely direct the conversations or stay in the background and only intervene when the discussion gets off track.

- The meeting agenda might include the following: Explain the reason for the meeting, introduce the general topic, introduce participants, and then pose the first specific question. After some discussion of the first question, move on to subsequent questions. Summarize some key points at the conclusion of the meeting.

- Be as specific as possible. If someone says she likes film, probe and find out what types. Ask questions that your group is capable of answering. Don't ask non-attenders what they think of your programs. To determine what people think of your

Planning Questions in Plain English

Questions that help identify people and institutions that should care, your stakeholders

- Who do you say you serve?
- Who do you really serve?
- Who should you be serving?
- Who would care if you went out of business?

Questions that may help clarify values

- What do you care so much about that you can't compromise?
- What do you believe in?

Questions to evoke a sense of vision or purpose

- What difference do you hope to make in this community?
- What do you want our organization to become?
- What, ultimately, do you want to accomplish?

Questions to assess conditions

- What do you do well?
- What could you do better?
- What are your internal strengths?
- What are your weaknesses?
- What opportunities are there in your community of which you might take advantage?
- Of what threats should you be aware of (economic, political, social, technological, environmental)?
- What do each of your major stakeholders need? How do you know?

Questions to help develop long-term goals

- What do you want this program/organization to look like in three years?
- What should each of our major programs accomplish in the long term?

Each of these can be a goal.

List the three or four major problems you or your constituents face and describe the solution to each as an intended goal, (i.e., "we can't raise enough money" becomes the goal, "Our goal is to develop a sustainable base of earned and contributed revenue."

Questions to help develop short-term objectives

- For a specific program, what specifically do you want to accomplish in the next year?
- What specific changes or improvements do you want to see in place by the end of this year?
- What observable outcomes should you be able to observe if the program succeeds?
- What results could be measured or counted?

Questions to discover strategies to achieve goals or objectives

- Consider the situation now (answers to questions about current conditions) and what you want the situation to be (your goals or objectives).
- What specific steps can you take to get from the current to the desired situation?
- Consider a goal (or an objective).
- What factors are helping accomplish it?
- What factors are working against accomplishing it?
- What can you do to reduce those factors that aren't helping?
- List the most feasible as strategies.

programs, show a video segment and invite reactions to it.

- Professional focus group researchers tape-record or videotape the focus groups, transcribe the discussions, and closely analyze the results. At the very least, take detailed notes.

- During the second and third focus groups, ask the same questions. Be sure not to let the group know what the first one said. The point of conducting multiple meetings is to determine whether perceptions are shared. If you ask leading questions–"We've been hearing that our ticket prices are too low. What do you think?"–You will get biased results.

- If you have conducted two focus group meetings and can successfully predict what the third one will say, you have done enough. If you keep getting new or conflicting information, you should continue.

- At the conclusion of all the focus groups, review the notes with an eye for patterns of interest and preferences that show up in more than one meeting. Test conclusions for validity by comparing them to other sources of assessment information such as ticket sales, competitors' trends, surveys, or first-hand observations.

Surveys. Surveys are commonly used to collect assessment information from large numbers of people. They can be simple cards distributed in program notes to audience members, surveys mailed to representative samples of a population, exit polls (a combination of survey and interview), or telephone polls of randomly selected households. Surveys generally collect demographic information: gender, age, occupation, education, income, family size; preferences (What do you do for recreation? What arts events have you attended?) and opinions (Do you like modern dance?).

Surveys are so common it's easy to forget that the successful ones are quite sophisticated. The most successful do-it-yourself surveys are those conducted with a known audience. If you distribute a demographic and opinion survey to

renewing subscribers, you can be reasonably sure that you understand the characteristics and opinions of your subscribers.

However, it is easy to collect misleading information. If you conduct a telephone survey of your community, you may get a limited picture. For example, afternoon calls will only reach people who do not work outside the home, and evening calls will reach people who stay home. A small survey may suggest a trend that is statistically insignificant, and the results you obtain may be solely a matter of chance. For an excellent guide that provides tested questions and step-by-step instructions, see the Appendix for the National Endowment for the Arts publication, *Surveying Your Audience*.

For general population surveys of the type needed for a community cultural plan, it is highly recommended that you seek professional advice. An experienced consultant or graduate student at a school of business or sociology may either design a survey or conduct one.

Steps of survey research

- Identify the problem to be solved or general questions to be answered. What are the characteristics of our audiences? How do people find out about us? What kinds of programming would appeal to nonattenders?

- Identify your sample. Start by identifying the overall population (community, neighborhood, or existing audience) and then selecting the study sample (specific individuals to be surveyed). A simple approach is to consider names in the telephone book to be the population and every hundredth listing (or other interval) to be the sample. (Remember that such a sample omits unlisted numbers and people without telephones.) A mailed survey requires getting names and addresses on mailing labels.

- Optionally, conduct interviews or focus groups to explore the issue in order to prepare relevant survey questions.

- Design the survey questionnaire, composing questions to elicit the required information. Questions can be open-ended (What kind of music do you like?) or closed-ended.

 (Check the most appropriate box: I like country and western music.

 ❑ I strongly agree ❑ I agree
 ❑ I disagree ❑ I strongly disagree

- Pretest the questionnaire with a smaller sample to weed out confusing questions or other problems. Some common errors are two questions in one, overly complicated questions, leading questions, and jargon.

- Distribute the questionnaires.

- Monitor returns, making up to two follow-up requests. A 50 to 60 percent return is acceptable.

- Edit the completed questionnaires, correcting obvious respondent errors or ommissions.

- Look for patterns in open-ended questions. Read through all the surveys, noting frequent responses. Then assign codes, for example, a CM in the margin for those who prefer classical music.

- Tabulate the survey results. The best way to do this is to enter the answers to survey questions in a file of a statistical computer program. Some spreadsheet and database programs also have statistical capabilities. If you conduct manual counts of responses, you can extract some simple summary information, such as how many people like classical music. With a computer program you can cross-tabulate between questions and determinethe music preferences of your African-American respondents or the media habits of country and western fans.

- Analyze the results. With manual tabulations you can determine totals, averages, and media figures. You can also pull out narrative responses that seem typical. With a computer program you can easily generate graphic portrayals of the data, such as bar and pie charts.

- Report the results to the planners and policy makers.

For a mailed survey, a higher rate of response will result from use of: first class mail—more likely to be opened (but more expensive) than bulk mail; a signed letter, explaining clearly and persuasively the importance of the survey; a return, self-addressed, stamped envelope; and a follow-up request with a duplicate survey.

Assure every child has a sequential program of arts instruction.

Identify critical issues. You should conclude your assessment by reducing all the information into a short list of critical issues to resolve in planning. If your assessment consisted simply of a brainstormed list of SWOT issues in a retreat, you can do this quite simply. Post all of the flip charts around the room and invite participants to walk around, reflect, and make notes about what issues seem to be the most significant. Then determine group consensus through discussion. Another method is to hand out colored markers or adhesive dots and ask people to put a red dot next to critical issues and an orange dot by important ones. The issues with the most red dots are likely to be the most critical.

If you're doing the assessment as part of a retreat, call for a coffee break while a member of the planning team writes up the critical assessment issues on a clean sheet from the flip chart and posts it for reference later in the retreat.

If your internal and external assessment is more thorough, it is best to go through the data and look for themes, patterns, problems, and opportunities that should be raised in the planning. It is best if the assessment is presented as a written report that concisely summarizes critical issues for planning.

Conclude the assessment step

The assessment concludes with planning team consensus on a pared down list of critical internal and external issues that must be considered during the remainder of the planning process. An arts agency might conclude its assessment with a recognition that they are sustained by an effective staff, a well-connected board, and a reputation for quality programs and services; and that they are

challenged by inadequate information about community artists and arts organizations, and their audiences do not sufficiently include the community's growing Latino and African American populations.

At this point the most important work requiring the broad participation of the organization's board and staff has been completed. While the retreat has not yet delved into specifics, important principles have been established that will guide the planning team as they proceed to work out long-range goals and more specific objectives and strategies. Critical issues have been identified. The simple act of articulating organizational values, vision, and critical issues helps volunteers and staff to recognize opportunities and to resolve problems as they arise.

You might be able to complete stage two (envisioning), and do much of stage three (assessment) in a single planning retreat. If the facilitator keeps an eye on the clock, the agenda, and people's energy, it is often possible to take further advantage of the organization's gathered leadership in a retreat. Before people disperse it is helpful to move on to the next stage of the process—planning more specifically for the next two or three years.

Revisit the mission

If your organization is new, you must write a mission statement, which becomes the fundamental principle or foundation of your strategic plan. If there is an existing mission or purpose statement, you will want to examine it to determine if it should be revised. There is no one perfect time in the planning to do this. This eight-step process recommends you consider mission as part of an envisioning exercise early in your panning retreat. Look again at your mission as you approach the conclusion of your planning.

We recommend that you not try to get twenty people in a retreat to write a mission statement. It is fine for them to discuss what the mission might look at, to work individually or in small

"An effective strategy has to be simple."
–Robert J. Waterman, Jr., management consultant

Questions to Inspire People to Express a Sense of Vision and Mission:

- What most inspires you about our work?

- Recall an incident when you observed this organization at its finest.

- When have you seen us doing the best work we were meant to do?

- What business are we in?

- If we went out of business, what would be the ultimate cost to our community? What would be lost?

How you might ask questions

- During a retreat, planning meeting, or similar planning discussion, a facilitator asks one of the above questions.

- Ask each individual to briefly write down one or more answers.

- After individuals have worked alone for a time, ask people to form groups of two or three and share their stories. Planners call these purpose stories.

- Ask a representative from each group to summarize stories that are typical of their group's discussion.

- A facilitator summarizes themes and patterns from the discussion by writing key words and phrases on a large pad of paper.

- Compare the elements of these visions to the current mission or purpose statement.

- If the formal mission statement seems to fit these stories, members of the group now have a better understanding of what that dry language means. If the mission seems out of synch with the values that group members most often described, this suggests that the planners may need to revise the mission.

groups on drafts, but group writing tends to be long-winded and clumsy. Better to have a small group or individual draft one or more carefully worded draft statements for the others to consider.

STAGE 4. ESTABLISH GOALS

The juxtaposition of a compelling vision and a realistic view of the current situation creates energy for change. Helping members of an organization become critically aware of the existing situation and then simultaneously visualize a desired change—a vision, mission, or goal—is to generate organizational energy to fulfill the vision, mission, or goal.

The vision expresses what could be, the assessment describes what is, and goals describe what it would be like if the gap between the vision and reality were bridged. With goals you articulate your long-term intended results.

This stage is one in which members of the group:

- Examine which programs and services are needed to meet community needs and opportunities as identified in the assessment;

- Identify steps to respond to threats and opportunities.

This step can't be finished at a single retreat. It is possible, though, to elicit some directions for the planning committee, specifying what the organization wishes to accomplish over the next two or three years. Then the planning committee and/or consultant writes goals based on their notes and observations from the retreat. Alternatively, the leaders can be convened for a second retreat that focuses on goals and objectives.

Writing goals

Goals are statements of desired future conditions that help to realize the vision or resolve critical issues. Goals tend to be general, long-term, and result oriented.

Goal: Assure every child has a sequential program of arts instruction.

One approach to goal setting is to consider the problems identified in the assessment that you need to solve. A goal describes what the situation will be like when those problems are solved. If an assessment identifies that school children are growing up musically illiterate, a goal might be: "Children will gain an awareness and appreciation of musical forms from around the world." A goal bridges the gap between the organization's vision and its current reality. A community without any essential facilities might describe as its goal: "To build a community cultural center."

Refining goals

It is a common mistake for planners to draft goals that describe symptomatic problems or superficial solutions. One way to get at more fundamental and long-range goals is to ask of a draft goal statement, "If this goal were resolved, what would that get us?"

For example, an artist advocate might propose the following goal: "Our goal is to renovate the front room of the arts center to serve as a local artists' gallery."

A planner asks: "What would that get us?"

Advocate: "It would provide artists a place to exhibit."

Planner: A more fundamental goal might therefore be, "To provide for local artists opportunities to exhibit their work. What would that get us?"

Advocate: "If they had opportunities to exhibit their work, more people would see their work, and the artists could make more sales."

Planner: If that is a more basic goal, a still more basic goal statement might be, "To provide opportunities for local artists to connect with their audiences."

With such a fundamental goal, many strategies may serve to help fulfill the goal: renovate the gallery, publish a map of local artist studios, encourage the local artist guild to hold open studios, work with the local newspaper to feature local artists, etc. By seizing on the first

obvious project as a goal, the planners may too greatly limit their thinking and subsequent programming.

One effective way your group can make headway in articulating long-range goals is by breaking into smaller task forces with each one working on a separate program or goal area. In each case the planners prepare rough notes for the planning committee to refine. (See the Goals/Objectives Worksheet, Appendix.) It is probably wise to limit the number of goals an organization commits to in its strategic plan. Many good plans have only three to five long-range goals.

Writing objectives

Specific objectives clearly state your intentions and set specific targets for which board, volunteers, and staff can aim. This may be the first time in the planning process that some bottom-line, results-oriented staff and board members get interested! The elusive stuff of vision gets translated into how many of what kinds of programs are offered when, and at what cost.

When you write objectives, you are setting the conditions for evaluation. If your objectives are specific and observable, you can evaluate the extent to which each is achieved. This will make evaluation simpler. If your objectives are less specific, you may later need to convert them into anticipated, measurable outcomes before they can be evaluated. See the evaluation chapter for a discussion of how intangible objectives (e.g., school children will use the arts to expand their creativity) can be evaluated.

Specific objectives connect the plan to current realities. Details anchor the plan to the real, immediate needs and opportunities of the organization and its constituency. This is where the expressions of high purpose answer the question, "So what are we going to do about it—now?" At this point, general intentions become linked to resources to realize them:

- Who will organize the program?
- How much will it cost?

- Where will the funds come from?
- If we do this project, what demands will it make on staff time, facilities, and supplies?
- Which objectives are important enough to merit scarce funds and time?

When it comes time to calculate the cost of your objective, "Build an interactive web site by the end of year that links to artists' studios and performance event," you may decide the objective is not as feasible as you thought.

Turning to the calculator, objectives are put to a test of commitment. What do you value highly enough to knock on doors to raise the money to achieve?

Here competing priorities are balanced. Some move forward as immediate objectives for the organization and community. Others are postponed until more resources can be secured.

But specificity has its limits. While the plan is guided by specific objectives for the near future, it is almost certain that conditions will change. A plan that projects overly specific objectives too far into the future may soon be out of date. To balance short-term specificity with long-term flexibility, many strategic plans project detailed objectives for the upcoming year and more general ones for the period thereafter.

Link the plan to the budget

To fulfill each objective, money will have to be raised and spent. A budget must be developed that translates the next year's objectives into anticipated revenues and expenses. A first-draft budget will likely reveal that all the objectives can't be realized as first hoped. The budget process provides a forum for debating the relative merits of competing objectives and programs.

It is helpful to organize the planning process so that it parallels the organization's budgeting process. The planning team can then focus on programmatic objectives, which the financial staff, or committee converts into a budget. (See the "Basic Financial Management" chapter for more on budgeting.)

STAGE 5. WRITE THE PLAN

Writing the plan is a dynamic phase of the planning process. The rigor of crafting words to clarify emerging directions and to identify dilemmas serves to ground ideas. It is not necessary that the planning committee leave a retreat with clear consensus on the organization's intentions or instructions for every element of the plan. Often it isn't until the planning team begins reworking retreat notes into a mission statement and the rough draft of expected results into goals that areas of consensus and disagreement become apparent.

Who writes?

The writing can be done primarily by one writer, with the rest of the planning committee serving as editors; the planning committee can write jointly; or sections of the plan can be delegated to various committee members. How you proceed depends on the skills and working styles of the committee. You may find that the single writer/multiple editor approach produces a more coherent, readable plan.

The drafting and review process

The planning committee or your planning consultant begins writing soon after the

Format of the Finished Plan

Narrative format

Commit to a policy of inclusion in every program, with particular attention to the unique needs of rural artists, and rural communities. In the first year, convene a meeting of the Rural Arts Panel to explore alternate programs for rural arts advancement if federal support is not available.

Outline format

1. Commit to a policy of inclusion.

1.1. Serve the unique needs of rural communities.

1.2. Explore alternatives to federal funding.

Graphic format

Goal 2 Remove barriers to access.

Objective 2.1 Commit to a policy of inclusion in every program with particular attention to artists of color and rural artists.

	FY2006	FY2007	FY2008
Tasks	Convene a panel of artists to assess needs and evaluate our programs Make changes as indicated Hold tour regional forums	Evaluate impact of changes Secure additional funds for a full accessibility plan Hold state conference	Complete accessibility plan Establish artist fellowships

planning retreat. They work up a first draft based on flip charts and from meeting notes (See boxed item, "Format for the finished plan). The draft is distributed to board and staff members in time for consideration at the next board meeting or at a second planning retreat. At the board meeting, portions of the plan with broad support are confirmed, allowing enough time for thorough discussion. Alternative goals or versions of goals are debated. Here the objective is to focus and reach closure on unresolved issues. The board should try to reach consensus in principle and let the planning committee revise the draft plan.

The planning committee meets again and incorporates these changes into another draft. The second draft, if approved by the board, becomes the strategic plan. If there is disagreement about the intentions of the group or need for further clarification, these are debated until there is consensus or an agreement to disagree. The finished plan is neatly typed and formatted, copied, and widely distributed.

Tips on writing the draft plan

Write the draft plan soon after the planning retreat while ideas are still fresh and momentum is strong. Express points of agreement clearly. Convey beliefs about which the group feels strongly.

Earmark for additional deliberation issues on which there is disagreement.

Outline the implications of various goals on courses of action that must still be decided.

Keep it simple! Aim for brevity, conciseness, accessibility, and a usable document.

The Format of the Finished Plan. It is useful as the writing proceeds to have a format in mind for the finished plan. There are three common formats: narrative, outline, and graphic. Often these three are combined in a single document. Following are characteristics of each type:

Narrative

* Written in sentences and paragraphs

* Advantage–familiar to readers

* Disadvantage–one has to read the whole text to extract key ideas; important points may be missed

Outline

* Uses a numbering system to identify key elements of the plan, expressed in key words, phrases, and sentences

* Avoids introductory, transitional, and concluding language

* Easy to consult throughout the year and to annotate with notes to indicate changes and progress or steps completed

* Advantage–less writing for the planners, and readers can easily see the key elements (mission, goals, objectives, strategies)

* Disadvantage–spare language of an outline may not communicate what the planners intended

Graphic

* Summarizes the plan in a graphic presentation, often a table or chart

* Provides board, staff member, or potential funder with a snapshot of the organization and its priorities

* Advantages–the entire strategic plan for several years can be presented on a single page

* Disadvantage–abbreviated style can cause miscommunication

Consider two versions of the finished plan

Many planners balance the advantages and disadvantages of format choices (see opposite page) by producing two versions of their strategic plan. A simple outline or graphic version communicates the key points of the plan. This version, run on a single page or as a brochure, is then produced in quantity and distributed widely. Every staff and board member, volunteer, and committee member gets a copy. Copies of this plan are included in all funding requests and made available to

audiences, municipal officials, and community partners. It is included in any package sent to communicate what the organization is.

A more comprehensive version of the plan, either in narrative form or in outline plus narrative, is produced to guide the organization's policymakers and those responsible for day-to-day operations and decision making. Goals, objectives, and strategies are explained in greater detail in this version. Objectives for the upcoming year are linked to the budget so that the commitment to arts-in-education programming is backed by expenditures in the budget.

STAGE 6. APPROVE AND COMMIT

The governing board ordinarily approves the final draft of the plan. Since board members have been a part of the planning process from the start, this process should be harmonious. It should be an opportunity to celebrate the organization's new or renewed commitment to a shared sense of purpose and the clarification of strategies that will be pursued to help fulfill that mission. This stage should also be the occasion to present the entire strategic plan in overview. Many board and staff members will not have participated in every planning step and some will have only a partial understanding of the plan. They may appreciate primarily those portions with which they are most closely associated. The strategic plan is meaningless unless members of the organization understand it and commit to carrying it out. Accordingly, the leadership should work to assure that everyone understands the group's intentions as expressed in the plan. If the plan can succeed in realigning the efforts of individual members toward a commonly shared sense of purpose, significant energy is released that can accomplish that purpose.

If the plan is a community cultural plan, the approval and commitment process should include a well-orchestrated publicity campaign and a celebratory arts and public relations event that presents the plan. Be creative here.

Design and print the finished plan

The finished plan should be attractively presented. Arts organizations are typically held to higher standards of graphic design than other not-for-profits. The plan can be produced with a simple word processor and photocopied, but do use good graphic design. Even better, recruit a graphic designer and illustrator to produce a professional-looking document.

Since you are an arts organization, consider incorporating visual art into the design of your printed plan. Produce enough copies of the abbreviated version to distribute it liberally. Produce enough of any comprehensive version for all board and professional staff, with some in reserve for new people. Many organizations are also publishing a summary version of their plans on their web site.

STAGE 7. IMPLEMENT

Implementation is simply what you do as an arts manager or volunteer. It is the day-to-day operation of programs and services of the organization. In the context of planning, implementation is the deliberate operation of the organization, mindful of the priorities that have been expressed in the strategic plan.

Considering implementation this late in the scheme suggests that conscious planning is a linear process that is concluded apart from action; then the plan is implemented in new and revised programs and services. In fact, the process is more circular. Assessing, monitoring, adapting, and implementing are ongoing processes.

Decisions to act—that is to implement—may occur at any point in this eight-stage process. Ideas are frequently expressed at the planning retreat that make such obviously good sense that the staff or volunteers responsible for the affected program resolve to take steps to implement the idea immediately, not waiting for the finished plan. The same thing may happen at any other time throughout the weeks devoted to planning. Still, as strategic planning is mostly devoted to describing how the organization will relate to the future, most implementation follows the conclusion of the strategic planning process.

Avoid the fate of abandoned plans

Following are some strategies to help ensure that the strategic plan becomes a useful tool that will inform and guide the organization's leaders and members.

● **Use an authentic, inclusive planning process** that fosters investment in the plan's success.

● **Keep it simple.** Keep the planning process and the written plan as simple as possible. People quickly tire of unnecessary meetings and protracted processes. Few will read or be advised by long planning documents. Take advantage of enthusiasm for the project and start and conclude the planning process in a short time, with no more meetings than are necessary. In the assessment stage, remember that you can never know enough to plan as thoroughly as you might wish, so be content with information that is "good enough." It will change anyway. Write the plan simply and succinctly. As E. B. White suggests, "Make every word tell."

● **Go public with your plans.** Print a sufficient quantity of your plan and distribute it both inside and outside of your organization. By publicly committing to the realization of your strategic plan, you have put yourself under some pressure to implement it.

● **Keep the objectives of your plan before you; keep your "eyes on the prize."** People who find they never have time for the crucial tasks that will help realize important goals should heed Stephen Covey's advice, "Don't prioritize your schedule; schedule your priorities." Post your one-page plan above your desk or somewhere you'll see it often. The most useful plan is the note-covered copy that you keep tucked into your appointment calendar. Highlight priorities, cross off strategies that haven't worked, and make notes about potential new objectives. It is most gratifying to check off accomplished tasks with a bold red pen stroke.

● **Recruit champions.** Identify people who care about the issues expressed in your

"Planning includes communication, elements of control, ways to keep organizations and the people in them from doing dumb things, ways of embracing opportunity on the fly, techniques for generating data, schemes for asking 'What if?' and getting sensible answers, means for reinforcing cultural values, and a whole lot more. The last thing planning seems to do is cough out a plan that anyone takes seriously."

–Robert J. Waterman, Jr., management consultant

plan and ask them to advocate for the implementation of specific elements of it. The board member who is a parent concerned about arts-in-education can become the advocate of your new arts-in-education goal. She or he would watch to see that education programs get into the budget and regularly remind the responsible staff or volunteers of the arts-in-education objectives.

● **Link fundraising and spending decisions to the strategic plan.** A plan that is not related to the budget can scarcely be called a realistic plan. If you don't plan to raise money for and spend money on activities to achieve planned goals; they probably are not your real priorities.

● **Acquaint new people with the plan.** As new volunteers and staff join your organization, make it a point to orient them to your priorities as expressed in your plan.

STAGE 8. EVALUATE AND ADAPT

"How are we doing?" and "What difference did we make?" are the questions at the heart of evaluation. The point of planning is to help make a difference by supporting improved programs and services for a positive impact on the community. The inevitable question then is "Did we?"

Not long ago most arts managers who made strategic plans tried to implement them, but did not feel the need to account for results. Planned objectives would show up in grant proposals, but accountability, to funders and to governing boards, was primarily limited to documenting

that programs were run as planned and that people did take part. Sometimes we even counted them and reported numbers served.

Now, accounting for results through evaluation is becoming much more common. Arts managers have long monitored how well programs are doing, and increasingly they are evaluating what results programs achieve. Evaluation is becoming so prevalent that it is now a fundamental arts management skill. Accordingly, we have added a whole new chapter on program evaluation to this new edition.

Much of the language of planning is similar to evaluation. Evaluators look for fit between programs and goals, and if objectives are realized. One significant difference is that short-term expectations of results are called "objectives" in planning. These are more often called "outcomes" in evaluation. They are the same thing. An anticipated outcome is often called an objective when it is projected in plans. That same objective is often called an outcome when it is measured in evaluation. For your plan and evaluation, you should use language that makes sense to you. Just be consistent.

While planning can be used for programs, agencies, or communities, evaluations are more often conducted at the level of programs. Agencies as a whole are not routinely evaluated except that funders sometimes audit organizations seeking funding.

The skills and methods of planning are familiar to evaluators. The assessment phase in planning uses evaluation methods. Interviews, focus groups, surveys, and public meetings are used both to assess needs as plans proceed, and to measure results when planned programs are evaluated.

You evaluate when you ask what are people's needs and how well you meet them in the early assessment stage of planning. Through assessment, an organization's leaders take stock of existing conditions (school children are not learning about cultural diversity). Through planning, the organization moves toward an improved set of conditions (diversity programming). Evaluations ask how conditions have changed, how well the plan has been

working. Information is collected to determine what the children have learned.

It is important for arts organizations to get into this habit of asking, "How are we doing?" Looking for evidence of success or problems after programs are underway is just as important as setting objectives before they are started. As arts organizations struggle to sustain programs and services in the face of budget cuts and reduced personnel, evaluation becomes a central tool to determine which programs to sustain and which to downsize or eliminate.

Strategic planning is an ongoing, dynamic process of action, observation, and reflection. Evaluation and adaptation are presented here as the final phase of the process. In practice, evaluation commences at the assessment stage of planning, and adaptation is something leaders do every day to cope with new information and unforeseen developments. Evaluation is ongoing attention to the effects of organizational action. "Did our advocacy campaign with the city council result in renewed awareness of the arts council's impact on the community?" Evaluation is also the periodic, deliberate collection of information to determine how well plans and programs have worked. "How many new subscriptions were sold as a result of the direct-mail campaign?"

Since mission and goals describe long-term and less tangible results, evaluation tends to focus on the extent to which the more short-term and tangible objectives are realized.

Use evaluation to adapt the plan

Ongoing informal evaluations and periodic formal reviews provide information essential to keeping organizations on course. (See also the "Program Evaluation" chapter for specific evaluation methods.) Keep the plan flexible and steer. Your strategic plan was your best guess about how the future would unfold. Evaluations show how it is in fact unfolding. Adjust strategies accordingly.

Schedule periodic reviews of the plan

Armed with evaluation information, review progress on important plan objectives. Ask the

advocates of planned programs to provide progress reports and note suggested changes in the plan at regular staff and board meetings. Many groups schedule an annual planning retreat both for the benefits of planning and evaluation and for the associated benefits of team building.

The learning organization

This chapter has offered instruction on how to organize a strategic planning process. Once such a process has become a way of doing business, planning becomes simply an increased capacity to learn.

Peter Senge argues, "Learning disabilities are tragic in children, but they are fatal in organizations. Because of them, few corporations live as long as a person–most die before they reach forty." The approach to strategic planning outlined in this chapter is designed to combat organizational learning disabilities. As our environment changes ever faster, the ability of organizations to learn or plan adaptively may become their most important skill.

"Smart strategists appreciate that they cannot always be smart enough to think through everything in advance . . . strategies need not be deliberate, they can also emerge. . . in response to an evolving situation."

–Henry Mintzberg, business writer

Planning adaptively means being tightly committed to your principles and your vision of what the organization can accomplish while being loosely committed to your strategies to get there. This is what Waterman and Peters in their search for excellence call "the simultaneous loose/tight" principle. Mindlessly sticking to specific strategies that no longer make sense is one of the things that give planning a bad reputation. Regularly re-create your strategies as you learn from experience but don't regularly re-create your value system or your sense of ultimate purpose.

Know what you believe in and care about. Know what difference you want your organization to make in your community. Keep your eyes and ears open for evidence about how you are doing–financial status, audience impact, and quality of programming–and look for unforeseen problems and opportunities. Robert Waterman in *The Renewal Factor* says that opportunities knock often but show up disguised as problems. Staying attuned to your vision for the organization plus regularly gathering information about how the organization is doing positions you to take advantage of opportunities. Learn by planning and you'll be able to recognize fruitful opportunities. Effective planning becomes second nature in a learning organization.

REFERENCES

Selected Resources

April, Arnold, Richard Deasy, and Craig Dreeszen. *Learning Partnerships: Improving Learning in Schools with Arts Partners in the Community.* Washington D.C.: The Arts Education Partnership, 1999.

Barry, Bryan W.. *Strategic Planning Workbook for Nonprofit Organizations.* St. Paul: Amherst Wilder Foundation, 1997.

Bryson, John M.. *Strategic Planning for Public and Nonprofit Organizations.* San Francisco: Jossey Bass, 1995.

Bryson, John M. and Farnum K. Alston. *Creating and Implementing Your Strategic Plan: A Workbook for Public and Nonprofit Organizations.* San Francisco: Jossey-Bass Public Administration Series, 1995.

Dreeszen, Craig. *Community Cultural Planning Handbook: A guide to community leaders.* Washington, D.C.: Americans for the Arts, 1998.

Senge, Peter. *The Fifth Discipline: The Art and Practice of the Learning Organization.* New York: Doubleday, 1990.

Stevens, Louise. *The Community Cultural Assessment Work Kit Vol. 1 and 2.* Amherst: Arts Extension Service, 1987.

Wolf, Thomas. *Managing Nonprofit Organizations.* New York: Prentice Hall, 1990.

Periodicals

Mintzberg, Harvey. "Crafting Strategy." *The Harvard Business Review.* July 1987: 66-75.

Online Resources

Dreeszen, Craig. "Who's on First: Resolving Problems of Implementation in Public Sector Planning" in Lessons Learned: A Planning Toolsite. 1999. National Endowment for the Arts. Mar. 2002 www.arts.endow.gov/pub/Lessons.

Other Resources

Goodstein, Leonard, et al. *Applied Strategic Planning.* Pfeiffer MacGraw Hill, 1993.

Surveying Your Arts Audience. Washington, D.C.: National Endowment for the Arts, 1985.

APPENDIX: STRATEGIC PLANNING

Survey questions excerpted from Surveying Your Arts Audience,
a Research Division Manual, National Endowment for the Arts, 1985.

Your age is (circle one):

Under 18	22 to 29	40 to 49	60 to 65
18 to 21	30 to 39	50 to 59	Over 65

Education (circle highest level):

1—Elementary school 5—Technical school graduate

2—Some high school 6—Community college graduate

3—High school graduate 7—College graduate

4—Some college 8—Postgraduate degree

Are you now (circle one.)

1—Working 4—Keeping house

2—Looking for work 5—Retired

3—Going to school 6—Other (specify)_____

How interested are you in attending the following kinds of exhibits or activities?

(Circle one number for each kind of exhibit or activity)

	Very	Quite	Somewhat	Slightly	Not at all
Folk and craft fairs	1	2	3	4	5
Workshops in household decoration and design	1	2	3	4	5
Contemporary music concerts	1	2	3	4	5
Theater productions	1	2	3	4	5
Film series	1	2	3	4	5
Studio art classes	1	2	3	4	5
Art or music appreciation classes	1	2	3	4	5
Lectures about exhibits	1	2	3	4	5
Dance performances	1	2	3	4	5

PLANNING RETREAT CHECKLIST

Background Materials

The following materials may be culled from grant applications, final reports, and file cabinets. Assemble as many of them as possible as resources for the planning committee. Look for trends, articulate expressions of your organization's intentions, hints about threats and opportunities, etc. It's not unusual to find a better version of your mission in a press release or brochure than in your formal statements.

Critical materials:

❑ Mission statement

❑ Bylaws

❑ Existing or previous plans

❑ Previous financial statements (a three-year period shows trends)

❑ Current year's budget

Helpful materials:

❑ List of current and two years' previous programs and services

❑ Numbers of participants for each program

❑ Press releases and promotions (look for good descriptions of organizational purpose, values, intentions, etc.)

❑ Evaluations and summaries of audience or participation evaluations

Optional materials:

❑ Grant applications (especially narrative sections for basic operating support grants that describe organizational purpose and priorities)

❑ Final reports to funders

❑ Annual organizational reports

❑ Recent consultant or technical assistance reports

❑ Results of any recent audience research or survey

Preretreat checklist:

❑ Ask planning team to refine ideas and rough drafts from retreat schedule into a written plan.

❑ Schedule planning committee meetings after the retreat and due date for the draft plan.

❑ Schedule retreat date well in advance and enter it on board and staff member calendars.

❑ Reserve comfortable meeting place (retreat site, board room, or residence).

❑ Select retreat facilitator, either a group member or outside consultant.

❑ Collect and distribute background information: mission, existing plans, relevant audience statistics, etc.

❑ Prepare and distribute preliminary agenda. Specify start and finish times.

❑ Collect tools: flip charts and easel, tape, markers, and worksheets.

❑ Arrange for refreshments and meal.

SAMPLE PLANNING RETREAT AGENDA

1. **Purpose** (ten minutes)

 President explains the purpose of the retreat, its role in the overall planning process, and steps to be taken; introduces the facilitator who manages remainder of the meeting (may be a designated group member or professional).

2. **Process** (ten minutes)

 Facilitator presents overview of the day's agenda and the retreat process—facilitator's role, opportunity for full participation, likelihood that problems will be raised that won't be satisfactorily solved, etc.

3. **Participant Introductions** (twenty to thirty minutes)

 A common approach is to ask, "Please introduce yourself and tell us why you have chosen to work with this organization." A variation is to ask each person to find someone else whom he or she would like to know better. Once the group is divided into pairs, each takes a turn interviewing the other, asking for information about the person's background, their role in and hopes for the organization. Facilitator keeps track of time and announces when they should shift roles (about five minutes each) and then asks each person to introduce to the group the person she or he interviewed. (Facilitator must be prepared to cut people off to use time economically.)

4. **Warm-up/Visioning** (twenty minutes)

 Serious discussions about an organization's purpose are difficult to generate until people get used to thinking imaginatively and individuals cohere into a working group. Here are some favorite AES warm-up exercises:

 - **Drawing.** (This is best done in small groups.) Draw a picture of this organization as a success. Post the drawings and discuss implications. Variation: Draw it as it exists now and will be in the future.

 - **Metaphors.** Invite participants to meet in small groups and consider the following series of questions: Imagine this organization as a vehicle: What kind is it? Over what kind of terrain does it travel? What powers it? How full is the fuel tank? What parts tend to break down? Who is driving? Who is riding? Where is it headed?

 - **Guided visualization.** Invite members to take an imaginary journey through their community in the near future when their arts organization will have succeeded. What do they see?

5. **Vision/Values/Mission** (one hour)

 Recalling the warm-up exercise, invite group members to talk about visions and values that seem to be shared by members of the organization. As people talk, the facilitator records key words and phrases on the flip chart. This can be approached with a larger group (more than twelve) as a brainstorming exercise, quickly generating ideas without discussion, or with a smaller group as an informal discussion. After everyone's ideas are noted on the flip chart, discuss and underscore with contrasting colored markers those that are most compelling. Write key words and phrases on another flip chart and post. Compare the existing mission statement (written in advance on a sheet of newsprint) with the newly articulated vision and values.

Discuss whether the mission is still relevant or if it may need to be reconsidered and rewritten by the planning committee for board consideration. Resist the temptation to write a new mission as a large group, it seldom works.

6. **Assessment** (thirty minutes)

Conduct a SWOT Analysis (internal strengths and weaknesses and external threats and opportunities). Ask members to name the organization's internal strengths and weaknesses and to record them with a key phrase on a flip chart. Mark each with an "S" or "W" to indicate whether it is a strength or weakness and an "S/W" when a factor is both. Don't be concerned if internal and external factors get all mixed up, just record the issues as they are named.

Note–This assessment assumes that the board and staff accurately represent the community they serve; that is, there is a mix of gender, professions, racial and ethnic groups, artists and business people, etc. If the board and staff do not represent the community, it is advisable to do some external assessment with interviews, focus groups, surveys, or public meetings *before* the retreat.

7. **Critical Issues** (thirty minutes)

Review the SWOT list and underscore critical items tha must be planned for. People can vote by show of hands, by putting a check on the flip chart by their most critical issues, or by trying to reach consensus through discussion. Write the critical issues on a flip chart sheet and post.

8. **Advice to Planning Team on Goals** (thirty minutes)

Quickly review the vision and values, and critical issues. Discuss long-range goals that are consistent with the mission/vision/values and that could resolve some of the most pressing critical issues. People will be tired. Don't try to write out the goals precisely. Simply record key ideas as raw material for the planning committee to work with as they start to write the draft plan. Write out the rough draft goals on a sheet of newsprint and post.

9. **Wrap Up and Looking Forward** (ten minutes)

At this point everyone is tired and likely to forget why they are here. Some may feel more confused about organizational priorities than when they started. It is wise to remind people that they have grappled with a lot of information in a short amount of time and that there is no need to wrap up each step in a tight summary statement. That is the job of the planning committee or consultant. Take down all the flip charts except for visions/values, critical issues, and draft goals. Remind the group of all they have accomplished. Reintroduce the planning committee. You may want to invite others to join the committee if they would like to participate in the next step. Announce the next meeting of the planning committee and the date by which a draft plan will be circulated to board and staff for consideration.

Note–If you wait until the end of the meeting to recruit planning committee members and to settle dates, you and group members may be frustrated that no one volunteers. If this happens, an unfortunate perception that the group talks well but acts poorly may be created or reinforced.

A PLANNING CASE STUDY: REAL ART WAYS, HARTFORD, CONNECTICUT

STAGE	WHAT	HOW	WHO	WHEN	COST
1. Organize	Executive director determines the need to plan; discusses idea with the board; calls consultant and asks for proposal. Consultant submits proposal; board decides to proceed. Director seeks planning grant from a Hartford foundation. Planning committee is recruited; and retreat is scheduled.	Director raises the issue at a board meeting; discusses the idea by phone with consultant; Director and consultant meet for coffee; consultant writes proposal; director writes grant.	Director	Oct 25 to Nov 26	$2.50 for coffee
2. Envision	Director invites stakeholders to attend focus group meetings. Invited are major foundations, local and state arts council staff, Puerto Rican neighborhood association, neighboring college staff, artists, known audience members, potential board members, and gay rights activists.	Seven, 45-minute interviews are scheduled on one day. Consultant and director draft list of questions. Board members take turns attending. Consultant poses questions and takes notes. Director and board participate in discussions. Consultant reports.	Director, board, staff, consultant, 40 stakeholders	Jan 31	$3000 for all consultant fees
3. Assess	Board and staff attend a daylong planning retreat; consultant facilitates.	Six-hour retreat. Agenda: Vision exercise, review of focus group results, internal strengths/weaknesses, draft mission and goals.	Board & staff	Feb 15	$40 for food
4. Plan	Planning retreat concludes with some rough draft goals and a brainstormed list of potential objectives.	A rough draft of goals is recorded on flip chart sheets. Preliminary objectives are stated but not yet prioritized or linked to budgets.			
5. Write and budget	Consultants summarize retreat in a Feb. 25 report. Planning committee writes first draft plan. Board reviews plan, makes suggestions. Committee rewrites.	Consultant writes retreat report by Feb. 25; Planning team meets once to write first draft by March 1; board reviews March 15 and planning team meets again to revise draft by March 30.	Planning team & Board	March 1 to March 30	
6. Approve and commit	Board approves final plan.	Planning team explains plan, board approves. Copies are made and distributed to board, staff, funders, and focus group participants.	Board	Apr 15	
7. Implement	Director writes grant to foundation (the one that funded plan and attended focus group) and receives $150,000 grant to implement major outreach program to Hispanic community.		Director		
8. Evaluate and adapt	Director keeps plan in his calendar, a planning team member reminds board members of progress on plan at each meeting, actions are guided by plan but adapted to changing circumstances.		All		

THE AES PLANNING PROCESS WORKSHEET

STAGE	WHAT	HOW	WHO	WHEN	COST
1. Organize					
2. Envision					
3. Assess					
4. Plan					
5. Write and budget					
6. Approve and commit					
7. Implement					
8. Monitor and adapt					

GOALS/OBJECTIVES WORKSHEET

Mission

Goal # _____

Objectives

Plan of Action

Strategies (how?)	Resources Needed (what?)	Undertaken By (who?)	Completion Date (when?)

Evaluation Criteria

CHAPTER 3

BOARD DEVELOPMENT:

LEADING TO EFFECTIVE GOVERNANCE

by Craig Dreeszen

Organizations are dynamic, more like organisms in ecosystems. They grow and evolve, responding with both structural and procedural changes to different internal conditions, such as new or lost resources, staff changes, new ideas, and plans.

Boards of directors, composed as they are of a changing mix of people with all their hopes and failings, are a challenge to analyze and improve. When you think you finally understand your board, new board members join and the complexion alters. Even experienced consultants and trainers are wise to recall the observation of Sandra Hughes of Board Source observation: "When you've seen one board, you've seen one board."

BOARDS COME IN ALL SIZES AND FLAVORS

Members of boards can be called board members, trustees, steering committee members, or (in public agencies) councilors or commissioners. Most boards are intended to govern but some advise only. Boards oversee both nonprofit organizations and public agencies. They may work with professional staff or work in all-volunteer organizations. We will consider all types and focus on the most common in community arts work, the governing board of a nonprofit organization.

Boards of directors are essential to the success of community arts organizations. The members of a board provide leadership, funding, and skills, and represent the interests of their community. Sometimes a board generates an enthusiasm that energizes the whole organization and enthralls its community. Other boards seem scarcely able to manage their own business meetings.

Improving boards of directors is an inevitable discussion topic at any arts conference. Effective organizations usually credit a strong board as a key to their success, while struggling agencies often cite problems with their boards. Arts service agencies report that the most frequent calls for help from community arts organizations are about problems with boards and money. The most frequently prescribed cure for both problems is board development. "Take a board development workshop and call me in the morning."

A FLEXIBLE APPROACH TO BOARD DEVELOPMENT

A board development text such as this one confronts a basic paradox. Board service is not an innate skill; board members must learn what they are expected to do and how to do it. At the same time, each board is different. Each has evolved from a unique combination of artistic vision, community needs, resources, and leadership personalities. The best advice on board development would be tailored to the current specific circumstances of each board.

In addition to the variation among boards, each board itself changes. Most tend to evolve over time from an entrepreneurial to a more collaborative approach to leadership. When its first staff are hired, the board's responsibilities change again. A board also adapts as leaders change. A group of board members that has learned to work with a hands-on president must learn again how to work with a new, laissez-faire one.

It is impossible to successfully prescribe generic solutions that will work for each board at each stage of its development. This chapter will instead provide a framework to help you examine what works and what could be improved for your board. Boards are so distinctive that you should think twice before changing something that works just because this book or someone outside the organization advises another way of working.

This chapter considers what is typically expected of a board and some arguments to keep expectations within reason. Then two overall strategies are described to improve boards: (1) improve the governing processes and (2) change the board's structure.

Most of this chapter is devoted to improving board processes. We assume that most readers of this text are attempting to learn how to work with an existing board of directors. More experienced readers, who are in a position to significantly influence their organizations, will want to attend particularly to the concluding section that questions basic assumptions about organizational structures, and refer to the books suggested in the references.

WHAT IS EXPECTED OF A BOARD OF DIRECTORS?

Fulfill the law. The one unavoidable expectation of all incorporated nonprofit boards or public commissions is that they assure fulfillment of certain legal requirements. In many cases staff or individual officers will actually fulfill the legally required tasks, but the board is legally responsible to see that each is done.

BoardSource describes the legal expectations of board members:

Duty of care. The duty of care describes the level of competence that is expected of a board member, and is commonly expressed as the duty of "care that an ordinarily prudent person would exercise in a like position and under similar circumstances." This means that a board member owes the duty to exercise reasonable care when he or she makes a decision as a steward of the organization.

Duty of loyalty. The duty of loyalty is a standard of faithfulness; a board member must give undivided allegiance when making decisions affecting the organization. This means that a board member can never use information obtained as a member for personal gain, but must act in the best interests of the organization.

Duty of obedience. The duty of obedience requires board members to be faithful to the organization's mission. They are not permitted to act in a way that is inconsistent with the central goals of the organization. A basis for this rule lies in the public's trust that the organization will manage donated funds to fulfill the organization's mission.

Board of directors responsibilities

Collectively, the board has a specific responsible to:

- govern the organization has a keeping with the charitable purpose for which the organization was incorporated;

- file annual reports with the state;

- file federal income tax returns and report the earnings of contracted workers (consult IRS 990 and 1099 forms to determine current regulations);

- pay payroll and social security taxes for employees;
- fulfill contracts.

Because of the "Duty of Care" Individuals or corporations suffering financial loss or personal injury as a result of alleged negligence may sue board members.

Be accountable. The board is the central link in an organization's system of accountability. Externally the board is accountable to the government on behalf of the public. The government entrusts the board with public funds in the form of grants and with the privilege of collecting tax-exempt contributions. The board is accountable to funders to fulfill their requirements and to implement grant-funded projects as promised.

The board is also crucial to internal accountability. In an effective organization, board members, volunteers, and staff are actively accountable to each other to fulfill their responsibilities in keeping with policies, plans, and budgets. Board members govern on behalf of organization or community members who "own" the nonprofit. In a volunteer organization, committee members and volunteers may be accountable to an individual board member—typically the chair of a committee—who, in turn, is responsible to the full board. In staffed organizations, volunteers and support staff members are responsible to senior staff who, in turn, are responsible to the board.

Ensure the financial well-being of the organization. We entrust boards with a fiduciary responsibility. This means they are ultimately responsible for the short- and long-term fiscal health of the organization. Boards fulfill this fiscal responsibility by fundraising, budgeting, and overseeing the group's financial management.

Raise funds. A nearly universal expectation is that board members will give and get money to help support program, operating, and capital expenses. A common recommendation is that all board members make, what is for each, a significant annual personal cash contribution. All should also participate in some way to support efforts to solicit contributions from individuals and businesses. Some board members can make fundraising calls, while others are better able to write letters, but all should participate.

Budget. The board is responsible to approve budgets. Organizational plans and priorities are expressed in financial terms through annual operating and program budgets. It may be that a finance committee or staff member will actually draft the budget, but the board should be sure that the budget both protects the organization's financial interests and furthers its purpose. Board members should insist that budgets are clearly presented and explained.

Oversee financial management. Day-to-day financial transactions are ordinarily the responsibility of the treasurer or staff. The board is responsible to see that financial controls are established and applied. The board sets financial policies to determine how money is accounted for and how expenses are approved. The board should regularly compare revenues and expenses to budget projections. If revenues drop or expenses rise above amounts budgeted, the board takes corrective steps—usually reducing expenses. Some boards have been publicly embarrassed and put legally at risk when they learn of dangerous deficits too late to act.

Govern and lead. Board members help shape an organization's vision, express that vision in plans, and represent and advocate the interests of the organization throughout the community. The board, a step removed from the details of day-to-day operations of committees or staff, can take the longer view: What are the core organizational values? What are the goals? The board is primarily concerned with ends—where we are going—and staff and committees are concerned with means—how we will get there.

Be clear about the distinction between *governing,* the making of plans and policies, and *managing,* the implementing of operations within those plans and policies. The board governs and the staff manages. We will consider this in more detail later.

In many all-volunteer organizations, however, the board may do everything. The same people who plan programs may also manage every detail of their operation. The challenge of leadership is to rise above the details to see the larger picture, to reserve time from managing to also govern. Otherwise everyone may end up rowing with no one steering.

Represent the community. The board provides a means for an organization to keep in touch with the community it intends to serve. Board members are recruited to represent important constituencies such as artists, funders, audiences, and community partners. A board that reflects the diversity of its community can govern the organization to serve that community's variety of interests. Serving a community well translates into support through audiences and funding.

A good way to reach into a community is to recruit a respected member of that community as part of the board. If the organization needs to work closely with the public school system, it is helpful to have an educator as part of the board. If funds are to be raised from corporations, the board must have access to corporate leaders.

Balance the demands of management and governance

The potential imbalance of the board placing too much attention on management and too little on governance can be addressed. This is valuable for all boards and critical for the all-volunteer organization. One simple technique is to schedule regular governing or planning meetings when the agenda includes only planning and policy issues. What are the pressing community needs? Who do we serve and who have we left out? How well are our services fulfilling our intentions? What external threats and opportunities should we address? In these governing meetings, details of programming are only raised to the extent that they influence policy. These sessions could be cast as an annual planning retreat, a quarterly taking-stock meeting, or an hour at the start of every other board meeting. A group might reinforce that they are in a governing mode by

changing their meeting location. The metaphor is often applied that the board must change hats, sometimes wearing a policy-maker hat and sometimes a volunteer-staff hat.

The board member as volunteer staff

For the all-volunteer organization, the board may also be the core group of workers. Even a staffed organization relies on the skills of board members to perform volunteer tasks for which the group might otherwise have to pay. Examples of skilled people recruited to boards for such expertise include lawyers, accountants, computer specialists, publicists, and teachers. These people are asked to help the board govern and also to advise and provide hands-on help as volunteer staff. It is important to remember though, that when a board member is volunteering in the office or managing a program, she or he is acting as volunteer staff, not as a member of the governing board. It is an unfortunately common mistake for a board member to pull rank and tell staff what to do when the board member is assisting as a volunteer. The board only governs as a body and an individual board member can only advise.

Are expectations of boards reasonable?

Board members are volunteer workers who are expected to lead, govern, raise funds, oversee finances, and ensure internal and external accountability. It is a common complaint that boards do not fulfill their roles. Before taking steps to improve the board, it seems appropriate to ask how reasonable those expectations are.

The central board function of fundraising is a tough responsibility. Arts organizations are attempting to sustain levels of programming and service that have been growing, sometimes over decades. There is an increasing gap developing between the quantity and quality of arts programs and services offered and the human and financial resources that a community can provide to sustain them.

George Thorn, of Action Research, argues that "most organizations [are] attempting to function at about 30 to 50 percent above the floor of realistically available and achievable human

and financial resources." Increasingly the board of directors is being called on to fill the gap. Boards are being asked to raise even more contributed funds to replace lost or reduced public grants.

In tight economic periods, arts organizations cut back staff due to decreased funding. Many of these seek to sustain programming levels by asking board members to manage programs previously run by staff. Such a strategy risks that board members become so consumed with their volunteer staff roles that they neglect their governing responsibilities or quit in fatigue.

Sometimes it is reasonable to expect increased fundraising and volunteer work from the board. A more successful remedy may involve a combination of reduced programs and expenses along with additional help recruited for specific operational tasks. See the Programming Chapter for a discussion of a process that focuses on programs that further core artistic goals at a level that the community can sustain.

It is likely, even with reasonable expectations, that a board of directors could benefit from some attention to its development. Board development may involve anything from fine-tuning to a complete overhaul. The remainder of this chapter explores two approaches. First, procedural improvements are suggested to make the traditional board structure more effective. Then structural changes are suggested, some of which survey new governing/managing paradigms.

TWO STRATEGIES FOR BOARD DEVELOPMENT

If a board of directors is not effectively fulfilling reasonable expectations, there are two fundamental strategies for improvement:

1. Improve the governing and managing processes

2. Revise the organizational structure

The first strategy focuses on who occupies positions, how they relate to one another, and how they do their work. An example of a procedural change would be a new system for identifying and recruiting board members.

The second strategy involves restructuring the board itself. Examples of structural changes range from a simple reduction of the number of board members or elimination of standing committees, to a more comprehensive redefinition of the board's policy making or advising.

Since the nonprofit arts board was invented, there have been dramatic social, political, and economic changes. The traditional board structure requires many people to fill offices and standing committees. In a restrained economy, it is more difficult to find people available for board service. There has been considerable experimentation with structural designs for boards that more flexibly accommodate the new environment.

Structural changes have the most potential for impact. Dramatic structural change can sometimes be just the jolt needed to bring the organization into alignment with its contemporary environment. In other cases, too many changes at once can so disrupt and discomfort organization members that they fail to provide the arts programming and services for which they were organized.

However, given that virtually all organizational development strategies include improvements to the governing and managing processes, we will start there.

STRATEGY 1: IMPROVE GOVERNANCE AND MANAGEMENT PROCESSES

Two approaches to improve processes are:

- improve the effectiveness of current staff, board members, and other volunteers;

- recruit additional people.

The first approach to improving boards: Improve effectiveness of current team

While both approaches are typically used, a common error is to recruit additional board members into a poorly functioning organization without improving the way they

work together. If board members don't understand what is expected of them or if they don't get the information they need to do their jobs, recruiting more people may only worsen the situation. In other cases, the existing team may have neither the skills nor the inclination to make the required changes, and the fresh perspectives of new board or staff members may be required.

Additional ways to engage volunteers. A common board development error is to assume that the only way to recruit people with the requisite expertise is to elect them to the board or to hire them. It may be more effective to invite people to advise or to undertake specific tasks as volunteers, committee members, task force team members, or volunteer consultants. A noticeable trend is to engage people with special skills to handle specific short-term tasks rather than to charge recruits with more general, long-term responsibilities.

Clarify board responsibilities

Most boards would benefit from a clarified sense of individual and collective responsibilities. The division of responsibilities among board members, officers, and staff can be vague. This ambiguity may result in failure to accomplish important tasks: "I thought you were going to write the grant!" This may also lead to confusion about authority. "You should have consulted us before you selected that artist!"

Boards manage policy and staff manage operations. In general, boards manage policy and planning and advise on operations, while staff or committees manage day-to-day operations and advise on policy. A separation of the responsibilities of governing and managing serves as a check and balance. The board is concerned with long-range goals, the staff and volunteers with implementing them. The distinction is not absolute, since staff may exercise considerable leadership and the board may do many management tasks as volunteers. But it is a useful separation of powers for the board to take the long-view thinking about *ends* while the staff focus on the *means* to achieve those ends.

Separating policy from operations has a useful function. Volunteer and professional staff have the skills and focus to attend to the immediate,

pressing tasks and many details of running an arts organization. The board, less consumed with the challenges of day-to-day operations, takes the longer view. However, an insistently strict division of duties may reduce the benefits of board and staff cooperation. A cooperative approach sees each member as contributing his or her expertise in support of the central artistic vision. Note that some writers do not agree that flexible roles make sense. (See the summary of Policy Governance ® on page 78).

Each board's responsibilities are a function of its history and circumstances, as well as the skills and personalities of its members. Therefore each organization needs to discuss and determine for itself what is expected of its board.

How to help board members understand their roles

- Board members should take advantage of arts conferences and board development workshops to discuss board development with other arts leaders. This is an excellent way to cultivate skills in board members with leadership potential.

- Encourage board leaders to read about boards. Circulate this chapter and consult some of the books and web sites listed in the references.

- Establish a board development or governance committee. This committee (or perhaps a single board member) organizes board responsibility discussions and oversees the identification, cultivation, recruitment, and orientation of new board members.

- Devote an hour to a board discussion of their responsibilities.

The statement of board responsibilities should be distributed to all board members as part of their board manual. The statement is shared with prospective board members as part of the recruitment process and becomes the central tool for orienting new members.

Please understand that board responsibilities change as the organization evolves and as external circumstances change. A board that works well with an experienced president or

An Exercise to Clarify Board Responsibilities

Here is a simple exercise to clarify board responsibilities Present the following questions to the board. Break them into small discussion groups of three to five people to determine their responses. Then ask each group to present their recommendations. Seek consensus with a summarized list of board responsibilities.

- What are the essential responsibilities of our board of directors?

- What are the responsibilities of an individual board member?

- What, beyond the essentials, would it be helpful for our board members to do?

- What are the essential responsibilities of the staff?

- What board responsibilities are delegated to the executive committee? How does the executive committee relate to the larger board and to staff?

The board development committee later drafts a statement of board responsibilities for the full board to consider, amend, and adopt as policy.

executive director must adjust when either resigns. Reconsider board responsibilities at least annually.

Whenever a serious problem arises related to ambiguity of responsibilities (missed opportunity or someone's sense of authority overstepped), approach the problem as an opportunity to address the larger issue of distribution of responsibilities rather than assigning blame.

Policy development is a primary board responsibility

Policy development is an essential responsibility of boards and reflects what is important to the organization as a whole. Policies are written statements approved by the governing board that are used to guide individual and group action toward organizational goals and objectives. A test of the need for a policy and of how well it is written is: "Will the policy help staff make subsequent decisions related to this issue?"

Policies allow for leadership continuity despite turnover. By setting policies to guide staff or volunteer action, the board is relieved from making day-to-day operational decisions. By setting limits, policies permit freedom of action within those limits. They therefore simplify decision making and provide for more consistent decisions. The protection that policies provide to staff from political and personal pressures is very important. For example, Mayor: "Why didn't my niece get accepted into your exhibition?" Gallery director: "According to our exhibition policy, selection is made by a jury of peers. Sorry, but the matter is out of my hands."

The most obvious feature to the Policy Governance model is that the board governs by setting policies. While there are many parallels between governance and management, "governance is more than management writ large". Board members tend not to understand how to govern, to enable a part-time, possibly inexpert group of persons to lead. Boards cannot manage better than staff and shouldn't try. "Boards caught in the trap of being better staff than staff, and boards bewildered by unending details or confused by technical complexities, cannot lead." The answer for John Carver is for boards to lead by policy making.

Values and perspectives, usually implicit, are the basis of any organization. However, to articulate a set of values for most nonprofits, one would have to observe specific actions and deduce a framework of values. Yet, even when they are unexpressed, values frame actions. Unrecognized values can create problems. "But when recognized and properly used, these values and perspectives offer leaders the key to effectiveness".

Carver blends values and perspectives in what he terms policy. He distinguishes the conventional use of policy, which sometimes

Policy Governance ®

Policy Governance ® is a system that has been adopted by some state arts agencies and larger cultural institutions. It is a proprietary theory of board governance developed by John Carver. Organizations adopting this model operate within explicitly defined roles for the board and chief executive officer. When done well, this system leaves little room for ambiguity. It best suits larger organizations with a professional chief executive officer and adequate additional staff so that the board can focus entirely on governing through policy. This system is less useful for working boards, where board members also serve as volunteer staff, and is inappropriate for advisory boards.

In this model, the board governs with total authority for the organization on behalf of the organization's owners. A community-based arts organization would understand the community to be its owners. The board of directors is seen as a representative of the owners, and as both servants of those owners and leaders of the organization.

"Traditionally, boards have developed their relationships largely inside the organization—that is, with staff. Policy Governance demands that boards' primary relationships be outside the organization—that is, with owners. ...the board is first servant, before it is leader. It must lead the organization subject to its discoveries about and judgments of the values of the ownership" (Carver and Carver, 2002).

1. **Ends to be achieved.** The most critical policy "concerns itself with what human needs are satisfied, for whom, and at what cost. The governing board's highest calling is to ensure that the organization produces economically justifiable, properly chosen, well-targeted results" (Carver 1997, 31).

2. **Executive limitations (constraints on means).** Carver argues that means to achieve ends are a concern of staff, not board. The board should only direct that staff choose "prudent and ethical" means. The board oversees the chief executive, not by approving his or her reports, plans or actions, but by setting limits on the means that may be used to manage the organization. As these are usually expressed in negative terms, limits on chief executive authority are perhaps the most difficult concept to grasp. An example of such a limit is, "The director shall not fail to file annual financial and tax reports."

Policies are flawed when they are out of date, ignored, or implicit and unwritten. Policies should be explicit, current, literal, available, brief and comprehensive. In policy governance, policies are "nested" like mixing bowls. "After addressing the largest of value choices (the biggest bowl), the board can either address the next level (the second largest bowl) or be content with having clarified the first level." The CEO can then deal with all smaller-level policies within the larger value articulated by the board (Carver 1997).

Carver finds a lot wrong with traditionally organized boards. They spend time on trivial matters, have a bias toward the short term, take a reactive stance (responding only to staff), tend to review, rehash and redo staff work, have "leaky accountability" (boards relating in their official capacity to subordinate staff), and operate with "diffuse authority" (ambiguity about board staff responsibilities).

Calling board members volunteers detracts from an understanding of their role. Their role is not to volunteer in the sense of helping the staff, but to "own the business—often in trust for some larger ownership. If anyone is helping, it is the staff". Of course board members serve

refers to procedures, such as in personnel policy. Carver uses policy to mean an articulation of an organization's values. A critical distinction exists for Carver between *ends* and *means*. "*Ends* decisions address what benefits will come to pass for whom, and the worth and cost of that benefit. ...*Means*, on the other hand, include practices, methods, conduct, and other activities done as people pursue those all-important ends" (Carver 2001).

Carver advises that there are two especially important policies for a board to determine.

individually as volunteer staff and help with operations, but in this they are not governing. Collectively they should limit their role to governing.

Policies of interest to arts organizations

Board operating policies relate to how board members should function in relation to each other and to paid staff and/or volunteers.

> "Board members are expected to attend all regularly scheduled meetings (four to six per year) and to serve on at least one committee."

> "Board decisions will be made by consensus and confirmed by formal vote."

Management policies concern planning and overall operation of the organization, as well as establishing accountability, responsibilities, budgets, and fiscal procedures.

> "The operating budget for the upcoming fiscal year shall be approved by the board at least one month prior to the end of the current fiscal year."

> "Year-end statements will be reviewed by an independent auditor."

Program policies deal with specific programs or projects.

> "In all programs, the Council has a policy affirming and supporting artistic freedom of expression."

Personnel policy relates to recruitment, affirmative action, selection, placement, training and development, discipline, compensation, grievances, termination, and fringe benefits.

> "Staff members are entitled to a formal performance appraisal each year."

Professional policy deals with professional actions of staff members in relation to performance of their organizational duties, confidentiality, and ethical standards.

> "It is the duty of board and staff members to act in the best interests of the gallery. Part

of that duty is to exercise confidentiality on matters conveyed to the board."

Artistic policies pertain to an organization's type and scope of artistic activity.

> "The gallery is committed to representing the fine artists and craftspeople emerging from the four-county region whose work meets the artistic standards of the director."

The development of artistic policy-producing organizations deserves discussion. A dance company, theater, or music ensemble is frequently founded by an individual artist. The organization provides the support that allows the choreographer, director, or musician to produce his or her work. A board is recruited to satisfy the law, raise funds, and provide volunteer help.

Arts organizations typically evolve from entrepreneurial groups into more collaborative institutions. The board, which attempts to set artistic policy, may find itself in conflict with the founding artist or current artistic director. Some argue that arts programs should be solely the responsibility of the artistic director. The board of a producing organization would affect artistic policy only through the selection of an artistic director. Arts programs would also be subject to the board's financial controls. A community arts board, however, often has dual obligations to its art and community. The board may need to collaborate with its artistic personnel to balance artistic and community development goals.

Clarify board and staff roles

Organizations with staff frequently contend with misunderstandings about the respective responsibilities of board and staff. The most common source of tension between board and staff derives from ambiguity about their respective responsibilities. Clarifying the inter-related roles and responsibilities of board and staff members could strengthen virtually any nonprofit organization.

Role ambiguity is most obvious when there are significant structural or personnel changes.

The Policy Sampler by Kathleen Fletcher and BoardSource (1999) describes a variety of other policies, including:

- anti-discrimination
- capital expenditures
- check signing and cash disbursement
- confidentiality
- conflict of interest
- expense reimbursement
- grievance
- indemnification
- investments
- nepotism
- sexual harassment

When an organization first hires staff, some board responsibilities shift to staff. Ordinarily the board governs, retaining policy making and planning, and delegates the management of operations to staff. Paid staff take over many day-to-day operations that board members had previously managed in their role as volunteer staff.

Roles may change again as the professional staff gains experience and respect, and accepts additional leadership responsibilities. An experienced staff will not only implement board policies, but also become important advisers and partners with the board as they set policy. A staff member may, for example, develop the annual budget draft. The board then fulfills its fiscal responsibility by thoroughly considering and approving the budget.

Just as the staff helps and advises the board with planning and policy, board members help and advise staff with operations. Board members usually continue to serve as occasional volunteer staff even with paid staff. The lawyer on the board reviews contracts, the teacher on the board develops arts curricula, and both may jump in to help paint the gallery. When board members don their volunteer staff

hats, they are no longer governing, but assisting staff in operations. The distinction is that a governing board, as a collective body, supervises the senior staff; the gallery director supervises an individual board member helping paint a gallery. Most confusion about roles and responsibilities arises from a lack of clarity about who is helping or advising and who is ultimately responsible for a task.

Sometimes highly capable executive directors are promoted to president/chief executive officer and asked to take on broad leadership responsibilities. In such cases, the board president becomes a chairperson and the board turns its attention to fundraising, community cultivation, and general responsibilities.

Board president and executive directors: complementary roles. Avoid the dilemma of the president and executive director competing for leadership authority. In most cases, the president looks outward toward the community, cultivating partners and support. The director looks inward to oversee programs and operations. They will advise each other, but the wise president will defer to the professional staff's judgment on organizational operations. If the professional director is taking the organization off course, this is cause for collective board intervention. Remember though that the board supervises the director as a body. This supervisory authority may be delegated to an executive or personnel committee. An individual board member, even the president, cannot pull rank on the staff.

A useful rule of thumb is that the board speaks as a body or not at all.

Roles in transition. In small organizations, the transition following the departure of a professional executive director may require the board to temporarily take a more hands-on management style like an all-volunteer organization does. This is less an issue in a larger agency where an assistant or program director may take charge of operations during a transition. As the new staff director matures on the job, the board increasingly lets go of operations until they are back to managing policy.

Build a sense of team

Even an understanding of responsibilities does not ensure that individual board members will work together as a team. Members of any small working group such as a board require time to get to know each other, build trust, clarify roles, rise to or accept leadership, work out conflicting interests, and learn how to make decisions.

A group needs to have some history together before it becomes effective. One classic description of group process predicts that a new group will spend time to *form*, then *storm* (encountering and resolving conflicts), then *norm* (working out effective procedures before they can effectively *perform* as a group). Recognizing this process helps keep perspective when a group struggles at first.

As new people enter an existing board, the group adjusts to the newcomers and vice-versa. A board may meet so infrequently that team building becomes protracted over months. Some groups never coalesce. It is not uncommon for a consultant to visit an arts board for the purpose of board development and find that board members don't even know each other's names. A breakthrough from such a visit might be the decision to prepare a tabletop tent card with each person's name.

Accommodate group dynamics of boards

If your board meets only to conduct business, team building will proceed slowly. Create opportunities for less formal gatherings–the development of the group's sense of team will be accelerated.

Working groups such as boards of directors have two parallel group dynamics, accomplishing group tasks and meeting members' social and emotional needs. To accomplish tasks, board members identify problems, determine agendas, consider alternatives, and make decisions. A skillful chairperson or meeting facilitator can help the group advance through its tasks. At the same time, a social and emotional dynamic is being played out. "Who is that new person? Should I volunteer? Who does he think he is, taking charge like that?" These dynamics are as much a part of the board meeting as the tasks, yet they sometimes go unacknowledged.

Lighten up. If your board members laugh together sometimes, they can later debate the tough issues and still like and respect each other. Get to know each other. Some fun time around a picnic table will make for productive time around the board table. Board members who care about each other work well together.

Manage meetings

Meetings are an occasion when both the group task and social needs of the board are accomplished. Most people have plenty of experience with agonizing meetings that waste people's time and fail to accomplish important work.

> "We finally managed to recruit the publisher of the newspaper and the vice president of the bank to join the board. They came to two meetings and never returned. When asked why, one explained that the meetings started and ended late and were devoted largely to minor details of programming."

Tips for more productive and satisfying board meetings

Respect board members' time. Schedule meetings that thoughtfully consider and respect busy volunteer schedules. Board meetings lasting more than two hours suggest that committees should do more work or staff between board meetings. A national trend suggests that boards are meeting less frequently than once was the case. On average, nonprofit boards meet six to nine times a year. They should also meet annually in a retreat.

Conduct some business electronically. Boards are increasingly doing business electronically. It is common for some actions requiring quick response to be taken through e-mail exchanges. You may need to amend your by-laws to accommodate virtual meetings. Agendas, minutes, and reports are often distributed by e-mail. National organizations sometimes conduct entire board meetings with conference

calls, videoconferences, or e-mail exchanges. Organizational web sites sometimes have password-protected areas where board members can post communications and drafts of policies and plans.

Do take care that no one is disenfranchised by lack of Internet access. Consider also the limitations of electronic communications and avoid working through conflicts or distributing sensitive information by e-mail. Virtual meetings work best when good personal relations are built and maintained through face-to-face contact.

Select a skilled meeting leader. Any gathering of more than three people can benefit from a facilitator. Usually the elected president or chair facilitates the meeting. If the president's skills don't include meeting management, consider appointing a meeting facilitator or rotating the task. The facilitator:

● manages the agenda and time;

● guides discussions, reigning in a long-winded speaker or drawing out a reticent one;

● clarifies issues;

● tests for consensus;

● recognizes decisions.

In some groups, the chair controls access to discussions by recognizing people who want to speak. In others, the chair only intervenes when someone can't get a word into a lively debate.

Work with an agenda. Board members appreciate receiving an agenda in advance of the meeting. In many organizations the president and the chief executive officer (or executive committee) develop the agenda in advance of the board meeting. The first item on the agenda should be a confirmation of the agenda. Consider important items brought forward by board members that aren't yet on the agenda. Schedule important issues early. As the meeting proceeds, watch the time. If a discussion is taking longer than anticipated, consider the impact on the rest of your business.

Meeting agenda types

Traditional. This type of meeting is used to approve the minutes, reports, old business, new business, etc. This is what people are used to. Unfortunately, it forces the board to look backwards to what has been. New thinking is relegated to the end of the meeting and may be cut short if the rest goes over the alloted time.

Operating. Here, the meeting is organized around major operations, i.e., finance, programs, and marketing. The meeting time is organized according to the areas of major work. This promotes better use of time than the traditional agenda, but does risk that the board oversees management, instead of governing.

Planning. The meeting is organized to discuss progress on each of the organization's goals. This is a fine way to ensure that the plan is

Agenda item	Presenter	Time required	Tab in binder	Outcome wanted	Action taken
				Discuss or vote	

lived, not filed away. This approach is ordinarily blended with one of the other models to accommodate business unforeseen in the plan.

Functional. This agenda starts with action items, then moves to matters that require discussion, and concludes with routine reports. This approach puts the important matters first.

Tabular agenda. A graphic presentation can be used for any of the agenda styles. Here is one way to organize a tabular agenda. Note that the agenda can be used to note action taken in minutes.

Timed agenda. A prediction of how much time should be allowed for each agenda item can be incorporated into any agenda style.

Consent agenda or consent calendar. Consent agendas have long been used in government to streamline board meetings, yet the idea is relatively new to nonprofit organizations. Action or information items placed on the consent agenda are voted on as a single item by the board. Board members may remove items from the consent agenda prior to the vote. Items removed from the consent agenda are discussed individually prior to taking action on the agenda. By dealing with lots of information, reports, and routine action matters quickly, the board can reserve time to discuss policy. The board may act on other matters through regular, item-by-item action. Board members must take care though, that they read the proposals on the consent agenda carefully so that they fulfill their governing responsibilities.

Provide information in advance. Provide the information board members need to make decisions. If the agenda includes budget approval, submit the budget in advance. Information to the board should be concise and timely. Board members will likely not read voluminous reports. Sarah Hughes of BoardSource recommends providing vital information in a one-page "dashboard report." Auto manufacturers had to solve the problem of giving drivers a quick assessment of critical systems. They created dashboard dials, lights, and bells to warn of problems that need attention. Your board would appreciate a monthly update that just shows critical facts.

Agree on how to make decisions. Parliamentary procedures, such as described in *Roberts Rules of Order*, are only one way to run a meeting. In large groups, such as an annual meeting of members, parliamentary procedure is a useful technique. It is also useful for crucial policy and financial decisions.

Most board decisions, however, are more effectively managed by consensus. A formal motion for a specific action tends to fix the group on one alternative too early in a discussion. A bad idea gets proposed as a motion, amendments are offered and debated, and the only way to proceed to a good solution may be for the motion maker to withdraw the motion or for the group to defeat it (and the person) by a vote. Consensus is a less formal process that is closer to the way people actually work together. A problem is clarified, alternatives are proposed in a brainstorming-like fashion, and alternative solutions are discussed until the best option becomes clear. The chair or another board member tests for consensus by suggesting something like, "I hear a lot of support for collaborating with the Latino Artists Collective on the full exhibition. Have we reached a decision?" If people agree, the matter is decided. If not, there is need for more discussion.

Recognize when the group has made a decision. At the conclusion of a discussion, the chair should acknowledge that a decision has been reached. Restate the decision. If the business item has financial or legal implications, or if people are more comfortable with formal rules of order, the consensus decision is confirmed with a motion and a vote. At the conclusion of a meeting, review decisions that have been reached.

Document decisions. Decisions should be recorded in writing and promptly distributed as minutes. Meeting minutes can be genuinely useful if they record decisions rather than whole discussions. Minutes should not include a summary of the discussion, only decisions made and actions required. The trend is toward shorter minutes. They usually need not be more than one page in length. Decisions that require

The Consent Agenda as described in the *Sturgis Standard Code of Parliamentary Procedure:*

> Organizations having a large number of routine matters to approve often save time by use of a *consent agenda*, also called a *consent calendar or unanimous consent agenda.* This is a portion of the printed agenda listing matters that are expected to be non-controversial and on which there are likely to be no questions.
>
> Before taking the vote, the chair allows time for the members to read the list to determine if it includes any matters on which they may have a question, or which they would like to discuss or oppose. Any member has a right to remove any item from the consent agenda, in which case it is transferred to the regular agenda so that it may be considered and voted on separately. The remaining items are then unanimously approved en bloc without discussion, saving the time that would be required for individual votes.

The Board of Governors at the University of Western Ontario explain how they use the consent agenda.

> The Secretary identifies action and information items that are routine and/ or likely non-controversial. In so doing, she may consult with the Chair of the Board, the relevant committee chair, and principal resource persons. In each Committee's report, these items are flagged. The unanimous consent motion lists each of the flagged items. Action and information items on the agenda and in committee reports that are not flagged will be presented singly for discussion and voting (when appropriate).
>
> When members receive their Board agendas, they should review all reports in the usual manner. If any member wants to ask a question, discuss, or oppose an item that is marked for the consent agenda, he or she can have it be removed from the consent agenda by contacting the Secretary of the Board of Governors prior to the meeting.
>
> At the Board meeting, before the unanimous consent motion is presented for approval, the Chair of the Board (1) will advise the Board of items that are to be removed from the list, based on prior requests from Board members; and (2) will ask if there are any other items that should be removed from the list. The remaining items are then unanimously approved *en bloc* without discussion, saving the time that would be required for individual presentation and voting. Those matters that have been struck from the consent agenda will be handled in the usual way as each Committee's report is presented.
>
> The minutes of the Board meeting will report matters approved as part of the consent agenda as "carried by unanimous consent." Information items received as part of the consent agenda will be reported as received.

Arts Council "Dashboard" Report (Quick assessment of critical indicators)

Examples of indicators–adapt to suit your specific needs	April 2004	April 2003	April 2002	April 2001	April 2000
New members					
Total members					
Number of grants written					
Grants receivable					
Grants received					
Earned revenues					
Administrative expenses					
Program expenses					
Other financial details					
Endowment balance					
Bank balance					
Audience numbers					
Other measures of interest					

action should acknowledge who does what by when and, if necessary, at what cost.

"We accepted the Latino Artists Collective's offer to develop a joint exhibition in the fall. Robert will meet with Eduardo and come back with a proposed concept, timeline, and budget in time for our May 15 meeting."

Underscore or otherwise highlight action steps in the minutes. One good method is to put an initial and a date in the margin of the minutes to indicate someone has agreed to take action by a certain date. If no one can be identified to take action, acknowledge that the group has not made a decision to act.

Monitor and follow through on agreed actions. A useful assumption is that even the best-intentioned board member needs encouragement or a reminder to complete board assignments. The minutes highlighting decisions and actions become a tool to provide that encouragement and to monitor implementation.

Monitoring tips.

● When preparing to send out the minutes, pull the copy designated for the person with a task and highlight the portion of the minutes that summarizes the agreed-upon action.

- Recruit a board member to monitor the fulfillment of important board or committee tasks. This is a good assignment for a vice-president. The vice-president makes a timely call to inquire, "How is the grant application coming?" This is a huge improvement over the belated, "What? You missed the deadline?"

- Dispense with the routine reading of the minutes at the next meeting. Instead determine the status of all of the action items.

Produce a timeline. A graphic summary of important tasks and key dates is a useful task-monitoring tool. The timeline is consulted by staff and committee chairs and brought out at board meetings for a quick visual overview of the work before them. Seeing all the projects and the key tasks on one chart also help to pinpoint bottlenecks and where people are being overburdened with work.

> "It wasn't until we charted our major events on a one-page calendar that what should have been clear became graphically obvious. We had two major fundraising events in March followed immediately by our festival. We knew we were always frantic in the spring but had accepted it as a fact of arts council life. Someone then asked the naive question, 'Why not move one fundraiser to the fall?' We did."

Learn to manage conflicts. While it is beyond the scope of this chapter to teach conflict management, the issue must be addressed. Conflicts are virtually inevitable and are sometimes useful. Conflicts tend to be about policy, programs, or personalities.

Conflicts can identify important differences that need to be aired and resolved. A fundamental misgiving about the mission of the arts council can manifest itself as a conflict over a detail. Rather than smoothing over the disagreement, leaders should treat the conflict as a sign that substantive discussions about the organization's purpose, policies, programs, or procedures are needed. Perhaps most conflicts, though, are personality clashes. These also need attention.

In any conflict, two factors need balancing. One is a concern for the relationships of the people involved, and the other is a concern for the task or the principle at stake. In some cases the cause of the disagreement (the color of the membership brochure) is relatively less significant than the relationships, and one party concedes or both agree to disagree. In another case (the need for genuine inclusion of people of color), the principle is so vital that it is worth risking the angry resignation of another board member in a win/lose solution.

Sometimes the best solution is to ignore the minor conflict. More often the best course is to develop a win/win solution that meets the interests of all parties. It is important to look beyond the specific positions taken by people to the interests they all have in common. Look for a solution that satisfies the common interests rather than pitting one position against the other. (For further discussion, see *Getting to Yes Without Giving In* by Fisher and Ury.)

The role of the president

The leadership provided by an effective president is a key ingredient of a successful organization. In all-volunteer organizations, the president may act like a chief executive. In a staffed organization, the president complements the executive director.

The board president provides a focal point for the various branches of an organization, a lever to bring the organization into balance, and a catalyst for action. The president should have an overview of the organization's purpose and management process, and may be the public spokesperson. He or she is the one person, in addition to the chief executive officer, who is concerned with the organization as a whole and with its process of fulfilling its purpose, goals, and objectives. To maintain an overview and to manage in the relatively little time available as a volunteer leader, the president must work by motivating others to act. To be effective, he or she must avoid getting bogged down with tasks that should be the responsibility of staff or volunteer workers. Staff can manage programs and volunteers can stuff envelopes. The president's time is better occupied with monitoring how well the organization is serving its constituents and fulfilling its mission.

A president's job description might include the following duties:

- lead the board of directors;
- oversee recruitment and orientation of board members;
- call for and conduct board meetings;
- prepare board agendas (with chief executive staff);
- appoint ad hoc committees and committee chairs;
- represent the organization to the public;
- link board and staff.

Equally important to the duties prescribed in the bylaws is the key leadership, visionary, people-managing role of the president. He or she should:

- provide leadership to help the group identify its goals and fulfill them;
- monitor the overall process of organizational governance and policy fulfillment;
- identify and recruit people who can contribute to the organization's success;
- inspire and motivate board members, staff, and volunteers to strive willingly toward organizational goals;
- manage conflicts;
- look out for future threats and opportunities.

The second approach to improve the board: recruit new members

The first step in board development has been to ensure that you do what you can to improve the way the existing team works together on behalf of the organization. The next step is to recruit new members. Community arts organizations often do not have enough depth of leadership on the board or staff.

Any strategy to improve the governing process will eventually involve the identification and recruitment of new board members. Without conscientious attention to the recruitment process, however, boards tend to perpetuate themselves by "rounding up the usual suspects"—that is recruiting people just like the ones who now serve. This leaves the same gaps in skills, representation, contacts, and resources. A better approach is to identify the organization's governing needs and find people who help meet those needs.

Create a board development or governance committee. Replace the nominating committee that typically operates short-term to recruit board members. Think instead of a year-round leadership-development group. This group could include a board member (someone in line to be president would be a good choice), a staff member, and someone with an outside perspective. This committee is charged with overseeing the profiling, recruitment, and orientation processes. In some effective organizations, the governance committee organizes board training, talks with non-performing board members, and helps manage conflicts.

Profile governance/board needs. Produce a written profile of the skills, contacts, resources and representation needs of the board. (See the tool in the Appendix.) Then compare the existing board to this profile. Needs that are not now met become the priorities for recruitment. Keep in mind though, that people may also be recruited to serve as advisors, on committees or temporary task forces, or in other capacities. Only a few identified candidates would ordinarily be approached to join the governing board of directors.

Identify priorities for recruitment. The committee prepares a summary of characteristics missing from the current board profile and reports to the board. Look for people who bring multiple attributes. It is dangerous to the artistic mission to recruit people who bring only financial expertise without some artistic sensibility. It is patronizing to invite a person of color who does not also bring needed skills or provide access to resources.

Identify stakeholders. It is wise not to limit recruitment to people immediately known to board members. One way to expand thinking is to list community types who ought to have a stake in your organization's success. These are

your stakeholders. Few people will make the commitment required of a board member unless they perceive they have a stake in your success. This stakeholder analysis can serve fundraising, membership development, and marketing functions as well.

Name potential candidates. With recruitment priorities in mind, look at the list of stakeholders and think of individuals who provide the priority attributes and who may see themselves as having a stake in your organization. People who fit into more than one category of stakeholder are more likely to appreciate the benefit of volunteer service.

If specific, qualified stakeholders cannot be identified, the board development committee should seek advice from people who know both your arts organization and other prospects. This list should be reviewed and prioritized by board and staff members along with individuals named by the board and staff.

Decide which individuals to invite and invite them. Make a short list of the most qualified candidates. As in fundraising, board recruitment is best conducted by someone known and respected by the candidate. Ask board and staff members who know invitees to make the approach. If none know the candidates well, determine who would be the most persuasive. Inform and invite candidates as follows:

1. Assemble a fact pack that helps an invitee to decide whether or not to accept your invitation. Such a kit might include a mission statement and plan, a description of programs, current year's budget and past year's financial statements, list of other board members and staff, a statement of board responsibilities, and a schedule of board meetings.

2. Make a call to the candidate. Most people are flattered to be asked. If you have done your homework, you should get agreement for more conversation. The best way to do this is face to face over lunch or coffee; second best is an extended telephone conversation.

Stakeholders analysis of a New England children's theater

The theater operated in a barely adequate church basement. The board was wholly composed of theater professionals and parents who did not have access to potential contributors. Among the identified stakeholders were parents and a local publisher of a children's magazine. Looking at the clusters, a board member realized the obvious: a senior executive of the publisher had a child who participated in the theater. This individual provided the link to the corporate community. The board development retreat concluded with the president's decision to invite the executive to lunch. That lunch concluded with an agreement by the executive to invite a group of his friends to another lunch. That lunch concluded with an agreement to form an advisory board to the theater. The advisory board was formed to plan corporate fundraising. Within two years several corporate leaders joined the theater board and the advisory board was disbanded. The contacts provided by these new board members eventually helped yield contributions sufficient to buy and refurbish a performance facility.

3. Meet to discuss the work of the arts organization, why the candidate is being asked to help, and the benefits and responsibilities of board membership. This discussion is similar to both a fundraising call, where you are trying to persuade the prospect of the value of your work, and a job interview, where you are trying to assess whether you want to commit to this individual. Try to determine the candidate's interests and how those interests may be served through your organization. This is an important step in later placing the board member with a specific responsibility. If you

want something specific from the candidate, this is the time to ask.

One arts center recruited a woman who had just raised $5 million for the hospital. The expectation was that she would raise money for the arts. At her first board meeting she exclaimed to her suddenly disappointed colleagues how happy she was to be working with the arts and how sick she had become of fundraising.

Invite the candidate to join the board. If there is initial interest and the match between the candidate and the organization seems good, extend the invitation. Your bylaws may specify that the invitation be in the form of a nomination to be confirmed by a vote of the board or members. It may be that the candidate will need to think about your offer and consult family members or an employer before responding. In that case, leave the fact pack and call back at a specific date.

Elect or appoint new board members. Your bylaws will specify how to formally approve new board members.

Board orientation

It may take up to a year for a new board member to be productive. You may accelerate this acclimation process with deliberate orientation. A woman who had been carefully cultivated in a recruitment process was heard to complain that she arrived to her first board meeting at an arts center and was never introduced. It wasn't until a planning retreat, months later, that she made this announcement and learned who her colleagues were. In the meantime, she held back from participating.

Board recruitment does not end with election. Efforts to improve board effectiveness do not end even with orientation of new board members. Board improvement needs to be built into regular board operations. New board members do not become productive team members without some deliberate orientation and team building. You can realize the potential of new board members by paying attention to the following.

Board manual. The materials identified earlier as a board member recruitment fact pack forms

the core of a board manual. Assemble them in a three-ring binder with index tabs so that changes can be easily incorporated. You may want to create an electronic version and provide board members with a CD or disk so that it is cheaper to update. The contents of such a binder could include:

- mission statement and plan
- brief history of the organization
- description of programs
- current year's budget and past years' financial statements
- bylaws
- list of major policies
- standing operating procedures
- statement of board responsibilities
- list of other board members
- names of committee chairs and staff
- biographical sketches of board members
- list of major funders
- calendar of upcoming events including a schedule of board meetings

Orientation meeting. The president and chief executive staff should meet with new board members to orient them to their responsibilities, to the organization's ways of working, and to current projects or issues being considered. This can be a separate meeting or can precede the first regularly scheduled board meeting. This can be organized and led by the governance committee.

Social gathering. A luncheon, dinner, or reception in honor of the new board members is a courteous gesture that may accelerate team building. Make sure to introduce the newcomers and to provide opportunities for people to meet each other one-to-one.

Planning/board development retreat. An annual planning retreat can serve both to advance the organization's planning and to build a team. Such an event takes time, energy, and perhaps money to do well, but can yield significant results.

Buddy system. Some groups find it helpful to assign a more senior board member to be a buddy to the new board member. Such a partner provides a direct and personal source of information, encouragement, and support in the first months of board service.

Specific assignments. An exhortation to "Do all you can for the arts council" is much less helpful than one or more specific responsibilities.

Ongoing board development. Attention to board development does not end with the recruitment and orientation of new board members. This is one of the reasons many organizations have board development or governance committees instead of nominating committees. Someone should be charged with ongoing attention to how the board is functioning as a team. Personal attention to the human needs of board members goes a long way.

Keep good board members

Some of the most common causes for board members resigning are that they misunderstand what is expected of them or that they never feel that they are an important part of the team. In some boards the president or executive committee makes most of the important decisions, so other board members feel uninvolved.

Often, too, key board members care a lot, work hard, and burn out. As one weary board president bluntly put it, "Our arts council recruits good people and sucks them dry." Burned out board members and volunteers may only find relief by dropping out completely.

Learn to delegate. If you delegate and involve more people periodically for shorter assignments over a longer period of time you can spread the workload and help prevent burnout. A good friend of the arts council could serve on a cultural planning task force one year, coordinate a fundraiser the next, take a year off, join the board for two years, and then retire to be an occasional advisor.

All-volunteer organizations, in which board members are also largely volunteer staff, face the challenge of managing the board's time so that the details don't always dominate. Set aside

specific meetings or portions of meetings for policy discussions. Change seats and meeting locations, or put on hats to indicate the board is serving in its governing role.

Boards that spend too much time on details of program and administration, and too little on matters of policy and planning, may need to delegate detailed operational decisions and tasks.

Creative organizations have many ways to involve people.

- Pool of volunteers under the direction of a volunteer coordinator;

- Short-term, task-specific volunteers referred by such agencies as Business Volunteers for the Arts, Society of Retired Executives, or other local service organizations;

- Ad hoc committees, project teams, or short-term task forces organized for a specific task and then disbanded;

- Consultants or volunteers working in a consultant-like role to accomplish specific tasks (funds for paid consultants are often available from state and local arts councils or foundations);

- Peer advisors (local arts leaders trained to do short-term consulting and referred by a number of state arts councils and statewide assemblies of local arts agencies).

Executive committees. If you have an executive committee, beware of this small group assuming too much authority. They can be very helpful for coordinating between board meetings, but there is a national trend toward eliminating the executive committee. This is because these so often concentrate authority and undermine the governing role of the board.

Additional measures you can take to help ensure that good board members stay long enough to help:

- Help them meet their needs. Try to understand why they are motivated to volunteer and match them to opportunities to fulfill those needs.

- Ask for specific help. People respond better to a request to "Organize a team to raise $2,000 from downtown business" than to "Do what you can to raise money."

- Share successes. People like to win. Bring to the board any positive news, good press reviews, a warm letter from a student, and good attendance figures.

- Involve board members in decision making. Ask the board to actively participate in management decisions. If you persist in bringing predetermined issues for the board to rubber-stamp, you'll lose good board members.

- Help them develop. Invite board members to professional conferences, management development workshops and networking meetings.

- Plan for fun. If all of your time together as a board is devoted to grappling with problems, dealing with money, and discussing administrative matters, interest will flag.

- Recognize them. Acknowledge the interests and the work of board members. Introduce them at public functions; list their names in your publications.

- Thank your board members. Never take them for granted.

STRATEGY 2: CHANGE THE GOVERNING STRUCTURE

The preceding pages explored strategies to improve governing and managing processes. However, it may be that procedural changes alone don't make enough difference to create an effective governing system. Structural changes may be required. Think of structures as the way your group would appear on an organizational chart. Structure includes the board, committees, and staff plus their responsibilities and how they relate to each other.

Structure should relate to your organization's mission. A major change in goals or program plans may suggest a corresponding structural reorganization. For example, some organizations facing financial crisis have responding by abolishing their fundraising committee. Fundraising was too important to delegate to a committee, so it became everyone's priority.

Structural changes can be minor or dramatic. Simple structural changes could be the creation or elimination of standing committees, the creation of new officer positions, or a change in the number of board positions. A more significant change could be reducing the frequency of board meetings and eliminating an executive committee. Another significant change could be appointing the executive director to the board as a voting member. A radical change might be reducing the board to the legally required number of members, who become charged solely with ensuring the organization's fulfillment of legal requirements, like filing income tax reports. Fundraising and all governing functions are fulfilled by task forces and staff.

Rethink old assumptions

Before considering specific structural changes, it may be helpful to question commonly held assumptions about community arts boards. If you consider structural change, it is useful to recall that the nonprofit board is an invention. Beyond that which is required by law, there is nothing carved in stone about the way we organize boards, committees, and staff.

Consider some common assumptions and some alternative thinking

Assumption. An organization should be steeply hierarchical, with information flowing up to a few leaders (board) and decisions flowing down to the staff.

Alternative. People in an organization can relate to one another on a level field, as peers. Information is communicated throughout the organization at all levels. Decisions are, as much as possible, entrusted to the people who are closest to the action. While important policy decisions may be reserved for a governing board or senior executive, everyone should have an opportunity to contribute to important decisions.

Assumption. An organization needs standing committees and every board member should be assigned to one.

Characteristics of Nonprofit Boards:
Excerpts from the Nonprofit Governance Index (1999)

BoardSource (formerly National Center for Nonprofit Boards) conducts periodic surveys of nonprofit chief executives and board members from all types of organizations. Here are some highlights from the 1999 study.

Board structure

- Median size of board is 15 members (this number comes from post-study research indicating the trend continues toward smaller boards).

- Women make up 43% of surveyed board membership.

- Minorities make up 15% of boards.

- Most board members (68%) serve three-year terms. Nearly half (48%) can serve only two consecutive terms.

Fundraising

- Nearly half (48%) of boards require personal financial contributions.

- More than one-third (36%) report 100% board giving.

- Over half (52%) require board members to identify donors or solicit funds.

- Less than a quarter (22%) of board members report that fundraising is one of their board's primary roles though most (88%) make annual monetary contributions.

Board roles

- Most boards see themselves as policy makers (69%).

- Then boards are seen as oversight bodies ensuring accountability (44%).

- Fundraising is third most often seen as boards' primary role (24%).

- Chief executives most often ranked fundraising (37%) as the area their boards most need to improve. New board member recruitment and orientation (21%) is the next most common need for improvement. Board members report these two areas as their greatest source of dissatisfaction with board service (28% cited fundraising and 32% recruitment).

Board policies

- Nearly all hire an external auditor (92%).

- Few boards reimburse members for expenses to attend meetings (14%).

- The chief executives sit as voting members in 17% of boards.

- Over a third of boards (38%) formally assess their own performance.

- Most (84%) annually evaluate the chief executive.

Board meetings

- Board members spend most of their time on policy (33%) or planning (32%).

- Less than half of boards spend any time on crises (48%) and only 39% spend any time on minor management issues.

- Median number of board meetings is 7.

- Board members spend on average 5 hours or more on committee business each month.

Board recruitment

- Nearly all board members (91%) report that fit between organizational mission and personal interests is one of the most important reasons for joining a board.

- Fewer than half (40%) are formally oriented.

Alternative. Create only those committees that are essential and convene meetings only when necessary. Avoid committees that mirror functions performed by staff. Their efforts could be redundant or even conflict with each other. BoardSource promotes the idea of a "zero-based committee structure." Like the parallel concept for budgeting, each committee should be justified each year or discontinued. The aim is for board members, volunteers, and staff to think about, and work on behalf of, the organization between board meetings.

Consider flexible committee structures

- A committee can be a single board member who invites some friends to work on a fundraising event or who develops a proposal for a communications policy.

- A committee meeting can be a conference call or e-mail exchange.

- A volunteer working in the role of a consultant can fulfill a governing task, such as designing a membership campaign.

- A temporary task force can be convened just for the life of a project. Ad hoc committees and task forces are becoming more common than standing committees. As a general rule, resist the temptation to set up a standing committee.

Assumption. "We need wealthy people and other heavy hitters on the board."

Alternative. Recruit people to the board who are deeply committed to the work of the organization. Free board members from routine project oversight and urge them to concentrate on communicating the mission and impact of the organization to the community and cultivating contributors and partners. Allow them to convert passion into support.

Assumption. More board members means more contributions.

Alternative. This is sometimes true, but managing communication among a group of thirty or more people is in itself a huge task. Recruiting someone to the board may help

ensure her financial contribution, but it commits the board member and the organization to each other with all the trappings of other board responsibilities. Consider instead cultivating a large number of contributors who have a stake in your organization's success and who commit themselves to giving.

Assumption. The functions of governance and management should always be fulfilled by separate groups of people.

Alternative. Consider whether these lines might be successfully crossed. Think about governing and managing as an alternating process of reflection and action and consider the possibility that governing is a crucial function in which all members of the organization should periodically participate.

Assumption. "But the bylaws say we can't."

Alternative. Bylaws have a clause that allows them to be amended. Use it.

Examples of organizational structures

Some examples of alternative organizational structures may stimulate your own thinking. Consider these as examples that may inspire or not, as models to copy. A successful structure should evolve from an organization's unique history and community environment. Following are some traditional forms.

All-Volunteer Nonprofit Organizations. The all-volunteer organization can be structured in various ways. One variation is the board plus executive committee. In this variation, the executive committee typically meets more frequently than the board and acts on behalf of the board. The full board is more concerned with policy and the executive committee with oversight of operations. In a staffed organization, the executive committee relates more directly with professional staff than does the rest of the board. In an all-volunteer organization, the executive committee may serve as the volunteer staff.

Another variation is the governing board plus advisory board. An advisory board may be formed to connect your organization to

Board Trends

Dr. Sandra R. Hughes, of BoardSource, observes these trends.

Trends in Nonprofit Governance, BoardSource (selected)	
From	**To**
Enjoying the public trust	Having to be accountable and transparent in everything the organization does in a climate of trust and candor
Operating as usual	Adapting to immense change, including the internal dynamics of boards and the incorporation of technology
Laissez-faire financial oversight	Strategic leadership and oversight; asking tough questions of the CEO, CFO and auditors
Forging individual participatory roles at the discretion of the individual directors	Being expected to govern; individual board member accountability
Recruiting new board members based on personal and/or family relationships with existing directors	Recruiting selectively based on future board member's skills and influence as they relate to the organization's strategic focus and direction
Agreeing to be a board member while being unclear about roles and expectations	Being clear about responsibilities
Holding meetings as the only avenue for decision making	Employing varied means of communication
Receiving and reviewing vast amounts of information	Receiving targeted and strategic information related to key critical issues
Preparing agendas which reflect immediate past activities; show and tell	Preparing highly structured agendas to address key organizational strategies and issues; give and take
Meeting monthly	Meeting less often and on a more ad-hoc basis to focus on key strategic issues
Long range planning	Strategic thinking and planning
Making modest or no financial contributions	Contributing personally
Having little or no involvement in fundraising	Being involved in fundraising according to one's means, talents, and contacts
Informally and irregularly assessing the performance of the chief executive officer	Structuring a regular review of the chief executive's performance as it relates to the organization's stated goals and expected outcomes

community leaders who offer expertise, perspectives, and contacts that are not found on the board or needed for particular programs. Advisory boards can be convened periodically as a group for discussions, or more often advisory board members are called upon by staff or governing board members for advice on specific issues. In the latter case, the advisory board enables key community leaders to be available for occasional requests for help or advice.

Staffed organizations managing or administrative director.
A managing director administers the policies and programs of the board. Organizations having an administrative director vary considerably from those where the administrative director serves a supportive, almost clerical role in support of board initiatives, to those where the executive director assumes a leadership role.

Managing director plus artistic director.
As organizations grow, artistic staff are sometimes hired to manage artistic programs, and the managing director's responsibilities are limited to administration. Sometimes the two staff are peers who together report to the board of directors. In other cases, either the managing or artistic director is the more senior staff and one reports to the other.

Executive director.
The title of executive director connotes a staff person more generally responsible than either a managing or artistic director. In a large organization, the executive director may have supportive management and artistic staff. In a smaller organization, the executive director is understood to possess overall programming and artistic responsibilities and may be assisted by board members and non-governing volunteers operating in the capacity of volunteer staff.

President/chief executive officer.
A trend in larger, well-established community arts organizations is to promote the experienced executive director to be the president and chief executive officer. He or she assumes much of the policy making responsibilities of the president, as well as the administrative responsibilities of the executive director. The board president is retitled "chair" or "chairperson."

Some alternative structural models

Staff driven with a nominal board.
An organization that does not much depend upon individual or corporate contributions may reduce its board to the legally required minimum and ask that they simply ensure the fulfillment of the organization's legal responsibilities. They might meet once a year for the legally required annual meeting, authorize the staff to sign contracts, note that tax reports have been submitted, and sign the annual report to the secretary of state. Otherwise they serve as advisors to the staff. The organization is staff driven.

In a variation, the nominally governing board is supplemented by a larger advisory board, which may help provide specialized advice, representation, access to constituencies or resources, and fundraising assistance to the staff.

Ad hoc task forces, temporary project teams.
A traditionally structured board can organize committees as they are needed. These are often called task forces or ad hoc committees to distinguish them from standing committees.

Like an independent film or theatrical production, a core leadership group organizes a team around a project. When the project is completed the team disbands. The core group puts together the next project and reorganizes some of the former team members, perhaps in combination with people with differing skills or resources.

Artistic board and governing board.
Some artistic producing organizations create both a governing board and an artistic one. The artistic board assumes the responsibilities that would be fulfilled by an artistic director in a larger organization.

Board composed of all the members.
Alternate Roots is an example of an organization whose board is composed of every member. Similar to a cooperative, the board of some 200 members meets annually in a conference-like setting to make policies and plans for the organization.

Not-for-profit board plus a profit-making subsidiary.
Some nonprofit organizations have organized profit-making companies. Craft

organizations are typical of these, which, because of tax regulations, have been required to separate their retail marketing operations from their nonprofit educational programs. In some cases the same professional staff support two separate boards. In others there is considerable, even complete, overlap between the membership of the two boards. Over time some of these subsidiary boards have grown so independent of the parent organization that they have split completely away and become wholly independent entities.

Cautions regarding structural changes

Experiment with incremental changes, see what works, and then expand on what is successful and discard what fails. You may wish to live with a change for a while before entrenching it in your bylaws or articles of incorporation. Successful organizations are perhaps more effectively grown than built.

The Internal Revenue Service and funding agencies prefer organizations with traditional boards of directors. Be prepared to do a lot of explaining if you innovate with other structures. It may be that you'll operate with an innovative board but describe it in a more standard format to funders.

CONCLUSION: A DO-IT-YOURSELF BOARD DEVELOPMENT KIT

This chapter is likely to have raised as many questions as it has resolved. It has questioned fundamental assumptions and raised issues about long-accepted board models. A perceptive reader is likely to ask, "But what can I do right now? I have a board meeting next week."

Board improvement checklist:

❑ Help board members get better acquainted with each other. Use introductions, name tags, or board member lists with brief biographical sketches.

❑ Host a social gathering of board and staff members.

❑ Manage meetings more effectively. Create an agenda that schedules important business first. Ask an experienced leader to facilitate meetings. Start and end on time. Recruit a timekeeper who reminds the chair and participants about time remaining.

❑ Document decisions and follow through on commitments. Note when decisions are reached. Record decisions, especially who does what by when. Promptly send meeting minutes with recorded decisions to board and staff; highlight the relevant task on the responsible person's copy. Assign the responsibility to follow up to a board officer. At the next meeting, determine the status of action items. Put key tasks and dates on a graphic timeline.

❑ Clarify responsibilities of board and staff. Engage board and staff in a discussion of their responsibilities. List them. Create a statement of responsibilities.

❑ Create a board development or governance committee. Charge the committee with managing tasks and with starting a board profile and recruitment process.

❑ Create a board manual. This is the perfect job for a single volunteer. Ask him or her to review board minutes, files, grant applications and publications and assemble a master set from which board manuals can be copied.

❑ Review your list of committees. If any have not been meeting or functioning well, ask if they are needed. Consider if temporary task forces or individual assignments could serve better.

❑ Organize a board development/planning retreat each year. This can yield both a clearer sense of direction and a more cohesive team. Start each year with a renewed sense of commitment and clarity about what will be the year's priorities for the board.

REFERENCES

Selected Resources

Carver, John. *Boards that Make a Difference: A New Design for Leadership in Nonprofit and Public Organizations* (2nd edition). San Francisco: Jossey-Bass, 1997.

Fisher, Roger and William Ury. *Getting to Yes: Negotiating Agreement Without Giving In.* New York: Penguin Books, 1983.

Kurtz, Daniel, L. *Board Liability.* Moyer-Bell, 1988.

McDaniel, Nello and George Thorn. *The Quiet Crisis in the Arts.* New York: FEDAPT, 1991.

_____. *Workpapers 1 Rethinking and Restructuring the Arts Organization.* New York: Arts Action Research, 1990.

_____. *Workpapers 2 Arts Boards: Myth, Perspectives and New Approaches.* New York: Arts Action Research, 1991.

Wolf, Thomas. *Managing a Nonprofit Organization.* New York: Prentice Hall, 1990.

Online Resources

Carver John and Miriam Carver "Carver's Policy Governance ® Model in Nonprofit Organizations" online at: www.carvergovernance.com, 2002.

APPENDIX

Possible Board Responsibilities

The board of directors of the arts council accepts the following collective responsibilities.

Lead. We commit to govern the arts council, to further our mission, and to recruit and nurture new leadership.

Community connections. The board represents the interests of the arts council and its programs to the community and relates the interests of our community to the arts council.

Plan. The board is responsible to determine the arts council's mission and long-range goals by means of a regularly updated strategic plan.

Set policy. The board establishes policies for the following areas: finance, fundraising, personnel, facilities, board operations, and artistic programs.

Raise funds. The board is responsible to set and meet annual fundraising goals through active solicitation of gifts from individuals, small businesses, and corporations.

Assure financial stability. The board approves an annual budget and oversees financial management through a monthly review of financial statements.

Assure legal accountability. The board assures that all legally required records are maintained, reports filed, and fees and taxes paid. The board makes sure that all grant reports are properly submitted and that grant-funded projects are completed as agreed, or amended.

Manage board development. The board oversees the recruitment and orientation of new board members and regular board development training; schedules board meetings, maintains board records and communications, and oversees its committee system.

Oversee executive director. The board hires, supervises, evaluates, and, if necessary, fires the executive director. All support staff and program and operational volunteers report to the executive director. (An all-volunteer organization might substitute committees and volunteers for executive director.)

Possible Individual Board Expectations

As a board member of the Arts Council, I accept the following responsibilities:

Fiscal. I understand that I am fiscally responsible to help ensure the financial solvency of this organization. I accept the responsibility to participate in budgeting and to understand and help evaluate financial performance.

Legal. I understand that I am legally responsible to see that the organization serves its mission and that legal responsibilities are fulfilled.

Raise funds. I commit to participate in the ongoing cultivation of community support; to actively participate in fundraising; and to make an annual financial contribution that I determine to be a significant amount for me.

Membership. I agree to maintain a current individual membership.

Participation. I agree to attend and participate in board meetings. When I am unable to attend, I will notify the secretary in advance and then review the minutes to remain current. I agree to attend as many artistic programs as possible.

Volunteer service. I may be asked to serve on a committee or to help as a volunteer with certain organizational tasks. When working as a program volunteer, I am accountable to the professional staff (or to the full board, depending on organizational structure).

Special Cases: Public Commissions and Coalitions

Public commissions. A quarter of local arts agencies nationally are public commissions. In some, the commissioners function just like a nonprofit board of directors. They are ultimately responsible for the commission and set policy. Professional staff report to the commissioners.

In other towns and cities, the commissioners advise the staff and elected officials. The

Summary: Governance and Management Responsibilities

Governance (board and others)	Management (staff, board members working as volunteer staff)
Manage policy and planning	Advise on policy and planning
Advise on operations	Manage operations
Concerned with *ends*	Concerned with *means*
Account to the public, law, and bylaws	Account to the board
Determine mission and goals	Determine strategies
Hire and supervise chief executive	Hire and supervise volunteers and staff
Ensure fiscal stability (raise funds, manage budget and oversee financial management)	Manage finances (accounting, reports, grant writing, and fundraising support)

professional staff are accountable to the mayor, city manager, or city council. In these cases the structure and governing procedures explicitly acknowledge the political role of a local arts agency. Problems arise when the commissioners don't understand their role. Especially problematic are commissioners who should be advising, but assume their role to be governance and supervision. In one city, the professional staff director of the arts commission had to seek a legal opinion from the city attorney to convince her commissioners that their role was to advise the staff and mayor.

Coalitions and networks. Local arts agencies that are organized as coalitions of other arts organizations are yet another special case. Here the board of directors may comprise representatives of the member organizations. These board members who represent specific constituencies must also learn to consider their collective interests. Such board members may encounter conflicting pulls on their time, energy, and loyalties. Avoiding conflicting interests while fundraising for the coalition and for the represented organization can be particularly difficult.

In these two cases, the board and staff may have a limited role in recruiting new commissioners or board members. In a public commission, the mayor appoints new commissioners. In a coalition agency, the member organizations may select their representatives.

Team Building Activities

Plan postmeeting gatherings with cocktails or a potluck supper. Schedule an informal party before or after a board meeting so people can get better acquainted.

Hold a reception before or after an arts event. This not only helps people get acquainted, it connects them with the programs of the organization.

Conduct a board retreat. A facilitated board retreat can be organized to resolve issues of board responsibilities and/or strategic planning, with the added benefit that board members get to know each other as people. Program the retreat loosely enough to encourage important informal conversations. (See chapter 2 for information on retreats.)

Ask board members to write one-paragraph biographical sketches. Provide all board and staff with a list of board members along with addresses and phone numbers, the names of any spouses or partners, and these short biographies.

Periodically "check in" with people to see what is happening in their lives as a preliminary to conducting business.

Identify one or more board members who concern themselves with the human, emotional side of board development. Ask them to call a board member who missed several meetings to see what is going on; or have a conversation with the person who doesn't participate in board discussions.

Unofficial leaders are often important to the group.

Effective leaders can switch from instructing to delegating as the situation requires.

People want to be a part of a winning team, and they need to be reminded when they are winning.

How to Profile Board Personnel Needs

Schedule an hour during a board meeting to profile the board's personnel needs. Invite staff to participate.

Brainstorm. What sorts of people do we need on our board to provide the resources, contacts, cultural representation, and constituent perspectives to fulfill our purpose? What skills do we need?

Record on newsprint the desired board attributes under these categories: arts knowledge; resources; skills; contacts; and constituencies.

When the list seems thorough, tape the newsprint sheets to a wall and take stock of your list. The list may be impossibly comprehensive. There also may be important omissions such as failure to notice that the list reflects only the interests of the white, middle class. Look for such omissions. Then rank in order those resources, contacts, representations, and skills which are the highest priority.

Chart board needs on a profile grid. The board development committee enters the desired characteristics as column headings across the top of a board profile grid (see Appendix). The names of existing board members are entered down the first column. Current board members are invited to check which desired attributes they are willing and able to provide. This step not only identifies what contacts, skills, resources, and representation is now represented on the board, it serves also to motivate board members to call upon those attributes.

Observe the gaps. The committee examines the profile to see what important board characteristics are lacking. The profile grid may also identify a few board members upon whom the organization is heavily dependent.

"You have been suggested as someone who both cares about the arts in our community and who has some valuable skills and contacts which could help us do our work. As you are likely aware from your attendance at our programs, we work to connect the people of our community with art and artists. May we meet and talk about the potential of your joining in that work, perhaps as a board member?"

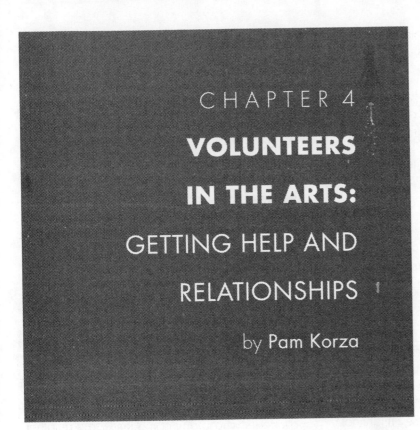

CHAPTER 4

VOLUNTEERS

IN THE ARTS:

GETTING HELP AND

RELATIONSHIPS

by Pam Korza

Volunteers constitute a key resource for arts organizations. In a field where economic pressures make the flexible use of people and skills a must, volunteers can provide essential services at all levels from staff to board to one-time helper. They extend staff resources by assisting or even running ongoing programs and services, launching new projects, serving on committees, providing invaluable clerical or technical support, researching and documenting. Volunteers may lend professional skills and advice—accounting, carpentry, graphic design—which can save arts organizations considerable money. And volunteers lend fresh perspectives and enthusiasm. In addition, volunteer involvement in your organization reflects the community's commitment to your organization, as well as your interest in having its input.

This chapter focuses on integrating into a cultural organization volunteers who support both ongoing and special activities. The principles presented regarding motivating, managing, and rewarding volunteers are equally applicable to your arts education committee chairperson, a college student intern conducting demographic research, or the helper who occasionally assists with bulk mailings. Considerations about recruiting, orienting, and managing board members as a specific type of volunteer are discussed in the chapter devoted to board development.

Age-old motivations, new conditions

The enjoyment and artistic stimulation the arts can provide has always attracted people to volunteer. In general, the things that motivate people to volunteer have remained much the same over time. They reflect an individual's values, needs, interests, and desire for self fulfillment. Volunteer work offers opportunities to:

- help others and make a difference;
- learn new things and develop new skills;

- belong to a group or institution;
- be needed;
- have fun;
- grow personally and gain self-esteem;
- share skills, knowledge, or talents;
- gain meaningful acknowledgment;
- enhance one's public image;
- gain valuable career insights;
- make professional contacts;
- enjoy social contact with others;
- support causes in which one believes.

Yet, while the desire to volunteer remains strong, the conditions which enable people to volunteer have changed dramatically in the past twenty-five years. Working adults, typically the most often tapped pool of volunteers, juggle demanding jobs and family obligations. Many are cautious about making long-term commitments that they might not be able to fulfill. Today's volunteers want to serve responsibly within the limited amount of time they have to devote to volunteer activities.

For arts organizations to succeed at developing a volunteer base of support given such competing demands for volunteers' time, they must make volunteering as easy and accessible as possible. Nonarts volunteer programs, such as City Cares of America, have found the following operating principles important:

- Arrange volunteer opportunities to involve short-term commitments and flexible hours.

- Offer choices in terms of the types of jobs that suit both individual motivations and availability.

- Minimize paperwork and procedures which might discourage busy people or those unfamiliar with institutional processes.

- Diversify the volunteer pool to reflect the growing populations of people over age fifty-five and people of color.

- Appeal to motivations unique to certain groups, such as young professionals' social interests or senior citizens' need remain active, contributing members of society.

THE NEED FOR A VOLUNTEER PROGRAM

To recruit increasingly selective volunteers, organizations must "sell" themselves. It is essential to plan ahead of time what you want and can offer. This means developing a serious, well-planned volunteer program.

Getting the organization ready

A first step in preparing your organization to fully incorporate volunteers into your operations is to assess staff attitudes and preconceived notions about volunteers.

Attitudes. The planned integration of volunteers into an organization may elicit from staff a variety of concerns and questions. "Can we maintain our standards of quality with volunteers providing service?" "How much time will it take to effectively manage them?" "I've been burned before when I counted on volunteers who didn't come through. I'd rather do it myself." These concerns must be acknowledged and dealt with in order to agree upon the purpose of the volunteer program and to foster an environment in which volunteers are respected and nurtured, but also where policies and expectations are clear to volunteers.

Roles. Organization staff and board should also clearly communicate their roles and degree of involvement in each volunteer's work. Who will coordinate the volunteer program—recruitment, placement, volunteer group needs? Assuming there is staff, what will individual staff members' roles be regarding interviewing, selecting, training, evaluating, firing? Such planning also clarifies a volunteer's rights, for example, to have information that enables her to carry out her work, defining limits, responsibilities, and authority, such as in negotiating advertising rates when selling ads for a program book or selecting artists.

Practical concerns. Also consider the following practical issues:

Work space. Can you provide work stations, phones, office supplies, access to computers to enable volunteers to do an effective job?

Accessibility. Can you make volunteer opportunities accessible to people with disabilities or for whom transportation might be a problem (teens, seniors, low-income individuals)?

Policies. What are your policies regarding reimbursement of expenses related to volunteering, benefits such as free or reduced tickets, termination procedures? Will you acquire volunteer liability insurance?

Components of a volunteer program

A successful volunteer program contains the following components:

Purpose statement. Describes why the organization includes volunteers.

Coordinator. Someone (sometimes a volunteer) who has primary responsibility for planning and implementing the volunteer program and for monitoring volunteer needs.

Policies. Reimbursements, insurance, benefits, termination.

Recruitment. Methods and tools to identify and recruit prospective volunteers, discover their interests, abilities, and experiences, and determine potential positions for them.

Selection and placement. A placement process to determine which persons are most qualified or have potential for particular volunteer positions, and what positions are most suitable for particular persons.

Training. Orientation which prepares and equips volunteers with the necessary information, knowledge, and skills to do a volunteer job.

Support. Guidance, ongoing support, recognition, and gratitude to volunteers for their work.

Evaluation. Appropriate processes to help volunteers reflect on their volunteer experience. Evaluation of the program to make necessary changes and keep it functioning effectively.

EVALUATING WHAT YOU NEED

In order to be clear with potential volunteers about what specifically they can do, it is first necessary for you to evaluate your own organizational needs.

- What are the specific jobs, tasks, projects which require doing?

- Is it cost-effective to use volunteers versus staff to accomplish activities and objectives? What is the potential to enhance or compromise the quality of programs and services with volunteers versus staff?

- How can jobs best be broken down in terms of responsibilities, time commitment, difficulty, interest, balance? For example, in trying to attract busy, working people, consider how jobs can be structured to be accomplished and monitored on weeknights or weekdays when many people are available.

- What are the volunteer benefits associated with each job?

- Are you looking for "members" with long-term needs (social, self-actualizing, learning, contributing) or "joiners" with short-term ones (social contacts, affiliation, status)?

Job descriptions

Drafting job descriptions serves several purposes. From your organization's standpoint, it forces you to summarize the work that needs to be done, assessing how many people are required, estimating work hours, projecting deadlines. It makes actual recruitment simpler and clearer. From the volunteers' viewpoint, it offers a more realistic picture of what they are getting into and of what they can expect to gain by being involved in your organization.

The job description most often expresses an ideal. In recruiting it is important to remain appropriately flexible and to balance the pros and cons of what each applicant has to offer. Perhaps two people with complementary skills can do the job better than either one alone. Keep in mind the implications of compromises,

however. Two people require twice as much oversight on your part, at least at first.

Allow room to grow. Balance between specifying responsibilities and leaving room for the volunteer's own initiative to shape the job. A sample job description is provided.

Where to find volunteers

Sources of volunteers are many. It is useful to first profile who your current volunteers are since they reflect likely sources of new recruits. What are their characteristics? What has motivated them to volunteer with you?

To focus your recruitment, determine the type of volunteers you are seeking, considering factors such as:

- special skills or knowledge (bookkeeping, graphic design, data base management, research);

- particular ages and backgrounds (youth, people of color, elderly, low income, people with disabilities);

- numbers, for example, large numbers needed for a short-term opportunity (festival, fundraising campaign).

These will suggest likely places to look for qualified prospects, as described by the volunteer coordinator for a children's museum:

Besides identifying skills and characteristics to define sources of volunteers, use your list of job benefits to help you to narrow down the field of prospects. Then conduct targeted recruitment.

Recruiting and involving for diversity

If people of color, senior citizens, people with disabilities, teens, people who are economically disadvantaged, or others are not frequenting your programs or using your services, it is almost a sure bet that they are not volunteering in your organization either. As is true in any effort to engage and involve diverse populations, you must first look at how you are currently serving their interests through your programs. You may find that there is work to be done that first ensures that your organization is relevant to various segments of the community.

In recruiting volunteers from diverse populations, be clear on why you are interested in including them in your organization. Are you seeking multiple viewpoints; better service to constituencies; enlightenment on issues or needs? Be sure your reasons are authentic and clear to you before you begin a recruitment plan.

Involve individuals from these groups in identifying, recruiting, and managing volunteers. If recruitment overtures, for example, are carried out exclusively by white or able-bodied members of your organization, these may be met with skepticism by those you are hoping to involve.

Make use of culturally specific media, organizations, and other resources in recruitment.

Internship programs

Internships are structured volunteer experiences which offer formal training and are designed as focused learning opportunities. Some arts organizations have developed their own internship programs, often attracting college students wanting practical experience, as well as adults in career transition. Many college programs require students to do internships as field training. Graduate degree programs in arts administration often require of students full-semester, full-time internships. In these cases, students are usually paid by the arts organization. In the case of internships, expectations on both the volunteer's and the agency's part are high, so special care is taken in assessing needs, making placements, and providing specific training and formal evaluation.

RECRUITMENT

Recruiting volunteers is not as simple as posting flyers saying that you need help. Effective recruitment first targets the people you believe have what you're looking for and who might be interested in volunteering with you. Then you find the best way to connect with them. A positive impression will convince discriminating people that you can provide an interesting, well-organized, and personally meaningful experience with your organization.

JOB DESCRIPTION

Job Title: Publicity Assistant for On the Road Theater

Job Description: Assist publicity coordinator with the following tasks:

- Writing press releases
- Writing radio advertising copy
- Making and following through on media contacts (feature writers, TV and radio personnel)
- Arrange guest spots on local TV shows
- Design poster and direct mail pieces; write copy for same
- Develop mailing list
- Orchestrate mass mailings

Skills and interests necessary or helpful for job:

- Good writing and interpersonal communication skills
- Graphic design skills helpful, but not necessary
- Computer skills helpful, but will train
- Knowledge of and interest in theater preferred

Benefits of job:

- Receive intensive one-on-one training in all aspects of publicity
- Gain knowledge of how a touring theater group functions
- Gain free admission to all shows; two complimentary tickets per show

Training provided:

- Copy writing
- Consumer targeting
- Graphic design
- Press releases
- Data processing
- Developing media relationships

Hours per week recommended: 10

Anticipated length of internship: minimum 6 months or ongoing

Other information/comments:

Staff Person _____ Date_____

Recruitment, whatever form it takes, should answer basic questions which a volunteer may ask:

- Who is your organization?
- Why do you need volunteers?
- What will a volunteer get out of working with you?

You should be able to demonstrate to a potential volunteer that:

- your organization is a worthy, credible one;
- you are well-organized, take volunteers seriously, and won't waste the volunteer's time;
- your organization can provide a meaningful, fulfilling, and challenging experience while being flexible given the volunteer's time limitations and need for appropriate training;
- you have specific opportunities in the form of job descriptions;
- others with similar experiences have been involved in a productive way in the organization.

Recruitment techniques

The same range of publicity and promotion opportunities that you use to market programs and services can be employed to announce volunteer opportunities as well.

Print and electronic media. Through press releases, public service announcements, and calendar listings in the general media, you can reach broad segments of your community. More specialized media (an African-American newspaper, a radio station with a large teen following) are effective in reaching certain segments.

Classified advertisements. Help wanted or opportunities placements might catch the eye of someone in career transition or interested in job training.

Feature articles, television and radio talk shows. These are great ways to recognize a

particular volunteer's efforts or a recent major accomplishment, and to promote the program at the same time.

Newsletters. Organizational bulletins and newsletters are effective at targeting certain groups (service organizations, clubs, select demographics).

Brochures, flyers, letters, mailing inserts. To satisfy ongoing or specific volunteer needs, a promotional brochure or information sheet is a handy tool that can provide immediate information and be used to reach targeted groups.

Personal contact. Because volunteering is a people affair, the most effective recruitment techniques are those enabling prospective volunteers to hear face-to-face from people involved in the organization. Volunteers who have had a good experience in your organization are often the most effective recruiters. Person-to-person recruitment may take the form of:

- presentations to clubs, corporations, senior groups, schools;
- presentations before or after performances when people are excited about what you do;
- door-to-door, neighborhood meetings;
- open house;
- word of mouth.

To recruit large numbers of volunteers for one purpose, the pyramid approach can be effective. Each board, staff, and key volunteer is responsible for recruiting a certain number of volunteers (say five), who in turn must each recruit additional volunteers (say two). By beginning with twenty individuals, you can recruit 300.

Volunteer agencies. In your community or in one nearby, there may exist branches of national volunteer organizations. By calling your state arts agency or legislator, you might also identify special government-run internship or volunteer clearinghouses. Some long-running volunteer placement agencies include:

- City Cares of America, a network of volunteer placement organizations catering

SOURCES OF VOLUNTEERS

Community and Professional Associations:

Civic organizations
Church groups
Trade associations
Fraternal associations
Labor unions, often offer union gatherings and newsletters for the purpose of publicizing volunteer opportunities; some labor unions provide expertise of union members

Youth:

Schools
Arts-related programs (dance schools, drum corps)
Clubs (scouts, 4-H)
Church groups
Vocational schools

Businesses and Corporations:

Companies sometimes have an executive loan program which enables employees to provide expertise or consultation to community organizations on company time.

People of Color:

Urban League
NAACP
Ethnic organizations
Church groups
Political, advocacy organizations
College departments (African American, Native American, Asian, Latin American studies)
Neighborhood associations

Volunteer Agencies:

Volunteer Action Center
City Cares of America
Business Volunteers for the Arts
Singles organizations

Unemployed, people looking for job retraining or career skills:

Unemployment office
Career counselors

Senior Citizens:

Councils on Aging
Senior centers
RSVP (Retired Senior Volunteer Program)
Green Thumb
SCORE (Senior Corps of Retired Executives)
AARP (American Association of Retired Persons)
Nursing homes
Retirement communities

People with Disabilities:

Statewide VSA arts agencies
Associations for Retarded
Citizens
Schools, clubs for the deaf or blind

College Students:

Academic departments
Internship programs
Work/study programs
Sororities, fraternities
Clubs and service organizations
Campus arts organizations
Career services
University Without Walls

Specialized Sources of Unpaid Workers:

Prisoners or individuals with community service sentences

U.S. Army Corps of Engineers, for traffic control, leveling earth, hauling major equipment, loaning and erecting tents
According to a 1992 Gallup poll, 86 percent of Americans who agreed to volunteer did so after being asked in person.

to matching busy people with a flexible program of community service projects;

- Voluntary Action Center;

- Senior Corps of Retired Executives (SCORE), provides in-kind business consultation;

- Retired Senior Volunteer Program (RSVP);

- Junior League, a women's organization that trains its members in skills for effective community service;

- Local volunteer liaisons, chambers of commerce, community development agencies, libraries, councils on aging, and other community-based organizations which may operate volunteer placement services.

To determine which techniques to employ, consider the following:

- Are your volunteer needs ongoing or sporadic? Recruiting 500 festival volunteers for a three-day event requires different strategies than recruiting five volunteers who will share receptionist duties year-round.

- How much time and resource do you have for the recruitment process itself? What are your capabilities for handling response to the recruitment process?

- What technique(s) will be most effective in eliciting the response you would like?

Above all, when communicating with prospective volunteers, make it easy to say yes. Avoid cumbersome and protracted application procedures. Be honest. Don't minimize challenges, time commitment, or other factors which you fear might discourage a volunteer. Whenever possible, send recruiters whose backgrounds reflect the types you are recruiting (send teens to recruit teens). Finally, stress the potential benefits to the volunteer and the people you serve rather than how your organization benefits from volunteers.

SELECTING AND PLACING VOLUNTEERS

In order to accomplish the tasks of your organization, both paid and unpaid staff need to be suitable to perform those functions. It is important, then, to choose volunteers selectively. Determine how selective to be based on the requirements of the job. Four steps are helpful in assuring appropriate selections:

1. Involve the person who will work most closely with the volunteer in the selection process.

2. Use a written application, but make it simple and suitable to the responders; use it to gain basic information about the person and his or her interests and qualifications.

3. Interview applicants to get to know each other's aspirations, goals, and interests, and to assess if a mutually beneficial match can be made.

4. Check references for volunteers who will be placed in highly responsible positions.

In making final selections, ask:

- What is the individual seeking from a volunteer experience?

- Can your needs be met given the skills, interests, and capabilities of the applicant?

- What are the applicant's personal qualities and how would she or he fit with other personalities in the office?

- What is the applicant's availability?

Rejecting and confirming volunteers

It's not easy to reject an applicant for a volunteer position. The reason may be a straightforward matter—that you cannot make the right match of skills and job so that both the volunteer and your organization benefit. In other cases, your reasons may be more difficult to explain, such as a problematic personality. Allow yourself an out from the start. State at the outset that sometimes more people are interested than you can accommodate. Even so, honestly assess an individual's skills and suitability. Suggest skill areas to strengthen. And provide alternatives, referring the applicant to local volunteer agencies or other arts groups with whom the applicant may find a more suitable opportunity.

Whether or not you accept an applicant, make decisions expeditiously and notify candidates on the status of their applications. Too much elapsed time leads good people to lose interest and pursue other opportunities.

Getting a good start

Once a volunteer is on board, a number of practical steps can be taken to ensure a successful experience for both the volunteer and the organization. Primary among them are a memo of agreement, orientation, and training.

Memo of agreement

At the outset clarify expectations about the volunteer's role on a project or in the organization. For a volunteer assigned to your fundraising auction, simply explain expectations before the volunteer goes on duty, perhaps with a written information sheet for referral during the job. If the volunteer position is long-term, for example, a semester-long student internship or a yearlong festival chairmanship, this may be accomplished through a memo of agreement. Such an agreement is generally similar to a job description and specifies:

- the volunteer's responsibilities and tasks;
- the volunteer's personal goals for the job;
- the organization's obligations (travel reimbursement, training opportunities, evaluation procedures).

A memo of agreement fosters a sense of commitment by both parties to meet their obligations to each other. It may establish a trial period during which both volunteer and organization can assess if things are working out. It is also a reference tool as the volunteer's experience is periodically evaluated. At the same time, a memo of agreement should remain flexible and open to revision as the job needs to change or as a volunteer grows into new responsibilities.

Orientation

Orientation integrates volunteers into your organization's activity. Orientation should address needs on three levels—individual, group, and task.

Individual needs

Individual needs are most basic and should be addressed first. Take care to make new volunteers feel welcome, comfortable, and a part of your organization. This may be accomplished by developing a buddy system where seasoned volunteers can help new volunteers get started, learning individual interests of volunteers and engaging in nonwork conversation, providing the volunteer with a space to work, giving sufficient attention and training in the early stages, and, most importantly, monitoring how the individual's own motivating factors are being met.

Group needs

Orient new volunteers to your organization. Cover the background, history, achievements, and aspirations of the organization, its programs, procedures, timelines, staff structure, and relevant policies. This may be done by inviting a new volunteer to a staff meeting, holding a special orientation meeting for several new volunteers, and making available annual reports, newsletters, and other written materials that convey a picture of the group. Volunteers should know each staff member even if they may not work directly with all of them.

Make sure that staff and board members introduce themselves and their roles to new volunteers individually or at an orientation meeting or reception so that volunteers connect to the people of your organization. Show how each member works toward and contributes to the larger picture. This team building creates a sense of belonging, of place, and helps to establish work and social relationships.

Task needs

Even the most experienced professional or savvy board member may benefit from orientation to the steps and mechanics of the tasks at hand. Struggling with the quirks of the office copy machine can be as frustrating to completing a task efficiently as composing a fundraising letter for the first time. For any new undertaking, stop and remember that this may be a new skill for the volunteer—newcomer or veteran volunteer.

Orientation to tasks is most often accomplished one-on-one between a supervisor and volunteer. Procedure manuals and instruction sheets are useful written tools. More extensive training may be critical for more demanding activities, such as making fundraising calls or coordinating an artist residency program for people with disabilities.

Training

Training is an investment in your organization. It helps a volunteer to acquire knowledge and skills beyond specific individual tasks. Through training you enable volunteers to understand their jobs better, take initiative, and therefore contribute in a deeper, more meaningful way.

Training may take a variety of forms, depending on the nature of the job and the skills being taught. These might include:

- one-on-one training, provided by a staff or board member, or a senior volunteer;

- in-house workshops, presentations, discussions, practice, role play;

- attendance at conferences or workshops, enrollment in continuing education or college courses.

VOLUNTEER MANAGEMENT

In rewarding relationships, there is a balance reflecting what both parties are getting from the association. If one party stands to gain disproportionately and this is apparent to the other, productivity sometimes diminishes. Everyone deserves to gain the satisfaction they expect.

Volunteer management is simultaneously the management of human relations and the management of work that needs to get done effectively. To be most productive and fulfilled, volunteers need to be supervised and nurtured on an ongoing basis, with special attention given to keeping each person motivated. Central to this process is effective communication. This means setting up regular opportunities to provide training and check on the progress of work, to work out problems which arise, and to talk about how the volunteer is feeling about her work. It also involves ongoing evaluation and a willingness to make changes as the volunteer adjusts to the position.

Leadership

Leadership can be defined as the ability to recognize potential in people and to integrate their needs with the goals of an organization. An effective leader maximizes opportunities to develop and utilize talents.

To accomplish this requires flexibility. Those overseeing volunteers need to recognize that different situations call for different approaches or styles of leadership and problem solving. These approaches include:

- authoritative (telling), where the leader makes decisions and informs a volunteer(s);

- political (selling), where the leader makes decisions and must convince others of the decision;

- evaluative (testing), where the leader presents ideas and invites questions;

- participative (consulting), where the leader presents alternatives and the volunteer(s) chooses;

- laissez-faire (joining), where the group defines boundaries and makes decisions.

Good leadership utilizes the potential and resources of the individual or group. When a volunteer is involved in and buys into pertinent decisions, confidence is built and commitment is reinforced.

Effective leaders:

- develop trust among those who work together;

- introduce challenges at appropriate times and accept risk;

- balance learning by mistake with averting mistakes;

- demonstrate confidence in volunteers, once it's earned;

- share individual and collective achievements with the entire group;

- model professional behavior and standards;

- project a positive view of the organization, its work, and people;

The Volunteer Coordinator

Recruiting, training, and managing volunteers requires time, energy, and planning. For an organization intending to work regularly with volunteers, a coordinator to oversee and to work with staff is essential. The coordinator could be a staff member, a board member, or a volunteer committee chair overseeing his or her own volunteers. In any case, the volunteer coordinator's job may include the following responsibilities:

Planning

- guide staff to define volunteer positions;
- identify volunteer needs for various projects;
- develop timelines for recruitment, training;
- research potential volunteer sources.

Recruitment, Placement, and Orientation

- recruit volunteers;
- oversee or implement the review and selection process;
- orient volunteers;
- train and monitor training by others;
- lead by outlining organizational goals, modeling professional behavior, and providing direction, guidance, and assistance.

Management

- organize meetings;
- monitor morale, work load, quality and quantity of work, the learning experience, and additional volunteer needs;
- replace volunteers who leave;
- keep records on volunteer program, including contact information, letters of recommendation, records on the economic value of program;
- facilitate information flow among staff and volunteers through meetings, bulletin board announcements, memos;
- provide support and recognition.

Evaluation

- provide mechanisms for assessment of volunteer work through meeting and discussion, and for volunteer assessment of the project and organization.

Recognition

- monitor staff or others who are overseeing volunteers' work to ensure ongoing recognition is provided;
- provide meaningful recognition, suitable to the volunteer's job, tenure, and accomplishments.

- perceive unspoken needs; foster a communicative environment;

- keep focused on the vision and the goals; keep the work in context of its significance and impact;

- help unravel and break down tasks;

- provide information tools;

- help solve problems effectively;

- empower volunteers with decision-making opportunities when they are ready.

Retaining volunteers

Some organizations have taken into account the changing conditions described at the beginning of this chapter and restructured their volunteer needs to accommodate flexible associations for people with demanding lives. They have shifted their expectations from long- to short-term commitments.

Yet organizations still need long-term commitments from board members or other key volunteers where continuity is an advantage. So it is frustrating when a board member resigns prematurely, a key volunteer leaves due to burnout, or a promising volunteer mysteriously quits midstream. Problems of volunteer retention can often be traced to ineffective recruitment, placement, orientation, training, or management. Many of these experiences can be averted by following some of the advice provided throughout this chapter.

The following are common reasons that organizations lose volunteers and suggested approaches for prevention:

Burnout

Recruit enough volunteers.

Divide labor to reduce the work load.

Allow longer lead time to accomplish the work.

Encourage delegation among volunteers.

Provide leaves of absence.

Respect people's limits.

Have fun!

Loss of interest

Make sure the position matches the volunteer's expectations.

Provide enough to do.

Offer more challenge.

Make clear the ways that the position makes a difference–the reasons for routine or clerical tasks–and provide support.

Recognize accomplishments.

Rotate responsibilities to offer variety.

Lighten up and have fun!

Lack of motivation

Recognize when a volunteer's goals have been met.

Match assignments with interests and motivations.

Equip the volunteer with the information, tools, and support to tackle the job.

Steer activity toward clear-cut successes.

Be sensitive to personal or other factors competing for a volunteer's attention.

Provide opportunities for advancement and participation in decision making or new programs.

Be attentive to and recognize successes.

Have fun!

Low energy

Check the work conditions–space, supplies, scheduling, transportation–for possible problems.

Keep an eye on the work load, providing a balance between work and play; have fun!

Interpersonal difficulties

Keep lines of communication open.

Detect problems before they flare up, anticipate trouble spots.

Contemporary Volunteer Organization Case Study: The Arts Commandos of St. Louis

Since 1990 the Regional Arts Commission of St. Louis, Missouri, has successfully organized a volunteer program that serves the short-term needs of the region's various arts organizations. Modeled after the Arts Commandos program created by the Oklahoma City Arts Council in 1982, the program is structured to take into account the busy lifestyles of primarily business professionals who would like to help arts groups but want finite and fun opportunities to lend a hand. Following is a description of the program. Examples of recruitment and management tools from the Arts Commandos are provided throughout the chapter.

Arts Commandos

The Arts Commandos, a special project of the Regional Arts Commission of St. Louis, is a group of about 400 energetic volunteers who carry out specific projects proposed by not-for-profit arts and cultural organizations in the St. Louis area. These volunteers are primarily business professionals who want to be involved in the arts beyond being loyal audience members.

Using a tongue-in-cheek name that underscores the concept of an autonomous volunteer task force, the Arts Commandos carry out projects that are one-shot in nature. While they do not promise to run an organization or to be fundraisers, the Arts Commandos do promise to commit their muscle, brains, or any combination thereof to solve problems for arts organizations. In 1993 this volunteer group completed thirty-four projects, donating over 4,000 hours to arts groups.

The Arts Commandos are an innovative source of volunteers that addresses the needs of the arts community, nurtures cultural leaders in the process, and provides personally rewarding experiences in a flexible format for volunteers.

How Arts Commandos Works

Arts and cultural organizations in the St. Louis area submit proposals to the Arts Commandos for short-term projects. Most projects are less than one day in length, and work shifts generally range from four to six hours.

Prospective Arts Commandos are invited to a biannual gathering where they can register (see Registration Form, Appendix) and learn about upcoming projects for the year, including descriptions of the work that has to be done and the dates needed (see page 217). Individuals sign up as a project manager or volunteer and have fun meeting other Arts Commandos in a social setting.

Arts Commandos can choose to volunteer for as many or as few projects as they like. Most often Arts Commandos find that they have so much fun working on a project that they volunteer for more and bring their friends along.

Two chairpersons (one male, one female) head up the Arts Commandos efforts each year. The chairpersons are aided by six to eight project managers (also paired in teams of one male, one female) who coordinate their favorite projects and do additional phone recruitment as necessary to ensure that there is sufficient volunteer help.

Tasks carried out by the Arts Commandos may include but are not limited to painting, carpentry, decorating, educational or docent work. Some projects require only a small Arts Commandos work force while others require many teams working at the same time.

The arts organizations utilizing Arts Commandos volunteers supply all materials needed for a project, as well as refreshments and freebies as a thank you.

Check organizational attitudes toward volunteers.

Reassign volunteer to a new staff person.

Validate positive effort through recognition and appreciation, both formal (events, certification, awards) and informal.

Recognition and thanks

Volunteers need ongoing recognition and thanks for their contributions. Most important, recognize and thank an individual volunteer in a way that is meaningful to him or her. If a volunteer is motivated to learn new skills, then sending him to a weekend workshop may be exactly the recognition that says, "We believe in your capabilities enough to invest in your training." A corporate executive who has volunteered time to put your books in order may be best served by a letter of thanks praising his help and sent to his employer as evidence of community service. For another volunteer seeking to make a difference in the lives of disadvantaged children, seeing the play produced in an artist residency may be the greatest possible reward.

Arts organizations have approached this important aspect of volunteerism in a variety of creative ways including:

- training opportunities;
- promotion to increased responsibility;
- involvement in decision making;
- certificates of appreciation;
- complimentary or reduced price tickets to programs;
- recognition in the media through feature articles, thank you ads, letters to the editor, or newsletter features;
- birthday celebrations;
- T-shirts, pins;
- parties;

- special opportunities, such as meeting guest artists.

However you show appreciation, tailor it to the individual as much as possible. Both individual and team recognition can help people feel good about their work and their contributions to the organization.

Evaluation

Evaluation should be appropriate to the job and the volunteer. A new ticket seller may need to be monitored by a veteran volunteer during her first shift or two. Volunteers involved in more extensive roles benefit from regular feedback on their work. Ongoing monitoring and feedback helps ensure quality and detects problems before they flare up. It is helpful when a new volunteer comes on board to discuss how you plan to evaluate work and to ask what will be the most helpful way to provide feedback.

Evaluation is a two-way street. It is equally important for you to know how the volunteer experience worked for the volunteer as it is for the volunteer to know how he is doing. Evaluation questionnaires are a useful tool for collecting information from volunteers about their own experience and about the volunteer program. Organizations should also consider some deliberate way of learning volunteers' opinions about and recommendations for the job they did—an evaluation form, an exit interview, a lunchtime debriefing, or a project staff meeting.

In closing

A successful volunteer program meets the needs of both the organization and the volunteer. This shows in the achievement of your organization's goals and in the personal and professional growth of your volunteers. Strive to create an environment in which people are encouraged to give their best and to grow in qualities such as commitment, confidence, productivity, initiative, cooperation, imagination, self-esteem, and pride in work well done.

SELECTED RESOURCES

Independent Sector. *Giving and Volunteering*. Washington, D.C.: Independent Sector.

Kimball, Emily Kittle. *How to Get the Most Out of Being a Volunteer: Skills for Leadership*. Phoenix, AZ: Jordan Press, 1980.

MacKenzie, Marilyn. *Dealing With Difficult Volunteers*. Downers Grove, IL: VM Systems, 1990.

McCurley, Steve. *Volunteer Management Forms*. Downers Grove, IL: Heritage Arts Publishing.

McCurley, Steve and Sue Vineyard. *101 Ideas for Volunteer Programs*. Downers Grove, IL: Heritage Arts Publishing, 1986.

Wilson, Marlene. *The Effective Management of Volunteer Programs*. Boulder, CO: Volunteer Management Associates, 1976.

ONLINE RESOURCES

The California Management Assistance Partnership maintains the Nonprofit GENIE web site (www.genie.org) as a free service to help nonprofit staff and board members manage more successfully.

www.search.genie.org/genie/ ans_result.lasso?cat=Volunteer+Management

The Association for Volunteer Administration, an international professional association, enhances the competence of its members and strengthens the profession of volunteer resources management.

www.avaintl.org

The Volunteer Resource Center of the Twin Cities is built on the successful history of two well-established volunteer centers, the Volunteer Center and the United Way of Minneapolis. The center's website provides links to useful information for volunteers and nonprofit staff volunteer managers.

www.volunteertwincities.org

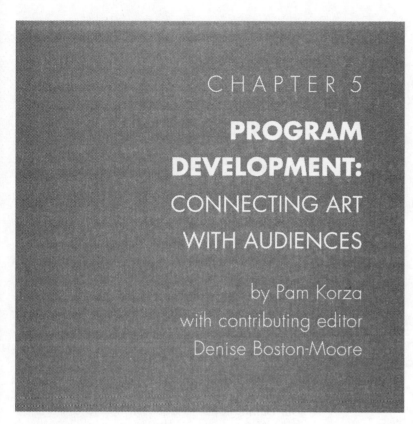

PROGRAM DEVELOPMENT:
CONNECTING ART WITH AUDIENCES

by Pam Korza
with contributing editor
Denise Boston-Moore

> *"The magic of the arts is that it opens a new and different way of learning for students. It is multisensory and multifaceted. It engages students on a variety of levels–in both body and mind and as a result many students who have not succeeded in traditional classroom methods suddenly blossom. We see their potential. We understand their gifts."*
>
> –**Lenore Blank Kelner,** *The Creative Classroom,* Heinemann,1993

Community arts organizations bring the arts to the people. Their wide range of programs entertain, delight, and may offer a creative source of insight. The way we connect the arts with audiences has evolved tremendously over the years. While public performances, arts exhibitions, and artist residencies continue to prominently reflect organizational goals, increasingly arts agencies are planning programs that redefine both community arts and the artist's role in the community. In order to create a greater access to the arts for a greater number of people, local arts organizations are developing opportunities for encouraging a community–wide celebration of cultural diversity, social change, health promotion, youth advocacy, elder appreciation, and neighborhood histories.

A collaborative approach to programming

Community arts organizations approach the practice of programming less as independent producers of arts related services and more as collaborators with community groups. More emphasis is being placed on developing stronger relationships between communities, arts organizations and artists. This approach uses the arts as a means of communication, thereby transcending ethnicity, language, age, customs, and risk factors. It is supportive of the voices of people who represent all sectors of the community and addresses a broad range of perceptions and creative directions.

This chapter focuses primarily on artistic programs–presenting or producing the arts–although the approaches to program development and management offered here are often equally relevant to service–oriented, advocacy, and grantmaking programs. Throughout the implementation of any initiative, careful planning is essential. The chapter provides a structure for conceiving, planning, and implementing programs that will successfully meet the

needs of artists and the community, and advance the arts themselves. This chapter aims to guide you through the program development process, from conceiving the initial idea to evaluating results. These critical questions are addressed:

- What difference will you make through your program choices?

- How will you include representatives of your target audience in the program planning?

- Is your program feasible, that is, grounded in a foundation of shared vision, necessary resources, and thoughtful planning?

- How do you design your program to achieve your goals for artists, art, and audience?

- How do you know if your program has succeeded?

We consider the arts here as but one aspect of cultural life, which also includes history, heritage, social conditions, health care, foodways, lifestyles, and religion–all expressions of the creative human spirit. This chapter looks at the concerns around both program development, or conceptualizing what programs to create, program management, or how to bring them to fruition.

PROGRAM PHILOSOPHY

An arts organization's program choices should reflect the program philosophy–a set of guiding principles, attitudes, and points of view that will guide its decisions and approach to its work. Your program philosophy is based on a variety of considerations.

The organization's mission and community context. Every program you choose to offer should reflect why you exist and whom you serve. As arts organizations strive to serve the needs of particular communities, memberships, and audiences, program planners should also resist the common compulsion to do more and more. Management specialist George Odiorne advises nonprofits to avoid the "activity trap" and to center instead on the highest priorities and excel in the delivery of service around them.

The concept of "audience" held by your organization. How do you define audience? *An American Dialogue*, the Association of Performing Arts Presenters' report resulting from a national study on performing arts presenting (see Selected Resources), suggests that the term audience is too limiting to describe the array of people, beyond valued ticket buyers, whom presenters and artists must engage. Instead, the term community acknowledges its participatory purpose, which emphasizes collaborations between artists and other community members.

A community concert association in a rural Midwestern town used to serve a fairly homogenous white, middle–class community. Today its programming needs to consider a growing elderly population and a small immigrant population, attracted by jobs to a local vegetable packing plant, as prospective audience members.

Your commitment to accessibility to audiences and artists with disabilities. In your program choices, how inclusive are you in serving the culturally diverse and underserved interests present in your community?

Source of your program ideas. How are board, staff, volunteers, members, citizens, youth, and artists involved in defining your programs? How successfully do you balance being responsive with being proactive vis–a–vis artists and the community in developing new program directions? Are the arts situated in more public, accessible and resonant places, geared to a specific audience?

Your risk–taking threshold. How much does the organization fall back upon certain comfortable and cautious program choices versus challenging itself and its audiences? "Reasoned" risk may move audiences forward in their engagement with the arts while meeting them at a new and appropriate learning point. Are you prepared to defend programmatic choices which may be controversial?

Your group's relationship to the world of art and ideas. Art is at the core of what we do, whether it is cultural programming or services; whether we present the work of contemporary

artists or those of the past. Are you abreast of what is currently happening in your part of the arts world? Arts organizations, even those that preserve art of the past, are increasingly challenged by artists, the media, politicians, and the public to clarify their positions on the relationship of art to politics, health promotion or social issues. Are you informed about the issues and clear on your own positions?

Your definition of success. What difference are you trying to make through your programs? How will you evaluate the impact of your programs and who will do the evaluating? What criteria will you use?

> "As a board, we have recently realized that the bottom line isn't the only measure of success. More adventurous art forms build audience gradually. We have to make a commitment to those forms over time, to introduce them again and again to our community. This we do in support of our goal to serve artists. So we've built in a fundraising event that helps to underwrite our financial loss."

"The most successful nonprofits, those that are built to last, incorporate the research, techniques, and methods of others that came before in conscious and deliberate ways. They look to collaborate and add to what has already been built."

–Bill Shore. *The Cathedral Within.* Random House, 1999.

PROGRAM PLANNING

Arts organizations are continually presented with opportunities to develop new programs. They are also presented with circumstances that suggest modifying, and sometimes terminating, existing ones. Possibilities such as the following may be prompted by constituent need, artistic impetus, new or reduced funding opportunities, influences of a changing social, political, or cultural environment or simply someone's great idea.

> An arts council thinks that expanding its successful holiday season craft sale to a year–round craft

shop can provide additional revenue and better serve the region's craftspeople.

A neighborhood community center staff member suggests to fellow workers that a dance project involving Hispanic youth would help them to understand the link with their family and ethnic community. The class will also focus on the interwoven cultural connections of Spain, Europe, and Africa.

"The Cutting Edge" roster of music presented by the performing arts center has lost money each of the last two seasons. The board of directors is suggesting to the program director that these types of programs be dropped in favor of the more profitable folk, classical, and world music offerings.

The arts council's grant–making program has withstood two consecutive years of severely diminished funds from state and local government sources that it can award to local arts organizations. It anticipates the trend will continue. The council's current multiple category program must be reevaluated and revised to reflect diminished resources and community need.

The program planning process serves to help an organization choose intelligently from various options and to test their feasibility.

Specifically, the process:

- gauges support for the idea and identifies potential partners;

- determines and averts or plans for financial risk;

- avoids overtaxing human and other resources;

- formulates a workable plan of action.

The planning stage could take a day, weeks, months, or longer depending on the complexity of the program! If you invest the time to plan, however, the program stands a better chance of being implemented smoothly and succeeding in serving its participants and recipients.

SIX STEPS TO DETERMINE THE FEASIBILITY OF A PROGRAM IDEA

1. Test assumptions inherent in the program idea.

2. Agree on the program's purpose (what difference do we want to make, for whom), goals, and objectives.

3. Define the program specifically. Answer who, what, when, where.

4. Examine resources you need, have, and can get. Answer how.

5. Identify and evaluate critical issues, obstacles, and opportunities.

6. Finalize the plan.

STEP 1. Test assumptions

Testing assumptions inherent in the program idea means talking with program beneficiaries, artists, partners, and other players to determine if, in fact, you are making assumptions and if these assumptions are valid. The organization begins to clarify:

● the perceptions of the problem or need held by various people, including staff, board, program or service recipients, etc.;

● who will benefit from the program and how;

● what support systems are available;

● whether your organization is the best one to do this program.

A community center staff member suggests that a Salsa dance project involving youth of a community would offer them an after-school leisure activity that is fun and connected to their cultural heritage. Possible assumptions are: the community members' viewpoints are known and understood; a shared project can surface issues in a meaningful way; dance is an appropriate project to achieve the goal; the community center has access to artistic resources; and such a project is a better use of scarce resources than other options.

STEP 2. Agree on program goals and objectives

Answer why you should engage in this program. This step:

● ensures that everyone is working from a common understanding of what you aim to accomplish as a result of the program;

● guides program development and implementation of decisions;

● provides a clear and consistent message to the community, your members, funding sources, the media, and volunteers about why you are doing what you're doing; and

● forms the basis for evaluating the impact of the program.

To arrive at clear program goals, some level of audience or community assessment, such as public meetings, round table discussions, focus groups, or surveys may be important. The Planning chapter discusses various assessment processes, as well as how to write purpose, goals, and objectives statements for your programs. If you are taking a community development approach to your programming, see the chapter on community development.

> *"There is a big difference between being an organization with a vision statement and becoming a truly visionary organization."*
>
> **–Jim Collins.** Aligning Action and Values, Leader to Leader, summer, 1996.

STEP 3. Define the program

Answer who, what, when, where. Visions are amorphous by nature. But it is difficult to project a budget, technical needs, or the terms of partnership based on a vague idea. Eventually a specific program concept (or a few variations on it) needs to be nailed down in order to evaluate its feasibility.

To bring your program idea from that initial fluid vision to a clear and more specific concept, you must answer the questions: who, what, when, and where.

Who. Clarify who the program will benefit. Whether you start with who the desired audience will be or whether the goals of the program lead you to pursue certain audiences, you need to carefully consider the relationship between audience and goals in order to successfully plan, promote, and present the program. One party's interests may emerge as primary, either for practical or philosophical reasons, and therefore shape the program in a certain way.

A cultural festival could be conceived as creating opportunities for local artists to present exhibitions and performances of their native lands; or might be approached as a vehicle for connecting and uniting people in the community. In the former, the artists use the creative space to share their knowledge and expertise. In the latter, powerful connections are made as the community is brought together to enjoy and learn.

"The arts elicit metaphors that reflect an individual's personal sense of meaning and the value the arts provide to that personal meaning."

Jerry Yoshitomi. *New Fundamentals and Practices to Increase Cultural Participation and Develop Art Audiences.* Grantsmakers for the Arts Reader, Volume II, No. 1, summer 2000.

Estimate the numbers of people to be served. Defining the numbers of program beneficiaries is important in the program planning stage. If your program relies on fee–based income from ticket sales or registration fees, making an accurate attendance estimate as you develop your budget is crucial.

Estimating the number of people may hinge on such factors as:

● capacity limits of the space you're using;

● drawing power of the program or artist;

● availability of the targeted audience or community of people;

● what it will take to effectively promote to this audience;

● competition for the targeted audience.

Clear audience targets and estimates may help you to design the program to best meet the interests of those people; attract artists; raise money; secure sponsors; negotiate a facility or setting for the program; determine ticket prices; and develop a marketing strategy.

Clarify who is responsible for program planning and implementation. Is it the board, staff, program director, executive director? Deciding "who's on first" early on avoids potential confusion later. See the People Resources section under Step 4 for further discussion.

What. At the planning stage, relate the program vision to specifics about purpose, content, structure, and scope. In simple cases, such as working with one artist, you will naturally want to check his or her availability and the details of presenting that artist. For other programs, such as a yearlong artist–in–the–schools program, you may want to at least clearly define the content, format, and types and numbers of participants, and set aside the details of which individual artists to hire until later.

Where. The real estate industry sums everything up as "location, location, location!" For arts and cultural programs, as well, location is certainly one of several important factors that can make or break a program. The choice of location can emphasize particular goals of the program.

A regional arts council holds summer performances in an open–air arena.

Alternating a weekday lunchtime concert series between the downtown business district, hospital patient units, neighborhood parks, and soup kitchens helps to meet community access goals.

Similarly, mainstream organizations with a goal of serving culturally diverse audiences must consider the relationship of program to location, for example, holding a Martin Luther King Day event in the neighborhood school auditorium rather than at the art center. Present programs in locations where new audiences feel comfortable.

It is sometimes impossible to find a location that is perfectly suited to accommodate all the

artistic, technical, and audience demands of a program. However, an organization should consider the following in determining where to hold its program:

- **Suitability**–Will the facility do justice to the art form? Does it have suitable technical support?

- **Capacity**–Can it accommodate the expected number of people?

- **Aesthetics**–What can the location lend aesthetically or conceptually to the program?

- **Accessibility**–Is the location physically accessible to people with disabilities? Is the location close to public transportation? What psychological perceptions may exist concerning accessibility to the location?

In Tucson, Arizona, three arts programs were specifically developed by the Tucson/Pima Arts Council and the Downtown Development Corporation to allay people's nighttime fears about going into a retail–abandoned downtown, also the location of the arts district. Phantom Galleries transformed a block once dark with vacant storefronts into well–lit temporary gallery exhibition spaces and window installations. Three–month residencies by artists who brought art to alleys and high–traffic areas of the downtown enlivened the area and brought extensive positive media coverage. The Downtown Saturday Night program, developed to provide a mini–festival atmosphere focusing on the arts and encouraging restaurants and existing retail shops to stay open, has been hugely successful. A local newspaper reported, "People from across the city immerse themselves in this mix of old and new–this renaissance of a place once abandoned when sleazy, rough bars made the area risky to hang around."

- **Availability**–Are prime spaces available on the date(s) you want? Much cogitation is wasted if your dream location is already booked. Get to know the booking patterns of various facilities so that you can plan well enough in advance.

- **Cost**–Are rental costs and/or costs of adapting the location realistic?

When. Choosing your program date can involve as much strategy as choosing location. Factors to check on are:

- availability of prime spaces;

- how long it will take to plan and promote the program;

- overlapping dates with other programs or interests which may compete for the same audience and/or for the media's attention;

- availability of the target audience, competing programs or diversions;

- complementary programs that may expand your audience and theirs;

- possibility of inclement weather for outdoor programs;

- possibility to block–book an artist with another organization;

- funding application deadlines;

- the desire to establish an annual date.

"By providing creative arts programming to children who otherwise would not have the opportunity to participate in the arts, Free Arts of Arizona acts as a catalyst for positive change."

Stephanie L. Small, Executive Director, Free Arts of Arizona

STEP 4. Examine resources

Answer how. Having defined your program concept in greater detail, you can test its feasibility against the money, time, and people needed to make it a reality. This step requires some objective assessment.

Financial resources. Only by developing a specific, research–based budget, can you hope to accurately assess the financial feasibility of your program. This step includes defining expense and income limitations and potential, how much money needs to be raised, and what's needed to raise it.

The budgeting process is usually one which requires a give and take between the expense and income sides until the bottom line is what you want it to be. Do not approach this as an exercise in creative arithmetic, however. Each shaving of an expense or increase in an income projection must be honestly and realistically assessed, considering its implications to the program.

See Financial Management, chapter 11, for more detailed discussion of budget development. Here are some pointers for developing program budgets:

Know your financial objectives

- Estimate income conservatively.

- Save money wherever possible by getting in-kind donations.

- Maximize earned income potential.

- Don't give away too much. Determine complimentary ticket policies thoughtfully. Can you afford to give away t-shirts to all your volunteers? Should corporate contributors be given a free ad in your program book or should they be asked to pay for advertising beyond their other contribution?

- Don't spend too much money raising money. Evaluate carefully the costs involved in certain income producing activities. The United Way keeps fundraising expenses within 15 percent of anticipated income.

- Understand what your cash flow needs are and how you will accommodate them. (See the Financial Management, chapter 11, for more on cash flow.)

- Minimize the chance for surprise expenses. Research as exhaustively as possible in determining expenses. Don't base projected costs on ballpark estimates or old information. Determine real costs from artists, vendors, etc.

- Plan for surprise expenses and inflation. Include a contingency expense figure. Three to five percent of total direct expenses (other than salaries and overhead) is common.

If expenses are greater than income, evaluate the possible courses of action:

- Can the program be scaled back? Can certain expenses be cut? Consider the implications of these actions in relation to your programmatic goals and maintaining the integrity of the art.

- Can expenses be shared with collaborative partners or other community organizations?

- Can certain expenses be amortized? A festival purchasing tents, a theater company creating portable sets for a tour, an art center purchasing display cases for an exhibition—these costs can be amortized or spread across a certain period beyond the program at hand since they will enable other programs in the future.

- Can income be increased? Estimate cautiously.

Play out different budget scenarios. It is useful to develop two or three budget scenarios that anticipate varying degrees of income:

1. The ideal scenario—your dream program achieves its income potential.

2. The compromise scenario—a modified program, can be mounted with anticipated lower income. This scenario should reflect acceptable programmatic compromises.

3. The no program scenario—assumes that adequate income is unavailable to support any program variation that still meets your goals. This scenario may suggest an alternate timeline that allows for sufficient fundraising.

In the fundraising stage, organizations often generate a budget for funders that reflects the ideal program and a fallback internal budget that reflects the compromise program the organization is willing to present with a certain minimum of earned income in hand.

The appropriate staff, board, and, perhaps, advisers in the community should review the financial picture drawn in this feasibility stage. At this point the review should test the validity of the figures. Did you project realistically? Are all

potential expenses outlined? Have incomes been reasonably projected? Are there any that have not been identified?

"We approach partnerships as budding relationships with the goal of learning as much as we can about the other's priorities, needs and culture."

–Laura E. Burham, executive director, Abbington Art Center, Pennsylvania

People resources

Arts organizations are notorious for greeting every exciting program idea with a resounding, "Yes, let's do it!" Such passion has also launched many an arts organization's staff and/or board into a state of perpetual overdrive. Whether a single event on a certain date or an ongoing program, the ebb and flow of work should be carefully calculated, as well as the specific skills and expertise required. Ask questions such as:

- Do the necessary skills, expertise, and connections exist within your organization?

- Is it feasible for staff or board members to devote time and energy to the program? If so, can other regular activities be sustained without compromising quality?

- Will volunteers or new staff be required? Will training be necessary? Do you have the time and money to make this happen?

- If you take on a new program, can you either recruit new people or let go of an old program to free up staff time?

If you must seek expertise outside the organization, consider these possible sources:

- a friends group or existing volunteer corps;

- an ad hoc advisory group;

- partnerships with other organizations;

- a hiring process.

The practice of community art collaborations requires:

- building trust and an appreciation of their expertise and unique identity;

- mutual understanding of the goals of the program and a commitment to help achieve them;

- understanding of the particular goals which each organization may have and a program design which aims to satisfy both partners' goals;

- delineation of authority, accountability, and responsibilities. Often you give up some control and should recognize this at the outset;

- agreement on financial risk–taking and gain;

- a written agreement outlining the above. See Learning Partnerships at www.umass.edu/aes

Time

The program should be based on a realistic assessment of the time it will take to plan and raise funds, and to implement the plan. Identify critical deadlines, including:

- research (of program components, community involvement; artists' availability, market potential, costs, funding sources, potential partners, technical concerns);

- grant application deadlines and notification dates; deadlines for other fundraising efforts to be completed;

- staffing of the program; recruitment of staff and/or volunteers;

- a finalized program when artists, artwork, and program participants are all secured and the program components and design are set;

- final dates for bidding out contracts for services (if applicable);

- key promotion opportunities and printing deadlines.

Create a timeline. A suggested timeline format is a grid with one axis for the months/weeks leading up to (and throughout) the program and the other axis for specific tracks of activities such as administration, fundraising, program research and implementation, marketing,

technical support. These tracks may correspond to specific committees working on the project. (See Appendix for a sample timeline.) Such a master timeline shows the relationship between activities.

In order for the marketing committee to send a press kit to the media six weeks before the program, the program committee must submit to the publicity committee a final lineup of participants with descriptions and photos four weeks before the press kit deadline, allowing time for the marketing committee to develop the kits.

In addition, the timeline helps everyone to visualize the plan's progress, the interdependence of various committees, and periods when people power may be in greatest demand. An agency timeline showing all of the organization's programs and services also helps place this program activity in a context of the total demand on the board, staff, and volunteers.

STEP 5. Identify and evaluate issues, obstacles, and opportunities

Defining program and resource needs will undoubtedly identify issues and obstacles, as well as opportunities, which your organization must analyze and evaluate.

A consultant conducting a feasibility study for a national festival to take place in a major city discovered that local cultural organizations were fearful that county arts council funds would be significantly diverted to support the new festival, reducing allocations that were an important part of the arts groups' revenue base. The county arts council had to determine how it could support the new event without unfairly stressing its ongoing constituents.

"In the local arts agency business, 'All things are good.' It is a black hole of possibilities. Hewing right up front to the mission and cultural plan's goals (if you have a cultural plan) is imperative if one is not going to run amok with work."

–Cindy Kiebitz, former director, Huntington (NY) Arts Council and former board president, NALAA

Some useful questions to ask are:

- What do we lose if the program does not meet our criteria for success? What are the implications of losing these things?

- What can we and others learn by doing this program?

- What relationships might be built?

- Can we sort out certain short–term activities from those that require long–term planning?

- What external conditions must be met before we can proceed?

STEP 6. Finalize the plan

At this point you should have the information you need to decide the likelihood of achieving your goals and objectives. Your options may be:

- Go ahead with the program with a better understanding of what you need to do to make it a success.

- Refine the program concept to bring it in line with resources you can reasonably secure.

- Delay until you are able to secure the resources you need.

- Stop if the program poses too great a financial risk, you don't have the time or personnel to carry it off, you don't have adequate community support, or it's outside your scope.

PROGRAM DESIGN

Regardless of the type of program or service you offer, you will face issues of developing policy, working with artists, ensuring access, and achieving the greatest impact. This section explores these common issues.

Program policies

Policies are guidelines which help an organization act consistently and in keeping with its values and principles.

An arts festival that values originality has a policy prohibiting exhibitors whose work is made from kits.

The concert association concerned about accessibility creates policies about child care or ticket subsidy in order to make a program accessible to economically disadvantaged community members.

A theater company committed to cultural equity institutes a policy of color–blind casting ensuring that people of color can perform any role where color is not integral to the character.

Policies are usually created out of good intentions. However, any policy in the making should be carefully evaluated by board and staff with input from the people who are most directly affected by the policy. While policies may be changed over time, because they are based in the principles and values of your organization, they should be somewhat enduring. It is important not to waver unpredictably in your policy decisions.

Quality: A multidimensional view

Discussions of artistic quality are characteristically challenging and ultimately elude definitive conclusions. Most arts organizations would agree that they strive to support the highest possible quality in the art they present, produce, or support. Mediocre or poor content and execution of the arts will negatively affect a community's view of the arts and its cultural values, and betrays the audience trust which we must continually nurture.

To build and sustain a constituency for the arts, local arts agencies are concerned with quality from two perspectives:

● the quality of the art;

● the quality of the overall experience for the program participant.

Defining standards of artistic quality

We are responsible to artists, our communities, and the advancement of art itself to be thoughtful about how we define standards of quality and to find appropriate and fair ways to evaluate quality. This is especially important as we seek to include new audiences by bringing new people in

contact with arts work. Here are some general guidelines about defining and fostering quality.

Involve people with expertise in a discipline, language, or genre to help you find the appropriate communication to define standards of excellence. Articulate criteria as specifically as possible. This is important when communicating to artists who might wish to apply to participate in a program and to jurors or judges who will be making decisions.

Criteria are sometimes more effectively expressed in terms of what is not desirable.

> The small college town of Amherst, Massachusetts, values its historic architecture and personages such as poets Emily Dickinson and Robert Frost. As community members discussed aesthetic standards for certain environmental changes which would be made to the downtown, an important distinction was drawn. While citizens were respectful of historic design standards, they also cautioned against the potential to overdo the historic references– running the danger of trivializing or even commodifying Amherst's history. By describing what was not acceptable, townspeople further clarified the originally stated design goal.

Culturally-relevant criteria. Employ culturally specific criteria to evaluate artistic quality of a particular culture. Visual artist and educator John Scott, in his June 1989 NALAA *Connections Quarterly* article, "Quality: Who Defines It and How," states that "the definition of quality used to evaluate a work is limited by deeply rooted cultural biases." He goes on to say that artists whose work is creatively or ethnically directed outside of the dominant culture are often, when judged by people not of that culture, described as "limited in scope, derivative, not innovative, or simply lacking quality." Scott continues:

> People who are a real part of the cultural community being evaluated should be a real part of the system doing the evaluating. If the community is made up of a culturally diverse population, so should the art agency that represents them, especially if it is using public monies.

Maintain the artistic integrity of whatever art or cultural form you present. Adapting certain types of traditional ethnic performance to Western stage presentation, for example, might render them inauthentic. Involve the performer and/or specialists from that culture to determine if reasonable adaptations can be made without compromising integrity.

Develop methods of evaluating quality that are fair, accountable, and rely on appropriate expertise. These might include auditions, review of slides, tapes, or other examples of an artist's work, recommendations, or jurying. Maintain standards once they are established.

Defining quality of experience

Sometimes the most outstanding performance of *La Traviata* will not be rewarding for a viewer who is unfamiliar with opera or who does not understand Italian. Preexisting perceptions of the arts or of your programs must be addressed. Elements of the total cultural experience that may contribute to enjoyment and enrichment include:

- how people are treated by the organization or box office staff;
- sign interpreters or translators to include a larger audience base;
- educational or informational components to enhance understanding of the art form;
- appropriate media criticism and other context–setting;
- informal opportunities to talk with the artist;
- the overall tone of the program.

Finding and selecting artists

Knowing where to find artists and how to work effectively with them is fundamental to the programming process. Many local arts agencies and presenters develop rosters of artists as a result of their own programs and services and/or by soliciting artists to be included on mailing lists, in artist directories, or slide registries. Through your own sleuthing of local artists, contacts with colleagues, and use

of cultural organizations, and directories that specialize in connecting organizations with artists, you can learn about artists who might serve your programming interests.

Who makes selections? Artistic choices might be made by staff, a board or volunteer programming committee, a jury of arts professionals, or peer panels. Whoever makes artistic decisions should have the appropriate expertise.

Who advises and who has final authority to make artistic decisions should be clear. Generally, if an organization has paid staff, the board helps to define overall program philosophy and policies and may work with staff to determine accountable processes. Staff then creates specific programs and invites artists. Ambiguity about these roles, or a board that second guesses staff's decisions, can lead to problems.

Selection by jury. A jury or peer panel whose members are from outside the organization enables one or more individuals with relevant expertise to select artists by reviewing examples of work (usually slides, video, or audiotapes) and/or proposals submitted by the artists. While staff or volunteers might serve as jurors, outsiders can lend fresh perspective and may, if notable, attract artists to participate. The credibility of decisions may also be greater if peers, rather than staff, are evaluating quality.

Composing a selection jury or committee is an art in itself. Several variables should be considered for the right balance of expertise and perspective:

"The interaction of an arts experience with the attendee's identity, sense of self, personality, etc. is a vital element related to both perception and experience. Aligning what has personal meaning for and individual with the content of a performance/ exhibition or to relationships an individual has with fellow attendees can significantly increase attendance and deepen the experience."

–Chris Walker, et. al, *Reggae to Rachmaninoff: How and Why People Participate in Arts and Culture,* The Urban Institute, summer 2000.

- knowledge of the art form being reviewed;

- other types of expertise which might be important, such as the skills an educator would bring to an artist–in–residence selection committee;

- belief in the goals of your program;

- representation of diverse cultures;

- for culturally specific programs, significant representation by members of that culture;

- gender balance;

- appropriate geographic representation.

It is important to determine how important reviewers' familiarity with the locale or region might be to achieving decisions that support the goals of the program. For example, an urban neighborhood arts program whose goal is to stimulate dialogue on issues important to residents warrants strong local representation. In other cases, an outside panel is likely to be freer of bias and can take the burden off of local decision makers. It is also important to orient jurors to program goals and policies in order to make decisions that meet your interests.

How to make selections

There are three general ways to select artists for your programs: direct invitation, application or call for proposals, and first–come, first–served.

Direct invitation. When you know what you want and which artist can satisfy your interests, make a direct invitation to that artist.

Call for application or proposal process. Applications are often solicited when the organization may not have a preconceived idea about which artist to choose, wants to give many artists equal opportunity to participate in a project, wants to give awards to recognize artistic accomplishments, or simply wants to make choices from a wide range of possibilities. Artists are commonly solicited for festivals or public art projects, or to apply to granting organizations for funding. Applicants are evaluated consistently according to pre-established criteria. An advantage of an application process is that it can uncover talent unfamiliar to you. Therefore it is important to get

the word out in as many ways as possible.

Applications or calls for proposals should include:

- a description of the program or project (mission, format, location, anticipated audience, schedule);

- eligibility requirements;

- selection criteria;

- documentation required to represent the artist's work, such as slides, audio or videotapes, real samples;

- explanation of the review process;

- application deadlines (two to four months);

- dates by which artists will be notified of the decision.

Administering an application or a call for proposals involves considerable time, staff resources, and expense to promote the opportunity and conduct a jurying process.

First come, first served. This process obviously requires the least amount of effort but also provides the least opportunity for quality control or programmatic design. You might employ some basic parameters to define who can submit work. Most serious professional artists would not respond to such a call for participants, wanting some guarantee that other work presented is of at least equal quality. However, a first–come, first–served approach may be quite suitable for an exhibition of children's work or a kind of "anything goes" event in which community members present their talents "just for fun."

Working with artists

Artists are your most valuable partners, and treating them and their work with respect is important to the end result and to your organization's reputation. Once again, the specifics will vary from program to program, but some common guiding principles can help ensure good artist relations and a quality program.

Include artists as program advisers and in planning. Artists are resources with valuable experience and insights that can be particularly

important if you are venturing into a new or unfamiliar area of programming, or one where the goals of the program warrant that artists become familiar with the context for their work, such as a residency or public art project. Artists can:

- determine possible educational or interpretive activities;

- advise on technical aspects of presenting their work most effectively;

- help design the specific content or format of a program;

- help identify audience segments who might be attracted to their work and suggest promotion strategies;

- serve on selection committees and juries.

Pay artists reasonable professional fees.
When estimating artists' fees, consult with artists or agents before you prepare a budget. Research fees for a variety of artists to become aware of the going rate. It is common practice, particularly when dealing with agents, to negotiate fees. You may be able to reduce the cost of a performance by block booking with other presenters in your area. Some artists will reduce their fees if there are other clear advantages that you can offer, such as sale of artwork.

In general, set levels you feel you can afford and that meet standards of fairness. Artists are professionals who deserve professional rates of compensation. Cultural groups are cautioned against asking for donations of service or artwork from artists who are trying to make their living from their work.

If you ask artists to do something not anticipated in the scope of the original contract, for example, to hold a post performance discussion, respect that the artist is providing additional service and is due additional compensation. While the artist may choose to do it at no cost, this should never be assumed.

Consider the fairness of artist entry fees and of asking artists to donate work. Entry fees are commonly charged in competition programs, festivals, and other situations, often

to offset costs of processing entries, provide return shipping of entry materials, insure work, etc. There is debate about the fairness of charging artists to "take a chance" since there is usually no guarantee that an artist will be accepted, win a prize, or make money by participating. Artist Equity and many other artist organizations have lobbied against such fees. In general, organizations should make every effort to earn revenue from other sources first.

Likewise, artists are often asked to donate a performance or artwork for a fundraising concert or auction.

Arts organizations should examine the fairness to artists of such requests. If you choose to make a request, ask what is something "concrete and valuable" to offer the artist in exchange for his donation.

Develop a contract. Contracts protect the artist's and your rights by spelling out precisely the responsibilities and requirements of each party. Contracts need not be formidable documents but should clearly outline the terms of the relationship. The complexity of the contract depends upon the complexity of the artistic service and on certain institutional requirements. Major artistic productions may have voluminous contracts. Remember that all contracts are negotiable and, if it is your first time entering into such an agreement, it is wise to seek help from an experienced arts administrator and/or legal counsel. For help on legal issues, contact your nearest Volunteer Lawyers for the Arts. For more on contracts, see Joseph Golden's *On the Dotted Line* under Selected Resources at the end of the chapter.

Work the system to support artists' interests.
Arts organizations which are a part of local government or state institutions face the challenge of working within a bureaucratic system never designed to accommodate the unique process and situation of artists. It often becomes necessary to advocate that the system operate more flexibly to support artists' needs.

Some state arts agencies prohibited by state law against funding individual artists have empowered another organization to re-grant its funds to artists.

Paying artists after "services are rendered," typical in public agencies, can put an undue burden on artists, particularly with public art projects. Artists, unlike a commercial construction company, don't usually have the cash reserves to cover up–front costs for a major public art project. Some organizations have changed the system to provide advance and/or mid–point payments.

Prepare artists with what they need to know.
Artists will do their best job if they are informed in advance of the program's goals, theme, the kind and size of audience to expect, the nature and limitations of the space in which their work will be presented, and that you care about their well–being, their work, and positive results for them.

Other information such as the following should be summarized in a preprogram letter and/or in the contract for the artist's reference:

● travel, airport pick–up, hotel arrangements made by you for the artist;

● location and directions to get where the artist needs to go; where specifically to report;

● expected arrival time; setup time; assistance provided for setup;

● hospitality and staff or volunteer assistance; whether there will be people to greet, escort, help unload equipment, etc.

Treat artists as professionals and as people.
If artists feel well treated, they will want to work with you again. Consideration, respect, and enthusiasm should extend through staff and volunteers in their interactions with artists, even in the most difficult moments.

A touring team of seven artists participated in a program that brought them to various rural communities in the state over a two–week period. The artists worked long days in various community settings giving performances and workshops. At the end of the day, they were put up in people's homes to save the arts council money. Said one artist in his evaluation, "We were beat after a long day's work and then we felt we had to entertain our host families. I just needed to be alone and go to sleep to get ready for the next day. As hospitable as the families were, I would have preferred a cheap hotel room and some privacy."

Arts organizations find out soon enough who their loyal audience members are. The maintenance of core audiences is essential to the survival of cultural organizations. However, there are many reasons to work creatively to develop new audiences. Practically speaking, it builds the revenue base. But more importantly, engaging more and varied segments of the community ultimately means an agency is serving its constituency's need and desire for cultural experience. In addition, engaging existing audiences on new levels by introducing new work means you are working to help stretch audiences' sights.

We may talk about "audience" development, but art is experienced first and foremost on an individual level. A successful experience may be an emotional, visceral, or intellectual connection but it is always a personal connection.

Program choice and design
Programmatic strategies to engage new audiences begin with designing programs that respond to the various interests and needs of people in the community. It also entails developing new cultural resources and capacities. This requires a long–term commitment between the local arts agency and its many community segments to guide program choices. The relationship between the arts council and those community segments should include representatives of new audience

Local arts agencies are often trying to balance appropriateness to a place and its people with professional responsibilities to artists and art forms. NALAA's 1988 "Position Paper on Excellence and Quality Access" states: "As the local arts agency seeks to develop high standards of artistic excellence within the community, it should involve broad segments of the community thereby creating standards that are relevant and purposeful to the specific local cultures."

segments in the planning and aim for understanding of the cultural standards, contemporary values, and the political positions of those community segments.

Other strategies that have been used successfully by both artists, arts educators, and arts organizations, include the following.

Sequential programming. Sequential arts programming is based on the same premise as any sequential learning. You must meet learners at their current level of skill or familiarity with the subject and challenge them to the next level of discovery.

Heather Gary's approach to program design for Countywide Community Arts in Arlington, Virginia exemplifies this strategy. Gary found that as a visual artist working with pregnant and postpartum women in a residential treatment program, she had the opportunity to present a meaningful art project to assist them in their healing process. Cognizant of their journey of rehabilitation, Gary had the women construct 3-dimensional multimedia portable altars. The process of transforming cigar boxes into altars was the catalyst for exploring healthy options and telling personal stories in unique and expressive ways. It also helped the women to design a structure from their ancestry, make relevant life connections, and take pride in their work.

Finding connections between the arts and fields with which people are familiar and comfortable, like medicine, science, and computer technology, is fertile ground for making the arts more accessible.

At the Cancer Support and Education Center, expressive artist Anna Halprin offered an interactive movement and imagery process for people living with cancer. This approach helped participants to access their life story, and then use the story as the base for creating art.

Frequency. By making one art form a frequent presence in your programming, audiences have multiple opportunities to experiment and get used to unfamiliar forms.

Hancher Auditorium at the University of Iowa has built an enthusiastic audience for dance over twenty years. Through a combination of frequent dance performances in the auditorium, in-community residencies by visiting dance companies, and a long-term relationship established with the Joffrey Ballet, Hancher has seen some amazing demonstrations of its audience's commitment. For example, 2,000 children attended a matinee performance of the David Parsons Company despite the fact that it was held on a school holiday. The Hubbard Street Dance Company's performance was postponed after the great flood of 1993. Despite this delay and the fact that the company hadn't performed at Hancher for ten years, 1,900 seats were sold.

Extended or return engagements. Multiple encounters with artists and their work help people to gradually understand and appreciate them on deeper levels than a single encounter might allow. An artist might speak about the work in tandem with a performance, hold a workshop, or conduct a residency.

A residency involves some mix of performing or presentation of the artist's work, education or training about the work, and participatory art-making with the audience. Residencies last over a period of anywhere from a couple days to many months.

Artist residencies enable the artist to get to know his or her audience and to develop specific artmaking or spectating opportunities in response to the needs and interests of the audience. Likewise, the audience gets to know the artist as both a professional and as a human being.

The Ying Quartet, a sibling classical string quartet, spent a two-year residency in the small farming town of Jesup, Iowa. The residency was funded by the National Endowment for the Arts' Chamber Music Rural Residency Initiative and organized by the Cedar Arts Forum. The Ying family played their music everywhere, at church services and schools, as well as on stage. The editor of the local newspaper took violin lessons from one of the Quartet members. The appeal of

a family musical group, plus the opportunity for citizens to make long–term personal connections with the musicians, reinforced the community's connection to the performers and the music. For the Ying Quartet, a group on the rise and receiving national attention, the residency in Jesup was an ideal laboratory to expand its repertory in a concentrated noncompetitive place. The musicians had the chance to learn how to convey the meaning of their music in conversation.

Idris Ackamoor, director of Cultural Odyssey, has developed deep artistic roots and community support in San Francisco by showcasing professional local and national productions that demonstrate the vision of "Arts as Social Activism." Cultural Odyssey interacts and connects with its community by developing performances and services that have transforming effects. Special programs such as the Medea Project: Theater for Incarcerated Women and Emergency Report: Theater For Inner City Youth provides visionary models that reflect the experiences and social climate of contemporary African Americans.

Interpretation

Interpretation of artists' work can help audiences to gain greater appreciation of the work. Some artists conduct audience discussions before or after the presentation. Program books or exhibition catalogues may include artistic intent statements. Feature articles or radio or television interviews with the artist provide insight into the work and the personality behind it. Demonstrations give perspective on the process of art making.

Some artists resist interpreting their work for their audiences, preferring instead that the work speak for itself. The programmer's role is to balance the artist's wishes with the needs of the audience.

"Community-based art is as much about the process of involving people in the making of the work as the finished object itself."

–Jan Cohen-Cruz

Tips for developing interpretive materials

Use user-friendly language. Develop information which is engagingly written and free of art jargon or terms. Whenever feasible, demonstrate your commitment to building multicultural audiences by providing written and spoken interpretation in the native language of non–English speaking audience members.

Decide when is best to introduce information in the total art experience. In viewing exceptionally challenging work, audience members might benefit from information before a presentation. At other times, it might be the artist's or your preference to wait until after in order not to influence the viewer's own interpretation. Aim for appropriate multiple opportunities to provide information.

Be creative in choosing what information to put forward. Traditionally, art interpretation has been information driven, taking a didactic approach emphasizing dates and chronologies, movements and academic analysis. For the art novice, much of this information may be unnecessary or irrelevant.

Seek instead information which establishes relevant connections between the work and the audience. These might include:

- insights on the art–making process;
- human interest stories about the artist;
- a more personal and casual range of information;
- a portrait of the personality as well as the artistic intentions of the artist;
- a variety of viewpoints and voices rather than just one.

"Audiences have become the single most valuable asset that any arts organization possesses. Stewardship of this asset requires building and nurturing a feeling of community within the audience."

–Neil Archer Roan, arts presenter Hult Center for the Performing Arts Eugene, Oregon

PROGRAMMING CONSIDERATIONS

There are few surprises in presenting a traditional performance of *The Nutcracker* each holiday season. However, when the local arts agency decides to replace its annual production of Tchaikovsky's *Nutcracker* with Langston Hughes' *Black Nativity* in order to exercise its commitment to more culturally diverse programming, such a move may be met with a variety of reactions from the public.

Arts organizations need to venture thoughtfully and knowledgeably into new programming territory. In presenting work, they need to be sensitive to current social conditions. Community art involves creating experiences where constructive discussions can occur. These dialogue sessions may be the catalyst for building alliances and bridging ideological differences. Following are some pointers on managing controversy, presenting culturally specific work, and making programs accessible to everyone.

Managing controversy

The arts community has contended with controversy since time immemorial. While the "culture wars" have faded in their virulence, risk of controversy remains a consideration for any arts presenter. Many factors in contemporary times—including competition between the arts and other sectors for decreasing public dollars, as well as vigorously wielded political and religious agendas—have made the environment for the arts more volatile and scrutinizing. Sometimes predictable and sometimes not, arts organizations need to act thoughtfully to try to avert, as well as deal constructively with, controversy when it does arise.

Take preventative measures that might avert controversy. Design a process for making program choices that is accountable to artist and community interests. For example, you might involve community people on your selection committee, hold community focus groups to discuss certain new program directions, involve arts professionals who can substantiate the artistic merit of a project. Collaborations based on respect are less likely to break down into misunderstanding when

values and practices other than those in the culture at large may be expressed. Educate and inform the media in advance and try to secure advance media coverage that will prepare the community about the project.

Be prepared. Clarify a process to deal with controversy with your board, staff, and other key partners ahead of time, in the event that controversy arises. What kinds and degree of negative response warrant action?

Be clear and consistent on your organization's position. Articulate why a certain program was done. It is valuable to designate one person to speak to the press on behalf of the arts organization in order to avoid inconsistencies. Agree that it is important for everyone associated with the controversial program to defend it and the artist, even if the work is personally not your cup of tea.

Respect opinions different than your arts organization's position. Provide opportunity for those opinions to be expressed and dialogue to take place.

Muster supporters of the art program to counter dissenting opinions. This means identifying your supporters and asking them to write letters to the editor and to make calls to city council members and to other powers that be who should know there are supporters out there.

The positive voices must be as loud and numerous (if not greater) than those opposed.

Although easier said than done, arts leaders must try to transform controversy into constructive results. This means questioning the issue beyond face value to understand the true causes for confusion or disputes. It means understanding the particular community context for presenting art and making thoughtful program choices, coupled with information and education.

Presenting culturally specific work

In order to move information and ideas to a broader audience, community arts programs must entail the actual shaping of information, experiences, images and feelings for and with a known audience. Presenting art that is

representative of many diverse cultures requires consideration of who is making decisions about programming, issues of authenticity, audience education, and cross–cultural audience development. Here are some considerations in creating programs that include representation of one or more cultures.

Aim for authenticity. As a criterion, the definition of authenticity stirs debate. Folklorists define folk art as those cultural traditions that are learned only by the passing down of skills and aesthetics through families or within the membership of the culture. Folklorists and traditional artists are adamant about retaining the purity of their cultural traditions. How far can traditional artists be allowed to exercise personal creative freedom? Another sticky question is, can an artist of one culture meaningfully interpret an ethnic form that is not of his or her own culture?

Consider what can be appropriately transferred to conventional stage, exhibit, festival, or other presentation modes. Authenticity can be lost or compromised in presenting traditional work out of its social, religious, or environmental context. Arts programmers must ask such questions as, "Can an African ancestor ritual be performed in a concert hall without stripping it of its meaning and authenticity?" Evaluate these opportunities with the advice of the artists.

Programmers may need to provide additional orientation to the project and its goals, a description of the audience, space, language, format, etc., and perhaps provide a partner who can work with the artist. In response to language barriers, it may be necessary to enlist an interpreter for written materials and presentations.

Recognize cross-cultural differences. Not everyone who is used to clapping along with certain types of music would know that folk fiddlers find audience clapping disruptive to the rhythm and to the way the music should be heard. Presenting the traditions of a culture unfamiliar to your audience often warrants informing audience members about what to expect and about appropriate behavior. For more on presenting folk culture, see Folk Festivals: A Handbook on

Organization and Management (see Selected Resources).

Discourage the commodification of traditional culture. In the American Southwest, Native American cultures seek to protect the integrity, privacy, and spirituality of religious dances. To safeguard sacred ceremonies from succumbing to the status of tourist attractions, many are not performed publicly. Through your own program choices, as well as advocacy among other local presenters, local arts agencies should take care to avoid romanticizing, commercializing, or otherwise commodifying cultural traditions.

Understand the needs of contemporary artists of a culture as well as those who practice traditional art forms. Culturally specific art does not necessarily equate to traditional art. Many artists of color or ethnic artists create work which makes little or no reference to their cultural traditions, while others combine native traditions with contemporary sensibilities. Do not assume that artists who are of a particular culture are traditional or folk artists.

Accessibility

The Americans with Disabilities Act (ADA) was enacted in 1990 to protect the employment and accessibility rights of people with disabilities. See chapter 7 on access for a fuller discussion of this issue. ADA is intended to remove barriers to employment, transportation, telecommunications, and public accommodations and services. Under Title III of the ADA, which covers art venues, organizations are required to remove all physical and programmatic barriers. This means your office, the facilities you use to present programs and provide services, and your programs and services must be accessible; and the policies that guide recruiting staff, volunteers, artists, and others must be disability–neutral.

Involve people with disabilities when planning and promoting programs. Have them troubleshoot your facility and recommend how to make programs most accessible.

Develop a written plan. Prioritize what is easily achieved in the short term and what things are longer–term objectives (such as raising funds for and purchasing an assistive listening system for your theater space).

Extend an invitation to artists who have disabilities. VSA arts organizations located in every state are a good resource for identifying artists with disabilities.

Sensitize staff and volunteers on how to treat individuals with disabilities. Special training for staff and volunteers who work with the public on what to do and how to approach people with disabilities is an important investment.

> Chesterwood, the historic home and studio of sculptor Daniel Chester French, has a large percentage of senior citizens among its annual visitors. Staff has sought guidance from the local office of elder services to design sensitivity training sessions for the guides. "The aim is for the [tour] guide to be aware of every person's needs," explains assistant director Susan Frisch Lehrer. "We try to give every visitor a very personal experience."

Do not segregate people with disabilities in the program setting. The exception is deaf individuals who may need to sit in a certain area in order to have the best possible sight lines to sign interpreters and the presentation itself.

Consider ways to make programming accessible. These include:

- sign interpretation;
- assistive listening devices;
- large print and/or braille programs, exhibit labels, tour brochures;
- audio descriptions for the blind;
- touchable visual art exhibitions.

> At the Paper Mill Playhouse, the State Theater of New Jersey, audience members with visual impairments are offered several opportunities to enjoy the show more fully. Preperformance "sensory" seminars enable patrons to feel props, costumes, and sets in order to gain a clear idea of the characters and setting of the show. Audio descriptions are transmitted using earpieces in between dialogue to describe objectively the action onstage. These audio-described performances are offered three times for each mainstage production and benefit more than 500 individuals annually. Large-print programs are also available for the visually impaired.

Make concerted efforts to build the audience of disabled individuals. Promote programs through organizations and media specific to people with disabilities. In addition, general promotion, including advertising, brochures, and flyers, should readily display the international symbols for wheelchair access, sign interpretation, and accessibility for the hearing impaired.

The financial cost of improving access is not negligible. The ADA takes this into account. If removal of barriers to accessibility is not "readily achievable" (that is, "easily accomplishable and able to be carried out without undue difficulty or expense"), then the ADA specifies that an organization should make programs accessible "through alternative methods."

TECHNICAL AND LOGISTICAL SUPPORT

Whether you are producing a weeklong outdoor festival in a city park, running a regular grant review panel, or transforming a boilerplate solid waste management plant into a community environmental educational facility through public art, the vast volume of technical and logistical considerations never ceases to amaze and sometimes pose significant obstacles to programmers.

For most programs, there are common areas of concern. These include:

- site design;
- regulations, permits, and licenses;
- signage;
- equipment, supplies, and services;
- insurance;
- security and emergencies.

Site design

How you use your space and situate various elements within it affects the quality of the experience that artists, audience, and organizers have. Before making decisions, consult with appropriate individuals such as the manager of the facility or property, police and fire marshals, and others who have used the space to learn about any overriding rules and concerns regarding the site. Following are some questions to answer in designing your site.

How does site design relate to the effective presentation of the art? What characteristics of the location lend themselves to the program? Is there a programmatic focal point? Are there relationships between various program components which need to be reinforced through their proximity to each other? What experience do you want people to have?

What will be the logical flow of people through the space? How will this affect placement of program components? Directional signs? How can you encourage or discourage people in and out of certain areas?

> An annual outdoor sculpture exhibition on the grounds of an historic estate displays sculpture on the lawn adjacent to the main house and along the walking trails in a more remote wooded area. While the woods offer a beautiful setting for the work, many artists have complained that visitors often overlook those pieces. The organizers improved signs and stationed docents at certain locations to encourage more people to venture beyond the lawn display.

For outdoor programs, how might various weather conditions affect the site? Check historical data and consider alternatives for inclement weather.

Regulations, permits, and licenses

The rules governing necessary licenses and permits vary from place to place. To learn exactly what you need, check with the license commission, liquor commission, police and fire departments, building and electrical inspectors, and the board of health. Permits or licenses are required for:

Selling alcohol. This requires both a liquor or beer and wine license as well as liquor liability insurance.

Selling food. Unless you are in a facility which has a food operation and is already approved by the board of health, all food vendors are required to get food permits from the local board of health to ensure sanitary food preparation, proper refrigeration, etc.

Gambling, raffles. Raffles, casino nights, and other pay–for–a–chance kinds of activity require a permit. Find out who authorizes such permits in your town by calling the city clerk's office.

Electrical. For significant modifications made to accommodate your electrical needs, a special electrical permit may be required.

Building permits. Attachments to buildings, such as signs or banners, or construction or erection of permanent or temporary art works or other structures may require permits from your local building commission.

Street closure and/or assembly permits. In some communities, festivals, parades, and other special events which take place in public settings require permission to close off or assemble in public ways.

Fire code compliance. Local fire marshals will want to evaluate the safety of your site in terms of maximum capacity, ingress and egress (where people enter and exit the location), and to ensure that standard fire lanes are adhered to for access by fire trucks. In addition, certain materials and objects, such as tents, projection screens, or curtains that you might bring to a location, must meet fire retardancy standards. In the latter case, the supplier might have such guarantee in writing from the manufacturer, or the fire marshal may require a sample of the material for testing.

Signage

Signs should assist people in identifying the location of your program and directing people to and within it. Find out from local officials if permission is necessary to post temporary signs and at what point in time they may go up.

Equipment, supplies, and services

Nothing is too big or too small to be considered in this area of logistics: from masking tape to videotape, podiums to portable dance floors, rented tables to tents, track lighting to theatrical lighting, sound systems and assistive listening systems, backhoes and bucket trucks. Here is where your detail–oriented people must think thoroughly about what is needed.

The costs of renting or purchasing goods, equipment, or services can easily consume a budget, so it is best to determine early which of these might be donated or borrowed; what can be secured in–kind or purchased at a reduced price.

The vocalist and her voice should be the center of attention . . . not the amplifiers

This is also where artistic integrity could be easily compromised to save a few dollars. Determine artists' needs very specifically. Talk honestly about any shortcomings related to your site or technical support before you contract with an artist. Providing dancers with an inadequate floor on which to perform may not only affect the quality of the performance, it could cause injury.

Insurance

In an increasingly litigious society, certain types of insurance must be considered seriously by cultural programmers. Types of insurance include the following:

Personal liability. Your organization may already be insured for personal injury for the confines of your own facility. If you present programs in other locations, understand who is responsible for liability coverage. Some facilities will insure rental users. Others will require you to purchase liability insurance and/or agree to a hold harmless clause in a contract.

Liquor liability. At many arts festivals, concert intermissions, and fundraising events, alcohol is a reliable revenue generator. If you are selling alcohol, you must do so responsibly.

1. Evaluate the potential for abuse. Is the audience you expect likely to consume excessively and put themselves and others in jeopardy?

2. Ask the site if there are any rules or laws prohibiting the sale or serving of alcohol. Some places, for example, have open container laws which prohibit individuals from walking around with alcohol in open containers. This can affect festivals, outdoor concerts, etc.

3. Consult with police or your local liquor board regarding specific rules about who can serve and what kind of training they may need.

4. Determine the coverage and cost of securing liquor liability insurance. Weigh the enhancements alcohol offers to your program or your pocketbook against costs such as insurance. Many arts organizations are presenting alcohol–free programs to be socially responsible and because the legal and financial risks are too great.

Inclement weather insurance. This may be especially attractive to outdoor festivals or concerts which stand to lose significant admission and/or concession revenues if crowds are kept away by bad weather. The costs are generally quite high. Cost and coverage of rain insurance, for example, are determined by complicated definitions of what constitutes damaging rain or other attendance–prohibiting weather.

> One festival pays $5,000 to $7,000 for rain insurance for the most lucrative hours of the festival. Another festival bought rain insurance to cover a $20,000 loss. Unfortunately it didn't receive a dime because the rain on the day of the event did not fit the definition of "five continuous hours of rain" that was specified when the policy was written.

Rain insurance premiums are typically calculated by mixing ingredients from the following recipe:

● the probability of rain as determined by the insurance company's weather maps;

● the projected revenue lost by the insured if it does rain;

- the deductible as expressed by the amount of rain in inches that you can tolerate over a given time period.

Theft, damage, loss. Valuable artwork, cultural artifacts, artist's equipment, and any other valuable objects should be insured for theft, damage, or loss. Insurance companies require the exact value of each item and specific information about security measures to be taken.

Security

Security encompasses the protection of people, art, the facility, and any on–site cash. Volunteers may be suitable to perform certain security functions, for example, guarding artists' equipment or seeing that the fire lane on your festival grounds is kept free of vehicles. However, official police security may be a necessary precaution for guarding the ticket office where cash is handled, a major celebrity who might pose a crowd control problem, a beer concession, or valuable art work.

Volunteers should be instructed never to risk their own safety nor to risk liability by trying to apprehend a thief, stop a physical conflict, or otherwise intervene physically. They should be instructed to notify an official security person, who is trained to respond and has the authority to apprehend, or a staff person who can in turn notify police.

Emergencies

Some emergencies can be averted.

> A prolonged heat wave prompted festival organizers in Wilmington, Delaware, to purchase huge quantities of water to help visitors and participating artists to stave off heat prostration.

> An artist doing a residency in a juvenile detention center was thoroughly oriented to the behavioral problems of participants well in advance of his on–site work. Staff members were also in attendance during the entire residency workshop.

However, by nature, most emergencies are unpredictable. No matter what the program, you should be prepared for medical emergencies. Staff and volunteers should know:

- who among them has special training in CPR;
- if there are on–site medical professionals, where they are located, and how they can be contacted quickly;
- where telephones are for calling 911;
- where first aid for minor accidents can be received;
- what the plan is for halting or continuing with program activities in the event of a disruptive emergency.

Other kinds of emergencies include severe weather for outdoor events, lost children, fire, or crowd control problems. Finally, if you have a program book, emergency procedures should be prominently displayed to inform the public how and where to get help quickly.

AFTER THE PROGRAM

Program wrap–up should be done with the same care and attention given to program planning. The potential range of post–program activity includes the following.

Media coverage

Reviews and articles in local newspapers relay the impact of the program. Because they address the quality of the artistic presentation, public or audience response, and artists' and organizers' perceptions of whether goals and objectives were met, positive post–program press provides useful documentation for future grant proposals, promotion, and artist solicitation.

If the press has moved on to other stories, you may write your own release and send it along with a photo. This should be done immediately after the program, as the press will not want to run a story too long after the fact.

The program coordinator should set an example of effective and efficient wrap-up to encourage everyone else to do the same.

Follow-through and thanks

Promises made before the program should be dutifully kept in a timely way.

- Return borrowed items.
- Pay bills promptly.
- Write and send final reports to funding sources and partners.

Everyone affiliated with the program should receive as personalized a thanks as is possible. Involve various volunteers or staff who had contact with participants, volunteers, etc., to take primary responsibility for drafting letters. To let people know their role has been important, it is a good idea to have letters cosigned not only by those who had most direct contact but also by the executive director, president of the board, or the director of the program.

Public opinion about certain types of programs may result in controversy or continued misunderstanding of the goals of your arts organization in presenting or funding challenging programs. The repercussions can live on for a long time and crop up as obstacles around future program efforts.

It is important that education and information about what you do continue even after the artist has left town. Finding ongoing opportunities to engage the community in discussion about your program objectives, countering negative opinion through letters to the editor which discuss the issues from your and your supporters' perspective, and highlighting positive attention your programs may have received from other places and professionals can help create inroads toward constructive exchange.

Program documentation

Records are essential tools for documenting the process and results of your program and for planning future programs. In the aftermath of a program, people may be less than enthusiastic about writing reports and cleaning out files. Two tips help ensure that the job gets done.

Plan for documentation and evaluation from the beginning. Let organizers know what information and documents they should be collecting and organizing so they can do it along the way. Encourage people to write down suggestions as they think of them so as

not to have to reconstruct those great ideas months later.

Encourage an expeditious closure to the program. Hold wrap–up and evaluation meetings very soon after the program has concluded while ideas and impressions are fresh, and before people begin to move on to other things. Set a deadline by which final summary reports should be completed and all records organized.

The types of information which should be documented or compiled are listed on the Program Documentation Checklist in the appendix. Documents should be saved in the most appropriate forms:

- databases
- computer discs (be sure there are backups!)
- procedures manuals
- reports
- press clippings
- organized files
- program documentation checklist

Program evaluation

Program evaluation is often approached as an obligatory burden, a chore, or a fulfillment of a funder's requirement. Its bad reputation is unfortunate, because program evaluation is really an opportunity to learn—about the impact of what you do (called product, outcome, or summative evaluation) and the effectiveness of your approach, process, and implementation; that is, how you went about making the program happen (called process or formative evaluation). More specifically, evaluation has many uses. It helps you:

- determine the degree to which you achieved your goals;
- identify and analyze what did not work well;
- analyze unanticipated results;
- substantiate need for the program;
- define new programming directions or reaffirm current directions;

- understand the effectiveness of certain policies; identify the need for possible changes in policies;

- support public relations efforts;

- understand the relationship of costs to benefits;

- provide data to assess economic impact, numbers served, etc.;

- determine the effectiveness of the administration, funding, personnel structure, and other aspects of program development and management in relation to the program goals; andassure funders, community leaders, and others that you are concerned about doing the best possible job and are accountable in your actions.

Planning for evaluation. Evaluation is often shortchanged simply because it can seem like such a monumental task. This is because it is frequently dealt with only after the program is completed. Evaluation planning actually begins at the program planning stage by asking key questions:

- Who are the beneficiaries of the evaluation and what do you want to learn by evaluating?

- When and where will the evaluations take place?

- Will you conduct a product evaluation, a process evaluation, or both?

- As you identify the goals and objectives of the program, how will you measure and monitor them?

- Who will carry out the evaluation?

- What methods will you use; that is, how will the evaluation data be collected, analyzed, and reported?

By considering these questions early, you won't have to reconstruct information that could have been more easily gathered during and after the project. You will also ensure an honest evaluation of outcomes against predetermined objectives.

What is the purpose of evaluation? In addition to your own organization, there are others who will have a vested interest in the results of a program—funders, partners, the school board, a corporate sponsor, participating artists or presenters. Each may have a different interest in evaluating the program.

Charles Muhammad, executive director of SETT (Self Expression Teen Theater Institute) points out that school administrators are just as interested in the evaluation outcome of the impact of his innovative and creative substance abuse prevention program that will target youth, ages 9–16, in Lucas County. The program will also train youth ages 11–16 as peer educators. The youth participants will participate in the theater's after–school programs and/or teen center, which offers classes, teen forums, field trips, and community projects.

Evaluation methods

See chapter 8 on Program Evaluation for more information on how to evaluate a program.

Program evaluation is an opportunity to learn.

Using evaluation results

Information should be interpreted against the goals and objectives originally defined. There may also be unanticipated results, which must be analyzed.

Analysis of information should involve more than one person, particularly if it is being done by someone from your organization. If you are working with outside consultants, it is valuable to build into the process an opportunity for staff discussion of raw data and/or the consultant's initial interpretation of the results before final evaluation reporting is done. This should be helpful to the consultant since program organizers may offer insights into the data that consultants might not see and vice versa.

How the evaluation is finally structured and presented is directly related to how the information will be used. Your state department of economic development might want a brief outline of statistics that enumerate the economic impact of your summer festival. If your board is trying to determine necessary changes to a

long-standing regranting program to reflect changes in needs expressed by the field, then the final report should help staff and board zero in on new needs, what is currently not working about the program, and possible new directions which emerged out of the evaluation process.

Most groups practice some degree of informal ongoing process evaluation which helps identify refinements or changes in the way they go about their day–to–day business. A program evaluation questionnaire, which might be used by staff and volunteers is included in the Appendix. It is useful periodically to step back and assess even tried and true programs to determine if new program design could achieve program goals even better or if certain refinements are warranted.

IN CLOSING

Program development must enlist the skills, vision, and commitment from the organization and all of the stakeholders. A solid community arts program plan incorporates an initiative of creating work that is reflective of a particular place and the people who thrive in that area. It also enables artists and their community partners to engage in long–term, sustainable and deep relationships.

For many arts organizations, innovative collaborations have paved the way for impacting and powerful creative experiences. For many arts organization leaders, the program development process is as much about the communication that occurs among the various stakeholders, as it is about the envisioned outcome. The challenges of audience, community, and artistic support and development offer endless program possibilities and rewards. Keep the spirit of fun and discovery central to your program making. Your community is bound to catch that spirit, too.

SELECTED RESOURCES

The Association of Performing Arts Presenters. *An American Dialogue*. Washington, D.C.: 1989.

Barrell, M. Kay. *The Technical Production Handbook: A Guide for Performing Arts Presenting Organizations and Touring Companies*. Santa Fe: Western States Arts Federation, 1991.

Cleveland, William. *Art in Other Places: Artists at Work in America's Community and Social Institutions*. New York: Praeger, 1992.

Cruikshank, Jeff and Pam Korza. *Going Public: A field guide to developments in art in public places*. Amherst: Arts Extension Service in cooperation with the Visual Arts Program, National Endowment for the Arts, 1988.

Dreeszen, Craig. *Intersections: Community Arts and Education Collaborations*. Amherst: Arts Extension Service, 1992.

Golden, Joseph. *Olympus on Main Street: A Process for Planning a Community Arts Facility*. Syracuse: Syracuse University Press, 1980.

_____. *On the Dotted Line: The Anatomy of a Contract*. Syracuse: Cultural Resources Council of Syracuse and Onondaga County, 1980.

Katz, Jonathan, editor. *Presenting, Touring and the State Arts Agencies*. Washington, D.C.: National Assembly of State Arts Agencies, 1992.

Kiritz, Norton. *Program Planning and Proposal Writing*. Los Angeles: The Grantsmanship Center, 1980.

Korza, Pam and Dian Magie. *The Arts Festival Work Kit*. Amherst: Arts Extension Service, 1989.

Shagan, Rena. *The Road Show: A Handbook for Successful Booking and Touring in the Performing Arts*. New York: American Council on the Arts, 1985.

Stevens, Louise K. *Through a Mirror: A Guide to Evaluating Programs*. New Bedford, MA: ArtsMarket Consulting, Inc. in cooperation with the National Endowment for the Arts, 1993.

Wilson, Joe and Lee Udall. *Folk Festivals: A Handbook for Organization and Management*. Knoxville: University of Tennessee Press, 1982.

Wolf, Tom. *Presenting Performances: A Handbook for Sponsors*. Washington, D.C.: Association of Performing Arts Presenters, 1991.

Periodicals

Inside Arts. The Association of Performing Arts Presenters. Washington, D.C., monthly.

Online Resources

Jan Cohen-Cruz. *An Introduction to Community Art Activism, Online at the Community Arts Network*. Online at CAN Reading Room, www.communityarts.net/readingroom/readingroom.php.

APPENDIX: Program Development
WAYS TO IDENTIFY ARTISTS

Attend arts events regularly:

- Scout out artists at festivals, exhibitions, performances, and other events.

Tie into the network:

- Get recommendations from other programmers.

- Ask artists for recommendations.

- Talk to folklorists in your region or state (ask your state arts and/or humanities council or historical commission).

- Explore the talents of local college or university faculty or students through art departments, outreach programs, and speakers bureaus.

- Contact your local arts agency, statewide assembly of local arts agencies, or other regional arts service organizations.

- Join state, regional, and/or national service organizations that represent your interests, such as the Association of Performing Arts Presenters, Theater Communications Group, or the National Association of Artist Organizations.

- Attend booking conferences.

Identify sources of artist lists:

- artist agencies and representatives

- state arts councils (applicants and recipients of fellowships, project and artist residency grants, council mailing lists, slide registries)

- regional arts organizations including New England Foundation for the Arts, Southern Arts Federation, Arts Midwest, Mid-Atlantic Arts Foundation, Mid-America Arts Alliance, Western States Arts Federation, sources of performing arts touring rosters, touring exhibitions

- artist organizations (contact the National Association of Artist Organizations, Washington, D.C., for its directory)

- Association of Performing Arts Presenters

- Young Audiences

- Affiliate Artists

- local or regional libraries

Find traditional or community-based artists:

- churches

- local libraries

- music stores

- local newspaper, radio, or television

- ethnic clubs, associations

- senior citizen clubs, homes

- civic organizations

PROGRAM DOCUMENTATION CHECKLIST

❑ Program purpose, goals, objectives

❑ Projected budget

❑ Actual budget

❑ Bookkeeping records of financial transactions

❑ Timeline (original projected timeline and actual)

❑ Copies of all essential correspondence (letters, memos, form letters, information sheets)

❑ Contracts

❑ Literature about artists and other participants (brochures, resumes)

❑ Brochures or printed pieces (retain a certain number of copies for posterity, future funding proposals, etc.)

❑ List of key contacts: address, phone, why contacted, results of contact, recommendations for working with each person

❑ Mailing lists

❑ Site requirements list

❑ Sign requirements list

❑ Procedures unique to the program (how to obtain insurance for gallery exhibitions)

❑ Volunteer needs

❑ Copy of press releases, public service announcements sent to media

❑ News clippings from newspapers, newsletters, magazines; dubs of radio and TV public service announcements, talk shows, news coverage

❑ Video documentation

❑ Photo documentation

❑ Completed evaluations from artists, audience, and other participants

❑ Attendance figures

❑ Your final written evaluation report

❑ Anything else that helps to make the program understandable to future planners

PROGRAM PURPOSE, GOALS, OBJECTIVES

- ❏ Projected budget
- ❏ Actual budget
- ❏ Bookkeeping records of financial transactions
- ❏ Timeline (original projected timeline and actual)
- ❏ Copies of all essential correspondence (letters, memos, form letters, information sheets)
- ❏ Contracts
- ❏ Literature about artists and other participants (brochures, resumes)
- ❏ Brochures or printed pieces (retain a certain number of copies for posterity, future funding proposals, etc.)
- ❏ List of key contacts: address, phone, why contacted, results of contact, recommendations for working with each person
- ❏ Mailing lists
- ❏ Site requirements list
- ❏ Sign requirements list
- ❏ Procedures unique to the program (how to obtain insurance for gallery exhibitions)
- ❏ Volunteer needs
- ❏ Copy of press releases, public service announcements sent to media
- ❏ News clippings from newspapers, newsletters, magazines; dubs of radio and TV public service announcements, talk shows, news coverage
- ❏ Video documentation
- ❏ Photo documentation
- ❏ Completed evaluations from artists, audience, and other participants
- ❏ Attendance figures
- ❏ Your final written evaluation report
- ❏ Anything else that helps to make the program understandable to future planners

Process evaluation, if done while a program is underway, can suggest adjustments while there is still time to affect outcomes. Product evaluations are important wrap-up tools of accountability to constituents, funders, and your organization.

The descriptive methods supply an affective or "emotional" dimension to the evaluation picture.

Work with stakeholders on potential next steps

Program evaluation serves to continually improve what you do toward the most effective outcome.

PROGRAM PLANNING AND EVALUATION WORKSHEET

Program Title _____

Purpose of Program (why do it and for whom) _____

Program Description (what, when, where) _____

Program Goals and Objectives _____

Besides achieving the goals and objectives of the program and reaching intended audiences, are there other criteria for evaluating success? (e.g., identify new organization volunteers, have fun, develop skills)

Who does this program/service aim to benefit?

Artists? _____

Administrators? _____

Primary targeted audiences

- age
- racial, ethnic composition
- income
- geographic draw
- lifestyle
- values

Secondary targeted audiences

- age
- racial, ethnic composition:
- income:
- geographic draw
- lifestyle
- values

What is your projected attendance? _____

EVALUATION QUESTIONS

Program

1. Does this program help your organization achieve its mission?

2. To what degree is the program achieving its own program goals and objectives?

3. How would you evaluate the artistic quality of the program?

4. How would you describe the audience's response to the program? Its impact on the audience?

5. Was the program's design effective in meeting the needs of artists, participants, and audiences?

Technical/Logistics

6. How would you evaluate the site/location in terms of
 - suitability for program needs
 - size for accommodating audience and program
 - aesthetics
 - accessibility to the differently abled
 - visibility
 - image
 - cost

7. How would you evaluate the date in terms of
 - availability of desired space(s)
 - conflicts with other programs competing for the same audience
 - planning and implementation time
 - weather risks

8. Comment on logistical aspects of the program which deserve discussion. Comment on availability, affordability, skills needed, managability.
 - space design
 - amenities
 - security
 - insurance
 - equipment
 - utilities
 - permits/licenses/regulations
 - information/signage
 - special services required

Marketing

9. What are the program's attendance figures? How does this compare to projected attendance and income?

10. Who is the program reaching?

 - age
 - racial, ethnic composition
 - income
 - geographic draw
 - lifestyle
 - values

11. Is the program sufficiently reaching its primary targeted audience(s)? If not, why? Evaluate product, price, place, promotion, physical evidence, people and process.

12. Evaluate the effectiveness of the marketing tools you used.

 - publicity
 - promotion
 - public relations
 - advertising

Administration

13. Evaluate the personnel needs of this program.

 a) Does the program have board endorsement?

 b) Did you collaborate with any other organizations on this project? Did the collaboration achieve the anticipated objectives for all collaborators?

 c) How much time is invested in this project?

 Board: _____ days _____ weeks _____ months
 Staff: _____ days _____ weeks _____ months
 Volunteers: _____ days _____ weeks _____ months

 Is this more than planned? Less? About the same?
 How does this impact the organization?

14. Evaluate the finances of this program.

 a) Did the program meet its financial objectives?

- break even?
- lost money? How much did you lose? $_____
- make money? What is your profit? $_____

If it did not meet financial objectives, why not?

 b) What income sources are realistic to support the costs of this program?

- earned program revenues $_____
- business/corporate $_____
- foundation $_____
- public funding $_____
- individuals (fees, donations) $_____
- in-kind $_____

 c) What is the risk factor to implement this program?

15. Evaluate the timeline and planning of this program.

 a) Did/do you have enough time to plan and implement this program? Consider

- research
- development/fundraising
- staffing
- implementation

 b) How does the work for this program relate to other things going on in your organization and staff, board commitments to those things?

 c) What things happened which were unanticipated which you should plan for next year?

CHAPTER 6

ARTS EDUCATION:

DEFINING, DEVELOPING, AND IMPLEMENTING A SUCCESSFUL PROGRAM

by Marete Wester

with contributing editor David O'Fallon

"In a school year that brought unthinkable tragedy and sudden horror into the lives and communities of so many we serve, it was gratifying to be in a position to be part of the healing process. Many schools turned to us for help through arts enrichment and residencies that dealt directly with the celebration of the American spirit and issues of diversity and moral courage. The same was true in our community arts initiatives as through a variety of programs for caregivers as well as children and families, we had the opportunity to demonstrate the power of the arts to comfort, inspire and empower."

–Caroline Ward, executive director, Arts Council of the Morris Area

The work of state and local arts agencies and state and local education agencies can intersect productively in numbers of ways. There is no one plan, no one formula. The rationale underlying such joint efforts is the basic assumption that these endeavors are of mutual benefit. To the arts agency whose primary concern is for artists and arts organizations and institutions, education is the infrastructure that discovers the artistic talent, nurtures it, and develops the audiences that sustain it. To the education agencies whose primary concern is to transmit civilization's cultural attainments to new generations, the arts as they exist in society are a concrete manifestation of one of the higher orders of human achievement. No art can thrive without education; no education can be complete without the arts.[1]

For over a decade, there has been a growing awareness that the arts are one of the most powerful means we have to address issues that concern a very broad and diverse set of public interests. Increasingly, the arts have made the case for their role in the revitalization of neighborhoods and communities, and economic renewal. When tragedy struck September 11, we saw a powerful city and country turn to the arts to help heal the wounded human spirit through song, poetry, murals, and tribute–a vivid demonstration of why the arts stand as the universal bridge to developing mutual understanding and collaboration among diverse cultures and ethnicities. No country relies more heavily on the creative spirit of its citizens than America, consequently, the arts occupy a fundamental role in the lifeblood of democracy.

Thus, the discussion of the arts as public policy cannot help but include the role of the arts in the many facets of education–one of the earliest fundamental rights established by our founders. Research continues to

demonstrate the impact of the arts on the development of young children and support of learning at any age. More schools are opening up to the idea of the arts as a sequential component of a quality K-12 education. More adults are longing to participate in learning that allows them creative freedom and the ability to be expressive. And more arts organizations are taking seriously their role in educating the public in, through, and about the arts.

While these trends grew stronger at the end of the twentieth century, we are realizing a greater interest from all sectors of our society in the critical role the arts will play in the twenty first century. In his speech to the National Governors Association in July 2000, Alan Greenspan—the chairman of the Federal Reserve Board—called for the need to support an "economy of ideas," stating,

> Even the most significant advances in information and computer technology will produce little additional economic value without human creativity and intellect. The heyday when a high school or college education would serve a graduate for a lifetime is gone; basic credentials, by themselves, are not enough to ensure success in the workplace. Workers must be equipped not simply with technical know-how but also with the ability to create, analyze, and transform information and to interact effectively with others.

> Critical awareness and the abilities to hypothesize, to interpret, and to communicate are essential elements of successful innovation in a conceptual-based economy. As with many skills, such learning is most effective when it is begun at an early age. And most educators believe that exposure to a wide range of subjects—including literature, music, art and languages—plays a considerable role in fostering the development of these skills.[2]

The world of arts education is an exciting one, delving into both the mysteries of the mind and the human condition. It is a subject that has been embraced and attacked, debated and extolled, politicized and ostracized by those who don't get it, those who are working against it—and sometimes even those who advocate for it.

At times those working in arts education—whether in the schools, in the community, or in cultural institutions—have behaved as the army most likely to form a circle and aim their guns inward. The history of arts education includes examples of when we have taken aim—and fired.

For instance, one of the most enduring—and needlessly polarizing—debates is, "Who should teach the arts to children?

This question represents one of the most fundamental and important issues in planning a quality arts education program. If the program is to succeed, attention must be paid to the *excellence of the experience* as both a learning and an artistic event. This requires valuing the skills of both the trained arts specialist and the professional teaching artist for the strengths each brings to the learning process.

Too often, however, this debate becomes oversimplified and rancorous for all the wrong reasons, degrading into "camps" that believe that only certified arts specialists should teach the arts to children under any circumstances, or that only practicing professional artists can deliver artistic quality. Not all great artists have the necessary skills to become effective teachers. There is little truth in the tiresome old adage that those who can't do, teach. Such extreme positions serve only the self-interests of those perpetuating them. The end result of ideological or power-based quarrels is a weakening of the arts in the educational setting, and resources and attention deflected away from creating the best possible experience for students.

Recognizing this, the arts education field as a whole has recently directed more effort toward forging a common agenda, by working together to create a supportive environment both in the schools and in the community that enriches learning in the arts. Taken as a whole, this is an enormous task. Consequently, we have come to realize that only by working

together can we as educators, artists, administrators, and supporters continue to move forward. As we gradually make the cultural shift from "making the case" for arts education to "making it happen," and as the demands on our already scarce resources continue to grow, we must explore and invent better ways to collaborate and deliver quality arts education experiences.

This chapter attempts to provide navigational tools to the new explorer making the journey into arts education. Each explorer will confront different terrain and environmental conditions— while some will be scaling cliffs, others may be taking a walk in the sun. For those of you swimming upstream in a driving rainstorm, take heart—the wisdom and advice of those who have crossed the ocean before you with no wind and a broken paddle are there to give you guidance and cheer you on.

"In essence, Who shall teach the arts? is a question undergoing redefinition. Within the context of the [National] Standards, the answer will become 'someone who is able to bring children to the knowledge and ability to do what the standards call for.' Regardless of what new credentialing processes may require, 'qualified' increasingly will mean someone who:

- *can guide children through a balanced, sequential process of learning that achieves clearly stated outcomes;*

- *can instill in children an appreciation for the various art forms and the products of the arts disciplines in all their diversity;*

- *can bring children to clearly stated levels of performance in a given arts discipline; and*

- *can help children arrive at a knowledge of the cultural and historical context of the arts disciplines."*

–Dr. John J. Mahlmann, executive director of the Music Educators National Conference (MENC), 1996.

WHAT YOU WILL LEARN
This chapter is divided into three parts.

PART ONE: THE EVOLUTION OF ARTS EDUCATION IN THE SCHOOLS–FROM FRILL TO FOCUS

- The Arts in the Schools: A brief history of (almost) everything.

- Making the Arts Basic: Standards-based education reform.

- Community involvement in arts education.

PART TWO: FIRST THINGS FIRST–PREPARING TO TAKE THE PLUNGE

- Is arts education the right thing to do? Conducting a self-audit.

- What are the needs in your community?

- Spheres of Influence: Understanding the players and their needs.

- Finding the Right Fit: Programs to suit the community's needs.

PART THREE: PLANNING YOUR ARTS EDUCATION PROGRAM

- Engaging the schools in planning.

- Defining the program.

- Developing a student-centered curriculum.

- Working with artists and arts groups.

- Partnerships and collaborations.

- Assessing learning.

- Assessing student performance.

EPILOGUE

- Advocacy for arts education.

- Avoiding the tiger traps—some final tips for surviving the jungle.

APPENDIX

Selected Resources

Sample arts education programs, forms, and worksheets

Web sites

THE EVOLUTION OF ARTS EDUCATION IN THE SCHOOLS– FROM FRILL TO FOCUS

The Arts in the Schools: A brief history of (almost) everything

There is no such thing as a "brief" history of the evolving role of the arts in public education and their educational role in the community. This topic can (and does) fill volumes of books, articles, essays, as well as public policy documents and legislation–not to mention being at the heart of countless organizations and associations across the country founded for the purpose of either promoting or fulfilling quality education in and through the arts. Those entering the world of arts education for the first time may find themselves overwhelmed by its apparent complexity. However, understanding a bit of the history and events that have led us to the present can help alleviate some of those feelings and pave the way for future success.

This section provides a cursory overview of some of the trends and events that have shaped the status of arts education today. In doing so, it pays tribute to those writers, thinkers, and activists who have contributed so greatly to the field. The visionaries no longer with us, yet whose writings continue to illuminate–such as Ernest Boyer and Charles Fowler–are authors whose books, speeches, and articles are worth reading for their prescient understanding of the value of arts education to our future. Serious students of history as well as those for whom arts education is, or will become, a lifelong calling are encouraged to delve into the works of our living standard-bearers as well.

Prominent educators, psychologists, artists, and administrators such as Howard Gardner, Elliott Eisner, Dennie Palmer Wolf, and Jane Remer have provided the field with some of the best and most pivotal thinking in arts education, spanning two centuries of written as well as professional work.

The advent of new brain research in how we learn along with the entrance of arts education into the pop self-help culture through research-based books such as *The Mozart Effect* has stimulated a growing public acceptance–and indeed thirst–for understanding and cultivating creativity and new ways to learn. As we continue our transition from one century's values to the next, the environment for arts education is changing rapidly. However, to better understand where we are–and where we are going, we need to take some time to understand where we have been.

Early efforts in arts education. Since the late 1800s, the arts have been part of our public school consciousness. Most frequently music but also dance, theater, and visual arts have appeared in elementary and secondary curriculums in varying degrees, and have experienced cycles of interest punctuated with neglect throughout the history of public education. As these cycles evolved, partners outside of the school setting emerged alternately to support, stimulate, or restore the loss of school arts programs. This has resulted in the expansion of the field of arts education to include school as well as community-based efforts, and those working in it to comprise arts specialists, generalists, artists, and arts groups.

The federal role in arts education. Federal interest and support for arts education as most of us in the nonprofit world are familiar with can be traced back to the founding of the National Endowment for the Arts (NEA) in 1965. Earliest examples of NEA support for arts education include the Arts and Education Laboratory Theater Project (1966), in cooperation with the U.S. Office of Education and state and local school boards, as well as the Artists-in-Schools Program (1969), which provided funds to state arts agencies to place professional artists in residency programs in both schools and in community settings. From the '60s onward, the NEA focused more of its energies on supporting the work of artists and arts institutions in the education realm, and less on efforts that directed support toward improving the arts in K-12 education.

Early national movements in arts education. During the 1970s, the U.S. Department of Education and the John F. Kennedy Center for the Performing Arts joined forces in an attempt

to strengthen state policy for arts education. These efforts created a network of state alliances for arts education, supported through the Kennedy Center with funding from the U.S. Department of Education. Now established as the Kennedy Center Alliance for Arts Education Network, the early results of this program created some of the first efforts in state planning for arts education, and helped to lay the groundwork at the state level for the future education reform movements of the 1980s and 1990s.

During the early 1980s, the National Endowment for the Arts became more involved in rethinking its role in relation to public education. The need for this reassessment was defined in large part due to the NEA's 1982 survey of public participation in the arts, which revealed dramatic declines in public attendance at live performances, and pointed to a growing concern on the issue of the cultural literacy of America's population.

The move to strengthen arts education within the public schools was further catalyzed by the 1983 report *A Nation at Risk*, which focused unprecedented attention on the state of American education as a whole. Concerned by the results of both the public participation survey and *A Nation at Risk*, Congress charged the NEA with preparing a study on the state of arts education in the nation. The NEA released *Toward Civilization: A Report on Arts Education* in 1985, creating new momentum to include the arts as an integral part of school reform.

Developments from the private foundation field. Nearly simultaneous to the increasing attention on arts education in the public sector, private foundations in the 1970s and 1980s began focusing their attention on developing and promoting strategies and initiatives aimed at improving public school instruction in the arts. Most notable among these early efforts are those of the Getty Center for Education in the Arts and the John D. Rockefeller III fund.

Over the years, the Getty Center for Education in the Arts in California has dedicated a substantial component of its resources to improving the quality and status of visual arts education in the nation's public schools (K-12), through advocating an instructional strategy known as Discipline-Based Arts Education, or DBAE. The influential Getty program has worked throughout the country with teachers to develop curriculum and use instructional methods based on the domains or disciplines that the theory proposed were central to creating and understanding art: art production, art history, art criticism, and aesthetics. Revolutionary in its time and a significant influence in the development of public sector arts education policy, the Getty Center and the DBAE theory was one of the first to put forth the premise that the most effective art education programs are based on working partnerships among teachers, school administrators, artists, museums, universities, parents, and the community. The Getty web site, ArtsEdNet, continues to support teachers through instructional materials, examples, and connections to its museums and other cultural resources.

In the 1960s, financier and philanthropist John D. Rockefeller III commented, "We need to expose all of the children in our schools to all of the arts, and to do so in a way that enriches the general curriculum rather than reinforcing the segregation of the arts." Unlike many radical new ideas that eventually languished due to lack of support, Rockefeller decided to invest in his idea and founded the JDR 3rd Fund's Arts in Education Program in 1967. In addition to its programs, the Rockefeller Fund was one of the first major foundations to support the research of Howard Gardner and Dennie Palmer Wolf in Project Zero and the Arts PROPEL project; fund task force reports; and support the discussion of the arts as a central part of education reform. The Rockefeller Fund also helped bring the influential writings of Charles Fowler to the forefront of the national debate, and supported some of the earliest national gatherings that brought arts educators, artists, community arts leaders, state arts councils, and state alliances for arts education together with federal officials and national leaders to discuss the case for arts education and to develop plans for comprehensive arts programs.

Though the program abruptly ended with the death of its founder in 1979, it was responsible for some of the most groundbreaking developments in presenting the arts as a catalyst for improving the school climate and environment. The fund's quest to develop and support six demonstration sites across the country to be used as models for changing schools through the arts helped form the foundation of similar efforts conducted by state and local partnerships years later. In the 1990s, the federal impetus finally caught up through the reform model posed by the Goals 2000 Educate America Act, and the inclusion of the arts in the model. Profiled in *Changing Schools through the Arts–How to Build on the Power of an Idea* (Jane Remer, ACA Books, 1990), the Rockefeller Fund set a unique standard among private foundations by supporting the growth of systemic approaches to the arts in public education throughout the country, by promoting private/public sector partnerships, and by opening the door for more private foundations to join in these efforts.

Congressional expansion of the role of the arts and humanities in education. In the mid-1980s, Congress expanded the role of both the NEA and the National Endowment for the Humanities (NEH) in arts and humanities education in the schools. In 1986, acting on the new provisions and its own research, the NEA moved toward a greater focus on curriculum-based arts instruction through its arts education program, instituting the 1987 Arts in Schools Basic Education Grants (AISBEG) Program. Perhaps no other single effort of the time or to date created more opportunity for the development of infrastructure, partnerships, and support systems for improving arts education at the state level. AISBEG catalyzed the work of state arts agencies with state education agencies to help influence local schools in making the arts a priority within the school day. It also created new opportunities to support and strengthen the work of these state agencies with state alliances for arts education, to focus attention on advocacy and statewide programmatic efforts for improving curriculum and creating a greater partnership role for artists and arts organizations with the schools.

Giving way to the NEA's Arts Education Program, the AISBEG Program ended in 1991, after being widely credited with supporting statewide arts education programs and joint state agency planning processes in nearly 2/3 of the states in the country.[3] During the mid-1990s and in spite of a more than 50 percent reduction in its federal budget, the NEA continued to support arts education not only through its grant programs to state arts agencies and arts organizations, but increasingly through its leadership initiatives, which have resulted in a strengthened support network for arts education throughout the country.

The emergence of national leadership efforts. A noteworthy example of the NEA's investment in leadership initiatives and cultivation of interagency partnerships is the establishment of the Goals 2000 Arts Education Partnership (now known as the Arts Education Partnership). An ambitious venture administered by the Council of Chief State School Officers and the National Assembly of State Arts Agencies, and funded through the National Endowment for the Arts and the U.S. Department of Education, the Arts Education Partnership continues to bring national associations and organizations who care about arts education together with business leaders in a national forum to support the continued progress of the arts in the national education reform agenda.

The growth of local arts agencies in arts education. The increasing level of support and attention to the growth and development of arts education in national and state policy has its parallel on the local level. Though less well-documented, community efforts to bring learning in the arts to its children and citizens have their roots in the country's rich folk arts traditions passed down from generation to generation, the community guild schools for the arts movement (a growing trend even today), and the emergence of children's theaters, as well as other arts and nonprofit organizations (such as National Young Audiences) who have decades of work to furthering arts education.

The emergence of the local arts agency (LAA) movement as a major force in arts policy

development has also impacted the arts education field in important ways. As the field has matured, the LAA's work in arts education has expanded, catalyzed with incentive funds from state arts agencies and the National Endowment for the Arts, but also as a result of community cultural planning efforts that pointed to a community desire for increased opportunities in arts education.

The recognition of the LAA's critical role in supporting state and federal initiatives to strengthen arts education and translating them to the local level has resulted in a burgeoning movement of community partnerships and advocacy efforts to influence local decision making. For no matter how strong the policy for arts education may be at the national or state level, the final decisions on what is taught in the school or local district and what is supported through funding, facilities, and staffing are made locally.

The 1995 survey of the field conducted by the National Assembly of Local Arts Agencies (NALAA) (now Americans for the Arts) reflected a growing number of LAAs participating in arts education activities in some way: 57 percent produced artists-in-the-schools programs; 42 percent conducted curriculum design in partnership with schools; and 71 percent were engaged in advocacy and lobbying efforts to strengthen the arts in the local school systems. In FY2000, a more detailed survey revealed that over 65 percent of LAAs produced arts education programs, with 58 percent partnering with other organizations to provide programs and services. On average, 45 percent are providing teacher training; 50 percent operate artist residency programs; and nearly 75 percent engage in advocacy for arts education. According to the survey, arts education is the fourth largest funding category for grant-making LAAs, averaging approximately 83 percent of the grants made, surpassed only by music (90%), visual arts (88%), and theater (84%).[5]

In 1995, NALAA launched the Institute for Community Development and the Arts, to promote greater government investment in the arts by educating state and local arts agencies,

government officials, and funders about using the arts as community change-agents for solutions to economic, social, and educational problems. Among its most important contributions to the field of arts education is the chronicling of innovative local approaches to arts education and the "nontraditional" funding sources that support them—in large urban settings, suburban communities as well as remote rural locations. In the resources that have been developed, one finds the LAA field engaged in unique arts education programs sensitive to and in response to local needs. The offerings reflect a growing diversity and maturing of the field, from job-training programs in the arts for young people, to family arts programs, to experiences in underrepresented art forms (such as dance and theater) in the schools or even in juvenile justice settings. As more diverse funding streams become open to the idea of the arts as a solution to societal problems, a growing number of communities are exploring new and ever-more sophisticated approaches to addressing local challenges through the arts.

"Young Artists at Work (YAAW) creates summer jobs for economically disadvantaged students. Workers create public art for the city, fulfill commissions and participate in community workshops under the guidance of professional artists and educators. Developed by the Arts Commission of Greater Toledo, with support from the Toledo Private Industry Council, Ohio Arts Council, National Endowment for the Arts, and local businesses, YAAW employed 40 economically disadvantaged youth, ages 16-18, through the Job Training Partnership Act's Summer Youth Employment Program. Besides the hands-on work, the program provided them with four established artists as mentors, four full-time community college teachers and all the supplies needed for various creative media. Working 30 hours a week for six weeks, the goal was for the young people to create public art for the greater Toledo area."

—"Learning by Working: Young Artists at Work," Arts Commission of Greater Toledo, p. 12, in Working Relationships: The Arts, Education and Community Development, by Nancy Welch and Paul Fischer, National Assembly of Local Arts Agencies and NALAA's Institute for Community Development and the Arts, Washington, DC, 1995.

Making the Arts Basic: Standards-based education reform

The move to create national standards in arts education. Perhaps no other single policy initiative in arts education has united the arts community more than the development of the National Standards for Arts Education in 1994. Borne out of the push by the National Governor's Conference in 1989 to establish National Education Goals and, subsequently, world-class education standards for all students in all "critical" subject areas, the development of the National Standards for Arts Education were–and continue to be–pivotal for several reasons:

- Impact on policy: The inclusion of the arts in the national standards movement has embedded the arts in national education policy, which in turn impacts state education policy and, subsequently, local education policy.

- Stimulus for systemic change: At the federal level alone, the inclusion of the arts as a core subject area in the National Education Goals and in the development of the national standards has triggered other major policy shifts, especially with regard to funding. Since 1994, the Elementary and Secondary Education Act (ESEA)–the most comprehensive piece of federal education legislation–has continued to broaden its funding opportunities to provide support for arts education in new ways. This has included support for the development of state and local arts standards, assessments, research, and professional development programs for teachers, and in opening competitive state and local grant initiatives to encourage the inclusion of arts education. This, in turn, has provided incentives for states to develop state standards and assessments in arts education, and to include the arts in the state's plan for standards-based education reform.

- Catalyst for collective action: In the thirty plus years of the modern arts-education "movement," progress has always been impeded to a certain degree by the competing voices and sectors who hold differing views of arts education. The National Standards for the Arts were developed through a broad-based process that brought together arts specialists and arts leaders in the disciplines of dance, music, theater and visual arts. Through the work of these committees, focus groups, and public commentary, the National Standards for Arts Education are the closest we have come to achieving consensus on what we believe a quality education in the arts is, can, and should be.

- Common Ground: By articulating a clear set of principles of what children should know and be able to do in all artistic disciplines, the National Standards for Arts Education have provided a valuable resource both to educators and to the arts community. The concept of "standards" is a principle that is readily accepted by educators, business leaders, parents, and politicians. Arts specialists, who are often banished to the fringe of the curriculum, are able to approach administrators and school boards armed with the language and demonstration of "academic rigor" in the arts. Artists and cultural groups use the arts standards to illustrate the connections between their work and the curricular goals of the school. Thus, the standards have become the banner under which we can collectively move forward, and the means by which the previously ephemeral has become concrete.

Even more enduring than the national standards, was the coming together in the early '90s of the various public, private, nonprofit, and education sectors around a national advocacy effort for arts education. While the governors succeeded in establishing National Education Goals and launching a major national effort in improving education in 1989, they also galvanized the arts education community by initially leaving the arts out of the national goals altogether. Thus, the fact that we have national standards for the arts at all is testimony to the power of collective action in support of a common goal. The fact that a new administration and Congress actually took steps to strengthen the arts in 2001 with the

"No Child Left Behind" legislation, is evidence that even the most diverse groups, with at times conflicting agendas and priorities, can succeed in moving forward when enough voices are making themselves heard.

The power of research to make the case. The efforts in the 1990s to make the case for arts education in the nation's reform movement also drew attention to the fact that the arts were one of the least researched areas of the curriculums placing advocates for the arts at a distinct disadvantage when confronted with school administrators or politicians asking for proof that it works.

The National Endowment for the Arts was an early leader in efforts to stimulate longitudinal research that attempted to provide evidence of the impact of the arts in the curriculum, releasing in 1995 *Schools, Communities, and the Arts: A Research Compendium* (Welch and Greene, Morrison Institute for Public Policy, Arizona State University and NEA, June 1995).

Though independent studies on the impact of arts education on a variety of topics from student learning to drop-out prevention had been taking place, this was one of the first efforts to gather this information together in a single document for policy makers, community advocates, and schools. Shortly thereafter, the President's Committee on the Arts and Humanities and the National Assembly of State Arts Agencies, with support from the GE Fund, released *Eloquent Evidence: Arts at the Core of Learning*, which summarized the key research findings into a compelling document that would not only make the case for arts education locally but for help to fuel the dramatic shifts in federal support for arts education that were to come.

"The value of arts education is now firmly grounded in theory and research. Although the hard-nosed, scientific language used in studies is often lacking in literary eloquence, the evidence accumulated is eloquent testimony to the remarkable relationship between learning, knowing, and the arts."

Eloquent Evidence: Arts at the Core of Learning, **President's Committee on the Arts and Humanities and the National Assembly of State Arts Agencies, 1995.**

Champions of change. In an effort to spur interest in improving the amount and quality of research available in arts education, the Arts Education Partnership's Research Task Force called for the federal government to support periodic compendia of the latest arts education research of importance to researchers, practitioners, and policy makers in its report, *Priorities for Arts Education Research.*

In 1999, the major research compendium *Champions of Change: The Impact of the Arts on Learning* was released, and reported on seven major research studies that sought to explore why and how young people were changed through their arts experiences. By examining a variety of arts education programs and using diverse methodologies, seven teams of researchers developed key findings of importance to the field of arts education. *Champions of Change* researchers were able to demonstrate higher levels of overall achievement among students taking part in the arts, a leveling of the playing field for disadvantaged students, as well as evidence of a positive impact on behavior in both school and personal lives. Collectively, the research provided compelling evidence to strengthen the need to include the arts in the educational life of children—for both their intrinsic and their educative value. As the executive summary reports, "Another broad theme emerges from the individual *Champions of Change* research findings: the arts no longer need to be characterized solely by either their ability to promote learning in specific arts disciplines or by their ability to promote learning in other disciplines. These studies suggest a more dynamic, less either-or model for the arts and overall learning that has more of the appearance of a rotary with entrances and exits than of a linear one-way street."

Critical links. Also in 1999, the National Endowment for the Arts and the U.S. Department of Education set the stage for the continued progress in arts education research, by providing grant support to the Arts Education Partnership to commission and manage the development of a second compendium, *Critical Links: Learning in the Arts and Student Academic and Social Development.*

Released in 2002, *Critical Links* promises to be an important step in the evolution of centering the arts in the education reform debate. The new compendium explores the arts as forms of cognition—ways of acquiring and expressing knowledge—that help every child reach the levels of achievement needed for academic and social success. Sixty-two studies of learning in dance, drama, music, visual arts, and multi-arts are profiled, and were selected for inclusion by Dr. James S. Catterall of the Imagination Group at UCLA; Dr. Lois Hetland and Dr. Ellen Winner, both of Harvard's Project Zero; and the Psychology Department of Boston College. Each of the studies is summarized by Catterall, Hetland, Winner or another member of the compendium's team of researchers. In addition, two other researchers provide comment on the contribution of a study to the field of arts education research and practice, and on its implications, strengths, and weaknesses.

Through this design, *Critical Links* helps focus understanding on the cognitive capacities used and developed in learning and practicing the arts, and the relationship of these capacities to students' academic performance as well as to their social interactions and development. It also explores achievement motivations—the attitudes and dispositions toward learning involved in learning and practicing the arts—and the relationship of these motivations to academic performance and social development.

Community involvement in arts education

As discussed earlier, community involvement in arts education has undergone a growing transformation, from program delivery to increasing levels of influence in local decision making and policy. As the field matures and the strategies for promulgating arts education in the community become more sophisticated, LAAs and nonprofit cultural organizations are being challenged to do more with the opportunities that have opened up as a result.

In the 1988 publication *Arts and Education*

Handbook: A Guide to Productive Collaborations, contributing writers Robert L. Lynch, Anne F. Jennings, and Jonathan Katz outlined the kinds of programs and services local arts agencies and nonprofit arts groups have typically sponsored or provided to schools and the community. By no means exhaustive, the list does define the broader arenas through which a local arts agency or nonprofit can engage in supporting arts education:

- *Providing resources for education*—includes curriculum development, artists-in-the-schools programs, artist residencies in nontraditional settings, arts classes or workshops outside of schools, and helping to organize advocacy efforts on behalf of mandated K-12 arts curriculum in schools.

- *Information and technical assistance*—includes curriculum consulting, developing in-service workshops for teachers and other teacher training models, and connecting the schools to cultural resources in the community.

- *Sponsoring events*—includes festivals for children and adults, performances, tours, exhibitions, workshops, and projects.

- *Artist listings*—includes directories of local artists, their contact information, and their artistic disciplines.

- *Rosters of artists who do residencies*—include artists who are part of official state, regional, and national residency programs that take place in the schools or in the community.

- *Preassembled exhibits*—feature a collection of a single artist's work, a regional show, or a thematic collection with information materials and presentations. Some LAAs belong to larger regional networks that connect with public, university and private collections and educational programs.

- *Touring services*—help link schools with regional artist touring agencies or artist representatives, keep costs down by "block booking" a touring artist over a several day period in a number of schools or communities, or even create their own touring educational programs.

- *Facilities, equipment and space*–provide access to facilities that support schools without proper equipment or studio, rehearsal, or performing space, or who may wish to expand students' experience beyond the school setting.

- *Trips*–help schools and the community organize study groups and trips with an arts or cultural theme in the community, region, or even international settings.

- *Assistance with advocacy*–training parents, teachers, and the arts community to be effective advocates, and helping to lobby for changes in local school curriculum or policy toward the arts.

- *Fundraising*–Though most if not all nonprofits have had to struggle for financial survival, many take their experience in fundraising to help support schools and educational programs. Private or publicly funded arts-in-education programs support additional activities in the schools. LAAs may also co-sponsor activities with other organizations, help identify an underwriter for a school program, or make key contacts with the private sector.

Since this list was compiled in 1998, two important areas in which LAAs are playing major roles in arts education include:

- *Partnership building*–more and more local organizations are finding that their programs are more successful and have greater impact in the community, when partnered with other cultural, civic, social, or governmental agencies that share similar goals. This is occurring within the public school arena, as well as throughout various community settings.

- *Community cultural planning which includes arts education*–the expanding role of the LAA in the field of education is spurred to a great extent by the engagement of LAAs in community cultural planning and in community development in general. Increasingly, the results of community cultural planning have revealed the community's desire for increased opportunities for young people–and adults–to

engage in the arts, both in school through curricular offerings, and in community settings. The sophistication of these plans has led to creative strategies, and a more prominent role for the LAA in the field of education.

"The development of partnerships and collaborations has brought new opportunities and challenges to arts agencies, schools, and community organizations. Through planning, innovation, and local action, the arts have become a valuable partner in community development and a driver of far-reaching education programs."

(*Working Relationships: The Arts, Education and Community Development*, Nancy Welch and Paul Fisher, National Assembly of Local Arts Agencies and NALAA's Institute for Community Development and the Arts, 1995)

FIRST THINGS FIRST–PREPARING TO TAKE THE PLUNGE

Is arts education the right thing to do?

"To do well in the arts-in-education business, you must ground your organization's efforts in a clear understanding of education and of what you hope to accomplish. You must be able to articulate an education mission, strategy and program to avoid criticism that your education program is just a marketing scheme to put bottoms in seats. To compete for funds to support education programs, you must excel in education, not just the arts."

–David O'Fallon, Former Executive Director of the Minnesota Center for Arts Education, in a contributing article for *Beyond Enrichment– Building Effective Arts Partnerships with Schools and Your Community*, by Jane Remer, ACA Books, 1996

The decision to embark on a program in arts education should not be entered into lightly. In order to be effective, the program must be integral to the mission of the organization, affirmed by stakeholders, and well within the organization's capacity to sustain it. It is true that with the national public's greater interest in education, there is unprecedented opportunity for the arts to assume a greater role in our schools and our community. While more funders are increasing their support for arts education, they are in turn demanding a greater accountability for programs both to advance the national education agenda

(through standards-based reform) and to demonstrate greater long-term impact rather than token exposure in one-shot programs. The costs—both human and financial—for any organization contemplating the development of an arts education program are substantial, and only sustainable if the capacity for which the program is undertaken is built on a sound philosophy and not merely as a potential fund–raising strategy or marketing ploy.

Conducting a "self-audit" for arts education: achieving clarity of purpose and direction. With the myriad of opportunities available to address arts education needs from pre-K through senior citizen, it is essential for the local arts agency or arts organization to first determine what its values towards education in the arts are based on or, rather, its mission in the community. Without a clear sense of personal direction, it is easy to become overwhelmed by the multitude of directions to pursue in the world of education or fall victim to the various pitfalls that litter the path.

The number one "pitfall"—following the money trail. Too often, the lure of potential funding is the primary catalyst for a nonprofit organization to decide work in arts education. Over the past several years, federal and state arts agencies, foundations, and corporations have increased funding opportunities, established prerequisites through guideline requirements, and provided other incentives to encourage more arts groups to adopt a philosophy and strategy for education. While most of these incentives emerged from a recognition of the importance of arts education for the long-term health of children and the stability of the cultural community, it is also true that many of these funders sought refuge in arts education, from the fall-out from the "culture wars" of the late '80s and early '90s that provoked restrictions in federal funding to the arts, court battles over "obscenity" versus "art," and a stepping away from funding the arts "for arts sake" by many private entities.

While the role of arts education as the "safe port in the storm" for funders has more or less subsided, instead evolving into an endorsement of arts education as an important national

policy goal, there nevertheless remains a dynamic tension between trying to divide the scarce available dollars between support for artistic development and support for arts education. The arts in general are among the most under-resourced of public obligations, whether we are examining them as part of the nonprofit sector or as part of the educational system.

Impact of limited resources and competing pressures. The difference in how the lack of appropriate resources for arts education plays out between the two areas is interesting. Historically, schools, when faced with limited resources and competing pressures, often eliminate arts programs as a means to cut costs (and balance the budget). Conversely, the arts organization, when faced with limited resources and competing pressures (and in some cases, prompted by well-meaning funding sources), tend to view arts education as a means to acquire badly needed new funding (and balance the budget). To *save* a dollar, the schools eliminate a fundamental means by which they can educate the whole child, thus losing sight of the learner. To *gain* a dollar, the arts organization may feel pressured to embark on a program that is only tangential to its mission, and thus in the process may lose sight of the artistic vision.

If decisions on arts education are made for purely economic reasons, then ultimately it is the learner who loses. Arts education cannot exist as an after-thought—not in the schools, and not in the structure of the nonprofit agency. If it is to fulfill its true potential, arts education must be viewed as a core value within the system—no matter where that system operates. It must be planned for purposefully, ingrained within the vision and policies of the organization—and all those involved should be committed to it for the long run.

What are the needs in your community?

Assessing the state of arts education in the community. As more local arts agencies have become involved in conducting community cultural planning, arts education has emerged as a central issue in the majority of these efforts. Many communities are engaging in additional

Self-Audit Worksheet: Deciding Whether Arts Education is for You
REFLECTION EXERCISES FOR BOARDS AND PROGRAM PLANNERS

Adapted from "The Arts Organization and Public Education–A Guide to Conducting a Self-Audit," by David O'Fallon, in *Beyond Enrichment–Building Effective Arts Partnerships with Schools and Your Community* Jane Remer. (1996)

FOCUS QUESTION #1: What is our philosophy of education?	• What does "education" mean to our organization? • What does "education" mean to the people we serve? • Where are the arts in this philosophy? What is the role of the arts in the national education reform agenda? How is it playing out in our state? In our community?

PURPOSE OF EXERCISE: *Developing a solid philosophy of education helps the organization to establish a strong sense of purpose and create an identity for its role in education. It also lends credibility to the organization seeking to develop sustained relationships with educational institutions– especially in the public school system. The self-knowledge gained from engaging in this dialogue helps the organization avoid being drawn into practices and activities that fall outside the agency's mission and strain the organization's capacity to deliver on its promises. The program will suffer if the educational goals become fragmented or are not clear from the start.*

FOCUS QUESTION #2: How are our core values related to education and our education programs?	• Is creating knowledge or awareness *about* an art form or artist our primary educational goal? (building knowledge, awareness) • Is the education of the person in or through the arts the primary goal? (building personal skills, creative abilities) • Is it a combination of the two? • What role can we do best? • What role is in the best interest of the organization?

PURPOSE OF EXERCISE: *The core values as defined by the organizational mission should form the foundation of the education program. For example, an organization founded with the mission of advancing American jazz as an art form would be ill-advised to decide to develop their education program around the American musical theater because that's what the middle school wants. While this seems self-explanatory, many organizations can get pulled in the wrong direction by trying to adapt themselves to fit a school's or funder's agenda that extends beyond the scope of their mission. By acting on its strengths, the organization will be better able to define the goals, purpose and resources available to launch the program effectively, as well as develop the will and capacity to sustain it.*

Is education part of our core mission or is it a separate component?	• Are artistic decisions (i.e., season selections, artists) made with discussions of education in mind? • Is education discussed at staff and board meetings? • Does education appear in organizational philosophy and mission, administration, operations, and budgets? • Are board and staff members able to explain what the organization's role in education is? • What is the education director's status within the staff? Is he or she given the same status as the administrative director, marketing director, development officer, and artistic director? • Do those in charge value education? Is there support for continuing staff development in education? • Why are we considering a program in education? To fulfill our mission? To respond to an external pressure? To solve a community problem, or fulfill an identified need? To attract new funding?

PURPOSE OF EXERCISE: *In order to build a successful arts education program, a local arts agency or arts organization must fully understand how education factors into its overall mission. If the vision is clearly understood, shared, and supported by all decision makers in the organization, the education program is more likely to be sustained and flourish. It is also more likely to be valued by the LAA's or organization's potential partners in the community–the schools as well as funding sources. With both the emergence of arts education as a primary concern of nonprofit and funding communities, and the evolution of understanding of what constitutes effective, quality programs, it is relatively easy to detect a program that is established as a "band-aid," or a jump on to the bandwagon. Ensuring that the education program is centered in the mission of the organization helps avoid the dilution of resources–both human and financial–and the potential risk of accomplishing neither the primary artistic purpose nor an effective education program.*

planning efforts that focus specifically on the needs of education in the arts–for children as well as adults.

Chapter 2 on planning explains many of the techniques and strategies that are applicable to a community cultural planning process. These strategies will well serve the local arts agency interested in focusing on meeting community needs through arts education.

Working with schools in the community planning effort. Schools present a special challenge for the community arts organization seeking to integrate issues of education into their community planning efforts. In many communities, the local education system occupies the largest local government expenditure–and a major political force. With the trends occurring on the national and state levels toward greater support for arts education, the local education system is also an important potential ally in a community's overall cultural plan.

Based on the seminal research reports released in 2000–*Gaining the Arts Advantage: Lessons from School Districts That Value Arts Education* and *Champions of Change: The Impact of the Arts on Learning*–and its own guidelines for the *Creative Ticket to Student Success* and other awards programs (see resource section in the Appendix, the Kennedy Center, through the Kennedy Center Alliance for Arts Education Network, developed a useful planning tool to guide efforts in community assessment of arts education. *A Community Audit for Arts Education: Better Schools, Better Skills, Better Communities* is designed to assist local education, community, and cultural leaders in assessing the status of arts education in their schools and school districts, as well as to encourage community partnerships to strengthen and expand arts education for all students. Among the most practical applications of *A Community Audit for Arts Education* is its usefulness as a vehicle for encouraging conversation and community planning in support of arts education, and in helping members of the school and general community understand the ingredients needed to support and sustain an effective arts education program.

Conducting a community assessment. A *Community Audit for Arts Education* helps leaders assess the status of the district arts programs through the lens of thirteen critical factors identified through research as essential to implement and sustain comprehensive arts education programs. These thirteen factors are derived from *Gaining the Arts Advantage* and were identified through a process that examined ninety-one school districts throughout the country with recognized, quality arts education programs, and are organized under three larger categories addressing "Informed Leadership," "Educational Content," and "Community Connections."

Summary of the six factors addressing the importance of "Informed Leadership."

1. The School Board provides a supportive policy framework and environment for the arts.

2. The Superintendent regularly articulates a vision for arts education and works to ensure its successful implementation and stability.

3. A Cadre of Principals collectively supports the policy of arts education for all students and are often instrumental in the policy's successful district-wide implementation.

4. The District Arts Coordinator facilitates program implementation throughout a school system and maintains an environment of support for arts education.

5. Parent/Public Relations efforts seize opportunities to make their programs known throughout the community in order to secure support and funding for them.

6. Continuity in Leadership is evident in the school and community leadership to implement comprehensive arts education.

Summary of the six factors addressing the importance of "Educational Content."

7. Planning results in a comprehensive vision and plan for arts education but recommends its incremental implementation.

8. An Elementary Foundation ensures that strong arts programs in the elementary school years form the foundation for strong system-wide programs.

9. Opportunities for High Levels of Achievement are made available by school leaders to provide specialized arts programs as part of their broad strategy for securing and sustaining community support for the district's overall educational goals.

10. The Teacher as Artist–Instructors are encouraged to continue to learn and grow in mastery of their art form as well as in their teaching competence.

11. National, State, and Other Outside Forces are effectively employed to advance arts education.

12. Continuous Improvement efforts promote reflective practices at all levels of the schools to improve the quality of arts education.

One Factor Addressing the Importance of "Community Connections."

13. The Community–broadly defined as parents and families, artists, arts organizations, businesses, local civic and cultural leaders, and institutions–is actively engaged in the arts politics and instructional programs of the district.

A Community Audit for Arts Education features worksheets for evaluating programs according to these factors and criteria, and may be downloaded in its entirety from the "Special Initiatives" section of the Kennedy Center Alliance for Arts Education Network web site. This information is available free of charge, however the Kennedy Center requests that those using the audit credit the Kennedy Center. The Kennedy Center is also available to answer questions and provide assistance in using the audit (see resource section, in the Appendix.

As with any community cultural planning process, the audit invites planners to expand their circle of "critical friends" and to use the audit with teams of school and community

leaders. This not only helps gain the broadest and most complete perspective on the state of arts education in the community but strategically begins the process of building a group of supporters with the power and influence to lead an improvement effort. The following section discusses these "spheres of influence" within the educational spectrum, who are central to the larger community development effort, and represent key target constituents critical to the planning process.

"In almost every instance where this kind of audit is used, leaders learn more about 'what is being done right' than they knew before the process began. By using the audit as a tool to come to consensus about the status of arts education, leaders can then work together to identify priorities and "next steps" which are appropriate for their community."

A Community Audit for Arts Education: Better Skills, Better Schools, Better Communities, Kennedy Center Alliance for Arts Education Network, 2000

Spheres of Influence: Understanding the players and their needs

Successful arts education programs often operate in a complex system, but manage to balance the needs of the target audience with the constantly changing environment. An important aspect of becoming adept at navigating the system is to develop a basic, working knowledge of the significant "players"– meaning those who influence, support, manage–or are impacted by education. One might assume that these various individuals unite under the mutual goal of providing the highest quality education possible for children or the adult community, and in fact, that is often the case. However, the educational "ideals" that each group adopts can lead straight into some of the most challenging debates–and in some cases, all-out wars–which are more about politics than education. It is important, then, to attempt to achieve an understanding of the people who are involved and have an interest in education in the community, what their beliefs are, and what motivates them. This knowledge will help you better understand the environment in which you will be operating and identify your potential allies and helpers, as

well as the potential obstacles you may have to overcome in order to achieve your goal. The major participants who impact arts education on the local level include:

Pre-K through 12, public elementary and secondary education.

- Students

- Arts specialists

- Arts and/or curriculum supervisors

- Generalist teachers, who may or may not use the arts in the delivery of their subjects, or who are teaching some aspect of the arts in lieu of an arts specialist

- Principals

- Superintendents

- Parents (PTAs, PTOs, or other parent advisory groups)

- Community education foundations (A growing trend of nonprofit education foundations being established as a separate fundraising arm of the public school; a community-based board is established to set grant-making policy for activities and programs that send additional funds into the school. Since many of these local education foundations support arts programs, these are important allies.)

Higher Education.

- Deans of fine and performing arts departments (who train artists/performers)

- Deans of education departments (who train new teachers)

- University or college art galleries or performing arts centers

- Student arts groups, associations

Nonprofit arts groups.

- Arts education providers or service organizations (whose primary mission is to conduct arts-in-education programs, artist residencies, and/or teacher training)

- Performing or producing arts organizations, (who operate an educational program, or

for whom education is a goal within the larger mission)

- Museums or cultural centers with education programs or divisions

- Individual artists, independent or as part of an organization's artist roster

- Community schools of the arts (which operate training programs in the arts for students of all ages, outside the formal school setting)

Government and private funding agencies.

- Town, city or county councils or commissions (approve funds for both the school district and the local arts agency)

- State arts agency

- State department of education

- Businesses and corporations supportive of education and arts education

- Chambers of commerce

- Foundations supportive of education and arts education

Who is really calling the shots? Trying to decipher the process behind school decision making often requires the arts administrator to do some detective work. On the surface (or according to the organizational chart), the chain of command may seem obvious. However, the power structure active in the local school is very much an individualized phenomenon, based on how much school policy is being driven by state mandate, local initiative, or a mix of the two.

The school may be embroiled in bitter politics—for example, Did the school board come into power on a platform of improving learning or of reducing the local property taxes? Are the teachers employed there happy or engaged in bitter contract disputes? Is the teachers' union more powerful than the administration? How active are the parents? How are the arts specialists viewed at the school? Are they considered full members of the academic faculty, or do students take arts classes so that the "real"

teachers have adequate planning time? (Consider that in New Jersey, there have been examples where as part of the teacher union contract, arts specialists were required to cover classes so that classroom teachers could have planning time. Such an agreement all but kills any effort to develop a team-teaching approach in the arts, and limits the amount of thematic planning that can be accomplished between arts specialists and classroom teachers.)

Build a network of "critical friends." While knowing the environment and the disposition of the players beforehand can help fend off future problems, it is almost impossible for one person to know everyone and all the dynamics at play in schools. One way to compensate, however, is to use the planning process to develop a network of "critical friends." This network can and should include individuals who may never be directly involved in supporting, developing, and implementing your program. However, many key decision makers and leaders central to early planning efforts will be more than willing to serve as informal advisors, especially when you ask for their expertise in navigating through the public school system. Asking questions before making a proposal for a program can help you avoid stepping into a potential minefield– and making enemies before you get a chance to make friends. It will also help you determine whether this is an environment that is conducive to ensuring a successful program–and ultimately worth the investment of precious time, energy, and resources in the first place. Maintaining open, ongoing, and positive relationships with the people involved in your planning strengthens the foundation for successful implementation later on.

Finding the Right Fit: Programs to Suit the Community's Needs. Arts education programs taking place in the community tend to fall into two general categories: those that take place in the K–12 setting or are integrally connected to the school curriculum, and those that take place beyond the school setting. Each broad area has its particular benefits and challenges to the local arts agency or arts

organization embarking on the development of a new program.

The following charts discuss various types of arts education programs that take place in schools, along with those that are based in the community. These are general descriptions that take into account the growing sophistication of arts education providers in recognizing the value in developing programs that meet the needs of schools in delivering effective standards-based education. Of equal importance is the recognition that community-based programs, whether serving a therapeutic, social, or recreational need, should also embrace the highest standards of both artistic and educational quality.

The after-school movement

The late '90s saw an increase in national attention and the direction of federal resources toward after-school programs. Federal agencies, such as the U.S. Department of Education and the U.S. Department of Justice, supported this movement not only through funding but also by providing resources for groups interested in developing quality after-school programs.

With the advent of the federal Twenty-first Century Community Learning Centers Program in the late 1990s, hundreds of millions of dollars have been made available to schools in collaboration with nonprofit and public agencies, community-based and social service organizations, as well as businesses to support the development of quality after-school programs in rural or inner city neighborhoods. While the administration of these federal funds has devolved from federal grant programs to the state level in 2002, resources to develop strong education-based after-school programs continue to be part of the federal government's national education strategy.

Through the work of several national organizations, the arts have become a visible part of after-school efforts. In 2000, under the auspices of the Kennedy Center's Education Department, leaders from the Kennedy Center Alliance for Arts Education Network and the

TYPES OF SCHOOL PROGRAMS Pre-K–12

CATEGORY	DESCRIPTION
Assembly/ Exposure	An artist or performing group will be brought to the school to perform—usually for large numbers of students. May take the form of lecture/demonstrations, abridged shows of classic or new works, or fully staged events. Even though the performance may be a single event, groups prepare curriculum guides for teachers and may be involved in pre- or post-event workshops to assist in extending learning objectives. Event is developed and produced by the arts organization and may or may not include developmental input from school.
Field Trips	Students are transported from school to a location to view exhibits or performances, or to take part in workshops. Again, most organizations design curriculum guides and instructional events to enhance student learning and increase the relevance of the educational experience.
Artist Residency	Includes anywhere from one-day to several week extended residencies, which involve a professional teaching artist in a meaningful, hands-on interaction with students. Residencies can be targeted to a particular class or grade level, to the general school population, or to encourage the artistic growth of advanced art students. Can include in-depth work in a particular discipline (creating or refining skills, critique and/or aesthetic awareness), or in using an artistic discipline to connect the art form to the study of another academic area. Most residencies now involve the active participation of both teachers and artists in defining residency goals and developing curricular outcomes, and *at minimum* involve one orientation session with teachers prior to the start of the residency.
Teacher Training	Teaching artists or other specialists meet with school staff in workshops, meetings, or conferences aimed at improving their skills in delivering instruction in and through the arts.
Curriculum Development	A natural extension of the teacher training model, artists work alongside teachers to develop curricular strategies to extend the development of lesson plans, interdisciplinary instruction, and extended units of study in the arts, or in employing the arts throughout entire curricular areas.
Pre-school/ Early Childhood Education	Through federal incentives and initiatives such as Head Start, preschool programs are an increasing concern of public schools. Preparing students to be ready to learn by the time they enter the K-12 system—especially for children in economically disadvantaged, urban, and rural areas—has also led states to support pre-school programs in their communities. Partnerships with schools, social service agencies, Head Start programs, and private day-care centers provide additional resources to help arts-based learning become part of the preschool curriculum.
After-School: School-Based	After-school programs that are operated either by the school or in partnership with nonprofit community-based groups, government recreational divisions, or social service agencies. School-based after-school programs do not replace quality arts instruction during the school day but are designed to provide activities for students that promote and reflect learning goals that complement school policies and curriculum.
Special Needs Students	The arts play a unique role in helping children with special challenges learn new ways of coping with their world. Artists in partnership with educators and health-care providers can develop programs and strategies to reach children who may not respond in any other way.

TYPES OF COMMUNITY-BASED PROGRAMS Pre-K–Senior Citizen

CATEGORY	DESCRIPTION
Community and Cultural Centers	A local arts agency or arts organization may run daytime or evening arts classes for very young children through senior citizens, as part of the management of a government or nonprofit facility. A cultural facility may also sponsor pre-performance lectures, gallery talks, or tours rather than formal instruction. The establishment of community schools for the arts is a growing national movement that allows affordable access to exceptional instruction in the arts for children and adults. The community schools' primary mission is to provide quality arts instruction, and may or may not provide performance or exhibit opportunities.
Parks and Recreation	Many parks and recreation divisions provide concerts and sponsor festivals and ongoing programs for residents to take part in the arts. Some divisions sponsor arts classes for children and adults through summer recreation and training programs or community theater and music programs; others contribute by offering their community space to local groups and clubs.
Health Facilities and Social Service Organizations	Programs in hospitals or care facilities that support children and adults dealing with physical or emotional challenges are an increasing part of LAA's work in arts education. Artists in residency settings, art therapists, and arts partnerships respond to the arts' power to heal and greatly impact lives.
Juvenile Justice and Preventative Programs	More enlightened correctional facilities for youthful offenders and adults recognize the importance of rehabilitative programs. Many employ artists to conduct classes; others have formed partnerships with artists and arts groups to bring in a poet, writer, or theater artist to work with the prison population. These programs not only impact the development of marketable language skills but contribute to the emotional rehabilitation and social development of participants.
After-School: Community-Based	After-school programs that are independently operated by nonprofit, community-based, local/government recreational divisions or social service agencies, designed to provide activities for students that are not formally linked to achieving school curricular goals.

Common Elements of High Quality After-School Programs for School-age Children

- Goal setting and strong management
- Quality staff
- Low staff/participant ratios
- Attention to safety, health, and nutrition issues
- Appropriate environments with adequate space and materials
- Effective partnerships among parents and volunteers, schools, community-based organizations, juvenile justice agencies, law enforcement, youth-serving agencies, business leaders, community colleges, etc.
- Strong family involvement
- Coordinating learning with the regular school day
- Links between school-day teachers and after-school staff
- Evaluation of program progress and effectiveness
- Activity choices to provide diverse educational enrichment opportunities
- Plans for sustainability.

from *Safe and Smart: Making After-School Hours Work for Kids* (Washington, D.C.: US Department of Education, U.S. Department of Justice, 1998)

Kennedy Center's Partners in Education program were convened to create a protocol for the development of quality after-school arts education programs. Its purpose was to guide groups in understanding what constitutes excellence in after-school arts programs and how they can be designed to complement in-school programs. With potentially hundreds of millions of dollars to be awarded through competitive federal grants, the report—*The Arts beyond the School Day: Extending the Power*—is in fact timeless in its recommendations for

designing an effective after-school arts education program.

Essential elements of quality after-school arts programs. The Kennedy Center's After-School Protocol Task Force identified nine essential Elements, which, when taken together, forge the framework for ensuring the development of a quality arts-based after-school program. In this framework, successful, arts-based, student-centered after-school programs:

- are focused on student needs;
- offer unique opportunities for imaginative learning and creative expression;
- employ and support quality personnel;
- are structured to maximize student learning;
- engage families with their children;
- are actively supported by school leadership;
- invite collaborations with community partners;
- are committed to ongoing planning and evaluation;
- leverage a wide variety of resources.

"Including the arts in after-school programs will not automatically ensure quality programs for students. It is important to remember lessons learned in school reform during the past ten years. Ultimately, it is the quality of the content, experiences and human interaction that will result in significant gains for students and keep them engaged."

Kennedy Center After-School Protocol Task Force, *The Arts beyond the School Day: Extending the Power*, John F. Kennedy Center for the Performing Arts, Washington, D.C., 2000, p. 16

The pre-school movement

The National Goals for Education catalyzed an interest in improving the quality of early childhood education by establishing as the first goal that all students will start school ready to learn. Taking up this charge, several major national studies focused on identifying the state of early childhood education and making recommendations for improvement. *Preventing Reading Difficulties in Young Children* (National

Research Council, 1998) was one of the first reports to highlight the arts' ability to provide language-building activities through the use of stories, games, songs, and poems that emphasize rhyming or manipulation of sounds.

In 1998, the Arts Education Partnership (formerly the Goals 2000 Arts Education Partnership) established the Task Force on Children's Learning and the Arts: Birth to Age Eight, charging it with developing a framework and resources to help guide arts organizations in creating arts-based, developmentally appropriate early childhood programs, and in linking the arts to the literacy of young children.

The task force report, *Young Children and the Arts: Making Creative Connections–A Report of the Task Force on Children's Learning and the Arts Birth to Age Eight (Arts Education Partnership, Washington, D.C., 1998)* defined three guiding principles to be used and thoroughly integrated in the development of arts-based programs and resources for young children:

FOCUS: The Child
PRINCIPLE: Children should be encouraged to learn in, through, and about the arts by actively engaging in the processes of creating, participating in/performing, and responding to quality arts experiences, adapted to their developmental levels and reflecting their own culture.

FOCUS: The Arts Experience
PRINCIPLE: Arts activities and experiences, while maintaining the integrity of the artistic disciplines, should be meaningful to children, follow a scope and sequence, and connect to early childhood curriculum and appropriate practices. They also may contribute to literacy development.

FOCUS: Learning Environment and Adult Interactions
PRINCIPLE: The development of early childhood arts programs (including resources and materials) should be shared among arts education specialists, practicing artists, early childhood educators, parents, and caregivers, and the process should connect with community resources.

"Through arts education, very young children can experience nontraditional modes of learning that develop intrapersonal, interpersonal, spatial, kinesthetic, and logic abilities, skills and knowledge, as well as traditional modes of learning that develop mathematical and linguistic abilities, skills and knowledge. Because children learn in multiple ways, activities should reflect these multiple ways of knowing and doing."

from *Young Children and the Arts: Making Creative Connections– A Report of the Task Force on Children's Learning and the Arts Birth to Age Eight*, Arts Education Partnership, Washington, DC, 1998

PLANNING YOUR ARTS EDUCATION PROGRAM

As discussed in part two, there are many types of arts education programs that target different audiences, and may take place in a variety of settings. The chapters on planning and program Development both contain information that will help structure program development in arts education in community settings and in fact contain many fine examples of how this can be accomplished. This section focuses on planning for arts education programs that either take place in schools or are designed to help support school learning and curricular goals.

Engaging the schools in planning
Starting off on the right foot. Many problems that can arise in building a relationship with schools can be avoided with careful pre-planning. The first step in developing an effective arts education program involves asking critical questions:

- *What are the school's educational priorities?* Ask for the school's mission statement–Is the school primarily focused on "basic" skills or higher-order thinking skills? Understanding where the school is operating from allows you to assess whether the program goals are aligned with school goals.

- *What is the teaching philosophy?* Are they engaged in standards-based reform or other state and local directives? Knowing ahead of time if the school is engaged in aligning its curriculum with state or national

standards makes it easier for arts groups to develop programs and activities that are aligned with the standards, and intersect with curricular goals.

- *Does the school have previous experience with bringing in artists and arts groups? If so, what worked? What didn't?* Knowing where potential "baggage" may be stored helps an arts group avoid stepping into a problem situation not of its own making. It pays to help repair the bridge before you step onto it.

- *What facilities will be available for a residency?* What performance or classroom space will be made available to you? If students will be transported to a cultural site, who will coordinate and pay for it? Most types of arts programs require adequate facilities in order to maintain the quality of the experience. If the school does not have appropriate space, transporting the students expands the available learning opportunities. If the school does have facilities but does not adequately account for scheduling and usage—the impact of the experience will be diminished.

- *What are the major events on the school calendar?* Understanding when it's a good time for a residency (e.g., the week when the state conducts its assessment and testing program is definitely a bad time for the school) helps ensure that the program will begin on a positive note. Teachers will have time to participate, and fewer distractions will be present.

- *Who will be the primary liaison from the school?* It is essential to have a spokesperson/coordinator from within the school environment to help outsiders navigate through the culture and bureaucracy. It is also important to have a willing coordinator who has the respect of others in the school and can get things done.

Although these questions are presented in the context of a school environment, they are equally appropriate with some adaptations for other settings, such as social service, hospital, or community agencies.

History is not destiny, and timing is everything. Having a history of good working relationships with a school or district is no guarantee that your program can or will be sustained in the face of change. Change can be as profound as a complete overhaul of the policies and procedures governing the education system—or as simple as the loss of one or two key personnel who usually make things happen. Schools have notoriously experienced the dramatic loss of wholescale arts programs or a long-term artist residency when the arts teacher retires or the outside funding stream dries up.

Conversely, a history of bad experiences can be erased with either a change of leadership or a change in internal school policies. Programs that have in the past been blocked by a disinterested superintendent or principal can receive new consideration with a new administration. A dance residency in one year can spark interest in the creation of a dance program the following year and the hiring of a part-time dance teacher.

Expand your network of "eyes" and "ears." It is always important to keep monitoring what is happening on the school level, but doing so requires time, energy, and access to information. Federal and state education policies and initiatives impact local schools—often in profound ways. Many groups develop relationships with a school district through a dynamic superintendent or district-wide curriculum coordinator only to find the following year that the district has switched to site-based management—meaning that decision making at all curricular and program levels becomes the province of the principal and school-based site-management teams. Where the primary "partner" was once a single individual in the central district office, contacts may now have to be made with each local leadership team.

Newer educational trends involve the inclusion of parents not only in the traditional supportive roles of raising money for isolated activities but in committees that make decisions on curriculum, budget and program offerings. Understanding how the school operates—where the spheres of influence really lie and what outside forces are at play—is the key to opening the door to a productive working relationship. Equally important, however, is investing the time to develop multiple

working relationships with a number of individuals in order to ensure the continuity of the program should the major players move on or transition into different roles.

Defining the program

Toward whom is the program targeted? As a result of the planning processes that have been previously discussed, the arts organization or LAA should have a fairly good understanding of whom the program will be targeted toward. The more the constituent population for the program can be narrowed down, the greater the ability to develop targeted and focused activities that can successfully meet program objectives.

How many students or participants will be served? This is one of the more difficult questions for an arts group to answer early on, because there may be views of what is possible versus what is preferable. Certainly, a start is to identify the programmatic strengths of the group or organization. A teaching artist who is brilliant with small groups of children may feel overwhelmed if the school insists on an assembly program for the whole fifth grade. Conversely, a fully staged production of Macbeth provided to a single seventh-grade English class of twenty students would be an opportunity lost if not presented to the whole middle school.

The numbers of students in exposure versus immersion programs. In general, exposure-oriented programs tend to be more successful in reaching greater numbers of students—if that is part of the decided goal. Programs designed for a more in-depth investigation into the art form are more successful for smaller numbers of students. However, these generalities are not absolute, and can be influenced by a number of factors, including the length of a residency, the number of teaching artists and educators involved, the opportunities given for teacher training, or the extent of the collaborative planning that occurs throughout a school or grade level. Many groups balance the need to serve a large number of constituents with the ability to conduct an in-depth arts experience by utilizing both performance and hands-on

EXAMPLE of targeted program:

In 2001, the Arts Council of the Morris Area (ACMA) in Madison, New Jersey, conducted Head Start in Dover, which served needy children and their families (535 total attendance). Teaching artist and child psychologist Claudia Benowitz led eight evening workshops for a diverse and largely Latino school population. Families made rainsticks, wreaths, hand-painted placemats, stamp-printed aprons, picture frames, sandpaper self-portraits, memory boxes, and Unity Quilt squares. Eighteen to 38 participants attended each workshop, and the final activity, the Unity Quilt, drew 135. In addition to the workshops, three family evenings of performances by musicians and/or dancers were presented. Pans, Rhythm and Song featured African musician Ahmodylla Best. Expecting 20 to 30 guests, the turnout at show time reached 75.

events or by providing thematic learning opportunities in multiple settings (e.g., classroom, art class, assembly, after-school).

What do we hope to accomplish by doing this? This question lies at the core of a "backwards design" process—that is, beginning with the end in mind. Although the notion seems abstract, it helps focus clarity on the mission and goals of the program, set standards that define program content, and lead to the development of criteria that can be used to determine whether or not goals have been achieved. Going through the exercise of constantly seeking answers to the question, What would it look like if the program meets our highest goals and aspirations? leads into the next programmatic planning phase, which asks the questions, How do we know what worked?, and How do we get the information that lets us know we've been successful?

How will we measure success? It helps at the onset to take a different view of assessment—especially in relation to the design of the program. The most common—and least helpful—view of assessment is that it is something that takes place at the end of an event. What happens in that case is usually a collection of miscellaneous facts and statements about what took place—for example, 100 students participated, 50 percent

of the students showed an increased understanding... However, if we view assessment as an ongoing element of the learning process, we can use it as a means to inform and improve the work or performance and still come away with the facts and statements needed to satisfy funders and bureaucratic reporting requirements.

Setting goals based on identified need. To illustrate this point, let's look at the example of the Head Start program in Dover. Let's assume the planners at the Arts Council of the Morris Area (ACMA) conducted a community needs assessment. One of the findings of the study was that Latinos—especially those residing in poorer communities in the county—were underrepresented at community arts events—even those offered free of charge. Based on this information, the ACMA might set a goal of "helping families in underserved communities see the arts as relevant to their lives."

Suppose, then, that during the planning of the program, ACMA asked the question, What would it look like if our family arts workshops met our highest goals and aspirations? Early in the discussion, answers might include things like "all the workshop slots would be filled" or "participants would say they enjoyed the experience and plan to return."

But in a deeper probing of what the ACMA would hope the workshop program would achieve in the best of all possible worlds, the answer might be, "Parents would use the arts techniques from the workshops in projects with their kids at home; and the experience in working with artists in the community would lead them to take their children to more community events."

Getting the right kind of information. Here is where planning backwards comes full circle: If ACMA decides that this is really what they want families to do, then the next critical question becomes, How are we going to get the information that lets us know they have done this? As a result of engaging in this kind of thinking process, the measurements that are put in place will be much more in line with the mission and goals of the program, and useful to the program improvement process.

For instance, ACMA program planners might come up with an incentive for participants to be part of a focus group or follow-up study; they might identify a group of parents to serve as a test group—these parents might be involved in the design of the pre- and post-workshop activities. There might be a wall in the arts room designated for workshop participants to post family projects they did together during the week or note places they visited—and time set aside in the workshop for them to talk about it, and share their thoughts, feelings and ideas.

Although this planning process requires thought and time, it usually results in the organization *measuring what matters*—rather than measuring things that are easy to measure—but little to do with examining program impact in meaningful ways.

The Evaluation Chapter in this book provides a greater, in-depth, and "how-to" discussion of some of the strategies and techniques that are useful in planning for and implementing a successful assessment program. The reference section in this chapter also provides several web sites and resources specific to evaluating arts education.

How will we document and report success? If schools and arts groups as a whole are guilty of anything, it is spending too little time and energy in finding ways to document and tell "our stories." Yet this, more than any other aspect of the program effort, helps us bridge the communication gap, and allows others the chance to understand the event and experience it in new and hopefully more positive ways. This is not only critical to continuing or expanding a program but essential to effective advocacy for arts education. Incorporating ongoing documentation of program activities into the program plan also helps the assessment process by displaying skills learned or acquired, products developed, and processes engaged in.

Decisions regarding the documenting of certain activities and events should be linked to program objectives and, in this way, become a vital part of the learning and assessment process. It is much easier to plan for and conduct an ongoing collection of images and products throughout the duration of the program rather than to scramble to find information at the end.

The uses of documentation are many: to display skills learned by participants; to demonstrate program effectiveness to potential supporters; to train new program leaders; and to report back to granting agencies. When looking at various means of documenting a project, it is helpful to keep these questions in mind:

- **Why is this needed?** Possible answers: As a learning tool—students are videotaped learning a dance. The tape is shown to students immediately after so that they can have feedback. Every lesson is videotaped—students use clips of themselves in a "video portfolio," which demonstrates their progress over time. As a training tool—a master artist is videotaped conducting a teacher training workshop. The videotape is used as part of a workshop to train new teaching artists. As a reporting tool—a video montage is prepared of all the school artist residencies. Parents take the video to a school board meeting to demonstrate the value of these programs.

- **Who is the audience for it?** Possible answers: funding sources, program planners, learners

Developing a student-centered curriculum

Pedagogy is not a punishable offense. The concept behind a student-centered curriculum is based on the assumption that the learner is the primary focus within the learning experience and environment. Thus, the learning event is about the person experiencing the event or artwork—rather than about the event or artwork itself. To distinguish between the two, consider the difference between the following two learning tasks.

The first task's educational goal is to help students know more about the choreography of Martha Graham. To support this goal, students may read a biography of Graham, view videotapes or films, or see a dance performance of Graham's work in a school assembly or at a performing arts center. At the end of the lesson, students should be able to answer basic questions about Martha Graham's life, her work, and various aspects of dance as it pertains to her artistic vision.

The second task's education goal is to help students make a personal statement by creating a dance in the style of Martha Graham. Obviously, many of the activities outlined above would still be appropriate—but as a means to an end rather than an end in itself. Students would learn about Graham's work, how her concepts developed, what techniques she used, and what influenced her work. They would then apply this knowledge in the act of creating a personal artistic statement through dance. In this example, the student is actively engaged in understanding a process, and demonstrates this understanding by the creation of a work of art. The understanding of dance extends beyond a single artist, performance, or event to an understanding of the process itself.

Understanding developmentally appropriate curriculum. The stages of artistic development in children are based in part on children's overall cognitive and motor abilities, but also in relation to how much and what kinds of arts experiences have been available to them in their home, school, or community.

Very young children are naturally drawn to the arts, largely as a result of play. Children who have not yet fully developed verbal skills will still move their bodies to sounds, respond to singing, and try to imitate their parents' facial expressions. With appropriate adult facilitation, these basic forms of play can evolve into the acquisition of skills and frames of mind that we recognize as rudiments of the artistic process:

- *Children learn to observe, organize, and interpret information they receive from their environment.* As they grow, these observations gain greater depth, more intricate patterns emerge, and interpretations grow more insightful.

- *Children learn to make decisions—even at the most basic level.* By engaging in the arts, children are required to take action. In the product or event, they are able to see concretely the results of their decisions and actions.

- *Children learn that they can communicate in many ways*–through words, sounds, movements, and pictures, with adults and with each other.

Early childhood thus presents both a unique opportunity and a unique challenge, and a part of that challenge is to engage and support all those who care for and educate young children in making the arts an integrated and vital part of their earliest experiences. A major component of that challenge is to ensure that artists understand and adapt to the developmental needs of young children and/or work in partnership with early childhood professionals who do. (Adaptedfrom the Arts Education Partnership, Washington, D.C., 1998).

Arts education program planners should have a general understanding of the various stages of learning development, and how these stages play out in the learning environment. An art experience given to an eight year old with absolutely no background or frame of reference for the arts form presented could prove overwhelming–the child, is likely to become frustrated and shut off from the learning experience. The same experience given to an eight year old with an extensive background and grounding in the fundamentals of the art form might view it as remedial–this child is likely to be bored and disinterested. In both cases, the child will have a negative view of the arts experience. Whatever program is eventually developed, it should build in adaptability, so that if the population encountered is either less prepared for the program than anticipated or more advanced in knowledge and abilities, the program can easily be adjusted. The more careful the preplanning, however, the less likely the artist or arts group is to step into a situation for which he or she is not prepared.

There are many web sites and other resources to assist program planners in an examination of age-appropriate activities. The John F. Kennedy Center's ArtsEdge and the Getty Center for Arts Education's ArtsEdNet, have curricular models and ideas based on actual field practice that serve as excellent resources.

The Need for Developmentally Appropriate Practice in the Arts and Early Education

Compelling evidence exists that early arts experience has an impact on all aspects of a child's learning and development and that, in many ways, "earlier is better." Yet earlier must not mean rushed, nor the extrapolation of adult approaches down to a younger age; a one year old is different from a three year old, who is different from a five- year old, and so are the strategies for engaging them appropriately, sensitively, and meaningfully in the arts. In fact, arts education that is not developmentally appropriate may be worse than no arts at all. For example, children should not be placed in high pressure programs that focus on product and performance, but rather placed in developmentally appropriate activities that engage them in process, experience, and exploration and build on what they naturally do. The differing needs of pre school children (age 0–5) from those of schoolage children (ages 6–8) is an example of one such important distinction.

For instance, consider this sequential model presented by the Getty Center on "Ideas for Art Making."

The National Standards for Arts Education (along with most state standards in the arts) define not only content–that is, what students should know and be able to do in the arts disciplines–but also "achievement standards"– those specific competencies within each of the disciplines according to grade clusters that together demonstrate whether the student has mastered or is proficient in the content. Thus standards, whether state or national, are written in a form that would be considered developmentally appropriate for students in the respective grade clusters and represent a good starting point for program planners to learn more about where to start in developing a program for children.

The very best strategy an artist or arts group can follow when developing a curriculum for a particular age group is to involve experts. Education professionals–including arts specialists, classroom educators, educators who work with special populations, early childhood educators, child psychologists, curriculum developers and administrators– undergo extensive training to understand how and when children develop different cognitive and motor skills. They can provide useful feedback as to whether a program is targeted to the appropriate age group.

What are the "essential questions" the program will answer? A useful planning and organizational tool for arts education program developers is the "essential question" conceptual framework. Essential questions help establish content themes, organize outcomes and activities for artists, teachers, organizers, and students; and stimulate inquiry-based learning. At the same time, they allow for thinking about how structure and sequence will play out in different time periods (e.g., a 45-minute workshop versus a two-week long

residency) and establish a basis from which to develop appropriate assessment measures.

Artists and arts groups can work with teachers as well as students to develop essential questions for the educational program. Essential questions can be derived from a number of different sources: from an exploration of a particular standard area (e.g., how dances are made), a specific part of the arts group's artistic season (e.g., the upcoming retrospective festival of the work of August Wilson), a critical issue for the students (e.g., "bullying"), or the identification of a specific theme (e.g., the year-long celebration of the 100th anniversary of the founding of the town).

Examples of essential questions might include:

(Dance) How have different ethnic groups used dance in celebration?

(Music) Where are "melodies" found in nature?

(Visual Arts) How does color convey moods or feelings?

(Theater) How can costumes tell a story?

Ability Area E: Ideas for Art Making

Ability Area E	Lower Elementary or Level 1	Upper Elementary or Level 2	Middle School or Level 3	High School or Level 4
Ideas for Art Making	Students use observations of people, places, objects, and events as sources of ideas for their art making.	Students consider purposes of art such as communicating, persuading, recording, celebrating, embellishing, and designing in developing ideas for their art making.	Students draw upon personal and cultural values and concerns as subjects and themes for their art making	Students critically examine trends in their choices of ideas for art making as a basis for future work.

Retrieved from *ArtsEdNet*, Lesson Plans & Curriculum Ideas– Scope & Sequence, © J. Paul Getty Trust, 1999. www.getty.edu/artsednet/resources/Scope/Abilities/abilityareas.html

Essential questions as a tool for program development. In New York City, Carnegie Hall's LinkUP! program uses essential questions in designing program activities and curricula that are aligned with the National Standards for Music Education and the New York State Standards for Music. The LinkUP! program integrates Carnegie Hall's concert series with educational units, and provides resources for teachers, including lesson plans, CDs, and companion slides in partnership with the Metropolitan Museum of Art.

For example, in its 1999–2000 education program, Carnegie Hall decided to explore the essential questions of Where Do Composers Find Ideas? and How Do Composers Use Songs To Create New Pieces of Music? Based on these ideas, the education program developed a series of learning activities that progressed to greater levels of investigation and learning. The seven units of study, excerpted from its 1999–2000 curriculum guide, explore the following questions:

1. Where Do Composers Find Ideas?

2. Where Can I Find Songs?

3. How Can I Write and Share the Song I Found?

4. How Is a Song Organized?

5. How Can I Use a Song to Create a New Piece of Music?

6. How Can I Perform my Music for Others?

7. How Can Composers Use Songs in New Pieces of Music?

The chart that follows lays out a pictorial representation of how the Carnegie Hall LinkUP! program used essential questions to design its 1999-2000 "Composer's World: Songs and Ideas" curriculum:

These essential questions formed the basis for a range of program units—lasting one week, two or three weeks, or one or two months—as well as one or two day preparations for the LinkUP! Carnegie Hall Children's Concert. In addition, the learning activities were designed so that teachers throughout the schools could

become involved. Some activities involved the classroom teacher or the music specialist, and others team taught. The example below summarizes objectives and some of the activities that support the first essential question:

LESSON #1: Where Do Composers Find Ideas?

Focus: Songs Composers Use

OBJECTIVES: Students will:

1. **Listen**, *as a class*, to three songs: "Simple Gifts," "La Marseillaise," and "America"

2. **Write**, *individually*, responses to questions about these three songs

3. **Gather**, *in groups of 2 or 3*, biographical information about Copland, Tchaikovsky, and Ives

4. **Discuss**, *as a class and individually*, questions about the songs the composers chose and songs that students might choose to use in their own compositions

5. **Discuss**, *as a class*, questions about how Ives used the song "America" in his composition "Variations on America"

STANDARDS ADDRESSED: NY State: 3, 4 National: 1, 6

EXTENSION ACTIVITY IDEAS: Have students use their Biography Research Charts on Copland, Tchaikovsky, and Ives to write their own biographies of these composers. Students may also use the same questions to conduct biographical research on a composer of their choice. Collect student composer biographies into an anthology or classroom "composer encyclopedia."

WRITING UNIT CONNECTION: Have students take their biography writings and create "Where I'm From" poems for each composer.

ASSESSMENT IDEAS–Begin your LinkUP! study with a class **K-W-L map** (What do we **K**now? What do we **W**ant to know? What did we **L**earn?) on the topic of how composers create a piece of music. Create a class chart/web/ poster and post it in the classroom.

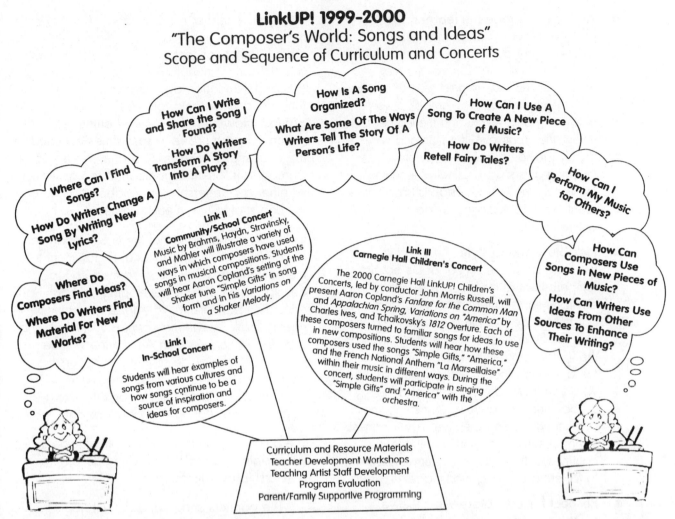

LinkUP! 1999-2000
"The Composer's World: Songs and Ideas"
Scope and Sequence of Curriculum and Concerts

How Can I Write and Share the Song I Found?
How Do Writers Transform A Story Into A Play?

How Is A Song Organized?
What Are Some Of The Ways Writers Tell The Story Of A Person's Life?

How Can I Use A Song To Create A New Piece of Music?
How Do Writers Retell Fairy Tales?

Where Can I Find Songs?
How Do Writers Change A Song By Writing New Lyrics?

How Can I Perform My Music for Others?

Where Do Composers Find Ideas?
Where Do Writers Find Material For New Works?

Link II
Community/School Concert
Music by Brahms, Haydn, Stravinsky, and Mahler will illustrate a variety of ways in which composers have used songs in musical compositions. Students will hear Aaron Copland's setting of the Shaker tune "Simple Gifts" in song form and in his Variations on a Shaker Melody.

Link III
Carnegie Hall Children's Concert
The 2000 Carnegie Hall LinkUP! Children's Concerts, led by conductor John Morris Russell, will present Aaron Copland's Fanfare for the Common Man and Appalachian Spring, Variations on "America" by Charles Ives, and Tchaikovsky's 1812 Overture. Each of these composers turned to familiar songs for ideas to use in new compositions. Students will hear how these composers used the songs "Simple Gifts," "America," and the French National Anthem "La Marseillaise" within their music in different ways. During the concert, students will participate in singing "Simple Gifts" and "America" with the orchestra.

How Can Composers Use Songs in New Pieces of Music?
How Can Writers Use Ideas From Other Sources To Enhance Their Writing?

Link I
In-School Concert
Students will hear examples of songs from various cultures and how songs continue to be a source of inspiration and ideas for composers.

Curriculum and Resource Materials
Teacher Development Workshops
Teaching Artist Staff Development
Program Evaluation
Parent/Family Supportive Programming

LINKUP! 1999-2000, "THE COMPOSER'S WORLD: SONGS AND IDEAS," SCOPE AND SEQUENCE OF CURRICULUM AND CONCERTS, Teacher's Guide, page 3.

Working with artists and arts groups

Criteria for the "teaching" artist. One of the most important roles a local arts agency or arts organization can play in the school or community is to help artists become partners in education programs. Consequently, an essential component of a successful arts education program is the selection of artists who excel not only in their art form but also in their ability to impart their knowledge and skills effectively. Not all great artists are effective teachers. It is the job of the arts organization to become the "broker" by matching the skills of the teaching artist with the needs of the learners.

Effective teaching artists share common qualities:

- **Artistic quality and professional integrity.** An effective teaching artist will possess exceptional skills in his or her discipline, present a body of professional work, and be able to demonstrate professional success in the art world.

- **Ability to communicate.** An effective teaching artist will not only be able to convey ideas and concepts about the art form verbally and in an interesting way, but use multiple means of demonstrating and illustrating the art form, and imparting understandings about it. Good communicators tailor their presentations to the age group and make an effort to understand special needs or challenges.

- **Ability to engage the learner.** An effective teaching artist engages the learner in the discovery of new ways of thinking and doing. One of the most valued aspects of an artist residency is the high degree of hands-on activity. These activities should encourage the learner to unlock the creative skills within and not merely provide a carbon copy of the teaching artist's work. Effective teaching artists help the learner establish a creative identity by not fostering a "do what I do" environment.

- **Flexible working style.** An effective teaching artist checks her or his artistic temperament at the door. The school environment is different from the studio–artists must be prepared to take the good with the bad. Most schools are still run on the factory-model–the period ends when the bell rings, the students in the class are who you have to work with, and the school functions on rules that sometimes conflict with being creative. A willingness to understand and work within the confines of the school structure is essential to fostering a strong working relationship.

- **Respect for educators.** An effective teaching artist makes use of the teacher as a "partner" in the residency. Arts specialists are often practicing artists themselves, but are generally not given credit for their work as artists in school. Teachers have expectations for what a residency can accomplish, and what experiences and activities could enhance educational objectives. By working together, the artist and the teacher can maximize their strengths for the benefit of the students.

- **Motivation for teaching.** Above all, effective teaching artists *want* to teach– and love to do it. Teaching is an important part of who they are. Teachers and students will pick up on someone whose primary motivation for being in the classroom is to earn some extra cash.

Partnerships

Partnerships and collaborations are a growing trend in the field of arts education. More often than not, these involve multiple organizations that cross a variety of sectors with a vested interest in arts education: nonprofit, for-profit, and public arts and education agencies; schools; private funders; and parent, volunteer, and community groups. However, the general enthusiasm for starting a partnership is sometimes eclipsed by the challenges of sustaining one. Therefore, it is important for an organization to consider whether a partnership or collaboration is really the best strategy for meeting a need.

In 1999, at the request of the U.S. Department of Education and the National Endowment for the Arts, the Arts Education Partnership developed a guide to developing successful arts education partnerships to address community needs. Entitled *Learning Partnerships–Improving Learning in Schools with Arts Partners in the Community*, the guide sought out leaders from the arts, education, business, civic, and government sectors to advise on effective approaches to partnership development.

The guide identified eighteen critical factors that will sustain an effective arts and education partnership over time:[5]

1. The partners understand shared goals that ultimately enhance student learning.

2. The individual partners' own goals are met within an effective partnership.

3. In sustained partnerships, leadership becomes shared.

4. Partners within effective partnerships assume a shared sense of ownership in the collaborative program.

5. Effective partnerships are creative.

6. The organization and structure of sustainable partnerships must be flexible.

7. Strong partnerships survive setbacks.

8. Effective partnerships engage multiple community sectors.

9. Good community arts and education partnerships involve multiple artistic and academic disciplines.

10. The arts are valued for themselves and for

their capacity to enhance student learning.

11. Sustained partnerships are concerned comprehensively with education.

12. Partnerships are best sustained when there is support at all levels of partner organizations.

13. Effective partnerships invest in the professional development of their personnel.

14. Partner institutions learn and change.

15. Evaluation and documentation helps achieve partnership goals.

16. Sustained partnerships create an infrastructure that supports community/ school learning relations.

17. Effective partnerships attract sustained funding.

18. Good partnerships require persistence and patience.

Assessing program effectiveness

Chapter 8 on evaluation makes an effective case for why program planners need to spend some time developing a quality assessment system:

> We are well into an era of increased expectation for accountability. It is no longer sufficient to promise in a grant application that you'll change people's lives with your arts programs and then note in your final report that lots of people attended and seemed to have a good time. Now funders are asking that we demonstrate results. Even if evaluations weren't required, they make good sense. Evaluations tell you how well your programs are doing and how well they meet people's needs. Evaluation helps you make the case for support for your programs and services and provides evidence that fuels advocacy. Evaluation results provide crucial information to help you plan to improve your programs and develop new ones. And when you must make hard choices, evaluation findings help you decide what programs to cut.

Chapter 8 goes on to describe concrete processes for setting up an effective program

evaluation that are applicable in an education setting. The tools and resources provide a perfect companion to this chapter's discussion on the whys and hows of program evaluation and student assessment.

Improving versus auditing performance. The key theme in this discussion is that the primary purpose of assessment should ideally be to improve performance—not merely audit it. This is the fundamental premise espoused by leading assessment experts, most notably Grant Wiggins of Relearning by Design (formerly the Center on Learning, Assessment and School Structure). Wiggins's work centers around moving schools, groups, and individuals toward a different mindset—away from the praise and blame paradigm of assessment to assessment as a means of growth.

Though one can make an argument that this should be true in all program endeavors, it is especially important within the context of arts education. As many educators are quick to point out, the Latin root of education is educare—"to draw out." If this is the core meaning behind the education program, then it is essential to build in opportunities for continuous learner improvement, since it is in the act of doing, reflecting, critiquing, and correcting—and repeating this process again and again—that we grow as artists and individuals.

Measuring what matters. Most arts groups working in education regularly conduct, and are required by funders to conduct, program evaluations. The information gathered is usually quantitative, such as the number of students who participated in the program. This information can lead to important programmatic improvements, especially when it is analyzed over a period of time. However, is having 100 percent attendance at a workshop what really matters, or is it simply the easiest thing to measure? Engaging in a substantive discussion with all stakeholders about what is important—something that should occur with the formulation of mission and goals—helps to raise important questions about the means of assessment, and how you go about measuring something that resists quantification.

If you can describe it, you can measure it. The enduring dilemma we confront as program evaluators is that most things that really matter *do* resist quantification. Chapter 8 offers a strategy developed by the United Way to determine if you have described program outcomes that can be evaluated (United Way pp. 54–55). These tests are especially applicable in arts education settings:

1. Is it reasonable to believe the program can influence the outcome in a non-trivial way, even though it can't control it?

2. Would measurement of the outcome help identify program successes and help pinpoint and address problems or shortcomings?

3. Will the program's various "publics"—staff, volunteers, participants, collaborating organizations, funders, and the general community—accept this as valid outcome of the program?

The right tools help you get the information you need. One of the more frustrating aspects of engaging in an assessment effort is that there is no one tool that will provide you with all the information you need to know. Conversely, having nifty, high-tech data-gathering techniques cannot substitute for having a clear understanding of what you need to know—and why you need to know it.

Typical evaluative tools include pre- and post-program questionnaires (e.g., What was the level of knowledge before and after the learning event?), surveys, reflective sessions (post-program and at periodic intervals), interviews, and focus groups, as well as more extensive assessment procedures such as follow-up or longitudinal studies, and the use of independent evaluators.

The cornerstone of continuous improvement— some thoughts on feedback. Most program planners would agree that feedback is a central component of a good assessment system. But the definitions we tend to hold about the nature of feedback—what it is, and what it is used for—limit its applicability. When we expand our thinking about feedback, we open up its usefulness to program improvement, and create opportunities to design effective means to get quality feedback in time for it to make the most difference.

Assessing learning

When we begin a conversation regarding the assessment of student learning in the arts, too often, the automatic reaction is that we are speaking about reducing an arts experience into a "true or false" standardized test. The phenomenon of the standardized test is that all adults have been a participant in (or victim of!) it since childhood—this is what we know. Success is viewed as "passing the test." But as respected educational assessment leaders such as Grant Wiggins and Dennie Palmer Wolf have independently argued for more than ten years, such assessment measures divert students' attention from the understanding of large ideas and processes to the mastery of facts. We have generations of students—now parents and adults— who grew up in essentially a "punitive" pass/fail system, in which success is measured by the "right answer" versus sustained exploration; correctness is valued over risk; and the mastery of information without context and conceptualization might earn you an A.

In their book *Taking Full Measure—Rethinking Assessment through the Arts* (College Entrance Examination Board, NY, 1995), Dennie Palmer Wolf and Nancy Pistone present a sound argument for the use of assessment as an "episode of learning," and lay out a framework of three "essential lessons" about monitoring or measuring student learning:

● **The contents of assessment**, as described by Wolf and Pistone, suggest assessments that address the full range of what is involved in making a work—a process of complex problem solving that is deliberately multidimensional. Within this framework, the contents of assessment are expanded beyond the quality of the final piece or performance to include early and ongoing processes, such as investigations into ideas, reflections, actions based on critique, and responses.

"In my experience, arts groups can fall into the same traps as educators do when it comes to assessment— they measure what's easiest to measure. That doesn't mean they are measuring what's important, or what they value. Too often, we don't take the time to ask the variety of questions that will lead to an understanding of what the program would look like at its best, or what the student will know or be able to do if we are successful.

"So getting good at assessment requires being comfortable with—more than that, expecting and demanding—questions like,

- What are we trying to do here?
- What would it look like if we succeeded?
- What standards are we aspiring to?
- By what criteria would we judge the success of our work?

"Having answers to those questions— and enough time and the right tools set aside to constantly get answers to those questions is to me what the makings of a good assessment plan are all about."

–David Grant, executive director, Geraldine R. Dodge Foundation

- **The conduct of assessment**, suggests that assessment in this context–as opposed to "testing"–is a process of ongoing monitoring of progress and quality, where students are active participants. Assessment is used for more than an occasion to assign grade or rank–it becomes an ongoing "episode of learning."

- **The tools of assessment** support the use of assessment as on ongoing component of learning. Since learning is measured over a longitudinal time frame, tests that measure knowledge or recall at a particular moment–that is multiple-choice or end-of-

year exams–give way to "process portfolios," which as Wolf and Pistone argue, are "longitudinal histories of themselves as people learning an art form."[6] Journals, critiques and portfolios by their very nature are designed to provide evidence of knowledge of the processes and values, as well as sustained work and reflection.

In today's climate, the subject of testing student learning has become a political tool, the result of taxpayers bearing the support for the public-school system, and anti-tax movements at the federal, state, and local levels. Much of the education debate from the public perspective revolves around whether the amount of funds spent on schools is justified by the level of student performance, as demonstrated through our standardized testing system.

The arts group entering this climate is usually frustrated by its limitations–which is understandable considering that most education leaders are frustrated as well. There are, however, ways to assess student learning in the arts that not only achieve what most standardized tests cannot–that is, the improvement of student performance–but demonstrate the benefits of breaking through these old mind-sets.

This section briefly discusses student learning assessment strategies. It draws extensively from the work of Grant Wiggins, a leading voice in school improvement and reform, and especially in good educational assessment practices. Though Wiggins's work is widely known and respected throughout the general education community, his techniques and theories are complimentary to, and in some ways exemplify what are considered best practices in the arts. The reader who is interested in exploring these concepts in greater depth is encouraged to visit the Relearning by Design web site at www.relearning.org, and sign on as an interactive participant in the dialogue on student learning assessment strategies. In addition, the writings and work of Dennie Palmer Wolf, as well as the assessment strategies employed through Harvard's Project Zero, are also worth further investigation.

FEEDBACK

Typical Perceptions of Feedback

- **"Good job" is good feedback.** Feedback tends to be viewed in its broadest sense–any statement will do. However, getting general compliments or criticisms don't provide enough descriptive data to help us to get better at what we're doing.

- **We already get lots of feedback.** Yes, but is it useful to help us improve? Unsolicited feedback usually comes from two groups: our best friends and our staunchest critics. Because we hear often from some voices does not mean that all voices are being heard.

- **Feedback must be verbal.** Obviously, certain forms of feedback are verbal— and usually come from participants in programs, funders, members, and others.

- **Feedback is usually:**

1. Honest

2. Constructive

3. Tactful

While hearing that your program stinks may provide an incentive to change, it doesn't tell you how, when or why you should. The scope of the information that is possible to obtain is often limited by the feedback system. Adequate reflective time is not provided for, or feedback questions end up soliciting answers unrelated to what the program planners need to know to improve.

Expanded Perceptions of Feedback

- **Good feedback provides information we can use to improve–not just to feel good about.** *"Because you did _____, we were able to do _____."* The types of feedback received are directly linked to the goals, standards, and criteria for success we have established.

- **Feedback comes from people beyond our circle of friends and critics.** Asking the question, Who aren't we hearing from? naturally leads into the discussion of how the feedback system can be set up or improved to get input from a variety of voices.

- **Feedback involves both verbal and other data.** Creating a large spectrum of opportunities for feedback helps answer the question, Are we getting the data that would help us know if we are being effective? This question expands the universe of information we can draw from to help us benchmark efforts, compare outcomes, and make improvements.

- **Feedback that is useful should be:**

1. **Timely.** Information is beneficial when there is still time to use it— not when it is too late.

2. **Descriptive.** For clients to describe what they see in a way that is helpful to the learning or improvement process, they should have a sense of what the person getting the feedback is trying to do, and what she or he needs to know.

3. **Contextual.** The best feedback systems are set up after the goals, standards, and criteria for success has been determined. We can then ask for feedback that will ultimately help us determine where our current efforts seem to be in relation to our vision of where we want to be.

Good assessment is about good design. The time to think about assessment is at the start of the project–not as a tack on at the end. Designing a good assessment plan brings the program developer full circle to clarify the *mission and goals* of the project. It involves setting *performance standards,* and developing a set of *criteria* by which to measure success. It is also a matter of beginning with the end in mind. If we do not have a clear idea of what "success" will look like for the learner, we have little chance of designing a system that can retrieve the information we need, and provide the evidence that the goals have been achieved.

As stated by Wiggins, "If our aim is to improve student performance, not just measure it, we must ensure that students know the performances expected of them, the standards against which they will be judged, and have opportunities to learn from the assessment in future assessments."[7]

As defined by Wiggins, educative assessment requires a "known set of measurable goals, standards and criteria that make the goals real and specific (via models and specifications), descriptive feedback against those standards, honest yet tactful evaluation, and useful guidance."[8]

Wiggins's educative assessment process presents an interesting framework for understanding the linkage between student learning and assessment. Standards are illuminated through the use of models and exemplars that can be used to view student progress along a continuum, as well as through a set of specific criteria that establish conditions that would have to be met to indicate that a goal was achieved. Learners understand the performance benchmarks that have been set, and are given the opportunity to incorporate ongoing feedback in their efforts to improve.

For example, let's say that in order to meet a specific national standard in theater—for example, "Acting by assuming roles and interacting in improvisations," groups of second grade students work with a theater artist to develop group improvisations based on characters in the fairy tale the *Three Little Pigs*.

In the accompanying achievement standards for this national content standard, students in grades K-4 are expected to "assume roles that exhibit concentration and contribute to the action of classroom dramatizations based on personal experience and heritage, imagination, literature and history."

Whether students meet this achievement standard could be determined by criteria measured on a performance scale of 0–5. (This process of building specific criterion for success, or performance "rubrics," is described in greater depth in Chapter 8.)

In this example, the performance scale developed to determine student achievement in this standard may look like this:

5. Excellent: The student is able to creatively portray through voice, facial expression, and mannerisms aspects of a character derived from the *Three Little Pigs*. The student is able to maintain the character throughout the exercise, and improvises statements that both creatively advance the plot and are consistent with the character.

4. Very Good: The student is able to convincingly portray through at least two of these three aspects—voice, facial expression, and mannerisms—a character derived from the *Three Little Pigs*. The student maintains the character throughout the exercise, and improvises several statements that both advance the plot and are consistent with the character.

3. Good. The student is able to portray through at least one of these three aspects—voice, facial expression, and mannerisms—a character derived from the *Three Little Pigs*. The student maintains the character through the majority of the exercise and is able to engage in improvised dialogue. At least one or more improvised statements advance the plot.

2. Limited: The student shows some ability to portray a character through voice, facial expression, and mannerisms. The student does not always maintain the character throughout the exercise and either has difficulty in engaging in improvised dialogue with other students or is not able to contribute improvised statements to advance the plot.

1. Poor: The student is unable to portray any discernible character through voice, facial expression and mannerisms. The student is unable to improvise statements that advance the plot.

0. No improvisation is attempted.

In order for students to achieve the performance sophistication indicated by the criteria above, they would need to be supported by a program

design that would allow them to receive the appropriate feedback in such a way and in time for them to be able to incorporate it into their next performance. Thus, feedback is not an end in itself but the means for driving the learning and improvement process.

The feedback loop: analyze, adjust, improve, repeat. From the leader's perspective, feedback follows a continuous loop of Fact-Impact-Commentary. *Facts* are presented about what did or did not happen related to the program goal, without interpretation or judgment. Through the analysis of the effects that occurred as an immediate result of the facts, students begin to understand the *impact* of their actions. The learning event comes full circle through *commentary*—that is, the explanation of the facts and their impact in the context of the goal—leading to an understanding of what adjustments must be made to the next performance to incorporate the feedback and subsequently improve the performance.

Whether feedback is given by an adult or is used as a tool for helping students understand how to give and receive effective self and group critique, the most important goal in setting up an effective feedback system is to help coaches or student "reactors" avoid or downplay language that stresses likes and dislikes. Again, the first step is building a set of coherent standards and criteria, and ensuring that everyone understands them. With the establishment of these guidelines, feedback can more easily be given in terms of whether the behavior witnessed met the standards and criteria, rather than on an emotional or personal reaction.

Feedback in evaluating program goals. The same process that is used to encourage individual improvement may also enable the person guiding the learning to evaluate the success of the program. When viewed as a whole, this information becomes part of the discussion of what actually happened in terms of the goal/standard, where effect matched intent, and which strategies worked and which didn't in light of the outcomes. Because

it is part of the ongoing learning event, this type of programmatic evaluation is not an afterthought, or a post-event "audit," but is linked to program planning and development, and helps program planners make adjustments as appropriate.

EPILOGUE

Advocacy for Arts Education: whose job is it anyway?

In *Life, the Universe and Everything,* book three of the cult science-fiction series *The Hitchhiker's Guide to the Galaxy,* author Douglas Adams describes a unique psychological phenomenon that afflicts most senescent beings in the universe. In the book, the SEP–"somebody else's problem"–theory explains how a large white spaceship is able to land in the center of Lord's Cricket Field in the middle of a cricket match, concealed from both spectators and players in spite of the fact that it lands in plain view. The theory is that most beings will go out of their way to ignore something if they believe it is "somebody else's problem," in order to comfortably avoid taking responsibility for something that looks overwhelming.

This tongue-in-cheek theory to a great degree explains what tends to happen with advocacy for arts education. In a room full of arts education advocates, for instance, it would not be unusual to spend a lively hour engaged in enthusiastic conversation about the need to have the arts in the schools. When asked if something should be done about increasing the arts programs in the schools, all hands would enthusiastically fly into the air. However, if the advocates were then asked how many of them attended a local school board meeting lately, only a handful of hands would appear. Most likely, more hands would go down if they were asked how many of them had voted in the local school budget elections.

Whose problem is the lack of quality arts education programs in schools? Ours, plain and simple. It doesn't matter if we don't have a child in school; it doesn't matter if we don't "do" education programs. If we, as a community concerned about the arts as a whole, do not

fight for it, it will not be there. Voicing support for arts education needs to be a part of every nonprofit arts organization, local arts agency, or cultural institution's mission—even if they are not directly involved in providing or supporting arts education programs. It is clearly in the best interests of children and the public good that the arts grow and flourish in lifelong learning opportunities both in school and beyond.

Advocacy for arts education is not necessarily easy; it involves bringing together a critical mass of individuals who may at times hold opposing views of the means and methods for making the arts a central part of the school and community. As discussed earlier, the enormous strides that have recently been undertaken and proven successful on the national and state levels indicate that reaching a common vision for arts education is achievable.

Local advocates need to be conscious of bringing all interested voices to the table. Engaging in local school politics can be messy, but it is necessary. Arts advocates can play a vital role by being active in school groups—parent committees, planning efforts—and, perhaps more importantly, by working to make sure supportive arts voices are elected to local school boards.

Avoiding the Tiger Traps: Some final tips for surviving the jungle

The most difficult aspect of arts education program development—especially when creating programs that take place in, or in conjunction with, schools—is negotiating through the political realities present in public education. More new programs fail or are thwarted not because of the lack of good ideas but because of a basic naivete or dismissal of the school culture. Hopefully, the previous sections have provided enough food for thought and concrete strategies to prevent the newcomer from stepping into the pitfalls that will invariably dot the path.

In summary, the best way to survive the most dangerous beasts in the jungle without being eaten alive is to know where they lurk. The best intentions are imperiled if the following factors aren't considered:

Common traps

- The organization is seen as a threat to teacher job security rather than as a partner in improving arts education.

- The organization ignores or fails to respect the school culture, or embarks on a competing rather than complimentary agenda.

- The organization is not able to win enough widespread buy-in from the major players or fails to establish a "win-win" relationship not only with school leadership but with those who will most feel the impact of the program.

- The organization loses sight of its commitment to quality in both artistic presentation and educational goals.

In the end, successful program development in arts education—whether for school students or the larger community—depends on building quality relationships, developing mutually supportive goals, and establishing a firm commitment to work toward achieving a greater good.

Practically speaking, this takes time and a willingness to prepare and nurture the soil before cranking up the plow and tilling the fields—especially if there isn't clear consensus on what it is you're being asked to plant. As with most good learning opportunities, however, in the long run, there is more to be gained from the journey than from rushing to reach the destination.

APPENDIX

Selected Resources

Sample arts education programs, forms, and worksheets

Selected resources

Publications

A Community Audit for Arts Education: Better Schools, Better Skills, Better Communities, John F. Kennedy Center for the Performing Arts and the Kennedy Center Alliance for Arts Education Network, June 2001. Based on the two major research reports *Gaining the Arts Advantage: Lessons from School Districts That Value Arts Education* and *Champions of Change: The Impact of the Arts on Learning,* the Community Audit was developed to assist local education, community, and cultural leaders in assessing the status of arts education in their schools and school districts and to encourage community partnerships to strengthen and expand arts education for all students. May be downloaded from the KCAAEN at www.kennedy-center.org/education/kcaaen

Artists as Educators: Becoming Effective Workshop Leaders for Teachers, John F. Kennedy Center for the Performing Arts Education Department. This booklet provides an introduction for artists and arts educators to designing professional development workshops for teachers of students in grades K-12. The publication examines characteristics of effective workshops for teachers, and provides an overview of the workshop development process with an emphasis on finding connections between artists' expertise and the curriculum. Available by contacting the Kennedy Center Partners in Education program at 202-416-8806.

The Arts and Children: A Success Story, video and tool kit with introduction by Meryl Streep, Arts Education Partnership,1996. This excellent advocacy tool describes the impact of the arts on students' school, work, and life. Reproducible handouts summarize research, national policies, and legislation, and gives tips on using the video along with the *Eloquent*

Evidence brochure. Available through Americans for the Arts, 800-321-4510.

Arts and Education Handbook: A Guide to Productive Collaborations, edited by Jonathan Katz, National Assembly of State Arts Agencies, 1988. A comprehensive handbook that provides insight and information on developing programs, participating in collaborations, and understanding the major political, social, and educational forces at play in the field of arts education. Available through the National Assembly of State Arts Agencies, 202-347-6352.

The Arts Beyond the School Day: Extending the Power, A Report of the After-School Protocol Task Force, written by Judith Ann Sarris Conk with the Kennedy Center Alliance for Arts Education Network and Kennedy Center Partners in Education Task Force, John F. Kennedy Center for the Performing Arts, 2000. A guide to forging a fundamental philosophy, along with sound practices for developing quality after-school arts programs. Available through the KCAAEN, 202-416-8845.

The Arts Go To School–An Arts-In-Education Handbook, by Thomas Wolf, Sharon Hya Grollman, Polly Price, and Dennie Palmer Wolf, New England Foundation for the Arts and American Council for the Arts, 1983. An oldie but definite goodie, this book takes readers through the steps for developing quality arts education programs. Available through Americans for the Arts, 800-321-4510.

Arts Programs: Positive Alternatives for At-Risk Youth, by Howard Spector, Americans for the Arts, 2001. This booklet provides statistics and case studies demonstrating how the arts positively impact at-risk youth. A how-to section outlines specific steps to planning programs and a listing of resources. Available through Americans for the Arts, 800-321-4510.

Beyond Enrichment–Building Effective Arts Partnerships with Schools and Your Community, by Jane Remer, ACA Books,1996. Noted expert Jane Remer provides an exceedingly comprehensive manual on developing and sustaining effective arts education programs through partnerships. Remer also includes writings from many of the top

professionals in the field, who provide thoughtful advice and sensible strategies based on solid experience. A lengthy yet insightful "must-read" for those seriously interested in delving into the world of arts education programming and partnership building. Available through Americans for the Arts, 800-321-4510.

Changing Schools through the Arts–How to Build on the Power of an Idea, by Jane Remer, ACA Books, 1990. At times reading like a cautionary tale, Jane Remer provides an insightful profile of one of the first major efforts to establish the arts as an important vehicle for school change. Excellent resource for any group contemplating working in education reform through the arts. Available through Americans for the Arts, 800-321-4510.

Critical Links: Learning in the Arts and Student Academic and Social Development, Arts Education Partnership, 2002. The most recent major compendium of arts education research studies focused on understanding the cognitive capacities developed in learning and practicing the arts, and the relationship of those capacities to students' academic performance and social development. Compendium studies also examine achievement motivations, attitudes, and dispositions toward learning fostered through the learning and practicing of the arts, and the link between these motivations and academic performance and social development. Available in print and in a PDF format on the AEP web site at www.aep-arts.org. Printed copies can be ordered from the Council of Chief State School Officers at 202-336-7016.

Gaining the Arts Advantage–Lessons from School Districts That Value Arts Education, President's Committee on the Arts and Humanities and Arts Education Partnership, 1999. Provides case studies and profiles of public school districts that have made competence and literacy in the arts a fundamental component of their curriculum for all students, and describes how this has been sustained. Available on the PCAH Web site at www.pcah.gov.

Giving Cues: Recommended Guidelines for Writing and Designing Performance Materials for Young People, John F. Kennedy Center for the Performing Arts Education Department. This booklet provides guidelines for the writing and designing of performance materials in music, dance and theater for young people, with suggestions for performances, student learning activities, advice about audience roles and responsibilities, and resources for students and teachers. Available by contacting the Kennedy Center Partners in Education program at 202-416-8806.

Learning Partnerships–Improving Learning in Schools with Arts Partners in the Community, by Craig Dreeszen, Ph.D., Arnold Aprill, and Richard Deasy, Arts Education Partnership, 1999. A guide for community leaders in the arts, education, business, and government sectors interested in combining resources in partnerships and collaborations to support arts education for young people. Available on the Arts Education Partnership web site at www.aep-arts.org.

National Standards for Arts Education–What Every Young American Should Know and Be Able to Do in the Arts, Consortium of National Arts Education Associations, 1994. A critical document developed in response to the acknowledgement of the arts as a core subject in the pivotal Goals 2000: Educate America Act, the National Standards for Arts Education are the result of a unique process of national consensus-building and dialogue about what constitutes a "world-class" education in the arts. Most states have used the national standards in their entirety, or as the basis to develop state arts standards.

Working Relationships: The Arts, Education and Community Development, by Nancy Welch and Paul Fisher, Americans for the Arts and the Institute for Community Development and the Arts, 1995. Eleven excellent case studies describe community efforts to build partnerships between local cultural agencies, schools, businesses, and community sectors to impact arts education. Available through Americans for the Arts, 800-321-4510.

YouthARTS Tool Kit, Americans for the Arts, 1998. This kit features a comprehensive step-by-step handbook to design and implement

youth arts programs. Based on research and practices from around the country, the kit includes a video and "lessons learned" video supplement, as well as a diskette with sample contracts, evaluation forms, and other practical guides. Available through Americans for the Arts, 800-321-4510.

National service organizations

(*A sample listing of the national service organizations providing resources and information about education in all artistic disciplines in both schools and community settings.*)

Americans for the Arts
1000 Vermont Avenue, NW, 6th fl.
Washington, D.C. 20005
202-371-2830 Fax 202-371-0424

One East 53rd Street, 2nd floor
New York, NY 10022
212-223-2787 Fax 212-980-4857

Arts Education Partnership
One Massachusetts Avenue, NW, Suite 700
Washington, D.C. 20001
202-326-8693 Fax 202-408-8076

Kennedy Center Alliance for Arts Education Network
John F. Kennedy Center for the Performing Arts
Education Department
Washington, D.C. 20566
202-416-8845

Web sites

American Alliance for Theatre and Education (AATE): The mission of the American Alliance for Theatre and Education is to promote standards of excellence in theater and theater education through the dissemination of quality practices and by providing opportunities for our membership to learn, exchange, expand, and diversify their work, the audience, and their perspectives.

www.aate.com

Americans for the Arts: Americans for the Arts is the nation's leading arts information

clearinghouse, including arts education and a new national advertising campaign, The Arts–Ask for More.

www.artsusa.org

Arts Education Partnership: AEP is a private, nonprofit coalition of education, arts, business, philanthropic, and government organizations that demonstrates and promotes the essential role of arts education in enabling all students to succeed in school, life, and work. Among the many valuable resources on the AEP web site includes a comprehensive list and links to other arts and education resources and web sites. The AEP web site also features a link to the new *Critical Links* research publication, with complete studies as well as a tool kit.

www.aep-arts.org

Arts for Learning (developed by Young Audiences, Inc.): Arts for Learning is a comprehensive educational program connecting community arts resources with K-12 curriculum across the country.

www.arts4learning.org

ArtsEdge: Formed through a cooperative agreement between the John F. Kennedy Center for the Performing Arts and the National Endowment for the Arts, with additional support from the USDOE. ArtsEdge supports the place of arts education at the center of the curriculum through the creative and appropriate uses of technology. Site includes teaching materials and professional development resources.

www.artsedge.kennedy-center.org

ArtsEdNet: A program of the J. Paul Getty Trust, ArtsEdNet provides a variety of visual arts resources and services for K–12 teachers, including lesson plans and curriculum ideas.

www.getty.edu/artsednet

Harvard Project Zero: Project Zero's mission is to understand and enhance learning, thinking, and creativity in the arts, as well as humanistic and scientific disciplines, at the individual and institutional levels. Site provides information on publications, books, articles, and workshops developed through the program.

www.pzweb.harvard.edu

John F. Kennedy Center for the Performing Arts, Education and Outreach: The Kennedy Center has dramatically expanded its education programs to reach young people, teachers, and families throughout the nation.

www.kennedy-center.org/education

Kennedy Center Alliance for Arts Education Network (KCAAEN): The Kennedy Center Alliance for Arts Education Network is dedicated to the support of policies, practices, and partnerships that ensure that the arts are woven into the very fabric of American education.

www.kennedy-center.org/education/kcaaen

MENC–The National Association for Music Education: The mission of MENC: The National Association for Music Education is to advance music education by encouraging the study and making of music by all.

www.menc.org

National Art Education Association (NAEA): NAEA is a nonprofit, educational organization that promotes art education through professional development, service, advancement of knowledge, and leadership.

www.naea-reston.org

National Dance Education Organization (NDEO): The National Dance Education Organization advances dance education centered in the arts. NDEO is dedicated to promoting standards of excellence in dance education through the development of quality education in the art of dance through professional development, service, and leadership.

www.ndeo.org

National Endowment for the Arts (NEA): The National Endowment for the Arts, the nation's leader in federal funding for the arts, recently opened a new arts education section on its Web site, linked to the Arts Learning funding category. NEA is providing an in-depth online resource on "outcome-based" evaluation, to help organizations and prospective applicants

learn more about this approach to program planning and evaluation. Includes FAQs, essential elements, forms and templates, tips, and examples.

www.arts.gov

National Guild of Community Schools of the Arts: The guild's mission is to foster and promote broad access to high quality arts education designed to meet community needs.

www.nationalguild.org

President's Committee on the Arts and the Humanities (PCAH): The committee works to encourage private sector support for the arts and humanities and public appreciation of their value through projects, publications, and meetings. PCAH's Coming Up Taller web site provides information on the national Coming Up Taller Arts and Humanities Program for Children and Youth at Risk. Site features the award application process, program profiles, and links to other resources.

www.pcah.gov and www.cominguptaller.org

U.S. Department of Education: The U.S. Department of Education was established on May 4, 1980, by Congress in the Department of Education Organization Act (Public Law 96-88 of October 1979). The department's mission is to ensure equal access to education and to promote educational excellence for all Americans.

www.ed.gov

VSA arts: VSA arts creates opportunities for persons with disabilities through education and employment in the arts. It's mission is to include all children, youth, and adults with physical, emotional, intellectual, and social challenges in integrated settings and improve their learning, employment, and life skills.

www.vsarts.org

Wolf Trap Institute for Early Learning through the Arts: Founded in 1981, the institute provides arts-in-education services for children ages 3–5 and their teachers and families through the disciplines of drama, music, and movement. Regional programs of the institute

are located throughout the country.

www.wolf-trap.org

Young Audiences, Inc. Since 1952, Young Audiences state chapters have presented performing and visual artists to children across the country. The Young Audiences National Organization certifies YA chapters for program quality, provides a wide range of services, and advocates quality arts education for all children. YA recently launched the Arts for Learning program, a professional development resource for teachers and artists, which includes a web site and companion CD that provides access to model programs, research, lesson plans, advocacy, and discussion groups.

www.youngaudiences.org

PROFILE: ONE LOCAL ARTS AGENCY'S COMMITMENT TO ARTS EDUCATION

The Arts Council of the Morris Area (ACMA) is located in northwestern New Jersey, and serves a diverse population and geographic region. Paramount to the ACMA's vision is one of its four goals: "to champion the arts as an integral part of education and lifelong learning."

Begun twenty-eight years ago, ACMA's Arts in Education (AIE) Program is the organization's largest and longest-running program. Beginning with 8 program offerings in 1975, AIE now offers 210 assembly programs, workshops, and residencies in dance, music, theater, storytelling, writing, circus, mime, poetry, photography, and masks, as well as professional development workshops, which have reached in excess of 118,000 school children (K–12) in thirteen New Jersey counties.

The AIE Program is guided by the belief that *"the experience of art is basic to the human spirit and essential to the educative process."* The AIE Program offers expert consultation, program design, and contractual services to schools and provides cost-effective, curriculum-relevant, quality arts programming. All programs are planned to enrich the overall curriculum, and every effort is made to incorporate these programs into the daily academic plan. Working in concert with teachers, school administrators, cultural arts coordinators, and artists, the AIE director is involved in the planning, scheduling, and designing of classroom workshops and residencies as the arts become an increasingly integral part of the learning process. All programs are previewed and carefully evaluated by the AIE director prior to recommendation to ensure that they incorporate educational as well as artistic value and quality.

In addition, ACMA offers a variety of services and programs that address the changing needs of schools and identified trends in education:

- Annual brochure of quality arts programs available to schools and cultural planners

- **Annual AIE showcase** so that decision makers can experience programs firsthand

- **The Arts Plus Residency Program.** Two-to-six-week multidisciplinary, in-depth art projects that continue to demonstrate that the arts, in concert with other academic disciplines, provide a uniquely creative and meaningful learning experience for the entire school community

- **Information and Resource Development Workshops for Cultural Planners**

- **Professional Development Opportunities for Artists and Teachers**

- **The Community Service Arts Initiative,** reaching children-at-risk and families in sites throughout the county, including Head Start programs and homeless shelters—demonstrates the creative and empowering role the arts can play in the lives of *all* children.

Target Audience(s): students, teachers, cultural planners, administrators, artists, children-at-risk, and families.

Statistics/Impact: ACMA offers 201 individual programs from 90 artists. In the 2001/2002 school year, ACMA scheduled and coordinated over 650 programs (not including Arts Plus Residencies) that reached over 116,000 schoolchildren (K-12) in 13 New Jersey counties (Bergen, Camden, Essex, Hunterdon, Middlesex, Monmouth, Morris, Ocean, Passaic, Somerset, Sussex, Union, and Warren)—an increase of 200

programs over last year's figures. In addition, ACMA coordinated six Arts Plus Residencies, reaching a core group of over 600 students, as well as many total school communities. Five Arts Plus Residencies were partially funded by ACMA, and one was managed by ACMA but self-funded (Briarcliff). Community Service Arts Initiatives for Children served 665 children and adults this year, bringing programming to Head Start in Dover, Homeless Solutions, Inc., and Family Service of Morris County, and Morris County Child Care Directors Association.

ARTS PLUS RESIDENCIES: This year, six Arts Plus Residencies brought artists and teachers together to collaborate on an interdisciplinary project designed to assimilate the arts into the learning process. For example:

Spiritree: Journeys, 300 students (grades 6, 7, and 8 from both schools), 8 teachers from Briarcliff School and Lake Drive School for the Deaf and Hard of Hearing, Mountain Lakes (Morris), April 29–May 10. Acknowledging the value of the Arts Plus Residency Program they had last year, Briarcliff School raised all of the funds necessary to support another interdisciplinary residency with Spiritree artists Marco Giammetti and Carol Hendrickson, which once again involves their school as well as Lake Drive School for the Deaf and Hard of Hearing. Bringing students with different needs and abilities together teaches new life skills as well as learning skills. Journeys involved sixth graders incorporating their social studies topics of westward expansion, immigration, and subsequent cultural adjustment; seventh graders, their knowledge of ancient Greece and Rome and legends; and eighth graders, their social studies topics of world changes from the Middle Ages to the Renaissance to the Modern World. Working within this thematic framework, Marco and Carol envisioned an outdoor student performance piece, which included giant puppets, masks, a ship, and other props in papier-maché, all symbolizing the "journey," or passage, into the inner self to a better world. The student body of both schools collaborated in the final pageant piece, which included poetry and journal readings, vocal and instrumental music and dance, as well as the visual pieces.

COMMUNITY SERVICE ARTS INITIATIVES FOR CHILDREN: With the success of the second year of community service arts initiatives, ACMA is committed to continuing to bring arts education as well as solace and joy into the lives of at-risk children. These projects reach beyond the classroom to provide mind-stretching and healing arts experiences for some of the county's most vulnerable residents—children and their families fighting poverty, hunger, homelessness, and neglect. We strive to promote these initiatives as proven models to arts agencies and service providers. For example:

Family Service of Morris County (FSMC) staff and Morris County Child Care Directors Association, 70 served; Madison Child Care Center, Roxbury Day Care Center, 40+ served. Working with the FSMC staff, Susie Schub and storyteller Mary Rachel Platt conducted a February seminar on the uplifting powers of the arts. Forty-five directors of early childhood education centers and social service agencies, head teachers, classroom educators, and aides plus FSMC social workers attended *Soaring with Chagall: Connecting with Your Creativity through the Arts,* which examined traits of a visionary leader as well as storytelling techniques through crafts, music, drama, and dance. This seminar was so successful that the directors of Head Start, Dalrymple House, and Neighborhood House asked if it could be repeated for their classroom teachers. A second seminar took place in April with 25 attending. Evaluation comments included, "I wish I could bring this to all the adults who work with children at risk" and "Thank you for 'awakening us.'" Three attendees from the first seminar shared with those at the second one the exciting results of applying new ideas they had learned to their classes. FSMC has asked to repeat the seminar next year. A second FSMC offering—two evening arts expos for 17 families of four and five year olds at the Madison Child Care Center and Roxbury Day Care Center—gave parents a chance to develop skills to share with their children through demonstrations of innovative projects for preschoolers.

A SUMMARY OF MAJOR TASK FORCE REPORT FINDING

POLICY	IMPACT
National Standards for Arts Education—What Every Young American Should Know and Be Able to Do in the Arts (Consortium of National Arts Education Associations, 1994)	*Gaining the Arts Advantage: Lessons from Schoo Districts That Value Arts Education* (President's Committee on the Arts and Humanities and the Art: Education Partnership, 1999)

Students should know and be able to do the following by the time they have completed secondary school:

- They should be able to communicate at a basic level in the four arts disciplines— dance, music, theater, and the visual arts.

- They should be able to communicate proficiently in at least one art form.

- They should be able to develop and present basic analyses of works of art from a variety of cultures and historical periods.

- They should be able to relate various types of arts knowledge and skills within and across the arts.

As a result of developing these capabilities, students can arrive at their own knowledge, beliefs, and values for making personal and artistic decisions. In other terms, they can arrive at a broad-based, well-grounded understanding of the nature, value, and meaning of the arts as a part of their own humanity.

Critical factors of success for **district-wide arts programs:**

- A **community** actively engaged in the arts politics and instructional programs of the district— inside and outside the schools.

- A **school board** providing a supportive policy framework and environment for the arts.

- A **superintendent** regularly articulating a visi for arts education in the district.

- A cadre of **principals** that collectively suppo the policy of arts education for all students.

- **Teachers** who practice their art and are encouraged by district administrators to grov their art as well as in their teaching competence.

- **District arts coordinators** who facilitate program implementation and maintain an ar supportive environment.

- **Parent/public relations programs** to inform community and gain its participation and support.

- National, state, and other **policies and programs** employed by the district to advanc arts education.

- Opportunities for higher levels of **student achievement** through specialized programs.

- **Continuous improvement** in arts education through reflective practices at all school level

- **Planning** with a comprehensive district-wide education vision but incremental implementation.

- **Continuity in leadership** in the school and ir the community.

CONTINUUM OF POLICY TO PROGRAM IMPACT

PROGRAM

The Arts Beyond the School Day: Extending the Power, A Report of the After-School Protocol Task Force (Kennedy Center Alliance for Arts Education Network and Kennedy Center Partners in Education Program, 2000)	*Young Children and the Arts: Making Creative Connections,* A Report of the Task Force on Children's Learning and the Arts Birth to Age 8 (Arts Education Partnership, 1998)
Essential elements of arts-based, student centered **after-school** programs: ● Are focused on student needs ● Offer unique opportunities for imaginative learning and creative expression ● Employ and support quality personnel ● Are structured to maximize student learning ● Engage families with their children ● Are actively supported by school leadership ● Are committed to ongoing planning and evaluation ● Leverage a wide variety of resources	Guiding principles for arts-based programs for **young children:** ● Children should be encouraged to learn in, through, and about the arts by actively engaging in the processes of creating, participating in/performing, and responding to quality arts experiences, adapted to their developmental levels and reflecting their own culture. ● Arts activities and experiences, while maintaining the integrity of the artistic disciplines, should be meaningful to children, follow a scope and sequence, and connect to early childhood curriculum and appropriate practices. They may also contribute to literacy development. ● The development of early childhood arts programs (including resources and materials) should be shared among arts education specialists, practicing artists, early childhood educators, parents, and care givers; and the process should connect with community resources.

The following series of worksheets have been adapted for use from the publication *Learning Partnerships–Improving Learning in Schools with Arts Partners in the Community*, Arts Education Partnership, Washington, DC, 1999, by Craig Dreezen, Arnold Aprill, and Richard Deasy.

LEARNING PARTNERSHIPS: WORKSHEET #1

Key questions: What partners should be asking themselves first as they think about a new partnership:

Do I need any help to:	What do I need?	Who could help me?	How could I help them?	What are my limits to working with them?
Solve a problem?	To fulfill a curriculum requirement?	Organizations?	Funds?	Time?
Meet specific student or member needs?	To better serve a specific population?	Elected officials?	Facilities?	Resources?
Develop, influence, or implement a plan, policy, or mandate?	To invest in teachers' professional development?	School leaders?	Staff Time?	Pending changes in leadership (retirements, downsizing)?
Build better community relations?		Community leaders?	Administrative services?	Other major initiative involvements?
Better use an available resource?		Parents?	Supplies?	
Take advantage of an opportunity?		Students?		
		Artists?		

LEARNING PARTNERSHIPS: WORKSHEET #2

Key questions: What partners should be asking themselves second when they have decided to collaborate:

QUESTIONS FOR COLLABORATORS:	ISSUES TO CONSIDER:	COLLABORATOR RESPONSES:
What are our shared goals?	Partners should agree on the reason for the partnership and shared goals. A partnership that advances each other's goals is more sustainable than one that creates new initiatives outside the partners' existing priorities.	
Who are we trying to help?	Ultimately, the students! Partners should be clear about the point of intervention–Is it through the professional development of classroom teachers and arts specialists? artists? parents? principals? Clarify the intended beneficiaries, and include them in the planning process.	
What are our specific objectives?	Convert a shared understanding of the problem into intended outcomes, then specific tasks.	
Who will make fundamental decisions for the partnership?	Be clear about who is responsible for the initiative. The collaboration will have a core group of decision makers informed by a larger circle of advisors. Partnership membership is often ill-defined; the process by which decisions are made, however, must be clear.	
How much will this cost?	Costs and revenues are established in a written budget for the partnership or project. The budget forms a basis for the partnership agreement and sets funding targets. Also determine the extent to which partner institutions will contribute their own resources. It is essential to resolve how expenditures are approved and documented.	

(continued)

LEARNING PARTNERSHIPS: WORKSHEET #2 (continued)
Key questions: What partners should be asking themselves second when they have decided to collaborate:

QUESTIONS FOR COLLABORATORS:	ISSUES TO CONSIDER:	COLLABORATOR RESPONSES:
Where will we get the funds?	Determine the likely source of funds. Decide which partner will raise funds from which source. Partners should be protected from partnership fund-raising that might limit individual access to their own contributed funds.	
How will we operate?	Develop a plan for regular communication. Written agreements and periodic planning and evaluation meetings are critical. Plan to communicate efficiently through e-mail and other means, taking into consideration demands on partner's time–for example, teachers' release time. Teachers must be valued and central to the planning effort.	
How will we know if we are succeeding?	Establish measurable objectives and plan to gather evidence of the extent to which they are achieved.	

[1] Charles Fowler "Arts and Education Handbook: A Guide to Productive Collaborations" (National Assembly of State Arts Agencies, Washington, D.C., 1988).

[2] Alan Greenspan, Chairman, Federal Reserve Board, "Structural Change in the New Economy" Remarks before the National Governors Association, (92nd Annual Meeting, State College, Pennsylvania, July 11, 2000).

[3] Morrison Institute for Public Policy, "Schools, Communities, and the Arts: A Research Compendium" from Arizona State University http://www.asu.edu/copp/morrison/public/schools.pdf (Washington, DC, 1995).

[4] Americans for the Arts, "Local Arts Agency Facts- Fiscal Year 2000" (monograph) (Washington, D.C., August, 2001).

[5] Craig Dreeszen, Ph.D., Arnold Aprill, and Richard Deasy, "Learning Partnerships: Improving Learning in Schools with Arts Partners in the Community" (Arts Education Partnership, 1999).

[6] Dennie Palmer Wolf and Nancy Pistone, "Taking Full Measure–Rethinking Assessment Through the Arts" (College Entrance Examination Board, NY, 1995).

[7] Grant Wiggins, Feedback, retrieved on May 6, 2002, from Relearning by Design, www.relearning.org,

[8] Ibid.

CHAPTER 7

CULTURAL ACCESS:

EVERYONE'S WELCOME!

by Gay Drennon

with Lisa Kammel

EXTEND THE COMPLETE INVITATION

Putting out your welcome mat to everyone brings in new artists, audiences, volunteers, employees, and funders to the arts. Cultural access means opportunities for local arts organizations to pursue excellence in community service. A wave of changes in society's demographics is restructuring the composition of our schools, businesses, healthcare agencies, and social services. According to Elaine Ostroff, founder of *Adaptive Environments*:

The Ordinariness of Difference in Ability

- 27 million Americans report some difficulty with walking (less than 3 million of them use wheelchairs).

- One in six Americans (17%), 45 years of age or older, reports some form of vision impairment even when wearing glasses or contact lenses.

- 22 million Americans have some level of hearing impairment, most with some residual hearing.

- The Arthritis Foundation estimates that 40 million Americans have arthritis.

Aging in America

- There are 77 million baby boomers in America.

- Between 2010 and 2030, the 65 and over population will rise over 70%.

- Of all the human beings who have ever lived past 65, half are currently alive.

- Throughout most of history, only 1 in 10 people lived past 65; now 80% do.

- Three-quarters of all assets in the United States are controlled by people 60 years of age and older.

—Adaptive Environments

"Our expectations have changed: we expect to have choices about what we do and where we go without regard to age or ability."

–Elaine Ostroff, Founder, Adaptive Environments

Accessibility is a work in progress because there are always new technologies and developments that advance inclusive programming. It is essential to review and evaluate–on a regular basis–policies and procedures, spaces and programs, print materials and web sites, and to include an accessibility component in all board, staff, volunteer, and constituent training.

There are many opportunities for growth by reaching out and opening up programs to older Americans and people with disabilities. For-profit businesses across the country recognize this and are attending to the concerns and needs of these burgeoning populations through advertising and realistic, positive images of the targeted populations.

Cultural organizations that are not actively concerned with accessibility and inclusion for staff, board, volunteers and constituents, not only risk the loss of funds and invite law suits, but are missing the opportunity to grow and learn about this country's 54 million citizens with disabilities who represent potential patrons, artists, teachers, students, administrators and audiences.

"'Nothing about us, without us' was the theme that emerged from the 1970s disability rights movement and continues to be echoed today by individuals with disabilities and even by older adults. "Inclusion" is the essential word in making the arts fully accessible. Make sure that you involve these targeted populations not only in planning for inclusive programming, but as staff, board members, panelists, creators, volunteers and as audiences."

–Paula Terry, director, AccessAbility Office,
National Endowment for the Arts

Arts administrators can ride this incoming tide and be enriched by the talents and resources of their fully engaged communities or they can be swamped and relegated to a backwater position of irrelevance where their facilities and programs will sink under the weight of inaccessibility.

Winston Churchill once said, "We shape our environments and our environments shape us."

Inclusion is a key issue to create cultural accessibility. All organizations need to extend a complete invitation to people regardless of their age, race, religion, and/or disability. Cultural organizations should do more than just invite people that have been excluded in the past to attend their programs. They must also work with their communities to remove the physical and attitudinal barriers that prevent a diverse population from participating in their organizations.

This chapter, *Cultural Access: Everyone's Welcome* discusses accessibility through explanations of basic philosophy, terms, best practices/model programs, tools, and resources. Readers will be introduced ways to adapt existing facilities and programs to create exciting new institutional changes that will bring the community into the organization and the organization into the community.

"Let's design all things, all the time, for everyone."

–Ronald L. Mace, former architectural program director, Center for Universal Design

Extending a full invitation to participate in your organization requires more common sense than funding. Attitude is of greater importance than the latest adaptive technology. Connections are made person to person with dignity and respect.

"The most important thing to remember when interacting with people with disabilities is exactly that–they're people."

–Rose Marie McCaffrey, Program Director, The Associated Blind, Inc

CULTURAL ACCESS PHILOSOPHY: CULTURAL ACCESS IS SOCIAL JUSTICE

The basic premise of cultural access is one of social justice. It is an ongoing process that assumes diversity of users and that a broad spectrum of abilities is ordinary, not special. Dr. Sharon Sutton, professor of architecture, University of Washington, refers to a community as "the great public theatre where all can perform their part." In order to attain inclusion and the gradual democratization of society, cultural accessibility seeks to give a voice to disempowered persons in shaping their social and physical environments.

"Though the disability rights movement grew up along side other identity-based movements in the 1960s and 70s, the particular discrimination disabled people have suffered–attitudinal, employment and architectural barriers; educational and social segregation; institutionalization; even forced sterilization– kept many isolated from one another. This made the formation of the disability subculture difficult, if not impossible. Only after several decades of disability activism–which has brought about landmark civil rights legislation, independent living centers and the formation of a distinct community–has the disabled American voice begun to reach a wider audience, both on and off stage. A growing number of playwrights and performance artists have given artistic expression to the experience and culture of disability from an insider's perspective."

–Carrie Sandahl,
Access, Activism & Art, American Theatre,
VOL 18, Number 4, April 2001

The earth is given to men in common good for the purposes of life. . . This common right of every man to what the earth produces before it be occupied and appropriated by others was by ancient moralists very properly compared to the right which every citizen had to the public theatre, where every man that came might occupy an empty seat. . . The earth is a great theatre, furnished by the Almighty with perfect wisdom, for the entertainment and employment of all mankind. Here every man has a right to accommodate himself as a spectator and to perform his part as an actor

–Pierre-Joseph Proudhon

When we enter human life, it is as if we walk on stage into a play whose enactment is already in progress–a play whose somewhat open plot determines what parts we may play and toward what denouements we may be heading. Others on stage already have a sense of what the play is about, enough of a sense to make negotiation with a newcomer possible.

–Jerome S. Bruner

Designing The Great Public Theater: Access for All Ages

Cultural access, the process of creating "the great public theatre," links physical and attitudinal changes with individual and community empowerment. All players want to participate in society and find their way independently. Based on professional literature and practical examples from *Access for All Ages*, the following points describe a philosophy of cultural access:

1. People are the measure of all things. The user should not have to adapt to the environment and service. The environment or service should adapt to the user.

2. The average person does not exist. The fact that everyone is different does not mean that separate accommodations should be made for each person in each group. People's varying and differing needs should be translated into provisions usable by everyone.

3. Realize the relation between age and accessibility. To serve children and older adults, accommodations should be designed to support their differences in size, physical endurance and perceptual changes. Issues regarding safety and independence should be addressed as well.

4. Design for all. The maximum number of people must be physically and mentally able to have access to the services they want to use.

5. Start with services that are frequently used. Achieving cultural access for all requires great effort with scarce resources. First, analyze the services most frequently used.

6. Connect form and content. Accessibility means more than a good building; more important is the organization's welcome attitude at all levels and phases of service.

7. Communication is key to cultural access. The realization of cultural accessibility is good communication with the user, both during the design phase of a certain service or accommodation and its use.

8. There is no end point, but a continuous process. Because each situation is different, new questions are constantly raised. Cultural access as a stream of experiences with challenges and opportunities has no end point, but is a continuous process of attention and communications.

From public parks to the private rooms of hospice patients, cultural programs are providing new avenues for community service. Case studies and best practices are available in each arts discipline—music, dance, drama, visual arts, and literature—as well as a listing of artists and arts organizations that are considered leaders in the field of cultural access. For more information on cultural access, refer to the Office for AccessAbility at the National Endowment for the Arts (NEA) located in the Government and Nonprofit Resources section in the Appendix.

The next section outlines the public mandate for access in the United States and provides a vocabulary to stimulate individual conversations and community partnership developments to establish "the great public theatre," a space that is accessible to everyone.

KNOWING THE LANGUAGE OF CULTURAL ACCESS: TERMS AND TYPES

Accessibility means different things to different people. Barriers to access can be based upon economic disadvantages, cultural/ethnic bias, ageism, and physical and/or mental disability. The remaining section, however, will address issues of physical and cognitive access.

Accessibility

To museums, according to *Everyone's Welcome: The Americans with Disabilities Act and Museums*, accessibility means making the site's exhibits and programs available to all visitors. The goal is to eliminate physical, communication and attitudinal barriers.

- Physical access means removing barriers to allow all people to move independently throughout a facility.

- Communication access means providing graphic information along with alternative formats such as assistive listening devices and visual aids, such as a raised line map of the space, to help all people receive and communicate information effectively.

- Attitudinal access means being sensitive to human diversity, so that all people feel respected and included.

Providing access is a good practice to follow for all cultural organizations. Accessibility features not only help people with disabilities, but it also make life easier and more

convenient for everyone involved. Fortunately, providing access is not just a choice, but it is a law. The Americans with Disabilities Act (ADA) was passed in 1990 as a comprehensive civil rights act enforced by the U.S. Justice Department.

Americans with Disabilities Act

The ADA is a federal civil rights law created to ensure equal access for people with disabilities to employment, government programs and services, and privately owned places with public accommodations, transportation and communications. It is modeled after earlier civil rights laws that protect individuals from discrimination based on race, color, sex, national origin, age, and religion. Unlike other civil rights legislation, non-discrimination laws for people with disabilities have specific design and technical provisions and requirements in order to provide equal opportunities for participation.

"Accessibility begins as a mandate to serve people who have been discriminated against for centuries; it prevails as a tool that serves diverse audiences for a lifetime."

–Janice Majewski, Smithsonian Institution accessibility program coordinator

According to the ADA an individual is considered to have a disability if he or she:

- has a physical or mental impairment that substantially limits one or more major life activities; (examples include people with paralysis, hearing or visual impairments, seizure disorders, HIV infections or AIDS, mental retardation, or specific learning disabilities);

- Has a record of such an impairment; (examples include cancer survivors or people who have recovered from a mental illness);

- Is regarded as having such an impairment (examples include people who have severe facial or other disfigurements that are substantially limiting only because of the attitudes of others).

The ADA also covers a person on the basis of a known association or relationship with a person with a disability, such as a family member, friend or acquaintance.

The ADA has five separate parts or titles that address a specific category of coverage. The ADA covers the following categories:

Title I: Employment.

Title II: Programs, services and activities of state and local governments, including public transportation.

Title III: Companies and nonprofit organizations that operate places of public accommodation, providing goods and services to the public and entities offering certain types of examinations and courses.

Title IV: Telecommunications access.

Title V: Miscellaneous provisions that are applicable to all other titles.

The ADA and other laws like it must have a system of implementing regulations that establish enforceable requirements. For example, the ADA requires the Department of Justice to establish regulations for Titles II and III, including cultural organizations such as museums and performing arts centers. The Department of Transportation also issues implementing regulations for Titles II and III. Title I has implementing regulations issued by the Equal Employment Opportunity Commission. Most cultural organizations, whether public or private, must adhere to the employment provisions of Title I.

Further, temporary events, rented facilities and contracted program services must be accessible and in compliance with the ADA.

Technical Local and State Accessibility Assistance Requirements

Many state and local governments have more stringent accessibility requirements than the ADA. For further assistance on local accessibility requirements, contact your state and local governments or refer to the Disability and Business Technical Assistance Center (DBTAC) found in the Disability Resources section of the Appendix.

Which Title Should I Follow, Title II or Title III?

If your cultural organization is owned and operated by a state or local government, you must follow Title II. If your cultural organization is privately owned and operated or a nonprofit 501(c)(3), you must follow Title III. If you are privately owned but receive funds from a state or local government, then you will follow Title III. However, the government funding source may, as a means of meeting its Title II obligations, require you to comply with certain Title II provisions.

–Everyone's Welcome: The Americans with Disabilities Act and Museums

Title II Cultural Organizations

Below is a summary for state and local government cultural organizations.

Cultural organizations

- Must ensure that individuals with disabilities are not excluded from services, programs and activities because buildings are inaccessible or because of policies or practices, unless to do so would result in a fundamental alteration;

- Are not required to take any action that would result in a fundamental alteration in the nature of the service, program or activity or in undue financial and administrative burdens;

- Must ensure equally effective communication with individuals with disabilities; and

- Must maintain accessible features of facilities and equipment.

Existing facilities

- State and local government cultural organizations must conduct a self-evaluation of all programs and activities to identify any physical or policy barriers that may limit or exclude participation by people with disabilities;

- Cultural organizations must choose to modify the facility, relocate the program or activity or provide the activity, service or benefit in another manner that meets other ADA requirements;

- If modifications are done, physical changes must comply with the ADA standards for Accessible Design (ADA Standards) or the Uniform Accessibility Standards (UFAS).

Alterations

- Any alteration that affects the usability of the facility must comply with the requirements of the ADA Standards (without the elevator exemption) or the UFAS to the greatest extent feasible.

New construction

● Must comply with the new construction requirements of the ADA Standards (without the elevator exemption) or the UFAS

Administrative requirements

For entities with 50 or more employees, the following are required in addition to the self-evaluation:

● Develop a grievance procedure;

● Designate an individual to oversee ADA compliance;

● Develop a transition plan that catalogs the physical changes that will be made to achieve program accessibility;

● Retain the self-evaluation for three years.

–Everyone's Welcome: The Americans with Disabilities Act and Museums

Title III Cultural Organizations

Below is a summary for private for-profit and nonprofit cultural organizations

Cultural organizations

● Must provide goods and services in an integrated setting, unless separate or different measures are necessary to ensure equal opportunity;

● Must eliminate unnecessary eligibility standards or rules that deny individuals with disabilities an equal opportunity to enjoy the goods and services provided;

● Must make reasonable modifications in policies, practices and procedures that deny equal access to individuals with disabilities, unless a fundamental alteration would result;

● Must maintain accessible features of facilities and equipment.

Existing facilities that are open to the public

● Cultural organizations must remove architectural and structural communication barriers in existing facilities where it is readily achievable to do so;

● Cultural organizations must provide readily achievable alternative measures when removal of barriers is not readily achievable.

Alterations for all facilities

● Any alteration that affects the usability of the facility must comply with the requirements of the ADA Standards to the greatest extent feasible.

New construction

● Cultural organizations must design and construct new facilities to comply with the ADA Standards.

–Everyone's Welcome: The Americans with Disabilities Act and Museums

What are the Meanings of Readily Achievable and Undue Burden?

Readily achievable means easy to accomplish and able to be carried out without much difficulty or expense. The following factors should be considered when cultural organizations are considering whether barrier removal is readily achievable:

- Nature and cost of removal;

- The cultural organization's overall financial resources; number of employees; effect it will have on expenses and resources; legitimate safety requirements necessary for safe operation, which includes crime prevention measures and necessary steps for protecting the integrity of art work; artifacts and historical structures on display; or any other impact on the organization's operation;

- The geographic separateness and the administrative or fiscal relationship of the cultural organization to any other associated cultural organizations or parent entities;

- If applicable, the overall financial resources and overall size with respect to the number of employees of any associated cultural organizations or parent entities as well the number, type and location of its facilities;

- If applicable, the type of operation or operations of any associated cultural organizations or parent entities, including the composition, structure and functions of their work forces.

Undue burden is defined as a significant difficulty or expense. The factors listed above should also be used when considering whether something is an undue burden.

A greater level of effort is required to meet the "undue burden" standard than the "readily achievable" standard for removing barriers in existing Title III cultural organizations.

—Everyone's Welcome: The Americans with Disabilities Act and Museums

Meeting Ongoing Obligations of the ADA

Cultural organizations need to constantly monitor their obligations with the ADA because it is an ongoing process.

Title II Cultural organizations

Program accessibility and providing effective communication requirements are an ongoing responsibility.

Title III Cultural organizations

Barrier removals, when it is readily achievable to do so, are an ongoing responsibility.

For all cultural organizations

Alterations, reconstructions, additions, or new constructions all have ADA requirements.

Cultural organizations should also understand how their local, state and federal laws affect each other. All cultural organizations must comply with the ADA Standards, however, additional steps may need to be taken to comply with state or local laws.

—Everyone's Welcome: The Americans with Disabilities Act and Museums

ADA Resources

Review the following for more information about specific ADA requirements:

Title II State or local government cultural organizations:

Title II Regulations

Title II Technical Assistance Manual

ADA Standards or UFAS

Title III Private cultural organizations

Title III Regulation (with ADA Standards)

Title III Technical Assistance Manual

Copies of the above are available from the ADA Information Line at (800) 514-0301 (Voice) and (800) 514-0383 (TTY).

Inclusion

Court cases continually test and refine protective limits and undue burdens. Ancient taboos that still exist regarding disabilities are causing forms of discrimination because cultural organizations are simply ignoring access issues due to other priorities. The results are thoughtless acts of exclusion in the planning, implementation and evaluation of cultural facilities and programs. These oversights are not only against the law but extremely costly.

"The disability community is coming of age with the advent of technology, changing social/ political attitudes and a growing understanding of abilities over disabilities. Like in the case of other minority groups, arts are an area that can give this previously stifled community a stage on which to present its issues, aspirations and triumphs."

–Douglas Towne, executive liaison, Disability Relations Group

People generally wish to visit places and see things that are easy to use, sturdy, safe, and welcoming. As our population ages and technology offers broader opportunities to be engaged in learning activities as well as a desire for freedom from office or home computers, members of our society are looking for new experiences to enjoy either alone or with family and friends. Cultural organizations stand to gain a new and larger audience, from older adults to volunteers to artists, who have been waiting a lifetime to become involved in making and appreciating the arts.

Creating a Notice for Visitors Requesting Access Services

Every event, activity and program should be accessible to people with disabilities. If the event is publicized, cultural organizations should provide people with disabilities the opportunity to request accommodations. To find out if accommodations are needed, list the following statement on all notices about the program, e.g., web site, newspaper ads, and flyers.

"For individuals with disabilities requiring access accommodations, please contact [Insert name of contact] within a minimum of [insert number*] hours of the event/ program so that proper consideration may be given to the request."

*The recommended notice is a minimum of 72 hours. This provides plenty of time to make the necessary arrangements. A more advance notice can be requested.

The next section describes universal design, a strategy for planning that goes beyond minimum access standards. Universal design and targeted program development serve as the building blocks for an inclusive community.

The Americans with Disabilities Act (ADA) in Relation to Universal Design

- The ADA is civil rights legislation that includes standards for access by people with disabilities, in an integrated approach.

- Universal design is about social justice by design; it supports inclusion, avoids exclusion.

- The ADA provides a baseline for universal design.

—Adaptive Environments

BUILDING INCLUSIVE COMMUNITIES

Cultural organizations that go beyond the minimum standards to design programs and places for all ages and populations create bridges from access to unlimited opportunities. People first language is an excellent first step in building inclusive arts environments. It costs nothing yet changes attitudes while opening the door to broadening opportunities for everyone.

"People First" Terminology

Place the person before the disability. For example, say "person with a disability" rather than "disabled person."

Avoid referring to people by their disability, for example, "an epileptic," "blind people," or "a deaf person." A person is not a condition. Instead, refer to people with disabilities as "a person with epilepsy," "people who are blind," or "a person with a hearing loss."

People are not "bound" or "confined" to wheelchairs. They use them to increase their mobility and enhance their freedom. It is more accurate to refer to a person in a wheelchair as a "wheelchair user" or "a person who uses a wheelchair."

—Adaptive Environments

Making All Guests Feel Welcome

Steps to make visitors with disabilities feel welcome and comfortable that may be included as part of an organization's plan for providing effective communication:

- Provide orientation brochures and guide maps (including raised line maps) that identify accessible features with disability symbols of accessibility.

- Provide orientation and information brochures in large type so that all users can use the same brochure.

- Provide an advertised incoming TTY (text telephone) line so visitors with hearing or speech impairments may contact the organization.

- Offer sign language interpreted tours for visitors with hearing disabilities.

- Provide captioned and audio-described orientation videos.

–Everyone's Welcome: The Americans with Disabilities Act and Museums

According to the *Global Universal Design Educator's Network*, "Universal design is an approach to design that honors human diversity. Universal Design addresses the right for everyone, from childhood into their oldest years, to use all spaces, products and information in an independent, inclusive and equal way. The process invites designers to go beyond compliance with access codes to create excellent people centered design."

"It's not about 'them' it is about us, our families, our friends."

–Global Universal Design Educator's Network

The Principles of Universal Design

Universal design is the design of products and environments to be usable by all people, with disabilities and without, to the greatest extent possible, without adaptation or specialized design. According to *Adaptive Environments*, the seven principles listed below may be applied to evaluate existing designs, guide the design process and educate both designers and consumers about the characteristics of more usable products and environments.

1. Equitable use

The design is usable and marketable to people with diverse abilities. For example, provide stair and smooth surface options for people.

2. Flexibility in use

The design accommodates a wide range of individual preferences and abilities. For example, provide different forms of vertical access such as stairs and an elevator.

3. Simple and intuitive use

Use of the design is easy to understand, regardless of the user's experience, knowledge, language skills, or current concentration level. For example, use clear parking zone signage that includes way-finding arrows.

4. Perceptible information

The design communicates necessary information effectively to the user, regardless of ambient conditions or the user's sensory abilities. For example, provide maps for orientation in different sensory forms such as tactile and visual models.

5. Tolerance for error

The design minimizes hazards and the adverse consequences of accidental or unintended actions. For example, provide lighted shapes that begin at the front door and continue to the reception desk so the path of entry is clear to all.

6. Low physical effort

The design can be used efficiently and comfortably and with a minimum of fatigue. For example, provide a door that requires a low physical effort to open, such as a sliding door with an automatic eye.

7. Size and space for approach and use

Appropriate size and space is provided for approach, reach, manipulation, and use regardless of user's body size, posture, or mobility. For example, provide water fountains that are the appropriate size and space for the approach and use by all.

For further information on Adaptive Environments, refer to the Government and Nonprofit Resources section in the Appendix.

Tips for Program Development for Five Target Populations

Requests for on and off site arts programs and services are providing opportunities for new and exciting partnerships that serve target populations with unique individual needs. Universal design can be partnered with adaptive or assistive technology to meet unique individual needs and be the foundation upon which broad-based community cultural access is built.

An organization's first priority should be basic facility and program accessibility. However, it is important to explore potential relationships with community partners to develop outreach programs that meet specific individual and group needs. There are basic protocols and best practices to follow for outreach programs to serve target populations with a high level of staff and environmental support.

Below are descriptions of program considerations for five major target areas of arts outreach: arts in education that includes students with disabilities; health care; juvenile justice/corrections; lifelong learning in the arts and aging, which includes intergenerational activities; and art centers for adults with disabilities.

1. Arts in education for students with disabilities

The inclusion of students with disabilities in school and community arts education programs is a reality that often catches educators unprepared. The prospect of adjusting teaching styles, instructional strategies and classroom management is a daunting task. The dynamics of arts education welcome such innovations. In *Strategies for Inclusive Classroom Environments*, VSA arts, an international nonprofit organization dedicated to promoting arts education opportunities for people with disabilities, asserts the compatibility between the arts and a diverse student population. VSA arts asserts the following:

- The arts appeal to diverse learning styles, creating greater opportunities for students and teachers to connect in productive ways.

- The arts make learning more interesting by correlating learning experiences to life experiences.

Points to Remember

After it works well for people with disabilities, it works better for everyone.
- Universal design is a response to the fact of the variability of the human condition.
- Universal design is a way of thinking about design as user-centered and problem solving. Diverse users should be engaged as experts and reviewers of your tentative solutions.
- Universal design is a transitional name while we shift to the assumption that good design integrates function and aesthetics.

–Adaptive Environments

- The arts provide a forum for creating innovative teaching strategies.

- Multicultural aspects of the arts foster appreciation and acceptance of diversity.

The following is a list of tips and strategies for the arts educator to keep in mind while creating an inclusive classroom environment:

- Capitalize on students' individual interests and suggestions for both content and strategy;

- Utilize content to reach and/or interdisciplinary lesson plans to stimulate interest and dialogue;

- Tap the network (exceptional student or special educator specialists, parents and other support staff) for moral, instructional and financial support;

- Discuss appropriate roles for teaching assistants or student aides before hand in order to prevent potentially uncomfortable or goal-defeating situations;

- Understand the Individual Educational Plan (IEP) process and incorporate arts education as a means to accomplish important goals;

- Modify the classroom environment to promote inclusive principles;

- Welcome ongoing evaluations, modification and reinforcement.

All arts-in-education programs, including artist residencies and performances, must provide accommodations for students with disabilities. Including all students in arts education is not only the right thing to do, but is also a powerful way to effect positive change in the academic and social life of students with disabilities.

For further information regarding best practices, model programs and technical assistance for developing inclusive arts programs contact VSA arts at 1300 Connecticut Avenue NW, Suite 70, Washington, D.C., 20036, (800) 933-8721.

"I'm not someone who just sits in a wheelchair all day. Singing has changed the way people perceive me."

–Jenna Feci, VSA arts youth performer

2. Arts in health care

"Throughout the ages the arts have been used to uplift the human spirit, provide expression for feelings and create a sense of community. Increasingly these strengths of the arts are becoming ever more valued for their contributions to the health and welfare of our communities and to individuals. As a consequence the arts are flourishing in hospitals, hospice, clinics, and nursing homes for their ability to reduce stress, enhance the healing environment, improve doctor-patient relations, communicate information, and provide patients with dignity, self expression and release from pain," states Naj Wikoff, Healing and the Arts Program Director of the C. Everett Koop Institute and President of the Society of the Arts in Healthcare, a national organization dedicated to the promotion of the arts as an integral component of healthcare.

John Graham-Pole, MD., founder of Arts and Medicine at Shands Hospital at the University of Florida in Gainesville, acknowledges the coming of a second renaissance—one that celebrates the marriage of art and science in medicine. No longer confined to the orchestra pit and the gallery wall, the arts are infiltrating the hallowed halls of medical science and hospitals nationwide. Modern scientific evidence supports this direction. The following list provides examples of controlled studies on the effect of art in health in diverse settings:

- Aesthetic environments shorten postoperative recovery and hospital stay;

- Artmaking reduces anxiety in patients with cancer and blood diseases;

- Artmaking raises circulating endorphin and natural killer cell levels;

- Cooperative play-acting and theater games raise pain thresholds and mood;

- Creative writing lessens the physical symptoms of asthma and arthritis;
- Creative writing reduces anxiety, depression and doctor visits;
- Dancing improves circulation, coordination and alertness in elders;
- Music enhances sleep patterns, alertness and growth of newborns;
- Music lowers state and trait anxiety in patients after myocardial infarctions;
- Music raises pain thresholds and reduces postoperative pain medications;
- Sharing stories regularly lengthens lifespan of advanced cancer patients;
- Sustained laughter lowers blood pressure and stress hormone levels.

"Arts programs for healthcare environments are no longer optional amenities; they are an important characteristic that distinguishes facilities in their communities and attracts patients, staff, and donors."

–Annette Ridenour, President of Aesthetics, Inc.

World-class art collections and performances inhabit the public spaces of major health care centers from Seattle, Washington to Iowa City, Iowa, to Gainesville, Florida. Artist residencies bring the arts to bedsides while impromptu dance and play-back theater groups can engage patients, families and their caregivers outside of hospital rooms. The opportunities for community cultural organizations to enrich the lives of their constituents in hospitals, hospices and long-term care facilities are expansive. For further information about arts in health care, contact the Society for Arts in Healthcare at 1632 U Street NW, Washington, D.C. 20009, (202) 244-8088.

3. Arts for juvenile offenders in retention and corrections

Adult crime is decreasing, but juvenile crime is on the rise. States pass bond issues to build more prisons and begin to imprison youths as adults at younger and younger ages. The cost of lost youth and the society burden of fully maintaining incarcerated youth are staggering. Grady Hillman, an award winning poet and technical assistance director for the arts partnership program sponsored by the National Endowment for the Arts and the U.S. Department of Justice's Office of Juvenile Justice and Delinquency Prevention, writes that evidence from adult and juvenile correctional arts programs have clearly determined that reduced recidivism rates occur among participants. Some states like California, with its Brewster Report, have quantified institutional benefits into cost savings for taxpayers.

Correctional arts programs take place in three unique settings according to Hillman: school alternative learning centers, community probation programs and detention facilities (county jails, prisons, or juvenile detention). Each has its own set of specific considerations for artists and arts administrations similar to other partnership programs. It is important to note that 50% to 75% of the youth involved in juvenile crime have an identified disability such as a learning disability, severe emotional disturbance and/or a form of mental retardation compounded by cycles of poverty, neglect and abuse.

Many youth-at-risk need accommodations of special education with supporting therapy. The arts offer youth involved in juvenile offenses a positive alternative to finding self-expression, increased self-esteem and windows of opportunity to achieve academic success. Artists become important role models as well. Hillman offers the following advice regarding artists working in juvenile/corrections environments:

- Artists need to be prepared for restrictions on art supplies and space;

- Artists should not try to "rescue" students;

- Artists should ensure that students' artwork is protected between sessions;

- Artists should never make promises they cannot keep.

Gaining experience is critical to longevity and creating acceptance within the correctional system. Accountability is key as well as clear and ongoing communications within the arts and juvenile justice partnerships. According to the Office of Juvenile Justice and Delinquency Prevention and the National Endowment for the Arts, the results of arts programs breaking the cycles of abuse and violence in the lives of youth involved in juvenile crime is shown in reduced disciplinary infractions in alternative education and correctional facilities, improved attendance in alternative education settings, and reduced recidivism upon release from correctional facilities. The arts offer youth at risk ways to re-enter community life and contribute successfully to it.

For further information, contact the U.S. Department of Justice, Office of Justice Programs, 81 Seventh Street NW, Washington, D.C., 20531.

"If children are to grow and make meaningful change there must be more than the fear of punishment as an enforcer. The artist becomes a mentor and conduit for change."

–Jack Rosati, director, Monroe County Children's Center, Rochester, New York

"The arts programs helped to set our girls free from the constraints placed on them by the lives they have led, the crimes they committed and the consequences they are now dealing with. They learned to think and express themselves by setting words and dance to the music within themselves."

–Jacque Coyne, executive director, Florida Institute for Girls

4. Arts and older Americans

Betty Friedan suggests that age allows us to pioneer and explore new horizons for society and our communities. In regard to the current "age wave," creativity is becoming an emerging metaphor with new possibilities for aging with integrity. It is an unprecedented time for America with:

- 70 million baby boomers aging;

- Americans living longer life-expectancies rising from 45 to 75 years of age;

- a declining birthrate juxtaposed against an aging culture.

To Dr. Andrea Sherman, Intergenerational Specialist, Mill Street Loft, this population revolution presents an extraordinary opportunity and challenge for arts organizations, artists and aging communities. Dr. Sherman, in the *Arts for Older Americans Monographs*, identifies specific ways in which the arts can be involved in this age shift.

1. The arts can help us understand and define aging, used as a vehicle to explore the "conversation" about what it means to grow old through writing workshops, forums, theatre, and dance.

2. The arts offer the opportunity for self-expression amidst loss, for achievement and re-engagement amidst voids and uncertainty. Many older adults face frequent loss in their lives–jobs, spouses, health, friends, or income.

3. The arts can provide ample opportunities for lifelong learning and service to others.

4. Arts organizations can expect to have older adults participate and need arts programming.

5. The arts can benefit from people's contributions and resources. Older adults can be creators, mentors, teachers, tutors and advisors, sharing the wisdom they have gained through a lifetime of experience.

Arts programs unite generations to develop mutual understanding–young and old celebrating culture and rebuilding communities

together. Opportunities to enter this new paradigm of program service and resource development have the potential to reinvigorate cultural activities community wide. However, cultural organizations must remember to address the "age wave" as it relates to the ADA accommodations in order to provide accessible and inclusive programs and services. For further information regarding best practices and model programs for services for older Americans, contact The National Center for Creative Aging, 138 South Oxford Street, Brooklyn, New York, 11217, (718) 398-3870.

"...We are on the threshold of a powerful and challenging time–an 'age wave'–where new paradigms for creative aging continue to be developed."

–**Susan Perlstein,** executive director, Elders Share the Arts

5. Arts centers and community day programs for adults with disabilities

Many arts centers offer programs developed primarily to meet the needs of adults with disabilities through creative expression in the arts. These centers, now established nationwide, also provide pre-vocational and vocational training in the arts and arts related fields thanks to the leadership of Florence Ludins-Katz, MA, and Dr. Elias Katz, at the National Institute of Art and Disabilities in Richmond, California. Due to the large-scale transfer of people with profound mental and physical disabilities out of large dismal state institutions to community residential facilities, the number of day programs for adults has greatly increased.

Such arts centers may include a gallery, performing arts areas, educational and vocational programs, and arts related community outings. The goals of the centers according to the Katzes include:

- artistic development;
- creation of work of the highest artistic merit;
- enhancement of self-image and self-esteem;

- strengthening of ability to make decisions for oneself;
- improvement of communication skills;
- Improvement of coordination and use of equipment and tools;
- development of potential for living independently;
- pre-vocational and vocational training;
- marketing of artwork;
- prevention of inappropriate institutionalization;
- involvement of families, caretakers and social agencies;
- active participation of the community, volunteers, interns, and students;
- involvement of children and youth with disabilities;
- education of the general public through exhibits, publications, seminars, and workshops.

The centers link professional artists and arts organizations to an underserved population of people with profound disabilities, their families and social service providers. ARCs (formerly known as the Association for Retarded Centers) adopted this innovative approach to day programming across the nation. For further information, contact the National Institute of Art and Disabilities at 551 23rd Street, Richmond, California 94804, (415) 620-0290.

"In contrast to earlier beliefs, there is widespread agreement that disabled people no only belong in the community but should be active members of the community, and should not be forced to exist in state institutions isolated from their fellow-citizens. As a consequence, large numbers of people with disabled persons now live in the community. But the question remains–how can they lead normal lives? Certainly, it is not normal to wander about the streets or to remain isolated in one's room at home. Therefore it is necessary to provide many different types of community activities and facilities to meet their special needs and desires...[by] the establishment of a

art center which has many similarities to an art studio or an art school, disabled persons come of their own volition. They work as artists and regard themselves as art students or as artists. They have an opportunity to exhibit their work and share it with others and in turn the community is enriched by their strength and creative power."

Florence Ludins-Katz, MA and **Elias Katz, Ph. D.** *Art and Disabilities: Establishing the Creative Art Center for People with Disabilities*

A Team Approach

All the target program areas described a team approach to developing high quality, sustainable arts and community service partnerships. The role of the artist is core to the development of program content with educators and health and social service providers in order to build out an effective context to form dynamic relationships that serve populations in highly structured environments.

Quality of Arts

There is an often-asked question: "What is arts therapy?" Art therapists receive training in both the arts and psychology and use the arts to improve the mental or physical condition of patients. A professional association such as the American Arts Therapy Association, which includes clinical and residency requirements, accredits art therapists. Although participation in the arts has therapeutic benefits, the arts should be presented in a professional and high quality manner as if within the walls of the originating cultural organizations.

The power of the arts in the lives of people with disabilities comes from its ability to transcend diverse abilities in the creation of an aesthetic experience. Disability culture is becoming an art form with a new aesthetic all its own in the arts.

"Identifying issues and working through and finding resolutions to problems is at the core of the expressive art therapists. Discovering meaning through art forms provides pathways for understanding self and others."

–Betty Jo Troeger, associate professor, Florida State University and registered art therapist

"A dynamic, rapidly developing international field of integrated and wheelchair dances is shattering boundaries in their artistic excellence and are rushing to the world stage, side by side with the best."

–Mary Luft, artist and executive director, Tigertails Productions, Inc.

THE PROCESS FOR CULTURAL ACCESSIBILITY

Strategies to create cultural access should begin with making the difficult easier. For example, ask the following questions: "What change can be made to enhance communications for all users?" and "Who should be involved?" The *Global Universal Design Educator's Network* then recommends drafting the strategies to make it happen.

The American Association of Museums, in *Everyone's Welcome: The Americans with Disabilities Act and Museums*, presents a "building block" process that cultural organizations, particularly museums, can use to plan, implement, evaluate, and advertise accessibility at their sites. To start, the short-term goal is compliance with the ADA minimum requirements. The universal design long-term goal is to achieve totally accessible programs and facilities at every level.

Comprehensive Accessibility Plan

The American Association of Museums suggests nine building blocks to achieve accessibility. Some of the steps provided below are required by the ADA, while others provide guidance in improving accessibility of programs, goods, services, and facilities. 504/ADA coordinators

are designated within each state arts council to monitor and assist cultural organizations with accessibility compliance and planning.

"Our policy at the Ohio Arts Council is to ensure everyone has access to the arts. People with disabilities are included on every grant review panel. Their expertise is invaluable in creating a universal environment for the arts in Ohio. We supply on going technical assistance and resources specially to support cultural access. Arts organizations must comply with the ADA and are encouraged to go beyond. We withhold state arts funding from any organization that is not in full compliance with this important civil rights law."

–Phyllis Hairston, 504/ADA coordinator, Ohio Arts Council

Nine building blocks to accessibility

1. Include a statement of commitment to accessibility in the institution's general policy or mission statement

The access statement should affirm that the institution welcomes people with disabilities and strives to provide access for all to the institution's programs, goods, services, and facilities. This is similar to the ADA Title II requirement for providing notice to the public. Embracing the concept of accessibility is essential and should have full support by the Director, Board and among all support staff.

2. Designate an accessibility coordinator

The accessibility coordinator could be a single individual or a group of employees. A single individual's job responsibilities could deal solely with facilitating access within the institution or in smaller organizations it could be one of several duties the individual carries out. Training should be provided to individuals who do not have knowledge and experience with disability and accessibility issues. Your local centers for independent living are excellent resources for training and ongoing technical assistance support. If a group of employees serves as the

accessibility coordinator, then each employee should serve as a resident "expert" for a particular accessibility goal and one person should be responsible for the overall coordination.

The overall responsibility of the accessibility coordinator is to oversee the implementation of the institution's accessibility plan. This plan should be institutionwide from facilities, programs, and public relations to financial, volunteer, and staff development.

3. Obtain input from people with disabilities

An effective way to achieve this is by organizing an Accessibility Advisory Council that typically consists of staff members, at least one board member, people with disabilities, and those who represent people with disabilities. Individuals should be chosen to participate because of their experience, knowledge, or interest in issues affecting how people with disabilities use cultural institutions, and they should reflect varied points of view on disabilities other than their own. The institution should have clear procedures for reviewing and implementing recommendations of the Accessibility Advisory Council.

4. Train staff on accessibility, the ADA and strategies for serving visitors

All staff, including volunteers, board members and outside consultants, should become familiar with accessibility issues. In order to achieve this, institutions should train staff on a regular basis. Training should include initial training to educate existing staff and assist with the evaluation process and ongoing training to refresh existing staff and educate new employees or volunteers. Accessibility training should include, but not be limited to meeting and hearing from individuals with disabilities as a first step in; providing specific and accurate information on the needs of people with disabilities; the institution's legal responsibility concerning non-discrimination of people with

disabilities and compliance with accessibility laws; and development of staff expertise on various-accessibility related solutions.

5. Conduct a review of facilities and programs to identify existing barriers and discriminatory policies or practices

Cultural institutions should examine all of their activities, programs, communications, services, policies, and facilities to determine how well they facilitate participation of people with disabilities. This is considered self-evaluation and is required by the ADA Title II. An accessibility study should review the following major issues: language of the institution's policies and practices; accessibility of programs, activities, events, web site, and publications from a communications standpoint; accessibility of buildings where programs, activities and events take place or where goods or services are provided; and adequacy of staff training for visitor and volunteer access. The review process should incorporate discussions by staff, volunteers, board members, the accessibility advisory council, and specialists or consultants.

6. Implement short and long term institutionwide accessibility including: program accessibility, barrier removal, effective communications, and new construction and alterations

After an institution has reviewed its facilities and programs, it should begin planning for needed accessibility modifications. Short-term modifications should be determined and handled immediately. Long-term modifications should be determined as well and a "transition plan," similar to the ADA Title II requirement, should be developed to help institutions implement the transformation to accessible programs and facilities in a realistic and cost-effective way.

One example of implementing accessible programs is to provide a sign language interpreter for a guided tour of an exhibition. This logo is used to inform the public that the guided tour will be interpreted in sign language.

7. Promote and advertise accessibility in the institution

An institution can effectively increase its audience by publicizing the accessibility of its programs, services and facilities. All promotional ads, institution literature, postings, and announcements should be accompanied by accessibility symbols where appropriate. Accessibility symbols include the following types of access: wheelchair accessibility, sign language interpreted programs and text telephone (TTY) availability. Institutions should also use other means of standard communications such as targeting specific media and contacting disability- related organizations, services and social groups.

8. Establish a grievance process

The ADA Title II law requires that entities with fifty or more employees have a grievance procedure. Though the ADA does not establish a specific process, all institutions should adopt a grievance procedure. Many institutions use the same procedures as with other civil rights complaints. Under the ADA, visitors and volunteers have the legal right to file complaints and lawsuits against cultural institutions that do not provide accessible programs and facilities. Institutions may be able to resolve potential disputes before formal complaints are filed by providing a grievance policy. By working with a complainant to identify and correct access problems, experience has shown that institutions can resolve most informal and verbal complaints.

9. Conduct ongoing review of accessibility efforts

The ADA requires cultural institutions to continually evaluate remaining barriers to determine whether or not their removal has

become readily achievable. Institutions should develop long-term policies and systems to incorporate accessibility into all new projects, programs and activities. Because accessibility is a work-in-progress, institutions should also periodically reevaluate themselves to make sure they are meeting the needs of staff and visitors in the most cost-effective ways possible.

Process Checkpoint List

Use the following list of checkpoints to help you achieve universal accessibility.

❑ Form an advisory committee on accessibility.

❑ Make an institutional commitment to universal accessibility.

❑ Do an accessibility survey.

❑ Develop a long-range plan with input from board, staff and the advisory committee.

❑ Develop a fundraising plan with input from board, staff and the advisory committee.

❑ Develop a marketing plan that includes outreach to new audiences.

❑ Make sure your goals are clear to everyone and that staff and volunteers are aware of how they are expected to participate in achieving them.

❑ Employ architects and other professionals to work with your staff, board and advisory committee to achieve facility accessibility.

❑ Review programming choices.

❑ Review way-finding plan.

❑ Review marketing and advertising promotions.

❑ Reevaluate on a regular basis.

—Beyond Access to Opportunity: A Guide to Planning a Universal Environment for the Arts
New York State Council on the Arts

Disability Issues

"Nine Building Blocks to Accessibility" addresses the issues of sensitivity training and developing an ongoing community advisory group to guide the creation of a universal environment for the arts. In the following section, Douglas Towne, from the Disability Relations Group, describes three key issues that determine the level of participation from people with disabilities—economy, transportation and cultural identity.

Issues Related to Disability

Organizations should start considering people with disabilities as persons with varying abilities. This is a way that many people with disabilities see themselves within communities. Below are three key issues related to disability:

Economy

Although there are increasing numbers of highly successful professionals with disabilities in every area of employment, among the disabled population in America, there is a 75% average unemployment rate. Many survive on the limited Social Security income or Supplemental Security income payments they receive from the government. This cash benefit can only amount to $400 to $700 per month. Cultural organizations should consider these factors when involving people with varying abilities as volunteers or participants. The cost of cab fare alone could keep them from participating in your organization. A ticket price of $20 could quite literally be 5% of their monthly income.

Transportation

Transportation is one of the most difficult barriers that block the way of people with varying abilities from full community inclusion. You will find that transportation systems come in many forms depending on your community. If you have a local transportation authority that provides mass transit, under the ADA, they are required to provide access to their system for people with disabilities. This includes "paratransit" services for those who cannot use the fixed route system. Check with your state and local government to determine what other resources may be available. You may find it necessary to partner with other community nonprofits that have the ability to offer accessible transportation. It is important to remember that moving people in wheelchairs around is costly. You may want to contact your local Center for Independent Living on the state of accessible transportation in your community at the beginning of your program to include people with varying abilities. A partnership with the local Center for Independent Living is recommended at the outset where all of these issues are concerned to avoid any misstep and to get the necessary support from the disability community.

Cultural Identity

When identifying different disability cultures, the deaf and blind communities often times may be best accessed through other local organizations such as the Deaf Service Bureaus or the local chapters of the American Council of the Blind and the National Federation of the Blind. These groups, in some cases, consider themselves separate cultures but still can be contacted through your local Center for Independent Living. Should you have any difficulty in accessing assistance locally, you can also contact the Disability Relations Group, toll free at (866) 550-4440 for further assistance.

—The Disability Relations Group

TOOLS FOR CREATING A UNIVERSAL ENVIRONMENT FOR THE ARTS

Universal Environment = Usability = Opportunity

Recently, studies have shown that architectural and other accessible adaptations that have been developed to serve people with disabilities are being used by people without disabilities as much if not more than people with disabilities. *Everyone's Welcome: The Americans with Disabilities Act and Museums* presents the following example for a universally designed museum exhibit:

"Suppose it (museum exhibit) was designed for use by a visitor in a wheelchair, labeled with large-print text, offered with tactile alternatives and included an audio-description tour. This can now offers greater access and convenience to families with babies in strollers, visitors at the back of a large group, and small children not yet able to read."

It is evident that people with disabilities, as well as the general public, are being served better by organizations that offer an environment that is usable by all. It is in an organization's best interest to not only address the ADA standards, but to reach out to all audiences with an environment that can be utilized by everyone. There are many important factors to consider when creating such an environment.

What Is a Universal Environment for the Arts?

A universal or inclusive environment for the arts is one that is usable by everyone, people with and without disabilities and people of all ages. It is an environment with a physical plant (buildings and grounds) and communication systems that go beyond minimum access standards to serve the broadest public. It is an environment where programs and exhibits are chosen that reflect a commitment to being part of an inclusive community.

In response to the passage of federal legislation requiring public institutions to make it possible for people with disabilities to use their programs and services, we saw the development of what are now commonplace architectural design features, curb cuts and ramps being the most familiar. Interestingly, the design elements originally developed for people with disabilities were adopted by people without disabilities. For instance, ramps are used by people pushing strollers, people making deliveries and many others without disabilities.

The way people choose to use so-called accessibility adaptations makes an important point: places and products can be designed that work better for everyone. We shouldn't be asking ourselves how to construct a ramp for one group of people and a staircase for another. We should ask ourselves how to create an entrance that everyone can use. The same is true of non-space issues. A tactile model can enhance everyone's enjoyment of a work of art. A readable print presentation is just that: more easily readable for all.

Using the model of universal planning moves the discussion beyond separate accommodations for people with and without disabilities to a discussion of how to create an environment that works for and is respectful of the independence and culture of everyone. Universal planning makes choices that recognize that we are all different, that we have different ways of doing things and that we have different preferences about how we access information and how we communicate. Universal planning makes choices that create flexibility so that, as the designer Satoshi Kose suggests, "we modify the environment, instead of modifying people to adapt to the environment."

—A Universal Environment: Beyond Access to Opportunity
New York State Council on the Arts

HOW TO MAKE FACILITIES, PROGRAMS AND COMMUNICATIONS USABLE BY EVERYONE

Developing an Accessible Facility– Enhancing Mobility, Vision and Hearing

Staff, volunteers and visitors should first and foremost be able to safely and successfully find, enter and move through a public facility and its designated visitor areas.

1. Provide a safe and independent route of travel for the site and its buildings that is accessible by all people, especially those who use wheelchairs, walking aids, walk with difficulty or have a visual impairment. Everyone, including people with disabilities, must be able to move about the site with safety and ease.

- A single continuous accessible pedestrian path should be provided that is at least 36 inches wide, firm, stable, and slip resistant without low or overhanging hazards or obstructions, and not require the use of stairs.

- All circulation paths provided must be free of protruding objects.

- The accessible route should provide a direct path from parking, bus stops, drop-off areas, and sidewalks into a primary building entrance that links or joins all designated visitor areas, such as exhibits, program spaces, gift shops, drinking fountains, and restrooms.

2. Provide an accessible route to the entrance of the facility.

- The route provided should be free of steps or have a ramp, elevator or a gently sloped walkway to change levels.

- Another entrance can be provided or converted into an accessible entrance it the existing main entrance is inaccessible, difficult to modify or modification would destroy historic significance.

- Signage should be installed at the accessible entrance if multiple entrances are available.

- If all entrances are not wheelchair accessible, signage should be installed at the inaccessible entrances directing people to the accessible entrance(s).

3. Provide an accessible ticket booth or information front desk, center or area.

- The ticket booth or main information desk, center or area should be on the accessible route that connects the parking and the accessible entrance.

- If there is an information desk or ticket booth, there should be sufficient space that allows a person using a wheelchair to approach and maneuver into a position to receive information or pay for a ticket.

- To be wheelchair accessible, a section of the desk or counter must be no higher than 36 inches.

- The information desk should provide a brochure that explains the facility's overall structure. The ADA requires directional information found in brochures to be available in alternative formats such as tactile or audible.

- A raised line-map or tactile model of the floor plan, with raised lines and Braille labeling is helpful to all visitors.

4. Provide an accessible circulation route throughout the facility.

- The circulation route should be well lighted, clearly defined and have a simple geometric layout that is easy to follow.

- The accessible route should be smooth, level, slip-resistant, and not have stairs or steps.

- Avoid highly glazed ceramic tile because its surface is slippery and makes it difficult for a person in a wheelchair to get sufficient traction.

- Sufficient room should be provided so a person in a wheelchair can maneuver throughout the space.

5. Eliminate protruding objects.

- Protruding objects must not infringe on any interior or exterior pathway.

- Building elements such as fire extinguishers, signs, drinking fountains, or plants may not protrude from walls or hang down from the ceiling in any way that a person with a visual impairment could run into the element and be injured.

6. Provide adequate signage, lighting and other way-finding cues.

- Signage should be located in standard, logical and predictable places that are perpendicular to the visitor pathway.

- Signage required to be accessible by the ADA Standards is divided into two categories: (1) signage that identifies permanent rooms and spaces must be tactile and visually accessible, and (2) signage that provides information about or directions to functional spaces must only meet the visual criteria.

- Directional signage must be high contrast and have a non-glare finish.

- Lighting of at least 5 to 10 foot-candles should be provided along the accessible route.

- Changes in illumination can be provided to indicate changes in direction.

- Pathways or accessible routes can be indicated by different surface texture.

- Signage should refer to the direction or accommodation and not to the users, i.e. "ramped entrance" or "accessible parking."

7. Use a consistent system of control barriers throughout the facility.

- Barriers should not be a hazard themselves therefore they should be cane detectable. A barrier's leading edge or detectable

element must be no higher than 27inches above the floor to be cane detectable.

- Barriers should not prevent a visitor from seeing, hearing or interacting with a program, performance or exhibit.

8. Provide an accessible emergency system.

- Provide as many accessible emergency exits as the number of fire exits required by the National Fire Protection Association's Life Safety Code (NFPA 101).

- Provide emergency exits that lead to the main accessible entry route or another accessible route.

- Provide notification about accessible emergency exits at key points in the facility.

- Provide both visual and audible fire alarm systems.

Developing Accessible Communications in Public Programs

It is equally important to ensure that people are provided with accessible information and services while visiting a cultural organization.

Readable print

Provide legible printed materials, such as publications, brochures, programs, and signage, that address the needs of people with disabilities, older adults, those learning English as a second language, those trying to read materials in low lighting, and those in groups reading to children.

- Use a simple typeface or font such as simple serif or sans serif for printed material and labeling. Helvetica, New Century Schoolbook, Arial, and Times Roman are also among the most legible fonts.

- All publications should use a minimum 12 point typeface size.

- Use upper and lower case type, type set in all caps is difficult to read and should be limited to titles and headlines.

- Avoid very condensed, extended, extremely bold or light typefaces, and underlining text.

- Type should exhibit a high degree of contrast from its background. Text and visuals should be at least 70% darker or lighter than their background.

- Illustrations should not be printed over text and vice versa.

- Make margins flush or justified on the left and ragged on the right.

- A matte or non-shiny paper or background that will not produce a glare is recommended for printing.

- The size and shape of a publication should be manageable by someone with a hand or motor disability.

- Spiral binding is recommended for large publications so the piece will lie flat if someone is using a reading machine.

For additional information regarding graphics for signage refer to the Communication Accessibility Resources section of the Appendix.

Examples of Print Readability in a Publication

Providing readable print for people with low vision depends on the size, spacing, contrast, and letterform shape of the text. Examples of the distinctions are provided below.

Example 1 exemplifies common, but inaccessible print. The font is Times New Roman, which is considered to be a highly readable old style serif font, but it is only 10 point. The type is also set justified or "square."

> **Example 1**
>
> Community organizations' program offerings today reflect the changing local and global environments. Programming is approached less as a static set of activities and more as a constantly changing and evolving mix of activities.

In example 2, the font is still Times New Roman, but it is larger now at 12 point. The space between the lines has also been increased to 20% greater than the height of the type. The type is also set "ragged" or flush left. 18 point is the minimum typeface size for large print in publications.

> **Example 2**
>
> Community organizations' program offerings today reflect the changing local and global environments. Programming is approached less as a static set of activities and more as a constantly changing and evolving mix of activities.

–Beyond Access to Opportunity: A Guide to Planning a Universal Environment for the Arts
New York State Council on the Arts

For exhibition label text, provide the essential information so that it is accessible to people with disabilities, older adults and people who have difficulty reading English or are learning English as a second language.

- Avoid the use of complex English, jargon and technical language in text panels unless such language is explained within the text or in supplementary handouts.

- Use the active voice in text panels; limit sentence label length.

- Use a maximum of 55 characters per line in exhibit text because text containing too many characters on a line is difficult to read.

- Provide a short overview paragraph set in clear, large print at the beginning of introductory and thematic label panels that allows visitors to gather key information without having to read all of the text.

- Carefully link sentences and paragraphs and try to limit a sentence or paragraph to one idea.

- Provide line drawings, silhouettes, and photographs that complement label text to aid comprehension for those with reading difficulties.

- Main exhibition label information must be available within the galleries in alternative formats (e.g., Braille, audio) for people who cannot read print.

- Use typefaces that are readily legible such as sans serif or simple serif.

- Do not set text in all caps and avoid the use of script and italic type for essential information. Alternatives to italic type, such as underlining, boldface, quotation marks, or another color, should be used for book citations, artwork titles, foreign words, and quotations whenever possible.

- If an exhibition title is presented in an ornate or decorative type, it should be repeated in a clearer type at an accessible location near the exhibition entrance.

- Select type size appropriate to the viewing distance. Keep in mind the effects of crowds on actual viewing distance when calculating distance. People who have low vision will need larger type than other visitors at every distance.

- Print only on a solid background. Print on imaged backgrounds, textured surfaces or backgrounds with differing colors and tones are unreadable for people with low vision and perceptual difficulties.

- Mount labels so visitors can get very close to read them. People with low vision often must be within 75 mm (3 in.) of a label to read it. Label and location should be situated so that the reader does not block his own light and should be out of the way of barriers, protruding objects, stairs, or the swing of a door.

- Keep in mind the natural line of sight when mounting labels. Labels mounted at 45 degree angles to the front of an exhibition case or vitrine are more accessible to people who have low vision than those that are mounted flat on the floor of the case.

- Mount wall labels at a height that is comfortable for both those seated and standing. Wall labels mounted with a centerline at 1370 mm (54 in.) above the floor are at an optimum height for everyone.

- Locate labels in consistent locations throughout an exhibition.

- Provide sufficient light to read labels. For text to be readable by people with low vision, lighting on the label must be between 0 footcandles to 30 footcandles.

Audio description

Provide audio description, a narration service that allows people to hear what cannot be seen. Audio description is intended for people with vision loss and is very useful with theater performances, film presentations and museum exhibitions because it allows people to experience such programs.

Audio describers are trained to:

- Capture the essence of a scene and provide detailed information in clear, concise statements;

- See all of the visual elements of an image or an event;

- Determine and convey the images most necessary to an understanding and appreciation of the event or program being viewed in as few words and in as little time as possible;

- Complement the program or exhibition with descriptions, not interfere with it.

Samples of Audio Description from *Audio Description Associates* can be found at their web site at www.audiodescribe.com.

Audio description

"This golden picture is almost entirely taken up by the symmetrical figures of the seated Christ on the right, placing a bejeweled golden crown on the inclined head of the Virgin Mary, who sits on the left, her hands crossed over her chest. Above them, centered in the rays of a golden sunburst, hovers a white dove with gray-tipped wings"

Tactile presentations

Provide tactile opportunities whenever possible. Touch allows people with vision loss to experience programs such as visual art exhibitions.

- Use original art and artifacts whenever possible for tactile exploration. Since most original art cannot be touched, casts and reproductions should be added, ideally for everyone to touch.

- Provide clear and concise verbal descriptions of works of art being touched to enhance the experience.

- Provide tactile pictures and hands-on art activities to supplement information about the artwork.

- For very large sculpture, small replicas may be mounted adjacent to the original at an appropriate height that allows people seated in a chair or children to explore it tactically.

Conveying audible information

Provide appropriate services to convey audible information effectively. Methods offered that allow people with hearing loss to experience programs will vary depending on the complexity of the program, the information being conveyed and an institution's budget.

Captioning:

- Provide captioning when necessary to translate the spoken word into simultaneously displayed text in programs such as films and video productions. There are several different captioning methods that may be used:

Open captioning is a useful method for displaying spoken portions of video programs because the captions always appear on the screen. It Is Important to consider the placement of the captions so they do not obstruct the screen and viewing of the program. Open captioning is preferred by many and is an excellent example of universal design as it improves reading skills, allows the audio volume to be turned down and is used by many to learn English as a second language.

Closed captioning is similar to open captioning except it allows captioning to be turned on or off. For television, it requires a special decoder or a television with a decoder chip to display the captions and control buttons for video displays.

Rear Window Captioning System® displays captions in reverse on a light-emitting diode (LED) text display mounted in the rear of a theater. People who wish to view the captions have a transparent acrylic panel attached to their seats to reflect the captions so they are superimposed on the movie screen.

Assistive Listening Devices:

- Provide assistive listening devices (ALDs) that increase the volume of desired sound without increasing the loudness of background noises. ALDs can be used in live performances, films, lectures, and guided tours. There are three types of ALDs: (1) inductive loop, which transmits sound using an electromagnetic field, (2) infrared systems, which transmit sound via light waves, and (3) FM systems, which transmit sound via radio waves. The equipment needed for ALDs depends on how they will be used; however, a transmitter and several receivers will be needed.

- Provide signaling systems such as flashing lights or vibrating receivers to alert visitors with hearing loss that a program or performance is beginning, going into intermission or ending.

- Provide certified American Sign Language (ASL) interpreters by request for meetings, special events and programs. Note in all publications, advertisements, registration forms, and at information desks that visitors should contact to arrange for an interpreter. Indicate deadlines for requests also.

"Cultural institutions have focused primarily on providing access to their buildings and to their public-education programs, but have paid scant attention to the content of their exhibits and what those presentations say—or don't say—about this newly enfranchised constituency. We need integrate ideas about disabled people into our exhibits and performances."

–Simi Linton, president, Disability/Arts

Training

Provide staff and volunteer training on effective ways to interact with people who have disabilities so that they feel welcome and included. Local training can be conducted by your local Center for Independent Living Center. Nationally, the VSA arts of Massachusetts' Cultural Access Institute provides annual national training.

Tips for Developing Disability Awareness

These tips are to be used as a starting point to developing a better understanding of disability issues and the disability community as a whole.

General suggestions to improve access and positive interactions

- Offer assistance, but do not insist. Always ask before you assist someone and do not help without permission. If you do not know what to do then ask the person what would be helpful.

- Focus on what the person is able to do, rather than on their disability. Be aware that alternative ways of doing things can be equally effective.

- Be aware of limitations specific to a disability, but do not be overprotective. Do not exclude someone from an activity because you think his or her disability would be a problem. People with disabilities need to be able to take risks and make their own decisions.

Tips for Developing Disability Awareness (continued)

Suggestions to improve access and positive interactions for major disabilities

Blindness and Visual Impairments

- When guiding a person who is blind, let him or her take your arm. If you encounter any obstacles, such as steps or curbs, pause briefly and identify them.

- Speak directly to the person in a normal tone and speed.

- Do not pet or play with a working service animal.

- Inform him or her that you are entering or leaving a room.

- When a person with vision loss is meeting many people, introduce them one at a time.

Deafness and Hearing Loss

- It is important to remember that the major issues for people who are deaf are the challenges they experience in trying to communicate with people, not their inability to hear, and gaining information from the hearing society.

- When talking to people with hearing loss, use a normal tone and speak clearly and distinctly.

- Use facial expressions, body language and pantomime.

- If there is a sign language interpreter, speak directly to the person who is deaf, not the interpreter.

- If you do not understand a person with hearing loss, ask them to repeat themselves.

Learning Disabilities

- It is important to remember that learning disabilities do not mean inferior intelligence.

- Be aware that periodic inattentiveness, distraction or loss of eye contact by a person with a learning disability is not unusual.

- Discuss openly with a person with a learning disability the preferred way to communicate.

- Be aware and sensitive that some information-processing problems may affect the social skills of someone with a learning disability.

Mental Illness

- It is important to remember that people with mental illness do not have lower intelligence.

- Be aware that people with more serious forms of mental illness may have difficulty processing or expressing emotions.

- Be aware and sensitive to the fact that a person with a mental illness may overreact to emotionally charged topics or discussions.

- It is helpful to learn more about the nature of a person's diagnosed mental illness.

Tips for Developing Disability Awareness (continued)

Developmental disabilities, which can include autism, cerebral palsy, brain injuries, and other neurological impairments

- Interact with a person with a developmental disability as a person first.

- Avoid talking around or about a person with a developmental disability when they are present.

- Break down concepts into small and easy to understand components.

- If necessary, involve an advocate when communicating with a person with a developmental disability.

Mobility impairments

- Do not be afraid to shake hands with someone who has very little grasping ability.

- Do not hold onto a person's wheelchair because it is seen as part of the person's body space. Holding on to, touching or leaning on a person's wheelchair is both inappropriate and can be dangerous.

- Talk directly to a person in a wheelchair not someone who is attending to them.

- Consider sitting down when talking to a person in a wheelchair to share eye level.

- Use people-first terminology such as "person with a physical disability." Avoid using inappropriate terms such as "cripple," deformed," or "wheelchair bound."

—Access and Opportunities: A Guide to Disability Awareness

Developing Accessible Communications in Promotions

People generally find out about programs and events at facilities like museums, performing arts centers, historic sites, or theaters from newspapers, radio, mailings, posters, newsletters, television, and web sites. In order to effectively inform people with disabilities about accessible programs and events, alternative approaches to providing public information should be practiced.

Provide simple, low-key statements regarding accessibility in all publicity.

- Example: "This facility is accessible to all people."

- Do not use the word "handicapped" or the phrase "accessible to the handicapped."

Use disability access symbols in publicity and promotional materials that indicate what type of accessibility the facility offers.

- The most recognized symbol is a stylized wheelchair, the International Symbol of Accessibility.

- Disability access symbols can be downloaded free of charge from The Graphic Artists Guild at www.gag.org.

Examples of disability access symbols

Accessibility symbol. The wheelchair symbol should only be used to indicate access for individuals with limited mobility, including wheelchair users.

Access for people who are blind or have low vision. This symbol may be used to indicate access for people who are blind or have low vision, including a guided tour or tactile description.

Braille Braille

Telephone typewriter (TTY). Also known as a text telephone, or telecommunications device for the deaf (TDD), TTY indicates a telephone device that is used with the telephone for communication between deaf, hard of hearing, speech-impaired and/or hearing persons.

Live Audio Description. This symbol may be used to indicate that live audio description will be available.

Sign Language. This symbol indicates that an American Sign Language interpreter will be available.

Design legible and easy to read printed promotional materials such as flyers, brochures, invitations, and newspaper advertisements.

- Use typefaces such as simple serif or sans serif that are large, high contrast and easy to read.

- If space is limited, use large print for key concepts, dates and telephone numbers.

- Avoid placing images over text and vice versa.

Use broadcast media when possible to reach people with disabilities, particularly people with visual and cognitive disabilities.

- Television can potentially be the ideal way to communicate to people with disabilities because it provides audio and visual elements as well as many programs that are audio described or captioned.

Provide an accessible website. Specific steps must be taken to ensure that your web site is usable by everyone, including people with sensory loss.

- Keep navigation simple, intuitive and easy to follow.

- Make text accessible by making text scalable, which allows visitors to view the text at whatever size is comfortable for them to read.

- Use text-based browsers as well as conventional graphical browsers and add audio to visual information whenever possible.

- Some specific features to make web sites accessible are:

 Alt-text tag—audio descriptions of the content of an image that interface with voice activated computers.

 D-link—provides a longer, more complete description of what an image looks like.

 Captions—multimedia captions can be used to make video or audio/sound clips in websites accessible.

 Descriptions—means descriptions of static images or more in depth narration of a video clip to describe what is taking place.

"The power of the Web is in its universality. Access by everyone regardless of disability is an essential aspect."

–Tim Berners-Lee, W3C director and inventor of the World Wide Web

Provide accessible telecommunication devices.

- Have a text telephone (TTY) available, which can be used with traditional telephone handsets to allow messages to be typed back and forth between staff and people with hearing or speech impairments.

- Publicity and promotional material should indicate TTY telephone numbers.

Notify local disability organizations and groups about accessible activities, programs or services.

- Local disability organizations and groups can usually be found listed in the resource pages of the telephone book.

- Additional information can be found through centers for independent living, school systems, health care organizations, and local government.

- Further information is provided in the Appendix section of this chapter.

FUNDING ACCESSIBILITY

Usually, one of the first concerns of accessible adaptations is the cost. Fortunately, since the development of universal design, designs and renovations are no longer considered as costly, disruptive or unsightly as they were before the ADA. It is estimated that for a new building, universal design elements amount to less than one percent of total construction costs. Universal design was developed to eliminate the need for "special features" that are costly and benefit only a small group, and instead designs structures that are more easily adapted to the changing needs of all building occupants and visitors.

Program service support can be cultivated from untapped sources as described below by Hope McMath from the Cummer Museum of Art and Gardens:

Cultural Access programs at the Cummer Museum have impacted thousands of children and adults with disabilities from our community. The

incredible reach of these programs has been achieved through diverse funding sources, all of whom support making the arts accessible to all. Many of these funders were otherwise outside of our radar, but came forward to assist the museum in specific initiatives. For example, the Metlife Foundation has generously funded a two-year program to make the museum accessible to individuals with visual impairments by supporting a partnership between the Cummer, the Florida School of the Deaf and Blind and local service agencies. Another example is Citibank, who has funded our VSA arts Festival for seven years. The partnership between Citibank and the Cummer has not only allowed the museum to financially handle the program, but it has raised community awareness of arts education and important issues in the disability community. Funders who do not traditionally fund art museums have stepped forward, the museum has new relationships with local and national foundations and corporations, and our entire community has benefited.

Look for available funding sources, such as federal, state and local grants, foundations, and corporations. You can research for funding sources on the Internet and at your local public or university libraries.

Examples of funding sources for disability related programs and projects and accessibility services:

- Department of Housing and Urban Development offers the Community Development Block Grant Program that provides funds each year to state, county and city governments for projects by public and private organizations involved with barrier removal in both public and private cultural facilities and programs.

- NEC Foundation of America provides grants that focus on science and technology education and the application of assistive technology for people with disabilities.

- Mitsubishi Electric America Foundation funds projects and organizations that

advance the independence, productivity and community inclusion of young people with disabilities through technology.

- MetLife Foundation supports various educational, health and welfare, and civic and cultural organizations. Recently, MetLife introduced a new initiative, Access to the Arts, that aims to encourage organizations to make the arts more inclusive and accessible for the special- needs community by funding innovative programs.

- The Foundation Center provides resources by geographic region and subject area to private and corporate foundations.

- For contact information see the Funding Resources section of the Appendix.

When applying for funding and writing grants, the Association of Science and Technology Centers (ASTC) recommends the following:

- Include target audience statistics when describing the need for an accessibility project. For example, about 20% of the United States population are classified as having a disability, with nearly half of them considered to have a severe disability.

- Use demographics of the cultural organization's surrounding community also. Contact the Bureau of the Census (www.census.gov) for census data in your particular area. Local government and organizations that serve people with disabilities also maintain current statistics.

- Use input from focus groups, visitor surveys and/or advisory committees in writing grant proposals to make sure the project is suited to its target audience.

- When applying to a federal agency, such as the National Endowment for the Arts (NEA), include the cost of program accommodations (e.g., sign language interpretation, audio description or large print programs) in your budget for the project

IN CONCLUSION

The "design for all" principal is an advantage for all ages. With the changing demographics, unlimited availability for community collaborations and technical assistance to support cultural access, a complete invitation can now be extended for the great public theater where everyone is a player.

To paraphrase *Access for All Ages*, providing cultural access to all, creates these advantages.

● the arts become accessible to more people;

● the arts become stable through the course of people's lives and accessible in each phase of their lives, especially for children and older adults;

● everyone profits from an accessible society because sooner or later everyone will belong to a special category;

● fewer additions and provisions will be needed for targeted populations, which will make arts facilities and program operations more durable and in the end cheaper;

● less stigmatization of people with disabilities and older adults will take place because many provisions specifically created for these groups will be superfluous;

● an accessible arts environment contributes to the realizations of other policy objectives related to social justice, safety, and quality of life, including independent living for all which includes young people with disabilities as well as older adults;

● arts programs and productions will profit from a larger circle of employees, volunteers and patrons.

Creating cultural accessibility through a universal environment where all can participate may require an organization system change, but the rewards will launch your programs and make your facility a vibrant part of community life in the twenty-first century.

"The Florida Department of State's Division of Cultural Affairs supports the development of partnerships and programs that ensures all of Florida's people have access to cultural programs, resources and opportunities that promote life long learning in the arts. By utilizing the power of the arts to enhance education, advance socialization, contribute to the economic life of the community and promote inclusion, the Division's programs have inspired and improved the lives of youth, adults and elders."

–Dana DeMartino, arts education program manager, Division of Cultural Affairs, Florida Department of State

REFERENCES AND SELECTED RESOURCES

American Association of Museums. *Everyone's Welcome: Universal Access in Museums.* Washington, D.C., 1996.

Hillman, Grady. *Artists in the Community: Training Artists to Work in Alternative Settings.* Washington, D.C.: Americans for the Arts, 1996.

Hillman, Grady. *Arts Programs for Juvenile Offenders in Detention and Corrections: A Guide to Promising Practices.* Washington, D.C.: National Endowment for the Arts, 1999.

Katz, Elias Dr. and Florence Ludins-Katz, M.A.. *Art and Disabilities.* Cambridge, MA: Brookline Books, 1990.

Katz, Elias Dr. and Florence Ludins-Katz, M.A. *Freedom to Create.* Richmond, California: National Institute of Art & Disabilities, 1987.

National Age Discrimination and National Bureau for Accessibility. *Access for All Ages!* Utnect, Netherlands, 2000.

National Assembly of State Arts Agencies and National Endowment for the Arts. *Design for Accessibility: An Arts Administrator's Guide.* Washington, D.C., 1994.

New York State Council on the Arts. *Beyond Access to Opportunity: A Guide to Planning a Universal Environment for the Arts.* New York, 2001.

Ostroff, Elaine, *"Beyond ADA to Universal Design."* St. Petersburg, FL: Arts Extension Service Program, 2002. (unpublished lecture)

Ostroff, Elaine, *"Designing for the 21st Century."* St. Petersburg, FL: VSA arts of Florida Universal Design Regional Workshop, 2002. (unpublished lecture)

Palmer, Janice and Florence Nash. *The Hospital Arts Handbook.* Durham: Duke University Medical Center, 1991.

Perlstein, Susan and Jeff Bliss. *Generating Community: Intergenerational Partnerships Through the Expressive Arts.* Brooklyn: Elders Share the Arts, 1994.

Proudhon, P.J. *What is Property: An Inquiry into the Principle of Right and Government.* Cambridge: Cambridge University Press, 1994.

Sanoff, Henry. *Community Participation Methods in Design and Planning.* New York: Wiley, John & Sons, Inc., 1999.

Sarkissian, Wendy. *The Community Participation Handbook: Resources for Public Involvement in the Planning Process.* Murdoch, W.A.: Institute for Science and Technology Policy, Murdoch University in association with Impacts Press, 1994.

Sherman, Andrea and Mill Street Loft, *"Arts Participation: A Greying America."* The Arts and Older Americans Monographs, Volume 5, Number 5. New York: Americans for the Arts, 1996.

Story, Molly F., James L. Mueller and Ronald Mace. *Universal Design File.* Raleigh: The Center for Universal Design, 1998.

Sutton, Sharon and Susan Kemp, *"Children as Partners in Neighborhood Placemakings."* Journal of Environmental Psychology, 2002.

Sutton, Sharon, Ph.D., FAIA, *"Designing A Great Public Theatre Where All Can Perform Their Part."* Tallahassee, FL: Florida A & M University, 2002. (unpublished lecture)

Thader, Barbara, James Chapple, and Christina E. Osco. *Strategies for Inclusive Classroom Environments.* Washington, D.C.: VSA arts, 1998.

Theatre Communications Group, *"Access, Activism and Art."* American Theatre, Volume 18, Number 4. New York, 2001.

APPENDIX: CULTURAL ACCESS RESOURCES, REFERENCES AND CHECKLISTS

Government and Nonprofit Resources

Adaptive Environments Center

374 Congress Street, Suite 301
Boston, MA 02210

Telephone: (617) 695-1225 (Voice/TTY)

Web site: www.adaptenv.org

Adaptive Environments Center is a not-for-profit organization that promotes accessibility as well as universal design through education programs, technical assistance, training, consulting, publications, and design advocacy. Their web site has a reference library and resource publications and materials for purchase.

American Association of Museums (AAM)

1575 Eye Street NW, Suite 400
Washington, DC 20005

Telephone: (202) 289-1818 (Voice),
(202) 289-8439 (TTY)

Web site: www.aam-us.org

AAM is dedicated to promoting excellence within the museum community through advocacy, professional education, information exchange, accreditation, and guidance on current professional standards of performance. AAM assists museum staff, boards, and volunteers across the country to better serve the public. Their bookstore has some very useful material on museum accessibility.

Association of Science and Technology Centers (ASTC)

1025 Vermont Avenue NW, Suite 500
Washington, DC 20005-3516

Telephone: (202) 783-7200 (Voice)

Web site: www.astc.org/resource/access/index.htm

The Association of Science and Technology Centers seeks to support science centers and museums in their ongoing efforts to open their doors to all people, and specifically to people with disabilities and their families and friends. The ASTC has a very useful web site with information, links, stories from the field, implementation strategies, resource lists and publications.

The Center for Universal Design

NC State University
School of Design
Box 8613
Raleigh, NC 27695

Telephone: (919) 515-3082 (Voice/TTY)
InfoLine: (800) 647-6777

Web site: www.design.ncsu.edu/cud/

The Center for Universal Design is a national research, information, and technical assistance center that evaluates, develops, and promotes universal design in housing, public and commercial facilities, and related products. The Center develops publications and instructional materials, and provides information, referrals, and technical assistance on issues of universal design.

National Center on Accessibility

5020 State Road 67 North
Martinsville, IN 46151

Telephone: (800) 424-1877 (Voice/TTY),
(317) 349-9240 (Voice/TTY)

Web site: www.indiana.edu/~nca/index.htm

The center produces a *Resource Guide* that is a comprehensive and well-organized compilation of publications, magazines and videos that are available on the topic of accessibility and recreation, including parks, museums, zoos, and related activities.

National Endowment for the Arts (NEA)

Office for AccessAbility
1100 Pennsylvania Avenue, NW
Washington, DC 20506

Telephone: (202) 682-5532 (Voice),
(202) 682-5496 (TTY)

Web site: www.arts.gov/partner/
Accessibility/ADALinks.html

The NEA web site includes the ADA act as well as the Americans with Disability Act Architectural Guidelines (ADAAG), an ADA compliance guide, specific access resources, and links to other useful sites. Resources include the Cultural Accessibility Checklist.

National Park Service

Office on Accessibility
P.O. Box 37127
Washington, DC 20013-7127

Telephone: (202) 565-1255 (Voice)
(202) 343-1344 (TTY)

Web site: www.nps.gov

The National Park Service preserves the natural and cultural resources and values of the national park system for the enjoyment, education, and inspiration for current and future generations. The Park Service cooperates with partners to extend the benefits of natural and cultural resource conservation and outdoor recreation throughout the country.

New York State Council on the Arts (NYSCA)

175 Varick Street, 3rd Floor
New York, NY 10014

Telephone: (212) 627-4455 (Voice)

Web site: www.nysca.org/home/html

The NYSCA, a nonprofit arts agency for the state of New York, has the valuable resource, *A Universal Environment: Beyond Access to Opportunity* on their web site.

Smithsonian Institution Accessibility Program

Arts and Industries Building
900 Jefferson Drive SW, Room 1239,
MRC 426
Washington, DC 20560

Telephone: (202) 786-2942 (Voice)
(202) 786-2414 (TTY)

Web site: www.si.edu/opa/accessibility/
start.htm

The program provides a free guide to visitors on disability access at the Smithsonian, access maps of museums on and near the National Mall and Smithsonian Guidelines for Exhibition Design.

U.S. Architectural & Transportation Barriers

Compliance Board (ATBCB or Access Board)
1331 F Street, N.W., Suite 1000
Washington, DC 20004-1111

Telephone: (202) 272-5434 (Voice)
(800) 872-2253 (Voice)
(202) 272-5449 (TTY), (800) 993-2822 (TTY)

Web site: www.access-board.gov

The ATBCB provides technical assistance and information on the architectural requirements of the ADA, other access-related legislation and on architectural, communication and transportation accessibility.

U.S. Department of Justice

Civil Rights Division
Disabilities Rights Section
P.O. Box 66738
Washington, DC 20035-6738

Telephone: (800) 514-0301 (Voice)
(800) 514-0383 (TTY)

Web site: www.usdoj.gov/crt/ada/
ada hom1.htm

The U.S. Department of Justice answers questions about the Americans with Disabilities Act and provides free publications by mail and

fax through its ADA Information Line (listed above.) The ADA section of its web site includes a technical assistance program and updates on the ADA law and how it is used.

Universal Designers and Consultants, Inc.

6 Grant Avenue
Takoma Park, MD 20912

Telephone: (301) 270-2470 (Voice/TTY)

Web site: www.UniversalDesign.com

Universal Designers and Consultants, Inc., provides accessibility consulting services and publishes *Universal Design Newsletter*.

Disability Resources

American Foundation for the Blind

11 Penn Plaza, Suite 300
New York, NY 10001

Telephone: (212) 502-7600 (Voice)

Web site: www.afb.org

The American Foundation for the Blind web site has extensive information on vision studies, adaptive technology information, recorded books, used equipment purchase, and publications.

Disability Business Technical Assistance Center

Telephone: (800) 949-4232 (Voice/TTY)

There are ten regional technical assistance centers across the country that provide ADA information and assistance. Call the number above to be connected to the center servicing your area.

Disability Relations Group

St. Petersburg, FL 33716

Telephone: (866) 550-4440

Disability Resources, Inc.

Four Glatter Lane
Centerreach, NY 11720-1032

Telephone: (631) 585-0290 (Voice)

Web site: www.disabilityresources.org

Disability Resources is a nonprofit organization that promotes and improves awareness, availability and accessibility of information for people with disabilities. Its web site has links to different resources on disabilities divided by subject.

Disability Rights Education and Defense Fund (DREDF)

2212 Sixth Street
Berkeley, CA 94710

Telephone: (800) 466-4ADA (Voice/TTY), (510) 644- 2555 (Voice/TTY)

Web site: www.dredf.org

DREDF is a legal resource center that provides training, technical assistance and informed analysis of requirements under disability law.

Learning Disabilities Association of America

4156 Library Road
Pittsburgh, PA 15234

Telephone: (412) 341-1515 (voice)

Web site: www.ldanatl.org

The Learning Disabilities Association of America is a nonprofit organization of volunteers including individuals with learning disabilities, their families and professionals. The association is dedicated to identifying causes and promoting prevention of learning disabilities and to enhancing the quality of life for all individuals with learning disabilities and their families by encouraging effective identification and intervention, fostering research, and protecting their rights under the law.

National Association for the Deaf

814 Thayer Avenue
Silver Spring, MD 20910-4500

Telephone: (301) 587-1788 (Voice)
(301) 587-1789 (TTY)

Web site: www.nad.org

Their web site offers resources and publications for the deaf and hard of hearing.

National Institute on Disability and Rehabilitation Research (NIDRR)

400 Maryland Avenue SW
Washington, DC 20202-2572

Telephone: (202) 205-8134 (Voice)
(202) 205-4475 (TTY)

Web site: www.ed.gov/offices/OSERS/NIDRR

NIDRR funds a network of ten regional Disability and Business Technical Assistance Centers (DBTACS) that provide information, training and technical assistance to businesses and agencies covered by the ADA and to people with disabilities who have rights under the act. To contact any center, call (800) 949-4232 (Voice/TTY) and you will automatically be connected to the center in your region.

National Library Service for the Blind and Physically Handicapped

1291 Taylor Street NW
Washington, DC 20542

Telephone: (202) 707-5100 (Voice)
(800) 424-8567 (Voice)
(202) 707-0744 (TTY)

Web site: www.loc.gov/nls

The National Library Service for the Blind and Physically Handicapped, within the Library of Congress, administers a free program that loans recorded and Braille books and magazines, music scores in Braille and large print and specially designed playback equipment to residents of the United States who are unable to read or use standard print materials because of visual or physical impairment.

President's Committee on Employment of People with Disabilities (PCEPD)

1331 F. Street NW
Washington, DC 20004

Telephone: (202) 376-6200 (Voice)
(202) 376-6205 (TTY)

The PCEPD is an independent federal agency whose mission is to facilitate the communication, coordination and promotion of public and private efforts to enhance the employment of people with disabilities. The Committee provides information, training and technical assistance to America's business leaders, organized labor, rehabilitation and service providers, advocacy organizations, families, and individuals with disabilities.

Arts and Disability Resources

American Art Therapy Association, Inc.

1202 Allanson Road
Mundelein, IL 60060

Telephone: (888) 290-0878 (voice)

Web site: www.arttherapy.org

The American Art Therapy Association promotes the field of art therapy and provides a forum for addressing legislative and professional issues as well as a network for people working toward common goals. Its web site lists resources, art therapy links and informs viewers about federal legislative issues and updates. Affiliate chapters have also been established in many states.

American Music Therapy Association, Inc. (AMTA)

8455 Colesville Road, Suite 1000
Silver Spring, MD 20912

Telephone: (301) 589-3300 (voice)

Web site: www.musictherapy.org/AMTA.htm

AMTA's mission is the progressive development of the therapeutic use of music in rehabilitation, special education and community settings. It

publishes a quarterly research-oriented journal called the *Journal of Music Therapy*, a semi-annual, practice-oriented journal, a quarterly newsletter called *Music Therapy Matters*; and a variety of other monographs, bibliographies, and brochures.

National Arts and Disability Center (NADC)

Tarjan Center for Developmental Disabilities
300 UCLA Medical Plaza, Suite 3310
Los Angeles, CA 90095-6967

Telephone: (310) 794-1141 (voice)

Web site: nadc.ucla.edu

NADC is a national information dissemination, technical assistance and referral center specializing in the field of arts and disability. It has resource directories, annotated bibliographies, related links and hosts conferences.

VSA arts (formerly Very Special Arts)

Education Office
1300 Connecticut Avenue NW, Suite 70
Washington, DC 20036

Telephone: (800) 933-8721 (Voice)
(202) 628-2800 (Voice)
(202) 737-0645 (TTY)

Web site: www.vsarts.org

VSA arts is an international organization that creates learning opportunities through the arts for people with disabilities.

Arts and Older American Resources

Center for Older Adults (AHRC)

700 Walnut Street, Room 310
Cincinnati, OH 45202

Telephone: (513) 579-1074 (voice)

AHRC has designed and presented mentally stimulating programs for thousands of older adults in a five-county area in greater Cincinnati since 1975. AHRC's programs often incorporate older adult's personal perspectives and memories of historic events into original songs, dances,

theatrical performances, and visual artwork. AHRC offers its programs free to adults age 65 and older.

Arts for the Aging, Inc. (AFTA)

4905 Del Ray, Suite 305
Bethesda, MD 20814

Telephone: (301) 718-4990 (voice)

Web site: www.aftaarts.org

AFTA is a not-for-profit organization dedicated to enhancing the lives of older adults by providing them with access to the arts. AFTA organizes monthly arts workshops in mediums such as painting, drawing, printmaking, sculpture, bookmaking, dance movement, music, and theater for older individuals in the Washington D.C. area. AFTA also offers intergenerational programs to more than 1,000 older adults and school-aged children.

Artworks

Mount Zion Institute on Aging
3330 Geary Boulevard, 2nd Floor
San Francisco, CA 94118

Telephone: (415) 750-4187 (voice)

Web site: www.mxweb.his.ucsf.edu/ioa

Artworks trains professional artists to conduct arts programs that accommodate the needs of older individuals and their families. These professionals design and implement projects in the visual and performing arts at adult day health centers and in the homes of frail older adults.

Elderhostel, Inc.

75 Federal Street
Boston, MA 02110-1941

Telephone: (617) 426-7788 (voice)
(877) 426-2167 (TTY)

Web site: www.elderhostel.org

Elderhostel, Inc., is a national nonprofit organization that provides high quality, affordable and educational adventures all over

the world to hundreds of thousands of adults aged 55 and older. Elderhostel offers arts programs such as art appreciation classes and hands-on workshops in mediums like quilting, woodcarving, photography, weaving, chorale music, dance, and theater. Distinguished arts museums and institutions around the world including the Peabody Institute, the London Symphony, and the Art Institute of Chicago host Elderhostel programs.

Elders Share the Arts (ESTA)

138 S. Oxford Street
Brooklyn, NY 11217

Telephone: (718) 398-3870 (voice)

ESTA is a community arts organization dedicated to validating personal histories, honoring diverse traditions and connecting generations and cultures through living history arts programs. Its staff of professional artists works with individuals of all ages to transform life stories into dramatic, literary and visual presentations that celebrate inner-city community life.

Full Circle Theater Troupe

Center for Intergenerational Learning at Temple University
1601 North Broad Street, Room 206
Philadelphia, PA 19122

Telephone: (215) 204-3195 (voice)

Full Circle Theater is an intergenerational ensemble of 50 to 60 teens and older adults who create improvisational, interactive performances and sociodramas on themes like ageism and the generation gap. The company performs up to 150 times a year.

Liz Lerman Dance Exchange

7117 Maple Avenue
Takoma Park, MD 20912

Telephone: (301) 270-6700 (voice)

Liz Lerman Dance Exchange is composed of ten dancers whose ages span six decades. These dancers perform, rehearse, teach, plan residencies, choreograph, assist in fundraising and administrative activities, act as spokespeople for the organization, and serve on the board of directors. Their current programs for older adults include dance classes at senior centers and nursing homes, community performance events, studio dance incentives for older adults, and training for dancers, health care professionals, teachers, gerontology students, and others in the art of making dance in community settings.

National Center for Creative Aging (NCCA)

138 S. Oxford Street
Brooklyn, NY 11217

Telephone: (718) 398-3870 (voice)

Web site: www.center-for-creative-aging.org

The NCCA is dedicated to fostering an understanding of the vital relationship between creative expression and healthy aging. The NCCA advocates for quality arts programs for older adults, evaluates arts and aging programs to identify and promote best practices, creates technical assistance materials and training programs, and provides vehicles for the exchange of information and resources.

The OASIS Institute

7710 Carondelet Avenue, Suite 125
St. Louis, MO 63105

Telephone: (314) 862-2933 (voice)

Web site: www.oasisnet.org

OASIS is a national education organization designed to enhance the quality of life for older adults through challenging programs in the arts, humanities, wellness, and volunteer services. It offers programs involving subjects like drawing, painting, sculpture, pottery, art and music appreciation, readers' theater, creative writing, acting, tap dance, and voice through a national network of community based OASIS centers in 26 U.S. cities.

Senior Performers Committee of the Screen Actors Guild

143 Prince Street
New York, NY 10012-3111

Telephone: (212) 533-1487 (voice)

The Senior Performers Committee strives to increase opportunities for seniors and change senior images in the television and movie industry. The committee hosts speakers, distributes flyers and questionnaires, and publishes brochures that demand revisions in the way that advertisers, directors, artists, and publicists view older adults.

Arts in Healthcare Resources

Arts and Healing Network

3450 Sacramento Street, PMB 612
San Francisco, CA 94118

Web site: www.artheals.org

The Arts and Healing Network is dedicated to celebrating the connection between art and healing. Its focus is its website, which serves as an international resource and exchange for anyone interested in the healing potential of art. The site includes an extensive community arts section, over 200 artist pages, resources for artists, and an interactive bulletin board where you can post your own messages.

Children's National Medical Center

111 Michigan Avenue NW
Washington, D.C. 20010-2970

Telephone: (202) 884-3225 (voice)

The Children's National Medical Center sponsors New Horizons, an arts education and cultural enrichment program that hosts exhibitions, performances, and artists-in-residence, that includes artists, writers, musicians, dancers and theater artists.

Duke University Medical Center (DUMC)

Cultural Services Program
DUMC 3071
Durham, NC 27710

Telephone: (919) 684-2007 (voice)

The Cultural Services Program of DUMC brings the arts into the medical center for the benefit of patients and their families as well as medical and support staff. Cultural Services sponsors original art in patients' rooms and display cases, a touchable art gallery in the Eye Center, visiting writers, writing discussion groups, journal writing assistance for long-term patients, and North Carolina Connections, a television channel featuring art and humanities projects created in or about North Carolina.

Shands Arts in Medicine

P.O. Box 100317
Gainsville, FL 32610-0317

Telephone: (352) 265-0151 (voice)

Web site: www.shands.org/aim

Shands Arts in Medicine program offers regularly scheduled workshops in patient units at both Shands at the University of Florida and Shands at Alachua General Hospital. Artists and trained volunteers also make daily patient and staff requested visits to patients' rooms where they engage in a variety of activities. Artists strive to accommodate each individual's needs to build close supportive relationships with the patients and their families throughout their stay.

Society for the Arts in Healthcare (SAH)

1229 15th Street NW
Washington, DC 20005

Telephone: (202) 244-8088 (voice)

Web site: www.societyartshealthcare.org

SAH promotes the arts as an integral component of health care by demonstrating how it enhances the healing process. It

promotes the inclusion of arts in the planning and operations of health care facilities and the professional development and management of arts programming for health care populations. SAH's conferences, seminars, newsletters, and database of Arts in Healthcare programs serve as important resources for administrators, artists, therapists, physicians, medical students, designers, architects, and other interested individuals.

Arts and Children with Disabilities Resources

Bethesda Academy of Performing Arts

7300 Whittier Boulevard
Bethesda, MD 20817

Telephone: (301) 320-2550 (voice)
(301) 229-3739 (TTY)

Web site: www.imaginationstage.org/access.htm

The academy was created to integrate the arts into the lives of children. Each year the academy offers classes, workshops, summer camp programs, childcare enrichment, a theater season, traveling troupes, performing opportunities and special-needs programs to more than 5,000 metropolitan-area children. The academy also mainstreams children with disabilities into the programs listed above.

Children's Theater Company

2400 Third Avenue South
Minneapolis, MN 55404-3597

Telephone: (612) 874-0500 (voice)

Web site: www.childrenstheatre.org

The Children's Theater Company is the largest theater for young people and their families in North America. The company offers infrared listening systems for deaf and hard-of-hearing free of charge, designated performances interpreted in American Sign Language and wheelchair seating.

Council for Exceptional Children (CEC)

1110 North Glebe Road, Suite 300
Arlington, VA 22201

Telephone: (703) 620-3660 (voice), (703) 264-9446 (TTY)

(703) 264-9494 (FAX)

Web site: www.cec.sped.org

The CEC is dedicated to the improvement of educational outcomes for individuals who are disabled and gifted.

National Dance Institute

594 Broadway, Room 805
New York, New York 10012

Telephone: (212) 226-0083 (voice)

Web site: www.nationaldance.org/frame01.htm

The National Dance Institute mainstreams youth with mobility, hearing, and vision disabilities into dance classes in New York schools. It also sponsors an intergenerational dance/choreography program for homeless children and older adults.

Arts and Juvenile Justice Resources

ArtsCorr

South Dakota for the Arts
Deadwood, SD 57732

This arts-in-juvenile justice program is a partnership between South Dakota for the Arts and the South Dakota Department of Corrections. It is a multimedia program that serves over 1,000 youth.

Art Inside

1442 Rufer Avenue

Louisville, KY 40204

Art Inside, in partnership with the Jefferson County Youth Center, offers a multimedia arts program to approximately 3,000 youth annually.

Gainesville State School

1379 FM 678
Gainesville, TX 76240

In partnership with the Texas Youth Commission, the Gainesville State School offers a visual and performing arts program to over 100 youth per year.

pARTners unlimited

3716 Ingersoll Avenue B
Des Moines, IA 50319

In partnership with the Polk County Youth Services, Des Moines Men's Correctional Facility and Youthful Offender Program, pARTners unlimited offers a multimedia arts program.

Monroe County Children's Center

Department of Social and Health Services
355 Westfall Road
Rochester, NY 14620

The Monroe County Children's Center partners with Monroe County detention, probation and teen court and the New York State corrections and parole to offer a visual arts program to over 750 youth a year.

N.E.T.

Broadlands Hospital
1621 34th
Des Moines, IA

N.E.T. serves over 10-20 youth per month in a visual arts program.

Office of Juvenile Justice Delinquency Prevention

Attn. Grady Hillman
Technical Assistance Program Consultant

Telephone: (512) 467-8382

E-mail: GradyH@prodigy.net

Peer Education Theater Program

528 Hennepin Avenue, Suite 704
Minneapolis, MN 55405

In partnership with the Hennepin County Juvenile Corrections, the Peer Education Theater Program provides a performing and visual arts program serving 350-450 youth and utilizing 5-12 peer educators.

Young Audiences of Greater Dallas Creative Solutions

4145 Travis, Suite 201
Dallas, TX 75204

In partnership with the Dallas County Juvenile Department and Correctional Services Cooperation, Young Audiences provides a visual and performing arts program working with 25 youth per project.

Centers for Independent Living Resources

Independent Living Research Utilization (ILRU)

2323 South Shepherd, Suite 1000
Houston, TX 77019

Telephone: (713) 520-0232 (voice)
(713) 520-5136 (TDD)

Web site: www.bcm.tmc.edu.ilru

The ILRU is a national center for information, training, research, and technical assistance in independent living. ILRU's goal is to expand the body of knowledge in independent living and to improve utilization of results of research programs and demonstration projects in the field.

Independent Living USA (ILUSA)

Web site: www.ilusa.com/links/ilcenters.htm

ILUSA houses a database of independent living centers from federal and state sources.

National Council on Independent Living (NCIL)

1916 Wilson Boulevard
Arlington, Virginia 22201

Telephone: (703) 525-3406 (Voice)
(703) 525-4153 (TTY)

Web site: www.ncil.org

The NCIL is a membership organization that represents over 700 organizations and individuals including: Centers for Independent Living (CILs), Statewide Independent Living Councils (SILCs), individuals with disabilities, and other organizations that advocate for the human and civil rights of people with disabilities. The NCIL offers training, technical assistance, advocacy information, disability links, and a national directory of Centers for Independent Living.

Communication Accessibility Resources:

• For Print Readability •

Graphics Artists Guild Foundation

90 John Street, Suite 403, 8th Floor
New York, NY 10038-3202

Telephone: (212) 791-3400 (Voice)

Web site: www.gag.org/das

The Graphic Artists Guild Foundation offers 12 universal accessibility symbols in electronic format to help organizations advertise their access services. The symbols are on its web site and you can download them at no cost.

The Lighthouse

The Lighthouse has two very good pamphlets on print legibility and color contrast. You can get them in hardcopy by calling: 1-800-829-0500 (Voice)

• For Assisted Listening Devices •

League for the Hard of Hearing

71 West 23rd Street
New York, New York 10010-4162

Telephone: (917) 305-7700 (Voice)
(917) 305-7999 (TTY)

Web site: www.lhh.org

The league's mission is to improve the quality of life for people with all degrees of hearing loss by providing hearing rehabilitation and human service programs for people who are hard of hearing and deaf—and their families—regardless of age or mode of communication.

Its web site has a list of manufacturers and distributors of listening devices.

Self Help for Hard of Hearing People (SHHH)

7910 Woodmont Avenue, Suite 1200
Bethesda, Maryland 20814

Telephone: (301) 657-2248 (Voice)
(301) 657-2249 (TTY)

Web site: www.shhh.org

SHHH opens the world of communication to people with hearing loss by providing information, education, support and advocacy. Its web site provides an overview of assistive listening devices, descriptions of different kinds of systems, a publication list, and much more.

• For Audio Description •

Audio Description Associates

6502 Westmoreland Avenue
Takoma Park, MD 20912

Telephone: (301) 920-0218 (Voice)

Web site: www.audiodescribe.com

This web site offers information, examples and resources on audio description.

The Metropolitan Washington Ear, Inc.

35 University Boulevard East
Silver Spring, MD 20901

Telephone: (301) 681-6636 (Voice)

Web site: www.washear.org

The Metropolitan Washington Ear provides services and information on audio description, radio reading services, and much more. The Ear's services are available to anyone certified as unable to read ordinary print because of visual or physical limitations.

For Braille, Tactile Drawings, Captioning, Computer Technology, and Web Site Accessibility

American Printing House for the Blind

1839 Frankfort Ave.
P.O. Box 6085
Louisville, KY 40206

Telephone: (502) 895-2405 (Voice)

Web site: www.aph.org

The American Printing House for the Blind will make Braille, tactile or audio versions of materials. Its web site has resource information and product catalogs.

Hotkey Systems

Makes Braille versions of publications from one page to books. They can be reached by telephone at (718) 335-1788 (Voice)

National Captioning Institute

1900 Gallows Road, #3000
Vienna, VA 22182-3865

Telephone: (703) 917-7600 (Voice)

545 Fifth Avenue, Room 1403
New York, NY 10017

Telephone: (212) 557-7011 (Voice and TTY)

Web site: www.ncicap.org

The National Captioning Institute provides

information, services and resources on captioning and audio description.

The Caption Center

WGBH
125 Western Avenue
Boston, MA 02134

Telephone: (617) 492-9225 (Voice and TTY)

Web site: www.wgbh.org/wgbh/pag es/captioncenter

The Caption Center is the world's first captioning agency and a nonprofit service of the WGBH Educational Foundation. With offices in Boston, Los Angeles and New York, the Caption Center captions nearly 100 hours per week of programming from all segments of the television industry.

Center for Applied Special Technology (CAST)

39 Cross Street, Suite 201
Peabody, MA 01960

Telephone: (978) 531-8555 (Voice)
(978) 538-3110 (TTY)

Web site: www.cast.org

CAST is an educational, not-for-profit organization that uses technology to expand opportunities for all people, including those with disabilities. CAST will analyze the accessibility/usability of your web site and when it meets universal guidelines you can put their "Bobby" icon on your web site. That will tell your visitors that your site meets the standards for universal web design and usability.

National Center for Accessible Media (NCAM)

125 Western Avenue
Boston, MA 02134

Telephone: (617) 300-3400
(617) 300-2489 (TTY)

Web site: ncam.wgbh.org/index.html

NCAM's mission is to expand access to present

and future media for people with disabilities; to explore how existing access technologies may benefit other populations; to represent its constituents in industry, policy and legislative circles; and to provide access to educational and media technologies for special needs students.

World Wide Web Consortium's (W3C) Web Accessibility Initiative (WAI)

MIT/LCS Room NE43-355
200 Technology Square
Cambridge, MA, 02139

Telephone: (617) 253-2613 (Voice)

Web site: www.w3org/WAI

The World Wide Web Consortium's (W3C) commitment to lead the web includes promoting a high degree of usability for people with disabilities. WAI, in coordination with organizations around the world, pursues accessibility of the web through five primary areas of work: technology, guidelines, tools, education and outreach, and research and development. Its web site provides information, resources and technical information on web accessibility.

Funding Resources

The Foundation Center

79 Fifth Avenue/16th Street
New York, NY 10003-3076

Telephone: (212) 620-4230 (Voice)
(800) 424-9836 (Voice)

Web site: www.fdncenter.org

The Foundation Center provides resources by geographic region and subject area to private and corporate foundations.

The Grantsmanship Center

1125 West Sixth Street, Fifth Floor
P.O. Box 17220
Los Angeles, CA 90017

Telephone: (213) 482-9860 (Voice)

Web site: www.tgci.com

The Grantsmanship Center provides resources for nonprofit organizations through the Whole Nonprofit Catalog.

MetLife Foundation

One Madison Avenue
New York, NY 10010

Web site: www.metlife.com

The MetLife Foundation supports various educational, health, welfare, and civic and cultural organizations. MetLife introduced a new initiative in 2000 that aims to encourage organizations to make the arts more inclusive and accessible for the special-needs community by funding innovative programs.

Mistubishi Electric America Foundation

1560 Wilson Boulevard, Suite 1150
Arlington, FV 22209

Telephone: (703) 276-8240 (Voice)

Web site: www.meaf.org

The MEA Foundation's focus is on helping young people with disabilities, through technology, to maximize their potential and fully participate in society.

NEC Corporation Foundation (NEC)

8 Corporate Center Drive
Melville, NY 11747

Telephone: (631) 753-7021 (Voice)

Web site: www.nec.com

NEC funds technology projects that benefit people with disabilities and organizations serving those with disabilities and older adults.

Research Grant Guides

P.O. Box 1214
Loxahatchee, FL 33470

Telephone: (407) 795-6129 (voice)

Produces a guide, *Directory of Grants for Organizations Serving People with Disabilities,* that lists more than 1,200 foundations, corporations and associations that grant funds to nonprofit organizations.

U.S. Department of Housing and Urban Development (HUD)

451 7th Street SW
Washington, DC 20410

Telephone: (202) 708-1112 (Voice)
(202) 708-1455 (TTY)

Web site: www.hud.gov./cpd/cdbg.html

HUD offers Community Development Block Grants that can be used to make access improvements in cultural buildings.

REFERENCES

American Association of Museums. *The Accessible Museum: Model Programs of Accessibility for Disabled Older People.* Washington, D.C., 1992.

This book offers insights from model programs from 19 American museums as to how institutions are successfully dealing with issues of accessibility, and making adjustments to policies, programs and facilities.

American Association of Museums. *Everyone's Welcome: Universal Access in Museums.* Washington, D.C., 1996 (video).

Illustrates how the museum can provide opportunities for learning and enjoyment for all visitors regardless of their ability, disability, age, or educational background.

American Foundation for the Blind. *What Museum Guides Need to Know: Access for Blind and Visually Impaired Visitors.* Brooklyn, NY: American Book Center, 1989.

This book offers practical ideas on how to best serve visitors who are blind or visually impaired.

Barrier Free Environments. *The Arts and 504: A 504 Handbook for Accessible Arts Programming.* Washington, D.C.: National Endowment for the Arts, 1992 (revised).

This handbook assists cultural organizations on complying with access regulations.

Department of Justice. *Americans with Disabilities Act Handbook.* Washington, D.C., 1991.

A free comprehensive publication that provides background, summary, rule-making history, and an overview of regulations of the ADA.

Everyone Can Win: Opportunities and Programs in the Arts for the Disabled. McLean, VA: EPM Publications, 1988.

This publication includes descriptions of programs on dance, drama, music, writing, and the visual arts; interviews with teachers and students about their experiences; and lists helpful organizations and services in the arts for adults and children with disabilities.

Hunter, Carol. *Everyone's Nature: Designing Interpretation to Include All.* Helena, MA: Falcon Press, 1994.

This design guide for outdoor recreation specialists and land managers focuses on interpretive modification for outdoor recreation. The guide is broken down into three parts: concepts and components of universal design; universal design in facility access; and universal design in program access.

Jester, T. and S. Park. *Preservation Brief 32: Making Historic Properties Accessible.* Pittsburgh, PA: Government Printing Office, 1993.

This document introduces the issues that accompany providing accessibility at historic properties and provides guidance on how to make historic properties accessible while preserving their historic character.

Library of Congress. *Volunteers Who Produce Books: Braille, Cassette, Large Print.* Washington, D.C.: National Library Service for the Blind and Physically Handicapped, 1996.

This directory provides the names of volunteer groups and individuals that transcribe and record books and other reading materials for people with visual and physical impairments.

Majewski, Janice. *Part of Your General Public Is Disabled: A Handbook for Guides in Museums, Zoos, and Historic Houses.* Washington, D.C.: Smithsonian Institution, 1987.

This book focuses on training docents to provide effective interpretation for visitors with disabilities. Specific issues and concrete examples are offered.

National Assembly of State Arts Agencies and National Endowment for the Arts. *Design for Accessibility: An Arts Administrator's Guide.* Washington, D.C., 1994.

This document offers suggestions on how to best comply with Section 504 and the Americans with Disabilities Act. It addresses ways of making access an integral part of an organization.

National Endowment for the Arts and the Graphic Artists Guild Foundation. *Disabilities Access Symbols Project: Promoting Accessible Places and Programs.* New York, NY: The Graphic Artists Guild Foundation, 2002.

This package includes an explanatory text and 12 graphic symbols designed to assist organizations with advertising their accessible programs to people with disabilities and senior citizens.

Ostroff, Elaine Dr. and Dr. Wolf Preiser. *Universal Design Handbook.* Mcgraw-Hill, 2001.

International compilation of universal design practices, which includes policies, guidelines, practice, education, research, and case studies.

Salmen, John P.S. *Everyone's Welcome: The Americans with Disabilities Act and Museums.* Washington, DC: American Association of Museums, 1998.

A manual for museum professionals and designers to help them better understand the requirements of the Americans with Disabilities Act.

Siller, M. and E. Joffee. *Reaching Out: A Creative Guide for Designing Cultural Programs and Exhibits for Persons Who Are Blind and Visually Impaired.* New York, NY: American Foundation for the Blind, 1997.

This video and manual offers examples of accessibility programming, shows the interaction between visually impaired visitors and their environments and describes how organizations can prepare and train their staff and volunteers to provide accessible environments and programs.

Smithsonian Institution Accessibility Program. *Accessible Exhibitions: Testing the Reality.* Washington, D.C., 1993.

This guide provides assistance on developing accessible programs, primarily exhibitions, and includes a step-by-step guide on how to conduct a site evaluation.

Smithsonian Institution Accessibility Program. *Disabled Museum Visitor: Part of Your General Public is Disabled.* Washington D.C. (video).

An open captioned video that discusses five not readily identifiable disabilities and provides information on how to accommodate visitors with those disabilities.

Smithsonian Institution. *Smithsonian Guidelines for Accessible Exhibition Design.* Washington, D.C.: The Smithsonian Institution, 1996.

This guide outlines topics and provides diagrams and illustrations on how to design an accessible exhibition for people with disabilities to experience.

Story, Molly F., James L. Mueller and Ronald Mace. *Universal Design File.* Raleigh, NC: The Center for Universal Design, 1998.

This book serves as an in-depth introduction to universal design, which includes the history, an overview of the diversity of human capabilities and the principles of universal design in practice.

VSA arts. *Disability Awareness Guide.* Washington, D.C.: The John F. Kennedy Center for Performing Arts, 2000.

This guide offers information on many different disabilities and provides suggestions regarding such issues as ways to improve access, myths and facts about disability and resources and references on disabilities. Disabilities addressed are visual and hearing impairments, hidden disabilities, learning disabilities, mental illness, mental retardation, mobility limitations, and traumatic brain injury.

Universal Access Surveys, Guidelines and Checklists

Adaptive Environments Center, Inc. *Checklist for Existing Facilities* (version 2.1). Boston, MA, 1995.

This checklist will help you identify accessibility problems and solutions in existing facilities in order to meet your obligations under the ADA. A PDF version of the Checklist for Existing Facilities is available online for free at www.adaptenv.org

Adaptive Environments Center, Inc. *Readily Achievable Checklist: A Survey for Accessibility.* Boston, MA, 1993.

This easy-to-use survey tool that helps owners and managers of public accommodations identify barriers in their facilities.

Architectural and Transportation Barriers Compliance Board. *Americans with Disabilities Act Accessibility Guidelines.* Washington, D.C.

This free publication provides the minimum standards for the design, construction and alteration of buildings to make them accessible to people with disabilities.

Brown, Catherine R. *Building for the Arts: A Guidebook for the Planning and Design of Cultural Facilities.* Santa Fe, NM: Western States Arts Federation, 1990.

This guide is a useful resource for developing and designing cultural facilities.

Department of Justice. *Title III Technical Assistance Manual.* Washington, D.C., 1993.

An 83-page manual that explains what businesses and nonprofit service agencies must do to ensure access to their goods, services and facilities.

MIG Communications. *The Accessibility Checklist: An Evaluation System for Buildings and Outdoor Settings.* Berkeley, CA, 1993.

A comprehensive two-volume system for achieving compliance with the ADA.

National Endowment for the Arts. *Section 504 Self-Evaluation Workbook.* Washington, D.C.: Civil Rights Office.

This is a very helpful guide to doing an accessibility survey of your programs, activities and facilities.

National Park Service. *Design Guide for Universal Access to Outdoor Recreation.* Berkeley, CA: MIG Communications, 1993.

This publication addresses the challenging issues associated with providing accessibility while maintaining the integrity of natural settings. It provides the latest in universal design concepts and accessibility guidelines for outdoor environments.

National Park Service Preservation Assistance Division and the Office on Accessibility. *Accessibility and Historic Preservation Resource Guide.* Windsor, VT: Historic Windsor, Inc., 1993.

These are two resources, a guide that has legal requirements and instructional articles to help historic property owners through planning and implementation of accessibility projects, and a video that summarizes the legal requirements and successful application of the ADA to historic sites.

Smithsonian Institution Accessibility Program. *Smithsonian Guidelines for Accessible Exhibition Design.* Washington, D.C.

Available on the web at: http://www.si.edu/opa/accessibility/exdesign/start.htm.

Cultural Accessibility Checklist

Below is an example from the NEA/NASAA of key components to address in an accessibility/usability survey.

1. Policies and Practices

2. Employment

3. Checklist for Existing Facilities

4. Outside Arrival Area, Parking Lot and Entrance Way

5. Emergency Evacuation

6. Interior Signage

7. Exterior Signage

8. Assembly/Auditorium Areas

9. Information Desk, Registration, Box/Ticket Officer, or Reception Area

10. Meetings

11. Food Service

12. Gift Shops and Other Retail Areas

13. Presentations, Programs and Performances

14. Exhibitions

15. Exhibition Labeling

16. Print Materials

17. Media

18. Marketing and Publicity

 —Beyond Access to Opportunity: A Guide to Planning a Universal Environment for the Arts

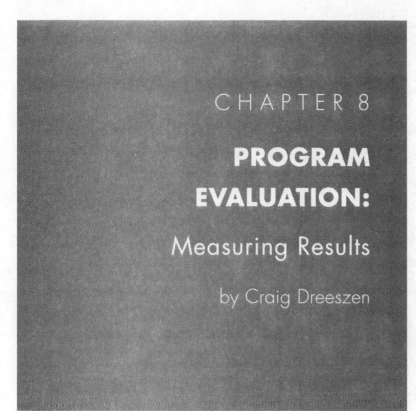

CHAPTER 8

PROGRAM EVALUATION:

Measuring Results

by Craig Dreeszen

Y ou want me to evaluate *what?*" The harried arts center director puts down the phone after a call from a foundation program officer and wonders where she will find the time to learn another management skill. As you may also discover, a basic understanding of program evaluation is becoming a fundamental skill for arts managers.

Most of us can remember a simpler time. When we ordered coffee we only had to choose between black or cream and sugar. If we wanted to know how our programs were working, we'd gather the staff or board, talk about it, and decide. If a funder wanted to know if our programs were effective, we'd report what we decided or use a simple measure like attendance numbers. If you haven't yet been asked to evaluate programs by funders, you will. Evaluating hasn't always been an expectation. It used to be that all we had to do was produce good work. But if you want public support, that time is gone.

While the incentive to evaluate comes primarily from funders interested in accountability, the real value of evaluation is the information it provides to improve programs. Fortunately, your programs and constituents will reap so many tangible benefits from evaluation that you will be very glad you learned to do it.

PART ONE UNDERSTAND THE PRINCIPLES AND PURPOSES OF PROGRAM EVALUATION

A New Era of Accountability

We are well into an era of increased expectation for accountability. It is no longer enough to promise in a grant application that you'll change people's lives with your arts programs and then note in your final report that lots of people attended and seemed to have a good time. Now funders are asking that we demonstrate results.

What you will learn This chapter is divided into three parts.

Part One Understand the principles and purposes of program evaluation

1. Welcome to an era of accountability.

2. The logic of evaluation: linking intended outcomes to activities to actual outcomes

3. Glossary of evaluation terms

4. Evaluating joy and other intangibles

Part Two Plan your evaluation: A six-step workbook

1. Frame your evaluation, identifying which program(s) you will evaluate; who are the stakeholders and audience for the evaluation; answer why you will evaluate; and who will do so by when.

2. Define evaluation questions (what do you want to learn about the program— usually this is the extent to which your intended outcomes are achieved plus unanticipated results).

3. Define intended outcomes for each program (or formal program goal).

4. For each intended outcome define indicators (evidence that outcomes will have been achieved).

5. Define data sources (where you will look for the evidence) and methods (how you will collect evidence).

Part Three Implement your evaluation

1. Collect evaluation data.

2. Analyze data.

3. Report your findings.

4. Use evaluation results to improve programs and be accountable

Evaluation Resources

Evaluation work sheets

References

Even if evaluations weren't required, they make good sense. Evaluations tell you how well your programs are doing and how well they meet people's needs. Evaluation helps make a case for support for programs and services, and provides evidence that fuels advocacy. Evaluation results provide crucial information to help planning to improve programs and develop new ones. And when hard choices arise, evaluation findings help decide what programs to cut.

"Mr. Bush asked Congress to require nonprofit organizations that participate in service programs to produce measurable results if they want to continue to receive federal funding" **Chronicle of Philanthropy, April 18, 2002**

Why evaluate and for whom? Why do you need to do this? The simple answer is, "Because you have to." External funders require it. But given this reality, why not look at what else evaluation can do for your program, organization, and important stakeholders. There

Stephen E. Weil, a Smithsonian Institution scholar, recently observed a revolutionary change for nonprofit organizations. Nonprofits are expected to benefit the public. According to Weil, we must competently carry out our public service obligations to achieve outcomes that " will demonstrably enhance the quality of individual lives and/or the well-being of some particular community." Success or failure is judged by an organization's "capacity to articulate the particular results it is seeking to achieve and...actually to achieve the results it has so articulated" (Weil, 2000).

are people who will want to know how you are doing and if your work is good because they want to fund your organization, attend your programs, or use your services. Use evaluation to improve your programs, enhance your organization, and explain what you do well.

Integrate evaluation early into your planning. By building in evaluation early, you can design an improved program—one that has a better chance to achieve its objectives.

Evaluation mysteries revealed. Evaluation need not be shrouded in mystery or jargon. It need not be any more complicated than the task requires. This chapter will explain the concepts and language of evaluation, and a simple, six-step process to define your hoped-for results and then to look for evidence that these were achieved. The text, examples, glossaries, and work sheets will prepare you to plan and implement an evaluation of a program. The text and work sheets build upon the online workbook, *Learning Partnerships: Online Help for Arts and Education Collaborations.*[1]

Outcome-based program evaluation. While there are many methods of evaluation, this chapter takes a goal and outcome-based approach. Essentially, program evaluation is the measurement of a program's outcomes. Planning defines what outcomes you hope a program will achieve consistent with your organization's goals. You design program activities, carry out those activities, and observe outcomes. Your evaluation design is a chain of logical reasoning that links assessed needs to program goals, to intended outcomes, to program activities, and finally to achieved outcomes.

The paradigm is shifting. Evaluation of arts programs becomes more accepted and expected. It used to be more common that we would promise in grant proposals to achieve more than we believed was possible. Sometimes we even fooled the panelists. Our grant reports were perfunctory and largely consisted of documentation of activities. "We presented the program as promised." Now funders increasingly want evidence of results. We are being held accountable to deliver what we promise. Knowing we must evaluate outcomes, it does not pay to promise more than is feasible to deliver.

David Karraker, who evaluates both arts and human service programs, asks these questions to a program planner trying to define a program outcome: "What do you want to hold yourself accountable to do?" and "If you don't do this, can I fire you?" If your program ultimately has little influence over the outcome you're hoping to achieve, don't hold yourself accountable for it. Aim at a target you can reach.

A Brief History of Evaluation

The move to "reinvent government" led to the passage of the U.S. Government Performance and Results Act in 1993 that required by 2000 that federal agencies demonstrate precisely what they intend to accomplish with federal funds and then to report the extent to which intended results were achieved. State governments are starting also to "fund for results."

The United Way led the nonprofit movement toward outcome-based evaluations when in 1995 it radically changed the way it evaluated its applicant programs. Previously they would ask if a program was well conceived. After 1995 they asked what were a program's outcomes. The United Way defined outcomes as "benefits or changes to individuals or populations after participating in program activities" Instead of asking of a literacy program "How many students took the reading course?" They asked, "How many students learned to read."

More private foundations, such as the Kellogg Foundation, followed suit, requiring outcome

Annotated Glossary

Much of the mystery of evaluation relates to its jargon. Common words have specific meanings in evaluation and many similar terms have subtly distinctive differences. To complicate matters, evaluators sometimes disagree on what the words mean. If you consult another reference on evaluation, you may find different models and terminology. The medical and social science models from which evaluation derived heavily influence the language of evaluation.

> *Don't panic about variations in evaluation jargon. Just be sure that folks within your organization know what you are talking about. If a funder requests an unusual evaluation measure, you can adapt your evaluation plan accordingly.*

> *The central element of evaluations is the outcome. You also should understand the relationship between outcomes and objectives, and between outcomes and indicators. While you're at it, you learn the difference between outcomes, activities, and outputs.*

Outcome is a specific result that can be attributed to your program.

Most evaluators insist that an outcome describe specific benefits to program participants. The United Way says that "outcomes are benefits for participants during or after their involvement with a program. Outcomes may relate to knowledge, skills, attitude, values, behavior, condition, or status."

Short-term outcomes are the immediate effects of your program: "Nearly all participants said they learned more than they had expected."

Intermediate outcomes are effects that linger over time: "Six months after the program the majority of participants were using what they learned in their work."

Long-term outcomes are lasting *impacts* of your program: *"Participants have incorporated what they learned into improved performance."*

Planners usually use the term *objective* to describe an *intended outcome*. An outcome is an achieved objective. These terms are virtually equivalent, although planners use objective to describe desired future results, and evaluators use *outcome* to describe either future or actual results.

Many evaluators distinguish between short-term, intermediate, and long-term outcomes. Others define long-term outcomes as impacts.

Activity is what program participants do to achieve an outcome. Your programs are made up of activities. You produce concerts or exhibitions, present performers, send artists into schools or community centers. These are your activities.

Outputs are the immediate products of your program activities.[2] Think of outputs as the results of your activities that do not describe specific benefits or changes to participants. Outputs may be tangible (a concert, book, or curriculum) but they are not measures of changed behaviors or environments (which would be outcomes). As we'll note shortly, the evaluations of arts programs more often report tangible outputs rather than intangible participant outcomes, as these may vary with each audience member. In arts evaluations, outcomes and outputs are often reported without distinction.

> **"We produced six concerts, attended by 2,800 people."**

> **"We developed a new curriculum guide that relates the museum's collection to the sixth-grade learning standards."**

Depending upon your evaluator or the audience for your evaluation, you may find it necessary to identify outcomes beyond your outputs. You may want or need to learn how a representative sample of audience members were affected by your concerts or how well the new curriculum helped sixth graders learn. These are outcomes.

Indicators are measurable evidence that shows the extent to which an intended outcome has been achieved. "Indicators are measurable approximations of the outcomes you are attempting to achieve" (*Kellogg Evaluation Handbook*). As outcomes may not be directly observable and often are not measurable, indicators provide indirect evidence. Indicators are proxies for what you cannot measure directly. Often you can identify multiple indicators for each outcome.

Indicators often are quantifiable so that the evaluation results can express the number or percentage of program participants that achieved the intended outcome.

Some evaluators use *performance measure* to mean *indicator.*

> Example: "Our intended outcome is that children participating in the artists' residency program will improve their self-esteem. As self-esteem cannot be observed directly, one indicator will be higher scores on the Coopersmith self-esteem test after the program compared with scores before our program. Another indicator will be teachers' observations of children's changed behavior as reported on our final evaluation form."

> Note that the first indicator in the preceding example is readily quantifiable, the second is

less so. Although with enough time you could ask the teacher to reflect on the behavior of each child and then quantify how many children demonstrated behaviors consistent with higher self-esteem.

"As you look for indicators, ask yourself, 'What does the outcome *look like* when it occurs? How do you *know* it has happened? What do you *see?*' " (United Way p. 62).

According to Lynn Greismeyer of the Donahue Institute, if you think of an outcome as the answer to the question, "What change will this program make in the world?" you can think of indicators as "what would you accept as evidence?"

The United Way has more useful definitions:

Outcome targets are numerical outcomes for a program's level of achievement on its outcomes.

Benchmarks are performance data that are used for comparative purposes. You may compare your results to a similar program or this year's results to last years.'

Logic model The United Way pioneered the idea that evaluation is based on a logical "if-then" relationship between intended outcomes, activities, and observed outcomes. The essence of program evaluation is the following logical chain of causes and effects. Organizational goals suggest program outcomes. For each program, the managers identify outcomes that will benefit participants and design activities designed to provide those benefits. Indicators will provide evidence that the outcomes have been achieved or not.

Purpose	Process (kind of evaluation)	Key questions
Designing programs	Needs assessments and feasibility studies	Whom should your program serve? What are their needs? How can these needs be met?
Keeping programs on track	Process evaluation or program monitoring	Is your program being implemented as planned? What are its interim effects? What should we change to improve the program?
Measuring results	Outcome evaluation	What is the impact of the program? Has it met its goals?

measurements of their grantees. This was a significant change. Before this, if we measured results at all, we usually observed and reported programs and activities but not the effects of those activities on our constituents. We counted heads but did not often attempt to measure changes in skills, knowledge, or attitudes. (See resource list for United Way and Kellogg Foundation publications on evaluation.)

Michael Sikes (evaluation specialist at the Cultural Education Collaborative) has summarized three broad kinds of evaluation. This chapter focuses on the third type, outcome evaluation, because this is the prevailing paradigm in nonprofit funding.

The Logic of Evaluation

To understand evaluation, it's necessary to understand its logic. It isn't complicated, but unless you grasp it, you will struggle.

To evaluate a program, we need to articulate what outcomes (benefits to participants) we hope to achieve, design programs intended to deliver the intended benefits, and then measure what we actually did achieve. In evaluation we explore a logical chain of expressed intentions, actions consistent with our intentions, and effects of those actions.

A logic model is simply a graphic representation of the if-then logic of your evaluation. *If* we do this, *then* we should accomplish thus. "If we implement a new arts-integrated curriculum, then children should learn how to analyze a painting." There are lots of different styles of logic models. There is no one right way. The United Way and Kellogg Foundation portray their logic models as causal chains that start with resources and conclude with impacts. The logic model that we use in this chapter is simpler and starts with goals and concludes with outcomes.

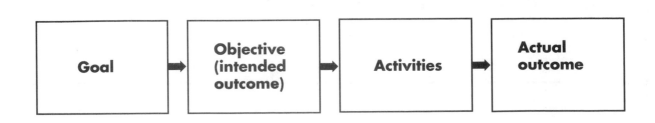

An Outcome-Based Program Evaluation Model

This model illustrates an approach to program evaluation that compares intended results (objectives) to actual results (outcomes). In deliberately planned programs, the process starts with the partners planning long-range goals and short-term outcomes. The best evaluations are planned at the outset by defining indicators, which will later provide evidence that the intended outcomes were met or not. Evaluations can also discover unforeseen outcomes in programs, working backward through the model from actual outcomes to develop planned outcomes for the next program that were implicit in the results.

Relax. You don't have to measure everything all the time. Start small with a manageable program. Once you have evaluated one program, turn your attention to another. Each program doesn't need continuous scrutiny until something significant in the program, environment, or constituency changes. If conditions don't change dramatically, you can use your evaluation over time to seek funding and plan subsequent programs. You will know

Objectives	Indicators	Program activities	Evaluation questions	Evaluation measures	Outcomes
Intended results (tangible or not) projected in planning to help fulfill a long-term goal	Predicted evidence that, if observed, will show the extent to which objectives are achieved	Actions that implement planned arts education program (also called outputs)	Questions about activities or outcomes to be answered in evaluation	Observation of indicators to document outcomes	Actual results that include achieved objectives and unanticipated consequences

Objective	Indicators	Program activities	Evaluation questions	Evaluation measures	Outcomes
White and Latino eighth graders in JFK School will learn improved mutual respect through a theater project.	1. Fewer stereotypes mentioned in interviews 2. Teachers observe changes 3. Fewer disciplinary reports 4. Play will be good	Playwright works with kids who produce their own play illustrating respect for other cultures.	1. Do kids describe each other with more respect? 2. Do kids demonstrate more respect? 3. Was the play good?	1. Pre and post-event-student interviews 2. Teacher observations and reports 3. Vice principal report 4. Critical reviews	Sixty percent of students report fewer stereotyped remarks after production. Teachers report less harassment. Race-based disciplinary actions down 30%. Play was good.

when things have changed enough that a reevaluation is in order.

Some program managers may conduct regular participant evaluations and then do more rigorous external evaluations less frequently. The Arts Extension Service asks students of each distance education class to rate their learning experience. After a year and a half, AES then commissioned an external evaluator to do in-depth evaluation research.

Program Monitoring and Documentation

When funders request evaluations, they sometimes get reports of program monitoring or documentation. Both are valuable functions that can inform evaluations, but neither measure results as do outcome-based program evaluation.

Program Monitoring Effective program managers always monitor a program's progress—its outputs—as it unfolds and make adjustments to improve the program based on observations of what is working or is not. This differs from formative evaluation in that monitoring need not measure outcomes.

Program Documentation is the reporting of monitored program activities and outputs. A documentary report describes what participants did in a program rather than what the results were. This can include descriptive narratives, anecdotes, testimonials, photographs, and other nontabulated data. Documentation can capture descriptions of program methods, activities, and tasks, and in partnerships is important to transfer what has been learned to new partners.

Prepare for the Evaluation

Before you start to evaluate programs, you must make some decisions. Decide if you will evaluate one or more programs. Determine which program or programs need evaluation and for which one evaluation is feasible. Decide if you will use the outcome-based evaluation described in this text or some other form of evaluation. Determine who will do so and decide whether you will evaluate during or

Evaluation Questions

Evaluation asks these kinds of related questions:

- What did you intend to achieve with your program?

- Were program activities consistent with your intentions?

- If so, did you observe the intended outcomes? What unintended outcomes did you also observe?

- How do you account for the variations (observed outcomes from intended objectives)?

- What changes should you make in your program based on evaluation?

- How likely is it that observed outcomes were caused by your program activities?

- How close were your actual outcomes to your intended outcomes?

- What were the program's unintended outcomes? You may achieve some positive results or negative consequences that were not part of your plan.

- What did you learn from your evaluation that will improve your program or plan new ones?

Evaluation results help policy makers answer questions such as:

- "Did this program serve the public interest?"

- "Was this a good use of public funds?"

Evaluation Model Portrayed as a Cycle

This is a less tidy diagram, but closer to the way things really work.

Indicators are like shadows of objectives. IQ scores are one indicator of intelligence. The scores, or indicators, are not intrinsically important, but they show (indicate) hoped-for results that we may not observe directly. *But don't mistake the map for the territory.*

Planning projects objectives

Indicators
Evidence that objectives are achieved

Evaluation compares actual to predicted results.

Objectives
Predicted results

Outcomes
Actual results

Program activities
Collaborative art education work

Evaluation measures
Observation and documentation of results

Evaluation questions
Inquiries that focus the evaluation.

Evaluation questions ask evaluators to gauge the extent to which programs have achieved their intended objectives and to track unintended results as well. Open-ended questions can help improve programs or show what participants liked or disliked.

at the conclusion of your project. Determine who has a stake in the evaluation and how they will be involved. Be clear about who is the audience for the evaluation.

Consider First the Feasibility of Evaluating a Program

Evaluator David Karraker starts with an "evaluability assessment." This is jargon for asking, "What is involved in doing this evaluation." David advises that "As you size up the evaluation task, consider what is involved in doing it. You don't want to evaluate a program if it's harder or more expensive to evaluate than to do the program itself. Be clear about the purpose of the evaluation. Ask where does information already exist. Consider how easy is it to get and use the information. Do you have to reorganize the data? Would less-straightforward measures work as well? Is there some information that we can get at easily enough, well enough to make competent decisions about the program?"

To get the most out of this section, you may want to define the program that you will evaluate and complete the exercises for that program. If you are a student or do not have an actual program, you can use the examples provided.

Assuming that you have chosen a program to evaluate, it is useful to ask yourself why you will evaluate. There are essentially two motivations: to improve programs and to be accountable.

Evaluate to improve programs

- To design a program;
- To better manage the program;
- To collect information to plan the next program;
- To provide feedback to program participants (artists, teachers, administrators, students, etc.).

Evaluate to be accountable

- To report results to your director or board;
- To report to program funders;
- To advocate for support of your program.

Note that the need to present outcome evidence of results and the need to demonstrate persuasive evidence to support advocacy and funding may sometimes be in conflict with each other. You have to be open to learn that you may not have obtained your outcomes. Funders should not (but may) expect that every funded program will work. Innovation entails risks. Learning what did not work through program evaluation is one of the benefits.

To Whom Will You Address Evaluation Results?

Different audiences may value different kinds of evidence. A parents group may be moved by a compelling anecdote, and a foundation may require experimental test results. Sometimes the same data can be reorganized to respond to the interests of different constituents:

- your board of directors;
- program participants (especially those who helped with the evaluation);
- funders;
- public officials;
- the press.

When Will You Evaluate?

Formative evaluation. You should evaluate while the program is in progress, while it is still forming. Formative evaluations are often informal and done primarily to improve programs. The program staff, or volunteers themselves as part of ongoing program management, typically do formative or in-progress evaluations. The purpose of formative evaluations is to improve programs.

Summative evaluation. You may need to evaluate at the conclusion of the program. Summative, or final, evaluations tend to be more formal and rigorous and are often done to demonstrate results in the service of accountability for funders or governing boards. They can also improve programs. Summative evaluations are also written, and often done by contracted professional evaluators often do them. The best evaluations are done while programs are in

progress (formative) to improve programs while there is still an opportunity to affect the outcomes and at the conclusion (summative) to observe what outcomes were accomplished.

Who Will Evaluate?

- **Use program staff.** This may be less expensive and more expedient. Internal evaluations have the advantage that evaluation skills are cultivated within the organization. Any self-evaluation presents the risk of bias.

- **Use an outside evaluator.** This is more costly but may yield more credible results. Be sure to include evaluator fees and expenses in your budget.

There are at least two opinions about external evaluators. Many believe that the closer the evaluator is to the program the better, and therefore the best evaluator is the program manager. Those responsible for the program know the nuances and are the most likely to immediately apply lessons learned from firsthand evaluation of results. Others believe only third-party evaluators have the critical distance to be objective. There is also a political advantage to a third-party evaluator, funders may require it and believe that an external evaluator is more reliable. If you do employ an external evaluator, incorporate good evaluation methods into the administration of the program so you can make the most effective and efficient use of external evaluators.

> **A note from your treasurer** The kinds of modest-budget outcome evaluations conducted by arts organizations typically don't have the kind of foolproof control groups or other experimental rigor that might be expected in medical research or some high-profile social service evaluations. We want "good enough" evaluations. Our evaluations should be good enough to tell us how to improve our programs and demonstrate that programs achieve our intended results. We often can't afford to do as thorough an evaluation as is theoretically possible.

Do You Need an Evaluation Consultant?

The same people who manage the programs do many evaluations. This has the advantage of economy and firsthand knowledge. Program staff often does formative evaluations. It may be that you want the outside perspective of an evaluation consultant, or your funder requires it. If so, you may need to write a request for proposal, or RFP.

How to Write A Request for Proposals

Sherry Wagner observes that a consultant must balance three variables:

1. Scope. How big and comprehensive is the evaluation?

2. Quality. How thorough and rigorous?

3. Price. How much time and money?

The larger the scope or higher the quality, the more costly will be the evaluation. If your budget is modest, define a modest evaluation project.

This workbook is intended to help you conduct a simple evaluation yourself or to be an informed consumer of consultant services. If you decide you need an evaluation consultant, you may request competitive proposals or invite a proposal for a consultant whose work you respect. Be sure however that the consultant evaluates what you need. You can help ensure a good evaluation by being clear in your request for proposals.

Outline for a Request for Proposals (RFP)

- Describe your organization and the program to be evaluated.

- Quote program goals and outcomes.

- Determine if the evaluation is formative or summative.

- Specify a deadline for the proposal and for the final evaluation report.

- Be clear about what you seek to evaluate:

evaluation of program outcomes, evaluation of the partnership, assessment of student learning.

- Cite work you have done with this Evaluation Workbook to outline indicators and data sources.

- Define the scope of work for the consultant.

- What data will you provide and what local help is available locally for data gathering?

- Ask for a summary of the consultant's experience with the kind of project you want evaluated, and references.

- Ask for names, resumes, and roles of consultant(s) who will do the work (may not be the principal of the firm).

- Ask the consultant to explain what evaluation methods he or she would employ and to propose a work plan with key tasks and dates.

- Ask for a budget in as much detail as you need. You may choose to specify the highest cost you would consider.

Evaluation Budget

Estimate how much you should allow for evaluation in your budget. Evaluators recommend allowing from 10 to 15 percent of your overall program budget for evaluation

depending on the scope and rigor of your intended evaluation plan. If you use outside evaluators, this may be the single largest expense.

What Can Be Evaluated?

The next step is to determine which of your intended results can be observed, (an observed result can be evaluated). In general, evaluate objectives (also called outcomes) but not goals.

This may be a good time to review planning language. See chapter 2 for definitions of mission, goals, and outcomes. Understand that in evaluation, we often use the term outcome to describe what in planning is usually called an objective. Your evaluation plan should fit into the larger context of organizational mission and program goals.

Check feasibility

Before you can evaluate, you should consider what is feasible to evaluate. You can plan to achieve profound or simple results. Many of these intentions can be readily evaluated and some cannot. In general, the more tangible the intended result, the more readily it can be observed and, therefore evaluated. Intangible results, like changed human attitudes, may also be sought in evaluations. In this case, some tangible evidence, like perceptions reported in

Guiding Principles for Evaluators

If you hire a professional evaluator you should be an informed consumer of the consulting services. Here are "Guiding Principles for Evaluators"[3] developed by the American Evaluation Association.

1. *Systematic Inquiry*: Evaluators conduct systematic, data-based inquiries about whatever is being evaluated.

2. *Competence*: Evaluators provide competent performance to stakeholders.

3. *Integrity/Honesty*: Evaluators ensure the honesty and integrity of the entire evaluation process.

4. *Respect for People*: Evaluators respect the security, dignity, and self-worth of the respondents, program participants, clients, and other stakeholders with whom they interact.

5. *Responsibilities for General and Public Welfare*: Evaluators articulate and take into account the diversity of interests and values that may be related to the general and public welfare.

A Note about *Proving* Impact

We must recognize that our programs are just part of the many forces that act upon our constituents and communities. It is difficult to *prove* that a program causes a specific result. If low-income kids in your arts education program do better in school, was it your art program that made the difference or was it a parallel supplemental reading program? Even when we can't cite proof that program A caused outcome B, we can say that there is a positive correlation between our program and an observed result. In other words, we ran our arts infusion program for disadvantaged youth, and we saw their grades, school attendance, and interest in learning go up. We should explore alternative explanations for the results we observe, but if we see the outcome you intended, we can brag about that even if we can't conclusively prove a cause-and-effect relationship.

We don't have to prove that there was no other cause of the improvement. Our observations are even more valid if we can compare this outcome with another time or place. What were these kids like before our program and after? How did our group of participating kids compare with a similar group without our arts experience? The former can be thought of as *pre* and *post intervention testing*. The latter proof is what evaluation researchers call *control group experimenting*.

You don't have to abandon your higher aspirations nor must you measure every hoped-for outcome. Why not aim for the transformation of humanity through art? But don't hold yourself accountable to measure your progress on this goal. We know art does save lives, but can we prove it? You can aim high for your goals and measure more modest outcomes in your evaluation. Did they enjoy the program, and would they come again?

"Whatever methods of data collection are used, the data collected must meet two conditions to be considered accurate: It must be valid and reliable. Respondents may be tempted to answer questions in ways that they think are expected of them or that does not place them in jeopardy. Evaluators should take steps to ensure that they have obtained the most accurate (i.e., valid and reliable) responses they can get. A data collection item (such as a question on a questionnaire) is valid to the degree that it actually measures what it claims to measure."

–U.S. Department of Education

interviews, is looked for that suggests or indicates the intended results have been achieved.

Goals describe long-term intentions, often based on shared values. You may remember that we defined a goal as a "desired, long-term result or condition that is generally intermediate and consistent with the overall purpose." Goals provide important context for evaluation, but the general, long-term nature of goals usually makes them too elusive for measurement. Evaluations more often focus on short-term outcomes.

Organizations make progress on general goals when detailed objectives (or anticipated outcomes) are achieved. These more specific plans stimulate activities, which achieve results. These results can be observed and documented in evaluation.

Here are examples of long-range goals from an arts and educational partnership.

- "Connect student learning experiences with the world of real work through the arts."
- "Use the arts to transform the environment for learning."

These are ambitious goals, and informed people would probably agree on their meaning. They would inspire the partners, program participants, and funders. The same

1 "Guiding Principles for Evaluators: A Report from the American Evaluation Association Task Force on Guiding Principles for Evaluators." http://www.eval.org/EvaluationDocuments/aeaprin6.html

people who understand the goals might reasonably disagree on whether or not the goals had been achieved. These goals are long-term and their full achievement might always be out of reach. So planners and evaluators look for more modest, and short-term, objectives to mark their progress toward larger changes.

Here are two potential outcomes for the second, learning-transformation goal:

● "Teachers in JFK Middle School will use student-produced theater to teach the Northampton history unit." This is an output that can be readily observed by the program coordinator. The evaluator need not identify an indicator, as the output, if fulfilled, will be obvious.

● "Eighth-grade students will improve problem-solving skills through playwriting."

This is an outcome that is not self-evident. You must look for evidence or indicators that the students learned the intended skills. Results of a pre and post program test designed to assess problem-solving skills might do this.

If your programs intend multiple outcomes, a single program might generate a series of benefits for kids, for their parents, and their community. You might choose one or two of these outcomes as the focus for your evaluation.

"The more immediate the outcome, the more influence a program generally has on its achievement... Conversely, the longer term the outcome, the less direct influence a program has over its achievement and the more likely other, extraneous forces are to intervene." (United Way)

The United Way offers three tests to determine if you have described outcomes that can be evaluated.

1. "Is it reasonable to believe the program can influence the outcome in a nontrivial way, even though it can't control it?

2. Would measurement of the outcome help identify program successes and help pinpoint and address problems or shortcomings?

Some Examples of Outcomes

Say you are doing an exhibition of contemporary Navajo rug weaving. You hope people will attend, enjoy the show, and learn to better appreciate Navajo culture. You have three hoped-for outcomes.

Attendance. Strictly speaking, attendance is a program output rather than an outcome (it does not describe how people are affected by their participation), yet for many arts evaluations, we blur this distinction. Attendance is the easiest indicator to measure. You can project a target number, or you can simply note how many participate. Gallery docents are supplied with clickers and instructed to count visitors and report at the end of their shift.

Enjoyment. Gallery visitors enjoying the show is a worthy outcome but difficult to measure. (Note that user satisfaction in a social service program is not usually considered an outcome.) The best way is to ask them. Ask for visitor comments in a guest book, hand exiting visitors a short form, or ask a few questions orally. To avoid bias, volunteers should be given a protocol to ask randomly selected visitors (every tenth one for example).

Appreciation. For this outcome, it's easy to think of indicators. The question is whether it is feasible to collect the data. One good indicator would be that people score better on a test about the Navajo culture after seeing the exhibition than before. This is pre and post testing. It can be quite reliable but may take more time, money, and visitor patience than you can muster. An alternative indicator is that people say they learned to appreciate the Navajo culture when asked as they exited the exhibition.

Outcomes That are More Difficult to Measure (from United Way)

If your contact with an audience or constituent is short-term and you cannot observe changes over time, you won't be able to determine if you have affected someone significantly. We don't have the advantage of a social service provider who sees a client over months or a school that can track individual students over years.

If your outcome will take a long time to achieve look for short or intermediate term outcomes that suggest progress towards your longer-term results.

If your outcomes are intangible, use qualitative measures.

If your outcomes require someone else to act (advocacy, technical assistance, community organizing, grant making), you are not directly responsible for your intended outcomes. Service organizations and funders are challenged in that their interventions are indirect. You award a grant to achieve a program outcome, but it is up to the grant recipient to implement the grant-funded projects. If your outcome is to favorably influence legislation, it is up to legislators to act. In these cases you may measure outputs (e.g., we awarded $150,000 in grants to 20 agencies) and note progress toward achieving your outcomes. If you are teaching grant writing to community arts groups, your intended outcome may be that they learn to write grants well enough to obtain more grants. You may need to be content in evaluation to ask if they thought they learned what you'd planned for them.

If your programs are intending to improve a community, region, or state, it will be difficult to demonstrate that a single program influences a wide geographic area. Your cultural tourism web site may intend to increase visitors to the region. But it would be very expensive to ask visitors why they chose to visit unless you build this question into research undertaken by a state tourism agency. You may be content to count numbers of visits to your web site as an indication of interest.

If your programs are aimed at preventing a problem, it is difficult to measure events that did not occur. If your youth writing program is intended to keep kids safe from drug abuse or violence, how can you tell if the kids avoided these risks? Control group experiments with a similar group of kids would work, but if your budget is modest, you may have to rely on testimony from the kids about their attitudes or observations from their teachers about apparent behaviors.

3. Will the program's various 'publics'—staff, volunteers, participants, collaborating organizations, funders, and the general community—accept this as valid outcome of the program?"

PART TWO PLAN YOUR EVALUATION: A WORKBOOK

This section is set up as a workbook. You can read it like a text or, work through some outcomes for a real program. You will find sample worksheets to define outcomes and indicators. You can try out an outcome or two and then copy blank work sheets from the appendix if you want to develop a full evaluation plan for your programs.

Preview of Your Evaluation Plan

The following work sheets will invite you to link your goals to intended outcomes. For each anticipated outcome or objective, you will identify indicators that will provide evidence that your objectives have been achieved. If an outcome is self-evident, you may not always need to look for indicators. You may summarize your evaluation plan with a sheet like the one

Goal. Integrate the arts into JFK Middle School curricula.

Intended outcomes	Indicators	Data sources	Data collection methods
1. Teachers will learn to develop arts-infused lesson plans.	Plans will have more arts sections than before.	Teacher lesson plans	Meet with teachers and review lesson plans.
2. Two artists in residence will help students learn their local history unit through story telling.	Higher scores on standard tests for participating students compared to similar classes.	Scores of tests designed to measure student learning for this curriculum standard	Gather scores from participating classes and from comparable group without residency.
3. Arts curriculum specialist will be hired by August.	Employment will occur, line item in budget for position.	Principal and school budget	Call principal.

illustrated here for each of your program's goals. Then you will plan how to collect the data. Following is an example of what you may produce (adapted from a framework developed by David Karraker and Dyan Wiley).

Program evaluators may encounter two scenarios.

1. The program being evaluated has evolved without deliberate planning, and objectives are not obvious.

2. Evaluators may encounter planned programs with clear, written objectives.

The evaluation methods presented here will serve either scenario. Most examples assume program managers have established objectives in advance of their assessment of outcomes. However, if your program has grown without the benefit of formal planning, you can still discover outcomes and clarify objectives for future planning and evaluation.

Is this outcome expressed as a perceptible, future result that you could observe directly during the evaluation? Could you see, hear, or touch the result? Could the intent of this objective be retained if it were revised to be a perceptible, results-oriented outcome (without losing the intent of the objective)? If your objective remains intangible, don't worry. You'll be asked later to discover evidence (indicators) for fulfillment of your objectives.

"One device to limit the inquiry is to ask each critical evaluation user to complete the statement, "I need to know ____ because I need to decide____.'" Evaluation Primer: An overview of education evaluation U.S. Dept. of Education.

Plan Your Evaluation

Step 1. State Goals

You should already have defined goals in planning. If so, copy them here. If not write goals in preparation for evaluation. Goals are general statements of long-term intended results, such as these from Charlotte's Cultural Education Collaborative:

Write your program's long-range goal(s).
Goal 1
Goal 2
Goal 3

Note that first-draft goals are often too specific to provide an inspiring, long-term target. To test whether these are good goals, ask yourself the following question: If the draft goal were achieved, what would that accomplish? Your answer may suggest a larger, more fundamental goal. Do you want to rewrite any goal?

Step 2. Write Outcomes

Your intended outcomes (or objectives in planning language) may be tangible or intangible. Following are examples of tangible, anticipated outcomes:

"Students participating in the artist residency will be able to integrate lessons from French Canadian history into their stories and drawings."

"Artists participating in the marketing workshop will be able to write an artist statement, will know how to write a press release, and learn how to develop a marketing plan."

"Our public art program will place three works of art in the community over the next two years."

"Advocacy to city council will yield a 10% increase in appropriations to the arts council."

"The board will be balanced with recruitment of three new board members in accordance with our board development plan."

"To advance cultural education program impact and excellence"

"To ensure diversity and equity for the overall cultural education program"

"Improve the self-esteem of participating students."

"Increase gallery visitor awareness and appreciation of Asian art."

"Increase the arts center's visibility in the community."

Write Your Outcomes

Copy your first goal and one or more intended outcomes for that goal. You will find reproducible forms such as this in the appendix.

Goal 1. Copy goal 2 here from page 267.

What is the first outcome for goal 1? Write outcome 1, goal 1

Is this outcome expressed as a perceptible, future result that you could observe directly during the evaluation? Could you see, hear, or touch the result? Could the intent of this objective be retained if it were revised to be a perceptible, results-oriented outcome (without losing the intent of the objective)? If your objective remains intangible, don't worry. You'll be asked later to discover evidence (indicators) for fulfillment of your objectives.

What is the second outcome for goal 1? Write outcome 2, goal 1

Outcome 3, Goal 1. Write another outcome if necessary, for goal 1

Outcome 4, Goal 1. Write another outcome, if necessary.

"One device to limit the inquiry is to ask each critical evaluation user to complete the statement, "I need to know ____ because I need to decide____.'" Evaluation Primer: An overview of education evaluation U.S. Dept. of Education.

Step 3. Write Indicators

Copy your first outcome for Goal 1 and then develop indicators that would demonstrate that your first intended outcome has been achieved. You may have several. You will find reproducible forms like this in the appendix.

Goal 1. Goal title:
Outcome 1:

Indicators What does the outcome look like when it occurs? What evidence will you look for?

After listing several potential indicators, select the two or three indicators for which the data is most readily available, is unambiguous, and is not likely to be caused by factors unrelated to your program.

Review of Outcomes and Indicators

Quick Review of the Key Terms

An *objective* is a planning term meaning a specific, intended, future result.

An *outcome* (or *result*) is an evaluation term for an achieved objective. While objectives and outcomes are frequently used interchangeably, outcomes should describe specific participant benefits or changes in the world.

An *activity* is what program participants do to achieve an outcome.

An *indicator* is *evidence* or a *performance measure*, often indirect, that shows if the intended outcome has been achieved. An indicator of increased student awareness may be higher scores on a test after a museum tour compared to scores before the tour.

The key term to grasp in this section is *Indicator.*

"Outcome indicators must be observable and measurable. If a condition is not observable and measurable, it may relate to the outcome, but it is not useful as an indicator. Indicators must also be unambiguous." (United Way p. 61)

For example, to say that "participants will demonstrate substantial improvement (p. 61)" is ambiguous. Some art program outcomes like "produce high-quality art" are inherently ambiguous. If quality is the outcome you hope to achieve, you must specify how it will be measured. Quality is an outcome but not an indicator. One unambiguous indicator of quality of a student's musical proficiency is a score by a trained adjudicator.

"Numerical targets meet the criterion of being unambiguous. (United Way p. 61)" However you may have no basis for setting a numeric target. If you don't know how many of your participants will achieve a certain benefit, you may not want to set a specific target. After the first evaluation, you may have the basis to set a numeric target for the next program evaluation.

You may identify many potential indicators that would serve as evidence that an intended outcome was achieved. Pick those for which the data is most feasible to gather, hopefully as an integral part of running the program. For example, a theater presenter wanted to learn if teachers and students were using their study guides after they returned from an arts center performance to their schools. It was a simple matter to ask the teachers this question when the coordinator called to start planning the next field trips. This way evaluation was integrated into program planning and marketing.

For any outcome that involves changed attitudes or learning, you can always just ask the participants if what you hoped to happen did occur. Understand though, the risk of error. Some people will say, "Yes, I now understand postmodernism" because they want to appear knowledgeable or because they want to please you.

Apples and Oranges: Outputs and Outcomes in Basic Art and Applied Art

We might debate endlessly the distinction between art for arts sake and art used to achieve some specific benefit. It is not productive here to compare which of these is more valuable. It does, however, make a difference in how we evaluate.

When we present performances and exhibitions that are intended to delight but are not intended to teach or change behaviors, we are challenged to measure outcomes. The kinds of outcomes we often intend are inspiring, life-affirming, and powerful, but hard to measure. Did the exhibition move to compassion? Did the performers inspire?

Outcome evaluation as described in the United Way Logic Model specifies initial, intermediate, and long-term outcomes. It is the prospect of effecting long-term outcomes that keep many of us coming back to work. Many of us are motivated each day to get up and go to work because we want to change people's lives and build better communities. In our evaluation of pure arts programs though, we may be content to track and measure outputs and short-term outcomes. Do more people attend? Do members of the audience say they appreciate the programs?

We measure some of what social science evaluators describe as outputs. Except for many arts-for-social action or arts education programs, we may not be trying to influence readily observable behaviors like learning to read, staying drug-free, or getting a job. We are trying to increase understanding and ennoble the spirit. Life changes aren't often affected by a single exposure to art and even if they were, they would be difficult to measure. So we measure how many people we serve and how well they think we serve them. We count heads and ask opinions. Outcome evaluation values these measures less than long-term outcomes, but it may be good enough to plan and improve our art programs.

When we enter the realms of education, social service, juvenile justice, and health education with our art programs, our evaluations should align more closely with the norms of outcome evaluation. If we say that the poet-in-the-school program will help kids learn to write, or that the AIDS education theater will raise AIDS awareness, then we have to demonstrate results. Schools and health educators have mostly embraced the need to be accountable for outcomes. In arts education or community action programs, we follow the stricter standards of accountability. In these cases, it is not sufficient to measure outputs. Funders and our partners want to know how many kids improved their reading (outcome) not how many kids studied with the poet (output).

The arts foster and dwell in the subjective knowledge areas of intuition, introspection, instinct, and the affective domain—areas much more difficult to measure than the empirical or rational knowledge base of many disciplines.

–Horowitz

Kinds of indicators

- physical evidence (examples of writing, photos of art work, portfolios, photos or videotapes of performances)

- participant answers to questions (interviews, focus groups, evaluation forms, questionnaires, tests)

- observation by a skilled teacher, evaluator, program coordinator, or participant observer

- archival information (attendance records, reported changes in school disciplinary actions, test scores, grade books, grant panel scores and comments, critical reviews of arts programs)

For example, If your outcome was increased self-esteem for seventh graders, the following might serve as evidence:

- improved scores on postprogram standard self-esteem test compared to the same test administered to the students before the program;

- teacher observations collected in a postprogram interview.

Refining indicators

Eliminate indicators likely to be caused by factors unrelated to your program. Some indicators result from chance or from forces that have nothing to do with your program. While it is sometimes difficult to be sure, you should look for indicators representing credible evidence that the intended outcome resulted from your program.

Focus on proposed indicators for which it is feasible to collect data. Some information is readily gathered in the course of managing programs, while others require the deliberate intervention of evaluators. Your choices have implications for your budget and human resources. Arts program evaluations may opt for less rigor in evaluations in exchange for economy, so time and money are primarily devoted to programs.

Avoid false results. Arts and education research needs to be rigorous to avoid false results. Some results occur by chance or from causes unrelated to your program. Ask if the proposed indicator could result from causes other than your program. If in doubt, don't claim cause and effect. Simply note, "We did the program and this resulted."

Step 4 Assemble your evaluation plan. Using a separate page for each goal, identify indicators, data sources, and evaluation methods for each outcome.

Goal 1 (Anticipated long-term, value-oriented result–plans at this level are not ordinarily subject to evaluation) Write your first goal here.

Outcomes (or objective), What observable results were or will be accomplished? Write outcomes here.	Indicators What evidence is there that outcome was or outcome will be accomplished? For outcomes that are not directly observable, define indicators here.	Data sources Where will you go to collect evidence? (Collect physical evidence, ask questions, review archival information.)	Evaluation methods Who gathers data and when? If methods are not obvious from indicators column, describe how data will be collected.
Example: Teachers will learn to develop arts-infused lesson plans.	Example: Plans will have more arts sections compared to those developed before start of program.	Example: Sample teacher lesson plans before and after program.	Example: Meet with participating teachers and review lesson plans.

Step 5. Define evaluation questions.

Your summary of intended outcomes and indicators from the previous work sheets may provide all you need in order to collect evaluation data. However, it is useful to pose the specific questions you want answered by evaluation, especially if an outside evaluator is engaged or if many people are participating in the evaluation.

- Questions about program outcomes: "To what extent has our program achieved the following outcomes?"

- Questions requiring specialized assessment skills: "Did the students learn what we intended?" or "What did the students learn?" Some program outcomes from above will be intended student learning.

- Questions about unanticipated results or unplanned outcomes: (These may be framed as open-ended questions.) "What did you observe about student reactions to the artist?" "What was the best part of the program?" "What could have been improved?" "Would you recommend the workshop to other teachers? Please explain."

Evaluation questions What questions will your evaluation answer?

If you request the services of an evaluation consultant, the evaluation questions will focus their efforts to provide the answers you need. In the absence of evaluation questions, some evaluators have been known to describe program activities, rather than evaluate what resulted.

Step 6. Assign evaluation tasks.

Use the following form to lay out key evaluation tasks. If you engage an evaluation consultant, this may be part of their work.

Complete by (date)	Evaluation task	Person or group responsible
Evaluation planning tasks		
June 15	Call arts council to get list of assessment consultants.	Director
Data collection tasks		
Data analysis and reporting tasks		
Other tasks		

PART THREE IMPLEMENT YOUR EVALUATION

Now that you have an evaluation plan, or know how to make one, consider how to implement it. The first step of implementation is to collect evaluation data.

1. How to Collect Evaluation Data

Look for existing information. Make evaluation easier by first identifying existing sources of evaluation data. Your evaluation plan should aim to use readily available information and then plan to collect new data.

If you are working in partnership with another institution, especially schools, social services or health agencies that routinely gather evaluation data, you may find a ready source of data on their constituents. You can save money and time by using such information.

Information gathered as part of routine record keeping, grant proposals, interim and final reports, etc., may provide important baseline data. You can compare your results with the situation before your program existed or compare your program constituents to a more general population and look for improvements.

Suggested sources of existing information

Your own records

- Attendance
- Annual reports
- Community assessments done for strategic planning
- Previous evaluation reports

Your grant records

- Proposals
- Interim and final reports
- Grant-review panel scores and comments

School partner records

- Attendance
- Ticket or gallery sales
- Scores for standardized tests
- Grade averages
- Disciplinary actions
- Reports of assessments, studies, evaluations, or plans
- Demographic reports

Community data

- Community assessments as part of community cultural planning
- Census demographic data—available from city or regional planning agencies, library and online
- Chamber of commerce or economic development assessments and economic data
- Health agency, community foundation, United Way and human service agency assessments
- Demographic data from local news media
- Police reports

Collect new information

Even if you can find existing information, it is likely that you will need more that relates to your specific outcomes. You have at least three options. You can (1) design experiments, (2) plan to observe directly, or (3) ask questions of participants.

Experimental designs. Experimental designs are less common in arts program evaluation than in medical research. Experiments do have the potential to be more rigorous and persuasive, so they are worth considering. If you intend to evaluate with an experimental design, this must be built in early in the design stages of the program.

It is sometimes a problem to design an experiment that controls the many variables. If

you intend that your arts education program will help teach tolerance, can you be sure that improved tolerance is a result of your theater program or another factor like church or parental influence. Another consideration is that experiments may increase personnel costs to programs.

Four Experimental Designs

Pre and post tests evaluate changes within a group after a program compared to before. You may administer a test that measures attitudes, knowledge, or skills related to your intended outcomes before and after your program. If your tests are accurate, then measured improvements represent positive evidence that you are advancing on your outcomes. Because of its relative simplicity, this may be the most common experimental design for program evaluation.

1. **Portfolio examination.** Student visual artwork or writing is gathered and assessed by qualified persons, noting changes in student work from the beginning of the program. Or the evaluator may note differences between students participating in the studied program and those not participating. This is a fairly common evaluation method for visual arts programs. It may also be readily applied to writing projects or other programs that produce tangible products that can be readily observed in evaluation.

 Parents of middle-school children will be familiar with this tool if you were shown handwriting or drawing samples at the beginning and end of the school year as part of your parent/teacher conference. The evaluation of portfolios is a contribution from arts evaluation that is being applied to other sectors.

2. **Control group studies.** Compare some aspect of an experimental group with the same aspect in a closely comparable group that does not participate in the program being evaluated. Your control group should be very much like your experimental group. So if you were

developing health-awareness theater programs for a group of at-risk teens, you would identify another group of teens. Control group arts evaluations are rare as this design requires that you find a control group and measure and compare some indicator for each group.

3. **Control group evaluation.** Designs are simpler if you have access to existing information that may serve as your indicator of outcome achievement. It is relatively simple to determine if your arts program improves school attendance in your experimental school compared to a similar school without your program. Each school will routinely track attendance, which is your indicator.

 Longitudinal studies track an experimental group of participants over time. As many arts program outcomes may not be realized over several years, a longitudinal study may provide the most effective evaluation. For this kind of experiment you would follow a specific group of individuals and measure one or more indicators at specific intervals over time. For arts program evaluations this may be most feasible with contained populations such as a class of school children or residents of a retirement home or correctional facility.

 If you use existing data collected by your partner institution, this evaluation design becomes more feasible than if you must observe or interview your sample over many years.

4. **Observation.** It is quite common to employ observation in program evaluation. This is a natural way to tell if a program is working and even before we started to learn formal evaluation this was and is the informal method most arts managers use to monitor if their programs are working or not.

 Ironically, this method may be overlooked since it's so obvious. The risk, of course, is that evaluations based on simple observation may not be valid if care isn't taken to maintain rigor and avoid bias. You may observe directly as a participant or an outside evaluator. Or you may observe indirectly by studying the results of your program.

Participant observer. Any knowledgeable participant in a program could be recruited to help evaluate by serving as a participant observer. To use participant observers, you must recruit and orient teachers, artists, or program coordinators who are participating in your program and also systematically record observations about the effects of the program.

An external funder may be skeptical of an evaluation based on observations by participants with a stake in finding positive outcomes. To counter this risk and to be effective, you should develop a rubric or other measurement checklist along with a research protocol, that prescribes when and how observations are to be recorded.

Sample project assessment rubric from Vermont Standards. "Students use a variety of forms, such as dance, music, theater, and visual arts, to create projects that are appropriate in terms of the following dimensions:"

	Not Yet	Almost	Meets Standard	Exceeds Standard
Skill Development	Little evidence of technique appropriate to the intent of the project	Exhibits technique appropriate to the intent of the project, with some weakness	Exhibits technique appropriate to the intent of the project	Meets standard plus highly sophisticated technique
Making Connections	No commentary on relationship between arts and math	Minimal comment	Thorough explanation of relationship between math and the arts	Meets standard plus additional insight
Reflection and Critique	No evidence of reflection or critique	Some evidence of reflection or critique	Written evidence of reflection of critique	Thorough use of reflection and critique
Approach to Work	No evidence of working through problems or creatively generating ideas	Some evidence of working through problems or creatively generating ideas	Evidence of both working through problems and creatively generating ideas	Meets standard plus extraordinary effort.

See the appendix for sources of more information and examples of rubrics.

Outside observer. You may employ a professional evaluator who observes the program and documents results. Observations by a disinterested evaluator may be more credible than those of a participant observer. An outside observer may increase costs, although this may not be significant if you are planning to employ a professional evaluator in any case.

Indirect observation. You may choose to observe indirectly to save costs, to protect privacy of participants, or to avoid any affect

on the program by the presence of observers during the program. A portfolio review cited earlier is a kind of indirect observation. You might also employ the following indirect observation tools:

- Photo, video, or audio documentation of process and/or results of the program (these can also be advocacy and fundraising tools if the program is successful)

- Journal writing–students or other program participants record their thoughts and observations in personal journals, which are reviewed to answer one or more evaluation questions by knowledgeable persons

Sampling. We must digress a bit into statistical science. There is a risk when you talk to just a few people from your program that your evaluation may be biased if those people differ in some significant way from others in your program with whom you did not talk. You should understand the distinction between a population and a sample.

If you observe all events or interview everyone who participated in your program under evaluation, evaluation is easier because you are contacting the whole *population* for your program. This makes for a thorough evaluation with no risk of statistical error, but can be too time consuming and expensive.

Most evaluation observes *some* of the programs and/or asks questions of *some* of the participants. The evaluators *sample* the population of activities and participants. If the sample looks very much like the whole population, conclusions drawn from the small, observed group will be true of the larger group. The evaluation will be free from sampling errors. Such errors occur when the observed group differs in some significant way from the larger population. If you talk with everyone in your program you have no risk of sampling error. Everyone is included. If however, you only interview people who volunteered to help with evaluation, you risk a sampling error by missing people who are less prone to participate. You minimize the risk of sampling bias by being deliberate about the people you question. This is called sampling. In essence, you pick a sample that is representative of the whole population of beneficiaries of your program.

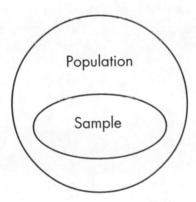

Sampling Methods

It is a highly recommended that you seek professional assistance in sampling.

- *Random sample.* Pull names from a hat, or number each participant. Obtain a list of random numbers from a statistics book or computer program and sample the corresponding numbers from your population.

- *Systematic sample.* Select every tenth (or third or whatever) name or event.

- *Segmented or stratified sample.* Group your population into similar clusters (i.e., by age, artists and teachers, etc.) and then select a random or regular-interval sample from each cluster.

- *Deliberate sample.* Intentionally select individuals from the population so that the mix of your sample is representative of the whole population.

Ask Questions

Asking questions and recording answers is another kind of indirect observation. Questioning is perhaps the single most common way to collect new information to evaluate a program. You have lots of choices, from oral interviews and group meetings to written evaluation forms and surveys. These can be as simple as a phone conversation with a member of your audience or as sophisticated as a stratified sample survey.

Four Ways to Ask Questions

There are at least four ways you can ask questions. See Planning chapter 2 for more information on asking questions. As you will note, many planning methods are useful in program evaluation as well.

- *Interviews of individuals* (in person or by phone). You may want to interview leaders or other designated spokespeople for groups (i.e., president of the neighborhood association) or you may interview a representative sample of the group itself (i.e., a random group of neighbors).

- *Moderated group discussions* (focus groups of participants and expert panels of observers). Group discussions are more efficient, in that one conversation taps the opinions of ten or so people. Group interactions may lead to richer information than single interviews.

- *Public meetings* (facilitated meetings of parents, neighbors, or other constituents the program intended to impact). Public agencies may be obliged by law to evaluate using open public forums.

- Written questions and answers to *evaluation forms* or *survey questionnaires*. Surveys and evaluation forms may be the most efficient way to sample opinions from large numbers of constituents.

Interviews

Most people have experience with interviews, so this is the easiest way to ask questions. Yet, for credible evaluation results, you must approach interviews with care. As with any questioning, you must first determine your sample. Ask yourself whom will you interview. If you are doing interviews and focus groups, consider who might best be heard individually or in a group.

First, determine the questions you will ask. Ordinarily you will ask simple, conversational questions at the outset and work toward more challenging questions. It is good to start with some factual questions like, "Can you tell me what the program looks like?" to get the conversation going. Then ask tougher questions like "What worked well?" and "What could have been improved?"

Set up an interview form that lists your questions for consistency among different interviews. The form may provide a space to summarize answers or just prompt you as you take notes on your note pad. If you take extensive notes, summarize key points on the interview form. This is particularly important if more than one person is interviewing. You might add prompting questions that you can use if your interviewee is reticent. For example for the question, "What could be improved?" some interviewees will go on at length about problems with the program. Others may need prompting questions such as "Knowing what you know now, what might you have done differently?" or "Where were the problems?"

For the most accuracy, you may audio or video tape record, transcribe, and then summarize. You may find that this is more time consuming and expensive than just taking notes during the interview, but it is more accurate. Research has documented that interviewers tend to hear what they expect to hear and disregard contrary information. An alternative to recording is to have two people take notes and then compare for common understanding.

Setting up interviews

1. Determine sample of participants to interview.

2. Schedule interviews.

3. Develop an interview guide of evaluation questions.

4. Ask your questions.

 a. Explain why you are asking questions and what will be done with the information.

 b. Promise anonymity (and keep that trust!).

 c. Ask for permission to take notes or record conversation.

 d. Ask and/or observe and record demographic questions (i.e., age, gender, race).

 e. Ask your program evaluation questions starting with simple descriptive inquiries (What did you make?) and move toward more subtle questions (How did you feel?).

 f. Thank the interviewee.

5. Listen well.

6. Probe as needed to clarify answers or elicit more details.

7. Take notes.

8. Summarize on a form such as below.

Interview Guide

Program _____

Interviewee _____

Interviewer _____

Date of interview _____

Hi, I'm _____ from _____ .

I understand you took part in the _____ program.

I'm asking questions of a few students to help us learn how well the program worked and how we can make it better. Would you have a few minutes to talk? Thanks (if not, schedule a later time).

I'll report what you say, but I won't report who said it. OK?

Question 1. _____

Question 2. _____

Question 3. _____

Focus Groups and Other Moderated Discussions

Plan focus groups like you would interviews. Someone must moderate. Groups may be more efficient than interviews. Focus groups may yield productive interactions among participants where one person's comments stimulate others to contribute related ideas in a way that can't happen with a single interviewee. In some settings however, individuals may be more cautious and less candid in group discussions. Particularly when people of differing rank or social status within a hierarchical organization are meeting together, some people may be inhibited to share critical information.

1. Select a representative sample.

2. Set a date and place and allow from 60 to 90 minutes.

3. Invite enough people to have about eight to ten in the discussion.

4. Offer an incentive to participate (food is good).

5. Develop a short list of questions—this could be the same as your interview guide.

6. Moderate the discussion.

7. Take notes and/or record discussion.

8. Summarize results.

Public Meetings

You can plan a public meeting much as you would a focus group. One critical difference is that you will have little idea how many people will show up. Unless the program being evaluated is very compelling, you may find that your audience is small. It may be helpful to invite some key people, as you would in a focus group, to be assured of a core group at the hearing. One variation developed in Vermont for strategic planning is a focus forum. This combines a focus group with a public meeting. A small group of people is invited to prepare to respond to a set of evaluation or planning questions. The forum opens with a conversation among the prepared panelists, and then the moderator invites the audience to participate in the latter half of the discussion. Any public meeting requires a skilled moderator and a recorder.

Asking Questions in Writing

Your evaluation questions should ask if your intentions have been realized. One way to do this is to state your intended objectives and the outcomes you seek to measure, and ask to what extent these have been realized. This is quite clear and direct, and works with open-ended and fixed-response questions. This direct approach does risk that people will say what they think you want to hear. You may also miss some unintended consequences. A less directed approach is to ask people to simply describe what resulted from their experience with your program. This has less risk of bias but requires open-ended questions and may generate lots of information unrelated to your intentions.

Evaluation forms. You can collect much evaluation data from evaluation forms. Think of these as written interviews. Unlike interviews, you cannot clarify questions that don't make sense or probe for better answers. The evaluation form must be short and simple, and the questions clear.

You can ask two kinds of questions—open-ended questions that request a narrative answer and fixed-response questions for which the respondent checks a box or circles his or her choice among a number of prepared answers.

Open-ended questions allow for more discovery as the evaluators do not predict anything about the answer. You may get answers to questions you didn't think to ask. Participant answers may be rich with emotion and nuance. "What did you like best about the program?" Remember as you write your questions to ask about outcomes that you hoped to achieve. If your intended outcome is that exhibition visitors get to know and appreciate their town's local artists, then ask a question like, "Did this exhibition help you get to know and better appreciate our local artists?"

Fixed-response questions are much easier to analyze. You have to be very clear with the question and anticipate likely, unambiguous answers.

Did this exhibition help you get to know and better appreciate our local artists?

❑ Yes, very much.

❑ Yes, a little.

❑ No, not very much.

❑ No, not at all.

Fixed-response questions are not subtle. In the above example, a visitor who already knew quite a bit about local artists may not find an answer that matches their experience. You might anticipate this by inviting comments. If you ask the wrong question, your answers may not be meaningful.

Fixed response questions should allow for a range of possible answers along a scale. A four-point scale is common. Avoid an odd number because it allows for a neutral middle choice. You want people to be decisive. An exception is a question about which a respondent might not have enough information to answer. Then add a "Don't know" response.

A good evaluation form includes both kinds of questions to combine the flexibility of narrative answers and the expedience and economy of fixed responses.

Evaluation forms are often handed out to participants at the conclusion of a program. Instructions can be repeated orally, and the evaluator can answer questions about the evaluation form. Because they are often administered within the program itself, evaluation forms must be very concise, as time will be limited.

Surveys

Mailed surveys. Surveys are typically mailed to program participants. A survey package may include an outside envelope, a brief note explaining why the survey is important, the survey instrument itself, and a return addressed envelope. Some surveys are designed to be self-mailers to reduce costs. Stamped or business reply envelopes will yield a higher rate of return. Alternatively, surveys can be inserted into newsletters or other correspondence.

Online surveys. You can reduce costs with electronic surveys. The obvious risk is that people without e-mail or Internet access will be excluded. Electronic surveys can be a simple text document distributed by email to a group of program participants or to a listserv. As text e-mails have limited formatting options, you may best rely on simple narrative questions rather than trying to devise a way for respondents to check boxes.

Web-based surveys allow for many kinds of questions. There are commercial and free versions. The best of these lead you through a process to design fixed-response, scaled answers, fill-in-the-blank, and open-ended questions. Then you can send an e-mail announcement to your list. Recipients of your e-mail message are asked to open a web site where they can answer your questions and submit their answers online. You need not do any data entry. These e-survey applications also will summarize responses and allow you to import raw data into a spreadsheet, word processor, or statistical program to do further analysis. Do a key-word search with your browser for "online survey. "Survey Suite at *www.intercom.virginia.edu/surveysuite* is a good survey tool.

Surveys are complicated enough that you should seek professional help. Evaluation consultants, marketing or social science faculty, graduate students, or planners could help with your survey.

Surveys are used to distribute evaluation forms to large groups of people usually by mail, e-mail, or on a web site.

1. Select a sample that represents the population (random, systematic, or deliberate).

2. Design the questionnaire.

3. Test the questionnaire on a small sample and correct any ambiguous questions.

4. Print and distribute.

 ● Keep survey to one page.

 ● Send with brief cover memo that explains why and requests response.

Program Evaluation Form

1. What was the best part of the program?

2. What could have been improved?

3. Did you learn what you had hoped?

❑ Yes, very much. ❑ Yes, somewhat. ❑ No, not very much. ❑ No, not at all.

4. Please rate with a check mark your ranking of each of the program components.

	Excellent	Good	Fair	Poor	Comments
[insert an intended outcome]					
How well did the program [insert an intended outcome					
How well did you learn [another outcome					

Additional comments:

[Alternative format for questions]

5. Did you _____ [insert student learning outcome(s) from your evaluation plan]?

❑ Yes, very much. ❑ Yes, somewhat. ❑ No, not very much. ❑ No, not at all.

6. Did the program meet _____ [insert program outcome(s)]?

❑ Yes, very well. ❑ Yes, somewhat. ❑ No, not very well. ❑ No, not at all.

- Enclose self-addressed return envelope–a stamp improves response.

5. Send reminders (if you want a good return).

6. Collect surveys.

7. Code open-ended questions (see next page).

8. Enter survey responses into a computer spreadsheet or statistical analysis program (or summarize responses by counting various responses with tick marks on a blank survey form).

9. Make sense of results (statistical analysis of numbers and content analysis of texts–see below).

10. Summarize and write report of findings.

2. Analyze Data

Analyze Numbers

This brief summary should prepare you to seek statistical data from your evaluation consultant or friendly college faculty member. As noted below, you can do some simple analysis without statistical training.

Making sense of evaluation information. The overall process is to reduce the bulk of data, display it, analyze the results, and decide what it means.

- Reduce the data (convert 100 survey responses to a few pages of summarized results).

- Display the data (present the few important trends or results. Graph numeric data).

- Analyze (consider what all this information means).

- Draw conclusions (what should be done with the program in light of evaluation results?)

Evaluation data comes to you mostly in numbers and words. If your data is primarily numeric, you are doing quantitative research. Historically this has been considered the most credible and is the domain of statistics. If your evaluation data are words or portfolios or

anything other than numbers, you can call your evaluation *qualitative research.* As you will see these labels are misleading in that you can also quantify common elements within qualitative data.

Making sense of numbers. To analyze numeric data, you first have to distill the information into summary form. If you have 150 surveys, evaluation forms or test scores, you must summarize this information. The low-tech way is to manually count the number of respondents who checked the different boxes–""excellent," "good", etc.–and record the results. Tick marks on a blank evaluation form are an easy way to keep track until you type up the summary.

When entering data it may be easier to set up a table on an electronic spreadsheet (Excel, Quattro, Lotus, etc.) and transfer the data from each completed form. These programs allow for summing, averages, and simple statistical analysis. For more sophisticated analysis, you may export the finished spreadsheet into a statistical analysis program (SYSTAT, SPSS, etc.). Some analyses, such as cross tabulations, are much simpler with statistical programs.

- *Count responses.* "12 artists completed evaluation forms." "240 kids participated in the program."

- *Mean or Average* "On average, the artists had 15 years of experience." "The average residency was 10 days."

- *Find the median.* "While the average was 15 years experience, the median age of participating artists was 10 years." When there are a few very large or very small numbers in a group, sometimes the median number, represents that group better than does the mean. For example, if you have a couple of millionaires in a group, their high incomes will skew the average upward.

- *Look for patterns.* "There were two groups of artists, those with significant teaching experience and those without"

- *Note most frequent responses.* "Artists most often reported that they learned more than they had expected."

- *Do cross-tabulations.* "Of the 6 artists who had not previously taught in classrooms, 100% said they would readily do so again." (Select responses from one variable (new teaching artists) and compare to another variable (willingness to teach again). This can be done manually or more simply with a statistics program.

- *Perform statistical significance tests.* "While students preferred painting to sculpting by a slight margin, the difference was not statistically significant." If you are asking questions of a sample rather than of the whole population, be aware that some differences may be so small that they could be the result of chance. Pollsters describe such differences as being within the *margin of error.* This is one area where you'll need the help of someone experienced in statistics. Informal evaluations probably don't need statistical significance testing. If you skip this step, be wary of making too much of small differences in your findings, especially if your sample is small. So if 20% of your sample said they learned a lot and 24% said they learned a little, you may not be able to say with confidence that more learned than didn't. You don't have to worry if you have asked questions of the whole population of program participants. Significance testing only applies to samples within larger populations.

- *Record findings.* Write up your results.

Making Sense of Words

1. Reduce textual data to summary form.

2. Analyze contents of the texts.

3. Report results.

Content Analysis

Much of arts program evaluation information is gathered in interviews, focus groups, and from written answers to open-ended questions. The results are expressed in words. Pages of notes may be intimidating, but it is

possible to boil these down into a credible summary with content analysis. This analysis will still be subjective, but it is possible to analyze written data with nearly as much rigor as numbers. Just as in numerical analysis, the bulk of the text must be reduced, analyzed, and reported to be useful for evaluation. Here is a summary of how to do "content analysis" of texts.

- Gather the summarized interview or focus group notes or evaluation forms with narrative answers. (If each interview or focus group meeting is not summarized into a page or two, do this first.)

- Read over the answers to one question in all of the evaluation forms or summary notes.

- As you read, look for patterns and make notes of recurring answers or themes.

- Make a short list of words or phrases that capture the sense of each recurring answer. Label each of these items with a word, number, or letter to create a code sheet. If several interviewees cited artistic quality as a problem, then "quality" becomes a category, and you may choose "Q" to be your code.

- Read through the answers again and code similar statements (e.g., coded as "Q" every mention of a concern for artistic quality). Some people use numbers so that "quality" concerns are coded 1, and the next problem, say "funding," is coded 2, etc.

- Count coded items and note your results.

- Select typical quotes to make your results more meaningful.

- Write up your findings, citing numbers and quotes.

Sixteen survey respondents, or 20%, noted that artistic quality was a big concern. One teacher expressed a typical sentiment; "Even as we strive to improve standard test scores, we can't ignore the quality of the artistic experience. It is the high quality of the arts process that gives this program the power to help kids learn."

3. Report Results

Evaluation results must be communicated if they are to do any good. Formal evaluations should be reported in writing.

The Evaluation Report

If you do a formal, summative evaluation, you will want to write a report. A less formal, or formative, evaluation may be delivered orally. In either case, it is useful to think of the audience, message, and format.

Report Evaluation Findings

Note to whom you intend to report evaluation results:

- partners and their governing boards;

- funding program officers and trustees (your evaluation can help the foundation officers make your case to the trustees or other funding committee);

- program staff and volunteers;

- constituents through newsletter or annual reports; The public (through press releases contact with legislators)

You may need to reorganize your report depending on the intended reader. You will not be distorting the results, but you may want to stress different findings for different readers. Your board of directors or funders may want to see that you achieved your outcomes. A school board member may want to see findings about student learning. Your partnership members will want to see this information plus evidence that the program may need changes.

Outline of an Evaluation Report

- Cover page
- Acknowledgments: funders, partners, program participants, evaluators
- Table of contents
- Executive summary
- Evaluation methods
- Evaluation findings (results of statistical and/or content analysis)

- Recommendations
- Appendix
- Evaluation questions
- Interview and survey forms
- Copies of program descriptions and materials

Use Evaluation Results

Evaluation becomes most useful when it is used. Evaluation results can be used:

- to improve programs;
- to plan future programs;
- to make decisions to cut or add programs;
- to allocate resources among competing programs;
- to be accountable;
- to provide solid information for advocacy and fundraising;
- to improve program or organizational marketing.

Conclusion

We opened by acknowledging that evaluation is becoming an expectation. It could be that you have read this chapter because someone has required you to evaluate. While it is sometimes a requirement, evaluation has the real power to help you run better programs. You are trying to do a good job. Evaluation is a fundamental tool that will help you succeed. If your programs are working well, evaluation gives you credible evidence. You can use this evidence to win support for your programs. Kris Sahonchik, director of Institute for Child and Family Policy at the Muskie Institute for Public Service, says that you can use evaluation as an educational and evaluation tool. "You can teach funders or legislators how you do your job."

If evaluation shows that your programs are not having the impact you intended, the evidence gives information to help fix what is not working. You may either improve the programs or design new ones.

With planning you can set meaningful targets. With evaluation you can measure how often you reach those targets. If you hit what you are aiming for, celebrate and tell the funders. If you miss, improve your aim. Use evaluation findings to improve your program or move the target by amending objectives or creating new programs.

Knowing where you intend to go and recognizing when you get there can make this otherwise elusive business of arts management quite rewarding.

"Evaluation can make you feel better about your work, in that you can be grounded and clear in what you intend to do and actually do. Even when things don't work as you hoped, you know where you stand. Better find that out before you spend more time and energy doing more of what doesn't work. Then you can develop some strategies to improve it. Clarity is better than ambiguity." David Karraker

APPENDIX

Workbook Work Sheets

Step 1. Write Program Goals.

Write your program's long-range goal(s). (You may have one or more.)
Goal 1
Goal 2
Goal 3

Step 2. Write Program Outcomes.

Goal 1. Copy goal 1 here from page 287.
What is the first outcome for goal 1? Write outcome 1, goal 1.
What is the second outcome for goal 1? Write outcome 2, goal 1.
Outcome 3, Goal 1. Write another outcome, if necessary, for goal 1.
Outcome 4, Goal 1. Write another outcome, if necessary.

Step 3. Write Indicators for Each Outcome.

Goal 1. Goal title:
Outcome 1:
Indicators: What does the outcome look like when it occurs? What evidence will you look for? After listing several potential indicators, select the two or three indicators for which the data is most readily available, unambiguous, and not likely to be caused by factors unrelated to your program.

Step 4. Assemble Evaluation Plan for Each Goal with Outcomes, Indicators and Data Sources.

Goal 1 (anticipated long-term, value-oriented result) Plans at this level are not ordinarily subject to evaluation. Write your first goal here.

Outcomes (or objective) What observable results were or will be accomplished? Write outcomes here.	Indicators What evidence do you have that outcome was or will be accomplished? For outcomes that are not directly observable, define indicators here.	Data sources Where will you go to collect evidence? (Collect physical evidence, ask questions, review archival information.)	Evaluation methods Who gathers data and when? If methods are not obvious from indicators column, describe how data will be collected.

Step 5. Pose Evaluation Questions.

Evaluation questions: What questions will your evaluation answer?

Step 6. Assign Evaluation Tasks.

Complete by (date)	Evaluation task	Person or group responsible
Evaluation planning tasks		
Data collection tasks		
Data analysis and reporting tasks		

REFERENCES

Selected Resources:

Barsdate, Kelly. *A State Arts Agency Performance Measurement Toolkit*. Washington, D. C.: National Assembly of State Arts Agencies, 1996.

Bond, Sally, Sally Boyd, Kathleen Rapp. *Taking Stock: A Practical Guide to Evaluating Your Own Programs*. Chapel Hill, NC: Horizon Research, 1997.

Herman, Joan and Lynn Winters. *Tracking Your School's Success: A guide to Sensible Evaluation*. Newbury Park, CA: Corwin Press, Sage Publications, 1992.

Stecher, B.M. and W.A. Davis. *How to Focus an Evaluation*. Newbury Park: Sage, 1987.

United Way of America. *Measuring Program Outcomes: A Practical Approach*. Alexandria, VA: United Way of America, 1996.

W. K. Kellogg Foundation. *Logic Model Development Guide: Using logic Models to Bring Together Planning, Evaluation, and Action*. Battle Creek, Michigan: W.K. Kellogg Foundation, 2000.

Wong-Rieger, Durhane and Lindee David. *A Hands-On Guide to Planning and Evaluation: How to Plan and Evaluate Programs in Community-Based Organizations*. Ottowa, Canada: Canadian Hemophilia Society.

Periodicals

National Arts Stabilization. *Measuring Joy: Evaluation in the Arts*. Fall 2000, no. 5.

Assessment: A Cultural Education Collaborative Tutorial. *www.cecnc.org*

W.K. Kellogg Foundation. Evaluation Handbook 1998. *www.wkkf.org*

U.S. Department of Education. Evaluation Primer. *www.ed.gov.offices/OUS*

Other Resources:

Institute of Museum and Library Services. (no date) Perspectives on Outcome- Based Evaluation for Libraries and Museums.

CHAPTER 9

MARKETING:

TOOLS FOR THE ARTS

by Shirley K. Sneve with

contrbuting editors Dorothy Chen-Courtin

and Barbara Schaffer Bacon

Americans are making more money, are working harder and longer, and want to make the most of their lives. As a result, they are very guarded of their leisure time and want their children get a good education.

The competition for that free time is immense. From 200-plus channels to watch on television, to professional sports events and community activities, choices even in the smallest rural communities are immense. With comfortable, fast, and efficient transportation, it's easier than ever to see professional theater or symphonies in major metropolitan areas all across the country. And with today's audio technology, one can listen to high quality recordings in the comfort of home, rather than drive across town to hear a live performance.

Arts organizations face tremendous competition for an individual's attention. Now more than ever, cultural groups need to deliver a clear message that engages participation from its community. Delivering the organization's message to the community and the individual is at the heart of marketing.

We are challenged, through marketing, to extend a complete and meaningful invitation to all Americans to seek the arts as a means of expression and celebration. Multiple strategies are needed to make the arts more central to the lives of more citizens.

Promotional tools are also changing. Powerful personal computers can extend an organization's marketing capacity through the Internet, desktop publishing, statistical and financial analysis, and database management. E-mail, high-speed Internet connections, cable television, and Geographic Information Systems (GIS) are becoming indispensable tools for increasing the capacity for effective communication. It is within this environment that we consider marketing.

Marketing is communication. Whether you represent a cultural group or a local arts agency, marketing is central to the fulfillment of your goals. Marketing is a means of telling the public who you are, what you do, and how they can be

involved. Marketing strategies can accomplish key tasks, such as:

- attracting donors, volunteers, and members;

- developing audiences and ticket sales;

- promoting events, artists, and cultural resources;

- advocating policies that support arts and cultural development.

This chapter introduces contemporary marketing principles and explores their application to the many marketing challenges faced by cultural organizations and local arts agencies. It also shows how to apply these various tools that connect arts and community.

THE ROLE OF MARKETING

Many people equate marketing with selling a product. While the promotion of specific programs and services is the most visible aspect of an organization's marketing efforts, marketing is much more than selling and includes a full range of communication activities.

Image Building

Ongoing efforts to establish a positive image and build a good reputation in the community will enhance your agency's ability to market programs and services. If the public image you create is consistent and credible, the community will trust your agency when making decisions about supporting and attending arts and cultural activities.

Education

A majority of people are familiar with only the most popular artists and traditions. Most arts presenters seek a balance between more recognizable and more challenging arts programming. Marketing, therefore, also educates audiences in order to make programs more accessible and familiar to them.

Don't assume that the public is familiar or comfortable with the artists, art forms, traditions, or ideas your organization promotes. Your promotional strategies should work to inform,

excite, or motivate the public about events or issues they may perceive as intimidating, dull, or "not for them." In order for your organization to inform and educate effectively, whoever is responsible for marketing must take the time to learn about the content and context of the artist or subject you are promoting.

At one art center, a volunteer publicist prepared some standard press releases for an upcoming exhibit of collage works by an older woman. Her releases focused on the look, style, and materials of the art, as well as the awards and recognition the artist had received. Three weeks into the show, a reporter interviewed the artist and published a profile that revealed how the woman had come to create art late in life after many bouts with depression. The story noted how the artist's work helped her to express her ideas and feelings. After the article, the center received calls from many seniors groups wishing to arrange tours.

In order to educate the public, arts promoters need to educate themselves. Although it isn't necessary to be an expert on every art form and tradition, you should learn enough about the art, the artists, and programs to describe the experiences they might offer and help your intended audiences find connections.

Participation Building

Most of the literature on participation uses the term *audience development* to describe the efforts of arts organizations to increase the populations they serve. More recently, there has been a shift to the term *building participation* because it avoids the connotation that people experience the arts exclusively by attending live performances or visiting a museum. The arts are an interactive experience, and participation can be enhanced in ways other than merely increasing audience size. *A New Framework for Building Participation in the Arts* by Kevin F. McCarthy and Kimberly Jinnett (Rand, 2001) sets the stage for organizations to increase their reach and effectiveness.

Institutions must determine how participation-building efforts fit with their overall purpose and mission, their available resources, and the

community environment in which they operate. In other words, arts organization must take an integrative approach to building participation, one that

- links the organization's participation-building activities to its core values and purpose through goals chosen to support that purpose;

- identifies clear target groups and bases its tactics on good information about those groups;

- clearly understands both internal and external resources that can be committed to building participation;

- establishes a process for feedback and self-evaluation.

McCarthy and Jinnett state that a central strategic issue involves deciding what an institution means when it says it wants to increase participation. An institution can increase participation in three basic ways:

1. **Broadening** it by capturing a larger share of the existing market by attracting individuals who constitute a natural audience for the arts but are not currently participants

2. **Deepening** it through intensifying its current participants' level of involvement

3. **Diversifying** its constituency by attracting new markets comprising those individuals who typically would not entertain the idea of participating in the arts.

An institution that decides to pursue all three ways at once faces a difficult challenge, because each of these markets requires a different engagement strategy.

Audience development goes beyond increasing attendance. It occurs when new groups of people are attracted to a program or organization and develop an interest, connection, or commitment. By combining program development and promotional strategies, arts marketers can provide bridges to connect new audiences with opportunities for expression and enrichment.

According to Brad G. Morison and Julie Gordon Dalgleish, authors of *Waiting in the Wings*, audience development involves first creating "points of entry"—opportunities for new groups to discover the benefits of arts participation in cordial settings that are "comfortable, and least intimidating." They recommend then offering "stepping stones"–program options and variations that allow new audiences to "gradually increase their interest, understanding, and adventurousness."

The demand and potential for audience development is great. The traditional "arts" audience is limited and graying. Now, with art more broadly defined, we can offer new audiences more forms, more traditions, more places, and more ways to experience the arts. Market research can provide insight into the needs and habits of potential audiences and enable arts organizations to design desirable programs, services and convincing promotions.

A theater has been offering contemporary works by artists of color for ten years. Through its programming, the theater has explored both the human and American condition from a diverse range of cultural viewpoints and theatrical styles. It is hosted by a presenting institution but operates and promotes its productions independently. The theater attracts an audience that is diverse both in race and age. Whites are attracted to the theatrical, cultural, and/or political content and the compelling nature of the programming creates a "point of entry" for Asian, African American, and Hispanic audiences. Recently, recognizing the potential for crossover between the theater's and the presenting institution's audiences, the theater began to promote its season through the concert hall's general season brochure as well as independently and vice versa. It is expected that concert hall audiences may consider trying the theater's programs and the theater's audiences may explore the wider selection of the concert hall's offerings. Each provides a "stepping stone" for the other's audiences to explore new cultural territory.

Assessment and Planning

When used as an integral part of an organization's planning and evaluation strategies, feedback from marketing efforts—whether successful or failed—can tell you more than how well your promotion worked. Market research activities such as focus groups, surveys, and participant evaluations can also reveal:

- how the agency is perceived in the community;

- what a community or a specific group expects or wants from your agency;

- how well programs work for targeted audiences;

- whether the marketing message was heard.

Good market research is key to strategic planning in that helps organizations allocate dollars to build on program successes, deliver audience and education needs, and increase the role arts and cultural organizations have in building strong communities.

Organizations that understand marketing as more than selling can use it as an assessment tool and a means of engaging in an ongoing dialogue with the public.

MARKETING DEFINED

The American Marketing Association defines marketing as

"the process of planning and executing the conception, pricing, promotion, and distribution of ideas, goods, and services to create exchanges that satisfy individual and organizational objective."

In *Marketing for Nonprofit Organizations*, Philip Kotler makes this differentiation:

"Marketing is the analysis, planning, implementation, and control of carefully formulated programs designed to bring about voluntary exchanges of values with target markets for the purpose of achieving the organizational objectives. It relies heavily on designing the organization's offerings in terms of the target market's needs and desires, and on using effective pricing,

communication, and distribution to inform, motivate, and service the markets."

K. Diggles places the artist in the foreground of marketing the arts:

"The primary aim of arts marketing it to bring an appropriate number of people into an appropriate form of contact with the artist, and in so doing to arrive at the best financial outcome that is compatible with the achievemen of that aim."

Francois Colbert's *Marketing Culture and the Arts*, states:

"The initial goal is not to satisfy a consumer need, but to invite consumers to get to know and appreciate a work. Unlike the commercial sector, which creates a product according to consumer needs, artistic concerns create a product first and then try to find the appropriat clientele."

While the classic principles of marketing are employed in the same professional manner in both the commercial and the nonprofit sectors, nonprofit arts organizations recognize the important educational role their product plays in a creative society.

These definitions incorporate several key marketing concepts.

Management

Marketing is not just the random use of press releases, posters, or advertising, but is a managed process involving analysis, planning, implementation, and control. Marketing is the implementation of a carefully formulated campaign using selected promotional tools designed and timed to achieve desired results.

Exchange

Marketing brings about voluntary exchanges of things of value that are mutually beneficial. In an exchange, all parties benefit—the patron enjoys the benefits of membership, art purchase, or experience, and the artist enjoys

remuneration for his or her work. A sponsor's financial investment advances the philanthropic mission of their business, and a state arts agency uses public funds wisely.

We ask audiences to exchange time and/or money for the experience of the arts. Often, time is the more crucial issue. While price can be a critical factor, consumers also ask themselves how they want to spend their time. If they consider investing time, they ask if the experience will be worth it. In promotions, featuring "added values" such as easy parking, parties, or educational events can enhance the value of the exchange. A promotion that speaks directly to consumers' interest in getting the most for their time might sound like this:

See where history was made.

Discover our architectural treasures.

Hear the stories of our community makers.

All this in 90 minutes ...and exercise, too!

Join us, weekdays and Saturdays at noon for a walking tour of downtown. This program is sponsored by the Arts Council, the Chamber of Commerce, and the Historical Society.

Markets

Marketing involves identifying, selecting, and cultivating targeted audiences. It is not an attempt to entice the general public. In market segmentation, specific groups are identified and research conducted to understand their attitudes about the arts and gain insight into their lifestyles. Programming and marketing campaigns are then directly targeted to capture their attention and elicit a response.

Target marketing is effective for drawing more of the kinds of audiences already supporting you and for developing support from new audience segments. It can be key in discovering how to overcome barriers to participation for previously excluded populations.

As a music presenter in a suburban area, you learn from national research that young singles and couples are good audience prospects for jazz performances. The program committee wants to offer a short series of Saturday night concerts that will appeal to a younger audience. Before investing in this new venture, however, you conduct two focus groups and get some surprising feedback about the attitudes, beliefs, leisure activity patterns, and media habits of the target population:

● Many affluent singles and young couples frequently go away on weekends.

● Weeknight performances are more likely to draw singles because they have no family obligations or childcare needs.

● Many singles are as interested in the social aspect of cultural events as in the artistic content.

● People think of jazz as "serious."

● Everyone goes to the Wednesday night two-for-one deal at the local cinema.

● A widespread perception exists that "there is nothing to do on weeknights."

You bring this information to the program committee, which uses it to design a Thursday night series featuring cabaret-style performers, sale of refreshments, and plenty of intermissions during which audience members can socialize. You promote it as a relaxed "jazz coffeehouse" evening and develop a joint promotion with the local cinema. By the third month, your performances are the "in thing" in your community.

THE MARKETING MIX

Many factors that could impact audience turnout—weather, local economics, and competing events—are outside of your control. But, as the above example illustrates, there are four marketing elements that you can control: product, price, place, and promotion. Known as the "four Ps," all are necessary and mutually dependent ingredients in the marketing mix, and should be considered when you aim to meet the needs of a particular audience.

New Considerations

Recent work in the marketing profession considers the importance of three more factors: Physical Evidence, People, and Process.

Product

Product is the mix of programs, products, and services your group offers to the public such as concerts, exhibitions, residencies, publications, or grant making. Often an artistic director or program committee has sole responsibility to develop or select programs. However, programs should be selected with target markets in mind, and marketing issues should be considered when designing programs. Communication between those responsible for programs and those responsible for marketing is key.

As noted earlier, audience development ultimately starts with program choices and design rather than with promotion. Extended residencies conducted in association with traditional performance presentations, for example, have helped audiences new to an art form get familiar with the medium, the work, and the artists. If your organization is trying to attract new population groups, you have to consider whether they will respond to it. Approaches to program development are described in Chapter 3.

Many consumers think about spending the evening out or an afternoon with the family when they consider attending a cultural event. They do not necessarily focus on the specific artists or works in a program. Amenities such as parking, refreshments, opportunities for socializing, and activities for children may all contribute to the quality of the consumer's experience. Therefore, such amenities should be designed and promoted with the program.

Price

Price is the value placed on the programs, products, and services offered for exchange, that is expressed in terms of money and time. A concept central to pricing programs is what the market will bear. The price should be not so high as to prohibit participation and not so low

as to shortchange income (or profit) potential. The cost of going to a local movie house is often a good indication of what many in the community consider an accessible price.

> **The Baltimore Symphony Orchestra, trying to turn around an elitist image, developed a new product, Casual Concerts. A shortened, hour-long version of evening concerts is performed, including friendly and informative discussion from the director. Orchestra members dress casually and audiences are encouraged to do the same. The symphony both reduced the admission price for its Casual Concerts and offered a shortened one-hour program. Presented at 11 a.m. on Saturday mornings, the series offered an alternative to the lengthy programs and costly tickets typical of classical music concerts.**

When setting prices, consider who is excluded at what price levels and how you can keep programs open to those less able to pay. Some approaches to keeping price affordable are:

- free or low-cost admission/registration, subsidized through grants or sponsorships;

- sliding scale, permitting the consumer to pay according to ability;

- early-bird incentives offering a lower price before a certain date, or other special incentives, such as buy one, get one free;

- complimentary tickets;

- premium price tickets that subsidize tickets sold at more affordable prices and might include admission to an artist reception.

Pricing a program or organizational membership should be based, in part, on a budget analysis that identifies real costs and a baseline per seat or person cost. By "running the numbers," you can compare various pricing scenarios to determine which is most likely to attract audiences or generate a profit. This kind of review will help you avoid under pricing and financial losses. Such analysis prepares you to seek program sponsorships.

Most cultural organizations cannot sacrifice earned income. Often programs that begin as free events eventually charge admission in

order to survive, but not without some degree of consumer dissatisfaction. An educational process can help audiences appreciate the cost of presenting the arts as well as their responsibility to help support them. Public radio and television have become particularly adept (and bold!) at this in their periodic fund drives.

> An arts council produced a popular folk festival. Offered free at first, the event attracted thousands of people. The arts council, however, anticipated the financial reality that it would have to begin charging admission. In order to retain its audience, paid admission was phased in gradually. First they set up unattended donation boxes; the next year people were personally invited by volunteers to make a donation at an attended donation box; then they suggested a specified donation amount; finally, they charged a ticket price of that same amount. The council was able to sustain attendance throughout the transition.

It might be more difficult for people to find the time to participate in a cultural activity than to spend money. Time is often a value of equal or greater importance than money.

Place

Place refers to the location of your programs. Convenience, desirability, and emotional obstacles associated with a location can affect the marketability of a program. Place also refers to distribution, that is, the means of making programs and services available and accessible to buyers. Does your theater program tour the region or promote regionally to attract audiences to a downtown hall? Are tickets available by telephone and mail order or only at the box office? Do you program only in one art center or use churches, business lobbies, and recreation sites for your offerings?

> The Baltimore Symphony Orchestra offered its Casual Concerts at a local shopping mall, whose customers included both current and desired markets. Since both groups already used the mall, they felt comfortable there and considered it a convenient destination for a Saturday morning.

Promotion

Promotion is communication to target audiences of messages that create an interest in or desire for programs and services. This includes use of advertising, posters, direct mail, telemarketing, press releases, and a host of other tools to inform the public about your program. The Marketing Tools section in this chapter focuses on this area.

Physical Evidence

Cultural organizations share a similar problem with the service industry, according to arts marketing consultant Dorothy Chen-Courtin. The arts represent an *intangible* product. The potential user cannot "kick the tires" prior to purchase, and the product or experience will never be the same to each individual, or even to the same person over time. Even when watching a movie for the second time, the viewers will have a different reaction to it based on their previous experience and the audience watching it with them.

Customers of an *intangible* product, such as a concert or visual arts exhibit, often rely on *tangible* cues or *physical evidence*, to evaluate the service before its purchase and to assess their satisfaction with the service during and after the experience.

The proper management of the physical evidence surrounding the visual and performing arts experience will assure or reassure the audience of the mission and objectives of the organization.

The following are two principal categories of physical evidence:

1. **Marketing communications materials.** Examples of marketing communications tools to provide tangible evidence include the logo and corporate identity, fliers and brochures, on-site signage, publications in which the organization chooses to place its advertisement, and the organization's Web site. These are all physical evidence of how the organization implements its mission and positions itself.

2. **On-site physical projection.** The outside appearance, architecture, and interior décor of the arts organization; on-site amenities; as well as the appearance and communications quality of front-line personnel all work in concert to assure and reassure the audience. The choice and management of these site-specific elements serve as physical evidence of how the organization carries out its mission. Does the message delivered through communications materials match that of the site? Customers will be able to recognize a logo if it is used consistently in print, on the web site and at the cultural venue.

Outside signage that clearly indicates you have arrived, where to park, and where to enter may be the deciding factor to someone considering a visit to your organization. Is the entrance accessible to all, including persons with disabilities? Are outside smoking areas well marked, kept clean, and away from main entrances?

People

Success, for the arts organization, depends on the seamless delivery of a great experience, be it an exhibition, a concert, a play, or a dance performance. Who and what can ensure this seamless delivery? People do through a good process—the last two Ps of the marketing mix.

The people we refer to include the audience-contact staff and volunteers such as the receptionist, box office personnel, the guards, the performers and specialists such as artists, musicians, and curators, as well as the Board of Directors, management and staff. Audience-contact staff creates an instantaneous and lasting impression on the public. The board, management, and staff members build, nurture, and sustain the ongoing rapport with the public. Performers and specialists, such as museum curators, are producers and deliverers of the experience that the public comes to see, hear, and enjoy.

The implication here is clear; the selection, training, and empowerment of people for the arts organization must be thoughtfully executed. Every individual in the organization has a specific functional responsibility. Collectively, everyone also has a quality-service-delivery responsibility. This is where cross-functional cooperation is critical. People in every part of the organization from executive, program, and operations, to marketing need to team up to deliver a quality experience for audiences.

Process

In this context of marketing, *process* refers to the smooth integration of all other aspects of the marketing mix. By now it should be clear that arts organizations are essentially service organizations delivering pleasurable experiences—from visual arts to performing arts—while catering to human-comfort needs. Those that succeed have effective processes in place to ensure that customers are well served from the time they first hear about a program until they leave the program, well satisfied with the experience.

Creature comfort needs include the auxiliary product benefits we discussed earlier. They may be basics such as well-lighted parking, properly air-conditioned and ventilated spaces, tasteful decor, handy water fountains, and clean restrooms. Additional benefits can include well-stocked gift shops, snack bars, and quality restaurants. All these basics and extras, as well as the core product offering of the organization, need planning, scheduling, and managing of capacity and logistics. The seamless delivery of the experience depends on effective operations management.

In marketing terms, we explored how products need to be designed as product bundles that include the core product, the extended product and auxiliary product offerings. Now we know that the core, extended, and auxiliary product offerings all depend on good process.

Traditionally, organizations view program operations and marketing as separate functions; however, managers today see that arts marketing and operations are interdependent functions. Success depends on cooperation, where administration, operations, facilities, and marketing all plan, schedule, and deliver as a team.

All seven elements—product, price, place, promotion, physical evidence, people, and process—are necessary and mutually dependent ingredients in the marketing mix. Not an excellent program nor a bargain price nor a massive promotion will, in and of itself, attract audiences. In order for a marketing campaign to succeed, all seven elements must be designed in relation to one another and with specific target markets in mind. Fortunately, this is easier than it sounds. For regularly offered programs, you may discover the right mix by trial and error. A deliberate examination of the seven Ps is particularly useful when designing new programs, reaching out to new market segments or evaluating a past campaign. If something didn't quite work—consider whether you offered the right mix of product, price, place, and promotion, as well as physical evidence, people, and process for your intended markets.

MARKET RESEARCH

Market research is a process of finding out more information about existing or prospective markets to help you make better program and marketing decisions. The goal of market research is to gain insight into the interests and behavior patterns of these markets. For many organizations, however, the idea of conducting market research seems overwhelming. The research process can, in truth, be as simple as observing who is attending your programs and reviewing existing box office records and program evaluation forms; or it can involve more complicated data analysis and survey methods.

Offering new programs or promoting to new audiences on a limited basis is a viable means of testing a market's response if these activities are accompanied by preplanned evaluations. For example, at a festival you might assess an audience's appetite for various arts offerings by stationing volunteers to ask exiting audience members which performances and exhibitions they look forward to seeing more of in the future.

Market research methods might be employed to:

- test interest in a new program direction;
- understand why membership is dwindling;
- learn about the interests of potential new audiences;
- identify a disinclined group's barriers to participation;
- gather market profile information needed to identify and secure media or corporate sponsors;
- determine the best placement for publicity, promotion, and advertising.

The time and energy invested in gathering market information pays off with the ability to pinpoint the most effective marketing resources and make expenditures in the most productive places.

If you know where to look, good information already exists and free or low-cost expertise in conducting market research is close at hand.

Market Research Information

The following outline indicates the kinds of information, input, and feedback which can be solicited through interviews, focus groups, and surveys. A researcher should select carefully and tailor the questions to meet specific needs.

Getting to Know a Market Segment

Values and beliefs (what this group believes about the arts)

- impressions of cultural life in the community;
- beliefs about the importance of the arts;
- feelings about the arts and culture that are currently available;
- perceptions of cultural activities lacking in the community.

Arts participation (how frequently and when this group engages in arts-related pursuits)

- attendance at cultural events or institutions; what kind? how often?

- obstacles to attending cultural events;

- impressions of particular events, organizations, or institutions.

Leisure activity (what members of this group like to do in their leisure time; when it is that they have leisure time)

- available leisure time;

- current ways of spending leisure time;

- most preferred leisure pursuits;

- feelings about the amount and kinds of activities currently available for adults; for children.

Media habits (where this group gets information)

- sources used to obtain information about cultural and leisure activities;

- typical advance planning time to participate in cultural activities.

Getting Feedback on Completed Programs and Events

- inclination to attend (support) the program again;

- suggested improvements to make this program better serve interests or needs.

Price

- opinion about fair price for the program;

- feeling about investment of time required to participate in the program.

Promotion

- response to the marketing campaign message and image;

- recommendation about different or additional information that should be provided in promotion.

Place

- opinion about convenience of the location and desirability;

- opinion about the date and time of the program;

- accessibility of registration/ticket purchase;

- recommendations for improvement.

Getting Feedback on Ongoing Activities
(for example, membership)

- how members first became aware of the organization

- benefits that convinced members to join

- most positive experience(s) since joining

- negative experience(s) with this organization

- most important benefits of belonging

- suggested other offerings

- plans to renew membership, reasons for not renewing

Market Research at Work

An art center noticed a small but steady increase in participation from senior citizens in its art classes. The program coordinator convened two focus groups of participants to learn if this market segment could be expanded and what would help them design programs and promotion. The groups of eight and ten seniors were asked to respond to a series of questions:

- Why do you participate in the center's programs?

- What do you get out of your participation in the center's programs?

- When is the best time for you to participate?

- What else do you do with your leisure time?

- Where do you get information about leisure/educational/arts activities?

The focus groups revealed that, while a few seniors had studied art in college or practiced handcrafts as hobbies, the arts had not played a big part in their lives. Several noted that they thought they might feel uncomfortable at the art

center. Many noted that they liked the exposure to "serious art" in contrast with the arts and crafts programs sponsored by the senior center. The quality of instruction was commended frequently.

Most enjoyed the social contact provided by the classes but emphasized that doing their own creative work was the primary motivation for enrolling.

While the groups ranged from people on fixed incomes to those with significant discretionary funds, all reported careful spending habits and concern for getting good value for their money.

Though there was no consensus, mornings were the most popular time for classes. The majority were reluctant to sign up for classes that stretch out over too many weeks because they could interfere with holiday or travel plans.

Participants mentioned the newspaper, senior events calendar, and church newsletters as their most frequently used information sources. Two radio stations were noted for their programming and news. Few were aware of cable television activity listings. Many noted that they frequently attended free arts festivals and other cultural events.

Based on these responses, the program coordinator set as an objective to increase senior participation by 20 percent over the next year. Specific efforts to meet that objective in the first year would be to:

- reconfigure the classes to run for fewer weeks but with longer sessions;

- increase morning offerings;

- design a promotional campaign around the message, "It's not too late to start with the arts!"

- give more emphasis in publicity and promotion to the quality of instruction and opportunity for serious art study;

- offer a program of studio art and gift shop tours, and short lectures on "what to look for in fine art and craft" to senior group.

Internal Information

Constituent data. Your own records are an important starting point for market research. For example, analysis of membership, subscriber, or class registration mailing lists by ZIP code indicates from where your participants are coming. How does your general mailing list compare with your membership? Is the audience for every program coming from the same location or does it vary?

Some agencies work to collect more specific data on their constituents and supporters including age, family status, occupation, media habits, and even preferences and opinions regarding programs. This information is solicited at various points of contact, such as registration, membership recruitment, or ticket purchase. With it you can construct demographic profiles of your market segments. If this information is charted over time, you may see where you are gaining or losing constituents, and discover other relevant trends.

A community music school learned that 65 percent of its students under twelve years old came from the inner-city neighborhoods surrounding the school, but 75 percent of the students twelve and over were from other city neighborhoods, with 50 percent coming from suburban communities. Based on these statistics the school sought to discover why the neighborhood children were dropping out and why more students from distant neighborhoods and communities tended to be enrolled at twelve and older.

Make it a priority to create systems to collect data and to regularly review constituent profiles.

Program evaluations. Many arts groups hold debriefing meetings or distribute and collect questionnaires at the conclusion of a program. These are a means to gain valuable feedback for future program design and promotion. Gear evaluation questioning so that it best serves your marketing needs. Questions should generally address each element of the marketing mix—product (the value and quality of the program); price (the fairness of the price, the value for time and/or money spent); place

(the convenience of the site and other logistical details); promotion (the effectiveness of message, image, and distribution of publicity and promotions); physical evidence (cleanliness and signage); people (helpful and courteous staff); and process (admission and ticketing).

Tracking. You can calculate the response rate to certain marketing efforts, and evaluate and compare cost-effectiveness.

Some simple techniques for monitoring the results of specific promotions are listed below.

- Ask callers and visitors how they heard about the program. Keep a tally of responses. A daily log of inquiries and registrations received can provide a useful comparison to monitor program registration in subsequent years.

- Insert different code names in newspaper, radio, and television ads. When callers respond to the ad by asking for "Nancy" or "George," it can be recorded and tallied. Code names can be assigned to certain stations or publications, or they can be more specifically associated with the time of day or day of the week the promotion is scheduled to appear.

- Code mailing lists used for direct mail. When creating the graphic piece, design it so that the registration/subscription form, which is returned to you, is on the backside of the mailer panel. Keep track of the different mailing lists you have used by coding them in some visible way (such as a code number or even a colored marker stripe down the edge of a purchased list). By counting the coded forms when they are returned, you will know which of your mailing lists are producing the best results.

- Use short audience surveys at events to collect demographics and/or assess media effectiveness and reach. Incentives, such as ticket giveaways and free beverages, are often used to encourage cooperation and increase the rate of return.

- Provide incentives for people to respond to a promotion. Offer a discount or free item

through coupons located in ads, direct mail, or flyers. This is especially useful for promotions that don't require a specific response, such as a general brochure about your organization. When people trade in their coupons for their discount or freebie, you get some idea of the impact. If coupons are coded according to which papers, magazines, or flyers they appear in, you can compare the return from each publication. Requesting that coupons are returned with that person's home ZIP code is another way to learn the geographic draw of your program.

Financial data. Documentation of marketing expenditures can provide a basis for comparative analysis and valuable data for projecting promotional costs for future programs. A spreadsheet that allows comparisons of marketing expenditures over several years could help in establishing a baseline for future marketing budgets. In *Waiting in the Wings*, Morison and Dalgleish recommend calculating the cost per dollar of income (all related direct marketing expenses divided by the total ticket, membership, or fund raising income) as the simplest way to compare the relative cost-effectiveness of various marketing strategies.

External Information

Census data. With information from the regional or state census bureau, town or regional planning officials, marketing specialists, or a nearby university or college, you can learn the demographic facts and trends about communities of interest. Population breakdowns, education and income levels, employment patterns, housing and community growth trends, and much more are all available from census data. The same information that your municipality uses to predict the need for sewers, schools, and roads can help you with your programming and marketing decisions. For example, if the per capita income in a region has dropped, it may be affecting citizens' ability or willingness to pay for cultural activities. A growing number of single-working-parent households might suggest the need for a

before-school program to assist parents who must leave for work before school officially opens.

Demographic analysis systems. More detailed demographic information is also available. One well-known system is called PRIZM, developed by Claritas Corporation. It combines ZIP code with information about people's age, income, and education, including spending habits and dozens of other factors, to identify forty "clusters" of consumer characteristics. Other systems can combine your database with census data to see at a glance where your audience comes from and where other similar consumer clusters might be found. These services are generally available through consultants. Organizations can use the information to aim mailings and other promotions at specific target markets or to identify target markets they want to learn more about through further research.

The competition. An important part of market research is to be aware of what arts colleagues and competitors are doing. Observe what programs are offered at what prices. Study promotions for clues as to what audience segments are being targeted. See if you can determine what their marketing strategy seems to be. Such information will help you define your organization's own image and position, or niche, in the market.

Direct Constituent Contact. Just as word of mouth is the best way to communicate your message, it is also a great way to hear what current or prospective constituents have to say. By seeking the opinions and responses of consumers, you can begin to view your organization and its programs from their perspectives and, therefore, more objectively.

Other data sources:

- The police or courts may be able to provide statistics on at-risk youth populations.

- The United Way records information on philanthropic trends and human service issues.

- Real-estate agents track who is moving into town and know their concerns for recreation, education, community services, and cultural activities.

- The public school system profiles its student population.

- Local newspapers and radio and television stations profile their own readers, listeners, and viewers.

- National arts service organizations such as the American Symphony Orchestra League, Dance USA, Chamber Music America, the National Jazz Service Network, and Americans for the Arts have profiles of constituents and audiences.

- Trade publications, like the Chronicle of Philanthropy and American Demographics, can provide useful statistics and information on audience, fundraising, and marketing trends.

Interviews, Focus Groups, and Surveys

The typical methods of market research through direct audience or constituent contact are personal interviews, focus groups, and surveys.

Interviews, focus groups, and surveys are useful as market research tools that allow you to:

1. get to know new market segments (at an introductory or assessment stage);

2. solicit input as programs and marketing campaigns are being designed (at a formative or planning stage);

3. receive feedback on programs after they have taken place (at the evaluation stage).

To determine which method to use and how to construct questions, you need to be clear about what information you are seeking. For example, if you want to gauge artists' perception of your grant-making programs for artists, then open-ended questioning via focus groups might bring the most useful response. If you want to know artist demographics, income, training needs, or other more factual information, then a survey would more efficiently gather that information from a larger number of artists.

Constructing questions is both an art and a science. It is easy to inadvertently weight questions according to your own biases or make assumptions about your respondents. Language, check-off options for multiple-choice questions, the way a question is worded, and the order of questions can all contribute to the effectiveness of an interview, focus group or survey.

A common error is to assume that the attitudes held by a targeted survey sample are also held by the larger population. Professional assistance in designing questions and sampling methods may be helpful when dealing with complicated market research efforts or where the stakes are high. At the very least, ask for help troubleshooting the questions from members of your organization and a sample of constituent types who will be among your respondents.

MARKETING TOOLS

Marketing campaigns typically utilize four communication strategies: public relations, publicity, promotion, and advertising. Within each there are specific tools that you can employ to accomplish different things. A press release, for example, presents the facts about an upcoming concert—the dates, location, price, and nature of the program—while a radio interview with the musician offers listeners a chance to hear what the music sounds like and to become familiar with the artist and her approach. Both are useful but each does a specific job.

Marketing as Management

Leaders of a museum's annual fund drive strategically coordinate or manage it marketing efforts as follows:

- Five weeks before the campaign, ideas for human interest stories are offered to the local newspaper editor and two radio talk-show hosts. These generate feature stories and radio interviews that appear two weeks before the fund drive is launched and serve to develop general awareness that the museum's fund drive is soon to be launched.

- Direct mail solicitations are mailed to previous and perspective supporters the day before a press conference that kicks off the marketing campaign. The press conference generated television news stories that night and paper coverage the next morning. The direct mail immediately reinforces these media messages.

- The telephone solicitation to those who received the mailing is implemented over five weeks following the press conference.

- Press releases are issued at regular intervals during the fund drive to update the public about campaign progress. Prerecorded radio sports, featuring local leaders discussing the benefits of the arts in the community, are aired for five weeks beginning with the press conference. Postcards are sent as a follow-up to the earlier direct mailing to remind people how to make a donation and of the deadline by which to pledge.

- Midway through the campaign a show of student work from local schools opens in the museum lobby, attracting parents, teachers, and friends in addition to community leaders. The annual drive is promoted during the awards ceremony. Also during this time, a series of short lunchtime concerts is offered downtown to maintain visibility for the museum and the fund drive.

- The six-week campaign ends publicly when the campaign chair accepts a check from the head of a local publishing firm that pushes the campaign over the top. A picture appears in the evening paper and the fund drive's success is reported on morning newscasts.

Public Relations

Public relations are those activities that build goodwill within a community or audience. Public relations concerns how the public perceives and regards your work. Aims of public relations efforts might be to enhance visibility or credibility for your organization, to build trust with a particular market segment (often a new one), to develop a particular

image for your organization (defining your niche or character), to inform your audiences of recent accomplishments, or to counteract general misperceptions, such as the effects of a particular controversy. Public relations involve several key components.

Networking can be accomplished by participating in professional and civic networks; hosting periodic breakfast or lunch engagements for community leaders, government officials, or members of the media; or participating in civic activities initiated by the chamber of commerce or service organizations.

An organization's board and key staff can advance their mission through active involvement in the community. Attending city commission meetings and participating in community events—including events put on by your competitors—increases the credibility and importance of the arts in your region.

Community relations can be built through friendly, helpful treatment of the public through frontline volunteers and staff; letters to the editor giving thanks or praise; offers of your resources, such as space, for other community purposes; or word-of-mouth recommendations.

Reliability, professionalism, and businesslike operations, which all contribute to an organization's reputation in the community, can be cultivated by maintaining a stable address (post office box for organizations without an office); investing in a quality phone answering system and replying to messages promptly; and paying bills on time.

Visibility for your organization can be enhanced through public speaking engagements; brief videos introducing your organization played at community events and meetings; regular programs on cable television; or volunteer participation by staff and/or board in public television auction phone-ins.

Publications communicate an organization's aims, scope, and quality, and offer opportunities to stay in touch with supporters and discover new ones. Invest time and effort to ensure high-quality publications, which

present a consistent, professional graphic image.

In the event of negative publicity, such as a publicized mismanagement problem or a controversy surrounding the content of an art exhibit, a proactive public relations effort grounded by a clear statement of your position may be necessary to reestablish credibility or to reinforce the organization's commitment to community interests while sticking to its principles.

Publicity

Publicity is the backbone of marketing for most arts organizations. It involves the dissemination of newsworthy information free of charge by newspapers, magazines, radio, and television. While the media is required by federal communications law to provide free service through which news of local and community interest is communicated, they have limited print space or airtime to accommodate all the potential requests for coverage. There is no guarantee that your press release will be printed or your public service announcement aired. Therefore, knowing how to present your information clearly, concisely, and in standard formats increases your chances of having your information used.

Publicity tools at your disposal include:

- Internet web sites and e-mail newsletters
- press releases
- calendar listings
- captioned photographs
- feature stories
- reviews
- event listings on automated telephone information systems offered by newspapers
- public service announcements
- cable television calendar listings
- radio and television talk shows
- press conferences
- newsletters

Meeting editors' needs. Publicity coverage depends on effective relations with key media contacts. This section offers guidelines on how to prepare and present publicity communications; however, it is wise to find out from editors with whom you will have frequent contact–especially local ones–what their particular style and format preferences are. Each editor has different requirements. One may welcome your phone offer of several ideas for feature stories on your annual concert series. Another might regard this as an annoyance and prefer to receive a full press packet, develop his or her own ideas, and then call you for feedback. Maintain an updated file (on computer, if possible) with information on deadlines, editors, and preferences. This will prove a valuable resource, especially if staff or volunteer publicity coordinators change often. Try to deliver your first article personally so that you can introduce yourself and begin to establish a relationship. Acknowledge assistance with thank-you notes.

Publicity tools. A press (or news) release presents factual, timely, newsworthy information. Not a sales pitch, it answers the questions: who, what, where, why, when, and how. Its opening sentence should be compelling, and its opening paragraphs should include all the essential information. This makes it easier for the editor to shorten copy if space is limited while still providing the reader with the most valuable and pertinent information.

The media are not in business to provide you with free publicity. Your stories will be used more often if they (1) contain news; (2) are presented in usable form and do not require research or revisions (more information, spelling corrections); and (3) are not filled with the writer's opinions and glowing remarks regarding the event. Give 'em the facts!

A calendar listing of daily events provides basic information: event name, times, location, price, ticket availability, or registration instructions. Some newspapers run calendar highlights offering descriptive listings and photos as well as the basics. Find out who the arts calendar editor is. Many newspapers provide call-in numbers for various subjects,

including the arts, supplying prerecorded local event listings.

A feature story highlights background and human elements behind the news; lending color and meaning to facts and events. Because features provide a sense of immediacy and depth of coverage, they can attract attention, offering readers substantial information and insight that may convince them to take action. A feature story can be timely–that is, related to a program you are mounting, a grant you recently received, or another newsworthy occurrence. As such, its timing in the news is important and could boost attendance or influence public opinion. Feature stories can also cover subjects not tied to any particular event, such as a special, long-term volunteer or the arts council's ongoing arts-in-education programs. Ideally, a feature story should contain a "news peg"–some connection with current events that supplies a reason for using it.

Feature articles are most often written by a publication's staff writer or by a "stringer," or frequent contributor. Therefore, your job is to suggest, or "pitch," story ideas and try to persuade the editor or writer to develop them into features.

> An arts council is launching a new project featuring art installations in abandoned downtown storefronts. Story ideas suggested to the arts editor include: the installation process, featuring artists explaining their aims and approaches; the public as critic–the reactions of passersby; and local businesses' perspectives on the art project's goal to help with downtown revitalization efforts.

Effectively pitching an idea for a feature article involves the following steps.

1. Develop the idea(s) or angle (different ways of looking at the subject) you want to propose based on the publisher's interests.

2. Determine to whom to pitch your idea (arts editor, suburban section editor, or a particular writer who might be interested in writing the story and who could propose your idea to his or her editor).

3. Send out a press release providing basic information with a cover letter suggesting your idea. Background materials can be helpful but should be kept to a minimum. Follow up the mailing with a phone call to discuss your idea and any responses that the editor might have. Be prepared to provide contact information on people who might be featured in the article.

Monthly magazines typically require three to four months lead time prior to publication; newspapers require three to six weeks prior depending on the nature of the article.

Captioned photos, even without an accompanying article, can be extremely effective in catching the reader's interest. Always try to obtain high-quality black-and-white photos (five-by-seven inches or larger) from your participating artists and plan to take professional quality photos at your own programs for future publicity use. Use of color is increasingly common among newspapers, so color slides might be requested, too.

Type photo captions on a separate sheet, succinctly describing what or who is portrayed and the other pertinent facts—when, where, and how. Accompany the photo with a cover letter providing contact information and, ideally, a press release with more details.

Press packets combine several of the above elements. Press packets allow you to present to the print and electronic media the full picture of a special program and perhaps to plan multiple opportunities for coverage. A press packet for an arts festival, for example, might include:

- a cover letter introducing the packet and any special comments on its contents;

- a press release providing an overview of the entire event;

- one or more additional press releases focusing on particular programs, highlighted artists, or aspects of mounting the event, conceived with the idea that the media might develop a feature story around a particular subject or run a series of releases building up to the event;

- a calendar listing;

- photos with captions;

- background description of the festival, its history and highlights;

- background information on particular artists or subjects about which you are pitching a feature story idea.

Program press packets should be sent out at least four weeks in advance; six to eight weeks is more typical. While planning, consult with key media to determine when and to what extent they might cover the program so that the press packet can be timed to meet their needs. Press packets can be costly, so plan when and how to use them most efficiently.

Press conferences are gatherings of the media to provide comprehensive information, discuss an issue, launch a campaign, or field questions. Press conferences are reserved for important or major occasions. Invitations are sent to key editors, writers, news directors, and anchors, and follow-up calls are made to encourage attendance. Often an appearance by one or more of the artists in your program, a spokesperson for the program, or other celebrity is built into the press conference to make it more enticing. Press packets may also be distributed.

In the case of a press conference called to clarify the arts council's stand on an immediate issue, a censorship controversy, or a city arts budget debate, prepare a written statement to announce at the conference and distribute to the press.

Letters to the editor and editorials are another way to express your views through print and electronic media. They are widely read and create an opportunity to influence public opinion. You can encourage supporters of your city arts budget advocacy efforts or your position on an arts-related controversy to write letters to the editor on your behalf, in addition to sending your own. Again, due to space limitations, there is no guarantee that your letter will be printed, and it may not always appear in a timely way relative to an important issue.

Guest editorials in your local newspaper allow contributors to express points of view on topics or issues of local, national, or global interest. Consider carefully what you want to express before you call the editor to propose it. If the issue is timely, be prepared to respond quickly.

Public service announcements (PSAs) on radio or television provide the essential information in standardized lengths of usually ten, thirty, or sixty seconds. Although each station is required by law to provide free time for public service announcements, there is no guarantee that your announcement will be aired or, if it is, that it will be aired frequently. Providing concise, usable copy increases the likelihood of frequent use. At the radio or television station's discretion, a public service announcement may be aired singly or grouped together with others. PSAs are often broadcast during less than prime time slots (late night, early morning, midday), with primetime slots reserved for paying advertisers.

Public service announcements may take the form of written announcements that broadcasters read on air (or scroll on television), or they may be recorded on tape with music, sound effects, or visuals added for television. In either case, your copy should take into account the difference between the written and spoken word. The spoken word can sound more informal, so sentences should be kept simple and short.

Before launching into producing recorded radio or television PSAs, determine from key electronic media that reach your targeted markets if they will actually use recorded announcements. Ask local radio, television, or cable stations to help you produce the spot and to make duplicates (dubs). This service is one that a media sponsor could be asked to provide as part of its donation.

Because your recorded PSA must compete with professionally produced spots, it should be of professional quality. Enlist the help of professionals in conceiving and producing recorded PSAs or ask for donated or reduced-rate assistance from the stations themselves.

A large regional festival negotiated a barter arrangement with a cable access television station, enlisting it to produce edited clips of the festival for the following year's PSAs in exchange for the station's right to produce programs of the stage performers. Releases were secured from performers, and the station offered performers the option of purchasing a professional quality demo tape at a modest charge.

Radio or television talk shows can publicize featured artists or organizational affiliates and provide thorough, insightful coverage. Talk show producers book six or more weeks in advance. It is important to research the interests and styles of particular programs in order to determine if they reach your market and provide an appropriate vehicle to discuss the subject. Local cable access stations are a great resource for interview programs; some local arts agencies have even created their own weekly program featuring local artists, organizations, and subjects.

Promotion

Promotion typically supports your publicity plan by providing supporting material that helps the consumer gain information, form an opinion, or make a decision to act. While the media cannot guarantee the use of your publicity materials, promotional methods are completely within your control. You can control what is said, where promotion is done, and how many people you will reach. For this reason, promotional strategies often target specific markets.

Types of promotions vary widely and include the use of graphics and print, as well as promotional events and presentations. Specific possibilities include:

- graphic items—brochures, heralds (throwaways), posters, stuffers, and postcards;
- information pieces—newsletters, reports, slide shows, and videos;
- signs and displays—signs, marquees, banners, table tent cards, and displays;

- telephone and computer resources—telemarketing, fax transmission cover sheets, electronic mail messages and bulletin boards, phone information lines;

- promotional events—preview performances or ceremonies;

- specialty items—buttons, bumper stickers, mugs, T-shirts, and caps.

One rural arts council utilized buttons as a main promotional vehicle. With a button machine they owned, they produced two sets of buttons for every event. The first button used a word or image to tease the viewer into asking what it meant. These were distributed to merchants in town five to six weeks before the event. Store clerks everywhere wore them, generating interest by word of mouth. Later, a second button and related flyers and posters sporting full information were released.

Pointers on Writing Promotional Copy

Before you begin, remember that copy should answer the essential questions:

1. Who are you? Establish your organization's image (family-friendly, cutting-edge, contemporary, an art oasis) through choice of language, tone, and writing style.

2. What is the aim of your promotion? Be clear on what the promotion should accomplish and what action you want the reader to take. For example, do you want to bring attention to your message, transmit news, inform about an issue, or elicit action?

3. To whom are you talking? Communicate with a person who is representative of the market segment you intend to reach with your message. Consider age, sex, income, education, occupation, social status, and area in which your audience lives. Imagine what would make that person respond to your messages. What benefits would move them?

As you write, make sure all important information is included and presented in an inviting, engaging way, considering these three pointers:

1. Double-check to ensure that information telling who, what why, when, where, and how it included.

2. Be clear about what action you want the reader to take.

3. Create compelling copy with the following guidelines in mind:

- Be specific, clear, and concise.

- Use active verbs and vivid language.

- Avoid jargon.

- Motivate and stimulate. Emphasize the benefits of the program—don't over promise.

- Emphasize unique aspects of your program—what sets it apart from similar programs.

- Be consistent in editorial style.

- Edit more than once.

- Get feedback before finalizing copy.

Image and message. Successful promotional efforts combine image and message to capture the target market's attention. Whether the promotion is a direct mail brochure, a poster, or a banner over Main Street, it should create a vivid impression in order to compete with the hundreds of other promotions and advertisements an individual encounters on a daily basis. Image is conveyed through both the choice of visual elements and the tone, content, and language of written copy. Image communicates how you want to be recognized and perceived by your market; message is what must be communicated. Unlike most publicity efforts, the information conveyed in promotion need not be newsworthy; it is often educational or informational—a brochure about your organization or an annual report, for example. Your message emphasizes the benefits the consumer seeks (discovered through your market research) and should be tailored to the specific targeted market.

It is a good idea to acknowledge and directly address obstacles perceived by your potential audiences. For instance, if you think some

people are worried that they don't have the proper attire, be sure to stress that they don't need a black tie to appreciate your symphony.

Are you trying to survive the terrible twos?

Are your in-laws coming for two weeks?

Has the tug-of-war over the remote control turned into all-out warfare?

Relax.

Get into something more comfortable!

A season of first-class entertainment tailored just for you.

The University of Massachusetts Fine Arts Center's 1993–1994 season brochure shows that the center has taken the time to understand the motivations and needs of working couples with young children. Staff realized that many of these potential ticket buyers weren't making the effort to go out. Staying at home was easier and "more comfortable" than planning ahead, getting baby-sitters, or making other arrangements. Recognizing these obstacles to attendance, the center's promotion suggests that being at home may not be the best way to relax.

Writing promotional copy is an art in itself. It requires conciseness, creativity, and an appropriate image and message for the market(s) you are trying to engage.

Distribution. Print promotions, such as direct mail, posters, or flyers, require careful distribution to achieve the best results. Random postings, for example, will not be as effective as strategically identifying locations that desired audiences frequent.

The timing of direct mail or other promotions must be carefully considered in relation to when people should, or are inclined to, take action and in coordination with other publicity and promotion efforts. For example, an attractive, well-written brochure enticing people to a fund raising dinner and concert loses its effectiveness

if it reaches people too late (or too early) for them to plan to attend.

The effectiveness of a promotion also relates to other activities you might build around it.

A mini-preview performance in the mall by a visiting performer may reach hundreds of passersby. But thousands of people may potentially be reached if the preview is announced in the local newspaper ahead of time and on the loudspeaker at the mall; an inexpensive flyer is distributed to mall audiences reminding them about the specifics of the full performance; and the final performance is well promoted in local newspapers.

Advertising

Advertising is the purchase of space in print media and airtime on radio and television. Its advantage is that, unlike a press release or public service announcement, it is guaranteed to appear and you can control when and where it does. Advertising is a sure way to reach a market if you determine that it responds to a particular publication or radio or television station. Effective advertisements reinforce messages and information with related graphic images and soundtracks. Professional production is critical. Advertising may take the following forms:

- display ads in newspapers, magazines, and trade journals;
- newsletters, playbills;
- classified ads;
- transit placards;
- billboards;
- radio/television ads.

The effectiveness of advertising is enhanced by frequency. A message must be repeated in order to reinforce it, especially amid the clutter of commercial advertising. Rarely will a single ad placement have significant effect.

Advertising can require a hefty financial investment to make an impact. Many arts organizations have a limited ability to

accommodate the costs of multiple ads, but resourceful ones take advantage of some of the following cost-saving means.

- Consider asking an advertising agency to assist you with media advertising purchases (there's no cost to you).

- Ask the media for ways to save money. Many offer special rates for nonprofits or reduced costs for multiple placements, camera-ready copy, and/or advance payment.

- Purchase advertising space with other arts groups. A quarter- or half-page ad promoting four to eight events will catch the reader's eye more effectively than smaller ads scattered throughout the paper. Further, ad rates usually decrease as the amount of space purchased increases.

- Arrange media sponsorships with newspapers and radio television stations that reach compatible or desirable markets and that include donated advertising.

- Ask your regional and state tourism departments to assist with money for advertising in order to attract visitors to your area.

- Ask businesses to let you use their regular advertising space or to add a line about your event to their ads (piggyback advertising). Find other creative ways to advertise cooperatively with the local business community.

The Northampton (Massachusetts) Center for the Arts negotiates a special arrangement with its local newspaper. On the third Friday of each month, the center runs a full-page ad featuring its upcoming monthly calendar of events. The center makes an annual contract with local businesses, guaranteeing them a small ad surrounding the center's ad. The businesses receive twelve placements, one per month. The center not only pays for its monthly ad but also makes a profit by selling to the businesses ad space at slightly above the newspaper's usual rate.

PLANNING A MARKETING CAMPAIGN

Effective marketing is accomplished through a planned campaign that draws on all four communication methods—public relations, publicity, promotion, and advertising—and utilizes a variety of tools. Public relations strategies build on an organization's image and contacts in the community. Publicity, because it involves free access to the media, is usually at the core of a nonprofit arts organization's marketing campaign. Promotional tools reach targeted audiences and can attract participation through images and messages that you control. Advertising reinforces messages and encourages the market to act.

The elements and design of a campaign derive from goals you want to achieve. Marketing goals could be increased attendance for your poetry series, greater visibility for your organization within the Latino community, a new image for the organization based on a redefined mission, or public education about your programs and their impact in preparation for an annual fund drive. With even more specific objectives in mind (for example, to increase by 15 percent the number of first-time donors to the annual fund drive), you can distinguish specific potential markets and design a strategic framework of activities to reach those markets.

A marketing campaign is an integrated set of activities involving three interrelated factors:

1. **The message and image you want to communicate.** What do you want to say or project? How do you want to distinguish yourself from the "competition"? What language and tone will you use? What visual image do you want to establish?

2. **The strategic timing of those messages.** When will you put your various marketing strategies into play? When should the public receive information?

3. **The means or media** (newspapers, magazines, cable television, radio, bulletin boards, posters, flyers, buttons) you will use to reach the desired markets. Where will

you be noticed by the market(s) or public(s) you want to reach? How do they get their information? What will be the most effective means to use to reach those markets?

A typical campaign involves four stages intended to respond to the rising awareness of targeted publics and build toward a cumulative effect.

Successive publicity activities and promotions can stress each of these stages in turn. However, each press release, brochure, or advertisement should also guide the reader/ listener through each stage. The four stages comprise a basic outline for writing promotional copy.

Criteria for Evaluating Marketing Strategies.

There are many possibilities for marketing your program, but you cannot accomplish them all effectively and not all will serve you equally well. Even though you may be able to afford advertising, it may not be the best way to reach a particular market segment. The availability of money, time, and labor also forces you to choose methods within your means that will bring you closest to your objectives. Each specific marketing objective should be approached by making deliberate strategic choices relative to particular markets and publics you want to reach and the message you want to send. The essence of a campaign is that its individual elements work together to achieve the desired objectives.

Criteria for choosing among the various promotion alternatives include money, skills and resources, and time.

Money. How much money is available or should be budgeted to achieve the desired results?

Publicity is crucial to most nonprofit arts organization's marketing campaigns because it allows you to exploit all appropriate free media for minimal cost. Ideally, beyond the use of free media, a budget is built based on the choice of campaign elements that will most effectively reach specific audiences. More frequently, however, organizations start off with a set amount in the budget for marketing. While

some organizations allocate 10 percent of their programming budget for marketing expenses, there are no rules of thumb. Organizational resources differ, and diligent use of in-kind services, volume or nonprofit discounts, and partnerships can all affect the need for cash.

Often the toughest marketing decisions concern whether or not to spend money on high-cost promotions. If these hold real promise for reaching target market(s), you must evaluate the potential reach (how many people will see the promotion) and effectiveness (how many people may respond) in relation to the cash cost.

To promote an annual event, a multicolor poster, despite its expense, may work more effectively than an inexpensive flyer. The poster not only calls the community's attention to the upcoming event but also may have a lasting impact if the image is popular and posters are collected and displayed afterward. At other times, less costly promotions may be more than adequate. You cannot apply the same marketing formula to every activity and event.

Many organizations develop a marketing plan centered around their own budget capacity but solicit partners or underwriters to support special, more costly promotional strategies that advance the marketing objectives in significant ways. Early campaign planning provides more time to recruit in-kind support for your campaign. Sponsorships and donations of goods and services can extend the impact of your own limited marketing dollars. Newspapers, radio, and television often make excellent sponsors for events because of their ability to provide donations of advertising, graphic design services, and distribution of promotional materials. They may also be willing to secure goods and services you need through trade of advertising with vendors.

Skills and resources. Marketing campaigns require skills, information, and equipment. These may include writing, editing, photography, design, and access to printers, mailing lists, and poster distribution systems. Your members or staff may have many of the required skills and resources and can acquire more through training. Sometimes you must recruit experienced

professionals as volunteers or pay them to help design or implement a marketing plan.

If you are trying to tap a new market, use media with which you may have no previous experience or rapport, or develop a graphic image, it may make sense to hire a publicist or public relations firm. If embarking upon an extensive regional or national program that involves marketing on a significant scale, your organization might also benefit from hiring a professional firm that knows your markets and can devote the attention necessary to ensure success. However, those who are involved with your organization and programs on a day-to-day basis are ultimately the most knowledgeable and enthusiastic promoters and can make the most genuine impression with the media.

In 1984 the New England Film and Video Festival, a regional festival of independent media arts, reached a turning point. After four years of relative obscurity in Boston, it gained the sponsorship of the *Boston Globe,* the city's major daily newspaper. Since The Globe considered it a test year, festival sponsors wanted to be sure they did their best to attract attention and attendance.

The Boston-based media had not previously provided adequate festival coverage. The Arts Extension Service (AES) and its cosponsor, the Boston Film/Video Foundation (BF/VF) employed the services of a Boston public relations firm whose clients were primarily arts presenters in an effort to build the festival's credibility and stature in the eyes of the Boston media. The firm helped ensure coverage by the newspapers and made inroads into television and radio, with which the festival previously had limited experience and success. Because it had already established a rapport with arts editors, film writers, and electronic media producers through its other work, the public relations firm readily established media contacts. The firm also gave the festival a new aura of importance by reaching beyond the limited sphere of BF/VF.

The festival worked with the firm for three years. During that time the reputation of the event within the press and electronic media became well established, and regional promotional efforts were coordinated and improved. After those three years, AES felt it had learned enough to implement the Boston-based campaign on its own and to save on the expense of the public relations firm.

Time. The timing and interrelationship of different marketing components is a key part of a campaign strategy. The most critical deadline is when you want people to act, but you must also consider when particular markets are likely to act. For example, by what date must the total number of advance ticket sales to your fund raising event be known in order to give caterers a head count? If your local market makes decisions to attend an outdoor festival within three to five days of the event, then advertising and feature stories in the local paper should be planned to culminate during that period. A direct mail effort might be planned to reach people three weeks before the event to prepare target markets with the information they need to act.

By determining these key audience "action points," you can then project backwards to give them enough time to get information and yourself enough time to implement marketing activities. Allow adequate time for distribution of promotional materials. Other timing factors to consider include:

- demands on staff or volunteer time to coordinate various marketing efforts;

- deadlines for program details to be set in order to include them in materials;

- service timelines, such as for graphic designers or printers;

- media deadlines.

Comparing Effectiveness. Ultimately, the effectiveness of different marketing strategies must be weighed against the following criteria:

Potential to meet your marketing objectives.

The Glimmerglass Opera of Cooperstown, New York, hoped to expand its audience from the five surrounding towns to those within a two-hour driving radius but had never promoted significantly beyond the local area. By evaluating the media habits of its market and the potential reach of various media and promotion methods, the company decided to invest $5,000 in television advertising for one season. Television, while costly, ensured the reach needed to the right market. The results were a 65 percent increase in subscription sales.

A festival located in a metropolitan area determined that posters could not compete for people's attention in the clutter of the urban landscape and were costly to print and distribute. The festival redirected some of its dollars from the poster campaign to direct mail, which would reach targeted markets more effectively.

A local arts council expanded the reach of its newsletter beyond its membership base of 600 by negotiating with the local newspaper to run it as a monthly insert in the paper. The arts council supplies the newspaper with copy on computer disk to facilitate the process and reaches thousands more people for a fraction of the cost and effort.

Value per Dollar Spent. To evaluate cost-effectiveness, a break-even analysis is often useful. Ask yourself these questions:

- How many responses do you need to cover costs and to generate a surplus?

- What is the likelihood that you will succeed in recovering costs?

- How many people will you reach with this effort?

The value of promotions sometimes reaches far beyond the audiences actually drawn. An exhibit may draw 12,000 visitors, but promotion and publicity may reach 35,000 homes and 60,000 people. This reach may prove valuable to corporate or media sponsors interested in increasing their own visibility. A high-quality, professional look for a particular promotion may make a more lasting impression and serve as a better investment in long-term public relations.

Labor Intensiveness

A part-time festival publicist determined that the time required to arrange live radio interviews with artists was too costly for the potential benefit. He noted that if he were successful in soliciting newspaper and magazine features, the impact would be far greater.

A promotional video about your organization's programs might require significant time, focus, and energy to produce but ultimately reduce preparation time and enhance your presentations to civic and other community groups.

Some organizations have all but abandoned huge press release mailings in favor of using FAX or electronic mail, which are less labor intensive and less costly.

Follow-through to promote the results of a program will also contribute to a general community awareness and extend the program's impact as an investment for the future. For example, your organization may wish to:

- generate follow-up features;

- sell posters;

- encourage letters to the editor;

- create photo displays;

- send thank yous;

- use video for local cable programming;

- release a summary report.

Campaigns are not necessarily designed from scratch every time. Comparisons are easier to make if you track the effectiveness of specific marketing efforts. Through experience organizations can observe what works, get the timing down, and devise a checklist of standard activities that can be incorporated into most every campaign.

RULES FOR MARKETING SUCCESS

While marketing has many variables, it need not be a complex endeavor. Seven basic principles can help guide your decision-making.

1. **Know your organization.** Good marketers must be familiar with all aspects of their organization and its mission. They must also believe in and be knowledgeable about the programs and services they promote.

2. **Know your audiences.** Market segmentation and targeting can net big returns if coupled with effective research, audience involvement in program planning, and record keeping. These activities can be a key to addressing audience development challenges in our multicultural society.

3. **Know your tools.** There are many promotional tools to choose from, each effective in its own way. Don't limit your repertoire to the same bag of tricks. Your publics and programs will demand a varied, creative approach. Explore the opportunities provided by newer technologies.

4. **Fight the urge to spend money.** Allow plenty of time for planning and implementing marketing campaigns so that you can locate and secure the resources to do more with less.

5. **Plan every move.** Use your market research to make decisions and use a timeline to design and manage your campaign.

6. **Follow through.** Once you devise a marketing plan, be sure to follow through with all commitments. Remember that in an effective campaign, each element is enhanced and reinforced by the others. If one falls short, the impact of the whole campaign may be lessened. Be alert also for unforeseen opportunities or problems that require changes in the plan.

7. **Be creative.** Creativity is the last and most important element of your marketing strategy. After all, we are marketing the arts. Fortunately, arts organizations attract creative people, and the same imagination that is applied to programming can also be applied to marketing.

COMPUTER USAGE

The 2000 Census determined that more than half of American households own one or more computers, compared to 42 percent in 1998. Nearly two-thirds (65 percent) of all children ages 3 to 17 live in a household with a computer.

In all, 85 percent of Americans online use search engines to find information on the web and 29 percent of Internet users rely on a search engine on a typical day. Only the act of sending or reading e-mail outranks search-engine queries as an online activity—some 52 percent of Internet users check email on a typical day.

The Internet has become an increasingly important feature of the learning environment for teenagers. Research by the Pew Internet & American Life Project shows that teens use the Internet as an essential study aid outside the classroom and that the Internet increasingly has a place inside the classroom. Ninety-four percent of youth ages 12-17 who have Internet access say they use the Internet for school research and 78 percent say they believe the Internet helps them with schoolwork. Forty-one percent of online teens say they use e-mail and instant messaging to contact teachers or classmates about schoolwork.

According to the Pew study released in 2002, 60 percent of adults in America use the Internet at least once a week. About half of Internet users (more than 50 million people) have access to the Internet at work.

Travelers' use of the Internet to plan and book trips continues to grow at a rapid rate, according to two reports released by the Travel Industry Association of America. More than 59 million online travelers used the Internet last year to get information on destinations or to check prices or schedules, growing 395 percent in the past three years. Of that group, 25 million actually purchased travel products or services online during 2000, representing a 384 percent growth from 1997.

Today, people expect that your organization will have a web site that is current and easy to navigate. We use the Internet to keep our constituents informed, give them the opportunity to purchase tickets, and even pay their membership online. It is becoming so common to purchase tickets online that even audiences of small community arts organizations are expecting this service. Small presenters may choose to partner with a larger presenter or a commercial ticket vendor in order to respond to this audience demand.

Web Site Essentials

The New York Foundation for the Arts offers these tips for your web site:

1. Integrate online and offline marketing strategies.

2. Send out announcements and regular press releases about your site.

3. Register in search engines and get listed in appropriate "filter" sites.

4. Trade links with similar sites.

5. Build relationships with visitors.

6. Use online promotional tactics.

Planning your Web site. Color printing is "free" on the Internet, so you can make your site as colorful as you want. Your web site should be a carefully planned part of your agency's overall technology plan. It is easy to learn how to use a web site editor or the tools that come with any word processing program, but difficult to learn good design and function without proper training. Your board member's kid may be able to design your web site for free, but you may end up getting what you pay for.

Online content. Information on an organization's web site should include information that helps meet the customers' needs and advances the arts organization's mission. It should be logically organized and easy to access. Just as you write a press release, consider these questions when designing a web site:

Who?

- Your address, phone/fax numbers
- Mission statement
- Staff and board
- Credit major donors

What?

- List your programs
- Provide a "press room" to assist with public relations by posting press releases online

Where?

- Provide a map and directions to your location
- Give parking information
- Include accessibility information, particularly if the handicapped entrance is not the front door

When?

- List updated calendar information, including ticket prices
- List hours of operation and duration of specific programs

How?

- Provide membership information and the ability to donate online
- List volunteer opportunities and job openings

Other considerations

- Keep track of your web site users. A growing number of web sites encourage visitors to register for an online newsletter or to receive particular information through the web site. This can become a valuable research and marketing tool that will help you better understand who your constituency is.

- Use your web site to update board members and patrons about your industry. Providing information about the impact of arts and education, legislation that affects how your organization and other nonprofits operate, or information about your community can help advance your mission.

- Link to your partners and funders. Travelers who seek out cultural tourism events and attractions are likely to be interested in other aspects of your community and region. Link to local restaurants, the chamber of commerce, state and regional tourism bureaus, other cultural attractions, or any service that you think may increase your constituent visits.

Customer Service. Like any interaction your organization has with the public, your web site should reflect the seven Ps of the marketing mix. Good customer service is just as important on the web as it is in person.

1. Don't overuse large graphic files that make your site slow to load.

2. Make your site accessible. Guidelines that assist the blind and persons with low vision are being developed constantly, along with the assistive technology. Sites like www.bobby.com or the Smithsonian have developed accessibility guidelines that you should consult while designing your web site.

3. If you use your web site to answer questions, provide an opportunity for the public to sign up for an on-line newsletter, or donate money, respond to them quickly.

4. Keep calendar information current. If your hours change, if road construction slows traffic down in front of your facility or if a performance is sold out, let the public know through your regular channels of communications, including Web site.

Promoting your web site

- Register with search engines to increase the availability of your site.

- List your Web site address on everything! Brochures, stationery, t-shirts, advert and press releases should list your web address.

- Encourage your partners to include your web site on their web site.

THE MARKETING PLAN

The following is an outline of the most basic elements of a marketing plan:

1. Executive summary

2. Statement of general organizational mission and goals, and specific marketing objectives

3. Market situation analysis:

 a. Market threats and opportunities: *What market trends must be considered in planning?*

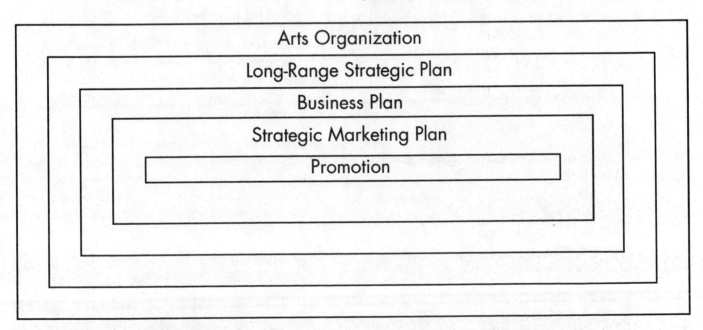

An organization's marketing plan must support the mission, goals, and objectives of its strategic plan. Chen-Courtin describes the marketing plan as part of a nested set of integral organizational strategic tools.

b. Audience analysis: *Who are your programs intended to benefit and what do you know of their characteristics, interests, and needs?*

c. Competitor analysis: *Who are your direct and indirect competitors?*

d. Position statement: *What do you uniquely do for whom?*

4. Marketing assumptions

5. Determination of marketing mix strategies:

a. Product

b. Price

c. Place

d. Promotion

e. Physical evidence

f. People

g. Process

6. Action steps with timeline

7. Budget with *pro forma* statement of expense and revenue

8. Monitoring and contingency planning

The Executive Summary

This is the quick summary for the harried director or board member. Ideally limited to one single page, this summary will capture the salient points of the analysis, summarize the plan's objectives, and demonstrate the strength of the action plans. This summary is best written *after* the entire marketing plan is completed.

Statement of mission, goals and objectives

The marketing plan furthers the organization's mission and long-range goals, as described in the strategic or long-range plan. If the marketing plan is embedded within the organization's strategic plan, the mission and goals will have been stated. If the marketing plan is a separate document, the mission and goals should be restated with emphasis on any marketing goals.

Mission. The organization's mission anchors the point of departure for the situation analysis that follows. In a very general way, the mission statement answers the questions, "What is our business? What should our business be? Why do we exist?" The marketing plan should help the organization fulfill its mission.

> **"The New England Foundation for the Arts connects the people of New England with the power of the arts to shape our lives and improve our communities."**

Goals. While mission statements tell us where the organization is coming from, goals tell us where it intends to go over the long term. Some goals will articulate the organization's artistic intentions; others will express desired community development results. We are concerned here with the long-term results you seek from marketing. Some plans may describe specific marketing objectives dispersed throughout the organization's overall plan. Some marketing plans are organized with a general marketing goal within the long-range plan. Develop a general marketing goal with related, more specific objectives and tactics within a separate strategic marketing plan.

> **"To develop and market programs that will serve and attract more families."**

Objectives. Objectives describe specific results anticipated within the near future. Objectives are ordinarily described no more than two or three years ahead. They are often expressed in quantifiable terms with a timetable.

For instance, if it is determined that a marketing goal is to attract more families, an implicit strategy to achieve this may be to improve its hands-on educational programs for children in order to serve parents and their children.

An objective consistent with this marketing goal, may be to increase family patronage by ten percent at year-end with an investment of $3,000 to support program upgrades and additional marketing communications to reach the target audience of families.

The market situation analysis: strengths, weaknesses, opportunities, and threats

Summarize your analysis of external opportunities and threats, internal strengths and weaknesses. This helps describe the relationship between the organization and its market environment.

- Strengths. What internal resources (skills, successful programs, good will) can you draw upon?

- Weaknesses. What internal limits (financial, personnel, facility, past mistakes) must you overcome?

- Threats. What potentially negative external forces (competition, economic stress, trends in philanthropy) must you accommodate?

- Opportunities. What positive external forces (partners, public opinion, growth, demographic changes) should you plan to use to good advantage in marketing planning?

Audience Analysis. In this section of your plan, you will summarize the results of your audience analysis. By now, you are well aware of the importance of knowing your audiences. Depending on the stated goals of the strategic plan, you may need to look into specific segments of your audiences for analysis.

- Audience segments: Who are your markets?

- Audience characteristics: What do you know of them? Consider age, gender, ethnicity, demographics, location, income, education, leisure habits, and media habits.

- Audience needs: What do you know of your audience interests and needs? In short, they will respond only if you meet a need.

Competitive Analysis. It is critical to understand the alternative ways your audiences meet their needs. Even if you are the only arts presenter in a rural community, you may still compete for your audiences' time, attention, and money with commercial films, videos, and sports.

- Direct competitors: Who are your direct competitors?

- Indirect competitors: Who else competes for your audiences' attention?

Positioning Statement. Describe your market position—how your organization or program relates both to your target audience and to the competition. You will not name your competition in this statement, but you will distinguish how your program uniquely meets the needs of your audience. You are describing your niche in the market environment.

Consider expressing your positioning strategy as a longer narrative and/or list of key words and phrases that helps you articulate the various elements of product, competition, and customer needs. Then distill this into a compact and memorable statement that could be used as a tag line in marketing materials.

> The Arts Extension Service: Connecting Community and the Arts.

Determination of marketing strategy: Assemble the marketing mix

Your marketing strategy outlines how you will combine the four Ps plus three—the elements of the marketing mix to connect your products with your intended audience—product, price, place, promotion, physical evidence, people, and process.

Look again at your market situation analysis. Consider the strengths, weaknesses, opportunities, and threats that you should accommodate in your marketing plan.

Review your alternatives based on the assumptions that guide your plan. Once the best option or options are determined, the marketing strategy can be described. Some of your marketing strategy can be expressed as a narrative with bulleted highlights. The rest can be portrayed with a timeline and budget (described below).

- Product: What are the program or programs developed in this marketing plan?

- Price: What will your audience be asked to pay in terms of cash and other costs?

- Place: Where and when will your program be presented or distributed?

- Promotion: How will your communicate your offer of this program? What marketing tools will you use?

- Publicity: What news media will you approach with what message through what tool (press release, calendar listings, request for feature stories, talk shows, etc.) and when? How will you use paid advertising?

- Print promotions: What fliers, brochures, catalogs, postcards, posters, etc., will you produce? How will you distribute them? When?

- Promotional events: Will appearances of artists at previews, social events, fairs or other gathering places be part of your marketing plan?

- People: Who will implement your marketing plan?

- Process: How will you proceed?

At this stage of marketing planning, you should evaluate the need for additional market research. As part of the thinking and planning behind the marketing mix, the arts manager may find that there are areas where there is insufficient information for decision making. For example, the arts manager may have insufficient knowledge regarding who and where the new immigrants are in the area, how many families are living within 15 miles of the organization, how to reach them, and what these parents' top concerns are for their children. These are essential information requirements when making product content, pricing, distribution, promotion—and investment decisions.

Action steps with timeline

The point of a market plan is action. Make sure your plan provides enough detail so that it is simple to determine who must do what by when. An action plan without deadlines tends to be ignored.

A good way to start is to identify necessary tasks and group them together by function. Groups of marketing tasks are drawn from the

Tasks	January	February	March	April	May
Program	Hire instructor (A.B. responsible)	Review lesson plans—— (A.B. and C.D.)		Test AV (J.R.) Assemble materials	5/15 workshop (Instructor)
Marketing (C.D. responsible)	1st press release 1/20 Direct mail Newsletter	2nd press release 2/15		Call those who have inquired by 4/24	
Administra-tion (A.B. responsible)	Adjust budget	Contract Rent space			Evaluate Report to funder 5/30

marketing mix and might include program planning, publicity, advertising, print promotions, and database management.

Chart these tasks together on a graphic timeline. Group functional activities together, then create a process and timeline for each group of tasks. The objective of a timeline is to see all the tasks as a whole, identify bottlenecks ahead of time, make the workflow over the year more even, and facilitate cooperation within your organization. For tasks that proceed over time, you may want to chart them as lines or arrows that end when the tasks need to be completed. Single events can be marked with the date they are to be done. Many find it very helpful to indicate who is responsible for each task with the person's initials beside the task.

You may prefer to expand the marketing row of this timeline into a separate row for each element of your marketing mix. You might have rows for program planning, pricing, tasks related to place, and perhaps multiple rows for promotion (advertising, publicity, print promotions, etc.). Create a tool that suits your marketing plan.

Budget with projected marketing expenses and revenue

An integral part of the marketing plan is the budget plan, showing estimated expenses and revenues. The budget will reflect the cost associated with the implementation of different marketing programs such as product development, targeted marketing, direct mailing, promotion, publicity, and audience feedback. As part of the strategic marketing thinking, a criterion of financial success may be a breakeven of expenses against revenue at the end of the budget year. Hence, the sources of revenue need careful consideration and early attention.

It is highly likely that the arts manager will have to seek additional sources of revenue beyond the program fees that can be charged. As part of the strategic marketing planning process, corporate sponsorships and philanthropic donations need attention. You will need to

know what portion of program and operation costs must be recovered from earned revenue before the marketing mix strategy can be fully designed and implemented. Depending on what your budget reveals, you may have to revise your marketing strategy to reduce expenses or raise more revenues.

Ordinarily a marketing budget is integrated into the organization's overall annual budget. Many marketing costs such as telephone and program printing are difficult to separate from general administrative or program costs.

For your final assignment you need only identify expenses directly related to your marketing strategy. You should understand, though, that marketing expenses must be considered in relation to revenues. If you prefer, you may present an overall organizational budget and identify line items that relate to your marketing plan.

If this is a new program, you must first determine categories of revenue and expenses and then estimate the amounts. At the minimum you must determine the expense categories related to your marketing plan and estimate the cost for each. Marketing costs may include these categories:

- Marketing-staff salaries and benefits
- Marketing-related printing (brochures and fliers, direct mail promotions, postcards, posters, banners, etc.)
- Design
- Postage and mailing supplies
- Purchased mailing lists
- Marketing photography
- Advertising
- Marketing share of general administrative expenses (executive and support staff, facility, telephone, utilities, etc.–this may not appear in a separate marketing budget)

Monitoring and Contingency Planning. As part of any marketing plan, some form of milestone and quantitative measurement must be incorporated. Example: At three-month intervals, there will be a review of progress to

date. At this point, a measurement of stated objectives against actual results, an assessment of the current situation, and an adjustment to the marketing plan for the rest of the year will be made accordingly. We know only too well how the vagaries of life can impose changes on our best-laid plans. The same thing can and will happen to our best thought-out marketing plan. As General Eisenhower once said, "The plan is nothing, planning is everything."

This periodic monitoring and control mechanism will allow us to fine-tune our marketing plan and make mid-course adjustments.

It is also valuable to include contingency planning. This plan does not have to be elaborate, nor does it need to be a separate document. It will simply be part of the strategic thinking process where several critical what-if questions will be asked with a few coping action items in response. Some examples of what-if questions can include: What if no corporate sponsorship is available? What if we find that our planned product offering has little appeal to the targeted audience? What if, by mid-year, we have reason to believe that we will not be able to increase family patronage by ten percent at the end of the year?

Contingency planning has several benefits:

● It improves the quality of our strategic thinking during the marketing plan process. Issues covered in contingency plans can be wake-up calls before we commit ourselves in the wrong direction or before we build unattainable expectations.

● It gives us the opportunity to play out a few possible future scenarios and have some form of plan A, plan B, etc., in our back pocket, just in case.

It is highly probable that the future will not play out the way we anticipated it in our contingency planning process. But the very fact that we have thought about the various probable alternatives will allow us to respond and adjust to new developments quicker.

Conclusion

Writing the plan is time consuming, but it is worth the time and money in the end. Due to the nature of nonprofit work, far too often the approach to marketing tends to be overly tactical and is characterized by fragmented actions. Quick, symptomatic fixes are often preferred while underlying strategic causes are ignored. Since nonprofits are increasingly required to be accountable for both the short and long term, a well-thought out marketing plan is an important step in that direction.

In brief, the plan will be developed with as much whole-organization participation as possible and will provide action items and responsibilities for different programs and functions. The plan will become a common road map for the fiscal year, serving to unite the shared vision of the organization as it moves toward a common goal.

STRATEGIC MARKETING PLAN WORKSHEET

1. Executive Summary: What, in brief, is your marketing plan? (Write this last)

2. Mission: What is the organization's overall mission?

3. Goals: What long-range goals does this marketing plan help fulfill? Quote from your organization's long-range or strategic plan if this exists. Otherwise specify what general results you hope to achieve through marketing over the next two or three years.

Marketing objectives: What specifically is your marketing plan intended to achieve in the short term?

Market Situation Analysis:

Your market's threats and opportunities

Your organization's marketing strengths and weaknesses

Competitor analysis, direct and indirect

Position statement

Marketing Strategy:

What product?

What price?

Where and when is it presented?

How is it promoted?
 Publicity plan
 Advertising plan
 Print promotion plan
 Other promotions…

People: Who implements marketing plan?

Process: How can tickets be purchased?

Action Steps: Who does what by when? Summarize key tasks, responsible parties, and deadlines in a table such as illustrated below.

Budget: What are the costs to implement this marketing plan?

Monitoring and Contingency Planning: How will you monitor the success of this plan and adapt it as required to achieve stated marketing objectives?

Marketing Tasks	Month 1	Month 2	Month 3	Month 4	Month 5	Continue as needed
Program development						
Pricing						
Place, timing, and distribution						
Promotion						
Monitoring and evaluation						

PREPARING FOR LOCAL ADVOCACY

by Barbara Schaffer Bacon

The more integrated the arts become in the life of a community, the more important advocacy becomes to the work of arts organizations. Artists and arts organizations are affected by many public finance and public policy issues such as arts funding, education, freedom of expression, zoning, community revitalization, and nonprofit laws.

Advocacy efforts are a major application of marketing strategy. The tools of marketing—public relations, publicity, promotion, and advertising—are the tools of effective advocacy. Like marketing, advocacy tends to be cumulative in effect. It's hard to point to individual turning points; it's more like an ongoing campaign.

Building a Local Advocacy Base

Advocacy is an ongoing process. In a marketing framework, it becomes clear that a strong public relations base is required to be effective. Getting to know local policy makers and being sure they are familiar with your activities is key. Then you will need to be prepared to monitor the policies and decisions that could affect you and to communicate your interests.

Understanding Advocacy

Our political system is based on the assumption that laws and policies will change and develop over the years and that citizens will participate in the process. Elected and appointed decision makers make different decisions when they feel they are being watched by concerned citizens. The legislative system relies on decision makers becoming informed on issues. Getting to the right people with facts and information about who will be affected, how they will be affected, and who is concerned can influence opinions, attitudes, decisions, and votes.

The concept of advocacy embraces both education—efforts to provide information and promote understanding; and lobbying—action to support or oppose policies and legislation. Advocacy efforts geared at public education are fully appropriate for any organization, but nonprofits must be cautious not to devote more than ten percent of their resources to lobbying efforts. To spend more will jeopardize tax-exempt status. Some organizations set up separate organizations expressly for lobbying purposes. State and federal guidelines about advocacy restrictions should be reviewed.

The advocacy activities of an organization should be distinguished from the personal political action of any individual member. Individual political involvement should be encouraged, since the contacts made through such involvement are likely to benefit the organization. While organizations cannot get involved in political campaigns, individuals can. Such activity should be separated from the activities of the organization so as not to jeopardize the legal status of a nonprofit organization. It would, of course, be desirable to have arts advocates as policy makers in positions of community and political leadership.

Five Basics of Local Advocacy

1. **Know the system(s).** Find out which organizations, government units, and agencies set policies that could affect cultural development. Besides the town council and mayor or city manager, this might include the parks department and commission, the school board and department, the department of public works, and the planning department. Learn how each works, how policies and decisions are made, and who or what influences decision makers. In some communities, elected officials have more power than the city manager or other staff, while in other communities, the professional staff might have a great deal of clout.

2. **Develop allies.** Develop personal contacts with key staff and officials. Be sure you put their names on your mailing list and schedule informal visits annually or

semiannually so that they come to know you personally—not only when you are asking for or complaining about something. Ideally they will come to rely on you as a friend, trustworthy contact, or responsible resource person on whom they can count.

It is a good practice to publicly recognize officials and other decision makers for their support. Don't overlook support staff; they can be allies or detractors depending on how they're handled, and they may have the ear of their boss.

Establish communication with other organizations and coalitions that are working on related issues or toward compatible goals.

3. **Establish a network.** The ability to generate calls and/or letters to public officials or the press is the backbone of most advocacy campaigns. An organization's political clout is often measured in relation to the number of constituents it can activate in a short amount of time. Everyone has heard stories of how legislators count letters and calls to gauge constituent interest and opinion. The objective is to be sure that within eight to twenty-four hours, you can mobilize supporters to make contact with decision makers. The fax or phone tree is a key element of any good advocacy effort.

You should be organized to mobilize your trustees, members, and audiences. Keeping in regular communication with your advocates will make them feel connected to your cause and ready to act on your behalf.

A local organization's advocacy network can be an asset when used to assist allies and elected officials in their own fund raising and advocacy efforts.

4. **Track issues.** It is a good idea to designate board members as liaisons to key commissions and agencies. Monitoring such things as the budget development process or the availability of an underutilized building may prepare you to act early and informally on your own behalf.

It is important to gauge when to make an issue public. Some issues, like a controversial performance, will gain public attention on their own. Sometimes advocacy efforts are best conducted quietly, as when you perceive no real opposition or if you don't want to create a stir that might bring out detractors. On other issues, such as turning an old school into an art center, you may want to demonstrate that there is public support.

5. **Be prepared to tell your story.** When you have something to say, you will need to deliver the message as clearly and concisely as possible. Telling the right stories and substantiating them with statistics can increase the impact of your case. Facts, not hype, are key to establishing your credibility.

In arts advocacy, it is particularly critical to connect with the relevant issues and concerns of the community. It is generally recognized that the argument of art for art's sake is noble but not terribly effective in influencing decision makers concerned with tangible community problems and needs.

Try to always stay on a positive note. Keep your message focused on positive results and mutual benefits.

> *"Advocacy is leading our public officials in framing policy, not taking our lead from them. Advocacy is writing legislation, not just letters of support. Advocacy is having a strong independent voice in the legislature that articulates our agenda and not one set for us."*
>
> **–Bruce Rossley,** former commissioner, Boston Office of Cultural Affairs

Supporting State and National Advocacy Efforts

Since all politics are local, local advocacy is often needed to support state and national advocacy efforts. Following are some additional ways to advocate on state and national issues.

- Join and support your statewide and discipline-specific arts advocacy network.

- Stay informed about state and national issues.

- Visit your state and national legislative representatives and be sure they regularly receive information from your group.

- Participate personally in specific arts advocacy campaigns.

- Activate your organization's network to support state and national groups.

- Regularly trumpet and define the role of local, state, and federal dollars in relation to local arts activities.

REFERENCES

Andreasen, Alan R. *Expanding the Audience for the Performing Art.* Arlington: Seven Locks P, 1992.

Colbert, Francois. *Marketing Culture and the Arts.* Bourcherville, QC: Gaeten Morin, 1994

Diggles, K.. *Guide to Arts Marketing: The Principles and Practice of Marketing as They Apply to the Arts.* London: Rhinegold Limited, 1986.

Gordon Dalgleish, Julie, and Bradley G. Morison. *Waiting in the Wings: A Larger Audience for the Arts and How to Develop It.* New York: American Council for the Arts, 1993.

Jinnett, Kimberly, and Kevin F. McCarthy. *A New Framework for Building Participation in the Arts.* Pittsburgh: Rand, 2001.

Kottler, Phillip. *Marketing for Nonprofit Organizations.* Englewood Cliffs, NJ: Prentice Hall, 1990.

Meredith, Judith C., and Linda Myer. *Lobbying on a Shoestring.* Boston: Massachusetts Poverty Law Center, Inc., 1982.

Mokwa, Michael P., and Arthur E. Prieve. *Marketing the Arts.* New York: Praeger, 1980.

Newman, Danny. *Subscribe Now! Building Arts Audiences through Dynamic Subscription Promotional.* New York: Theater Communications Group, 1983.

Online Resources

Bobby was created to help web page authors identify and repair barriers to access by individuals with disabilities. Bobby tests web pages using the guidelines established by the World Wide Web Consortium's (W3C) Web Access Initiative (WAI) as well as Section 508 guidelines from the Architectural and Transportation Barriers Compliance Board (Access Board) of the U.S. Federal Government.

Web site: www.bobby.watchfire.com

MuseumMarketingTips.com is the project of writer and consultant Katherine Khalife, and features museums marketing resources.

Web site: www.museummarketingtips.com

Arts administrators at small to mid-sized nonprofit arts organizations in the U.S. are the target audience for the marketing information on this site. ArtsMarketing.org is also a resource for teachers and students in arts administration/arts management programs and for all members of the arts community, across all artistic disciplines. Through ArtsMarketing.org, artistic peers and marketing professionals address daily marketing needs and longer-term marketing issues. It is a project of the Arts & Business Council Inc.® and Arts & Business Council of Chicago.

Web site: www.artsmarketing.org

CHAPTER 10

THE ART OF FUNDRAISING:

"STILL, NEVER ASK A STRANGER FOR MONEY!"

by Halsey M. North

and Alice H. North

THE ART OF FUNDRAISING

This chapter is written to demystify the fundraising process. It describes the key elements—from basic fundraising events through sophisticated capital campaigns. Your organization may be ready to tackle a large campaign or your first request for gifts from members. Whatever the scale of your fundraising, you should be familiar with all of the alternatives.

A small, all-volunteer arts council will find this chapter as instructive as the largest arts organization. The same principles apply to the approach of a corner grocer for an in-kind donation of refreshments for the opening reception as to the approach of the corporate chief executive officer for the $20,000 sponsorship of a concert. The prospect is identified, contacted and cultivated over time, presented with a well-considered idea, asked for the contribution, and thanked, and the relationship is sustained. The larger donor takes more research and cultivation and expects the idea to be presented as a tight case statement supported by financial reports. But the same clarity of purpose and decisiveness of approach is necessary for the smallest potential donor.

Those of you who work in arts commissions as part of a local government should read this chapter with the following four ideas in mind:

1. Making a case for the community impact and worthiness of your agency's work for public support is much like making a case for private contributions. The ongoing cultivation of private donors has its parallel in the public sector with the year-round preparation for the annual municipal budgeting process.

2. Cultivation of the public and their elected officials parallels the development of supportive relations with corporations, foundations, and individual donors.

3. Public commissions usually do seek funds from outside local government sources. They write grants

Fundraising Assumption:
Idea
⬇
Proposal
⬇
Funding Source
⬇
Decision
⬇
Money

Fundraising Reality:
Research
⬇
Contact
⬇
Cultivation/ Involvement
⬇
Funding Source
⬇
Idea
⬇
Proposal
⬇
Funding Source
⬇
Decision
⬇
Money

to state, regional, and national agencies and foundations. Some have arranged to seek contributions from businesses and individuals as well by setting up a nonprofit organization or making arrangements for a dedicated municipal fund or community foundation to receive donations.

4. Arts commissions often advise their constituent arts organizations on fundraising and sometimes re–grant funds themselves and should, therefore, know the principles of effective fundraising.

AN OVERVIEW OF SOURCES AND STRATEGIES

Earned revenue from sources such as admission tickets and participation fees, sales, and advertising provides the largest proportion of most arts organizations' income. A strong foundation of unrestricted earned income should be a central part of any organization's funding mix. However, it almost always costs more to produce arts programs and sustain organizations than can be earned through tickets, sales, and other earned revenue. Effective fundraising is therefore essential.

There are essentially four sources of contributed funds for the arts:

- Individuals and small businesses
- Corporations
- Governments
- Foundations

Individuals are the largest source of contributed revenue. Understanding how to raise funds from individuals not only yields the most contributions, but also applies directly to raising funds from the other sources. Consequently, this chapter begins with an explanation of how to raise funds from individuals. This approach to individuals is then adapted for corporations, foundations, and government grants.

FUNDRAISING IS "RELATIONSHIP BUILDING"

Think of fundraising as an opportunity to share your passion about an arts organization with others you know. Successful fundraising is built on the infectious enthusiasm of a few dedicated volunteers who can show their acquaintances that a gift to the arts organization will not only benefit the community but also the donor.

Passion bends reality!
The passionate support of volunteers can make the impossible possible for an arts group. Achieving that support takes time, organizational skills, and commitment. Fundraising is a continuous process. Asking for money is just one component. Fundraising is informing and educating prospective donors, keeping them interested and involved, and showing them how they can help

People give money to people they know and trust.
At its very core, all fundraising is built on the personal relationships and links between individual people. *Individuals* give money– whether they are representing themselves, corporations, foundations, or governments. People give money to people they know and trust.

Many people equate fundraising with grant writing. Grant writing is only a small part of what is needed to be a successful fundraiser, and successful grants are often the end product of a personal relationship that has been established between the representative of a funder and an organization.

Never ask a stranger for money!
Successful fundraising results when an organization develops relationships with potential donors *before asking* for money. The basic principle is: never ask a stranger for money.

Fundraising is nurturing a sense of ownership and trust over time. It is "friend raising," enabling people to feel such a part of your organization that they feel a sense of ownership. With ownership comes a sense of

responsibility for the organization's financial well being.

Think of the needs of the donor!

You develop relationships with a potential donor by thinking about the donor's perceptions and needs, not the needs of the organization. The basic principle is: "speak to the needs of the donor."

Your organization's needs are not a motivating force for a donor. Individuals, corporations, foundations, and governments all give to support their own needs or to fulfill their own agendas.

Find out what interests the donor has and think through how the donor will benefit by giving. A corporation, for example, may want visibility and an individual newly arrived in town may want opportunities to meet people.

The key is to define your organization's dreams in such a way that potential donors can buy into it so that they know what they can do to help and how they will benefit.

Fundraising is not just asking for money. The solicitation of the donor is the last act of a long-term strategy of relationship building and donor involvement.

WHO WILL BE INTERESTED IN GIVING TO YOUR ORGANIZATION?

Donors are asked to give to many different causes and organizations. Those to which they contribute are ones in which they have developed a special intellectual or emotional interest or, even more importantly, one in which they have become involved or from which they have benefited.

In general, arts organizations that had established strong relationships with individual donors before the emotional turmoil of September 11, 2001, kept those donors because their donors had a sense of "ownership" and responsibility. Many of those donors were determined that the organizations they supported would thrive in spite of September 11. One donor to an arts center said to us, "It is my patriotic duty to make certain the arts center raises the money it needs." On the other hand, arts organizations that had passive mail-based relationships discovered their donors' loyalties had shifted to disaster relief and other human service causes.

About 83 % of the total dollars given in the United States to nonprofit organizations is given by individuals. For you, these individuals can be those who attend your events and enjoy the art you produce as well as the friends, neighbors, and acquaintances of your volunteers. You, your board members, and other volunteers can help to strengthen your arts organization by exciting these individuals to *join* you in giving and asking others to give.

> *Gifts from individuals are the key to successful fundraising; 68% of the gifts from individuals go to organizations to which the donor belongs.*

When you study fundraising, you are learning how to develop a systematic approach for developing relationships with people. It is the human element of personal relationships that makes fundraising an "art" rather than a "science."

Whether your organization is volunteer-run, has a one-person staff, or is so huge that it has lots of staff, the same principle applies — fundraising is about relationships between individual human beings.

THE FIVE ELEMENTS OF SUCCESSFUL FUNDRAISING

As you focus your organization's fundraising energy on developing relationships with donors, realize that there are five elements that are crucial for successful fundraising:

1. **Case.** A clear, compelling reason why your organization is raising money, what you are going to do with it, and who will benefit. Need is not a compelling factor. Most potential donors want to understand why their gifts will make a positive difference.

2. **Confidence.** Both in the organization and its board and staff and in that their gifts will be well used.

3. **Constituency.** A sufficient number of prospective donors capable and willing to give major gifts to the organization at a level that meets the organization's needs. Otherwise, the organization will operate at a level that the constituency is willing to provide.

4. **Leadership.** Access to effective volunteer leaders with clout in the community who are capable, available, and willing to commit the time and energy needed to make your fundraising successful. Leadership is often the most difficult fundraising component to put into place. Leaders will often give money but not time or, more usually, leaders will give time but do not have the clout or money your organization needs. The key is to find a balance of both. If you have to choose, go for the clout or money and support the leadership effort with additional staff or volunteer efforts.

5. **Organizational fundraising capacity.** Both the staff with enough time, knowledge, and organizational resources dedicated to the development of donor relationships, and the key volunteers with the power, influence, and financial resources are needed to fund raise successfully.

WHY PEOPLE GIVE

There are over 865,000 501(c)(3) nonprofit organizations in this country asking for money. Most of them do good and important work. Individuals, businesses, foundations, and governments are besieged with requests. Why should they give to your arts organization and not something else?

Fundraising for the arts is different from other forms of fundraising. Individual donors to organizations such as the United Way, hospitals, American Cancer Society, American Red Cross, and Salvation Army generally hope they won't have to "benefit" from the services such organizations offer.

Arts and cultural organizations offer donors opportunities to support things not only where they will benefit directly, but also where being involved will be fun, exciting, and personally enriching.

The arts can offer joy, hope, education, and improved quality of life. The arts can help people feel good about themselves. As arts organizations, we can ask people to invest in the quality of their own lives. Even better, we can ask them to invest in the quality of life for the next generation.

You can position your organization to foster active involvement and participation in ways which simply are not available to other nonprofit organizations in the United States. This is an advantage you will want to utilize.

People will only give to your arts organization if you are doing demonstrably good work—but they will not give *because* you are doing good work (so does the Red Cross). People as individuals and in businesses, foundations, and the government will give to you because:

● Know the people asking for the gift and like, trust, and respect them; and

● Perceive that they and/or the community will benefit from the work of an arts organization.

The best way to develop prospective donor confidence in the organization is to involve them in some way—through governing boards, advisory boards, committees, support groups, and special events, etc. Such involvement can bring them into the "family."

The Importance of Face-to-Face Visits

Personal visits and face-to-face discussions are also good ways to cultivate people's interest. By involving a person in the development and creation of ideas and solutions, a potential donor can become emotionally involved in the success of those ideas and solutions.

People give more and are more likely to give when asked in person.

Personalize your solicitation! The more people give, the more personalized the approach must be. Personal calls raise more than phone calls. Phone calls raise more than letters. And personalized letters and handwritten notes raise more than form letters.

INCORPORATE LONG-RANGE PLANNING INTO YOUR FUNDRAISING PLANS

Potential donors will want to know what your organization is going to do with their money. You can't be vague with donors—you need to be able to tell them clearly what you are going to be able to accomplish with their support.

Planning defines your organization's future so funders can "buy in" to it. It shows how the donors' money will be used and how the community will benefit.

Planning also gives potential donors confidence because they will realize your organization has been thoughtful in determining what it would accomplish and how much would be needed to get the job done.

You can also use the process of planning as an opportunity to involve potential major donors in your organization before you ask them for money.

New philanthropists in the United States have grown up in an entrepreneurial era. They have a hands-on approach to their work and their philanthropy. One of the most effective ways to engage them in your organization is through the long-range planning process. When potential donors are involved in helping to determine what an organization is trying to accomplish, they are much more likely to give at a level to ensure success. When potential donors identify with the goals and become emotionally involved in the success of the organization, they become more generous.

START FUNDRAISING FROM THE INSIDE

Raise money from the inside out! Start your fundraising with your organization's own board of directors. Each board member should be asked for and should give a gift which is, for them, an important gift. This is easier said than done. Board members often say, "I give time, I give my expertise, I give up hunks of my life working for this organization, and, now, you want me to give money?" Yes!!! It takes cash to

run a nonprofit organization. If your board members are unwilling to give cash to your organization, why should others support it? Your board members should demonstrate a strong leadership commitment to your organization that is demonstrated to the rest of the community, in part, by their personal financial commitment.

> **Each board member should give, what is for him or her, an important gift.**

Reasons to start your fundraising with your own board members include:

- 100% board giving builds community confidence;

- A board member campaign teaches your board members how to ask and how it feels to give;

- A board member campaign helps your organization test its "case" for giving, refine its fundraising materials, and train staff on how to organize a fundraising effort; and

- Your board members will become much more effective fundraisers once they have given and can say, "Won't you *join me* in supporting . . ."

Boards which, when they recruit new members, instill the "expectation" that all board members will give are more likely to be able to announce 100% board participation in the organization's fundraising.

RAISE MONEY FROM THE TOP DOWN

Larger donors will set the pace. Once you have started raising money from your own board of directors, then you can begin to approach your largest potential donors. Focus on the BIG gifts first. The larger donors will set the pace of giving for your campaign. Not all donors are equal in importance to a fund drive. Large, early gifts to a campaign help to build volunteer and staff confidence that the campaign will succeed. Go to these large donors before you go public and announce a goal because the size of the gifts from these early donors will, to a large extent, determine how much you can raise and the goal that can

be set. These early, large gifts determine your fundraising fate because:

- 75% to 95% of all the money you raise will come from 10% to 15% of your donors which is usually 50 to 100 prospects.

- These 50 to 100 prospects will usually be solicited by 10 to 15 individuals.

In essence, effective fundraising consists of a few of the right people (leadership) asking people they know and can influence (constituents) to give.

Fundraising, by its very nature, may seem elitist. You will target your fundraising to those who have the most capacity to give. Only individuals, foundations, corporations, and governments with accumulated assets can contribute substantial amounts of money. Focus on their gifts first, and then broaden your base of support by going after smaller gifts.

Smaller gifts do matter. You can demonstrate your broad-based community support with larger numbers of contributors, even if individual gifts are modest. Your funding agencies will value the numbers of contributors in addition to the total amount of gifts. Note too that people who admire your work may be encouraged to increase their initial contributions in subsequent years.

POSITION YOUR ORGANIZATION FOR SUCCESSFUL FUNDRAISING

There are several key elements which need to be in place to enable you to raise money successfully.

Mission

Why do you exist? First, you need a clear, concise mission statement specifying why the organization exists. A commonly agreed upon mission helps focus the energies of the board, staff, and volunteers. It ensures that the community is receiving a clear message about the purpose of the organization. Mixed messages about mission can confuse potential givers. Make certain your mission can be stated clearly during a fundraising call so that prospective donors will know to what purpose you will be using their money.

Strategic Plan

What are you going to do? Who will get it done, when, and at what cost? If your organization has established priorities in a strategic planning process as we have recommended, these should be reflected in your fundraising goals. You will be raising the funds needed to fulfill the intentions of your plan.

The plan will also help you make a convincing case to funders who will have more confidence in your organization if they know you have thought through the options, established the priorities, and determined who will do what, when, and at what cost. Funders want to know how you will be spending their money, and a multi-year plan helps give them the answers they want.

Funders will also be reassured when they can see your fundraising history, how much you need to raise, and a reasonable projection estimating the sources of those funds. The details give an organizational plan credibility. Funders can see that you have a strategy to bring your vision from a dream to a possible future reality.

Financial Information

Show donors you will spend their gifts wisely. Clear financial information, in the form of Statement of Activities (operating statement) and Statement of Position (balance sheet), demonstrates an organization's ability to manage money. Exhibit 1 in the Appendix is a sample "summary of historical and projected cash flow" which gives two years of financial history, the current budget, and six years of projections (two years is often sufficient) of an organization's Statement of Activities or income statement. This sweep of information gives donors an understanding of your organization's operations, stability, and financial needs—current and projected.

You will notice that Exhibit 1 places "expenses" first and "income" second, reversing the format used by profit-making corporations. We recommend this format because it differentiates your organization as a not-for-profit enterprise and focuses a reader's attention first on the *cost*

of the art, and then on how much money it takes to support those programs and services. This format enables you to put your request of a potential donor—and the level of that request—into the context of an overall plan.

Financial information can be presented as backup for a written request or taken along on a fundraising call as evidence of thoughtful planning. In either case, it will strengthen a potential donor's confidence that a gift will be well spent.

How much do you need to raise and how will the community and donor benefit?

Case for Giving

Once you have developed a succinct mission, a clear multi-year plan, and businesslike financial projections, you will have the information you need to create a document known as the "case for giving" or the "case statement," or simply the "case."

> The case for giving outlines how your organization will serve the community, your qualifications to do so, how the donor will benefit, how much money you need to raise, and why.

The case for giving describes the programs and services your organization will provide and the funds needed to accomplish the reasons for the fund drive. The purpose of the case is to give potential donors the information they need to understand why they are being asked to give and how they will benefit. The case does not need to convince a prospective donor of the value of supporting the arts—that can be done, if needed, as part of the in-person call. Instead, the case focuses on how your organization will strengthen the community and the quality of life for the donor and the donor's children, family, employees, etc.

The case can be summarized in a single page or it can be printed in a multi-page document which can contain, as appropriate:

- the community leadership and volunteers involved with your organization as board members and working on the fund drive (this list acts as a stamp of community endorsement);

- the mission of the organization, why you are raising the money, the amount of money being raised;

- the project's budget, how the community benefits, how donors will benefit and be recognized for their gifts; and

- your organization's goals, achievements, and financial health.

Make the case larger than the organization! From a fundraising standpoint, it is important to think about your organization in a larger community context. What is your organization's contribution to your community in terms of:

- Economic impact?

- Impact on downtown revitalization?

- Impact on the quality of life?

- Impact on the schools and education?

- Impact on corporate recruitment?

- Impact on tourism?

Package your organization's needs and dreams in such a way that donors can relate to you in terms of their own needs. Make the case larger than the organization. Give people a sense of possibility of how they can help your organization make a difference that benefits them.

Annual Report

Show the donor you know what you are doing. An annual report is useful for showing what your organization can accomplish. It can list your volunteer leadership, professional staff, what you do for the community, and what it costs. It can state your mission and include clear and succinct financial information. It can outline next year's goals, discuss future plans, and list and thank donors. Annual reports demonstrate that you know what you are doing.

Organizational Attitude

Give fundraising the time it deserves, and incorporate fundraising into the everyday life of your organization. Every board member must be involved with fundraising at some level at appropriate times.

The act of giving money–like the act of participating in creating the long-range plan–enables people to feel that they are a part of the "family," that they are important to the success of a worthwhile organization. Fundraising involves marketing, membership, and the cultivation of resources–leadership, constituencies, and money.

Fundraising takes time.

Fundraising is not effective when it is rushed or done at the last minute because the money has run out. Such a state of panic does not build confidence in volunteers or donors.

Fundraising cannot be "tacked on" to an organization's already full work load. It has to be given staff and board time and resources as well as the money to pay for supplies, receptions, meetings, computer software, printed materials, annual reports, etc. Fundraising is an ongoing process that needs advanced planning, as well as staffing and money. Successful fundraising takes time and attention on a daily basis.

Volunteer Leadership

To raise funds, you need time, money, power, and passion from your board and other volunteer leadership. Ideally, you want some volunteers who are part of your community's power structure and who can give as well as ask their peers for money.

Your organization's need to raise contributions means you need people with money or access to money. To survive over the long run, your organization must have political and social access to the people who control public and private giving in your community. This does not mean that every board member should have wealth and political clout. Your mission and commitment to the community may require that you also have artists and other community members of modest means. What you need is balance and a commitment from every board member to cultivate potential contributors throughout the community, including those who have wealth and power.

Everyone enjoys being an expert. If you do not have "power people" involved with your arts agency, then you need to identify specific people who could help you and develop an individualized cultivation strategy for each one you want to bring into the "family." You can develop a series of small lunches, receptions, or special orientation meetings to ask for specific advice or help. Or you can ask them to work on projects, ad-hoc committees, an advisory board, etc.

Make volunteers feel important, and use their time wisely. The key is to use their time wisely. Recruit them using clear expectations (verbal or written). Enable them to feel helpful and important. Make certain they have fun, learn something, and enjoy the experience. Provide follow-up information by newsletters, notes, and phone calls. And, say thank you–it leaves the door open to be able to ask for their help again.

To summarize, in addition to giving what is for them an important gift, campaign leaders should have:

- understanding of the case for giving;
- commitment to the organization;
- confidence the money will be used wisely;
- an opportunity to learn how to make a fundraising call;
- appropriate fundraising materials;
- clear tasks that are organized into doable bite-sized pieces;
- the recognition and thanks they deserve.

Treasure your volunteer leadership! Good leaders are rare. Don't take them for granted once they are involved. Thank them often and in many different ways. Make them feel special and appreciated. Remember, you can't thank volunteers enough.

Staff and Office Resources

Fundraising requires professional or volunteer staff to provide the information and administrative support that board members and key volunteers need to raise funds.

> **We all avoid fundraising because we all fear rejection. The only answer is to stack the deck through cultivation so we know we will get a "yes." The question then becomes how much to request.**

For a larger organization, it is best to hire a part- or full-time staff member whose sole function is fundraising. When staff functions are combined, fundraising often comes up short. Someone responsible for both marketing and fundraising, for example, will spend more time on marketing—it is more fun to write a press release than a gift request which might be declined.

Many smaller arts organizations find that they can hire excellent part-time help from the pool of parents who want to work from 10 a.m. to 3 p.m. so they can be home with their school-age children. When hiring or recruiting volunteer fundraising staff, look for:

- fundraising experience;
- organizational ability and attention to detail;
- writing skills;
- ability to work with and motivate volunteers.

Also make certain that you have the computer support you need, including software for record-keeping and word processing. There are a number of fundraising-specific software packages on the market, some of which, if you need, can interrelate to ticketing, accounting, and scheduling software, too. Even the smallest arts organization can find a board member or key volunteer with an adequate computer system to support fundraising.

Constituency of Donors

Developing an ongoing process of cultivation to involve as many potential donors as possible is essential to effective fundraising. People do not usually give to strangers or causes with which they have no relationship. Your job is to bring potential donors into the family, develop their interest, and get them involved. Develop monthly newsletters, reminder postcards, annual reports, special receptions, preview parties, or post-performance gatherings. Develop guilds, friends groups, advisory boards, volunteer committees. Try to involve as many community members as possible in your organization. If your arts organization is run with the input and involvement of only a few individuals, then those few people will be your only significant source of contributed income.

> **People do not give to causes or good work. They give to people they know, trust, and respect.**

The section Raising Money from Individuals discusses how you can identify, cultivate, and focus your search for specific prospects. Keep in mind that the best prospective donor is someone who *already* feels like they are *part of the family*. The *next best* prospect is someone who is *beginning* to feel *part of the family*. This is because fundraising is, in part, the process of giving people a sense of ownership in your organization.

> **501(c)(3) – You can't really raise money without it.**

Legal Readiness

Donors are not able to deduct their gifts to you unless you are designated as a 501(c)(3) tax-exempt organization by the U.S. Internal Revenue Service. To receive this status, you need to be incorporated as a not-for-profit tax-exempt organization by your state government. Corporations, foundations, the National Endowment for the Arts, and state arts agencies can, generally, only give to 501(c)(3) tax-exempt organizations. If you do not yet have your tax-exempt status from the IRS, it may be possible to find a 501(c)(3) organization willing to accept gifts and grants on your behalf as a fiscal agent.

DETERMINE YOUR FUNDRAISING CAPABILITY

Before you can establish how much you are going to raise, you have to determine not only how much you need but also how much your arts organization is capable of raising.

As you evaluate your fundraising capacity, remember that fundraising is built on the relationships between individual human beings. So, in a real sense, what you are evaluating is your organization's capacity to initiate, strengthen, and maintain relationships with people who can give money.

Is our board committed to fundraising? Do we have the key volunteer and staff support we need to make our efforts successful?

To determine your fundraising capability, begin by evaluating your organization's internal resources and its access to outside funding sources. Does the organization have:

- Key board members/volunteers who have fundraising experience?

- Key board members/volunteers who have access to funding sources?

- Key board members/volunteers who are capable of providing leadership?

- Advisors who can help provide information and assist with donor cultivation and solicitation?

- Staff or dedicated volunteers who have the time and expertise to do the "homework"?

- Computer capabilities or access to computers to do the record-keeping and reports?

- Existing and prospective members/friends and donors who will give?

- The support of local businesses (including restaurants, stores, law firms, doctors' offices, real estate agencies, motels and hotels, grocery stores, etc.) in the area who know your work?

- The support of decision makers in local and state governments whom you know and who will help you get funding?

- Strong peer relationships with colleagues who will make grant decisions on local, state, and National Endowment for the Arts panels?

There are six primary sources for raising money. Determine which should be your organization's

focus in order to maximize the amount of money you can raise given the time and energy you can put into it. Remember that gifts from individuals are how most nonprofits get the most money. Public grants and national foundation contributions may be a part of your fundraising mix, but there is no substitute for cultivating local individual donors. The six sources, in priority order, are:

1. contributions from board members, former board members, and other key volunteers;

2. contributions from other individuals;

3. net contributed income from benefits and special events;

4. contributions from local businesses and foundations;

5. grants from local, state, and federal governments,

6. contributions from national corporations and foundations.

Successful fundraising is built on relationships.

Individuals

For most arts and cultural organizations, the best results are achieved when funds are first raised from board members who are then enlisted to solicit, face-to-face, other key, potentially significant donors. For those organizations limited by the number of individuals they can send out to ask for money, solicit other individuals by personalized letters followed up by personal phone calls. Why emphasize the "personal?" Because the basic component of successful fundraising is building and maintaining relationships.

Start planning fundraising benefits a year in advance.

Benefits

Fundraisers and special events are another source of funds for arts and cultural organizations. They can devour staff and volunteer time and take a lot of work. They require long-term planning to secure sponsorships, in-kind donations, and attendance

that will generate maximum revenues and minimum expenses. They are most effective when they are run, from beginning to end, by a group of committed volunteers. The best benefits and special events can be a lot of fun and can help with donor cultivation and involvement.

Local Businesses and Foundations

Personally soliciting local businesses and foundations is very similar to asking local individuals for money. Success is based on cultivating a relationship with them. So, the key question to ask before looking to local businesses and foundations as sources of contributed income is: Do you have the manpower to develop and maintain good relationships with these folks?

Governments

Many nonprofit cultural organizations do receive grant support from their local and state governments and this area is worth exploring. Does your organization's staff or volunteers know any local or state politicians who can help you organize a lobbying effort for a major grant from your city, county, or state government? If no one knows any local or state politicians but there is strong feeling that the city, county, or state government should support the organization, then the strategy may be to develop a cultivation plan so the decision makers get to know and become involved in the organization so you can ask them for money in the coming year. Also contact your state arts council and get to know the staff. Ask them to help you understand what grant programs they offer that might help your organization. Once your organization has established a relationship with your state arts agency, then you may want to ask them whether there are any grant programs at the National Endowment for the Arts to which your organization should apply.

National Corporations and Foundations

Proposal writing to national corporations and foundations is generally the least effective form of fundraising for nonprofit arts and cultural organizations. Exxon, for example, won't give

to you because there is a gas station on the corner. National corporations generally give only when they have a factory in your community and its officers have a relationship with your organization. National foundations generally give when an organization is doing something unique which can have national impact or which can become a model for other organizations.

Exhibit 2: Evaluating Internal Resources (see Appendix) is a chart you can use to get an overview of your organization's fundraising options and capabilities. The left-hand column lists fundraising options the organization might want to consider; the other axis evaluates internal and external resources. You do not have to, nor should you, attempt all options. Decide what strategies are best for your organization.

Develop fundraising strategies you know you can implement.

If, for example, several of your board members are politically well-connected with city officials, you may decide to organize a lobbying effort for a major grant from city government. Again, if no one knows anyone in city government but there is strong feeling that city government should support the organization, then the strategy may be to develop a cultivation plan so that decision makers get to know and become involved in the organization so you can ask them for money next year.

Another option, if you have been working with the chamber of commerce and its arts committee is willing to help you launch your first local business fund drive, is to develop a cultivation and solicitation strategy for the 50 to 75 most likely business prospects.

Create a Fundraising "Work Plan"

Once you have evaluated your organization's internal capacity to fundraise, you will need to make some choices. What fund raising options will realistically produce the most money from donors for the time, energy, and resources your organization invests? You do not have to attempt all options. Decide what options your

organization can undertake effectively. If you have a board of directors, it is recommended that your board undertake the option of a personalized campaign to raise money from board members and other key volunteers. Then, option by option, develop a **work plan** to implement each fundraising option, as follows:

1. Select the fundraising options your organization will undertake.

2. For each option:
 - list the tasks that need to be done to raise the money;
 - negotiate with the staff, board, and other volunteers who will do what tasks;
 - establish a timetable–who is going to do what, when;
 - determine the costs–the direct costs in dollars plus the staff/board/volunteer time needed (who, number of hours, tasks) and consultants, if any (who, number of hours, tasks, cost);
 - determine the funds expected to be raised from each option.

3. Set the total dollar fundraising goal for your organization.

4. Step back, review the plan and ask whether it is realistic and feasible. Can your organization–staff, board, and other volunteers–actually do the work you have outlined?

> **Aim for success. Don't overreach. Fundraising success builds community, donor, and volunteer confidence so you can ask again.**

5. Revise the work plan as needed.

6. Distribute the work plan to those who will do the tasks and ensure buy-in from all involved. Revise the plan as needed.

7. Regularly update everyone on tasks accomplished and costs/funds raised compared to the work plan.

Exhibit 3 is an example of a fundraising work plan that you can use as you develop your own work plan. Included are examples of a board giving campaign, a membership campaign, and a special event.

The goal is a compromise between how much you need and how much your volunteers feel comfortable raising.

Set the Goal

Now you can compare the dollar goal established in the fundraising work plan (how much you think the organization can raise) with the numbers in the financial projections (how much it needs to raise). The two numbers usually differ. Arts organizations often find that their needs outstrip their fundraising capabilities. Groups get into trouble by increasing their estimates of how much they can raise to equal the amount needed. A goal set too high can demoralize volunteers and put the organization at financial risk because it arouses unrealistic expectations that cannot be met.

On the other hand, an organization which always reduces its staff or operations to reduce the demands on the organization's fundraising efforts will limit the organization's growth and ability to serve.

The goal should be a realistic stretch. The overall fundraising goal should be established by the organization–board and staff–as a compromise between the need and the fundraising capacity. The need should be lessened and the goal should be increased to slightly more than what the fundraising team feels is comfortable. The overall fundraising goal should at least balance the budget and be a realistic "stretch" for the fundraising team.

THE ROLE OF THE BOARD AND STAFF IN FUNDRAISING

Simply stated, the role of the staff in fundraising is to do the homework (with board help; the role of the board is to do the solicitation) with staff support.

Role of the Board

The board of your arts organization has the legal and moral responsibility to make certain the organization has the financial resources it needs to operate. When the board approves the budget, they need to realize that they are setting their own fundraising goal. If they do not feel they can make the goal, they should adjust the budget.

Have the board help develop a fundraising work plan. To build confidence and a sense of ownership, have board members help to develop the fundraising work plan and present it to the rest of the board for approval. By participating in the development and approval process, board members are more likely to ensure that the fundraising work plan is implemented successfully.

Board members ask each other. The first step of the fundraising work plan should be to implement the board giving campaign. It is important to start your fundraising with board members personally soliciting each other. Such a board gift campaign can be run as a "mini campaign" to give each board member (1) a feel for the steps involved in raising money, and (2) the experience of completing a call successfully.

One hundred percent board giving is required by many government, corporate, and foundation funders. Board giving is essential. Many government, corporate, and foundation funders require 100% board giving before considering making a contribution to a nonprofit organization.

Personally, board members are more comfortable and effective as fundraisers when they have already given themselves and can say "Join me!" Giving a cash donation strengthens board commitment to the organization and the fundraising process. Moreover, the giving enthusiasm of board members sets the pace of support for the organization.

The amount a board member gives is also important. We recommend that board members be recruited with the expectation that they will give, what is for them, an important gift. The expectation can be:

> **"To make cash contributions—what is for each of us an important gift."**

Board members should give the organization gifts comparable to what they give to the United Way, their place of worship, their college, and/or other nonprofits in which they are interested and involved. The actual dollar amount they give is not as important for setting the pace for giving as the perception that each and every board member is stretching to be as generous as possible. We are not suggesting that board members be required to give a specific minimum amount as a gift but, rather, that each board member be challenged to maximize their personal giving commitment. So, the first step that board members take in fundraising is to give what is for them an important gift.

In addition to setting the pace by giving, the board needs to accomplish these tasks:

1. **Ensure fundraising staff and systems are in place.** It is a board's responsibility to make certain the organization is investing enough of its resources in fundraising. If the board has set an ambitious fundraising goal, it needs to make certain the staff and fundraising information-gathering and record-keeping systems are in place needed to help ensure success. It takes money to raise money, and it is a board's responsibility to make certain the needed staff time and systems are available.

 Spend money to raise money.

2. **Identify and cultivate prospects.** A key role board members play is to introduce their friends, business acquaintances, and associates to the organization and excite them about the organization's work. The board needs to make certain there is an ongoing, systematic approach to: a) gathering and updating information about prospective donors from board members, and b) utilizing board members to cultivate prospects. These prospects can be individuals as well as key contacts at

corporations, foundations, and governments. A good way to identify prospects is to initiate one-on-one discussions which center around the board member's Palm Pilot, address book, or holiday card lists. Or, have one-on-one discussions which focus on lists that you bring to the discussion names already drawn up of potential prospective donors. Does the board member know any of the names on the lists? Of the names they know, what are their interests? Who is best to cultivate their interest in the organization? Who is best to ask them for a gift? What is the best strategy for cultivating and asking for the gift?

Take the time to show prospects you care about them before you ask them to give.

3. **Advocate with local governments and businesses.** The board is the "good housekeeping seal of approval" for your organization. Board members' ability to talk about the organization knowledgeably and with enthusiasm will go a long way in convincing others to give. Board members are your best advocates to work with local government officials and for support.

Board members should be passionate advocates.

4. **Be passionate.** How a community thinks about an organization is often determined by the hundreds of brief remarks and discussions people hear at meetings, social gatherings, and events. This "gossip" can set the tone for what community members are thinking about your organization when they are approached for money. The board of the organization in small- and medium-sized communities can, to a very real extent, influence the tone of the community's perception by talking about the organization with enthusiasm and passion. Board members' passion can be infectious and can get many other people excited about the organization and its prospects for the future.

Expedient fundraising leaves money on the table!

5. **Solicit gifts in a thoughtful manner.** Board members often want to ask others for gifts by phone or letter. It is easier and, on the surface, more efficient and less time-consuming. If board members want significant gifts from individuals, businesses, or foundations, they need to make the request in a considered and thoughtful manner. Taking the time to do it right will pay off in the long run. Expedient fundraising wastes time, creates frustration, and will "leave money on the table"—failing to produce the kinds of gifts the board needs to succeed

An effective thank you gives you the right to ask again.

6. **Say thank you.** Board members can help keep donors interested by saying "thank you" when they see them as part of their everyday work life. You can't thank a donor too often, and a thank you from a board member is much more powerful than a staff thank you. Board members can also help by writing personal notes or making phone calls to donors to thank them. An effective thank you gives you the right to go back and ask again.

Role of the Staff

Volunteer time and commitment is becoming a rare and valuable resource. As nonprofit arts organizations, we need to cherish our volunteers and make certain we maximize their effectiveness and personal satisfaction by giving them the staff support they need.

Good staff back-up is the key to good volunteer involvement. If you do not have adequate staff time dedicated to fundraising, then you need a few dedicated volunteers to fulfill the support role that staff would normally provide. Staff would support fundraising volunteers with:

- background materials;
- data on potential donors;
- training materials;
- individualized solicitation letters;
- examples of thank-you letters;
- their presence on calls;
- confirmation calls for appointments;
- information on developments and funds raised to date;

- the calendar of meetings, appointments, and follow up;

- agendas for meetings;

- meeting spaces, names tags, refreshments, and clean up;

Staff can help focus volunteer efforts, time, and energy where they can provide the most help:

- advocating for your organization;

- identifying prospective donors;

- cultivating prospective donors;

- asking for money.

Trust is an important part of fundraising. Volunteers need to have confidence that they can rely on the fundraising staff. Donors need to have confidence in the people to whom they are giving.

As a result, **consistency** in the fundraising staff is another element to consider when your organization is working to strengthen its fundraising efforts. The trust needed for successful fundraising is built upon hours and hours of staff time and dedication to building the relationships needed over time—with volunteers and donors.

Because relationship building takes so much time—as does day-to-day homework, information-gathering, and record-keeping—fundraising is not a "project" that can be dumped on top of everything else the staff is doing. To be successful, arts organizations are having to invest more and more money to hire and train fundraising staff. Each organization needs to make certain it has adequate staff or dedicated volunteer fundraising leaders in place to:

- develop on-going relationships with volunteers and donors;

- support volunteer fundraising efforts;

- organize the homework—making certain the record-keeping and accounting systems are up-to-date and accurate;

- write grants and proposals.

If your organization is staffed by a single individual or if your organization has no staff, you must still find ways to provide the support to fundraising as provided by a development director in a larger organization. Consider these alternatives.

- Recruit an exceptional volunteer to lead a time-limited fundraising campaign.

- Seek the loan of secretarial help from a local corporation or public agency.

- Seek the loan of database-design or data-entry personnel.

- Contract with an independent fundraiser to help staff your fundraising campaign.

- Seek the help of a fundraising consultant to advise how to manage your fundraising. Note: be clear about whether you are seeking advice or supplemental staffing. Most fundraising consultants are in the advising business.

- Seek a donor to invest in fundraising staff.

Fundraising is 90% homework (staff role) and 10% solicitation (board role).

Fundraising is 90% homework and 10% solicitation. The role of the staff is to do the homework—with board help. The role of the board is to do the solicitation—with staff support.

It is the staff's responsibility to give the board/key volunteers the support and information they need to do their jobs successfully. The staff collects, organizes, and produces information (the homework) and then develops the letters and materials needed for the cultivation and solicitation process.

The reality is that the staff cajoles, prods, educates, and pushes board members and other volunteers to complete their fundraising tasks. The staff should:

- Make certain that board members learn how to ask for money.

- Organize the fundraising tasks into doable, bite-sized pieces. When we ask board members to "fundraise," they often don't. The task is too open-ended. When we encourage them to "cultivate and solicit five people they know for gifts similar to their own," they usually respond positively.

- Organize the "homework." Make certain a board member has all the information needed to make a successful call–that the right solicitor is asking the right prospect for the right amount for the right reason at the right time;

- Organize the fundraising materials; develops the solicitation letters, case statement, prospect information, pledge cards, receipts, brochures, newsletters, and calendars;

- Create giving opportunities with benefits. It is easier for board members to ask prospects to join them as a "patron member" or a "sponsor" of a special event;

- Say thank you for fundraising as well as for giving.

In summary, the staff is the glue that holds the fundraising effort together–setting up the meetings, gathering the information, educating the volunteers, and saying thank you. The board members are the community volunteers who say; "The work of this arts organization is important. Please join me in supporting it to enrich the lives of our children and the quality of life in our community!"

Six "rights" of fundraising are:

–the right person asking

–the right prospect

–the right amount

–the right reason

–the right time

–the right way.

RAISING MONEY FROM INDIVIDUALS

As noted earlier, gifts from individuals account for over 83% of U.S. philanthropic dollars. Your organization's ability to keep potential individual donors happy and satisfied is

fundamental to your organization's future fundraising success.

Basically, what most donors want from a relationship with a nonprofit arts organization is to:

- be thanked in an appropriate and thoughtful manner;

- feel good about themselves and what they have done;

- be confident that their money will make a difference;

- feel special with access to select privileges, people, savings, or experiences not generally available to others;

- have a sense of being special, a sense of satisfaction, recognition, importance, appreciation, belonging, and being "part of the family."

An organization has "cultivated" and "involved" a donor well when that donor believes the organization is an important part of his or her life.

In general, individuals give money to people they know and trust for organizations in which they have a personal interest. The size of the gift will be influenced by:

- their capacity to give;

- their level of interest in the organization;

- who asks them for the gift;

- the manner in which they are asked.

Your organization cannot influence an individual's capacity to give, but it can influence their interest, who asks, and the thoughtfulness of the ask. To develop an effective individual gifts campaign, you need and two-phased process:

Asking is the easy part. It's the research that's hard!

Phase One: **Research:** Identify the highest potential individual donors and find out about their needs and interests. **Planning and cultivation:** Determine the best way to position your organization potential donor by potential

donor, develop a connection, and get them interested,

Phase Two: **Solicitation:** Have people who potential donors respect and trust ask them for a gift face-to-face in a thoughtful manner.

PHASE ONE: Research, Planning, and Cultivation

Step 1: Work Plan

Develop a **work plan** for the individual gifts campaign. Identify how much you need to raise, how many volunteers you will recruit to work, how many prospects you need to identify, how you will cultivate the prospects, and the approaches you will use to ask them for money.

Step 2: Staff Support

Determine the **staff** support you have for the fundraising effort. Do you have enough staff support? Limited staff support will limit your fund drive efforts. Is your organization expecting too much from its current staff or do you need to commit additional staff time? Do you need to hire fundraising staff and/or do you need to free up more of the executive director's time to devote to fundraising? Often, hiring fundraising staff (or staff to free up the executive director's time) is a cash-flow issue rather than an expense issue. You should be able to expect competent fundraising personnel to more than pay for their salary and expenses after the first year because they should increase the organization's capacity to raise money.

Step 3: Job Descriptions

Develop **job descriptions** for staff and board members/volunteers so each person in the individual gifts campaign knows what their role will be and a **timetable** to know when they are to get work done. Deadlines are important in fundraising because they help give a sense of urgency to staff and board/volunteers so the work gets done in a timely manner.

Step 4: Prospect Lists

Begin to develop **prospect lists** for different elements of the campaign. Who are the prospects with the highest potential that require

special personal attention? Who are the intermediate givers who will respond to some personal cultivation? Who are the others you should solicit by mail?

You have limited staff and volunteer time available to solicit gifts from individuals, so you want to develop a fundraising work plan to give you the greatest dollar return for the time invested. Prospects who have the capacity to give substantial gifts need a personalized, face-to-face approach which can be quite time–intensive.

> *Ask board members, other key volunteers, and staff who they know and can involve in your organization.*

There are two primary sources of individuals whom you can solicit for your arts organization:

1. those who are involved or benefit from your services, such as audience members, constituents, board members, guild members, committee members, other volunteers, artists, students, alumni, parents of students, friends, group members, organizational members, etc.;

2. people known personally by your board members, other key volunteers, and staff.

To find those potential donors who can and are most likely to give, you first have to do some donor research and organize the information you have.

Step 5: Prospect Research

Do **prospect research** to gather as much information as possible about the prospective donors you have identified.

Take all the lists of the names of people you serve—those who support you, encourage you, volunteer for you, get your newsletter, attend events, etc; and gather them together with an annotation of where the name came from and their relationship to your arts organization. Then, using staff and key volunteers who know your community well, divide these lists into three categories:

> *The more potential a donor has, the more time you want to spend getting to know and cultivating them.*

1. High potential—worth the time for personal cultivation and solicitation;

2. Medium potential—worth a personalized letter and telephone follow-up;

3. Little potential and don't know—solicit by mass mail and telephone campaigns.

Once you have completed this broad-brush-stroke sort, you can begin to refine your placement of donors into appropriate solicitation categories.

First, review your high-potential list and try to make certain it is less than two hundred names. Type these names on a form similar to Exhibit 4: Prospect Research Chart. (It takes about two hours for two to three volunteers to review one hundred names on such a set of worksheets. If you have more names than that, you may want to have two sets of worksheets.)

Successful fundraising is built on organized gossip.

Then, ask a number of your staff members and key volunteers to review these worksheets and tell you (or your development staff or designated volunteer) as much as possible about the prospective donors. Do they actively participate in the arts? What is their occupation, perceived worth, community involvement, history of giving to other organizations? Is there anything else it would be helpful to know?

Assess the donor potential of board and key volunteer contacts.

Another approach to developing a list of high-potential donors is to ask your board members and key volunteers who they know in the community who has the capacity to give generously and who might be interested in your organization. Sit down with each board member and key volunteer and go through their Palm Pilot with them, noting names, addresses, and phone numbers on a worksheet like *Exhibit 4: Prospect Research Chart.* Ask them to tell you anything helpful to know about the donors. Then, using the upcoming year as a time frame, ask them to divide the resulting names into the three categories:

- High potential—personal calls,
- Medium potential—personal letters, and
- Little or uncertain potential—mass mail.

The average volunteer can solicit 5 to 7 people face to face.

Step 6: Recruit Volunteers

Once you have done enough research to know the potential donors you want to cultivate and solicit face-to-face in a thoughtful manner (and the best people to solicit them), you are ready to **recruit the volunteers.** The average fund drive volunteer can solicit between five and seven prospective donors. So, if you have 100 prospects that you want to cultivate and solicit face-to-face, you will need 15–18 dedicated volunteers. Actually, you may need to recruit more volunteers- experience shows that volunteers are more effective, especially for major gifts prospects, when they work in teams of two people. These teams can consist of a volunteer and a staff person or any effective combination of board members, key volunteers, previous donors, and/or staff members.

Passionate volunteers can ask many more potential donors when the organization has become an integral part of their lives

In a typical campaign, some wonderful volunteers may solicit 15 to 20 prospects and others may have to be hounded to follow through on only one or two prospect solicitations. So, determine how many volunteers you will need, recruit a chairperson or co-chairs, and work with the chairperson or co-chairs to identify and recruit the volunteers they believe will be effective and who they can motivate to do a good job. The volunteers can then review the list of prospective donors, tell you who they can help call upon, and give you additional information on the prospects.

Step 7: Calculate Need

Calculate the organization's fundraising **need.** Determine how much needs to be raised and how it will be spent.

Step 8: Case for Giving

Once you know how much your organization needs to raise, develop a compelling written description, or **case for giving**–what will be accomplished with that money. If you have a need for unrestricted annual operating support, look at your programs and services and package your "need" in a way that captures people's attention. Examples might include:

- subsidizing tickets for school children;

- enhancing the quality of productions;

- providing scholarship support;

- strengthening the staff so you can take more artists into the schools.

As you develop your case for giving, remember that prospects give to things in which they are personally interested. As you write the case, include how your organization will benefit, for example the quality of education in the schools, the community's quality of life, economic development, downtown revitalization, corporate recruitment, and providing people with educational, enriching, and entertaining opportunities.

Step 9: Fund Drive Materials

Create the printed **fund drive materials** in such a way that they serve a two-fold purpose: (1) they inform potential contributors about the organization and help build confidence that contributions will be well utilized, and (2) they are tools designed to help the volunteers go on calls with confidence that they have in hand all the key information they need to complete a successful call. Fund drive materials your organization may wish to prepare can include:

Create fundraising tools to make the volunteer's job easier.

- case statement;

- personalized letter requesting the gift,

- pledge form;

- volunteer information sheets;

- answers to most frequently asked questions;

- thank you letters;

- contribution acknowledgment and tax receipt form;

- annual report;

- record-keeping sheets for calls, gifts, acknowledgments, etc.

PHASE TWO: Solicitation

Step 10: Solicit the Board First

Start the fund drive with a board campaign, that is, board members asking other board members (and former board members asking other former board members) for gifts to support your organization. Doing this first gives board members practice in being solicited and making successful calls.

Board members can set the pace of giving.

Step 11: Solicit Fund Drive Volunteers

Concurrently with the board campaign, begin to solicit the other volunteers who have agreed to work on the campaign. Try to arrange this effort so everyone has a chance to go on a call and experience being called upon before they start solicitations in the broader community. If your volunteers have successful fundraising experiences with each other first, then they will have more confidence as they begin to approach prospects who are not as close to the organization.

Volunteers should give before they ask.

Step 12: Solicit Major Gifts

Once the board and fund drive volunteers have been solicited, you can then move on to the select group of prospects who are capable of giving your organization larger gifts. The major gift prospects should be cultivated before they are asked for money. They should be personally invited to special events, receptions, private dinners, etc., where they can learn more about your organization before they are solicited. Remember the basic fundraising principal, "never ask a stranger for money." Make certain the prospective donors know about your organization and how they personally and/or the community will benefit from your work.

Step 13: The Campaign Goal

Up to this point, you have been soliciting the board, campaign volunteers, and major gift prospects based on the "need"–how much money the organization needs to raise. Once your organization has an understanding of how generous these advance donors will be, then you can project forward and guesstimate how much you will raise from a broader, public campaign. At this point, set a publicly-announced campaign goal that you have some confidence in achieving. Remember that 75% to 95% of all the money raised will come from 10% to 15% of your donors. The publicly-announced goal may be more or less than the actual need. It is often less than the organization had hoped to raise, but it is better to make a goal and even exceed a goal than to fail trying to raise too much.

Step 14: The Broader Campaign

Once you have publicly-announced a goal and publicly launched the campaign, then you can go after a broader range of gifts using:

● personalized letters;

● telephone calls;

● mass mail;

● special events;

● grant writing, etc.

Step 15: Thank You

It is crucial that each donor be thanked properly, in fact several times for major donors. Proper thank-yous are personalized thank-yous. All donors should be thanked by the appropriate staff person who sends the formal acknowledgment for tax purposes. Major donors should also hear from the solicitor and the board president. Hand-written notes–even if at the bottom of a personalized, computer-generated letter–are effective ways of making the donor feel special. At the beginning of the campaign, thank volunteers in advance for their hard work and, at the end of the campaign, thank them in writing and with some kind of celebratory event.

ESTABLISH AN INFORMATION SYSTEM

The person responsible for fundraising should oversee the creation and maintenance of a "file"–computer file and hard copy/desk file–on *each* prospective high-potential donor. Establish a system to collect and enter information continuously into these files. Everyone–board and staff –having contact with these people on behalf of the organization needs to know how to feed information into the system so that the files are always up-to-date.

Solid homework builds confidence and helps break down the fear of fundraising.

ORGANIZE THE FUNDRAISING TASKS

Exhibit 5 is a sample timetable for a campaign to solicit gifts from individuals. Its list of tasks will guide you through the steps necessary to put together such a fund drive.

Exhibit 6 lists steps for making a fundraising call to an individual. We recommend you use it, or something similar, as a basis for training for board members and other volunteers. You can also include it in the packet of fundraising materials you provide to solicitors.

Divide the work into specific tasks or "bite-sized pieces."

DEVELOP A "FRIENDS OF . . . " PROGRAM

People like to join or belong to groups. We are members of clubs and places of worship, and we live in neighborhoods. We belong to Chambers of Commerce, Rotary, and League of Women Voters. We are Republicans and Democrats. How do you position your arts organization so people will want to join and be identified as being a member?

By developing a "Friends of . . . " or membership program, you are giving people

"Everyone wants to be a worthwhile member of a worthwhile organization."

—Si Seymour

An example of a benefit structure might be:

Gift	Category	Benefits
$50	Donor	Member card + monthly newsletter + advance notice of events + volunteer opportunities
$100	Patron	All the above + recognition in the annual report + quarterly preview seminars and receptions
$250	Sponsor	All the above + advance ticket purchase capability + priority access to special trips + private receptions with artists
$500	Sustainer	All the above + access to house seats + private tours of exhibits with curators + recognition in monthly newsletters
$1000	Producer	All the above + special reserved parking privileges + annual dinner with the board
$1000+	Benefactor	All the above + use of the Green Room for a private party + curbside parking at all events

an opportunity to "join." You are also creating a structure of benefits which make people feel special and involved. People like to be recognized for their generosity, and they like getting something in return for their gift.

It is important to build a structure where people receive more benefits the more they give—thus encouraging them to give generously. The package of benefits will be different for every organization.

> Try to make the benefits meaningful to the donor and of minimal cost to the organization.

This kind of friends/membership structure helps formalize your organization's cultivation of donors. The newsletter, benefits, and special events will keep donors informed and make them feel special. The benefits can be important, too. You will attract some people you did not know to the higher levels of giving. For current friends/members, you will have mechanisms for involving them and

Focus on giving donors: access, ease, fun, information, recognition, education, and special experiences.

encouraging them to give at higher levels. For potential donors, volunteer fundraisers will be able to say: "Join me as a sponsor. It will give us a good opportunity to see more of each other!" - which is even easier to say than: "Join me in giving $250 to a wonderful arts organization."

This kind of program is usually promoted through a mass-mail effort, but it can implemented more effectively through personalized letters, phone calls, and, at the higher levels, personal visits from volunteers.

It is easier for a volunteer to offer benefits and to say "join me" than to ask for a specific amount of money.

Friends/membership programs take a lot of work. You have to write and send the newsletters, host the receptions, and provide the special tickets, dinners, and parking if you offer them. Start them out as volunteer-run programs. As they grow, hire staff, at least on a part-time basis, to provide the services you offer. The prompt, complete provision of these services and making people feel special is the best cultivation (fundraising) you can do.

Remember! You have to deliver the benefits you promise.

TAX-DEDUCTIBILITY OF CONTRIBUTIONS FOR WHICH DONORS RECEIVE BENEFITS

The Internal Revenue Service requires not-for-profit organizations to make clear, at the time

At the time you solicit contributions, state how much is tax deductible.

contributions are solicited, exactly how much the donor can take as a tax deduction. The federal law is summarized in *IRS Publication 1771, Charitable Contributions–Substantiation and Disclosure Requirements* which is available at the IRS web site:

http://www.irs.gov/forms_pubs/forms.html

The law requires organizations that receive tax-deductible charitable contributions to:

Provide written acknowledgements to donors for their gifts–all gifts–even if the IRS doesn't require it.

1. Provide written acknowledgment to donors for any single contribution of $250 or more so the donor can claim a tax deduction. Cancelled checks are no longer acceptable. Such acknowledgements must express the amount of a cash contribution and a description (but not the value) of a non-cash contribution. The valuation of such donated non-cash property is still the responsibility of the donor. Note: Even though the law only requires a written acknowledgement if a gift is $250 or more, consider doing it for all gifts. Donors will appreciate having the receipt, and you can take advantage of the opportunity to communicate, say thank you, and let donors know how much you value their support!

2. Provide written disclosure to donors with a description and good faith estimate of the value of goods or services received *in exchange* for a single contribution in excess of $75. Written acknowledgments would state either: "In exchange for your contribution, we gave you [description] with an estimated fair market value of

[$__]" or "No goods or services were provided in exchange for your contribution."

The IRS allows full deductibility of a contribution and no written disclosure when:

1. the goods or services given to a donor are considered insubstantial and meet either the "token exception" or "membership benefits exception" (see *IRS Publication 1771* for the current dollar amounts considered to be insubstantial), or

2. there is no donative element involved in a particular transaction, such as a typical museum gift shop sale.

The benefits described on the previous page would be considered insubstantial. The written acknowledgement would state: "No goods or services were provided in exchange for your contribution."

Any questions after reading *IRS Publication 1771*? You would do well to seek advice from your organization's accountant or lawyer.

METHODS OF INDIVIDUAL GIVING

Individuals may choose from a number of methods for making contributions. Larger gifts may require longer payment periods or more sophisticated methods of payment.

Gifts That Would Benefit the Organization Now

Cash gifts. These can be in the form of checks made payable to your organization or pledges paid over a period of time. The pledge form should state who the donor is, how much they are giving, and the date(s) when they will make the gift.

Matching gifts. Your donors or their spouses may work for or serve on the board of a company which will match their gift. Have your donor contact their company's matching gifts officer, if appropriate.

Gifts of appreciated securities. Larger gifts are frequently paid with long-term capital gains

securities, which can provide donors with a more attractive income tax benefit. If your organization has the potential to attract gifts of securities, develop a relationship with a stock broker who will offer free or reduced-price services in facilitating the transfer and sale of the securities.

Gifts of tangible personal property. Gifts that are useful to your organization, including real estate, can provide donors with an immediate tax deduction and, if qualified as a long-term capital assets (held for a year and a day), offer avoidance of capital gains tax, removal of the assets from the donor's estate, and, if appropriate, elimination of maintenance costs of the property. Valuation for income tax purposes can require an independent appraisal. The deduction is limited to 30% of adjusted gross income. Excess beyond 30% can be carried forward for five additional years.

Charitable lead trusts. This planned giving method can enable a donor to reduce gift and estate taxes, leave property to heirs, *and* make a contribution to your organization. The donor contributes assets to a trust and sets an amount or fixed percentage that is paid to your organization for a specific period of time. At the end of the time period, the trust is dissolved and the property returned to the donor or the donor's designated beneficiaries, thereby removing the assets from the donor's estate. This and other planned giving transactions can be complex and offer the opportunity to involve professional advisors as volunteers with your organization.

Gifts of life insurance proceeds. A donor might decide to liquidate a life insurance policy no longer needed for family protection and give the proceeds to your organization. This would give the donor an immediate tax deduction (for the value of the gift) and would reduce the donor's estate and inheritance taxes by removing the asset from the donor's net worth.

Gifts That Would Benefit the Organization in the Future

Bequests/giving through a donor's will. A donor may make a bequest to your organization by preparing a new will or adding a codicil amending an existing one. A bequest is not subject to federal or state estate or inheritance taxes and is, in fact, deductible in calculating the taxable estate. There is no limit to the amount of that deduction. The following language is appropriate for making an unrestricted bequest: *"I give (the sum of ____ dollars), (all or _____percent of the residuary of my estate), to (organization), for its general corporate purposes."*

Charitable remainder trusts. These enable a donor to contribute to the future of your organization, retain lifetime annual payments, and generate significant tax benefits. The donor makes an irrevocable gift of cash or marketable securities and sets an amount or fixed percentage that is then paid to him or her, providing life income for the donor (and a survivor). For an **annuity trust**, the amount is set when the trust is created, either as a fixed percentage or a set dollar amount of the then fair market value of the trust assets. For a **unitrust**, the amount is a fixed percentage of the fair market value of the trust assets as determined annually.

Charitable gift annuity. A donor can make an irrevocable gift of cash or marketable securities for which your organization contractually guarantees to pay a specified annuity to the donor and/or another beneficiary for life. The donor receives a charitable deduction and other tax benefits (which depend on the type of gift) and, in return, secures a stream of income for life, often at the rate of return recommended by the American Council on Gift Annuities when the charitable gift annuity is set up. If the donor didn't need income now but wanted to secure income sources for retirement, a **deferred gift annuity** would allow for a gift and charitable deduction now with higher income payouts due to deferring the payments for a period of years.

Gifts of life insurance. A donor can name your organization as a beneficiary of all or part of the proceeds from a life insurance policy. Or, the donor can give a paid-up policy, a new policy, or a policy on which you are still paying —naming the organization as sole owner and beneficiary—and take a deduction for the "present value" of the policy (approximately the

cash surrender value or the cost basis, whichever is less). In these instances, you diminish your estate and inheritance taxes by distributing part of your net worth during your lifetime. If the donor continues to pay the premiums to maintain the life insurance policy, he or she will also be able to deduct the premium payments as charitable contributions. A donor can also use life insurance as a "replacement" asset.

Gifts of real estate, reserving the right of occupancy as long as donor and spouse live. A gift of a remainder interest in a personal residence can entitle a donor to an income tax deduction of the asset's fair market value, an avoidance of capital gains tax, and the removal of the asset from his or her estate. To qualify, a donor must make the gift now rather than in a will. Through a "reserved life estate contract," a donor can reserve the right to occupy the property during his or her (and a survivor's) lifetime, while making an immediate and irrevocable transfer of title to the organization. Any real estate transaction is complex and should be reviewed with both the organization and a donor's financial advisors.

This outline is prepared as a guide to planning. Donors should be encouraged to consult their own legal, accounting, and other professional advisors as they consider the best possible ways to benefit their individual tax situation.

SPECIAL EVENT FUNDRAISING

Special events can help your organization raise money creatively while attracting new members, developing new leadership, and providing opportunities for publicity. Special event fundraising can also be the fastest way to bankrupt your organization. Numerous arts organizations boldly decide to host a special event, spend lots of money on it, and then wake up to realize they did not focus enough energy on developing strategies for selling tickets.

Special events should be volunteer run and involve the staff as little as possible.

Remember that there are pros and cons to special event fundraising:

PROS	CONS
They are fun.	They are hard work.
They cultivate prospects.	They take staff time.
They attract new friends.	They take volunteer time.
They get volunteers involved.	They cost money.
They raise money.	They can lose money.

The key points to consider with special events.

- Plan ahead (select your chairperson up to fourteen months in advance, enabling the chair to help on the event the year before and start planning early for a successful event).

- Start small.

- Set the fundraising goal early and stick to it. Do not compromise later on.

- Evaluate the risk (via expenses, break-even point, number of sales needed at what ticket price to reach your financial goal, potential for loss or net profit).

- Seek as many donations as possible of space, labor, food, liquid refreshments, entertainment, auctioned items, favors/gifts, printing.

- Maximize volunteer involvement.

- Have fun.

- Recognize and thank everyone involved.

- Keep the mailing list updated.

Special events have a life cycle of about seven years. Do not try to do something new every year. Build on the experience of past years until the event starts losing energy or no longer attracts the volunteer support it needs to succeed.

Always remember that the purpose of a fundraising special event is to raise money. Do not spend more money because your volunteer chairperson wants a nice party and could not get the food donated. Be creative. Give

yourselves plenty of advance time. Set the fundraising goal and do not compromise. If the volunteers want to fancy things up a bit, let them pay for it or seek donations. Do not spend any money you do not have to.

RAISING MONEY FROM LOCAL AND NATIONAL CORPORATIONS

Cultivation and solicitation of **locally owned businesses** is similar in approach to raising money from individuals. You focus on the owners/decision makers and do the same kind of homework, cultivation, record keeping, planning, and follow-through. Help them feel more like "family" and less like strangers.

You can help plant managers new to town feel welcome. Arrange for board members to invite them to dinner and an event.

The approach for **national corporations with plant or branches in your area** will be different because the motives for giving will be different. Often, plant/branch managers are from out of town and are emotionally uninvolved with the local community. They may look at your request and ask themselves, "Does this make me look good in the community and/or the home office?" "Does it put me at risk?" and then, "Does it meet our guidelines?"

Corporate giving comes more easily when you first involve one or more executives in your work – they can help to position your request.

Local managers have a limited contributions budget over which they have discretion. Normally, they can award grants of $1,500 to $2,500. Larger grants usually have to go to the home office but need the blessing of the local facility to have any chance of success.

As you approach businesses for gifts, be aware that there are a number of ways in which businesses can support your efforts. The four primary types of support are:

Philanthropic gifts. Tax-deductible as charitable deductions, these come out of the "contributions" budget and/or a separate corporation foundation. The corporations and foundations often have specific policies and

guidelines for grant applications. Decision making may take one to six months.

Sponsorships and ads. These are often (but not always) considered marketing expenses and can come out of budgets other than for contributions. They are typically sought through the marketing, community, public relations departments. An ad sale might take a month; however, sponsorship solicitations and negotiations can take considerably longer. Allow a minimum of three months, six or more for larger corporations.

Employee matching gifts. Some corporations offer programs to match the gifts their employees make to not-for-profit organizations like yours. Others have a matching gift program restricted to gifts to higher education. Such funds come out of the contributions budget.

In-kind gifts can lead to future cash gifts.

In-kind Contributions. These are gifts of goods and services such as paper, printing, mailing newsletter, office furniture and equipment, graphic design work, computer help, accounting services, space, office supplies, loaned secretarial services, loaned executives, food, lumber, hotel rooms, or rental cars for visiting artists. The expenses associated with such gifts are tax-deductible as part of the normal course of doing business, and this is often the easiest type of corporate support to attract. Often a frontline manager can make such a decision without getting elaborate upper management approval.

One arts group takes its mail each day to a bank's mail room to be sent out. The bank pays for all postage.

You will get more from a company if you first involve some of their key executives in your organization. Then they can guide you through the process of asking for various kinds of gifts from different departments within the company. We recommend the following strategy when asking national corporations for support:

- Do research.
- Prioritize and select the most likely prospects.

- Try to identify contacts of board and staff at the corporations.

- Cultivate the individuals identified on the local level.

- Ask for help positioning the gift request at national headquarters.

- Ask for the gift (make a formal proposal).

- Receive and acknowledge the gift.

- Maintain contact.

- Ask for help positioning the next gift.

Develop descriptions of the volunteer talents you need. Then ask for help from those companies which encourage their executives to get involved in the community.

Remember, the key to success is identifying, cultivating, and involving the key decision makers so they will want to help you get money from the corporations for which they work. Enable them to help you determine the best strategy for approaching the corporation and deciding what the appropriate request or requests might be.

RAISING MONEY FROM FOUNDATIONS

Focus your efforts on raising money from **local foundations** which you know already have an interest in your community. You will raise more money per hour of time invested with local foundations than you will with national foundations.

Approach **small family foundations** without professional staff in the same manner as you would an individual. In these cases, the foundation is usually just a mechanism for giving which has certain personal tax advantages.

The staff of foundations can often direct you to other potential donors if you ask.

For **established foundations** with professional staff, a more formal approach is required:

1. **Do research** through such places as:

- The Foundation Center, a nonprofit organization that can provide, for a fee, information on foundations, including which ones give to the arts and which ones give to the arts in your state. Its publications are excellent. You can use them at most pubic libraries. The Foundation Center also has research centers across the country. Their web site is www.fdncenter.org

- *The Chronicle of Philanthropy.* Published biweekly. Their web site is www.philanthropy.com

- Web sites of larger foundations and places such as GrantsStation www.grantstation.com

- colleagues with similar situations.

2. **Develop a list of appropriate foundations,** those which fund: organizations in your region/community, the type of work you are doing—arts, education, beautification, urban renewal, senior citizen projects; and the type of fundraising you are doing—annual operating support, project support, endowment campaigns, capital improvements, renovations.

3. **Review the list and develop cultivation strategies.** Meet with key volunteers to review the information gathered. Find out whether your volunteers know individuals on the staff or boards of the foundations. If no one knows anyone at the foundation, search within your organization's "family" of supporters for someone who does. Never ask a stranger for money! Once you make a personal contact, develop a cultivation strategy for each foundation to **educate**:

- the foundation about your arts organization and how you serve the community;

- yourself about the foundation, what they fund, their guidelines, timelines, funding preferences, and real criteria for funding decisions.

4. **Review a "draft" proposal with the foundation.** Based on this research, respond accordingly to the foundation's guidelines. Some will welcome an initial

phone call. Others will require or encourage a letter of inquiry summarizing your request in order to determine whether a full proposal should be invited. Others may be willing to critique a draft proposal. In this case, you can ask how to strengthen or revise the request to best meet the foundation's needs. Then finalize the proposal and submit it to the foundation for review. If you take this step, build in at least six to eight weeks before any deadline to give the foundation time to review and to give you time to revise.

5. **Write a thank-you letter.** Once the foundation makes a decision, say thank you in writing, even if the response is negative. Once you know the foundation representative, you can ask why your application was rejected. The answer may be simply that there were more good requests than could be funded. Reapply if you get any encouragement from the foundation.

6. **Maintain contact.** Maintain contact with foundation representatives. Make certain they get your newsletter, invitations to openings, etc. Keep them up to date on how your arts organization is serving the community.

RAISING MONEY FROM GOVERNMENTS

Raising money from government agencies or other public funding sources is also a process of identifying the right people, cultivating them, and having them help you get funding. Each level of government requires a different approach.

Local government fundraising equals politics and the art of persuasion through lobbying.

Local Government Funding

Your city and county governments can be your best prospective funders if you organize those who believe in your work to help you lobby for government funds. Identify who has the power and makes the decisions on how local government funding is spent. Develop a cultivation strategy for each decision maker so they understand how your organization serves the community and so they understand that you have a powerful constituency that supports your organization's work. Because many good organizations are asking for money, make certain you are capable of making the politicians look good.

Local government funding can be delivered through:

- line item direct funding,
- local government departments such as libraries, school systems, parks and recreation departments,
- community development funds,
- dedicated or special taxes such as ticket taxes, cable franchise fees, entertainment taxes, hotel/motel taxes, special tax districts, and voluntary tax check-offs,
- general county funds,
- local access to federal community development funds (community development block grants), historic preservation, social service, and more. (Talk with municipal staff in various departments to see what sources you might tap through them.)

State Government Funding

State funding for the arts comes primarily through your state arts council. Call your state arts council and ask their staff for the guidelines and for assistance to understand how and to what you should apply. The staff members are there to help you, and you will enjoy getting to know them. Typical state arts agency funding programs might include:

- project support,
- general operating support,
- artist fellowships,
- artists-in-schools or in residence,
- technical assistance funds,

Peer panels often make funding recommendations. It helps to be known by your colleagues.

- touring performance/exhibition funds.

In most states, peer panels recommend which grants should be funded. While it is ultimately the quality of your proposed project or use of funds that will reap a positive funding decision, it helps if peers in other arts organizations in the state know you, your organization, and the good work you are accomplishing.

Other avenues of state funding can include:

- line item direct funding;
- state government departments such as education, tourism, economic development, human services, humanities council, community development, rural development, rural health, historic preservation;
- going through states to access federal funds;
- state income tax check-offs.

Federal Government Funding

The National Endowment for the Arts (NEA) is the most visible source of federal arts funding. Its web site is www.nea.gov/.

Local arts agencies can access some federal sources (some National Endowment for the Arts funds are set aside for this purpose) through their state arts agencies or statewide assemblies of local arts agencies.

Talk to NEA staff before you apply. If they encourage you, try; if they discourage you, do not apply.

The NEA stresses quality, excellence, and professionalism in its funding considerations. You should have unique, special, or strong programs before you consider spending your limited fundraising time approaching the NEA. The NEA funds only specific, definable activities by professionally-staffed organizations. Currently, the NEA provides grant support in four general areas:

1. **Supporting and preserving artistic excellence:** to ensure that the finest examples of our country's artistic accomplishments are available to the American people.

2. **Challenge America:** to provide communities access to artists and to help strengthen arts in underserved communities.

3. **Partnerships:** to fund local arts agencies, statewide assemblies of local arts agencies, and national service organizations.

4. **Arts education:** to support education in and about the arts for all ages.

As with state funding, NEA funding recommendations are made by peer review panels, so it can be helpful to be known nationally by your peers in the field. The best way to do this is by participating actively in national and regional conferences.

Listed below are some of the other federal departments and agencies that offer arts funding opportunities. Collaborations and partnerships with other organizations–often local government agencies–are essential for access to most of these federal grants.

- U.S. Department of Agriculture (USDA)
- U.S. Department of Commerce (DOC)
- U.S. Department of Defense (DOD)
- U.S. Department of Education (ED)
- U.S. Department of Energy (DOE)
- U.S. Department of Health and Human Services (HHS)
- U.S. Department of Housing and Urban Development (HUD)
- U.S. Department of Interior (DOI)
- U.S. Department of Justice (DOJ)
- U.S. Department of Labor (DOL)
- U.S. Department of State (DOS)
- U.S. Department of Transportation (DOT)
- Advisory Council on Historic Preservation (ACHP)
- Appalachian Regional Commission (ARC)
- Corporation for National and Community Service (CNS)
- Environmental Protection Agency (EPA)

- Federal Emergency Management Agency (FEMA)

- General Services Administration (GSA; surplus goods)

- Institute of Museum and Library Services (IMLS)

- National Aeronautics and Space Administration (NASA)

- National Endowment for the Humanities (NEH)

- National Science Foundation (NSF)

- Save America's Treasures

- Small Business Administration (SBA)

Expand Your Options through Partnerships

Don't just consider arts sources. Be alert to opportunities in your own community to create innovative collaborations that can expand your resources, programming, and audiences.

Requests for funding are often strengthened by collaborating with other organizations.

Local arts agencies around the country have partnered with such groups as school systems, universities/community colleges (good sources of interns, too), civic organizations and clubs, restaurants, radio/television stations, cable television systems, other businesses, chambers of commerce, schools of business, libraries, churches, festivals, rescue squads, volunteer fire departments, home extension service programs, outdoor recreation facilities and parks, tourist development authorities, planning departments, historic preservation agencies, community centers, transportation agencies, prisons, economic development organizations, elder care facilities, the United Way, health and social services agencies, and human services.

HOW TO WRITE A PROPOSAL

Your state arts council, the National Endowment for the Arts, and some foundations and corporations have their own forms to fill out when you apply. Be as concise as possible, leaving lots of white space. Do not crowd the form with

"Please give me large print and lots of white space."

—NEA Panelist

tiny print. How your application looks will influence readers who may have hundreds of applications before them. They will respond favorably to an application which is clear, easy to read, logical, and straightforward—indicating that you have thought through what you want and can do.

Your proposal should distinguish your project from all other applications. Tell them why this effort is special. Find out whether the organization to which you are applying has guidelines. Follow the guidelines carefully. You do not want to give them an excuse not to fund you.

If you are writing a general grant request without stringent guidelines, keep your request short (two or three pages plus appendices). The request should include:

1. **Summary:** How much you want and how you will spend it—what, where, when, how much, who will do it, and who will benefit. In some cases, the summary is used to screen proposals or to submit to trustees, so spend time to make this complete, concise, and compelling.

2. **Problem statement:** The issues, problems, or interests the project will address, such as children are growing up without access to the arts. Substantiate need or intent, whenever possible, with data, testimonials, or other documentation.

3. **Qualifications:** Your organization's qualifications for accomplishing the work, including experience, expertise, significant accomplishments, complementary partners, if any, awards.

4. **Funding:** The other sources of funding for the project, and how the effort will continue after the grant funds run out, if applicable.

5. **Funder benefits:** How this project fulfills the funder's needs, for example, meets a foundation's funding goals, makes a corporation visible, provides employees' children with arts education opportunities, helps a state arts council reach an underserved audience.

6. **Evaluation:** How you will evaluate the success of the effort, including methods and who will conduct the evaluation. Be aware of documentation and other costs related to evaluation and include these in the budget.

7. **Budget:** An important and carefully scrutinized section of the proposal. If funds are being raised for a specific program, a project budget should be provided with an organizational budget included in the appendix. All in-kind donations should be footnoted and assigned a dollar value.

8. **Appendix:** Any other pertinent information such as the organization's annual report and financial summary and forecasts, and a list of the board of directors. Many funders will also ask you to include copies of the prior year's audit and your IRS tax exemption letter.

These proposal components are also summarized in *Exhibit 7* in the form of eight key questions which, when answered, form the basis of a sound proposal.

BUILD ONGOING RELATIONSHIPS

Once you have received a gift or a grant, you have the opportunity to create an ongoing relationship with the donor, which can produce major amounts of money in the years to come. Fundraising is built on trust and the development of ongoing personal relationships. Always be open and honest with your donors. Keep them informed about your successes, problems, and planning. Avoid surprises. Work to make certain they understand what is happening within your organization, and, if possible, involve them in ways they can feel helpful and supportive. Help your donors realize that a gift to your organization will enrich their lives.

Maintain the relationship so that donors are never strangers again.

SELECTED RESOURCES

American Association of Fundraising Counsel, *Giving USA*. Indianapolis, Indiana: AAFRC Trust for Philanthropy: 2002. Researched and written by the Center on Philanthropy at Indiana University. Web site: www.aafrc.org

The Chronicle of Philanthropy: The Newspaper of the Nonprofit World. 1255 23rd Street, N.W., Washington, D.C. 20037 Published biweekly. Web site: www.philanthropy.com

The Foundation Center publications (web site: www.fdncenter.org including:

The Foundation Center's Guide to Grantseeking on the Web, 2001.

Foundation Fundamentals: A Guide to Grantseekers, 1999.

Seltzer, Michael. *Securing Your Organization's Future: A Complete Guide to Fundraising Strategies*, 2001.

Jossey-Bass/John Wiley & Sons, Incorporated publications Web site: www.josseybass.com including:

Alan, Russ, Alan Prince, and Karen Maru. *The Seven Faces of Philanthropy: A New Approach to Cultivating Major Donors*, 2001.

Bancel, Marilyn. *Preparing Your Capital Campaign*. The Excellence in Fund Raising Workbook Series, The Fundraising School at the Center on Philanthropy at Indiana University, 2000.

Dove, Kent E., Alan M. Spears, and Thomas W. Herbert. *Conducting a Successful Major Gifts and Planned Giving Program: A Comprehensive Guide and Resource*, 2002.

Dove, Kent E., Jeffrey A. Lindauer, and Carolyn P. Madvig. *Conducting a Successful Annual Giving Program*, 2001.

Dove, Kent E. *Conducting a Successful Capital Campaign*, 2000.

Greenfield, James M. *Fundraising Fundamentals: A Guide to Annual Giving for Professionals and Volunteers*, 2002.

Hodiak, Diane and John S. Ryan. *Hidden Assets: Revolutionize Your Development Program with a Volunteer-Driven Approach*, 2001.

Jordan, Ronald R. and Katelyn L. Quynn. *Planned Giving for Small Nonprofits*, 2002.

Mixer, Joseph R. *Principles of Professional Fundraising: Useful Foundations for Successful Practice*, 1993

Rosso, H.A. *Rosso on Fund Raising: Lessons from a Master's Lifetime Experience*, 1998.

Seiler, Timothy L. *Developing Your Case for Support; Capital Campaign; Special Events; Build Direct Mail; Major Gifts*. The Excellence in Fund Raising Five Workbook Set, The Fundraising School at the Center on Philanthropy at Indiana University, 2001.

Books by other publishers:

Gingold, Diane. *Strategic Philanthropy in the 1990s: Handbook of Corporate Development Strategies for Nonprofit Managers*. Washington, D.C.: 1993.

Legon, R. D. *The Board's Role in Fund Raising*. Washington, D.C.: Association of Governing Boards of Colleges and Universities, 1997.

Lord, James Gregory. *The Raising of Money: Thirty-five Essentials Every Trustee Should Know*. Cleveland: Cleveland Third Sector Press, 1990.

Seymour, Harold J. *Designs for Fund-Raising*. New York, NY.: McGraw-Hill, 1996.

Wolf, Thomas. *Managing a Nonprofit Organization in the 21st Century*. New York: Prentice Hall Press, 2000.

Exhibit 1: Capital and Endowment Campaign for the Well-Established Arts Center

Summary of Historical and Projected Cash Flows -- Confidential/for Planning Purposes

Fiscal year ending June 30:	Actual Year 1	Actual Year 2	Budgeted Year 3	Budgeted Year 4	Year 5	Year 6 (Construction)	Year 7 (Construction)	Year 8	Campaign TOTALS
CASH DISBURSEMENTS:									
PROGRAM & OPERATING COSTS:									
> Production	1,617,367	1,606,136	1,581,723	1,746,372	1,798,763	1,852,726	1,908,308	1,965,557	
> Administration	196,110	211,668	184,032	215,976	222,455	229,129	236,003	243,083	
> Other Operating Costs	209,772	213,872	166,781	216,417	222,910	229,597	236,485	243,579	
Total program+operating costs	2,023,249	2,031,676	1,932,536	2,178,765	2,244,128	2,311,452	2,380,795	2,452,219	
CAPITAL NEEDS:									
> Construction costs + equipment purchases					548,320	596,230	935,142	693,230	2,772,922
> Architect + theatre consultant						166,375	166,376		332,751
> Development + marketing			28,179	159,342	57,300	25,000			269,821
> Financing costs					15,274	98,821	60,582	17,736	192,413
> Endowment					775,000	975,000	1,000,000	1,250,000	4,000,000
Total capital needs	0	0	28,179	159,342	1,395,894	1,861,426	2,162,100	1,960,966	$7,567,907
Campaign LOAN Retirement						347,000	600,000	275,907	1,222,907
TOTAL CASH DISBURSEMENTS	2,023,249	2,031,676	1,960,715	2,338,107	3,640,022	4,519,878	5,142,895	4,689,092	
CASH RECEIVED:									
EARNED INCOME:									
> Ticket sales	1,123,467	1,028,915	1,057,710	1,353,280	1,393,878	1,435,695	1,478,766	1,523,129	
> Concessions	20,858	21,131	20,000	20,000	20,600	21,218	21,855	22,510	
> Advertising	69,017	71,309	60,000	65,000	66,950	68,959	71,027	73,158	
> Rentals and Miscellaneous	172,067	203,489	139,280	153,880	158,496	163,251	168,149	173,193	
> Foundation Distribution		43,144	74,000	41,000					
Total earned income	1,385,409	1,367,988	1,350,990	1,633,160	1,639,925	1,689,123	1,739,796	1,791,990	
CONTRIBUTED INCOME:									
> To support operating needs	560,807	585,638	507,500	497,500	512,425	527,798	543,632	559,941	
> To support program needs	77,659	80,400	85,000	95,000	97,850	100,786	103,809	106,923	
> Proposed Capital Campaign *(Campaign need: $7,567,907)*			25,000	125,000	977,300	1,401,375	2,800,000	2,239,232	$7,567,907
Total contributed income	638,466	666,038	617,500	717,500	1,587,575	2,029,958	3,447,441	2,906,096	
Campaign LOAN proceeds					414,291	808,616			1,222,907
TOTAL CASH RECEIVED	2,023,875	2,034,026	1,968,490	2,350,660	3,641,791	4,527,697	5,187,237	4,698,086	
Cash in Excess of Disbursements	626	2,350	7,775	12,553	1,769	7,819	44,342	8,994	

Exhibit 2: Evaluating Internal Resources

Organization: _____ Completed by _____ Date: _____

Fundraising options to consider (in priority order)	Do we know how?	Do we have needed staff time?	Do we have needed volunteer time?	Do we have needed space/ equipment?	Do we have needed prospects?	How much can we raise?	How much will it cost?	Should we do it?
1. Board/key volunteer gifts.								
2. Individual gifts:								
a. Personal solicitation of major gifts.								
b. Membership campaign:								
1) Personal solicitations.								
2) Personalized letters.								
3) Telephone follow-up.								
4) Mass mail campaigns.								
3. Fundraisers/benefits/special events.								
4. Personal solicitations:								
a. Local businesses.								
b. Local foundations.								
5. Cultivation and grantwriting:								
a. Local governments.								
b. State government.								
c. Federal government.								
6. Cultivation and proposal writing:								
a. National corporations.								
b. National foundations.								
Other:								

Exhibit 3: Fundraising Work Plan Example
Capital City Performing Arts Center 5-Year Plan

Goal: To increase annual contributed income by 250% from $77,100 to $192,7500

1. Board Solicitation

Plan and Rationale: Our 18 board members have been pushed hard to give to their maximum over the last 5 years. They have given to the annual fund drive and capital campaign. There is little room for improved giving. Each board member is required to give to the best of his/her ability.

Strategy: Continue to have the Chair solicit the Executive Committee members and to have the Executive Committee members solicit the other board members. All solicitations will be made in person.

Time:
Executive Director 5 hours to help with "prospect research"
Development Director 10 hours
Board Chair 6 hours
Executive Committee members 4 hours each.

Timetable: Board solicitation is to be completed within the month of September.

Direct Cost: Minimal.

Projected Income:	Year 1	Year 2	Year 3	Year 4	Year 5
	$37,100	$40,000	$47,000	$58,000	$65,000

2. Individual Gifts Solicitation

Plan: Start small, build a strong base, and give our board and staff experience in raising money from individuals. By Year 5, achieve 400 high-level members, assuming we keep cultivating current members as we add more.

Enhance membership benefits: New 7-8 member Individual Gifts Committee improves special privileges/ benefits provided for those at $50 to $1,000 levels of membership.

Personal solicitation: Given new benefits, board members submit information on 15 individuals/couples capable of memberships of $100+ a year. Staff compiles list and eliminates duplicates. Committee discusses list, prioritizes top 80 most-likely prospects, and determines who is best to cultivate/solicit each one. Those "best," personally invite prospects to attend special show and private reception. That night, solicit prospects to become members at $100 to $1,000 a year. Repeat each year with new prospects.

Mail campaign: Committee arranges for those next on the list to receive letters with hand-written notes from people they know, inviting them to become high-level members ("Please join me as a Patron-level member"). Committee organizes phone follow up by "best" person for mail prospects who did not respond. Start calls with "thank you" for past support and/or participation. Timing: within a month after mailing.

Time:
Development Director 30 days of coordinating, motivating, following up, record keeping, and list/ letter preparation

Individual Gifts 2 meetings + Committee members
 5 performances with guests + 2 evenings for phoning

Other board members
2 performances each with guests + 2 evenings each for phoning

Direct Cost: Supplies and mailings $3,800; receptions $1,850; and 160 complimentary tickets.

| Projected Income: | Year 1 | Year 2 | Year 3 | Year 4 |
Year 5					
Personal solicitation	$14,000	$25,000	$35,000	$48,000	$55,000
Mail and follow-up phone	$6,000	$9,750	$13,500	$18,500	$20,000

3. Special Fundraising Event:

Plan and Rationale: Establish a gala cocktail party, sit-down dinner, and show as a special event to kick-off the season. Involve up to 150 people and get donations in a way that is not extra work for our technical crew. We have already recruited to the board the head of food service at the Capital Hotel and his wife, former president of Junior League, specifically to establish this event as an important community occasion. They will recruit the Gala Team from prominent couples on the subscription list.

Strategy: Secure a headline artist. Charge for dinner and tickets. Gala patrons can secure best seats in the house through the Development Director. Use this opportunity to get current and potential donors into the theater who don't have the time to come on a regular basis. Make the evening very special.

Time:
Development Director. Several days for Gala Team back-up, invitations, ticket-related phone calls, ticket and dinner arrangements, and helping with marketing and publicity;

Co-Chairs and Gala Team members. 1 meeting + time to address envelopes and write personal notes to tuck in invitations + gala evening.

Timetable: Secure commitment of Capital Hotel, headline artist, and Co-Chairs up to 13 months ahead.

Direct Cost: Pay Capital Hotel for set-up, flowers, food, clean-up, everything — an agreed-upon $5,000 (rest of cost is their contribution).

Projected Net Income:	Year 1	Year 2	Year 3	Year 4	Year 5
	$20,000	$30,000	$35,000	$40,000	$52,750

Exhibit 4: Prospect Research Chart

Organization: _____ Completed by _____ Date: _____

Prospect	Giving history	Capable of gift of	Likely gift	Best solicitor	Comments
1. Names Address Phone Email					
2. Names Address Phone Email					
3. Names Address Phone Email					
4. Names Address Phone Email					
5. Names Address Phone Email					

Exhibit 5:
Sample Timetable to Solicit Gifts from Individuals

Quiet In-house planning phase

Research and Planning

1. Analyze fundraising resources.
2. Develop fundraising plan, including cultivation strategies.
3. Identify staffing needs based on the plan.
4. Develop staff & board job descriptions (who will do what, when).
5. Develop volunteer job descriptions.
6. Develop prospect lists for different elements of fund drive.
7. Begin prospect research.
8. Identify volunteer leadership.
9. Recruit campaign chair.
10. Review and verify needs based on the plan.
11. Set the need
12. Develop the case for giving.
13. Develop fund drive materials, including:
 - Pledge forms
 - Solicitor and donor packets
 - Format for personalized letters
 - Tax-deduction receipt forms
 - Thank you letters
 - Call status sheets.

Solicitation

14. Solicit the board.
15. Solicit the fund drive leaders.
16. Solicit major gifts.
17. Recruit other volunteers.
18. Train volunteers.
19. Solicit volunteers.
20. Negotiate with solicitors the best prospects.

> **Once 70-85% of the projected goal is raised, set the public goal based on what is raised to date.**

Public "Fundraising" Phase

21. Set the goal
22. Kick off the fund drive publicly.
23. Hold report meetings.
24. Do follow-up on calls.
25. Do "clean up."
26. Thank each donor.
27. Thank each solicitor.

Exhibit 6
Steps for Making a Fundraising Call on an Individual

1. **Ask in a face-to-face meeting.**
 - Solicit gifts in a thoughtful manner, not casually.
 - Cultivate the prospect and ask face-to-face if you are asking for a lot money.

2. **Be prepared and brief.**
 - Know as much about the prospect as possible.
 - Be clear about the amount or range of money you are requesting.
 - Have a personalized letter with you which asks for a specific amount or range (and includes the pledge form).
 - Include attachments explaining the fund drive/organization which the prospect can review later.

3. **Be confident, positive, and passionate.**
 - You are not begging; you are sharing an opportunity to enhance your organization and to satisfy the prospect's need.

4. **Focus on the prospect's needs.**
 - Successful fundraising speaks as much to the needs of the donor as it does to the needs of the arts organization.

5. **Up front, ask for a specific amount or range of money:**
 - Mention a need or goal of the prospect which the gift will satisfy (based on your research). Lead with the strongest opportunity. (Mentioning more than one may give the prospect a chance to shoot down your request.)

6. **Don't fill the silence after you make the request.**
 - Give the prospect a chance to respond.
 - Then continue based on the response.
 - Involve the potential donor in the development of the idea/proposal so the donor is emotionally involved in its success.
 - Remember that everyone wants to be a worthwhile member of a worthwhile organization.

7. **Mention that the amount requested may be high or low.**
 - It is only a suggestion.
 - Only the prospect knows the appropriate gift level.

8. **Follow up with a thank-you letter.**
 - Even if the prospect turns you down.
 - In fact, thank donors every time you can.
 - Saying thank you gives you the right to ask again.

9. **"Involve" the donor and follow through to make the contribution an annual gift.**

Exhibit 7
Key Questions to Consider When Writing a Funding Proposal

The following questions form the basis of a standard proposal format. Think about your ongoing activity in light of these questions to develop a comprehensive proposal.

1. Summary:
What is the project for which you want funds?

2. Problem statement:
What is the problem your project would address? Can you pose the problem as a *community issue* that will be of concern to the funding source? Don't define a problem that is self-serving, such as a tour bus for the theater. Rather, discuss the need to bring live theater to rural schools.

3. Qualifications:
Why should your organization do the project? Do you have the capability, track record, qualifications, staff? Are you ready to act and able to be effective? Can you demonstrate a local base of support for your work?

4. Project plan:
What, specifically, will be achieved with the help of the funds? Do you have quantifiable objectives and a timeline for accomplishing them?

5. Evaluation:
How will you know if you are successful? By what criteria and methods will the project be evaluated? What quantitative factors, such as the numbers of people affected, can be measured? Who will do the evaluating? When?

6. Continued support:
Will the project continue after the funding is used up? If so, how will it be supported? Will the project generate earned income? Will it make your organization more visible and better positioned for future fundraising? Will the problem be solved and the project completed, or will you be requesting annual support?

7. Funder benefits:
How will the funder benefit? What will you provide in return for his/her investment --a consistency with funding priorities, national visibility, goodwill in the community, employee discounts, free tickets, etc.? How will giving to your organization be in the funder's own best interest?

8. Budget:
What are the projected incomes and expenses? For which line items are you requesting support?

CHAPTER 11

FINANCIAL MANAGEMENT:

THE BASICS FOR NON-FINANCIAL MANAGERS . . .

by Christine Burdett

with contributing editor Sally Zinno

To many volunteers and staff of community arts organizations, financial management is an area best delegated to the accountant or banker on the board. Financial responsibility, by law, rests with every member of the board who are "fiduciaries," caring for the nonprofit organization as a public trust for the rest of the community. Financial management is such a fundamental aspect of organizational sustainability that every board member and staff person should understand the basics. The good news is that the principles of financial management are easy to understand and well within the grasp of every key member of the organization.

Good financial management can provide vital support to arts programs and important evidence of organizational stability to funding sources. Keeping accurate, up-to-date financial records guarantees that you will be ready any time those records are requested by the IRS, donors, loan officers, or members. Those records are proof that the organization has upheld its fiscal responsibility. If an organization's programs and budget are significant, the board and staff need qualified financial advice to ensure that the financial operations and data are appropriate.

Most importantly, financial management helps board members govern effectively and staff members operate efficiently, and it assures your constituency that your organization is run responsibly.

This chapter presents one approach to financial management. It covers how to:

- designate responsibility for financial planning and evaluation;

- set financial objectives;

- develop and use a budget effectively;

- apply basic principles of accounting that affect not-for-profit organizations;

369

- prepare and read financial statements;

- meet reporting requirements common to most nonprofit organizations;

- evaluate options for computerization;

- foresee financial problems and opportunities;

- analyze an organization's financial health.

The Management Control Cycle

In essence the financial management cycle consists of three activities:

1. setting financial objectives with a budget;

2. carrying out programs and measuring performance against objectives;

3. taking corrective action.

These elements constitute the basic management controls. First, set objectives in measurable, financial terms, using a budget. Then begin to conduct your programs according to that financial plan. At regular monthly or quarterly intervals, measure financial performance using operating statements. Comparing actual revenues and expenses to those predicted in the budget and projecting end of fiscal year results provides a basis to take corrective actions so that overall objectives may be met or revised. In this way, problems may be uncovered before they become unmanageable crises. The plan also facilitates the process of evaluating opportunities that may arise.

Board Responsibility

When it comes to financial management, the buck stops with the board of directors. Financial management is the board's "fiduciary responsibility," both as individuals and as a group. When board members take their financial responsibility seriously, they will reap substantial rewards. First, they can feel confident that they are fulfilling the public trust; second, it is much less likely that they will encounter legal difficulties from mismanagement or debt.

Specifically, the board is responsible for ensuring that the organization has the resources available to achieve its mission. That

responsibility includes approving the budget and monitoring actual performance, as well as setting and enforcing fiscal policy. Ordinarily the board is advised by a treasurer, a finance committee, and professional staff (when there is one). It is each board member's responsibility, however, to understand financial information that is reviewed and to make informed decisions.

Board and staff members need adequate time to review financial information before discussing or voting on it. Financial statements, budgets, and written explanations of the impact of the financial status on the organization should be available in advance of meetings to allow for examination and questions.

The Treasurer's Role. The treasurer is the board's chief financial representative. In smaller organizations with no director or finance staff, the treasurer may be responsible for signing legal financial documents (including checks), loan applications, or grant reports. The treasurer is also responsible for carrying out key functions or for seeing to it that paid or volunteer staff carry out those functions, which may include keeping the books, writing checks, reconciling bank statements, monitoring petty cash, preparing financial statements, and filing state and federal tax forms. When paid or volunteer staff members are assigned some or all of these tasks, the treasurer oversees their activities so that financial operations are performed in a responsible and ethical manner.

The treasurer is the primary communicator to the board of directors concerning the organization's financial position, and helps the board to understand the organization's finances. Most meeting agendas include a treasurer's report to update the board on financial activity.

Finance Committee. The finance committee plays a key role in overseeing the financial operations of the organization and building public confidence in the organization's fiscal management. The finance committee advises the board on financial matters and typically exercises the following responsibilities:

- Recommends an annual operating and capital budget and the multi-year budgets needed for long-term planning;

- Monitors income and expenditures against budget and projections during the year and recommends changes to meet established goals;

- Reviews and recommends financial policy and ensures compliance with legal reporting requirements;

- Oversees investments.

Set Financial Objectives with a Budget

A budget is a financial plan expressed in quantitative, monetary terms over a specific time period. It is the central instrument of financial planning and control. If a budget is prepared correctly and evaluated throughout the year, an organization can prevent or be forewarned of financial difficulty.

Budgets may be presented in various formats, but they always reflect revenues and expenses and the difference between them. Revenues can be called income, and expenses can be called costs. The difference is termed a surplus (excess of revenues over expenses) or, if the figure is negative, a deficit (excess of expenses over revenues).

Why Prepare a Budget?

A budget is more than an accounting exercise done to satisfy the state arts council, although that is an excellent reason to prepare one. It is the means by which arts managers allocate resources to fulfill organizational goals. A budget:

- provides a plan that helps guide management decisions;

- guides subsequent spending decisions and serves as a yardstick to measure actual performance;

- spurs the keeping and maintaining of adequate financial records;

- clarifies the need to expend scarce resources effectively;

- supports grant applications and fundraising campaigns;

- provides an objective standard for evaluation.

Who Develops the Budget?

A budget projects anticipated revenues and expenses based on the organization's operational plan for the year. In all but the smallest organizations, the budget should be generated from the bottom up. People who make the day-to-day spending decisions and must live within a budget should have key roles in creating the budget. The program managers are closest to the action and understand best what expenses are incurred and what revenues are likely to be generated. If the board has a related committee, the program manager often works with a board committee chair or the committee as a whole to review the budget recommendations. The arts education manager, for example, would work with a board education committee on the budget for education programs and services.

Types of Budgets

There are three basic types of budgets:

- organizational budget—a financial plan developed for an overall operation;

- program budget—a financial plan developed for a single project;

- cash flow budget—a projection of available cash over a specified time period.

An organizational budget can be created by combining all of the individual program budgets and adding general administrative revenues and expenses.

The Budget Process

Each organization's budget process must be developed to fit its mix of board and staff members and governing procedures. Some boards will expect a treasurer or finance committee to take the lead on budgeting, while others will entrust more of budget development to professional staff. Boards that meet quarterly are likely to plan their budgets earlier in the fiscal year than will boards that meet monthly.

An annual budget is based on the program and operational plan determined by the board and staff. The board and staff must first agree on the program goals and priorities for the year

and the administrative and operating objectives required to achieve the organization's mission. The budget process, then, attaches expenses and revenues to the strategies required to implement the plan.

Eight steps to budgeting. Keeping in mind that preparing a budget is a dynamic process, here are eight key steps:

1. The board determines budget guidelines, including time period of budget (fiscal year), the percent for salary increases or anticipated inflationary increases, and the target for the bottom line surplus; dates by which drafts and final version must be prepared; and general budgeting guidelines (for example, all programs must break even or no major capital expenses may be incurred).

2. Program managers working with committee chairs, where appropriate, create a revenue and expense budget for each program area and earned income service such as a retail store.

3. The chief executive officer or finance committee adds overall administrative expenses and considers program and service revenues before drafting an organizational budget.

4. The board negotiates potentially conflicting uses of resources, eliminates costs, and combines resources to prevent deficits. Grant and contribution projections are discussed by the fundraising committee and development staff.

5. The board presents, considers, and approves the final budget. The budget for the following fiscal year should be approved before the start of that year.

6. The board or chief executive communicates the approved budget back to the committee or staff responsible for each program.

7. The staff, the treasurer, and finance committee monitor revenues and spending throughout the fiscal year.

8. Staff and committee chairs adjust programs and spending decisions to keep the budget on target.

Additional Budget Concepts

Zero-based budgeting is a popular approach to developing a budget. Each revenue and expense is justified by current programs and conditions without regard to previous years. The budget is built from scratch, zero.

Historical-based budgets are developed by reviewing the organization's recent expense and revenue history and adjusting last year's budget by a factor that compensates for new conditions—inflation, economic trends, new programs. In practice, most planners use a combination of the historical and zero-based approaches.

Fixed and variable costs are usefully distinguished during budgeting. Some costs, like administrative salaries, rent, insurance, or utilities will not be affected by the number or kinds of programs that are presented or by audience turnout. These are fixed costs. Variable costs depend upon the kinds and numbers of programs and include artist salaries, printing, advertising, technical staff, concessions, etc.

Relevant costs are those that planners consider as they decide whether or not to continue an existing program or develop a new program. Planners consider program costs and revenue among the issues that determine program value. The costs directly related to the program including, for example, artist fees and marketing expenses, are clearly relevant costs in a decision about whether or not to expand a concert series. The mortgage payments on the theater are not relevant to making such a decision. Usually only the variable and direct costs for that program are significant in making the decision.

Case in Budget Preparation

Let's walk through the preparation of a budget for a hypothetical case, the Gotham Arts Council, following the budget process steps previously outlined.

Step 1. Determine budget guidelines.
For the Gotham Arts Council, our budget covers one fiscal year, July 1 to June 30. Our general guidelines are that the total budget must generate a surplus in the range of $5,000 and that salaries and general overhead will be

presented separately (rather than prorated to programs).

Step 2. Create program area budgets.
Gotham Arts Council sample program area budgets have been developed for fundraising and the artists-in-residence project using our budget worksheets (see Figure 1). These worksheets would be completed by a program manager working with the committee chair. In these cases, the artist in residence program would be discussed with the education committee and the fund raising budget with the board's development committee. Single program worksheets serve as a tentative budget until after they are incorporated into the total budget and approved by the board.

Step 3. Draft an organizational budget.
Completed revenue and expense budget worksheets for the whole organization are shown in Figure 2. Combining these two sheets provides an organizational budget for the year.

Step 4. Budget for a surplus and prevent deficits.
The total picture is now reviewed to see if it meets budget guidelines and if it is realistic and achievable.

Step 5. Present, consider, and approve the final budget.
The budget worksheets and preliminary organizational budget are shown in the examples using a functional break down such as travel or utilities. Such information is important to the staff and finance committee, and can be seen in Figure 2. The budget presented to the board often is presented in a program summary format so the board can focus on the mission and operating activities that are needed to operate the organization. An example is presented in Figure 5. The figures in the "proposed budget" column correspond to the totals from the worksheets. These are then compared to the previous year's actual figures and budget. Unusual deviations, higher or lower, may be explained by accompanying notes. If the program summary format is used in the budget, it should also be used in the statement of activities report that compares budget to actual performance throughout the year.

Step 6. Communicate the approved budget.
Once the Gotham Arts Council budget is approved by the board, the earlier draft budgets are discarded and the approved one is presented to program directors and committee chairs.

Estimating Income. Always calculate income first. The anticipated level of revenue will guide the change in expenses that you can afford. If you calculate expenses of $1,000 first, it is too easy to predict that you'll sell 100 tickets at $10 each even if your experience makes this number unrealistic. So protect yourself from optimistically inflating revenues to match the expenses you want to meet by realistically estimating revenues first.

Estimate the amount you can conservatively expect to collect from each of the proposed activities. Don't guess. Consider past sales records, the economic climate, changes in your planned promotions, how competitors are doing, how peer organizations did with a similar program, and other related factors. Based on this information, develop models that will help you to predict results and reduce guesswork.

To estimate performance revenues from ticket sales, for example, the model would multiply the seating capacity for each performance times your usual percentage from previous sales. Modify that base figure for each performance according to the anticipated popularity of each of the proposed performances, the attractiveness of the price, and the likely success of your marketing campaign. Variably priced seats must also be accounted for. Take the same approach for calculating likely registration fees for a workshop or sales in a gift shop.

For the Gotham Arts Council we arrived at the ticket income for the jazz concert and dance performance as follows:

Seating Capacity	800
Usual Paid Attendance	x 70%
	560 tickets sold
Jazz	650 tickets sold
Concert	x $12
	$7,800
Dance	400 tickets sold
Performance	x $9
	$3,600

Figure 3—Gotham Arts Council Organization Budget (Step 3)

Figure 1—Gotham Arts Council Program Budget Worksheets (Step 2)

Expense Worksheet (Artists in Residence)

	A	B	C	D	E	F	G	H	I	J	K	L	M
					PROGRAMS			FUNDRAISING			SERVICES		
1	EXPENSE												
2	WORKSHEET		General	Artist in	Jazz	Arts	Dance	Member	Special				
3	DESCRIPTION	Total	Admin.	Residence	Concert	Festival	Performance	Ship	Events	Other	Newsletter	Other	Other
4	Salaries & Benefits												
5	Outside Fees & Services												
6	Office Supplies												
7	Phone/FAX												
8	Travel												
9	Memberships												
10	Professional Development												
11	Space Rental												
12	Utilities												
13	Insurance												
14	Printing/Copying			1,500									
15	Postage/Shipping												
16	Artists Fees			7,500									
17	Art Materials			2,000									
18	Equipment:												
19	Purchase												
20	Repair												
21	Rental												
22	Hospitality												
23	Other												
24	Total			11,000									

Revenues Worksheet (Artists in Residence)

	A	B	C	D	E	F	G	H	I
				Programs/Projects					
1	REVENUES								
2	WORKSHEET		Artist in	Jazz	Arts	Dance			
3	DESCRIPTION	Total	Residence	Concert	Festival	Performance	Fundraising	Services	Other
4	Corporate Grants		5,000						
5	Foundation Grants								
6	Government Grants								
7	Federal								
8	State		3,000						
9	Local								
10	Business Contributions								
11	Membership Drive								
12	Other Private Donations								
13	Fundraising Events								
14	Program Admissions								
15	Fees/Tuitions								
16	Advertising								
17	Sales								
18	Interest								
19	Other-School District		3,500						
20	TOTAL		11,500						

Revenues Worksheet (Fundraising)

	A	B	C	D	E	F	G	H	I
				Programs/Projects					
1	REVENUES								
2	WORKSHEET		Artist in	Jazz	Arts	Dance			
3	DESCRIPTION	Total	Residence	Concert	Festival	Performance	Fundraising	Services	Other
4	Corporate Grants						5000		
5	Foundation Grants						10000		
11	Membership Drive						15000		
13	Fundraising Events						25000		
14	Program Admissions						10000		
20	TOTAL						55000		

Expense Worksheet (Fundraising)

	A	B	C	D	E	F	G	H	I	J	K	L	M
					PROGRAMS			FUNDRAISING			SERVICES		
1	EXPENSE												
2	WORKSHEET		General	Artist in	Jazz	Arts	Dance	Member	Special				
3	DESCRIPTION	Total	Admin.	Residence	Concert	Festival	Performance	Ship	Events	Other	Newsletter	Other	Other
4	Salaries & Benefits												
5	Outside Fees & Services												
6	Office Supplies												
7	Phone/FAX												
8	Travel												
9	Memberships												
10	Professional Development												
11	Space Rental												
12	Utilities												
13	Insurance												
14	Printing/Copying							2000					
15	Postage/Shipping												
16	Artists Fees												
17	Art Materials												
18	Equipment:												
19	Purchase												
20	Repair												
21	Rental												
22	Hospitality								2500				
23	Other												
24	Total							2000	2500				

Expenses and revenues for Artists in Residence program. Expenses and revenues for fundraising activities. Build your budgets up from individual pieces of well-considered information rather than by making gross estimates.

Figure 2—Gotham Arts Council Organization Budget (Step 3)

	A	B	C	D	E	F	G	H	I	J	K	L	M
					PROGRAMS				FUNDRAISING		SERVICES		
1	EXPENSE												
2	WORKSHEET		General	Artist in	Jazz	Arts	Dance	Member	Special				
3	DESCRIPTION	Total	Admin.	Residence	Concert	Festival	Performance	Ship	Events	Other	Newsletter	Other	Other
4	Salaries & Benefits	60,000	60,000										
5	Outside Fees & Services	1,000	1,000										
6	Office Supplies	500	500										
7	Phone/FAX	2,000	2,000										
8	Travel	2,500	1,000		1,000		500						
9	Memberships	600	600										
10	Professional Development	1,200	1,200										
11	Space Rental	3,600	3,600										
12	Utilities	0											
13	Insurance	250	250										
14	Printing/Copying	14,600	600	1,500	1,000	2,500	1,000	2,000			6,000		
15	Postage/Shipping	1,200									1,200		
16	Artists Fees	25,000		7,500	10,000	2,500	5,000						
17	Art Materials	5,000		2,000		3,000							
18	Equipment:	0											
19	Purchase	6,000	6,000										
20	Repair	0											
21	Rental	5,500				5,000	500						
22	Hospitality	3,000			500				2,500				
23	Other	1,000				1,000							
24	Cash Reserve	10000	10000										
25	Total	142,950	86,750	11,000	12,000	14,500	7,000	2,000	2,500	0	7,200	0	

	A	B	C	D	E	F	G	H	I
				Programs/Projects					
1	REVENUES								
2	WORKSHEET		Artist in	Jazz	Arts	Dance			
3	DESCRIPTION	Total	Residence	Concert	Festival	Performance	Fundraising	Services	Other
4	Corporate Grants	19,000	5,000	4,000		5,000	5,000		
5	Foundation Grants	25,000		5,000	5,000	5,000	10,000		
6	Government Grants	0							
7	Federal								
8	State	11,000	3,000	5,000	500	2,500			
9	Local								
10	Business Contributions	22,500			7,500		15,000		
11	Membership Drive	25,000					25,000		
12	Other Private Donations	3,000			3,000				
13	Fundraising Events	10,000					10,000		
14	Program Admissions	11,400		7,800		3,600			
15	Fees/Tuitions	6,500			6,500				
16	Advertising	5,000		2,500		2,500			
17	Sales	1,050			1,050				
18	Interest	0							
19	Other	3,500	3,500						
20	TOTAL	142,950	11,500	24,300	23,550	18,600	65,000	0	0

The program manager first determined the average number of tickets sold per performance in the past. The jazz concert has been presented for several years and has developed a loyal audience (it has sold out in the past). The jazz concert revenue budget is above average. The dance performance is a newer event that has not yet built as large an audience, and its budget is below the average.

Revenue forecasting should be made in conjunction with a marketing plan. A program that has a related promotion budget and public relations plan is more likely to realize earned income objectives than one that has no plan or minimal promotion.

Program planners are often tempted to be overly optimistic about attendance, sales, or a membership drive. Resist this. Apply the conservancy principle. If you are in doubt and must choose among a range of possible revenue figures, select the lower one for budget purposes. This protects the organization from deficits.

List a grant as a revenue only if you are certain you will receive it. Base estimated fundraising revenue on previous successes and this year's planned campaign. Develop models for fund raising goals. For example, use your average membership renewal rate and your own past experience with a mail membership solicitation campaign to predict revenue. Be wary of dramatically increased fundraising goals, and exercise caution in estimating a big increase in any revenue figure unless there is a specific, achievable plan for realizing the increase including the expenses needed to carry out the plan.

Estimating Expenses. The sample expense worksheet lists possible areas in which you may incur expense. Add to it any categories that apply specifically to your organization. Expenses should relate directly to the programs in which you expect to generate income. You may choose to list general administrative or fixed expenses first and then the variable expenses necessary to create the programs.

Take time to consider what it will actually cost to run each program. Base estimates on your own experience or the related experience of others. Call printers, insurance agents, and suppliers to get estimates. Consider the effects of the rate of inflation on last year's expenses and the impact of increased activity in a program or administrative area.

Employ the conservancy principle. If in doubt about which of several likely values to assign for an expense, select the most expensive. In developing draft budgets you may use ranges of expense and related revenue to determine what you can do with the available funds. You may also wish to allow an amount in the budget for contingencies, unexpected or miscellaneous expenses.

Some planners allocate administrative expenses for each program. Staff salaries, rent, utility bills, insurance, postage, and other overhead expenses are charged to each program according to the amount of time or space that each one requires. This method more accurately projects the resources and costs necessary to conduct each program, but it is more complicated to calculate. One must estimate how much time the staff expends on each program. Then one can calculate the percentage of floor space each occupies to determine its share of the rent, its portion of postage costs, etc. Some choose to allocate the obvious expenses—such as printing bills—to each program; they then come up with a rule of thumb to allocate other overhead expenses. For example, the proportion of staff time devoted to each program can be used to determine the share of other overhead expenses.

In most organizations that have more than one paid staff person, the chief executive submits a total amount for salaries and benefits for inclusion in the budget rather than line items for each position.

A budget's expenses should reflect an organization's priorities. For example, an arts organization committed to an education program that spends less and less of its money on its education program should take a closer look at the program. For estimating your own expenses and income, see blank worksheets, Figures B and C, Appendix.

Cash Flow Budget

Cash management is a critical issue for most

nonprofits. Cash must be available when the organization needs it to pay bills, salaries and other obligations; however the annual business cycle usually results in an uneven flow of cash through the year. A cash flow forecast can help predict cash shortfalls or times of surplus. Knowing in advance of an impending cash shortage or surplus allows the nonprofit to manage cash flow rather than be managed by it.

If a shortage is predicted, the organization can ask a donor to advance a planned gift, negotiate a short-term bank loans, or make spending decisions that minimize or eliminate the temporary shortage. Similarly, the prediction of a temporary cash surplus can allow the financial manager to make short-term certificate of deposit investments to realize a higher interest return.

A cash flow budget begins by determining the opening cash balance for the period, then adding anticipated revenues received and deducting expenses that will be paid for each month. The ending cash balance for January becomes the opening cash balance for February and so on. Projections are based on past experience, anticipated activities and events, and anticipated obligations. All staff that has responsibility for programs revenue and authorizing expenses should provide on-going information for the cash flow budget.

Cash flow projections are useful only if they are compared to actual performance. At the end of each month when the actual cash results are known, the future cash flow projection should be revised.

Figure 4—Gotham Arts Council Cash Flow Projection

A	B	C	D	E	F	G	H	I	J	K	L	M
CASH FLOW	July	August	September	October	November	December	January	February	March	April	May	June
Beginning Balance	40,000	40,142	32,984	32,158	35,049	33,291	31,533	27,207	33,299	48,741	67,583	57,758
EXPENSES												
Gen. Admin.	11,558	6,558	5,559	5,559	6,158	6,158	5,559	5,808	5,558	5,558	5,558	17,158
Project A			3,667				3,667				3,667	
Project B	12,000											
Project C				14,500								
Project D									7,000			
Membership								2,000				
Special Events			2,500									
Other												
Newsletter	600	600	600	600	600	600	600	600	600	600	600	600
Other												
Other												
142,950	24,158	7,158	12,326	20,659	6,758	6,758	11,826	6,408	13,158	6,158	9,825	17,758
Balance	15,842	32,984	20,658	11,499	28,291	26,533	19,707	20,799	20,141	42,583	57,758	40,000
REVENUES												
Program A			11,500									
Program B	24,300											
Program C				23,550								
Program D									18,600			
Fundraising					5,000	5,000				25,000		
Contributions							7,500	7,500				
Grants								5,000	10,000			
Other												
142,950	24,300	0	11,500	23,550	5,000	5,000	7,500	12,500	28,600	25,000	0	0
Closing Balance	40,142	32,984	32,158	35,049	33,291	31,533	27,207	33,299	48,741	67,583	57,758	40,000

The figures in the cash flow projection (see Figure 4) correspond to the revenues and expenses in the Gotham Arts Council organizational budget. (See Figure A, Appendix, for a sample cash flow worksheet.)

Operate and Measure Performance

Since nonprofit organizations hold assets in trust for the public good, they must establish and maintain financial operations and controls that ensure that they function in a responsible and ethical manner. In addition, the board and staff need to rely on systems and reports that allow them to monitor results and measure performance against expectations established in the budget.

The management control cycle explained earlier shows how the interdependent elements of financial management intersect. The projections are budgets, the measurement is done through accounting record keeping, and the comparison and monitoring are made possible with financial statements. The previous section considered budgets. Now we look at some fundamental principles of accounting—what you need to account for with bookkeeping, how to track cash, and then how to summarize the many daily transactions into summary financial statements.

What follows is intended to introduce some basic elements of financial recording and measurement. Nonprofit financial systems records, like those of all businesses, provide critical data needed by board and key staff and are subject to monitoring by outside authorities. As a result, they should be set up and maintained carefully and reviewed periodically by a person with accounting expertise so that the nonprofit is run according to generally accepted accounting principles (GAAP). GAAP, which are defined by the American Institute of Certified Public Accountants (AICPA) and the Financial Accounting Standards Board (FASB), provide the basis for sound accounting policies and procedures.

Financial records should be maintained by a qualified bookkeeper or a person with specific training. Reasonably priced and user friendly accounting software is available to nonprofits. Using such software facilitates the process of managing financial information and producing financial reports.

GAAP classifies the assets of a nonprofit organization into three classifications. These classifications are: unrestricted, temporarily restricted, and permanently restricted net assets, and they indicate whether the funds have any restrictions on how they may be used. Temporarily and permanent restrictions are set by the donor.

Unrestricted net assets have no donor-imposed restrictions and they can be used for any operating and programmatic expenses authorized by the board. Restrictions placed on funds by the board, but not by the donor, are considered unrestricted. Examples of unrestricted funds include revenue from ticket sales, membership, retail operations and an annual appeal for general operations.

Temporarily restricted net assets have donor-imposed purpose or time restrictions. Once the restrictions are met, the funds may be used. A grant for a school program is temporarily restricted until the program is complete, at which point the funds are released from restrictions.

Permanently-restricted net assets are made up of contributions for which the donor requires that the funds be used in a specific way indefinitely. A gift to an endowment usually has a permanent restriction.

Such restricted funds must be tracked separately from funds donated for use in general operations. Regardless of how funds are designated, management has the obligation to use these various funds for the purposes for which they were intended and not use restricted funds inappropriately .

Accounting Methods

The process of financial record keeping is called accounting. A nonprofit organization chooses a "method of accounting" to show when revenues or expenses are recorded.

Cash basis accounting means that revenues are recorded when received, expenses are recorded when paid, and non-cash transactions (such as credit cards) are recorded upon their

Figure 5— Gotham Arts Council Annual Budget (Step 5)

Gotham Arts Council
ANNUAL BUDGET
July 1, 2002–June 30, 2003
Approved May 15, 2002

	Proposed '03 Budget	FY '02 Actual	FY '02 Budget
REVENUE			
Contributed Revenue			
Corporate grants	$19,000	$15,000	$13,000
Foundation grants	25,000	23,000	30,000
Government grants			
Federal			
State	11,000	13,000	13,000
Local			
Business contributions	22,500	22,000	20,000
Membership drive	25,000	22,750	22,000
Other Private donations	3,000	3,000	
Fundraising events	10,000	12,000	10,000
Earned Revenue			
Program admissions	13,000	12,798	13,000
Fees/tuition	6,500	5,575	5,500
Advertising	5,000	5,000	5,000
Sales	1,050	1,037	1,000
Investments		475	
Other	3,500		
TOTAL REVENUE	**144,550**	**135,635**	**132,500**

	Proposed '03	FY '02	FY '02
EXPENSES			
Salaries & benefits	60,000	56,392	56,500
Outside fees & services	1,000	1,000	1,000
Office supplies	500	428	500
Phone/FAX	2,000	1,837	1,500
Travel	2,500	2,500	2,500
Memberships	600	600	600
Professional development	1,200	1,000	1,200
Space rental	3,600	3,600	3,600
Utilities			
Insurance	250	250	250
Printing & copying	14,600	13,798	13,350
Postage/shipping	1,200	1,223	1,000
Artists' fees	25,000	22,500	22,500
Art materials	5,000	4,782	4,500
Equipment:			
Purchase	6,000		
Repair			
Rental	5,500	5,000	5,000
Hospitality	3,000	2,467	2,500
Other	1,000	1,000	1,000
Cash reserve	10,000	15,000	15,000
TOTAL EXPENSES	142,950	133,377	132,500
Net Surplus (Deficit)	1,600	2,258	-0-

Larry misunderstood the need for a bookkeeping system to leave a "trail" for others.

occurrence (Recording a transaction means entering it in your ledger or accounting system). Receivables, money that is owed to you but that you have not received, and payables, bills you have received but have not paid, are not recorded. While this method is easy to understand and implement, it often results in misleading financial information because it does not reflect financial obligations that may have been incurred but have not been recorded.

Accrual method accounting, is a method in which all committed income and expenses, whether or not they have been actually received or paid, are entered in the books. Promised income, a grant or written pledge for example, are entered as income (account receivable); a promise to pay (for example, a purchase of art supplies) is entered as an expense (account payable).

In contrast to cash basis accounting, the accrual method aims to accurately reflect all of the activities and obligations made during the current accounting period, not just cash transactions.

Modified cash basis accounting is often used by exempt organizations. Under this method, bookkeeping entries are made strictly on the cash basis throughout the accounting period. At the end of the period, entries are made at one time to adjust the financial records to an accrual basis form. This is usually done so that summarizing financial statements may be later presented in accrual form. Many exempt organizations have their auditors make these journal adjustments for them, so that the organization need only be concerned with maintaining accurate cash basis records.

Accounting procedures

The following briefly identifies and explains the steps to be followed in setting up a bookkeeping system. It is usually wise to seek the help of an experienced accountant or bookkeeper. When an organization's financial activities are substantial, the ongoing services of a bookkeeper or accountant are essential.

Internal control. Refers to procedures and policies that an organization can implement to improve security and avoid mismanagement of funds. A primary control measure is the separation of duties which requires that different people be responsible for aspects of the financial process such as check approval, check signing, and bookkeeping. However, in an all-volunteer organization or when there is only one staff member, this is nearly impossible. In these cases, the minimum safeguard is to require two signatures on checks. Often board members become involved in check signing and approval especially for expenses over a specified dollar amount. An experienced bookkeeper or CPA should review your internal control practices periodically and make recommendations for improvement.

Bookkeeping. From its inception, a tax-exempt organization receives money and incurs expenses. Accounting for these, as well as many other types of transactions, is accomplished through bookkeeping.

A bookkeeping system enables an organization to produce financial statements and monitor the budget. It provides the basis from which an audit is completed and is one of the most useful of management tools.

When establishing your bookkeeping system, picture yourself at audit time having to explain how money was spent and where money came from. Your bookkeeping system provides a "trail" of transactions for future workers to review.

Chart of accounts. A chart of accounts assigns a number or code to each type of transaction using five categories: revenue, expense, assets, liabilities and net assets, making it easier to keep track of transactions and produce reports in a consistent manner A sample of a simple chart of accounts for an organization is shown in Figure 6.

Recently several nonprofit support organizations have joined to develop a Unified Chart of Accounts for Nonprofit Organizations (UCOA). UCOA is available free through web sites and publications. The system is designed so that nonprofits can quickly and reliably translate their financial statements into the categories required by the IRS Form 990 and Form 990EZ, and other government reporting formats. UCOA is

Figure 6—Cash Receipts Journal

Date	Check No.	Source	Amount	Membership	Grants	Ticket Sales	Donations	Other
3/12	5762	E.E. Cummings	$500.00	$500.00				
3/12	148	John Smith	$ 30.00				$30.00	
3/13	A5487	Acme Foundation	$2,000.00		$2,000.00			
3/13		Total Deposit	$2,530.00					

extensive, but any nonprofit could select the categories that apply to their own operations. A copy of UCOA is available from the National Center for Charitable Statistics at the Urban Institute in Washington DC through their web site at www.nccs.urban.org/ucoa/.

Recording cash transactions. For a small organization with few transactions, the simplest way to record cash transactions is with the checkbook, check register, and deposit slips. Use a chart of accounts to help you determine to which source each transaction should be assigned and use the codes when you enter information in your cash journals.

Cash receipts journal. A cash receipts journal is a record of all checks and cash received by the organization. The journal identifies the source of the money received and the type of income it represents. The information in the cash receipts journal is then transferred to the general ledger at the end of the month.

The cash receipts journal records all of your cash income in one place. When you have more than one bank account, all deposit entries should be recorded in the cash receipts journal. It serves as a source document for the income amounts listed in your financial reports. It also provides a cash control when it is reconciled with your bank statements and with the general ledger's cash control account.

Entries in the cash receipts journal originate from your bank deposit slips. We suggest using deposit books with duplicate sheets and stapling each deposit receipt to its page in the deposit book. Cash receipts must be deposited intact. Currency income should be deposited along with checks, not used to pay expenses directly. The same controls, which apply to cash generally apply to credit card receipts and procedures should be established for submitting, checking and reconciling credit card receipts.

FASB defined separate accounting standards for contributions. When recording grants and

Figure 7—Cash Disbursements Journal

Date	Check No.	Description/ Paid To	Amount	Gen. Admin.	Program A	Program B	Fund-raising	Services
4/15	1174	AT&T	$85.00	$85.00				
4/15	1175	Acme Systems (rent)	$475.00	$475.00				
4/15	1176	Glory Productions artist fee	$3,500.00	$3,500.00				
4/15	1177	John Smith	$30.00*					

*The refund to John Smith must be recorded in the general ledger as a reduction in revenue rather than as an expense.

contributions, the actual payments and formal written pledge should be checked to determine if the donor restricted the funds. Restricted funds should be coded accordingly. Tax deduction acknowledgement forms may need to be sent to the donor to comply with applicable regulations. In-kind contributions and donated services, including volunteer hours, are also recorded in the accounting system.

Cash disbursements journal. A cash disbursements journal is a record of all cash disbursed by the organization. Most organizations use checks, and if you have only one checking account, your check register can serve as the cash disbursements journal.

For organizations with few transactions and only one bank account, the check register can be used as both the cash receipts and cash disbursements journal. Notations should still be made in the register regarding the source of cash and the appropriate accounts for expenses and income. Simply write the code number from your chart of accounts on checks, in the check register, and on deposit slips.

Bank reconciliation. The monthly bank statements must be reconciled with the cash journals. The reconciliation is the primary control over cash accounts and should be completed as soon as the bank statement is received. This verifies that the recorded information is correct. The reconciliation should be completed before amounts are entered into the general ledger so that you can avoid having to make correcting entries related to cash.

Other Financial Record Keeping

The accounting system should establish specific procedures for recording and reporting payroll expenses in accordance with procedures that are mandated by the Federal Government and each state. Organizations can receive guidance in setting up procedures and preparing reports from the Internal Revenue Service and the designated state government agencies. Since organizations that fail to comply with the requirements are subject to penalties, the board and staff must ensure that the proper procedures are always followed.

Fixed assets are the property and equipment owned by the organization and valued over a certain amount. Accounting guidelines define how the purchase or donation of fixed assets is recorded. Because equipment and property lose value over time as they are used, their value is reduced over time according to guidelines for "useful life." The process of reducing the value is called depreciation and depreciation is recorded in the accounting system.

Financial Statements

Financial statements provide the information that the board and staff need to measure the financial status of the organization. The two core financial statements are the statement of position (SOP), formerly called the balance sheet, and the statement of activities (SOA) also called income or operating statement. Data for both reports are compiled from the accounting system.

Generally accepted accounting principles (GAAP) set guidelines for the statements, and those guidelines are always followed when an organization uses an auditor to do a financial audit. For internal reporting, the board may modify the formats to provide data that they need for decisionmaking.

The SOP is a record of the organization's financial health at one point in time, such as the end of a month or fiscal year. It shows what the organization owns, what it owes and the difference between the two. That difference, or total net assets, are similar to what is called net worth, in for-profit organizations. The SOA summarized the organization's financial activity over a period of time and allows comparisons between time periods.

Statement of Position (Balance Sheet)

The statement of position is a snapshot of an organization's financial position as of a specific date. The key sections of the SOP are:

● **Total assets.** What the organization owns and is owed. Assets are divided into current assets or those available within the year and long term or fixed assets

● **Total liabilities.** What the organization owes. Liabilities are divided into current

Figure 8—Gotham Arts Council chart of Accounts

Gotham Arts Council / CHART OF ACCOUNTS

Statement of position Accounts Statement of Activities Accounts

Asset		Revenues	
101	Cash	401	Grants
102	Petty Cash	402	Donations
103		403	Memberships
104	Accounts Receivable	404	Fundraising Events
105	Grants Receivable	405	Program Admissions
106	Donations Receivable (Pledges)	406	Fees/Tuition
		407	Sales
107	Other Receivables	408	Advertising
108			
109		Expenses	
110	Inventory	501	Salaries
111	Prepaid Expenses	502	Benefits
112	Bulk Mail	503	Artist Fees
113		504	Outside Fees & Services
114		505	Art Materials
115	Equipment	506	Office Supplies
		507	Printing
Liabilities		508	Copying
201	Accounts Payable	509	Postage
202	Accrued Expenses	510	FAX
203	Notes Payable	511	Shipping
204	Other Liabilities	512	Telephone
205		513	Utilities
		514	Space Rental
Net Assets		515	Equipment
301	Unrestricted	516	Insurance
302	Temporarily Restricted	517	Travel
303	Permanently Restricted	518	Hospitality
		519	Memberships
		520	Professional Development

Figure 9—Gotham Arts Council Statement of position

Gotham Arts Council

STATEMENT OF POSITION

as of

July 31, 2002

ASSETS

Current Assets

Cash	$48,000	
Accounts Receivable		
Grants Receivable	7,000	
Other current Assets	150	
Total Current Assets		$55,150

Fixed Assets

Equipment

Office Furniture	$6,500	
Less: Accumulated Depreciation	(1,200)	
Total Fixed Assets		5,300
TOTAL ASSETS		$60,450

LIABILITIES AND Net Assets

Liabilities

Current Liabilities

Accounts Payable	$8,132	
Long term liabilities		
Notes Payable	3,300	
Total Liabilities		$11,432

Net Assets

Unrestricted

Beginning Balance	$31,760	
Net Income 2,258		
Balance at July 31, 2002	$34,018	
Temporarily Restricted 15,000		
Total Net Assets		49,018
TOTAL LIABILITIES AND NET ASSETS		$60,450

liabilities or those due within the year and long term liabilities that are due beyond the year, such as a mortgage

- **Total net assets.** The value of the assets minus the liabilities. Net assets are divided into unrestricted net assets, temporarily restricted net assets and permanently restricted net assets

The total assets presented on an SOP will equal the total liabilities plus the total net assets. Hence, the term "balance sheet." The formula that applies is "Total Assets = Total Liabilities + Net Assets."

Many organizations compare statement of position on the same date over several years to chart organizational change over time. An annual audit compares the end of the fiscal year audited to the end of the previous fiscal year. (See Figure 8, Gotham Arts Council Statement of position.)

The SOP is an essential tool for board and staff to monitor on a regular basis in order to determine whether the organization is financially healthy or at risk. Each organization should set a target for the level of assets it needs in order to support its mission for the long term. Board and staff also need to identify key indicators that they will use to monitor change.

Other Indicators of Financial Health

Some indicators that are recommended to test financial health compare current assets and current liabilities. By comparing current assets to current liabilities, you can determine the organization's ability to meet its present debts.

Current ratio. Current Assets (unrestricted cash and assets that can be converted into cash) ÷ Current Liabilities (debts payable within one year) = Current Ratio

Generally a current ratio of 2 to 1 is considered sufficient for the organization to pay its current obligations and have funds in reserve.

Current unrestricted net assets. (Current Unrestricted Assets – Current Liabilities) /

Annual Operating Expenses = Current Unrestricted Net Assets (as percent of operating expenses)

Generally an unrestricted net asset level of 10% to 30% of annual operating expenses is adequate to support current obligations and for cash flow management. Less than 10% means that the organization will often experience financial crisis.

Quick ratio. To determine how well the organization can meet its immediate obligations, compare cash and accounts receivable to current liabilities to determine quick ratio.

Current Assets + Accounts Receivable ÷ Current Liabilities = Quick Ratio

A quick ratio of 1 to 1 means that the organization can pay its current obligations and could survive only one month if it received no new money.

Statement of Activities

The statement of activities (SOA) is a summary of various revenues received and expenses incurred throughout the accounting period. It is also referred to as the income statement or budget-to-actual report. The functions listed as revenue and expenses are set up as they are in the budget so that the actual results can be consistent with and compared to the budget.

The SOA reports in a one-page summary what money came in and went out over a specified period. Board and staff compare actual financial performance for the fiscal year to date to that which was projected in the budget. Differences between what the budget projected and what actually occurred are noted as variances. Negative income variances mean that revenue is less than expected and may mean a problem exists. Negative expense variances indicate that the agency is spending less in a category than was forecast. In either case, a variance means that the leaders need to look more closely at that income or expense item to learn what has happened. If lower-than-forecast contributions suggest that donors are not responding to the annual appeal as usual,

Figure 10—Gotham Arts Council Statement of Activities

Gotham Arts Council, Statement of Activities as of July 31, 2002

Budget INCOME	Actual to Date from Actual	Total Annual	Variance
Corporate Grants	$15,000	$13,000	$2,000
Foundation Grants	23,000	30,000	(7,000)
Government Grants			
Federal			
State	13,000	13,000	-0-
Local			
Business Contributions	22,000	20,000	2,000
Membership Drive	22,750	22,000	750
Other Private Donations	3,000		3,000
Fundraising Events	12,000	10,000	2,000
Program Admissions	12,798	13,000	(202)
Fees/Tuition	5,575	5,500	75
Advertising	5,000	5,000	-0-
Sales	1,037	1,000	37
Interest	475		475
Other			
TOTAL INCOME	135,635	132,500	3,135
EXPENSES			
Salaries & Benefits	56,392	56,500	(108)
Outside Fees & Services	1,000	1,000	-0-
Office Supplies	428	500	(72)
Phone/FAX	1,837	1,500	337
Travel	2,500	2,500	-0-
Memberships	600	600	-0-
Professional Development	1,000	1,200	(200)
Space Rental	3,600	3,600	-0-
Utilities			
Insurance	250	250	-0-
Printing & Copying	13,798	13,350	448
Postage/Shipping	1,223	1,000	223
Artists' Fees	22,500	22,500	-0-
Art Materials	4,782	4,500	282
Equipment:			
Purchase			
Repair			
Rental	5,000	5,000	-0-
Hospitality	2,467	2,500	(33)
Other	1,000	1,000	-0-
Cash Reserve	15,000	15,000	-0-
TOTAL EXPENSES	133,377	132,500	877
Net Surplus (Deficit)	2,258	-0-	2,258

then you have a problem. Lower figures, however, could simply reflect that the annual benefit auction that will not take place until the next month and there is no reason to be alarmed. As a result, the SOA should include a column with the projection for the end of the fiscal year so the annual budget can be compared to the expected results for the year.

SOA is always prepared at the year's end. The report should also be prepared monthly and reviewed by the staff and treasurer and at least quarterly by the finance committee so board and staff can observe discrepancies and take steps to protect the organization from spending more money than it receives. This allows an organization's leaders to manage, not merely report the group's finances. (See the Gotham Arts Council's end of year operating statement, Figure 10.)

The statement of activities (SOA) also relates directly to the statement of position. The net revenue, the excess or deficiency of revenues over expenses, is added to the net assets on the statement of position. If the net revenue is positive (surplus), the net assets are increased. If the net revenue is negative (deficit), the net assets are decreased. Thus, all revenues and expenses flow to the statement of position. For the Gotham Arts Council, the net revenue from the SOA amounted to $2,258. This amount was added to the net assets as shown on the SOP.

The SOA can serve to evaluate performance when actual figures are compared to the budget. This financial picture reveals whether revenue targets are being met and whether expense limits are being exceeded.

You can compare total revenues to total costs to determine if the surplus will be maintained. Compare administrative expenses to program expenses. Be alert for an increasing proportion of the organization's funds being spent for administration. This is especially significant when you look for trends over several years. Your objective is to put the majority of the organization's resources to the mission directed activities. You may also compare your results with those of similar organizations to determine

if your trends are similar; however, such comparisons should be used only to indicate that added research is needed since each organization's circumstances are different.

Express each program's revenues and expenses as a percentage of total revenues and expenses. Look for programs that consume more than their share of expenses and contribute less than their share of revenues. If such a program is also peripheral to the fulfillment of your mission, it is a likely candidate for cost-saving measures or elimination.

Comparing several years' operating statements, look for significant changes in a revenue or expense category. A drop in sales, grants, or fundraising should cue a close examination of the cause.

Audits

An independent accountant can review an organization's various financial statements and operations, and produce a full audit, a review or a compilation.

- **Audit.** Certifies the fairness of the presentation of the financial statements based on an examination in accordance with generally accepted auditing standards

- **Compilation.** A service in which the financial data for the accounting period is compiled and the financial statements prepared without expressing any assurances that the statements are in compliance with GAAP

- **Review.** Reviews the financial statements issued by the organization on a limited scope and does not indicate whether the statements are in compliance with GAAP.

An audit is a series of procedures used to test transactions and internal controls employed by the organization. The accountant does this in order to form an opinion on the fairness of the presentation of the financial statements for the period. An auditor does not examine every transaction that has been recorded. Instead, he conducts a series of tests, the result of which will give him a basis for evaluating the

accuracy of accounting records and the degree of reliance he can place on the organization's internal controls. The end result of an audit is the expression of an opinion.

The compilation and financial review are most common for smaller organizations. Audits are usually performed only when required by funding sources or where dictated by the size and complexity of the organization.

Audit Opinions

The auditor may render one of four basic opinions:

- Unqualified. The financial statements are considered to be fairly presented in conformity with GAAP.

- Qualified. The auditor takes exception to some specific part of the financial statements as presented or is unable to form an unqualified opinion because of some contingency which might affect the financial statements.

- Adverse. In the auditor's opinion, the financial statements do not present fairly the financial position in conformity with GAAP.

- Disclaimer. The auditor is unable to form an opinion due to limitations of scope, uncertainties in the future, or poor bookkeeping by the client.

Audit benefits

Credibility of financial statements. The purpose of financial statements is to communicate in a direct manner what has transpired during the fiscal period. The presence of an auditor's opinion helps in this communication, because an independent expert has performed an examination and determined that the financial statements are presented fairly. If an organization can tell its financial story accurately and completely and it is accepted at face value, the potential contributor is more likely to feel that the organization is well managed. A certified public accountant (CPA) can provide key assistance in this process.

Meaningful statements. A CPA has years of experience in helping organizations prepare financial statements in a format that will be clear and understandable to the reader.

Advice on internal control and other matters. A CPA is in a position to advise the board on how to strengthen internal control or simplify bookkeeping procedures.

Assistance in tax reporting and compliance requirements. A CPA can help submit reports to regulatory agencies and/or the IRS.

Reports to the Internal Revenue Service

Annual tax return. Organizations with 501(c)(3) status are required to file a yearly tax return, IRS Form 990 or 990EZ. If your gross receipts are normally not more than $25,000 (check current 990 regulations for changes), you are exempt and do not have to file a completed return with the IRS. However, even if you are exempt, if you receive a Form 990 package in the mail, you should file a return without financial data. In addition, some states require a completed return regardless of your federal exemption.

Salaries and wages. Several forms are required when an organization has employees. These include:

- Form W-4 Employee's Withholding Allowance Certificate—enables an employee to define the correct amount of Federal income tax to be withheld from pay.

- Form 941 Employer's Quarterly Federal Tax Return—quarterly statements submitted to the IRS report tax liability.

- Form W-2 Wage and Tax Statement—An annual statement provided by an employer to an employee that summarizes gross wages and deductions.

- Form W-3 Transmittal of Income and Tax Statements—cover sheet that must accompany W-2 forms sent from an employer to the IRS.

Contractor-Related Forms include:

- Form W-9 Request for Taxpayer Identification Number and Certification–

given to the employer by the contractor. When the contractor is an individual, this form is used to report his or her social security number.

- Form 1099-Miscellaneous—the equivalent of a "W-2" form for contractors.

- Form 1096—cover sheet that must accompany 1099 Miscellaneous forms sent from an employer to the IRS.

Computerizing Your Financial System

A computerized accounting system may prove beneficial to your organization if any of the following apply:

- You write many checks each month or at certain times of the year.

- You must track a number of programs and/ or grants.

- You must produce specific kinds of reports (such as multiyear comparisons) that your current system cannot produce.

- Your accountant recommends it.

The transition process from manual system (or no system) to computerized system will be easier if you allocate sufficient time for research, testing of software packages, installation, and practice. Be prepared for even the most proficient bookkeeper to make mistakes when using a new computer system.

Accounting software. User friendly and affordable accounting software packages are readily available at your local computer retailer. As a result, most nonprofits now use computerized accounting systems to maintain the ledgers and report financial transactions. Computerized systems ease the work of the bookkeeper and enable the managers to get reports more quickly. Most commercial software packages provide the flexibility that allows you to make modifications that are usually necessary for a nonprofit organization.

The most popular basic systems are QuickBooks from Intuit, Inc, – www.quickbooks.com; and Peachtree from Peachtree Software, Inc. at

www.peachtree.com. These systems include, along with the basic ledgers, the ability to prepare budgets, cash flow reports, check writing, and payroll.

While the basic systems will work for many nonprofits, larger or more complex organizations may choose systems designed for nonprofits that provide additional system features including links to ticketing and fund raising components.

Decide how sophisticated you want your system to be by first evaluating your existing system and determining what features you want in the new system. Compare the features of several software packages, talk to other nonprofits that are using the software, and compare prices before making a decision. A key consideration should also be ease of use and the availability of training for staff.

Several Internet resources offer comparisons of nonprofit accounting software features including:

- The American Institute of CPA's web site: www.aicpa.org

- The NFP Accounting's web site: www.nfpaccounting.org

Spreadsheets. Spreadsheet programs computerize the simplest mathematical functions and provide the ability to prepare specialized reports and graphs. Microsoft Excel and QuatroPro are two of the most common. Basic software packages that come with most computers include spreadsheet software. Microsoft Office, for example, includes Excel. The accounting software packages provide links to spreadsheets and some versions have the ability to download data directly from the accounting system into a spreadsheet so a specialized report can be created without re-entering all the data.

New software packages continually appear on the market. We recommend that you ask your computer vendor about the current accounting and spreadsheet programs available.

APPENDIX

FINANCIAL MANAGEMENT

GLOSSARY

Accounting System
A series of manual and electronic processes and procedures used to accumulate financial transactions and information.

Accounts Payable
Outstanding obligations of an NPO (nonprofit organization) generated from day-to-day business activities which have been incurred but not paid. Obligations are generally supported by an invoice. Also see "Accrued Expense."

Accrued Expense
Outstanding obligations of an NPO generated from day-to-day business activities that have been incurred but not paid. Accrued expenses differ from accounts payable because they are estimates. Such estimates include accrued vacation, pension obligations, payroll, and taxes. Often accrued expenses and accounts payable are combined and shown on the same line item of the financial statements. Also see "Accounts Payable."

Asset
An item providing future economic benefit or future service potential in the form of future cash flows. Assets represent the total resources of an NPO and include cash, investments, receivables, prepaid expenses, office furniture and equipment, and inventory. Most assets are recorded at cost value (meaning the amount you paid is the dollar value of the asset recorded on your books.) Investments are generally recorded at fair market value rather than cost value.

Capitalize
To record the outlay of cash for a piece of equipment as an asset rather than as an expense. When you capitalize an asset (the equipment) you decrease cash and increase a fixed asset account. Then you will expense the item through periodic depreciation expense. For example, if a piece of equipment is expected to have a useful life of five years, you will record the asset when purchased (i.e., you will "capitalize" it) and you will record expense for the equipment over the five years its use.

Cash Disbursements (Payments) journal
An electronic or manual journal, which is used to record the disbursement of cash. Activities in this journal are summarized and posted to or included in the general ledger Also see "General ledger."

Cash Receipts journal
An electronic or manual journal which is used to record the receipt of cash. Activities in this journal are summarized and posted to or included in the general ledger. Also see "General Ledger."

Chart of Accounts
An electronic or manual listing of accounts, which usually includes an account number and description for each account. Account numbers are typically grouped together based on the nature of the account. For example, all assets have similar account numbers and all liabilities have similar account numbers. Transactions are recorded in these accounts.

Conditional Promises to Give
A promise to give, which is contingent upon a specific event occurring.

Contra-asset Account
An account (with a credit balance) that offsets an asset (with a debit balance). For example, accumulated depredation is a contra-asset account to the fixed asset balance. A reserve for uncollectible accounts is a contra-asset account to the accounts receivable balance. Such accounts are sometimes referred to as allowances.

Contribution
An unconditional, voluntary transfer of assets to the NPO, which is not intended to be payment for services or goods received by the transferor.

Credit
Balances are adjusted in the general ledger by recording debits and credits to accounts. A credit decreases an asset, increases a liability increases net assets, or records revenues/ gains. Also see "Debit and General Ledger."

Debit
Balances are adjusted in the general ledger by recording debits and credits in accounts. A debit increases an asset, decreases a liability decreases net assets, or records expenses/ losses. Also see "Credit and General Ledger."

Deferred Revenue

A liability balance related to cash received for goods not sent or services not frilly rendered. This could include advance payments for performances or cash received for publications not yet shipped.

Endowment Funds

When a donor permanently restricts all or part of his contribution, an "endowment" is created. For example, Donor X may ask that the principal amount of his gift be kept in perpetuity and that the interest be used to further the NPO's exempt purposes. This type of gift is commonly referred to as an endowment

Expenses

Result from the use of assets or the incurring of liabilities to achieve an NPO's objectives. Expenses are usually evidenced by invoices from vendors.

Fair Market Value

The amount for which you could currently sell an asset on an open market is the asset's fair market value (FMV). Investments should be recorded on the statement of activities at FMV. FMV is obtained from investment statements or quoted market prices in publications such as *The Wall Street Journal*.

Functional Classification of Expenses
The grouping of expenses by programs, or functions, is referred to as functional classification of expenses. The typical functional classification of expenses might include: Program A, Program B, Management and General (M&G), and Fundraising. Fundraising and M&G are referred to as supporting activities.

Fund Accounting

Fund accounting is the segregation of activities and/or assets and liabilities into specific funds within the chart of accounts.

General ledger

The summary of an NPO's accounts. Detail account transactions and journal activity is summarized in an organization's general ledger. Also see "Journal."

Generally Accepted Accounting Principles (GAAP)

Financial accounting and reporting standards, practices, and assumptions that all organizations must use in preparing external financial statements.

Grant

A grant is funding from an outside source to perform a specific function outlined in the grant agreement or grant proposal. Often, grant income is not considered to be contribution income if the grantor is receiving the primary benefit of the specified activity. If the activity benefits the general public rater than just the grantor (and especially if the activity fulfills the NPO's exempt purpose), the grant income would be considered contribution income.

Journal

An electronic or manual ledger used to record a type of business transaction or event. Journal activity is summarized in the general ledger. Also see "General Ledger," "Cash Receipts Journal," and "Cash Disbursements Journal."

Liability

An obligation to transfer cash or other assets, or to provide services, at some point in time. Typical liabilities include accounts payable, accrued expenses, and deferred revenue.

Liquid Asset

An asset which can be put into use in the near future. Cash is the most liquid asset on an organization's balance sheet. When assets are listed in order of liquidity, this means that cash is listed first. The assets are then listed in the order of how easily they can be converted to cash. Investments can be liquid, but a building would not be considered a liquid asset.

Net Assets (fund balance)

The residual amount of revenues less expenses from inception of the NPO. Net assets may have a audit, or positive balance, if life-to-date revenues exceed life-to-date expenses. Conversely, net assets may have a debit, or negative balance, if life-to-date expenses exceed life-to-date expenses. See also "Statement of Position."

Nonprofit Organization (NPO)

An entity organized and operated in accordance with federal and state nonprofit statutes, Although an NPO's objective is not to generate profits, an NPO may generate profits

as long as that profit is devoted to the NPO's purpose. An NPO may have to generate profits and establish reserves to insure the continuity of the organization into the future.

Permanently Restricted Net Assets

Those net assets whose purpose is permanently restricted by a donor. Note that a donor can designate a principal amount as permanently restricted, but indicate that earnings from the principal balance may be used for operations or another specific purpose. Also see "Endowment Funds."

Pledge

A promise or intention to give. If the pledge is a legally enforceable promise, it should be recorded as contribution income when the pledge is made. If it is merely an intention to give, it should not be recorded as contribution income until the contribution is received.

Receivables

An NPO's claims for assets from other entities. Different types of receivables include account (or trade) receivables, notes receivable, deposits, and pledges. Receivables can be classified as current, if expected to be received within one year of the reporting date, or noncurrent, if not expected to be received in the upcoming year.

Revenue

The inflow of economic resources (usually cash or accounts receivable) for goods sold, support received, or services performed.

Statement of Activities (SOA) (Also known as statement of change, profit & loss or income statement)

A financial statement, which summarizes the amount of revenues earned and expenses incurred by an NPO over a period of time (usually one month, one quarter, or one year).

Statement of Cash Flows

A financial statement, which shows the inflows and outflows of cash from operating activities, investing activities, and financing activities over a period of time.

Statement of Position (SOP) (Also known as balance sheet)

A financial statement that shows the assets, liabilities, and net assets of an organization at a specific point in time.

Tax-exempt Organization

An entity classified by the Internal Revenue Service as exempt from federal income taxes under certain provisions of the Internal Revenue Code. Nonprofit cultural organizations are usually classified as 501(c)(3).

Temporarily Restricted Net Assets

Those net assets whose use by an NPO has been limited by donors to later periods of time, after specified dates, or to specified purposes.

Trial Balance

A listing of the ending balances in each account. The ending total debit balances and ending total credit balances must equal. If they do not, the accounts are out of balance and there is an error somewhere in the posted transactions,

Unrestricted Net Assets (Including board designated net assets)

Those net assets whose use is not restricted by donors, If the board of directors opts to designate a portion of an NPO's net assets for a specific purpose, this portion of net assets would be a sub-category of unrestricted net assets called board-designated net assets.

Figure A — Sample Cash Flow Worksheet

	A	B	C	D	E	F	G	H	I	J	K	L	M
		July	August	September	October	November	December	January	February	March	April	May	June
1	CASH FLOW												
2	*Beginning Balance*												
3	EXPENSES												
4	Gen. Admin.												
5	Project A												
6	Project B												
7	Project C												
8	Project D												
9	Membership												
10	Special Events												
11	Other												
12	Newsletter												
13	Other												
14	Other												
15	Total Expenses												
16	*Balance*												
17	REVENUES												
18	Program A												
19	Program B												
20	Program C												
21	Program D												
22	Fundraising												
23	Contributions												
24	Grants												
25	Other												
26	Total Revenues												
27	*Closing Balance*												

Figure B — Sample Revenues Worksheet

	A	B	C	D	E	F	G	H	I
			\\multicolumn Programs/Projects						
1	REVENUES								
2	WORKSHEET								
3	DESCRIPTION	Total	A	B	C	D	Fundraising	Services	Other
4	Corporate Grants								
5	Foundation Grants								
6	Government Grants								
7	Federal								
8	State								
9	Local								
10	Business Contributions								
11	Membership Drive								
12	Other Private Donations								
13	Fundraising Events								
14	Program Admissions								
15	Fees/Tuitions								
16	Advertising								
17	Sales								
18	Interest								
19	Other								
20	TOTAL								
21									

Figure C — Sample Expense Worksheet

	A	B	C	D	E	F	G	H	I	J	K	L	M
					PROGRAMS			FUNDRAISING			SERVICES		
1	EXPENSES												
2	WORKSHEET		General										
3	DESCRIPTION	Total	Admin.	A	B	C	D	Member Ship	Special Events	Other	Newsletter	Other	Other
4	Salaries & Benefits												
5	Outside Fees & Services												
6	Office Supplies												
7	Phone/FAX												
8	Travel												
9	Memberships												
10	Professional Development												
11	Space Rental												
12	Utilities												
13	Insurance												
14	Printing/Copying												
15	Postage/Shipping												
16	Artists Fees												
17	Art Materials												
18	Equipment:												
19	Purchase												
20	Repair												
21	Rental												
22	Hospitality												
23	Other												
24	Total												

FIGURE D – SAMPLE MONTHLY STATEMENT OF ACTIVITIES

For the month ending:

	End of Last FY Actual	Year to Date Budget	Year to Date Actual	Variance	Total Budget Current Fiscal Year	Year-end Forecast Current Fiscal Year
Contributed Revenue						
Foundation grants						
Government Grants						
Federal						
State						
Local						
Business contributions						
Membership						
Other Private Donations						
Fund raising events						
Earned Revenue						
Program Admissions						
Fees/Tuition						
Advertising						
Sales						
Investment earnings						
Other						
Total Revenue						
Expenses						
Salaries and Benefits						
Outside fees and services						
Office Supplies						
Phone/FAX						
Travel						
Memberships						
Professional Development						
Space Rental						
Utilities						
Insurance						
Printing and Copying						
Postage/Shipping						
Artists' Fees						
Art Materials						
Equipment						
Purchoaase						
Repair						
Rental						
Hospitality						
Other						
Cash Reserve						
Operating surplus(deficit)						

CONTRIBUTING WRITERS AND EDITORS

Mary Altman • Barbara Schaffer Bacon

Denise Boston-Moore • Janet Brown

Tina D. Burdett • Craig Dreeszen

Gay Drennon • Maryo Gard Ewell

Lisa Kammel • Pam Korza

Halsey and Alice North • David O'Fallon

Shirley K. Sneve • Marete Wester • Sally Zinno

Mary Altman has worked for over twenty years in the fields of public art, community art and art education as an administrator, organizer, instructor, volunteer and consultant. She has worked with arts groups across Minnesota and in several states on collaboration, cultural planning, artist training, rural arts development, budgeting, fundraising and evaluation. She is currently the public arts administrator for the City of Minneapolis. Her publications include *A Handbook for Rural Arts Collaborations* (COMPAS 1993). Through a 1999 Leadership Initiatives in Neighborhoods fellowship, she studied cultural planning and community development models.

Barbara Schaffer Bacon is co-director for the Animating Democracy Initiative at Americans for the Arts' Institute for Community Development and the Arts. Funded by the Ford Foundation, the project's purpose is to foster artistic activity that encourages civic dialogue on important contemporary issues. During 13 years at the Arts Extension Service at the University of Massachusetts, Barbara worked to foster arts development in western Massachusetts' communities and nationally. She served as its executive director from 1985-1990. Barbara now works as a consultant with partner Pam Korza. Her work includes program design and evaluation for state and local arts agencies and private foundations. An arts management educator, Barbara has served as a designer and primary instructor for the arts management seminars nationally including AES sponsored summer and winter programs in arts management.

Denise Boston-Moore, Ph.D. is an educator, consultant, and expressive arts specialist. Denise earned her Ph.D. in counseling psychology at Walden University, her M.A. in counseling and psychology from Goddard College and a B.F.A. in Theatre at the North Carolina School of the Arts. She has lectured and facilitated workshops in arts and healing, arts education and community arts. Denise developed expressive arts programs for the Department of Parks, Recreation and Community Resources Community Arts in Arlington, Virginia and is a faculty instructor for the Arts Extension Service.

Denise is the founder of CIE (Create Impacting Experiences), a consulting firm in Silver Spring, Maryland.

Janet Brown is a consultant, teacher and keynote speaker with over thirty years of experience in nonprofit arts management. She has worked in urban and rural environments for nationally recognized arts institutions, community organizations, state arts agencies and statewide organizations. Janet has received the South Dakota Governor's Award in the Arts, the Selena Roberts Ottum Award from Americans for the Arts, Washington, DC and the Robert Gard Award from the University of Massachusetts Arts Extension Service, Amherst, MA. She is an adjunct faculty member at Goucher College, Baltimore, MD and is currently a Masters of Public Administration candidate. Janet has a passion for rural community arts development and advocacy.

Tina D. Burdett is an administrator, consultant and educator in the nonprofit sector. She is currently serving as development director at the Center for Children and Families in Norman, Oklahoma. Tina is also an instructor in the MAAA program at Goucher College in Baltimore where she teaches the distance learning course "Financial Management of the Arts." Tina's background in the arts includes community arts development with local arts agencies, state arts agencies, statewide assemblies and national service organizations. She also serves locally on the board of directors of the Children's Arts Network and as treasurer of the Oklahoma Coalition for School Age Care.

Craig Dreeszen, Ph.D. is an educator, consultant, and writer who works nationally with arts and other community organizations to do organizational development and strategic planning, collaborative planning, program evaluation, and community cultural planning. Craig earned his Ph.D. in regional planning and his M.ED. in organizational development at the University of Massachusetts Amherst. He is author of books, articles and courses on planning, board development, arts education collaborations, and program evaluation. Craig directed the Arts

Extension Service at the University of Massachusetts for twelve years until 2002. Dr. Dreeszen directs Dreeszen & Associates, a consulting firm in Northampton, Massachusetts.

Gay Drennon, Ph.D. is the director of The Florida Center for Creative Aging, a partnership project supported by The Florida Department of State, Division Of Cultural Affairs, VSA arts of Florida and an affiliate of The Florida Policy Exchange Center On Aging at the University of South Florida. Gay served for the past fifteen years as the chief executive officer of VSA arts of Florida. She additionally holds a visiting research associate appointment at Florida State University in the area of accommodations for students with disabilities in arts education. Her educational background includes a Ph. D. in arts education specializing in arts in community service with a certificate in program evaluation from Florida State University; a M.F.A. in sculpture from University of Georgia and a B.A. magna cum laude in studio art from Old Dominion University. Gay maintains a studio in Tallahassee, where she continues to produce sculpture that is exhibited and collected throughout the southeastern United States.

Maryo Gard Ewell is associate director at the Colorado Council on the Arts, where she has worked since 1982. Prior to that, she worked for the Illinois Arts Council and two community arts councils. She received an M.A. in Urban and Regional Planning from the University of Colorado-Denver, and an M.A. in Organizational Behavior from Yale. Recent honors include an Honorary Doctor of Humane Letters from Goucher College, and the Selina Roberts Ottum Award for community arts leadership from Americans for the Arts. She has authored numerous articles and serves on arts and community development boards statewide in Colorado and locally in her hometown of Gunnison.

Lisa Kammel is an arts consultant with an M.A. in Arts Administration from Florida State University. After completing her graduate degree, she spent four years working in

North Carolina at the United Arts Council of Raleigh and Wake County and the Southeastern Center for Contemporary Art (SECCA) in Winston-Salem. She has recently returned to Florida and has worked with Arts for a Complete Education (ACE) and with VSA arts of Florida as a fundraising consultant and program coordinator for Putting Creativity to Work. Currently, Lisa is a program specialist in the School Choice Office at the Florida Department of Education specializing in research and public outreach with charter schools.

Pam Korza is co-director of the Animating Democracy Initiative and provided research for and co-wrote the previous Animating Democracy study. She works with Barbara Schaffer Bacon in organizational assessment and planning and program design and evaluation for cultural organizations. For seventeen years, Pam worked with the Arts Extension Service (AES). While at AES, she coordinated the National Public Art Policy Project in cooperation with the Visual Arts Program of the National Endowment for the Arts, which culminated in the publication, *Going Public: A field guide to developments in art in public places* which she co-wrote and edited. She directed the Boston-based New England Film and Video Festival, a regional independent film festival, coordinated the New England Arts Biennial, and co-authored *The Arts Festival Work Kit*, and was co-editor and contributing writer to *Fundamentals of Local Arts Management*, also published by AES.

Halsey and Alice North are arts management consultants, specializing in fundraising, capital fund drives, feasibility studies, strategic planning, and community cultural planning. They have 30 years of experience working with arts councils, theaters, performing arts centers, and arts organizations. They are nationally recognized teachers of fundraising, board development, and planning. Halsey is the former executive director of the North Carolina Arts Council, the Charlotte Arts & Science Council, and New York City's Cultural Council Foundation. He has also

been vice president of C.W. Shaver & Company and Corporate Contributions Manager of Philip Morris Companies. Alice is a former investment banker. Halsey and Alice are both MBAs and, between them, have received the Distinguished Service Award from the North Carolina Association of Arts Councils, the Chairman's Award from the National Assembly of Local Arts Agencies (now Americans for the Arts), and the Fan Taylor Award from the Association of Performing Arts Presenters. They formed The North Group Inc. in 1987.

David O'Fallon, Ph.D. is an experienced leader of arts agencies and programs who has worked at the national, state and local levels to develop innovative programs to improve education through the involvement of the arts. He recently became president of MacPhail Center, one of the nation's largest community music schools. He was the executive director for the Perpich Center for the Arts. Dr. O'Fallon speaks and consults on leadership issues, the role of the artist in society and culture, the future of the arts, and the changing nature of arts organizations. He was director of education for the National Endowment for the Arts and a senior staff at the John F. Kennedy Center for the Performing Arts.

Shirley K. Sneve is the director of Arts Extension Service. A member of the Rosebud Sioux Tribe, Shirley was a founder of Northern Plains Tribal Arts Juried Show and Market, the Oyate Trail cultural tourism byway, and the Alliance of Tribal Tourism Advocates. She has been the director of the Washington Pavilion of Arts and Science Visual Arts Center in Sioux Falls, and assistant director of the South Dakota Arts Council. Shirley has been adjunct professor in Native American Studies at Augustana College and the University of Sioux Falls. She has served on numerous boards, including Native American Public Telecommunications, the National Alliance for Media Arts and Culture, South Dakotans for the Arts, Lutheran Social Services of SD, the Five College Native American Advisory Board and the Western Massachusetts Arts Alliance.

Marete Wester is an arts and education consultant, and faculty member of the Nonprofit Sector Resource Institute and an adjunct professor in the Arts Management division of Seton Hall's Center for Public Service Graduate School of Public Administration. From 1991 to 2002, she served as executive director of the Alliance for Arts Education/New Jersey. Marete has conducted workshops and presentations on arts education planning and coalition-building, advocacy campaign development and arts management on the international, national, state and local levels. She has held positions at the National Endowment for the Arts, and the Staten Island Council on the Arts.

Sally Zinno directs a consulting practice that works with the boards, chief executives and staff of arts and cultural organizations to develop and strengthen the managerial, planning, and financial skills they need to thrive. Formerly senior program advisor and director of evaluation at National Arts Stabilization (NAS), she directed the Columbus, Ohio stabilization project. and currently serves NAS as a senior associate. Sally directed the administrative and financial operations at the Delaware Art Museum and the Harvard University Art Museums and was the chief administrative officer at the Boston Museum of Science. She taught graduate courses in nonprofit administration and finance at Harvard, George Washington, and Tufts Universities. A graduate of Brown University, she earned a Masters Degree in Public Administration from Syracuse University.